www.wadsworth.com

wadsworth.com is the World Wide Web site for Thomson Wadsworth and is your direct source for dozens of online resources.

At *wadsworth.com* you can find out about supplements, demonstration software, and student resources. You can also send e-mail to many of our authors and preview new publications and exciting new technologies.

WADSWORTH.COM

Changing the way the world learns®

FROM THE WADSWORTH SERIES IN BROADCAST AND PRODUCTION

Albarran, Management of Electronic Media, Third Edition

Alten, Audio in Media, Seventh Edition

Alten, Audio in Media: The Recording Studio

Craft/Leigh/Godfrey, Electronic Media

Eastman/Ferguson, Media Programming: Strategies and Practices, Seventh Edition

Gross/Ward, Digital Moviemaking, Fifth Edition

Hausman/Benoit/Messere/O'Donnell, *Announcing: Broadcast Communicating Today*, Fifth Edition

Hausman/Benoit/Messere/O'Donnell, Modern Radio Production, Sixth Edition

Hilliard, Writing for Television, Radio, and New Media, Eighth Edition

Hilmes, Connections: A Broadcast History Reader

Hilmes, Only Connect: A Cultural History of Broadcasting in the United States

Mamer, Film Production Technique: Creating the Accomplished Image, Fourth Edition

Meeske, Copywriting for the Electronic Media: A Practical Guide, Fifth Edition

Stephens, Broadcast News, Fourth Edition

Viera/Viera, Lighting for Film and Electronic Cinematography, Second Edition

Zettl, Sight Sound Motion: Applied Media Aesthetics, Fourth Edition

Zettl, Television Production Handbook, Ninth Edition

Zettl, Television Production Workbook, Ninth Edition

Zettl, Video Basics, Fourth Edition

Zettl, Video Basics Workbook, Fourth Edition

Zettl, Zettl's VideoLab 3.0

Television Production Handbook

NINTH EDITION

Herbert Zettl

San Francisco State University

AUSTRALIA ■ BRAZIL ■ CANADA ■ MEXICO ■ SINGAPORE ■ SPAIN

UNITED KINGDOM UNITED STATES

Television Production Handbook, Ninth Edition Herbert Zettl

Publisher: Holly J. Allen

Senior Development Editor: Renee Deljon Assistant Editor: Darlene Amidon-Brent

Editorial Assistant: Sarah Allen

Senior Technology Project Manager: Jeanette Wiseman

Marketing Manager: Mark Orr Marketing Assistant: Alexandra Tran

Marketing Communications Manager: Shemika Britt Project Manager, Editorial Production: Jennifer Klos

Creative Director: Rob Hugel
Executive Art Director: Maria Epes

© 2006 Thomson Wadsworth, a part of The Thomson Corporation. Thomson, the Star logo, and Wadsworth are trademarks used herein under license.

ALL RIGHTS RESERVED. No part of this work covered by the copyright hereon may be reproduced or used in any form or by any means—graphic, electronic, or mechanical, including photocopying, recording, taping, Web distribution, information storage and retrieval systems, or in any other manner—without the written permission of the publisher.

Printed in the United States of America

1 2 3 4 5 6 7 09 08 07 06 05

ExamView® and ExamView Pro® are registered trademarks of FSCreations, Inc. Windows is a registered trademark of the Microsoft Corporation used herein under license. Macintosh and Power Macintosh are registered trademarks of Apple Computer, Inc. Used herein under license.

Library of Congress Control Number: 2005927283

Student Edition: ISBN 0-534-64727-8

International Student Edition: ISBN 0-495-00908-3

Print Buyer: Karen Hunt
Permissions Editor: Joohee Lee
Production Service: Ideas to Images

Cover and Text Designer: Gary Palmatier, Ideas to Images

Art Editor: Gary Palmatier, Ideas to Images

Photo Researcher: Roberta Broyer Copy Editor: Elizabeth von Radics

Illustrator: Ideas to Images

Compositor: Robaire Ream, Ideas to Images

Cover Printer: Phoenix Color Corp Printer: R.R. Donnelley/Willard

Thomson Higher Education 10 Davis Drive Belmont, CA 94002-3098 USA

For more information about our products, contact us at: Thomson Learning Academic Resource Center 1-800-423-0563

For permission to use material from this text or product, submit a request online at http://www.thomsonrights.com. Any additional questions about permissions can be submitted by e-mail to thomsonrights@thomson.com.

FOR ERIKA

Brief Contents

1 The Television Production Process

1.1 What Television Production Is All About 4

	1.2 Studios, Master Control, and Support Areas 18	11.2 What Switchers Do 254
2	Analog and Digital Television 26	12 Video-recording and Storage Systems 260
	2.1 Analog and Digital Television 28	12.1 How Video Recording Works 262
	2.2 Scanning Systems 36	12.2 How Video Recording Is Done 276
3	The Television Camera 40	13 Postproduction Editing 284
	3.1 How Television Cameras Work 42	13.1 How Postproduction Editing Works 286
-	3.2 From Light to Video Image 63	13.2 Making Editing Decisions 308
4	Lenses 68	14 Visual Effects 320
	4.1 What Lenses Are 70	14.1 Electronic Effects and How to Use Them 322
	4.2 What Lenses See 82	14.2 Nonelectronic Effects and How to Use Them 337
5	Camera Mounting Equipment 88	15 Design 342
	5.1 Standard Camera Mounts and Movements 90	15.1 Designing and Using Television Graphics 344
	5.2 Special Camera Mounts 98	15.2 Scenery and Props 355
6	Camera Operation and Picture Composition 104	16 Production People 366
	6.1 Working the Camera 106	16.1 What Production People Do 368
	6.2 Framing Effective Shots 115	16.2 How to Do Makeup and What to Wear 386
7	Lighting 126	17 Producing 390
	7.1 Lighting Instruments and Lighting Controls 128	17.1 What Producing Is All About 392
	7.2 Light Intensity, Lamps, and Color Media 150	17.2 Dealing with Schedules, Legal Matters, and Ratings 407
8	Techniques of Television Lighting 156	18 The Director in Preproduction 412
	8.1 Lighting in the Studio 158	18.1 How a Director Prepares 414
	8.2 Lighting in the Field 178	18.2 Moving from Script to Screen 431
9	Audio: Sound Pickup 188	19 The Director in Production and Postproduction 444
	9.1 How Microphones Hear 190	19.1 Multicamera Control Room Directing 446
	9.2 How Microphones Work 209	19.2 Single-camera Directing, Postproduction, and Timing 464
0	Audio: Sound Control 218	
	10.1 Sound Controls and Recording for Studio	20 Field Production and Big Remotes 470
	and Field Operations 220	20.1 ENG, EFP, and Big Remotes 472
	10.0	20.2 Counting Major France 497
	10.2 Postproduction and Sound Aesthetics 235	20.2 Covering Major Events 487

11 Switching, or Instantaneous Editing

11.1 How Switchers Work

242

Contents

ADOUT THE AUTHOR XXV
Preface xxvi
The Television Production Process
What Television Production Is All About 4
BASIC TELEVISION SYSTEM 4
EXPANDED STUDIO AND ELECTRONIC FIELD PRODUCTION SYSTEMS System Elements of Studio Production 4 Studio System in Action 5 System Elements of Field Production 7
PRODUCTION ELEMENTS 8 Camera 8 Lighting 9 Audio 10 Switching 12 Videotape Recording 13 Tapeless Systems 14 Postproduction Editing 14 Special Effects 16
Studios, Master Control, and Support Areas 18
TELEVISION STUDIO 18 Physical Layout 18 Major Installations 19
Program Control 21 Switching 22 Audio Control 22 Lighting Control 22 Video Control 23

Photo Credits

xxiii

	Scenery and Properties 24 Makeup and Dressing Rooms 25	
CHAPTER 2	Analog and Digital Television	26
section 2.1	Analog and Digital Television 28	
	BASIC IMAGE CREATION 28	
	BASIC COLORS OF THE VIDEO DISPLAY 28	
	WHAT DIGITAL IS ALL ABOUT 28 Why Digital? 30 Difference Between Analog and Digital 30 Digitization Process 30	
	Quality 32 Computer Compatibility and Flexibility 33 Signal Transport 33 Compression 34 Aspect Ratio 34	
SECTION 2.2	Scanning Systems 36	
	INTERLACED AND PROGRESSIVE SCANNING Interlaced Scanning System 36 Progressive Scanning System 36	
	DTV SYSTEMS 37 480p System 37 720p System 37 1080i System 38	
	FLAT-PANEL DISPLAYS 38 Plasma Display Panel 38 Liquid Crystal Display 38	
CHAPTER 3	The Television Camera	4
section 3.1	How Television Cameras Work 42	
	PARTS OF THE CAMERA 42	
	FROM LIGHT TO VIDEO SIGNAL Beam Splitter 42 Imaging Device 43	

MASTER CONTROL

Program Input 23 Program Storage 23 Program Retrieval 24

CAI	AEDA	CHAIN	45
LAI	NEKA	CHAIN	447

Camera Control Unit 45
Sync Generator and Power Supply 46

TYPES OF CAMERAS 46

Analog Versus Digital Cameras 46
Studio Cameras 47
ENG/EFP Cameras and Camcorders 4
Consumer Camcorders 48
Prosumer Camcorders 50

ELECTRONIC CHARACTERISTICS 50

Aspect Ratio 51
White Balance 51
Resolution 52
Operating Light Level 55
Gain 55
Video Noise and Signal-to-noise Ratio 5
Image Blur and Electronic Shutter 56
Smear and Moiré 56
Contrast 57
Shading 57

OPERATIONAL CHARACTERISTICS 57

Operational Items and Controls: Studio Cameras 57
Operational Items: ENG/EFP Cameras and Camcorders 59
External Operational Controls: ENG/EFP Cameras and Camcorders 6:

SECTION 3.2 From Light to Video Image 63

CCD PROCESS 63

NATURE OF COLOR 64

Color Attributes 64
Color Mixing 64

CHROMINANCE AND LUMINANCE CHANNELS 65

Chrominance Channel 65 Luminance Channel 65 Encoder 66

ELECTRONIC CINEMA 66

CHAPTER 4 Lenses

68

SECTION 4.1 What Lenses Are 70

TYPES OF ZOOM LENSES 70

Studio and Field Lenses 70 Zoom Range 70 Lens Format 72

88

OPTICAL CHARACTERISTICS OF LENSES Focal Length Focus 74 Light Transmission: Iris, Aperture, and f-stop Depth of Field **OPERATIONAL CONTROLS** 78 Zoom Control Digital Zoom Lens Focus Control 80 SECTION 4.2 What Lenses See **HOW LENSES SEE THE WORLD** 82 Wide-angle Lens Normal Lens Narrow-angle, or Telephoto, Lens **Camera Mounting Equipment**

SECTION 5.1 Standard Camera Mounts and Movements 90

BASIC CAMERA MOUNTS 90

Handheld and Shoulder-mounted Camera 90
Monopod and Tripod 90
Studio Badastal 02

Studio Pedestal 92

CAMERA MOUNTING (PAN-AND-TILT) HEADS 94

Fluid Heads 94 Cam Heads 95 Plate and Wedge Mount 95

CAMERA MOVEMENTS 95

SECTION 5.2 Special Camera Mounts 98

SPECIAL MOUNTING DEVICES 98

High Hat 98
Beanbag and Other Car Mounts 98
Steadicam 98
Short and Long Jibs 100
Studio Crane 100

ROBOTIC CAMERA MOUNTS 100

Robotic Pedestal 101 Stationary Robotic Camera Mount 102 Rail System 102

CHAPTER 6	Camera Operation and Picture Composition	104
section 6.1	Working the Camera 106	
	WORKING THE CAMCORDER AND THE EFP CAMERA Some Basic Camera "Don'ts" 106 Before the Shoot 107 During the Shoot 108 After the Shoot 111	
	WORKING THE STUDIO CAMERA Before the Show 112 During the Show 113 After the Show 114	
section 6.2	Framing Effective Shots 115	
	SCREEN SIZE AND FIELD OF VIEW 115 Screen Size 115 Field of View 115	
	FRAMING A SHOT: STANDARD TV AND HDTV ASPECT RATIOS Dealing with Height and Width 116 Framing Close-ups 117 Headroom 118 Noseroom and Leadroom 119 Closure 120	
	DEPTH 123	
CHAPTER 7	SCREEN MOTION 123 Lighting	126
SECTION 7.1	Lighting Instruments and Lighting Controls 128	
	STUDIO LIGHTING INSTRUMENTS 128 Spotlights 128 Floodlights 130	
	FIELD LIGHTING INSTRUMENTS 133 Portable Spotlights 133 Portable Floodlights 136 Diffusing Portable Spotlights 138 Camera Lights 139	
	LIGHTING CONTROL EQUIPMENT 140 Mounting Devices 140 Directional Controls 144 Intensity Controls: Instrument Size, Distance, and Beam 146	

Intensity Controls: Electronic Dimmers 147

SECTION 7.2

	Foot-candles and Lux 150 Incident Light 150 Reflected Light 151	
	CALCULATING LIGHT INTENSITY 151	
	OPERATING LIGHT LEVEL: BASELIGHT 152 Baselight Levels 152	
	TYPES OF LAMPS 153 Incandescent 153 Fluorescent 153 HMI 153	
	COLOR MEDIA 153 How to Use Color Media 154 Mixing Color Gels 154	
CHAPTER 8	Techniques of Television Lighting	156
SECTION 8.1	Lighting in the Studio 158	
	QUALITY OF LIGHT 158 Directional Light and Diffused Light 158	
	COLOR TEMPERATURE 158 How to Control Color Temperature 159	
	LIGHTING FUNCTIONS 160 Terminology 161 Specific Functions of Main Light Sources 161	
	Flat Lighting 165 Flat Lighting 165 Continuous-action Lighting 166 Large-area Lighting 167 High-contrast Lighting 167 Cameo Lighting 169 Silhouette Lighting 170 Chroma-key Area Lighting 170 Controlling Eye and Boom Shadows 171	
	CONTRAST 172 Contrast Ratio 173 Measuring Contrast 173 Controlling Contrast 173	
	BALANCING LIGHT INTENSITIES 174 Key-to-back-light Ratio 174 Key-to-fill-light Ratio 174	

LIGHT PLOT

175

Light Intensity, Lamps, and Color Media 150

OPERATION OF STUDIO LIGHTS 176

Safety 176

Preserving Lamps and Power 176 Using a Studio Monitor 176

SECTION 8.2 Lighting in the Field 178

SAFETY 178

Electric Shock 178 Cables 178 Fire Hazard 178

ENG/EFP LIGHTING 178

Shooting in Bright Sunlight 179
Shooting in Overcast Daylight 180
Shooting in Indoor Light 180
Shooting at Night 184

LOCATION SURVEY 184

Power Supply 185

CHAPTER 9 AL

Audio: Sound Pickup

188

SECTION 9.1 How Microphones Hear 190

ELECTRONIC CHARACTERISTICS OF MICROPHONES 190

Sound-generating Elements 199 Pickup Patterns 191

Microphone Features 192

OPERATIONAL CHARACTERISTICS OF MICROPHONES 193

Lavaliere Microphones 193

Hand Microphones 195

Boom Microphones 197

Headset Microphones 201

Wireless Microphones 202

Desk Microphones 203

Stand Microphones 205

Hanging Microphones 206

Hidden Microphones 207

Long-distance Microphones 208

SECTION 9.2 How Microphones Work 209

SOUND-GENERATING ELEMENTS 209

Dynamic Microphones 209
Condenser Microphones 209
Ribbon Microphones 209
Sound Quality 210

SPECIFIC MICROPHONE FEATURES 210

Impedance 210

Frequency Response 210

Balanced and Unbalanced Mics and Cables, and Audio Connectors

MIC SETUPS	FOR	MUSIC	PICKUP	214
------------	-----	-------	---------------	-----

Microphone Setup for Singer and Acoustic Guitar 214

Microphone Setup for Singer and Piano 214

Microphone Setup for Small Rock Group and Direct Insertion 215

MICROPHONE USE SPECIFIC TO ENG/EFP 215

					1	0	
СН	ΑF	T	E	R		0	

Audio: Sound Control

218

SECTION 10.1

Sound Controls and Recording for Studio and Field Operations 220

227

PRODUCTION EQUIPMENT FOR STUDIO AUDIO 220

Audio Console 220
Patchbay 224
Audio-recording Systems 225
Analog Recording Systems 225
Tape-based Digital Recording Systems

Tapeless Recording Systems 228

AUDIO CONTROL IN THE STUDIO 229

Audio Control Booth 229 Basic Audio Operation 230

PRODUCTION EQUIPMENT AND BASIC OPERATION FOR FIELD AUDIO 232

Keeping Sounds Separate 233 Audio Mixer 233

AUDIO CONTROL IN THE FIELD 233

Using the AGC in ENG and EFP 233 EFP Mixing 233

SECTION 10.2

Postproduction and Sound Aesthetics 235

AUDIO POSTPRODUCTION ACTIVITIES 235

Linear and Nonlinear Sound Editing 235
Correcting Audio Problems 236
Postproduction Mixing 236
Controlling Sound Quality 236

AUDIO POSTPRODUCTION ROOM 237

Digital Audio Workstation 237

Analog Audio Synchronizer 238

Keyboards and Sampler 238

Automatic Dialogue Replacement 238

SOUND AESTHETICS 239

Environment 239
Figure/Ground 239
Perspective 239
Continuity 240
Energy 240

STEREO AND SURROUND SOUND 240

Stereo Sound 240 Surround Sound 241

CHAPTER 11	Switching, or Instantaneous Editing	242
SECTION 11.1	How Switchers Work 244	
	BASIC SWITCHER FUNCTIONS 244	
	Program Bus 244 Mix Buses 245 Preview Bus 245 Effects Buses 246 Multifunction Switchers 246	
	Cut or Take 248 Dissolve 249 Super 251 Fade 251 Additional Special-effects Controls 251	
SECTION 11.2	What Switchers Do 254	
	Production Switchers 254 Postproduction Switchers 255 Master Control Switchers 256 Routing Switchers 256	
	ELECTRONIC DESIGNS 256 Composite and Component Switchers 256 Analog and Digital Switchers 258 Audio-follow-video Switchers 258	
CHAPTER 12	Video-recording and Storage Systems	260
SECTION 12.1	How Video Recording Works 262	
	RECORDING SYSTEMS AND TECHNOLOGY 262 Analog and Digital Systems 262 Linear and Nonlinear Systems 263 Composite and Component Systems 263 Sampling 265 Compression 265	
	TAPE-BASED RECORDING AND STORAGE SYSTEMS 266	
	How Videotape Recording Works 266 Operational VTR Controls 267 Electronic Features 269 Analog Videotape Recorders 269 Digital Videotape Recorders 270	

TAPELESS RECORDING AND	STORAGE SYSTEMS	273
Hard Dick Systems	272	

Hard Disk Systems 273
Read/Write Optical Discs 274
Flash Memory Devices 274
Data Transfer 274

SECTION 12.2 How Video Recording Is Done 276

USES OF VIDEO RECORDING AND STORAGE 276

Building a Show 276

Time Delay 276

Program Duplication and Distribution 276

Record Protection and Reference 276

VIDEO-RECORDING PRODUCTION FACTORS 276

Preproduction 277
Production 279

CHAPTER 13

Postproduction Editing

284

SECTION 13.1 How Postproduction Editing Works

EDITING MODES: OFF- AND ON-LINE 286

Linear Off- and On-line Editing 286 Nonlinear Off- and On-line Editing 287 286

BASIC EDITING SYSTEMS 287

Linear Systems 287 Nonlinear Systems 287 Editing Principle 287

LINEAR EDITING SYSTEMS 288

Single-source System 288
Expanded Single-source System 289
Multiple-source Systems 290

CONTROL TRACK AND TIME CODE EDITING 291

Control Track, or Pulse-count, Editing 291 Time Code Editing 293

LINEAR EDITING FEATURES AND TECHNIQUES 294

Assemble Editing 294 Insert Editing 295

AB ROLLING AND AB-ROLL EDITING 295

AB Rolling 295 AB-roll Editing 297

NONLINEAR EDITING SYSTEMS 297

NONLINEAR EDITING FEATURES AND TECHNIQUES 298 Capture 298 Compression 299 Storage Juxtaposing and Rearranging Video and Audio Files 299 **PRE-EDITING PHASE** 300 Shooting Phase Review Phase 301 Preparation Phase 301 **EDITING PROCEDURES** 304 Shot Selection 304 Shot Sequencing Audio Sweetening Creating the Final Edit Master Tape Operational Hints SECTION 13.2 **Making Editing Decisions** 308 **EDITING FUNCTIONS** 308 Combine 308 Shorten 308 Correct 308 Build 309 **BASIC TRANSITION DEVICES** 309 Cut 309 Dissolve 309 Wipe 309 Fade 310 MAJOR EDITING PRINCIPLES Continuity Editing 312 Complexity Editing 317 Context 317 Ethics 318 Visual Effects 320 SECTION 14.1 Electronic Effects and How to Use Them STANDARD ANALOG VIDEO EFFECTS Superimposition Key 322 Chroma Key 324 Wipe 327 **DIGITAL VIDEO EFFECTS** 329

Computer-manipulated Effects 330 Image Size, Shape, Light, and Color 330

Motion 333 Multi-images 335

SECTION 14.2	Nonelectronic Effects and How to Use Them 337	
	OPTICAL EFFECTS 337 Television Gobos 337 Reflections 338 Star Filter 338 Diffusion Filters 338 Defocus 339	
	MECHANICAL EFFECTS 339 Rain 340 Snow 340 Fog 340 Wind 340 Smoke 340 Fire 340 Lightning 341	
CHAPTER 15	Design Designing and Using Television Graphics 344	342
SECTION 13.1	Designing and Using Television Graphics 344 SPECIFICATIONS OF TELEVISION GRAPHICS 344 Aspect Ratio 344 Scanning and Essential Areas 345 Out-of-aspect-ratio Graphics 346 Matching STV and HDTV Aspect Ratios 346 Information Density and Readability 348 Color 350 Style 352 Synthetic Images 353	
SECTION 15.2	Scenery and Props 355	
	TELEVISION SCENERY 355 Standard Set Units 355 Hanging Units 357 Platforms and Wagnes 358	

Platforms and Wagons 358 Set Pieces 359

PROPERTIES AND SET DRESSINGS 360

Stage Props 360 Set Dressings 360 Hand Properties 360 Prop List 360

ELEMENTS OF SCENE DESIGN 361

Floor Plan 361 Set Backgrounds and Platforms 363 Studio Floor Treatments

CHAPTER 16	Production People	366
SECTION 16.1	What Production People Do 368 NONTECHNICAL PRODUCTION PERSONNEL 368 TECHNICAL PERSONNEL AND CREW 370	
	NEWS PRODUCTION PERSONNEL 370	
	TELEVISION TALENT 371	
	PERFORMANCE TECHNIQUES 373 Performer and Camera 373 Performer and Audio 375 Performer and Timing 375 Performer and Postproduction 376 Floor Manager's Cues 376 Prompting Devices 376	
	ACTING TECHNIQUES 382 Audience 383 Blocking 383 Memorizing Lines 383 Timing 384 Actor and Postproduction 384 Director/Actor Relationship 384	
	AUDITIONS 384	
SECTION 16.2	How to Do Makeup and What to Wear 386	
	MAKEUP 386 Materials 386 Application 387 Technical Requirements 387	
	CLOTHING AND COSTUMING 388 Clothing 388 Costuming 389	
CHAPTER 17	Producing	390
SECTION 17.1	What Producing Is All About 392	
	PREPRODUCTION PLANNING: FROM IDEA TO SCRIPT 392 Generating Program Ideas 392 Using Production Models 393 Writing the Program Proposal 395 Preparing a Budget 397 Writing the Script 401	

PREPRODUCTION PLANNING: COORDINATION 401

People 401

Facilities Request 402

Schedules 403

Permits and Clearances 403

Publicity and Promotion 404

LINE PRODUCER: HOST AND WATCHDOG 404

Playing Host 404

Watching the Production Flow 404

Evaluating the Production 404

POSTPRODUCTION ACTIVITIES 405

Postproduction Editing 405

Evaluation and Feedback 405

Recordkeeping 405

SECTION 17.2 Dealing with Schedules, Legal Matters, and Ratings 407

TIME LINE 407

INFORMATION RESOURCES 407

UNIONS AND LEGAL MATTERS 409

Unions 409

Copyrights and Clearances 409

Other Legal Considerations 410

AUDIENCE AND RATINGS 410

Target Audience 410

Ratings and Share 410

CHAPTER 18

The Director in Preproduction

412

SECTION 18.1 How a Director Prepares 414

THE DIRECTOR'S ROLES 414

Director as Artist 414

Director as Psychologist 414

Director as Technical Adviser 415

Director as Coordinator 415

PREPRODUCTION ACTIVITIES 415

Process Message 415

Production Method 415

Production Team and Communication 416

Scheduling 416

Script Formats 416

Script Marking 419

Floor Plan and Location Sketch 427

Facilities Request 428

SUPPORT STAFF 429

Floor Manager 429
Associate, or Assistant, Director 430
Production Assistant 430

Moving from Script to Screen 431

VISUALIZATION AND SEQUENCING 431

Formulating the Process Message 435
Medium Requirements 435
Interpreting the Floor Plan and the Location Sketch 437

SCRIPT ANALYSIS 440

Locking-in Point and Translation 440 Storyboard 440

CHAPTER 19 The Director in Production and Postproduction 444

SECTION 19.1 Multicamera Control Room Directing 446

THE DIRECTOR'S TERMINOLOGY 446

MULTICAMERA DIRECTING PROCEDURES 446

Directing from the Control Room 447 Control Room Intercom Systems 447

DIRECTING REHEARSALS 455

Script Reading 455
Dry Run, or Blocking Rehearsal 456
Walk-through 457
Camera and Dress Rehearsals 457
Walk-through/Camera Rehearsal Combination 45
Preparing a Time Line 459

DIRECTING THE SHOW 461

Standby Procedures 461
On-the-air Procedures 461

SECTION 19.2 Single-camera Directing, Postproduction, and Timing 464

SINGLE-CAMERA DIRECTING PROCEDURES 464

Visualization 464
Script Breakdown 466
Rehearsals 466
Videotaping 466

POSTPRODUCTION ACTIVITIES 466

CONTROLLING CLOCK TIME 467

Schedule Time and Running Time 467
Clock Back-timing and Front-timing 467
Converting Frames into Clock Time 468

CONTROLLING SUBJECTIVE TIME 468

								١.	<u> </u>	V	
_			n	_	_	R	/	4		۱	
L	Н	A	P	1	E	K	4	-	V		

Field Production and Big Remotes

470

SECTION 20.1

ENG, EFP, and Big Remotes 472

ELECTRONIC NEWS GATHERING 472

ENG Production Features 473 Satellite Uplink 473

ELECTRONIC FIELD PRODUCTION 474

Preproduction 474

Production: Equipment Check 475

Production: Setup 476

Production: Rehearsals 477

Production: Videotaping 477

Production: Strike and Equipment Check 477

Postproduction 477

BIG REMOTES 477

Preproduction: The Remote Survey 478
Production: Equipment Setup and Operation 480
Production: Floor Manager and Talent Procedures 485

SECTION 20.2

Covering Major Events 487

SPORTS REMOTES 487

LOCATION SKETCH AND REMOTE SETUPS 487

Reading Location Sketches 487

Production Requirements for Public Hearing (Indoor Remote) 495

Production Requirements for Parade (Outdoor Remote) 497

COMMUNICATION SYSTEMS 499

ENG Communication Systems 499
EFP Communication Systems 499
Big-remote Communication Systems 499

SIGNAL TRANSPORT 500

Microwave Transmission 500

Communication Satellites: Frequencies, Uplinks, and Downlinks 501

Cable Distribution 503

Epilogue 505

Glossary 506

Selected Reading 532

Index 534

Photo Credits

360 Systems, 10.12

Edward Aiona, author portrait p. xxv, 1.1, 1.2, 1.5, 1.13, 1.14, 1.15, 1.16, 1.17, 1.18, 1.19, 1.20, 1.21, 1.22, 1.24, 2.1, 3.6, 3.9, 3.11, 3.19, 3.22, 3.23, 4.1, 4.2, 4.5, 4.15, 4.18, 4.19, 4.20, 4.21, 4.22, 4.23, 4.24, 4.29, 4.30, 5.13, 5.15, 5.19, 6.1, 6.2, 6.3, 6.4, 6.5, 6.6, 6.7, 6.14, 6.15, 6.16, 6.17, 6.18, 6.19, 6.20, 6.21, 6.22, 6.23, 6.24, 6.25, 6.26, 6.27, 6.30, 6.31, 6.34, 6.35, 6.36, 6.37, 7.4, 7.6, 7.22, 7.27, 7.28, 7.29, 7.33, 7.34, 7.37, 7.38, 7.39, 7.40, 7.44, 7.45, 7.47, 8.3, 8.4, 8.5, 8.6, 8.8, 8.9, 8.11, 8.16, 8.17, 8.18, 8.19, 8.20, 8.21, 8.22, 8.23, 8.24, 8.29, 9.1, 9.7, 9.8, 9.9, 9.15, 9.16, 9.17, 9.18, 9.24, 9.32, 9.35, 10.1, 10.3, 10.5, 10.7, 10.10, 10.16, 10.20, 11.1, 11.4, 11.5, 11.6, 11.7, 11.8, 11.9, 11.10, 11.11, 11.15, 11.16 (lower), 12.15, 12.18, 12.19, 13.2, 13.14, 13.16, 13.20, 13.21, 13.22, 13.23, 13.24, 13.25, 13.26, 13.27, 13.28, 13.29, 13.33, 13.34, 13.35, 14.3, 14.8, 14.9, 14.11, 14.12, 14.13, 14.14, 14.16, 14.17, 14.19, 14.20, 14.21, 14.22, 14.23, 14.24, 14.25, 14.32, 14.34, 14.36, 14.37, 15.8, 15.9, 15.12, 15.13, 15.19 (left), 15.20, 15.27, 15.37, 16.6, 16.7, 19.1, 19.6, 20.1

AKG Acoustics, 9.6, 9.25, 9.34

Alesis, 10.13

Alex Zettl, 4.27

Apple Computer, Inc., 10.14, 13.15

Avid Technology, Inc. (owns ProTools), 10.21

beyerdynamic, Inc., 9.10, 9.34

Broadcast and Electronic Communication Arts Department at San Francisco State University, 8.7, 9.29, 13.13, 14.18, 14.30, 15.26, 17.6

Renee Child, 14.31

Chimera, 7.20, 7.24

Cinekinetic Pty Ltd., Australia, 5.18

Franke D. Cocke, courtesy Okino, 15.21

Cooperative Media Group, 14.27

Creation Technologies, LLC, 11.12

Denon Electronics, 10.15

DykorTech, 5.20

Echolab, LLC, 1.11

Electro-Voice, 9.34

Frezzi Energy Systems, 7.25

Fujinon, Inc., 4.17

Leviton, Colortran Division, 7.1, 7.36, 7.41

Loud Technologies, Inc., 1.10

Lowel-Light Mfg., Inc., 1.8, 7.9, 7.10, 7.12, 7.14, 7.15, 7.18, 7.19, 7.21, 7.23, 7.26, 7.35

Mole-Richardson Company, 7.3, 7.5, 7.7, 7.8, 7.11, 7.13, 7.17

Neumann USA, 9.34

NewTek, 11.14

Nikon, Inc., 4.6, 4.7, 4.16

OConnor Engineering, 5.4, 5.14

Gary Palmatier, 3.15, 3.16, 6.12, 12.20, 14.26, 20.2

Panasonic Broadcast & Digital Systems Co., 3.30, 4.3, 11.13, 12.14, 12.16, 13.1, 13.3, 13.4

Pioneer New Media Technologies, 12.17

Professional Sound Corporation, 9.34

QTV, 16.8

Steve Renick, 5.12, 5.19 (right)

Sachtler GmbH & Co., 5.1

Selco Products Company, 10.4

Sennheiser Electronic Corporation, 9.14, 9.21, 9.34

Shure, Inc., 1.9, 9.22, 9.23, 9.34, 10.18

Sony Electronics, Inc., 1.6, 1.12, 3.5, 3.10, 3.12, 3.13, 9.34, 12.8, 12.9, 12.10, 12.11, 12.13

TASCAM Corporation, 10.8, 10.11

Telescript, Inc., 16.9

The Tiffen Company, LLC, 5.16, 5.17

Thomson/Grass Valley, 11.16 (upper), 14.15

Video Robotics, Inc., 5.24

Vinten, Inc., 5.2, 5.3, 5.5, 5.6, 5.8, 5.9, 5.10, 5.11, 5.21, 5.22, 5.23

Vizrt, 15.22, 15.23

Herbert Zettl, 1.7, 3.8, 3.14, 3.20, 3.21, 4.12, 4.13, 4.25, 4.26, 4.28, 6.8, 6.9, 6.10, 6.11, 6.13, 6.28, 6.29, 6.32, 6.33, 7.16, 7.30, 7.31, 7.32, 7.42, 7.43, 9.5, 9.11, 9.12, 9.13, 9.19, 9.20, 9.31, 9.33, 13.31, 13.32, 14.1, 14.10, 14.28, 14.29, 14.30 (inset), 14.35, 15.16, 15.19 (center), 15.25, 15.28, 15.31, 15.36, 20.3, 20.4, 20.18

The CNN logo (15.1) is courtesy of Cable News Network.

The hand-drawn storyboard (18.20) is courtesy of Bob Forward, Detonation Films.

The computer-generated storyboard (18.21) is courtesy of PowerProduction Software.

About the Author

ERBERT ZETTL is a professor emeritus of the Broadcast and Electronic Communication Arts Department at San Francisco State University (SFSU). He taught there for many years in the fields of video production and media aesthetics. While at SFSU he headed the Institute of International Media Communication. For his academic contributions, he received the California State Legislature Distinguished Teaching Award and, from the Broadcast Education Association, the Distinguished Education Service Award.

Prior to joining the SFSU faculty, Zettl worked at KOVR (Stockton-Sacramento) and as a producer-director at KPIX, the CBS affiliate in San Francisco. While at KPIX he participated in a variety of CBS and NBC network television productions. Because of his outstanding contributions to the television profession, he was elected to the prestigious Silver Circle of the National Academy of Television Arts and Sciences (NATAS), Northern California Chapter. He is also a member of the Broadcast Legends of the NATAS Northern California Chapter.

In addition to this book, Zettl has authored *Television Production Workbook*, *Sight Sound Motion*, and *Video Basics*. All of his books have been translated into several languages and published overseas. His numerous articles on television production and media aesthetics have appeared in major media journals worldwide. He has lectured extensively on television production and media aesthetics at universities and professional broadcast institutions in the United States and abroad and has presented key papers at a variety of national and international communication conventions.

Zettl developed an interactive DVD-ROM, Zettl's VideoLab 3.0, published by Thomson Wadsworth. His previous CD-ROM version won several prestigious awards, among them the Macromedia People's Choice Award, the New Media Invision Gold Medal for Higher Education, and Invision Silver Medals in the categories of Continuing Education and Use of Video.

Preface

THE FACT that anyone with a digital consumer camcorder and a laptop computer loaded with special-effects software can produce high-quality images may mislead some students into believing that they are ready to shoot an Emmy award–caliber documentary even before taking a television production class. Far from it. Even the especially gifted ones who have managed to produce some impressive videotape segments all by themselves will soon discover that professional television requires a mastery of a great many more production tools and techniques. All are usually surprised by the extent of teamwork required for the efficient and effective production of even a relatively simple show. The *Television Production Handbook* is designed to help students acquire these skills.

My emphasis in this edition of the *Handbook* is not so much on highly detailed descriptions of available equipment, such as specific model numbers or the locations of various switches and jacks on a popular camcorder, but rather on what the major tools of television production are, what they can and cannot do, and how to make use of them in a variety of production situations. In this edition I emphasize the production requirements of digital television, without compromising the proven production methods.

PRODUCTION HIGHLIGHTS

The *Handbook* focuses on a variety of points that are especially relevant to the television production of today and tomorrow. The following summaries will provide you with an overview of these major production points.

Television system Television production is explained as a system in which equipment, people, and processes interrelate. It is important to learn how every element in television production is essential for the proper functioning of all the others. Once students perceive television

production as a system, they are better prepared to see and understand how the production details interact as essential parts of a larger process.

Analog and digital The text delineates the major differences between analog and digital television processes and how they apply to production. Related coverage also clarifies the often-puzzling terminology of digital television and explains the various interlaced and progressive scanning systems. The key concept about digital television is that its signal is highly robust, which means that it remains relatively noise-free through many generations and can be easily manipulated.

Consumer, prosumer, and professional equipment The differences among consumer, prosumer, and professional equipment are often exaggerated by the manufacturers and distributors to define their markets rather than their concern with production quality. With adequate lighting the difference between a good prosumer camera and low-end professional one is incidental.

HDV and HDTV The various scanning, sampling, and compression standards of digital television (DTV), high-definition video (HDV), and high-definition television (HDTV) are explained in various chapters. The major differences between HDV and HDTV are listed, as are the differences among the three digital scanning standards: 480p, 720p, and 1080i.

Studio and field production Because of the mobility of DTV equipment, the argument prevails that studios are obsolete and that the traditional multicamera approach to television production has largely been replaced by the much more efficient single-camera field production. But simply watching a day's television programs or reading the evening lineup of shows in a program guide reveals that a

surprising amount of shows were created as multicamera studio productions. The studio still provides maximum production control for single- and multiple-camera productions. Contemporary film directors too tend to use a multicamera television setup in addition to the traditional film camera.

Nevertheless, small, high-quality camcorders and portable audio and lighting equipment often make it more practical to take the production to the street corner rather than simulate the street corner in the studio. To function effectively in video production, we can no longer specialize in studio or field production but must be equally proficient in both. This is why both production approaches are thoroughly integrated throughout this book.

Aesthetics and design Despite the DTV revolution, it is still the story that drives production techniques and not the other way around. And many traditional aesthetic factors of picture composition, lighting, and shot sequencing are relatively independent of technological advances and therefore form the basis of effective television production. The extended description of basic aesthetic principles is not intended to detract from learning the major technical aspects of production equipment but rather to facilitate their optimal application.

Aspect ratio For some time to come, students must learn to compose shots for both the 4×3 standard television aspect ratio and the stretched 16×9 HDTV screen. Stretching the 4×3 pictures into a 16×9 frame is still necessary when showing old footage but is no longer acceptable when producing exclusively for wide-screen HDTV. Almost all screen images in this book are therefore presented in the new 16×9 aspect ratio. This presentation should help students visualize shots in the stretched frame and study the advantages and the disadvantages of the 16×9 ratio. Coverage also includes valuable information on designing for the traditional 4×3 aspect ratio as well as for the stretched 16×9 HDTV screen.

PEDAGOGICAL FEATURES

To facilitate student learning, I have incorporated several pedagogical principles into the *Handbook*.

Brief sections Each chapter is broken up into relatively short sections marked by separate headings. I hope that such a layout will counteract reading fatigue without fracturing chapter content.

Two-tier approach The *Handbook* is designed to serve beginning students as well as those who are more adept at television production. To prevent the less advanced reader from getting bogged down by the multitude of technical details, each chapter is divided into two sections. Section 1 contains the basic information about a specific topic; section 2 presents more-detailed material. The two sections can be assigned and read together or independently.

Redundancy As in learning a new language, a certain amount of repetition is important in helping the student learn and remember the major television vocabulary and production concepts. The key terms are listed at the beginning of each chapter. To benefit from this learning aid, the student should read the key terms *before* committing to the chapter. The key terms appear in *bold italic* in the context in which they are defined in the text and are repeated as part of the extensive glossary at the back of the book. Other glossary terms appear in *italic* type throughout the text. The Main Points section at the end of each chapter summarizes its essential content. Students should use these summaries as a checklist of what they are expected to know.

Illustrations The numerous full-color pictures and diagrams are intended to bridge the gap between description and the real thing. All appropriate illustrations that simulate TV images are in the 16×9 HDTV aspect ratio. In most cases the pictures of equipment are to represent a generic type rather than a specific preferred model.

NEW TO THIS EDITION

In response to the helpful feedback I've received from students and teachers using the *Handbook*, and to keep the text current, I've made several important changes. Readers familiar with the previous edition will notice the following differences in this new edition:

- Fully updated throughout
- Full-color interior design
- Most screen images in the HDTV aspect ratio
- Extended coverage of the 16×9 aspect ratio in relation to the 4×3 screen
- New section on HDV and the differences between HDV and HDTV
- Emphasis on nonlinear editing
- Detailed coverage of visual effects
- Coordination with Zettl's VideoLab 3.0 DVD-ROM

ACCOMPANYING RESOURCES: AN EXCLUSIVE TEACHING AND LEARNING PACKAGE

As with previous editions, the Ninth Edition of the *Television Production Handbook* offers a wealth of support materials for both students and instructors. Wadsworth has prepared the following list for your consideration.

TELEVISION PRODUCTION WORKBOOK

Written and revised by Herbert Zettl, with assistance from Ronald J. Osgood of Indiana University, the *Workbook* enables students to apply the concepts introduced in the *Television Production Handbook* to real-world production scenarios. Organized to follow the main text, the *Workbook* contains tear-out worksheets that reinforce and review the chapter material. Also, because students in beginning production classes tend to have widely differing experience levels, the *Workbook* can be a useful diagnostic tool to determine who knows what about television production.

ZETTL'S VIDEOLAB 3.0 DVD-ROM

Zettl's VideoLab 3.0 is an interactive DVD-ROM (Windows and Mac compatible), based on the award-winning CD-ROM Zettl's VideoLab 2.1. It is intended to give students some virtual hands-on practice and a proven shortcut from reading about production techniques to actually applying them in the studio and the field.

Changes to ZVL 3.0 include the following:

- Greater freedom of camera movement
- Increased interactivity, especially in the Try It and Quiz sections
- Enhanced module on lighting, which allows students to experiment with gels and to choose specific instruments and position them to see the correlating lighting effects
- Enhanced module on audio, which enables students to hear the quality and the directionality of various microphones
- A new section on switching, which permits students to practice takes, dissolves, wipes, and keys, with preview and line monitors showing the results
- New editing exercises that give students experience with sequencing and trimming shots

THE TELEVISION PRODUCTION HANDBOOK COMPANION WEBSITE

http://communication.wadsworth.com/zettl_tvphb9
This outstanding site features such materials as chapter.

This outstanding site features such materials as chapter-bychapter tutorial quizzes, maintained and updated Web links, and key term flashcards, as well as a practice final exam.

INSTRUCTOR'S MANUAL WITH ANSWER KEY TO WORKBOOK

Written by Herbert Zettl, this manual is for the instructor who may be quite experienced in television production but relatively new to teaching. Even as an experienced instructor, however, you may find information that makes your difficult job of teaching television production just a little easier. The manual comprises four parts: Part I, "General Approach to Teaching Television Production," presents information on teaching approaches and ideas about how to teach television production most effectively. Part II, "Key Concepts, Activities, and Tests," contains expanded definitions of the key concepts introduced in each chapter, appropriate activities for reinforcing them, and multiplechoice problems to test student retention of the material. Part III, "Additional Resources," is a compact reference that recommends additional teaching and learning resources. Part IV is the answer key to all of the problems in the Television Production Workbook.

EXAMVIEW® COMPUTERIZED TESTING

Create, deliver, and customize tests and study guides (both print and online) in minutes with this easy-to-use assessment and tutorial system. ExamView offers both a *Quick Test Wizard* and an *Online Test Wizard* that guide you step-by-step through the process of creating tests, while its "what you see is what you get" interface allows you to see the test you are creating on-screen exactly as it will print or display online. You can build tests of up to 250 questions, using up to 12 questions types. Using the complete word-processing capabilities of ExamView, you can even enter an unlimited number of new questions or edit existing ones.

For additional information please see the Preview at the front of this book, consult your local Thomson Wadsworth representative, or contact the Wadsworth Academic Resource Center at 1-800-423-0563.

ACKNOWLEDGMENTS

Once again I was privileged to have Wadsworth call upon the expertise of its "A-team" to produce this Ninth Edition of the *Television Production Handbook:* Holly Allen, publisher; Renee Deljon, senior development editor; Mark Orr, marketing manager; Darlene Amidon-Brent, assistant editor; Sarah Allen, editorial assistant; Maria Epes, executive art director; Jennifer Klos, production project manager; Roberta Broyer, photo editor; Gary Palmatier of Ideas to Images, art director and project manager; Robaire Ream, page layout artist and illustrator; Elizabeth von Radics, copy editor; and Ed Aiona, principal photographer. All you need to do is skim through this book to understand my admiration and deep gratitude for their exceptional work.

A number of dedicated instructors gave me the benefit of their experience and numerous excellent suggestions when they recommended changes for the Ninth Edition. Many thanks to these reviewers: Mara Alper, Ithaca College; George Bagley, University of Central Florida; Karyn Brown, Mississippi State University; Hamid Khani, San Francisco State University; Michael Korpi, Baylor University; Ronald J. Osgood, Indiana University; Paul Rose, University of Utah; and Jo-Anne Ryan, Western Kentucky University.

I am also greatly indebted to Michael Korpi and Paul Rose, who also reviewed the manuscript of this edition and suggested numerous improvements, and to Ronald J. Osgood, who recommended some changes to the main text and also helped revise the *Workbook*. Many thanks to Joshua Hecht and Vinay Shrivastava, who reviewed and helped update the audio chapters. I also received generous assistance from my colleagues at San Francisco State University: Marty Gonzales, Chul Heo, Rick Houlberg, Stuart Hyde, Hamid Khani, Phil Kipper, Steve Lahey, Winston Tharp, Michelle Wolf, and Lena Zhang.

I also want to give a big thank-you to all of the people and organizations who responded quickly and positively to my numerous requests for assistance: Stanley Alten, Syracuse University; Rudolf Benzler, Plazamedia, Munich, Germany; John Beritzhoff and Greg Goddard, Snader and Associates; Corey Carbonara, Baylor University; Ed Cosci, associate chief engineer, KTVU, Oakland–San Francisco; Sonny Craven, Virginia Military Institute; Ed Dudkowski, Creative Technologies; Elan Frank, Elan Productions; Jim Haman, director of local programming/production, KTVU, Oakland–San Francisco; Manfred Muckenhaupt, chair, Media Studies, University of Tuebingen, Germany; Steve Shlisky, producer/editor, KTVU, San Francisco–Oakland; and Manfred Wolfram, chair, Electronic Media Division, University of Cincinnati.

The many people who gave a considerable amount of their time and displayed an amazing level of professionalism during our photo sessions also deserve high praise: Talia Aiona, Karen Austin, Ken Baird, Jerome Bakum, Rudolf Benzler, Tiemo Biemueller, Monica Caizada, William Carpenter, Andrew Child, Laura Child, Rebecca Child, Renee Child, Skye Christensen, Ed Cosci, Carla Currie, Sabrina Dorsey, Tammy Feng, Jedediah Gildersleeve, Cassandra Hein, Sangyong Hong, Akiko Kajiwara, Hamid Khani, Philip Kipper, Christine Lojo, Orcun Malkoclar, Michael Mona, Johnny Moreno, Anita Morgan, Jacqueline Murray, Tuan Nguyen, Richard Piscitello, Matthew Prisk, Marlin Quintero, Kerstin Riediger, Suzanne Saputo, Alisa Shahonian, Steve Shlisky, Talisha Teague, Takako Thorstadt, and Yanlan Wu.

Once again, I have dedicated the new edition of this book to my wife, Erika. It is my humble attempt to let everybody know how much I appreciate her support each time I retreat to a TV world while working on the *Television Production Handbook*.

Herbert Zettl

CHAPTER

1

The Television Production Process

You may think that television production is a relatively simple task. After all, you do pretty well with your camcorder. When watching a newscast from the control room at a local television station, however, you realize that television production involves much more than just operating a camcorder. Even a seemingly simple production—such as a news anchor first introducing and then playing a videotape of the school principal showing to parents and reporters the computer lab—involves a great number of intricate operations by news production personnel and the use of many sophisticated machines. A 55-second chitchat between a TV news anchor in Portland and a tennis star in London presents a formidable challenge even for highly experienced production personnel.

When watching television, viewers are largely unaware of such production complexities. But as you can see, professional television production—regardless of whether it is done in a television station or in the field—is a complex creative process in which people and machines interact to bring a variety of messages and experiences to a large audience. Even when involved in a relatively small production, you need to know what machines and people are necessary to achieve a certain type of television communication and how to coordinate the many creative and technical elements.

Chapter 1 is designed to provide you with an overview of the various equipment and production processes. Section 1.1, What Television Production Is All About, introduces the television system and its many production elements. Section 1.2, Studios, Master Control, and Support Areas, describes the environment in which the television studio system operates.

KEY TERMS

- camcorder A portable camera with the videotape recorder or some other recording device attached or built into it to form a single unit.
- control room A room adjacent to the studio in which the director, the technical director, the audio engineer, and sometimes the lighting director perform their various production functions.
- **electronic field production (EFP)** Television production outside the studio that is usually shot for postproduction (not live). Usually called *field production*.
- electronic news gathering (ENG) The use of portable camcorders or cameras with separate portable VTRs, lights, and sound equipment for the production of daily news stories. ENG is usually not planned in advance and is usually transmitted live or immediately after postproduction.
- **expanded system** A television system consisting of equipment and procedures that allows for selection, control, recording, playback, and transmission of television pictures and sound.
- **feed** Signal transmission from one program source to another, such as a network feed or a remote feed.
- **house number** The in-house system of identification for each piece of recorded program material. Called the *house number* because the code numbers differ from station to station (house to house).
- intercom Short for intercommunication system. Used by all production and technical personnel. The most widely used system has telephone headsets to facilitate voice communication on several wired or wireless channels. Includes other systems, such as I.F.B. and cell phones.
- **lighting** The manipulation of light and shadows: to provide the camera with adequate illumination for technically acceptable pictures; to tell us what the objects on-screen actually look like; and to establish the general mood of the event.
- **line monitor** The monitor that shows only the line-out pictures that go on the air or on videotape. Also called *master monitor* or *program monitor*.
- **line-out** The line that carries the final video or audio output for broadcast.

- Iog The major operational document: a second-by-second list of every program aired on a particular day. It carries such information as program source or origin, scheduled program time, program duration, video and audio information, code identification (house number, for example), program title, program type, and additional pertinent information.
- master control Nerve center for all telecasts. Controls the program input, storage, and retrieval for on-the-air telecasts. Also oversees technical quality of all program material.
- **monitor** (1) *Audio:* speaker that carries the program sound independent of the line-out. (2) *Video:* high-quality television set used in the television studio and control rooms. Cannot receive broadcast signals.
- **P.L.** Stands for *private line* or *phone line*. Major intercommunication system in television production.
- preview (P/V) monitor (1) Any monitor that shows a video source, except for the line (master) and off-the-air monitors.
 (2) A color monitor that shows the director the picture to be used for the next shot.
- **program speaker** A loudspeaker in the control room that carries the program sound. Its volume can be controlled without affecting the actual line-out program feed. Also called *audio monitor*.
- **studio talkback** A public address loudspeaker system from the control room to the studio. Also called S.A. (studio address) or P.A. (public address) system.
- **system** The interrelationship of various elements and processes whereby the proper functioning of each element is dependent on all others.
- **tapeless system** Refers to the recording, storage, and playback of audio and video information via computer storage devices rather than videotape.
- **television system** Equipment and people who operate the equipment for the production of specific programs. The basic television system consists of a television camera and a microphone that convert pictures and sound into electrical signals, and a television set and a loudspeaker that convert the signals back into pictures and sound.

1.1

What Television Production Is All About

The major problem in learning about television production is that to understand one specific production tool or technique, such as optimal lighting, you should already know the functions of the lens, the iris, maximum and minimum aperture, and depth of field. In turn, you need to know something about how colored light behaves before you can adequately understand how a camera or a color television receiver works. Because I can't cram all the necessary information into a single paragraph, and you can't learn the various production elements and operations all at once, we compromise and begin this book with a broad overview of the television production system. By viewing television production as a system, you will readily see the interconnections among the various system elements, even when they are presented piecemeal.

■ BASIC TELEVISION SYSTEM

The equipment that converts optical images and actual sounds into electric energy, and the people who operate it

EXPANDED STUDIO AND ELECTRONIC FIELD PRODUCTION SYSTEMS

The system elements of studio and field productions, and the studio system in action

PRODUCTION ELEMENTS

Camera, lighting, audio, switching, videotape recording, tapeless systems, postproduction editing, and special effects

BASIC TELEVISION SYSTEM

A system is a collection of elements that work together to achieve a specific purpose. Each of the elements is dependent on the proper workings of all the others, and none of the individual elements can do the job alone. The television system consists of equipment and people who operate that equipment for the production of specific programs. Whether the productions are simple or elaborate, or originate in the studio or in the field—that is, on location—the system works on the same basic principle: the television camera converts whatever it "sees" (optical images) into electrical signals that can be temporarily stored or directly reconverted by the television set into visible screen images. The microphone converts whatever it "hears" (actual sounds) into electrical signals that can be temporarily stored or directly reconverted into sounds by the loudspeaker. In general, the basic television system transduces (converts) one state of energy (optical image, actual sound) into another (electrical energy). SEE 1.1 The picture signals are called video signals, and the sound signals are called audio signals. Any small consumer camcorder represents such a system.

EXPANDED STUDIO AND ELECTRONIC FIELD PRODUCTION SYSTEMS

The basic television system is considerably expanded when doing a television production in the studio or in the field, such as a telecast of a sporting event. The *expanded system* needs equipment and procedures that allow for the selection of various pictures and sound sources; for the control and monitoring of picture and sound quality; for the recording, playback, and transmission of pictures and sound; and for the integration of additional video and audio sources.

SYSTEM ELEMENTS OF STUDIO PRODUCTION

The expanded studio television system in its most elementary stage includes: (1) one or more cameras, (2) a camera control unit (CCU) or units, (3) preview monitors, (4) a switcher, (5) a line monitor, (6) one or more videotape recorders, and (7) a line-out that transports the video signal to the videotape recorder and/or the transmission device. **SEE 1.2** Usually integrated into the expanded system are videotape machines for playback, character or graphic generators that produce various forms of lettering or graphic art, and an editing system.

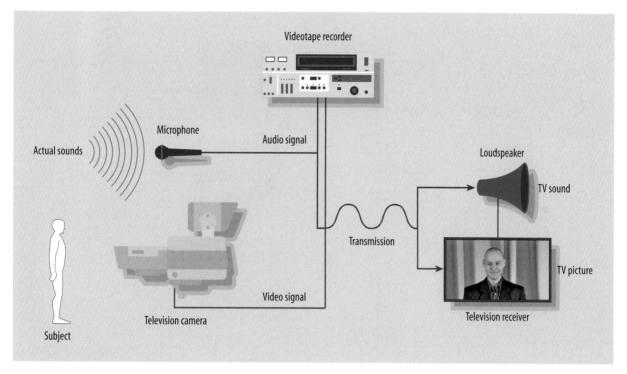

1.1 BASIC TELEVISION SYSTEM

The basic television system converts light and sounds into electrical video and audio signals that are transmitted (wireless or by cable) and reconverted by the television receiver into television pictures and sound.

The audio portion of the expanded system consists of (1) one or more microphones, (2) an audio mixer or console, (3) an audio monitor (speaker), and (4) a line-out that transports the sound signal to the video recorder and/or the transmitter (see figure 1.2).

Note that the system elements are identical regardless of whether the individual pieces of equipment are analog or digital.

STUDIO SYSTEM IN ACTION

Let us now put the expanded system to work and see how the various elements interact when a news anchor in the studio introduces a videotape of the school principal showing her guests the new computer lab. Cameras 1 and 2 are focused on the two news anchors. Camera 1 provides a close-up of one of the anchors, and camera 2 shows a close-up of the co-anchor. The video signals from these cameras are fed and quality-controlled by their respective camera control units (CCUs). The CCUs can enhance and match certain video elements of the pictures sent by the two cameras. With the CCUs the video operator (VO) can,

for example, lighten the dark shadow area on the anchor shown on camera 1 and reduce the glare on the co-anchor's forehead as seen by camera 2. Or the video operator can adjust the colors so that they look the same from camera to camera.

The quality-controlled pictures from both cameras are fed into preview monitors, one for each camera, so you can see what they look like. A third preview monitor is necessary to show the videotape of the principal. These three video signals (from cameras 1 and 2 and the videotape) are simultaneously fed into the switcher, which allows you to select and switch any of the three video feeds to the line-out for transmission or videotape recording. Pressing the button for camera 1 will put the close-up view of one of the anchors on the line monitor, which displays the line-out signals that go on the air or on videotape. Pressing the camera 2 button will put camera 2's close-up of the co-anchor on the line monitor. Pressing the button for the videotape insert will put the principal on the line monitor. Whatever appears on the line monitor will be sent to the line-out that feeds the transmission device (on the air or cable) and/or the video recorder.

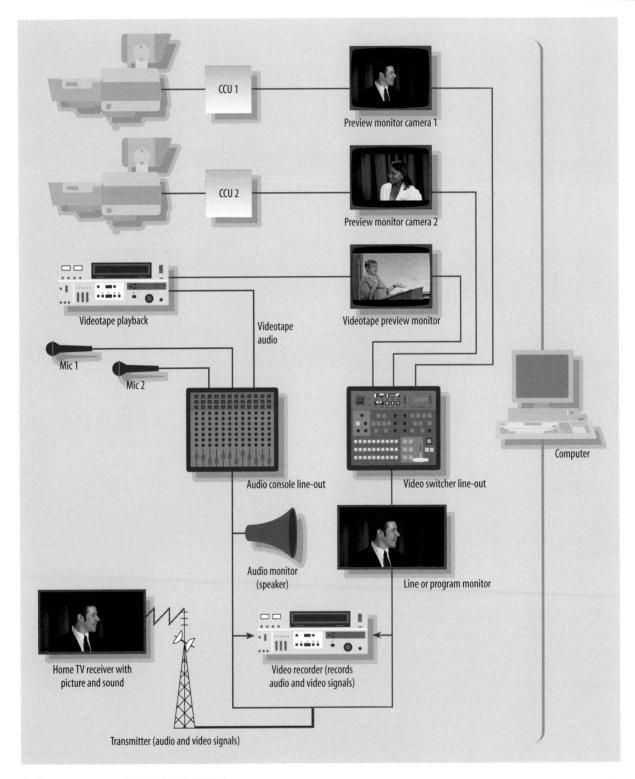

1.2 EXPANDED STUDIO TELEVISION SYSTEM

The expanded studio television system contains quality controls (CCU and audio console), selection controls (switcher and audio console), and monitors for previewing pictures and sound.

The signals from the news anchors' microphones are fed into the audio console, as is the audio track of the principal's videotape. The audio console now permits you to select among the anchors' voices and the sound track on the videotape and to control the quality of the three sound inputs. You can, for example, select the voice of the person on the screen, match the volume of the three sound sources (anchor, co-anchor, and principal), or keep one lower than the others.

Unaware of all the complex production maneuvers, the viewer simply sees close-ups of the personable and knowledgeable news anchors introducing the upcoming story about the school principal and then showing the principal walking through the new facilities, pointing proudly to the latest computer equipment.

SYSTEM ELEMENTS OF FIELD PRODUCTION

The principal obviously could not bring her new computer lab into the studio, so someone had to go on location to videotape the event. Such location shooting normally falls into the *ENG* (*electronic news gathering*)

category and is accomplished with a relatively simple field production system. All you really need is someone who operates the camcorder and a field reporter who describes the action and tries to get some brief comments from the principal and perhaps a teacher or student. Once the footage reaches the newsroom, it is drastically cut and edited to fit the brief time segment (10 seconds or so) allotted to the story.

Had the scene with the principal been a live insert, you would have had to expand the system still further, with a portable transmitter to transport the signal from the field to the station. The ENG signal is often transmitted live to the studio. **SEE 1.3**

If the field production is not for news or is more elaborate, you are engaged in *EFP* (*electronic field production*). Sometimes field cameras that feed their output to separate *VTRs* (*videotape recorders*) are used. **SEE 1.4** *Big remotes* are field productions whose production system is similar to the studio's, except that cameras are placed on location and the control room is housed in a large truck trailer. (For a detailed discussion of EFP and big remotes, see chapter 20.)

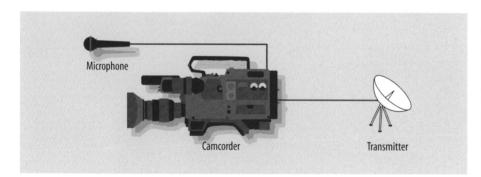

1.3 ENG SYSTEM

The basic ENG system consists of a camcorder and a microphone. The camcorder includes all video and audio quality controls as well as video- and audio-recording facilities. A portable transmitter is necessary to send a live field pickup to the studio.

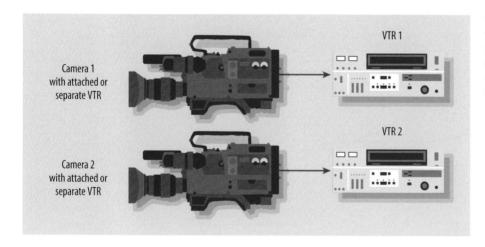

1.4 EFP SYSTEM

The EFP system is similar to that for ENG, but it may use more than one camera to feed the output to separate VTRs.

PRODUCTION ELEMENTS

With the expanded television system in mind, we briefly explore eight basic production elements: (1) the camera, (2) lighting, (3) audio, (4) switching, (5) videotape recording, (6) tapeless systems (7) postproduction editing, and (8) special effects. When learning about television production, always try to see each piece of equipment and its operation within the larger context of the television system, that is, in relation to all the other pieces of equipment that are used and the people who use them—the *production personnel*. It is, after all, the skilled and prudent use of the television equipment by the production team, and not simply the smooth interaction of the machines, that gives the system its value. (The specific roles of the production personnel are outlined in chapter 16.)

CAMERA

The most obvious production element—the *camera*—comes in all sizes and configurations. Some cameras are so small that they fit easily into your coat pocket, whereas others are so heavy that you have to strain yourself to lift them onto a camera mount. The *camera mount* enables the operator to move a heavy camera/lens/teleprompter assembly on the studio floor with relative ease. **SEE 1.5** Portable cameras are often used for ENG and EFP.

Many ENG/EFP cameras are camcorders that combine the camera and the videotape recorder in one unit, much like popular consumer models. The ENG/EFP camcorders, however, are of higher quality and cost considerably more. It is often the high-quality lens that distinguishes a professional ENG/EFP camera from a high-end consumer model. Some ENG/EFP cameras are built so that they can "dock" with a videotape recorder, a digital disc, or hard-drive recording unit; such units are simply plugged into the back of the camera to form a camcorder. Regardless of whether the camcorder is analog or digital, its operational features are basically identical. **SEE 1.6**

The studio television camera has three fundamental parts: the lens, the camera itself, and the viewfinder.

The lens In all *photography* (meaning "writing with light"), the *lens* selects part of the visible environment and produces a small optical image of it. In standard still and movie cameras, the image is then projected onto film; in digital still cameras and television cameras, it is projected onto the *imaging device*, which converts the light from the optical image into an electrical signal. All television cameras have a *zoom lens*, which allows you to smoothly

1.5 STUDIO CAMERA WITH PNEUMATIC PEDESTAL High-quality studio cameras are mounted on a studio pedestal for smooth and easy maneuverability.

and continuously change from a long shot (showing a wide vista) to a close-up view without moving either the camera or the object you are photographing.

The camera itself The camera is principally designed to convert the optical image as projected by the lens into an electrical signal—the video signal. As mentioned earlier, the major conversion element is the imaging device, a small electronic chip called the *CCD* (*charge-coupled device*). It responds to light in a manner that resembles a light meter. When the CCD receives a large amount of light, it produces a strong video signal (just as the needle of a light meter goes way up); when it receives faint light, it produces a weak signal (just as the light meter needle barely moves from its original position). Other optical and electronic components enable the camera to reproduce

1.6 PROFESSIONAL CAMCORDER

The professional camcorder is a highly portable, self-contained camera/video recording unit. It is usually battery-powered.

the colors and the light-and-dark variations of the actual scene as accurately as possible, as well as to amplify the relatively weak video signal so that it can be sent to the camera control unit without getting lost along the way. For both analog and digital cameras, the basic imaging devices are the same.

The viewfinder The *viewfinder* is a small television set mounted on the camera that shows what the camera is seeing. Most viewfinders of professional cameras are *monochrome*, which means that the display is in black-andwhite. Many consumer camcorders and some high-quality studio cameras, on the other hand, have color viewfinders, so you can see the color pictures that the camera delivers. Generally, black-and-white viewfinders show more picture detail than color displays do, which makes it easier to achieve sharp focus.

Mounting equipment Portable cameras and camcorders are designed to rest more or less comfortably on your shoulder. But even a small, handheld camcorder can get quite heavy when you operate it for prolonged periods of time. In such cases a *tripod* not only relieves you of having to carry the camera but also ensures steady pictures. The heavy studio cameras also need mounts; these range from tripods, similar to those used for ENG/EFP cameras, to large cranes. The most common studio camera mount is

the *studio pedestal* (shown in figure 1.5), which lets you raise and lower the camera and move it smoothly across the studio floor while it is "hot," that is, on the air. Some news studios use robotic cameras that are remotely controlled via computer by a single operator in the studio control room. Because high-quality cameras can be relatively small and light, such robotic systems have become quite popular in newsrooms.

LIGHTING

Like the human eye, the camera cannot see well without a certain amount of light. Because it is not objects we actually see but the light reflected off of them, manipulating the light falling on objects influences the way we perceive them on-screen. Such manipulation is called *lighting*.

Lighting has four broad purposes: (1) to provide the television camera with adequate illumination for technically acceptable pictures; (2) to tell us what the objects shown on-screen actually look like; (3) to show us where the objects are in relation to one another and to their immediate environment, and when the event is taking place in terms of time of day or season; and (4) to establish the general mood of the event.

Types of illumination All television lighting basically involves two types of illumination: directional and diffused. *Directional light* has a sharp beam and produces harsh shadows. You can aim the light beam to illuminate a precise area. A flashlight and car headlights produce directional light. *Diffused light* has a wide, indistinct beam that illuminates a relatively large area and produces soft, translucent shadows. The fluorescent lamps in a department store produce diffused lighting.

Studio lighting consists of carefully controlling light and shadow areas. The lighting requirements for electronic field production are usually quite different from those for studio work. In electronic news gathering, you work mostly with available light or occasionally with a single lighting instrument that gives just enough illumination for the camera to record an event relatively close to the camera. For EFP you also use available light, especially when shooting outdoors, or highly diffused light that provides optimal visibility indoors. Some field productions, such as documentaries or dramatic scenes, require careful interior lighting that resembles studio lighting techniques. The difference is that the location lighting for EFP is done with portable lighting instruments rather than with studio lights, which are more or less permanently installed.

1.7 STUDIO LIGHTING

The typical studio lighting uses spotlights and a variety of floodlights.

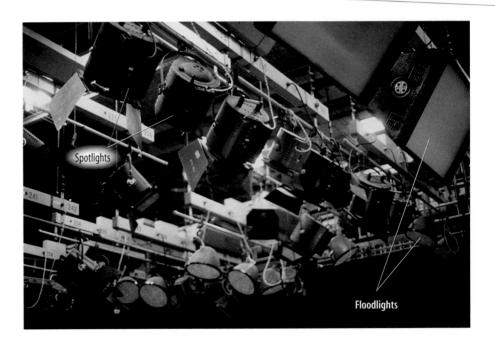

Lighting instruments The lighting instruments that produce directional light are called *spotlights*, and the ones that produce diffused light are called *floodlights*. In the television studio, the various types of spotlights and floodlights are usually suspended from the ceiling. **SEE 1.7**

Studio lights are much too heavy and bulky to be used outside the studio. Most EFPs use portable lighting packages that consist of several small, highly efficient instruments that can be plugged into ordinary electrical outlets. There are also larger fluorescent banks for large-area or virtually shadowless lighting. Most portable instruments can either be mounted on collapsible floor stands or clipped onto doors, windowsills, or furniture. These instruments generally operate as floodlights, but they can be adjusted to function as spotlights as well. To obtain more directional control, EFP lighting packages include a number of small spotlights, which can be diffused with a collapsible diffusion tent, often called *soft box* (see chapter 7). **SEE 1.8**

Lighting techniques All television lighting is based on a simple principle: use some instruments (usually spotlights and floodlights) to illuminate specific areas, soften shadows, and bring the overall light on a scene to an intensity level at which the cameras can generate optimal pictures. In general, television lighting has less contrast between light and shadow areas than do film and theater lighting. Diffused light is therefore used extensively in

television lighting, especially on news and interview sets, for game shows and situation comedies, and in many field productions.

AUDIO

Although the term television does not include audio, the sound portion of a television show is nevertheless one of its most important elements. Television audio not only communicates precise information but also contributes greatly to the mood and the atmosphere of a scene. If you were to turn off the audio during a newscast, even the best news anchors would have difficulty communicating their stories through facial expressions, graphics, and video images alone. The aesthetic function of sound (to make us perceive an event or feel in a particular way) becomes obvious when you listen to the background sounds during a crime show, for example. The squealing tires during a high-speed chase are real enough, but the rhythmically fast, exciting background music that accompanies the scene is definitely artificial. After all, the getaway car and the police car are not followed in real life by a third vehicle with musicians playing the background music. But we have grown so accustomed to such devices that we probably would perceive the scene as less exciting if the music were missing.

The various audio production elements are microphones, ENG/EFP and studio sound control equipment, and sound recording and playback devices.

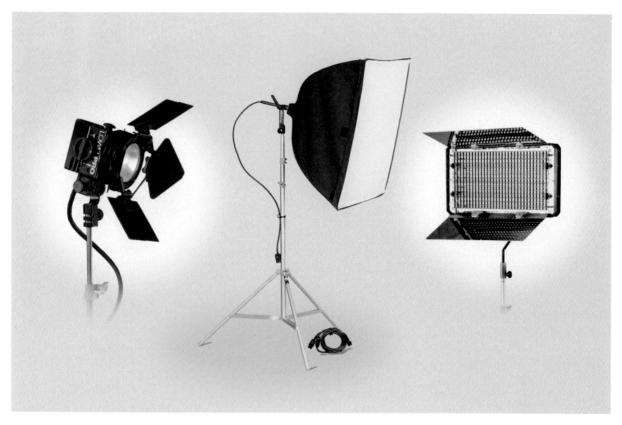

1.8 PORTABLE LIGHTING INSTRUMENTS

Portable lighting instruments consist of versatile spotlights and floodlights that can be plugged into regular household outlets.

Microphones All microphones convert sound waves into electric energy—the audio signals. The sound signals are amplified and sent to the loudspeaker, which reconverts them into audible sound. The myriad microphones available today are designed to perform different tasks. Picking up a newscaster's voice, capturing the sounds of a tennis match, and recording a rock concert—all may require different microphones or microphone sets.

ENG/EFP sound control equipment In ENG the audio is normally controlled by the camera operator, who wears a small earphone that carries the incoming sound. Because the camera operator is busy running the camera, the sound controls on the camcorder are often switched to the *automatic* setting. In the more critical EFP, the volume of incoming sounds is usually controlled by a portable *mixer* and recorded not only on videotape but also on a portable audiotape recorder. **SEE 1.9**

1.9 AUDIO MIXER

The portable audio mixer has a limited amount of inputs and volume controls.

Even a relatively simple audio console has many controls to adjust the volume and the quality of each incoming sound signal and to mix them in various ways.

Studio sound control equipment The *audio console* is used to control the sounds of a program. At the audio console, you can (1) select a specific microphone or other sound input, (2) amplify a weak signal from a microphone or other audio source for further processing, (3) control the volume and the quality of the sound, and (4) *mix* (combine) two or more incoming sound sources. **SEE 1.10**

Recall the example of the news anchor introducing a videotape of the principal and visitors at the new computer lab. The first two audio inputs come from the signals of the two anchors' microphones. Because the principal is busy escorting the visitors into the room, one of the news anchors talks over the initial part of the videotape insert. To convey a sense of actuality, you can mix under the anchor's narration the actual sounds on the videotape—the excited voices of the parents, a question or comment by one of the reporters, and the occasional laughter of the students. Then, when the principal finally begins to speak, you increase the volume of the videotape sound track and switch off both anchors' microphones.

Sound recording and playback devices Even when an event is recorded on videotape for postproduction, its sounds are usually recorded at the same time as the picture. In ENG the pictures, the reporter's voice, and the ambient sounds are picked up and recorded simultaneously. In EFP most speech sounds, such as an interviewer's questions and the interviewee's answers, are recorded on location with the picture. Some sounds, such as musical bridges and a narrator's voice-over, are usually added in postproduction.

But even in more-complicated studio productions such as soap operas, the background music and the sound effects are often added during the live pickup of the actors' dialogue.

In large and complex studio productions in which a single camera shoots a scene piecemeal, much in the way films are made, the audio track is subjected to much manipulation in postproduction. The sounds of explosions, sirens, and car crashes, for example, are normally *dubbed in* (added) during the postproduction sessions. Even parts of the original dialogue are occasionally re-created in the studio.

Prerecorded sound, such as music, is usually played back from various digital storage devices, such as digital audiotape (DAT), compact discs (CDs), and digital computer disks. Various compression techniques allow a great amount of such audio information to be recorded digitally without the need for excessive storage space.

SWITCHING

The *switcher* works on a principle similar to that of push buttons on a car radio, which allow you to select certain radio stations. The switcher lets you select various video sources, such as cameras, videotape, and titles or other special effects, and join them through a great variety of transitions while the event is in progress. In effect, the switcher allows you to do *instantaneous editing*.

Before learning about the switcher, look for a moment at the diagram in figure 1.2 of the expanded studio television system. Cameras 1 and 2 deliver their pictures first

1.11 VIDEO PRODUCTION SWITCHER

The production switcher has several rows of buttons and other controls for selecting and mixing various video inputs and creating transitions and special effects. It then sends the selected video to the line-out.

to the CCUs and then to the preview monitors. Preview monitor 1 shows all the pictures that camera 1 is taking, and preview monitor 2 carries the pictures of camera 2. Preview monitor 3 shows the selected videotape recordings. These three video signals are fed into the switcher. Each source (camera 1, camera 2, and VTR) has its own switcher input. Pressing the camera 1 button puts camera 1's signal on the line-out and shows its pictures on the line monitor. Pressing the camera 2 button puts camera 2's pictures on the line monitor and on the line-out. Pressing the VTR button puts the pictures of the videotape on the line monitor and the line-out. This switcher "output" (line-out) is what goes on the air or is recorded on videotape.

Any switcher, simple or complex, can perform three basic functions: (1) select an appropriate video source from several inputs, (2) perform basic transitions between two video sources, and (3) create or retrieve special effects, such as split screens. Some switchers have further provisions for remotely starting and stopping various video recorders. **SEE 1.11**

VIDEOTAPE RECORDING

Most television shows are recorded on videotape or computer disk before they are aired. Even live football broadcasts include plenty of prerecorded material. The "instant replays" are nothing but digital replays of key moments after the fact. Videotape or a computer hard disk is used for the playback of commercials, even those originally produced on film.

1.12 VIDEOTAPE RECORDERAlmost all VTRs use videocassettes for recording and playback. All professional VTRs have various video- and audio-recording, playback, and editing controls.

One of the unique features of television is its ability to transmit a telecast *live*, which means capturing the pictures and the sounds of an ongoing event and distributing them instantly to a worldwide audience. Most television programs, however, originate from playback of previously recorded material. Videotape is still an indispensable medium for *production* (the recording and building of a show), for *programming* (when and over which channel the show is telecast), and for distribution.

Videotape recorders Because videotape will be in use for some time to come, you must acquaint yourself with the basics of videotape recording. All videotape recorders, analog and digital, work on the same principle: they record video and audio signals on a single strip of plastic videotape and later reconvert them into signals that can be seen as pictures and heard as sound on a television receiver. Most VTRs use videotape cassettes, similar to the ones you use in your camcorder or home *VCR* (*videocassette recorder*). Professional videotape recorders are similar to a home machine, except that they have more operational controls, more-rugged tape drives, and more-sophisticated electronics that ensure higher-quality pictures and sound. **SEE 1.12**

Videotape recorders are classified by whether the recording is done in digital or analog form; by the electronic system used for the recording (Betacam SP or SX, DVCAM, DVCPRO, S-VHS, Hi8, or VHS); and sometimes by the tape *format* (the width of the videotape in the

1.13 VARIOUS CASSETTE FORMATS

Videocassettes come in a variety of sizes and are manufactured for specific recording systems.

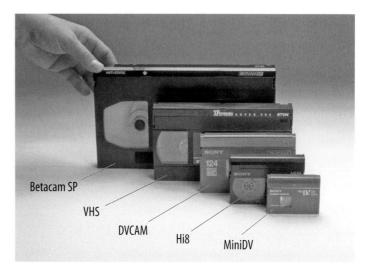

videocassette). Many VTR systems use ½-inch videocassettes (Betacam SP, digital Betacam SX, Digital-S, S-VHS, and VHS), but there are also systems that use small 8mm cassettes (Hi8) or even narrower digital ¼-inch cassettes (6.35mm DVCAM and DVCPRO). **SEE 1.13**

TAPELESS SYSTEMS

Great and rapid progress is being made toward a tapeless environment wherein all video recording, storage, and playback is done with non-tape-based systems. Such a *tapeless system* makes use of memory sticks and cards, optical discs such as CDs and DVDs, and large-capacity computer disks rather than videotape.

Memory sticks and cards These small yet powerful memory devices are used in some cameras to record brief video sequences. Some cameras also use them as a video buffer: such a prerecord device allows you to have the camera on and capture footage while running toward a news event, without using tape. By pressing the *record* button, you can then transfer this footage—dump it—onto videotape.

Optical discs and hard drives Optical discs such as *CD-ROMs* (compact disc–read-only memory) and *DVD-ROMs* (digital versatile disc–read-only memory) are *read-only*, meaning you can play back the information on the disc but you cannot record your own material onto it. Digital read/write discs such as *CD-RWs* (compact disc–read/write) and *DVD-RWs* (digital versatile disc–read/

write) let you record and play back entire video sequences and reuse them for other recordings.

Some camcorders use small but high-capacity *hard drives* instead of videotape to capture and play back video and audio information. High-capacity hard drives are used extensively for the storage, manipulation, and retrieval of video and audio information by desktop computers in postproduction. Hard drives that are even larger (in the multi-terabyte range) have all but replaced videotape as the storage and playback device of daily programming in television stations.

Note that the optical, laser-activated discs are spelled with a *c*, and the disks used in hard drives are spelled with a *k*.

POSTPRODUCTION EDITING

For some people postproduction editing is heaven: they feel totally in command of putting together the bits and pieces of recorded material into a story that tells the event in a clarified and intensified way. For others it is a tedious, albeit necessary, evil. Irrespective of how you feel about postproduction, it is usually the most expensive and time-consuming production phase. In principle, *postproduction editing* is relatively simple: you select the most effective shots from the original source material, usually on videotape, and copy them onto another videotape in a specific order. In practice, however, postproduction editing can be extremely complicated, involving such fundamentally different systems as nonlinear and linear editing and special-effects equipment.

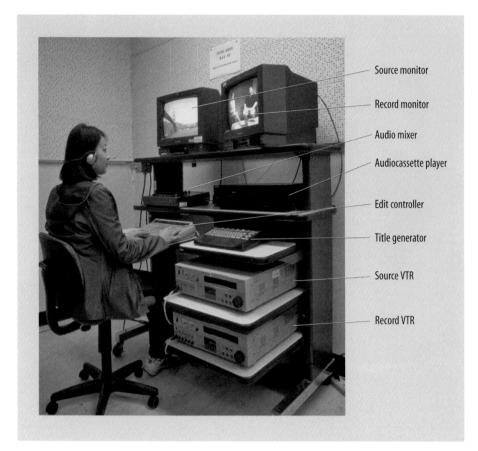

1.14 LINEAR EDITING SYSTEM

The linear, cuts-only editing system consists of a source VTR and a record VTR, source and record monitors, an edit controller, a title generator, an audiocassette player, and an audio mixer.

In *nonlinear editing* you transfer all source footage (videotape or camcorder disks) to a computer disk and then edit the video and audio portions pretty much as you would edit text with a word-processing program. You call up, move, cut, paste, and join the various shots much like words, sentences, and paragraphs when editing a document. Most nonlinear software programs let you produce an *edit decision list* (*EDL*) and either low-resolution or high-resolution full-frame, full-motion video and audio sequences. The final high-resolution editing sequence is then transferred directly onto an edit master tape for onthe-air use. The *linear editing* system normally requires two *source VTRs*, which contain the original material that you recorded with your camera or cameras, and the *record VTR*, which produces the final edit master tape.

The computer plays an important role in both linear and nonlinear editing. In linear editing the computer acts as an *edit controller* (also called an *editing control unit*), which helps find a particular scene quickly and accurately,

even if it is buried midtape. It starts and stops the source and record machines and tells the record VTR to perform the edit at the precise point you have designated. **SEE 1.14**

Nonlinear editing is done exclusively with a computer. Once the analog video and audio information on the source tapes has been digitized and stored on the high-capacity hard drives, you do not need VTRs in the editing process. You can simply call up particular shots and see whether they provide the desired sequence. The software programs for nonlinear editing also offer a wide choice of electronic effects and transitions. **SEE 1.15** Once you have decided on the sequencing, transitions, and effects, you can tell the computer to print out an EDL. This list is necessary for editing the source tapes into the final edit master tape. Some systems provide the EDL and the sequenced audio and video material for the final edit master tape without having to go back to the original source tapes.

Keep in mind that even the most elaborate digital editing system cannot make the creative decisions for you.

1.15 NONLINEAR EDITING SYSTEM

In nonlinear editing, all audio and video information is stored on large-capacity hard drives. You manipulate pictures and sound with the computer much like words and paragraphs during word processing.

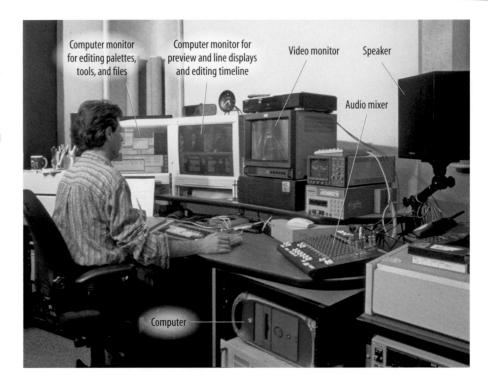

You can improve on the original source footage, such as by balancing the colors from shot to shot, but the better the original material is, the easier and more efficient the postproduction activities will be. Thinking about postproduction as early as the shooting stage facilitates your editing chores considerably. Always consider postproduction an extension of the creative process, not a salvage operation.

SPECIAL EFFECTS

Special effects can be as simple as adding a title over a background scene, done with a *character generator* (*C.G.*), or inserting the well-known box over the newscaster's shoulder. **SEE 1.16** Or they can be as elaborate as the gradual transformation of a face into a series of intensely colored, mosaic-like screen patterns. **SEE 1.17**

1.16 TITLE KEY

One of the most common effects is lettering *keyed* (cut into) a background scene. The key looks as though the title is printed on top of the background image.

1.17 MOSAIC EFFECT

Various special-effects devices can create or alter video images without the aid of a video camera. This mosaic effect was created by the digital manipulation of a video picture.

A character generator is a dedicated computer system used exclusively for still or animated titles and relatively simple special effects. With the right software, you can use your desktop computer as a C.G. for simple titles. A *graphics generator* produces a number of static or animated two- and three-dimensional images. The complex weather maps in television newscasts are usually done with a graphics generator. Using software and a standard desktop computer, you can create stunning special effects. Even simple switchers have an abundance of built-in special effects that allow you to generate a great variety of (often unnecessary) transitions. These effects are used frequently in television news, music videos, and commercials and are explored in depth in chapters 14 and 15.

MAIN POINTS

- The basic television system consists of equipment and the people who operate the equipment to produce specific programs. In its simplest form, the system consists of a television camera that converts what it sees into a video signal, a microphone that converts what it hears into an audio signal, and a television set and a loudspeaker that reconvert the two signals into pictures and sound.
- The expanded studio television system adds equipment and procedures to the basic system to make possible a wider choice of sources, better quality control of pictures and sound, and the recording and/or transmission of video and audio signals.
- The ENG (electronic news gathering) television system consists basically of a camcorder and microphones. The EFP (electronic field production) system may include multiple camcorders or field cameras and some lighting and audio/ video control equipment.
- The major production elements are the camera, lighting, audio, switching, videotape recording, tapeless systems, postproduction editing, and special effects.
- All television cameras have three main parts: the lens; the camera itself with the camera imaging device (the CCD),

- which converts an optical image into an electrical signal; and the viewfinder, which reconverts the signal into visible images.
- Lighting is the manipulation of light and shadows that influences the way we perceive objects on-screen and how we feel about a screen event.
- The two types of illumination are directional light, produced by spotlights, and diffused light, produced by floodlights.
- Audio, the sound portion of a television show, is necessary to give specific information about what is said and to help set the mood of a scene.
- Audio production elements include microphones, sound control equipment, and sound recording and playback devices.
- The switcher enables us to do instantaneous editing by selecting a specific picture from several inputs and performing basic transitions between two video sources.
- There is a variety of analog and digital videotape recorders, which differ in terms of the electronic system used for recording as well as tape format and quality.
- Television production is fast becoming a tapeless environment in which all video recording, storage, and playback is done with non-tape-based systems. These include memory sticks and cards, optical discs such as CDs and DVDs, and large-capacity computer disks.
- Postproduction editing involves selecting various shots from the source material and putting them in a specific sequence. In nonlinear editing, the digital video and audio material is stored on a computer disk and manipulated using a computer program. Most nonlinear editing systems produce an edit decision list (EDL) and high-quality video and audio sequences that can be transferred directly to the edit master tape. In linear editing, videotape is used as the source material and for the final edit master tape.
- Special effects are an important ingredient in video presentation. They range from simple lettering, produced by a character generator (C.G.), to elaborate effects, produced by a graphics generator. The right software can make your desktop computer a C.G. or graphics generator.

1.2

Studios, Master Control, and Support Areas

Telecasts can originate anywhere, indoors or out, so long as there is enough light for the camera to see. With the highly portable, battery-powered cameras and recording facilities and the mobile microwave transmitters, television has the whole earth as its stage. Our ability to transmit television programming from just about anywhere does not render the studio obsolete, however. Television studios persist because, if properly designed, they offer maximum control and optimal use of the equipment. This section focuses on the three major television production centers.

► TELEVISION STUDIO

The origination center where television production takes place

STUDIO CONTROL ROOM

Where directors, producers, and technical personnel exercise program control, switching, audio control, lighting control, and video control

MASTER CONTROL

The technical nerve center of a station, with tapebased or tapeless program input, program storage, and program retrieval

STUDIO SUPPORT AREAS

Space for scene and property storage and for makeup and dressing rooms

TELEVISION STUDIO

A well-designed studio provides for the proper environment and coordination of all major production elements—cameras, lighting, sound, scenery, and the action of performers. Here we explore the physical layout of a typical studio and the major studio installations.

PHYSICAL LAYOUT

Most studios are rectangular with varying amounts of floor space. Because the zoom lens can make a scene look closer or farther away, it has drastically reduced the need for actual camera movement, but room size nevertheless greatly affects production complexity and flexibility.

Size The larger the studio, the more complex the productions can be and the more flexible they will be. If all you do in the studio is news and an occasional interview, you may get by with amazingly little space. In fact, some news sets are placed right in the middle of the actual newsroom. **SEE 1.18** Other news sets may take up a substantial portion of a large studio.

Elaborate productions, such as musical or dance numbers, dramas, or audience participation shows, need large studios. It is always easier to produce a simple show in a large studio than a complex show in a small one. The larger the studio, however, the more difficult it is to manage, requiring more equipment and qualified people to properly run it. Medium-sized or even small studios are generally more efficient to manage, but they are not as flexible.

Floor The studio floor must be even and level so that cameras can travel smoothly and freely. It should also be hard enough to withstand the moving about of heavy equipment, scenery, and set properties. Most studios have concrete floors that are polished or covered with linoleum, tile, or hard plastic.

Ceiling height Adequate ceiling height—a minimum of 12 feet—is one of the most important design features of a television studio. If the ceiling is too low, the lights are too close to the scene for good lighting control and there is not enough room above them for the heat to dissipate. Also, the low lights and the boom microphone will encroach into the scene, as well as make it uncomfortably hot. Higher ceilings can accommodate even tall scenery. Many large studios therefore have ceilings more than 30 feet high.

1.18 NEWS SET IN NEWSROOM

This news set is part of a working newsroom. It is designed to project the up-to-date character of the news presentation.

Acoustic treatment The studio ceiling and walls are usually treated with acoustic material that prevents sound from bouncing indiscriminately around the studio. This is why television studios sound "dead." When you clap your hands in an acoustically treated studio, the sound seems to go nowhere; in a more "live" studio, you hear reverberations, similar to a slight echo.

Air-conditioning Because television studios typically have no windows (to keep out noise and light), air-conditioning is essential. Incandescent studio lights generate a great amount of heat, which has an adverse effect on performers and delicate electronic equipment. Unfortunately, many air-conditioning systems are too noisy for studio productions and must be turned off during the recording of a show—just when cool air is needed the most.

Doors Studios need heavy, soundproof doors that are large enough to accommodate scenery, furniture, and even vehicles. Few things are more frustrating than trying to squeeze scenery and properties through undersized studio doors or to have the doors transmit outside sounds, such as a fire truck screaming by, right in the middle of a show.

MAJOR INSTALLATIONS

All studios need major installations that facilitate the production process.

Intercommunication system The intercommunication system, or *intercom*, allows all production and engineering personnel actively engaged in a production to be in constant voice contact with one another. For example, the director, who sits in the control room physically isolated from the studio, has to rely totally on the intercom to communicate cues and instructions to the production team. In most small stations, the *P.L.* (private line or phone line) system is used. Each member of the production team wears a telephone headset with an earphone and a small microphone for talkback. Larger stations use a wireless intercom system. (For a more thorough discussion of intercom systems, see chapters 19 and 20.)

Studio monitors Studio *monitors* are high-quality television sets that display the video feed from the program switcher. Contrary to the television set in your home, a monitor cannot receive a broadcast signal. A studio monitor is an important production aid for both crew and talent. The production crew can see the shots the director has selected and thus anticipate their future tasks. For example, if you see that the on-the-air camera is on a close-up rather than a long shot, you can work closer to the set without getting into camera range. Also, after seeing that one camera is on a close-up, the other camera operators can go to different shots to give the director a wider choice. The studio monitor is essential for the newscaster

to see whether the various tape or live inserts are actually appearing as per the script. Sometimes laptop computer screens serve as monitors for news anchors. In audience participation shows, several studio monitors are usually provided so that the studio audience can see how the event looks on-screen.

Program speakers The *program speakers* (also called *audio monitors*) fulfill a function for audio similar to what the studio monitors do for video. Whenever necessary they can feed into the studio the program sound or any other sound—dance music, telephone rings, or other sound effects—to be synchronized with the studio action.

Wall outlets As insignificant as they may seem at first, the number and the locations of wall outlets are critical factors in studio production. The outlets for camera and microphone cables, intercoms, and regular household current should be distributed along the four studio walls for easy access. If all the outlets are on one side of the studio, you will have to string long and cumbersome cables around the various sets to get equipment into the desired positions.

Outlets must be clearly labeled to avoid patching cables into the wrong type of outlet.

Lighting dimmer and patchboard Most studios have a dimmer control board to regulate the relative intensity of the studio lights. The lighting *patchboard*, or patchbay, connects the individual instruments to the various dimmers. Unless the patching is done by computer, the patchboard is usually located in the studio. The dimmer board itself is either in a corner of the studio or in the control room (discussed in detail in section 7.1).

STUDIO CONTROL ROOM

The *control room*, adjacent to the studio, is where all the production activities are coordinated. Here the director, the associate director (AD), the technical director (TD), and a variety of producers and production assistants make the decisions concerning maximally effective picture and sound sequences, which are to be videotaped or broadcast live. **SEE 1.19**

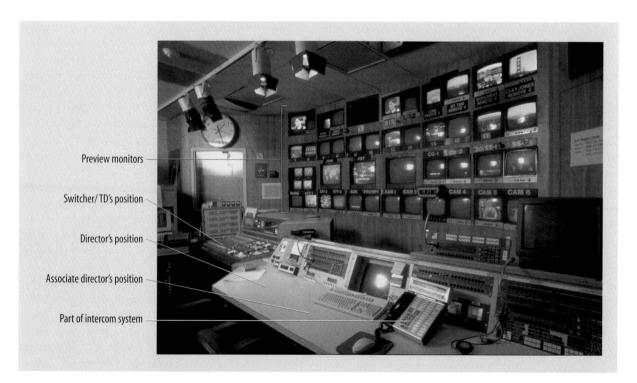

1.19 STUDIO CONTROL ROOM

All control rooms have distinct controlling areas: the program control, the switcher, the audio control, and sometimes the lighting and video controls. The audio control is in an adjacent room.

PROGRAM CONTROL

Program control does not mean the critical examination, or perhaps even censoring, of program content; it refers to the equipment the director needs to select and organize the various video and audio inputs so that the end result makes sense to the viewing audience. The program control area of the control room is equipped with (1) video monitors, (2) speakers for program sound, (3) intercom systems, and (4) clocks and stopwatches.

Video monitors Even a simple control room holds an amazingly large number of video monitors. There is a (usually black-and-white) *preview* (*P/V*) *monitor* for each of the studio cameras and separate preview monitors for videotape recorders, the C.G., and other special-effects devices. There is also a larger color P/V monitor that shows the director and the technical director the upcoming picture before it is punched up (put on the air), as well as the large color *line monitor*, which is fed by the video line-out. If you do a live remote or are connected with a television network, you need at least two more monitors to preview the remote and network sources. Finally, the off-the-air television set receives the broadcast signal that you are telecasting. It is not uncommon to find thirty or

more monitors in the control room of a medium-sized studio. **SEE 1.20**

Speakers for program sound The production personnel in the control room, especially the director, must hear what audio is going on the air. The director can adjust the volume of the monitor speaker without influencing the volume of the line-out audio.

Intercom systems In addition to the all-important P.L. system that connects the director with all the other members of the production crew, there is the *P.A.* (public address system), or simply the director's studio talkback. The *studio talkback* allows the director to talk directly to the crew or talent in the studio when the show is not in progress, but the studio people cannot use this system to communicate with the control room. With the *I.F.B.* (interruptible foldback or feedback) *system*, the director and the producers can talk to the talent while the show is on the air.

Clocks and stopwatches Time is an essential organizing element in television production. Programs are aired according to a second-by-second schedule called the *log*. The two timing tools for the director are the clock and the

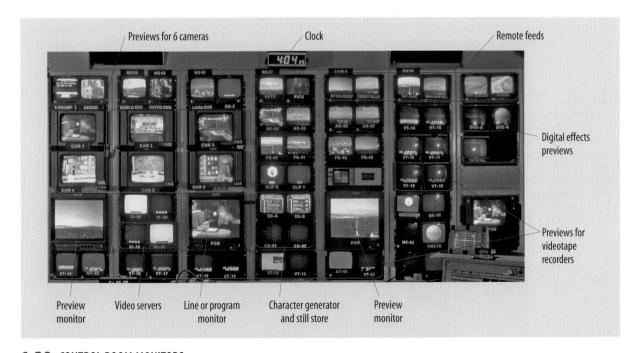

1.20 CONTROL ROOM MONITORS

Each of these monitors shows a specific video image as supplied by video sources such as studio cameras, VTRs, the C.G., special effects, or remote satellite feeds. The large preview monitor shows the upcoming shot. The large line monitor shows what goes on the air (and/or on videotape).

stopwatch. The clock indicates when a certain program should start or finish. All television clocks in the United States are precisely synchronized. The stopwatch is used for timing inserts, such as a 20-second videotaped public service announcement (PSA) within a news program. Most control rooms have a regular clock (with hands), a digital clock (showing time in numbers), and digital stopwatches that can run forward and backward. The advantage of a clock with hands is that you can look forward in time and, for example, actually see how much time you have left until the end of a program. The digital clock simply indicates where you are at a precise moment in time.

SWITCHING

Switching refers to the selection and proper sequencing of video images as supplied by cameras or other video sources. It also includes the control of video special effects. The main piece of image control equipment is the switcher, which is located next to the director's position (see figure 1.19). Although the director and the person doing the switching (usually the technical director) are connected via the P.L., the director often resorts to pointing and finger snapping to speed up the cues to the TD. In small stations the director sometimes does his or her own switching, but that arrangement has more disadvantages than advantages. The C.G. is also located in the control room so that the C.G. operator can call up the various preprogrammed titles or create new ones even during the show.

The program control section sometimes houses the computer and the control panel for robotic cameras. A single robotic-camera operator can then operate all cameras from the control room.

AUDIO CONTROL

The audio control booth can be considered a small radio station adjacent to the studio control room. It usually houses the audio console and a patchbay (or patch panel), as well as audiotape recorders, DAT machines, CD and DVD players, or other read/write digital devices. The audio engineer can listen to a cue speaker when cueing an upcoming audio source and the program sound on high-quality program speakers. The audio booth also contains a clock and a line monitor. **SEE 1.21** Because the audio engineer must be able to work undisturbed by the apparent confusion and inevitable noise in the control room, the audio control booth has visual contact with the control room through a large window but is otherwise self-contained. The audio engineer listens to the director's cues through either the P.L. system or a small intercom speaker.

LIGHTING CONTROL

The lighting control board can be located in the control room or in a corner of the studio. The advantage of placing it in the control room is that the lighting director (LD) has close contact with other control room personnel. The lighting control operator is, as are all other pro-

1.21 AUDIO CONTROL

The audio control area contains the audio console, patchbays, DAT machines, other digital record/play devices, various computers that display log information or assist with the audio control functions, and a monitor that shows the line-out video.

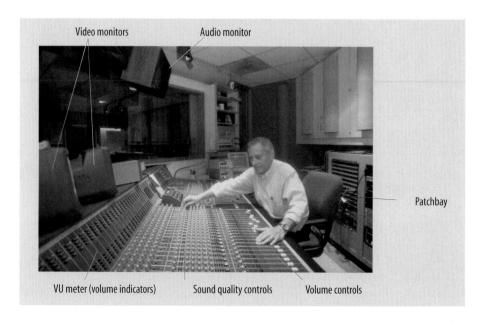

duction team members, connected with the director via the P.L. system.

VIDEO CONTROL

The video controls allow the video operator to achieve optimal pictures. Most often the cameras are set up for the prevailing lighting before the show, and then adjusted as necessary during the show.

MASTER CONTROL

Master control is the nerve center of a television station. Every second of programming you see on your home screen has gone through the master control room of the station to which you are tuned. Master control acts as a clearing-house for all program material. It receives program feeds from various sources then telecasts them at a specific time. Many of the programs are still on videotape but are usually transferred to the large-capacity hard drives of video servers (large computers). The advantage of tapeless master control operation is that the servers allow easy sequencing of program events, highly precise starts and stops, and a high degree of automation. SEE 1.22

The major responsibility of master control is to see that the right program material (including commercials and PSAs) is broadcast at the right time. Master control is also responsible for the technical quality of the programs: it has to check all program material against technical standards set by the Federal Communications Commission (FCC) and a critical chief engineer.

The specific activities of master control consist of (1) program input, (2) program storage, and (3) program retrieval.

PROGRAM INPUT

Program material may reach master control directly from its own studios; via satellite or other remote feeds, such as a network show or a live telecast outside the studio; or by courier in the form of videotape. The live shows are routed through master control to the transmitter for broadcast, but the bulk of the program material must be stored before being aired.

Master control also airs the various station breaks. A *station break* is the cluster of commercials, teasers about upcoming programs, PSAs, and station identifications that appears between programs.

In nonbroadcast production centers, *master control* refers to a room that houses the camera control unit (CCU), the high-end video-recording equipment, special-effects devices, large-capacity computers that perform a variety of production functions, and test equipment.

PROGRAM STORAGE

All recorded program material (videotaped or captured digitally on other video-recording devices) is stored in master control itself or in a designated storage room. Each

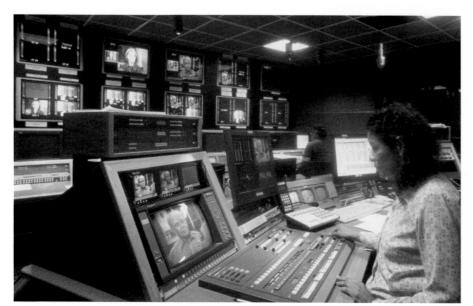

1.22 MASTER CONTROL SWITCHING AREA

Master control serves as the final video and audio clearinghouse for all program material before it is broadcast or distributed by other means (satellite or cable). Computers run all master control functions, with the master control technician overseeing the automated functions and, if necessary, taking over control manually in case of emergency.

program is given a station code, or *house number*, for fast identification and retrieval. Although computer retrieval has introduced some commonality in terms, many stations have their own procedures and codes.

PROGRAM RETRIEVAL

Program retrieval involves the selection, ordering, and airing of all program material. It is determined by the program log, the second-by-second list of every program aired on a particular day. The log contains information necessary for efficient station operation: it identifies scheduled program time, length, and title; video and audio origin (videotape, server, network, live, or remote); house numbers; and other pertinent information such as the name of the sponsor. The log is issued daily, usually one or two days in advance. Most stations display the log on computer screens but may also distribute a hard copy to key personnel. **SEE 1.23**

The master control switching area looks like the combined program control and switching areas of the studio control room. Master control has preview monitors for all studio cameras, videotape recorders, special effects, and network and other remote feeds, plus at least one off-the-air monitor.

Although all master control switching is done by computer, most master controls also have a manual switcher, which looks similar to the studio switcher, as a fail-safe

HSE NUMBER	SCH TIME	PGM	LENGTH	ORIGIN VID	
N 3349	10 59 40	NEWS CLOSE	015	VT4	VT4
	10 59 55	STATION BR	005	ESS	CART20
E 1009	11 00 00	GOING PLACES 1	030	VT5	VT5
C5590	11 00 30	FED EX	010	VT2	VT2
C 9930-0	11 00 40	HAYDEN PUBLISHING	010	VT18	VT18
C 10004	11 00 50	SPORTS HILIGHTS	005		CART21
PP 99	11 00 55	STATION PROMO SPORTS	005	VT22	VT22
E 1009	11 01 00	GOING PLACES CONT 2	1100		
C 9990-34	11 12 00	HYDE PRODUCTS	030	VT34	VT34
C 774-55	11 12 30	COMPESI FISHING	010	VT35	VT35
C 993-48	11 12 40	KIPPER COMPUTERS	010	VT78	VT78
PS	11 12 50	RED CROSS	005	ESS	CART22
PP 1003	11 12 55	STATION PROMO GOOD MRNG	. 005	VT23	VT23
E 1009	11 13 00	GOING PLACES CONT 3	1025		
C 222-99	11 23 25	WHITNEY MOTORCYCLE	020	VT33	VT33
C 00995-45	11 23 45	IDEAS TO IMAGES	010	VT91	VT91
	11 23 55	AIDS AWARENESS	005	ESS	CARTO2
E 1009	11 24 00	GOING PLACES CONT 4	100		
N 01125	11 25 00	NEWSBREAK ***LIVE	010	STILV	ST1
C 00944-11	11 25 10	ALL SEASONS GNRL FOODS	030	VT27	VT27
N 01125	11 25 40	NEWS CONT***LIVE	200	STILV	
C 995-89	11 27 40	BLOSSER FOR PRESIDENT	020	VT24	VT24
PP 77	11 28 00	NEXT DAY	010	VT19	VT19

1.23 COMPUTER DISPLAY OF LOG

The program log shows the schedule (start) times for each program segment, however short; program title and type; video and audio origin; the identification (house) number of the various program pieces; and sometimes other important information, such as the name of the sponsor.

backup device. When the computer goes down, the master control technician must take over and use the manual switcher for all on-the-air program sequences. When all is going well, the computer switching will follow the sequence of events as dictated by the log. The computer will also activate various playback operations. For example, it can start a specific server and switch the picture and sound on the air at a precise time, change to a still picture and play an audio recording of the announcer's voice, switch to another spot in the server or play a brief VTR insert, and then switch to the network program. If the house number of the actual program does not match the number specified in the log, the computer can flash a warning in time to correct the possible mistake.

STUDIO SUPPORT AREAS

No studio can function properly without a minimum of support areas. These include space for scene storage, property storage, and makeup and dressing rooms.

SCENERY AND PROPERTIES

Television scenery consists of the three-dimensional elements used in the studio to create a specific environment for the show or show segment. The most common scenic element is the *flat*, a wood frame covered with soft material (muslin or canvas) or hardwall (plywood or various types of fiberboard). The flat is generally used to simulate walls. Other scenic elements include columns, pedestals, platforms, doors, windows, and steps.

Furniture, curtains, hanging pictures, lamps, books, desks, and telephones are considered the properties, or *props*, and set dressings. The props used to make the set functional, such as tables and chairs, are the *set properties*. Items handled by the performers, such as the telephone, are called *hand properties*. Pictures, indoor plants, sculptures—and anything else used to dress up the set—constitute the *set dressings*.

Depending on the type of show, a set will simulate a real environment, such as a living room, or simply provide an efficient and attractive workspace, such as an interview set. **SEE 1.24** Whatever the purpose of the set, it must allow for good lighting, favorable camera angles, optimal camera and microphone placement or movement, and smooth and logical action of the performers.

Producing a large number of vastly different television programs, from daily newscasts to complex dramas, requires large prop and scenery storage areas. Otherwise, the support areas can be fairly simple. The most important

1.24 STUDIO SET

A set provides a specific environment in which the performers or actors can move about. Some sets simulate real environments such as a café or a living room; others provide suitable workspace for a specific type of show. The furniture in this set is part of the set properties.

part of any storage area is its retrieval efficiency. If you must search for hours to find the props to decorate your office set, even the most extensive prop collection is worth very little. Clearly label all storage areas, and always put the props and scenery back in their designated places.

MAKEUP AND DRESSING ROOMS

These support areas are commonplace in large production centers where soap operas or other daily series programs are produced. In smaller production centers, makeup and dressing are done wherever it's convenient. The closer they are to the studio, the better it is for the talent.

MAIN POINTS

- Telecasts can originate almost anywhere, but the television studio affords maximum production control.
- The studio has three major production centers: the studio itself, the studio control room and master control, and the studio support areas.
- Important aspects of the physical layout of the studio are a smooth, level floor; adequate ceiling height; acoustic treatment and air-conditioning; and large, soundproof doors.

- Major installations include intercom systems, studio video and audio monitors, various wall outlets, and the lighting patchboard.
- ◆ The studio control room houses the program control with the various preview monitors, program speakers, intercoms, and clocks; the switcher; the audio control with the audio console, patchbay, program speakers, and audiotape recorders and other read/write digital devices; sometimes the lighting control board through which the intensity of the studio lights is regulated; and often the video control, which allows the video operator to achieve optimal pictures.
- Master control is the nerve center of a television station. It has facilities for program input, storage, and retrieval. It also checks the technical quality of all the programs that are broadcast.
- Program input is from such diverse sources as a station's own studios, via satellite or other remote feeds, or in the form of videotape. Program storage includes a unique house number for each program segment for fast identification and retrieval. Program retrieval is coordinated by the log, a second-by-second list of every program aired on a particular day.
- The studio support areas include space for property and scenery storage, as well as makeup and dressing rooms.

2

Analog and Digital Television

The big buzzword in television, as in other branches of electronic communications, is digital. You have probably heard many times that digital television (DTV) revolutionized television. In one way such claims are true; in another way, DTV influences certain production techniques only minimally. For example, whereas the electronic characteristics of a digital camcorder differ considerably from the traditional analog one, its operation is pretty much the same. Both types of camcorders—analog and digital—require that you look through a viewfinder and point the lens in a certain direction to get the desired image. On the other hand, the switch to wide-screen DTV requires different ways of framing a shot. Changing from an analog (linear) editing system to a digital (nonlinear) one calls for not only different operational skills but also a whole new concept of what editing is all about. More so, digital processes have led to a convergence of various media: television is becoming interactive; large, centralized digital databases offer television news organizations instant access to news files; and computers are streaming audio and video "content" over the Internet.

A good way to grasp the workings of a digital television system is to learn, first of all, some basics about general analog and digital television processes.

Section 2.1, Analog and Digital Television, explains the basics of how a color television image is created, what digital processes are all about, and how they differ from analog systems. Section 2.2, Scanning Systems, introduces you to interlaced and progressive scanning and the current major DTV standards.

KEY TERMS

- **480p** The lowest-resolution scanning system of DTV (digital television). The *p* stands for *progressive*, which means that each complete television frame consists of 480 visible, or active, lines that are scanned one after the other (out of 525 total scanning lines). It is sometimes considered the low end of HDTV.
- **720p** A progressive scanning system of HDTV (high-definition television). Each frame consists of 720 visible, or active, lines (out of 750 total scanning lines).
- **1080i** An interlaced scanning system of HDTV (high-definition television). The *i* stands for *interlaced*, which means that a complete frame is formed from two interlaced scanning fields. Each field consists of 539½ visible, or active, lines (out of 1,125 total scanning lines). As with the traditional NTSC analog television system, the 1080i system produces 60 fields or 30 complete frames per second.
- analog A signal that fluctuates exactly like the original stimulus.
- **aspect ratio** The width-to-height proportions of the standard television screen and therefore of all analog television pictures: 4 units wide by 3 units high. For DTV and HDTV, the aspect ratio is 16 × 9.
- binary A number system with the base of 2.
- binary digit (bit) The smallest amount of information a computer can hold and process. A charge is either present, represented by a 1, or absent, represented by a 0. One bit can describe two levels, such as on/off or black/white. Two bits can describe four levels (22 bits); three bits, eight levels (23 bits); four bits, sixteen (24 bits); and so on. A group of eight bits (28) is called a byte.
- coding To change the quantized values into a binary code, represented by 0's and 1's. Also called *encoding*.
- **compression** Reducing the amount of data to be stored or transmitted by using coding schemes that pack all original data into less space (*lossless* compression) or by throwing away some of the least important data (*lossy* compression).
- **decoding** The reconstruction of a video or audio signal from a digital code.
- **digital** Usually means the binary system—the representation of data in the form of binary digits (on/off pulses).
- **digital television (DTV)** Digital television systems that generally have a higher image resolution than STV (standard television). Also called *advanced television (ATV)*.

- **downloading** The transfer of files that are sent in data packets.

 Because these packets are often transferred out of order, the file cannot be seen or heard until the downloading process is complete.
- **field** (1) A location away from the studio. (2) One-half of a complete scanning cycle, with two fields necessary for one television picture frame. There are 60 fields, or 30 frames, per second in standard NTSC television.
- frame A complete scan of all picture lines by the electron beam.
- high-definition television (HDTV) Has at least twice the picture detail of standard (NTSC) television. The 720p uses 720 visible, or active, lines that are normally scanned progressively each 160 second. The 1080i standard uses 60 fields per second, each field consisting of 539½ visible, or active, lines. A complete frame consists of two interlaced scanning fields of 539½ visible lines. The refresh rate (complete scanning cycle) for HDTV systems can vary.
- interlaced scanning In this system the beam skips every other line during its first scan, reading only the odd-numbered lines. After the beam has scanned half of the last oddnumbered line, it jumps back to the top of the screen and finishes the unscanned half of the top line and continues to scan all the even-numbered lines. Each such even- or odd-numbered scan produces a field. Two fields produce a complete frame. Standard NTSC television operates with 60 fields per second, which translates into 30 frames per second.
- **progressive scanning** In this system the electron beam starts with line 1, then scans line 2, then line 3, and so forth, until all lines are scanned, at which point the beam jumps back to its starting position to repeat the scan of all lines.
- **quantizing** A step in the digitization of an analog signal. It changes the sampling points into discrete values. Also called *quantization*.
- **refresh rate** The number of complete digital scanning cycles per second.
- RGB Red, green, and blue—the basic colors of television.
- **sampling** The process of reading (selecting and recording) from an analog electronic signal a great many equally spaced, tiny portions (values) for conversion into a digital code.
- **streaming** A way of delivering and receiving digital audio and/or video as a continuous data flow that can be listened to or watched while the delivery is in progress.

2.1

Analog and Digital Television

Before you submerge yourself into the digital world of television, you should know how the basic television image you see on-screen is created. Many system elements and production techniques were developed to facilitate this basic technical image creation and display. Also, to really understand how various digital elements of the television system—such as digital cameras and nonlinear editing systems—interact, you need to know what the basic digital processes are and how they differ from analog ones.

■ BASIC IMAGE CREATION

The travel of the electron beam forming the television image and basic colors

▶ BASIC COLORS OF THE VIDEO DISPLAY

Red, green, and blue as the primary colors

▶ WHAT DIGITAL IS ALL ABOUT

Why digital?—the difference between analog and digital and the process of digitization

▶ BENEFITS OF DIGITAL TELEVISION

Quality, computer compatibility and flexibility, signal transport, compression, and aspect ratio

BASIC IMAGE CREATION

The video image is literally drawn onto the television screen by an electronic pencil—the *electron beam*. Emitted by the *electron gun*, the electron beam scans the inside surface of the television screen line by line, from left to right, much as we read. The inside of the television screen is dotted with light-sensitive picture elements, or *pixels* (round dots or tiny rectangles), that light up when hit by the beam. If the beam is powerful, the dots light up brightly. If the beam is weak, the dots light up only partially. If the beam is really tired, the dots don't light up at all. The process is similar to the large displays that use light bulbs for outdoor advertising, except that the light bulbs on the screen are extremely tiny. **SEE 2.1**

The traditional television system consists of 525 lines on the screen, of which you can only see 480. It was developed by the National Television System Committee and is appropriately called the NTSC system. To produce an image, the electron beam scans the odd-numbered lines first, then it jumps back to the top of the screen and scans the even-numbered lines. The complete scan of all odd-numbered or even-numbered lines, which takes 1/60 second, is called a *field*. A complete scan of all odd- and even-numbered lines is called a frame. In the traditional NTSC system, there are 30 frames per second. Because the beam is such a speed-reader and lights up the pixels at a pretty fast clip, we perceive them as a complete video image. Because the beam scans different sets of lines for each field, the scanning process is called *interlaced*. (Section 2.2 explores the various scanning processes in more detail.)

BASIC COLORS OF THE VIDEO DISPLAY

All the beautiful images you see on television—even the black-and-white pictures—are a mixture of three basic colors: red, green, and blue. Depending on how hard the pixels are hit by an electron beam, they light up in different intensities. Mixing these intensities produces all the other colors. Each line must, therefore, have groups of *RGB* (red, green, and blue) dots or rectangles. But how can a single electron beam hit each RGB group (the three dots that are grouped together) with various intensities? It can't. There must be a separate electron beam for each basic color: one for the red dots, a second for the green dots, and a third for the blue ones. **SEE 2.2** The three electron beams can hit each group of RGB dots with various intensities, thus producing the different color mixes. Just how these three colors create all the others is explored in chapter 3.

WHAT DIGITAL IS ALL ABOUT

All *digital* computers and digital video are based on a *bi-nary* code that uses the either/or, on/off values of 0's and 1's to interpret the world. The *binary digit*, or *bit*, acts like

2.1 INTERLACED SCANNING

A The electron beam first scans all odd-numbered lines, from left to right and from top to bottom. This first scanning cycle produces the first field.

B The electron beam jumps back to the top and scans all even-numbered lines. This second scanning cycle produces the second field.

C The two fields make up a complete television picture, called a frame.

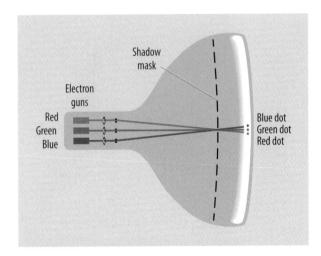

2.2 IMAGE FORMATION FOR COLOR TELEVISION

The color receiver has three electron guns, each responsible for either a red, a green, or a blue signal. Each of the beams is assigned to its color dots or rectangles. The shadow mask keeps the beams from spilling into the adjacent dots.

a light switch: it is either on or off. If it is on, it is assigned a 1; if it is off, it is assigned a 0.

WHY DIGITAL?

At first glance this either/or system of binary digits may seem awfully clumsy. For example, the simple decimal number 17 reads 00010001 in the binary code. Nevertheless, this either/or, on/off system has great resistance to data distortion and error. If, for example, you turn on a light switch and the light flickers instead of staying on, there is obviously something wrong. If you turn the switch off and the light stays on, you certainly know that something went wrong again. The digital system simply ignores such aberrations and reacts only if the switch triggers the expected on/off actions.

DIFFERENCE BETWEEN ANALOG AND DIGITAL

Before getting too technical, let's use a simple metaphor to explain the difference between analog and digital signal processing. The analog signal is very much like a ramp that leads continuously from one elevation to another. When walking up this ramp, it matters little whether you use small or big steps; the ramp gradually and inevitably leads you to the desired elevation. **SEE 2.3**

To carry on the metaphor, in the *digital* domain, you would have to use steps to get to the same elevation. This is much more an either/or proposition. The elevation has now been *quantized* (divided) into a number of discrete units—the steps. You either get to the next step or you don't. There is no such thing as a half or quarter step. **SEE 2.4** More technically, the *analog* system processes and records a continuous signal that fluctuates exactly like the original signal (the way you moved up or down the ramp). Digital processing, however, changes the ramp into discrete values. This process is called *digitization*. In the digital process, the analog signal is continuously sampled at fixed intervals; the samples are then quantized (assigned a concrete value) and coded into 0's and 1's.

DIGITIZATION PROCESS

Digitizing an analog video signal is a four-step process: (1) anti-aliasing, (2) sampling, (3) quantizing, and (4) coding. **SEE 2.5**

Anti-aliasing In this step extreme frequencies of the analog signal that are unnecessary for its proper sampling are filtered out.

Sampling In the *sampling* stage, the number of points along the ramp (analog signal) are selected for building the steps (digital values). The higher the sampling rate, the more steps chosen and the more they will look like the original ramp (analog signal). Obviously, a high sampling rate (many smaller steps) is preferred over a low one (fewer but larger steps). **SEE 2.6 AND 2.7** The sampling rate of a video signal is usually expressed in megahertz (MHz).

Quantizing At the *quantizing* digitization stage, we are actually building the steps so that we can reach the top of the staircase (which was previously the predetermined high end of the ramp) and assigning them numbers. Technically, *quantizing* means to separate a continuously variable signal into defined levels (steps) and fitting them into the desired sample range (the height of the ramp). For example, an 8-bit quantizing has a maximum number of 256 (2⁸) levels. (In our metaphor we cannot use more than 256 steps). **SEE 2.8**

Coding The process of *coding* (also called *encoding*) changes the quantization numbers of each step to binary

^{1.} The binary system uses the base-2 numbering system. The number 17 is represented by an 8-bit binary code. All values are mathematically represented by either 0's or 1's. An 8-bit representation of a single color pixel or sound has 2⁸, or 256, discrete values. For more-detailed information on the binary system, see Arch C. Luther and Andrew F. Inglis, *Video Engineering*, 3rd ed. (New York: McGraw-Hill, 1999), pp. 45–47.

2.3 ANALOG SIGNAL

The analog signal can be represented by a ramp that leads continuously to a certain height.

2.4 DIGITAL SIGNAL

The digital signal can be represented by a staircase that leads to a certain height in discrete steps.

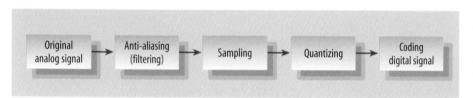

2.5 DIGITIZATION

The digitization of an analog signal is a four-step process: anti-aliasing, sampling, quantizing, and coding (short for *encoding*).

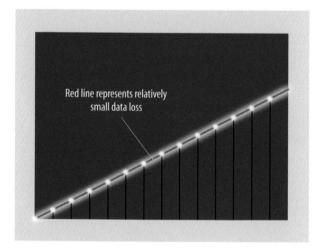

2.6 HIGH SAMPLING RATE

Sampling selects points of the original analog signal. A high sampling rate selects more points of the original signal. The digital signal will be made of more, smaller steps, making it look more like the original ramp. The higher the sampling rate, the higher the signal quality.

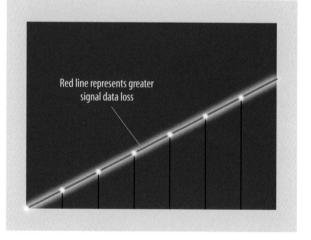

2.7 LOW SAMPLING RATE

A low sampling rate selects fewer points of the original signal. The digital signal will be made of a few large steps. Much of the original signal is lost.

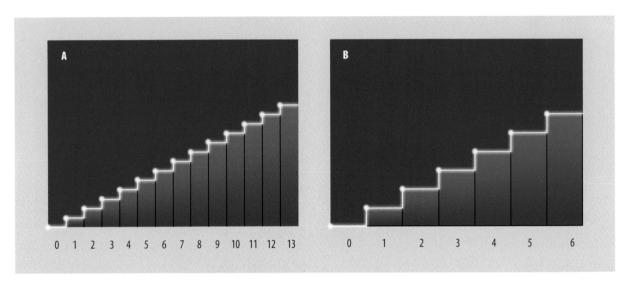

2.8 QUANTIZING

Quantizing assigns the selected signal samples a fixed position. This is the step-building stage. Each step gets a particular number assigned. **A** High sampling rate: many small steps. **B** Low sampling rate: fewer large steps.

2.9 CODING

Coding, or encoding, assigns each step a binary number and groups the steps in a specific way.

numbers, consisting of 0's and 1's, and the various grouping of the bits (for us, steps). **SEE 2.9**

BENEFITS OF DIGITAL TELEVISION

Why go through all these processes? Wouldn't it be easier simply to walk up the ramp (using the analog signal) instead of climbing thousands or even millions of steps per second (digital signal)? After all, television worked quite well before the digital revolution. The simple answer is that the digital format has major advantages over the analog one: (1) quality, (2) computer compatibility and flexibility, (3) signal transport, (4) compression, and (5) aspect ratio.

QUALITY

Since long before the advent of digital video and audio systems, picture and sound quality have been a major concern of equipment manufacturers and production personnel. A high-end studio camera can cost many times more than a consumer camcorder, mainly because the studio camera produces higher-quality pictures. Even a modest *digital television* (*DTV*) system delivers amazingly sharp and crisp pictures that show not only a great amount of fine detail but also improved color. Such initial high-resolution picture quality is especially important for extensive postproduction.

Complex editing and the rendering of special effects require many tape generations (the number of *dubs*—copies—away from the original). Unfortunately, the higher the number of generations in analog recordings, the greater the loss of quality. This is not unlike making progressive copies of a letter by photocopying each previous copy. Before long the print has deteriorated so much that you can hardly read it.

But this is where digital recordings shine: there is hardly any noticeable quality loss even after dozens of generations. For all practical purposes, the twentieth generation looks as sharp as the original source tape. In fact, through some digital wizardry, you can make a copy look even better than the original recording! Another important quality factor is that the simple binary code is relatively immune to extraneous electronic signals—noise or artifacts—that infiltrate and distort analog signals. With digital signal processing, electronic noise is held to a minimum, if not altogether eliminated.

There is a trade-off, however. With high-resolution pictures it is often difficult to obtain and maintain optical focus; and they require that we pay more attention to detail, from makeup and clothing to scenery and properties. There is another downside to superclean signals, especially when dealing with sound. Sometimes digital music recordings sound so crisp and clean that they lack the warmth and texture of the original piece—or even of an analog recording. You may remember the monotone sounds of synthesized computer speech; it was missing all the complexity and subtleties (overtones) of actual speech. Audio professionals are using higher sampling rates and more-complex digital signal combinations to make up for this deficiency. Paradoxically, a certain amount of noise seems to contribute to the "warmth" of sound.

COMPUTER COMPATIBILITY AND FLEXIBILITY

One of the big advantages of digital television is that its signals can be transferred directly from the camera to the computer without the need for digitization. The elimination of this step is especially welcome to news departments, whose members work under tight deadlines. It is also a great relief to postproduction editors, who can now devote more time to the art of editing rather than sitting idle during the digitizing process.

The flexibility of the digital signal is especially important for creating special effects and computer-generated images. Even a simple weathercast or a five-minute newscast features a dazzling display of digital effects that was all but impossible with analog equipment. The opening animated title, the scene that expands full-screen from the box over the newscaster's shoulder, or the graphical transition from one story to the next where one picture peels off to reveal another underneath—all show the variety and the flexibility of digital effects. The multiple screens-within-the-screen and the various lines of text that run simultaneously on the bottom, sides, or top of the main television screen are possible only through *digital video effects* (*DVE*). Computer software that allows the alteration or even the synthetic creation of audio and video images has become an essential digital production tool.

SIGNAL TRANSPORT

Your Internet connection most likely comes into your room via a regular telephone line. Becoming increasingly more common are ISDN (integrated services digital network) and DSL (digital subscriber line) connections, which are larger conduits, or pipelines, that can get more digital information to your computer faster than ordinary telephone lines can. But, as you know, even these larger pipelines seem rather slow for Web streaming or when downloading a large file.

There is often confusion about the difference between downloading and data streaming. When you are *downloading*, you receive data that are sent in *packets*. Because these data packets are usually sent out of order to make full use of the available pipeline, you cannot call up the entire file until the downloading process is complete. With *streaming*, on the other hand, you receive digital audio and/or video data as a continuous data flow. Because the data stream is sent continuously and not converted into out-of-order packets, you can listen to the music or watch the initial video frames while the files for the following frames are still being transferred.

Unfortunately, these computer pipelines are relatively small for carrying the huge amount of information necessary for a full-motion (30-frames-per-second), full-screen television sequence. The huge amount of digital data necessary for *high-definition television* (*HDTV*) or, even more so, interactive digital television needs much larger pipelines. One of these large pipelines is provided by broadband transmission. *Broadband* lets you split the original signal or simultaneously send a number of different signals (voice, music, or video, for example) via several smaller pipelines. Ironically, to transport the digital data over great distances at high speed, they must first be transformed into analog signals and then reconverted to digital at the receiving end.

2.10 4 × 3 ASPECT RATIO

The traditional aspect ratio of the television screen is 4×3 (4 units wide by 3 units high). It can also be expressed as 1.33:1 (1.33 units in width for each unit of height).

You might ask yourself why such a complicated transmission process can be called an advantage over processing and sending analog signals. You already know one reason: the binary system is extremely robust and highly resistant to signal distortion and interference. Another reason is that the size of the digital signal can be reduced dramatically without doing too much damage, through a process called *compression*.

COMPRESSION

Compression is the temporary rearrangement or elimination of redundant information for easier storage and signal transmission. Digital information can be compressed by regrouping the original data without throwing any away. Once at the destination, the data can be restored to their original positions—a process called *decoding*—for an output that is identical to the original input. We do this frequently when "zipping" (on a Windows PC) or "stuffing" (on a Mac) large computer texts for storage and transmission and then "unzipping" them when opening the file. Or you can simply delete all data that are redundant.

Compression that results from rearranging or repackaging data is called *lossless*—the regenerated image has the same number of pixels and values as the original. When some pixels are eliminated in some frames because they are redundant or beyond our ordinary perception, the compression is called *lossy*. Even if the lost pixels are not essential for the image creation, the regenerated image is nevertheless different from the original. The obvious advantage of lossless compression is that the original image

is returned without diminished quality. The disadvantage is that it takes more storage space and usually takes more time to transport and bring back from storage. Most image compression techniques are therefore the lossy kind.

One of the most widely used digital compression standards for still images is *JPEG* ("jay-peg"), named for the organization that developed the system—the Joint Photographic Experts Group; *motion-JPEG* is for moving computer images. Although a lossless JPEG technique exists, to save storage space most JPEG compressions are lossy. Another compression standard for high-quality video is *MPEG-2* ("em-peg two"), named and developed by the Moving Picture Experts Group. MPEG-2 is also a lossy compression technique, based on the elimination of redundant information. MPEG-4 and MPEG-7 differ from MPEG-2 in that they are intended more as standardized systems for organizing multimedia content than mere compression of moving images. (We discuss MPEG formats in more depth in chapter 12.)

ASPECT RATIO

One of the most visible differences between traditional (analog) and digital television systems is the horizontally stretched television picture of HDTV. The new television *aspect ratio*—the width-to-height proportions of the screen—resembles more a small motion picture screen than the traditional television screen. Although we discuss the various aspect ratios more thoroughly in chapter 15, we'll take a brief look here at the main characteristics of the two principal aspect ratios.

2.11 16 × 9 ASPECT RATIO

The aspect ratio of DTV is 16×9 (16 units wide by 9 units high), which is a multiple of the 4×3 ratio ($4^2 \times 3^2$). Its horizontally stretched aspect ratio of 1.78:1 resembles that of the movie screen (1.85:1).

4 × 3 aspect ratio The aspect ratio of the traditional television screen and of computer screens, which dates back to the earliest motion picture screens, is 4×3 , which means that its frame is 4 units wide by 3 units high, regardless of whether the units are inches or feet. This aspect ratio is also expressed 1.33:1. For every unit in screen height, there are 1.33 units in width. **SEE 2.10**

The advantage of this classic aspect ratio is that the difference between the screen width and the screen height is not pronounced enough to unduly emphasize one dimension over the other. A close-up or an extreme close-up of a face fits well in this aspect ratio, as does a horizontally stretched landscape.² The disadvantage is that it does not accommodate wide-screen movies that have the much more horizontally stretched aspect ratio of 1.85:1.

16 \times **9 aspect ratio** The horizontally stretched aspect ratio of DTV systems is 16×9 ; that is, the screen is 16 units wide by 9 units high, or 1.78:1. As you can see, this aspect ratio resembles that of a movie screen. **SEE 2.11** Because this aspect ratio is so closely associated with high-definition television, it is also called the HDTV aspect ratio. (See chapter 15 for a more in-depth discussion of aspect ratio.)

MAIN POINTS

- In the basic interlaced scanning process, the electron beam reads all odd-numbered lines first (the first field), then the even-numbered lines (the second field). The two fields constitute a single television frame. In the NTSC system, there are 60 fields, or 30 frames, per second.
- ◆ The basic colors used in television are red, green, and blue—RGB. Each of the 480 visible lines on the face of the display tube consists of groups of red, green, and blue dots or rectangles. Three electron beams activate these basic color dots—one beam for the red dots, one for the green, and one for the blue. The varying intensities of the three beams produce the colors we see on television.
- Digital computers use binary code, consisting of 0's and 1's.
 This code resists data error.
- In the digital process, the analog signal is continuously sampled at specific intervals. The samples are then quantized (assigned a discrete value) and coded into groups of 0's and 1's.
- Digital television produces pictures and sound of superior quality, allows many tape generations with virtually no signal deterioration, provides great flexibility in image manipulation and creation, and permits data compression for efficient signal transport and storage.
- Compared with the traditional television aspect ratio of 4×3 (1.33:1), HDTV systems have a wider aspect ratio of 16×9 (1.78:1).

^{2.} See Herbert Zettl, Sight Sound Motion, 4th ed. (Belmont, Calif.: Thomson Wadsworth, 2005), pp. 83–92.

2.2

Scanning Systems

This section takes a closer look at interlaced and progressive scanning and digital display systems. All standard television uses interlaced scanning; digital television systems, on the other hand, produce their high-resolution pictures through either interlaced or progressive scanning.

- ► INTERLACED AND PROGRESSIVE SCANNING
 - The interlaced and progressive scanning systems
- The 480p, 720p, and 1080i systems
- FLAT-PANEL DISPLAYS

 Plasma displays and liquid crystal displays

INTERLACED AND PROGRESSIVE SCANNING

As mentioned in chapter 1, the television image is formed by the three RGB (red, green, and blue) electron beams that scan the light-sensitive pixels lining the inner surface of the television screen. Although color television scanning requires three electron beams, to simplify the explanation we assume here that only a single beam is scanning the surface of the screen.

INTERLACED SCANNING SYSTEM

In *interlaced scanning*, the electron beam reads all the odd-numbered lines first, then it jumps back to the top to

read all the even-numbered lines. In this process some of the lines get lost. The lines we actually see on the screen are called *active* or *visible* lines.

The 525 lines of traditional (NTSC) analog television are divided into two fields: 262½ lines for the first field and another 262½ lines for the second field. The beam scans 60 alternate fields, or 30 complete frames, each second. This scanning speed is so fast that we perceive the two fields as a complete, relatively flicker-free picture. Of these 525 lines, only 480 are visible, or active. **SEE 2.12**

The lines are interlaced to save *bandwidth*, the electronic pipeline that transports the television signal. By splitting each frame in half and sending the two halves—the two fields—one right after the other instead of simultaneously, the video information is reduced and you get by with a smaller bandwidth.

Retrace and blanking Both the interlaced and the progressive scanning systems use retrace and blanking. The repositioning of the beam from the end of the scanned line to the starting point of the next is called *horizontal retrace*. When the beam reaches the end of the last line and jumps back to the starting point of line 1, it is referred to as *vertical retrace*. To avoid any picture interference during the horizontal and vertical retraces, the beam is automatically starved so that it won't light up any pixels that might interfere with the original scan; this process is called *blanking*. Hence, *horizontal blanking* occurs during the horizontal retrace, and *vertical blanking* is during the vertical retrace.

PROGRESSIVE SCANNING SYSTEM

Unlike interlaced scanning, which displays half the picture information followed immediately by the second half, the *progressive scanning* system scans every line from top to bottom and displays a full frame. Technically, the electron beam in the progressive system starts at the top left of the screen and scans the first line, then jumps back to the left at the start of the second line, scans the second line, jumps back to the third line, scans the third line, and so on. As soon as the scanning of a frame is complete, the beam jumps back to its original starting point at the top left of the screen and starts scanning the second frame, and so forth. As you can see, the beam scans all lines progressively, hence the name of the system. **SEE 2.13** The *refresh rate*, that is, how often the beam jumps back to scan another frame, can be 60 frames per second or even higher.

Let's apply the two scanning systems to DTV and see how they fare.

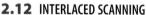

In interlaced scanning, the beam reads every other line from top to bottom. Each scan produces one field (odd-numbered or even-numbered lines). Two fields make up a complete frame.

DTV SYSTEMS

After years of wrangling over the former *ATV* (*advanced television*) and DTV (digital television) scanning standards, the industry seems to have settled on three systems: the 480p, the 720p, and the 1080i.

480P SYSTEM

The 480p system uses 480 active lines that are scanned progressively every ½0 second. Let's take a closer look at these numbers. As you can see, the 480p system has the same number of scanning lines as does standard television; but because the beam in progressive scanning reads all the lines before it jumps back to begin reading the next page, progressive scanning generates a complete frame in each scanning cycle. Instead of the 60 fields, or 30 frames, per second of standard television, the 480p system generates 60 complete frames per second. The main reason for the higher refresh rate of this and all other progressive scanning systems is to avoid flicker.

The problem with all these scanning standards is that what you get is not necessarily what you see. Because the signals are digital, the digital display (what your television receiver shows) does not have to mirror exactly what is being sent. For example, a DTV receiver may receive an interlaced frame but show it as a progressive scan. It can also show the frames at a different refresh rate from what

2.13 PROGRESSIVE SCANNING

In progressive scanning, the beam reads every line from top to bottom. Each complete scan produces a television frame. Retrace lines (shown as dashed in these figures) are blanked so they do not appear on-screen.

was delivered to the set. To make things even more complicated, each of the scanning formats (480, 720, and 1080) can have a variety of refresh rates. You may, for example, assign an HDTV camera to shoot at a frame rate of 24p (24 frames per second), but send it as a 60i (60 fields, or 30 frames per second) sequence. To fool you into an even higher resolution, the receiver may decide to double the refresh rate and show the sequence at 60 frames per second. It all boils down to giving you as sharp a picture as possible without taking up too much transmission space and time to deliver it. The resolution table gives some idea about the variations in scanning lines (vertical pixels), lines of resolution (horizontal pixels) per line, and the various refresh rates. **SEE 2.14** The number of combined pixels determines the spatial resolution; the number of frames per second (refresh rate) determines the temporal resolution. Note that the 480-line and 1,080-line digital frame can have interlaced or progressive scanning formats.

720P SYSTEM

Both the 720 visible, or active, lines (of 750 actual scanning lines) that are scanned progressively in the *720p* system and its refresh rate of 60 (all lines are scanned every ½00 second) contribute to true high-definition television images. This means that the pictures have superior resolution and color

2 4	# DTV	DECOL	LITION	TADIE
2.14	4 DTV	KESUI	UHUN	IABLE

SPATIAL RESOLUTI	ON	TEMPORAL RESOLUTION		
Height in Pixels scanning lines)	Width in Pixels (pixels per line)	Complete Frames per Second i = interlaced scanning p = progressive scanning		
480	704	24p	30p, 30i	60p
720	1,280	24p	30p	60p
1,080	1,920	24p	30p, 30i	60p

Table courtesy of Michael Korpi, Baylor University.

fidelity. The advantages of the 720p system are a relatively low number of scanning lines, efficient compression, and ease of conversion when transmitted via cable.

1080L SYSTEM

The *1080i* system (1,080 visible lines of 1,125 total lines) uses interlaced scanning. Much like with standard NTSC scanning, each field of 539½ visible lines is scanned every ½60 second, producing 30 frames per second. The high number of scanning lines of the 1080i system dramatically improves the resolution of the television picture—at the cost of requiring a fairly large bandwidth for signal transport. But in the end, as we all know, it depends on how much of the original picture quality is maintained during the entire production process and, especially, during signal transmission.

Regardless of the relative picture quality of the three standards, like any other system all are ultimately dependent on the program content. A bad program remains bad even when received in digital HDTV; a good program is good even if the picture quality is slightly inferior. Note, however, that picture quality becomes a real issue when using an HDTV system for instructional or training purposes, such as medical programs.

FLAT-PANEL DISPLAYS

Hand-in-hand with the development of DTV goes the search for high-definition receivers. Because there is a limit to the size of the *CRT* (*cathode ray tube*) of the regular tele-

vision set, the industry has turned to flat-panel displays, such as those on laptop computers. The advantage of flat-panel displays over regular television receivers or large-screen projection systems is that flat panels can be made very large without getting thicker or losing their resolution. In fact, a flat-panel display resembles a large painting with a modest frame. Even large flat panels can be hung on a wall like a painting. As always with video technology, there are two different, incompatible types of flat-panel displays that can reproduce high-definition video images: the plasma display and the liquid crystal display.

PLASMA DISPLAY PANEL

The plasma display panel (PDP) uses two transparent (usually glass) wired panels that sandwich a thin layer of gas. When the gas receives the voltages of the video signal, it activates the RGB dots that are arranged very much like those of the standard television receiver.

LIQUID CRYSTAL DISPLAY

The *liquid crystal display* (*LCD*) also uses two transparent sheets, but instead of gas the panels sandwich a liquid whose crystal molecules change when an electric current is applied. Rather than RGB dots, the LCD uses tiny transistors that light up according to the voltages of the video signal. Laptop computers, digital clocks, telephones, and many other consumer electronics use LCD.

Both flat-panel displays are capable of producing true high-definition pictures.

MAIN POINTS

- With interlaced scanning, the beam skips every other line during its first scan, reading only the odd-numbered lines. After the beam has scanned half of the last oddnumbered line, it jumps back to the top of the screen and finishes the unscanned half of the top line and continues to scan all the even-numbered lines. Each such even- or odd-numbered scan produces a field. Two fields produce a complete video frame.
- In the progressive scanning system, the electron beam scans each line, starting with line 1, then line 2, then line 3, and so on. When all lines have been scanned, the beam jumps back to its starting point to repeat the sequential scanning of all lines. Each scan of all lines results in a video frame.
- During the horizontal and vertical retraces, the beam is starved so that it will not activate the pixels and thus interfere with the clarity of the picture.
- The most common refresh rate of the 480p and 720p systems is 60 fps (frames per second), whereas for the 1080i system it is 30 fps. Many high-definition television (HDTV) systems have a variable frame rate.
- ◆ Digital television (DTV) employs three principal scanning formats: the 480p (480 lines progressively scanned), the 720p, and the 1080i (1,080 lines with interlaced scanning). All have a 16 × 9 aspect ratio but can be switched to the traditional 4 × 3 aspect ratio.
- The two flat-panel video displays are the plasma display panel (PDP), which sandwiches gas between two transparent panels, and the liquid crystal display (LCD), which sandwiches a liquid between two transparent panels. The PDP activates RGB (red, green, and blue) dots; the LCD panel activates a number of tiny transistors that change according to the charge they receive.

3

The Television Camera

The television camera is the single most important piece of production equipment. Other production equipment and techniques are greatly influenced by the camera's technical and performance characteristics. Although the electronics of the television camera have become increasingly complex, its new systems make it much simpler to operate. As you probably know from operating your own camcorder, you don't have to be a skilled electronics engineer to produce an optimal image—all you need to do is press the right camera buttons. Section 3.1, How Television Cameras Work, identifies the parts, types, and characteristics of cameras and how they operate. Section 3.2, From Light to Video Image, provides more-detailed information about the function of the CCD, the nature of color, and the chrominance and luminance channels.

KEY TERMS

- **beam splitter** Compact internal optical system of prisms and filters within a television camera that separates white light into the three primary colors: red, green, and blue (RGB). Also called *prism block*.
- **brightness** The color attribute that determines how dark or light a color appears on the monochrome television screen or how much light the color reflects. Also called *lightness* and *luminance*.
- **camcorder** A portable camera with the videotape recorder or some other recording device attached or built into it to form a single unit.
- **camera chain** The television camera (head) and associated electronic equipment, including the camera control unit, sync generator, and power supply.
- camera control unit (CCU) Equipment, separate from the camera head, that contains various video controls, including color fidelity, color balance, contrast, and brightness. The CCU enables the video operator to adjust the camera picture during a show.
- camera head The actual television camera, which is at the head of a chain of essential electronic accessories. It comprises the imaging device, lens, and viewfinder. In ENG/EFP cameras, the camera head contains all the elements of the camera chain.
- **charge-coupled device (CCD)** The imaging element in a television camera. Usually called the *chip*.
- chip A common name for the camera's imaging device. Technically, it is known as the charge-coupled device (CCD). The chip consists of a great number of imaging sensing elements, called pixels, that translate the optical (light) image into an electronic video signal. Also called camera pickup device.
- **chrominance channel** Consists of the three color (chroma) signals in a video system. The chrominance channel is responsible for each of the basic color signals: red, green, and blue (RGB). Also called *C channel*.
- contrast ratio The difference between the brightest and the darkest portions in the picture (often measured by reflected light in foot-candles). The contrast ratio for most cameras is normally 40:1 to 50:1, which means that the brightest spot in the picture should not be more than forty or fifty times brighter than the darkest portion without causing loss of detail in the dark or light areas. High-end digital cameras can exceed this ratio.
- electronic cinema A high-definition television camera that has a frame rate of 24 frames per second, which is identical to the frame rate of a film camera. Most electronic cinema cameras use high-quality, state-of-the-art lenses and highdefinition viewfinders.
- **ENG/EFP cameras and camcorders** High-quality portable field production cameras. When the camera is docked with a VTR or other recording device, or has the recording device built into it, it is called a *camcorder*.
- **gain** Electronic amplification of the video signal, boosting primarily picture brightness.

- high-definition television (HDTV) camera Video camera that delivers pictures of superior resolution, color fidelity, and light-and-dark contrast; uses high-quality CCDs and zoom lens.
- high-definition video (HDV) A recording system that produces images of the same resolution as HDTV (720p and 1080i) with equipment that is similar to standard digital video camcorders. The video signals are much more compressed than those of HDTV, however, which results in lower overall video quality.
- hue One of the three basic color attributes; hue is the color itself—red, green, yellow, and so on.
- **luminance channel** A separate channel within color cameras that deals with brightness variations and allows them to produce a signal receivable on a black-and-white television. The luminance signal is usually electronically derived from the chrominance signals. Also called *Y channel*.
- **moiré effect** Color vibrations that occur when narrow, contrasting stripes of a design interfere with the scanning lines of the television system.
- **operating light level** Amount of light needed by the camera to produce a video signal. Most color cameras need from 100 to 250 foot-candles of illumination for optimal performance at a particular *f*-stop, such as *f*/8. Also called *baselight level*.
- pixel Short for picture element. A single imaging element (like the single dot in a newspaper picture) that can be identified by a computer. The more pixels per picture area, the higher the picture quality.
- **resolution** The measurement of picture detail. Resolution is influenced by the imaging device, the lens, and the television set that shows the camera picture. Often used synonymously with *definition*.
- **saturation** The color attribute that describes a color's richness or strength.
- **shading** Adjusting picture contrast to the optimal contrast range; controlling the color and the white and black levels.
- signal-to-noise (S/N) ratio The relation of the strength of the desired signal to the accompanying electronic interference (the noise). A high S/N ratio is desirable (strong video or audio signal relative to weak noise).
- **studio camera** High-quality camera and zoom lens that cannot be maneuvered properly without the aid of a pedestal or some other camera mount.
- **sync generator** Part of the camera chain; produces electronic synchronization signal.
- sync pulses Electronic pulses that synchronize the scanning in the various video origination sources (studio cameras and/or remote cameras) and various recording, processing, and reproduction sources (videotape, monitors, and television receivers).
- white balance The adjustments of the color circuits in the camera to produce a white color in lighting of various color temperatures (relative reddishness or bluishness of white light).

3.1

How Television Cameras Work

To use computer jargon, television cameras have become user-friendly, yet you still need some basic knowledge of how a camera works so that you can maximize its potential and understand how it affects the rest of a production. This section takes a close look at the camera.

► PARTS OF THE CAMERA

The lens, the camera itself, and the viewfinder

► FROM LIGHT TO VIDEO SIGNAL

The beam splitter and the imaging device

CAMERA CHAIN

The camera head, camera control unit, sync generator, and power supply

■ TYPES OF CAMERAS

Analog and digital cameras, studio cameras, ENG/EFP cameras and camcorders, consumer camcorders, and prosumer camcorders

▶ ELECTRONIC CHARACTERISTICS

Aspect ratio, white balance, resolution, operating light level, gain, video noise and signal-to-noise ratio, image blur and electronic shutter, smear and moiré, contrast, and shading

OPERATIONAL CHARACTERISTICS

Power supply, camera cable, connectors, filter wheel, viewfinder, tally light, intercom, and additional ENG/EFP elements

PARTS OF THE CAMERA

When you take vacation pictures with your camcorder, probably the last thing on your mind is what makes a video camera work. But if you were to open up a camera (not recommended) and see the myriad electronic elements and circuits, you would probably wonder how it functions at all. Despite their electronic complexity, all television cameras (including the consumer video cameras) consist of three main parts.

The first is the *lens*, which selects a certain field of view and produces a small optical image of it. The second part is the camera itself, with its *imaging*, or *pickup*, *device* that converts into electrical signals the optical image as delivered by the lens. The third is the *viewfinder*, which shows a small video image of what the lens is seeing. Some cameras have a small foldout screen that enables you to forgo looking through an eyepiece to see the camera picture. **SEE 3.1**

FROM LIGHT TO VIDEO SIGNAL

All television cameras, whether digital or analog, big or small, work on the same basic principle: the conversion of an optical image into electrical signals that are reconverted by a television set into visible screen images. **SEE 3.2** Specifically, the light that is reflected off an object is gathered by a lens and focused on the imaging (pickup) device. The imaging device is the principal camera element that transduces (converts) the light into electric energy—the video signal. That signal is then amplified and processed so that it can be reconverted into visible screen images.

With these basic camera functions in mind, we can examine step-by-step the elements and the processes involved in the transformation of light images into color television images. Specifically, we look at (1) the beam splitter and (2) the imaging device.

BEAM SPLITTER

The *beam splitter* contains various prisms and filters. They separate the white light that passes through the camera lens into the three light beams—red, green, and blue, usually referred to as *RGB*. As discussed later in this chapter, these three primary colors are then electronically "mixed" into the many colors you see on the television screen. Because all of these prisms and filters are contained in a small block, the beam splitter is often called the *prism block*. **SEE 3.3**

Most consumer camcorders use a filter rather than a prism block to split the white light into the three RGB

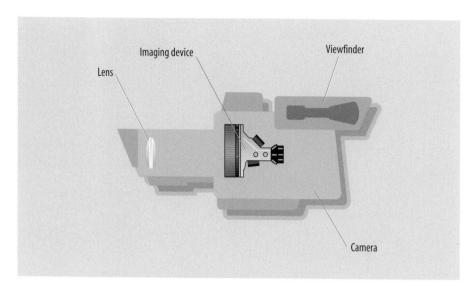

3.1 PARTS OF THE CAMERA

The main parts of a television (video) camera are the lens, the camera itself with the imaging device, and the viewfinder.

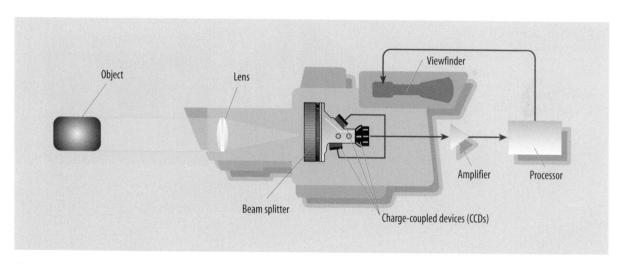

3.2 BASIC CAMERA FUNCTIONS

The light reflected off the object is gathered by the lens and focused on the beam splitter, which splits the white light of the image into red, green, and blue pictures. These beams are directed toward their respective CCDs, which transform the RGB light into electrical RGB signals; these are amplified, processed, and then reconverted by the viewfinder into video pictures.

primaries. That filter, located behind the lens and in front of the chip (CCD imaging device), consists of many narrow stripes that separate the incoming white light into the three primary colors or into only two colors, with the third one generated electronically in the camera. More-efficient systems use a mosaic-like filter that transforms the colors of the lens image into the additive primaries of red, green, and blue. **SEE 3.4**

IMAGING DEVICE

Once the white light that enters the lens has been divided into the three primary colors, each light beam must be translated into electrical signals. The principal electronic component that converts light into electricity is called the *imaging device*. This imaging, or pickup, device consists of a small solid-state device (about the size of a button on a standard telephone keypad) normally called a *chip* or,

3.3 BEAM SPLITTER

The beam splitter, or prism block, splits the incoming white light (representing the picture as seen by the lens) into RGB (red, green, and blue) light beams and directs them to their respective CCDs.

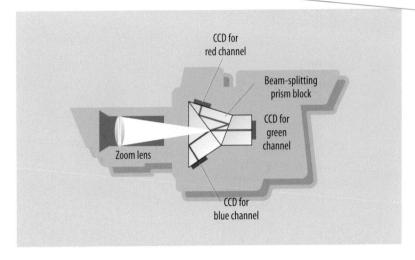

3.4 STRIPED AND MOSAIC FILTERS

Most consumer cameras have only one imaging chip (CCD) and use a striped or mosaic-like filter instead of the prism block to divide the white light into RGB color beams. Each of these colored beams is then transduced (changed) by the single CCD into the RGB signals.

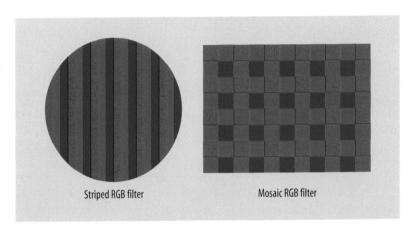

3.5 CHARGE-COUPLED DEVICE

The CCD holds many rows of thousands of pixels, each of which transforms light that enters through the window into an electric charge.

technically, a *charge-coupled device* (*CCD*). A CCD normally contains hundreds of thousands or, for a high-quality CCD, millions of image-sensing elements, called *pixels* (a word made up of *pix*, for picture, and *els* for elements), that are arranged in horizontal and vertical rows. **SEE 3.5**

Pixels function very much like tiles that compose a complete mosaic image. A certain amount of such elements is needed to produce a recognizable image. If there are relatively few mosaic tiles, the object may be recognizable, but the picture will not contain much detail. **SEE 3.6** The more and the smaller the tiles in the mosaic, the more detail the picture will have. The same is true for CCDs: the more pixels the imaging chip contains, the higher the resolution of the video image.

Each pixel is a discrete image element that transforms its color and brightness information into a specific electric charge. In digital cameras each pixel has a unique

3.6 PIXELIZED SUBJECT

Pixels function much like tiles that make up a complete mosaic image. Relatively few mosaic tiles—pixels—contain little detail. The more and the smaller the tiles, the sharper the image will look.

computer address. The electric charges from all the pixels eventually become the video signals for the three primary light colors. These RGB signals make up the *chrominance* (color) information, or the *C signal*. The black-and-white, or *luminance*, information is provided by an additional signal, the *Y signal* (explained in detail in section 3.2).

CAMERA CHAIN

When looking at a high-quality studio camera, you can see that it is connected by cable to an electrical outlet. This cable connects the camera to a chain of equipment necessary to produce pictures. The major parts of the *camera chain* are (1) the actual camera, called the *camera head* because it is at the head of the chain; (2) the *camera control unit*, or *CCU*; (3) the *sync generator* that provides the synchronization pulses to keep the scanning of the various pieces of television equipment in step; and (4) the power supply. **SEE 3.7**

CAMERA CONTROL UNIT

Each studio camera has its own *camera control unit* (*CCU*). The CCU performs two main functions: setup and control. During setup each camera is adjusted for the correct color rendition, the white balance (manipulating the three color signals so that they reproduce white correctly under a variety of lighting conditions), the proper contrast range between the brightest and the darkest areas of a scene, and the brightness steps within this range.

Assuming that the cameras are set up properly and have fair stability (which means that they retain their setup values), the video operator (VO) usually need control only

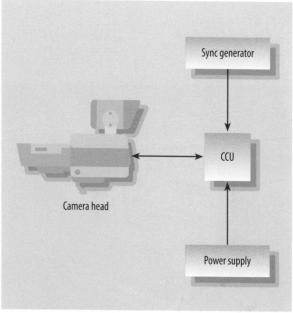

3.7 STANDARD STUDIO CAMERA CHAIN

The standard camera chain consists of the camera head (the actual camera), the camera control unit (CCU), the sync generator, and the power supply.

"master black" or "pedestal" (adjusting the camera for the darkest part of the scene), and the "white level" or "iris" (adjusting the *f*-stop of the lens so that it will permit only the desired amount of light to reach the imaging device). The VO has two primary instruments for checking the relative quality of the color signal: the *waveform monitor*, also called the *oscilloscope*, that displays the luminance (brightness) information, and the *vector scope* that shows the chrominance (color) signals. Both displays enable the VO to achieve optimal pictures. **SEE 3.8**

Sometimes, when the actual operational controls are separated from the CCU, they are known as a *remote control unit* (*RCU*) or, more accurate, an *operation control panel* (*OCP*). For example, the actual CCUs may be located in master control, but the OCPs are in the studio control room. This arrangement allows the video operator to do the initial camera setup in master control and then sit in the control room with the production crew and "shade" the pictures (maintain optimal picture quality) according not only to technical standards but also to the aesthetic requirements of the production. Now you know why the VO is also called a *shader*. The term *RCU* also refers to a small CCU that can be taken to EFP locations to make field cameras perform at optimal levels.

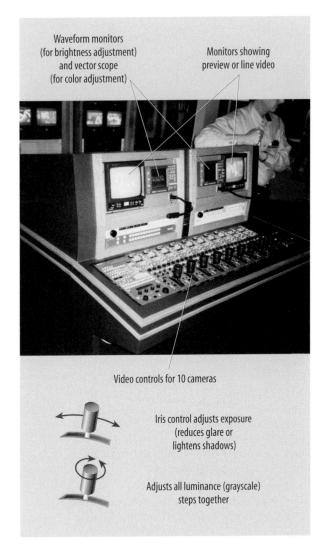

3.8 CAMERA CONTROL UNIT

The CCU adjusts the camera for optimal color and brightness and can adjust for varying lighting conditions.

SYNC GENERATOR AND POWER SUPPLY

The *sync generator* produces electronic synchronization pulses—*sync pulses*—that keep in step the scanning in the various pieces of equipment (cameras, monitors, and videotape recorders). A *genlock* provides various pieces of studio equipment with a general synchronization pulse, called *house sync*. Through the genlocking process, the scanning of video signals is perfectly synchronized, allowing you to switch among and intermix the video signals of various cameras and/or videotape recorders (VTRs) without the need for additional digital equipment.

The *power supply* generates the electricity (direct current) that drives the camera. In a studio the power supply converts *AC* (alternating current) to *DC* (direct current) power and feeds it to the cameras.

The camera cable feeds all the CCU functions to the camera and transports the video signals from the camera back to the CCU.

Field (ENG/EFP) cameras and all camcorders are self-contained, which means that the camera itself holds all the elements of the chain to produce and deliver acceptable video images to the VTR, which is either built into the camera, attached to it, or connected to it by cable. The only part of the normal camera chain that can be detached from the field camera or camcorder is the power supply—the battery. All other controls are solidly built-in and automated. Some of the more sophisticated field cameras accept *external sync*, which means that they can be genlocked with other cameras and/or an RCU.

Most cameras have built-in control equipment that can execute the CCU functions automatically. Why bother with a CCU or an RCU if you can have the camera do it automatically? Because the automated controls cannot exercise aesthetic judgment; that is, they cannot adjust the camera to deliver pictures that suit the artistic rather than the routine technical requirements. <

TYPES OF CAMERAS

Television cameras can be classified by their electronic makeup and by how they are used. As you may have guessed, cameras grouped by electronic makeup are either analog or digital. Cameras classified by function are for either studio or ENG/EFP use.

ANALOG VERSUS DIGITAL CAMERAS

Although most cameras are digital, regardless of whether they are large studio cameras or small camcorders, there are nevertheless many analog cameras still in use, mainly because of their high initial cost (such as Sony Betacam) and their remarkably good picture quality (such as the S-VHS and Sony Hi8 camcorders). Regardless of the type of camera, all of them—analog and digital, large and small—start out with an analog video signal. The light that is transported through the lens to the beam splitter and from there to the imaging device remains analog throughout. Even after the translation of the three RGB light beams by the CCDs, the resulting video signals are still analog. But from there analog and digital part company.

In the analog camera, the video signal remains analog throughout the processing inside the camera and during

the recording, assuming that the VTR is also analog. In the digital camera, however, the analog RGB video signals are digitized and processed right after leaving the CCDs.

Although digital signals are much more robust than analog ones (that is, less prone to distortion), they are not automatically high-definition. Despite their superior picture quality, many digital cameras still operate on the traditional 480i (interlaced), 30-frames-per-second NTSC system and therefore are not considered high-definition. Sometimes you will hear the 480p system described as high-definition, which is not surprising when looking at its high-resolution pictures, but only the 720p and 1080i systems, or some variations thereof, are truly high-definition.

Despite the differences between analog and digital, standard or high-definition, high-end or low-end, television cameras fall into four groups: (1) studio cameras, (2) ENG/EFP cameras and camcorders, (3) consumer camcorders, and (4) prosumer camcorders. This classification is more useful because it is based on the primary production function of the camera, not on its electronic makeup. Some camera types are better suited for studio use, others for the coverage of a downtown fire or the production of a documentary on pollution, and still others for taking along on vacation to record the more memorable sights.

STUDIO CAMERAS

The term *studio camera* is generally used to describe high-quality cameras, including *high-definition television* (*HDTV*) *cameras*. They are so heavy they cannot be maneuvered properly without the aid of a pedestal or some other camera mount. **SEE 3.9** Studio cameras are used for various studio productions, such as news, interviews, and panel shows, and for daily serial dramas, situation comedies, and instructional shows that require high-quality video. But you can also see these cameras used in such "field" locations as concert and convention halls, football and baseball stadiums, tennis courts, and medical facilities.

The obvious difference between the standard studio camera and ENG/EFP and consumer cameras is that studio cameras can function only as part of a camera chain; all other camera types can be self-contained, capable of delivering a video signal to a recording device, such as a VTR, without any other peripheral control equipment. Because the picture quality of a studio camera is determined by the VO who is operating the CCU, there are relatively few buttons on studio cameras compared with ENG/EFP models.

Considering that you can get pretty good pictures from a camera that fits into your pocket, why bother with such

3.9 STUDIO CAMERA ON STUDIO PEDESTAL Studio cameras have high-quality lenses and CCDs. They are quality-controlled by the CCU. Studio cameras are too heavy to be carried and are mounted on a sturdy tripod or studio pedestal.

heavy cameras and the rest of the camera chain? As indicated, the overriding criteria for the use of studio cameras are picture quality and control. We usually judge picture quality by the amount of sharp picture detail the camera and the monitor can generate. The virtue of HDV and HDTV (480p, 720p, and 1080i) is that both systems can produce high-resolution pictures. But *quality* is a relative term. In many productions the extra quality and control achieved with studio cameras is not worth the additional time and expense necessary for operating such equipment. For example, if you are to get a picture of an approaching tornado, you are probably not thinking about optimum picture quality. Your attention is on getting the shot and then getting out of harm's way as quickly as possible. But

if picture quality is paramount, such as in the production of commercials, medical shows, or dramas, you would undoubtedly choose a high-end studio camera. Of course, picture quality is an important factor for most shows, even in everyday news coverage.

Besides the electronic system used in the camera, another major factor that affects picture quality is the lens. You will notice that the lens of a studio camera is as large as (or even larger than) the camera itself. When buying a medium-priced camera with a top-quality lens, you will spend quite a bit more money for the lens than for the camera. The HDTV cameras used for the creation of electronic cinema use special, high-quality lenses. (We elaborate on various lenses in chapter 4.)

ENG/EFP CAMERAS AND CAMCORDERS

ENG As mentioned before, the cameras for *electronic news* gathering (ENG) and *electronic field production* (EFP) are portable, which means that they are usually carried by a camera operator or put on a tripod. They are also self-contained and hold the entire camera chain in the camera head. With their built-in control equipment, ENG/EFP cameras and camcorders are designed to produce high-quality pictures (video signals) that can be recorded on a separate VTR, on a small VTR or disk-recording device that is docked with the camera, or on a built-in VTR or disk recorder. As noted, when docked with a recording device, the camera forms a camcorder. SEE 3.10

ENG/EFP camcorders operate on the same basic principle as the smaller consumer models except that the

3.10 ENG/EFP CAMCORDER

This one-piece camcorder has its VTR permanently attached. Other models have a dockable VTR, which can be used independent of the camera.

CCDs, the video-recording device, and especially the lens are of much higher quality. Most newer digital camcorders use either the Sony DVCAM or the Panasonic DVCPRO system and record on ¼-inch (6.35mm) videocassettes. In conforming to a tapeless production environment, an everincreasing number of camcorders use small hard drives or optical discs as the recording device. (See chapter 12 for more information on video recording).

The ENG/EFP camera has many more buttons and switches than does a studio camera or a home camcorder mainly because the video control (CCU) functions, the VTR operation, and the audio control functions must be managed by the camera operator. Fortunately, you can preset many of these controls using an electronic menu or by switching to automatic, similar to the auto-controls on a consumer camcorder. These automatic features make it possible to produce acceptable pictures even under drastically changing conditions without having to manually readjust the camera.

The picture quality of the high-end ENG/EFP camera is so good that it is frequently used as a studio camera. To make it operationally compatible with regular studio cameras, the ENG/EFP model is placed in a specially made camera frame; a large external *tally light* is added; the small (1-inch) eyepiece viewfinder is replaced with a larger (5- or 7-inch) one; and zoom and focus controls that can be operated from the panning handles are added. The ENG/EFP lens, which offers a relatively wide-angle view, must be substituted with a zoom lens that is more suitable to the studio environment. **SEE 3.11** Other important conversion factors include an intercom system for the camera operator and a cable connection to the CCU that enables the VO to control the camera from a remote position just like a standard studio camera.

CONSUMER CAMCORDERS

Despite the dazzling variety advertised in the Sunday papers, most consumer cameras have a single-chip imaging device and a built-in VTR. All have automated features, such as *auto-focus*, which focuses on what the camera presumes to be the target object, and *auto-iris*, which regulates the incoming light. In addition to the regular eyepiece viewfinder, most consumer camcorders have a foldout screen on which you can see the picture you are taking without having to hold the camera close to your eye. **SEE 3.12**

Even very small digital camcorders produce astonishingly good pictures and, if everything is done correctly, acceptable sound. The VTR of the consumer camcorder

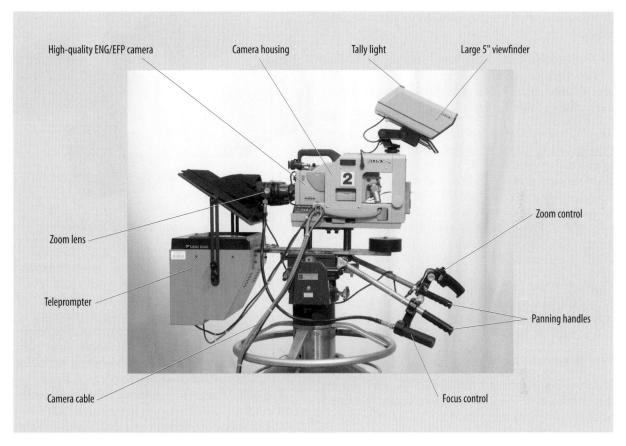

3.11 ENG/EFP CAMERA IN STUDIO CONFIGURATION

When converted for studio use, the high-quality ENG/EFP camera is mounted into a camera housing and equipped with a lens that is more suitable for studio operation, cable controls for zoom and focus, a large (5- or 7-inch) viewfinder, and an external tally light.

uses the *digital video* (*DV*) system, which records on a very compact (¼-inch, or 6.35mm) minitape cassette. Why, then, are professional ENG/EFP camcorders you see on the shoulders of news shooters so large compared with the consumer camcorder you can slip into your pocket? The reasons for their larger size are outlined here, as well as the various other advantages of professional camcorders over small consumer models:

- Professional camcorders have three high-resolution CCDs, whereas most consumer camcorders have only one. Each of the three CCDs is assigned to a specific color (red, green, or blue) as provided by the beam splitter. Three-CCD cameras produce truer colors than do cameras with a single CCD, especially in low light levels.
- Professional camcorders have larger and sturdier recording devices (VTRs or disks).

3.12 CONSUMER CAMCORDER

Small consumer camcorders have controls similar to those of professional models, with many of the functions fully automated. Most consumer camcorders have a single CCD imaging device.

- Professional camcorders use larger and better-quality lenses.
- Professional camcorders have better audio systems. The microphone inputs, preamplifiers, and sound controls are less noisy and more flexible than the simple camera microphone of the consumer camcorder.
- Professional camcorders have more operational controls that let you manually adjust the camera to a variety of production conditions. The automatic controls of the small camcorders may seem like an advantage over manual operation, but this is true only in ideal situations. If you shoot under adverse conditions, such as in dim light, extremely bright sunshine, or noisy surroundings, or if you want to achieve a certain mood, the automatic controls will no longer suffice for producing optimal images.
- Professional camcorders can transport their signals to an RCU. This transmission can be done through a thin cable or via a small transmitter attached to the back of the camera.
- Professional camcorders have larger batteries.
- Professional camcorders have smoother mechanisms for zooming in and out, better focus controls, and larger and higher-resolution viewfinders.

PROSUMER CAMCORDERS

Nevertheless, there are smaller camcorders on the market that incorporate many of the aforementioned features of professional camcorders. These high-end consumer models, called *prosumer camcorders*, are finding more and more acceptance in news and documentary productions. Some of the top documentaries shown in movie theaters are shot with such prosumer camcorders. **SEE 3.13**

HDV camcorders High-definition video (HDV) digital camcorders are the prosumer model for high-definition television. The HDV camcorder captures video with three fairly high-quality imaging devices. They can be the standard high-quality CCDs or high-resolution CMOS chips, which are similar to CCDs but draw less power. This is an important consideration when using a relatively small battery as the energy source. The HDV camcorder uses a high-definition VTR that records on ¼-inch full-sized or mini-cassettes just like other digital video prosumer camcorders. And, like the HDTV camcorder, the HDV camcorders use the 720p/30 (720 progressively scanned lines at 30 frames per second) or the 1080i (1080 interlaced

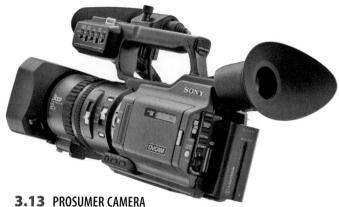

This high-end prosumer camera has three CCDs and can be used for on-the-air work.

scanning lines at 30 frames per second) system. Does this mean that the HDV pictures look as good as the HDTV ones? Yes and no. Under normal circumstances you will have a hard time seeing a big difference between the two, especially if the HDV images are displayed on a high-resolution monitor. Thanks to the signal processing of HDV, which detects and corrects many video signal errors, the HDV pictures look amazingly sharp.

The initial limiter for delivering pictures as good as or better than HDTV systems is the lens. An HDTV lens can cost thousands of dollars more than the entire HDV camcorder, which may not be a worthwhile investment for a slightly better picture. The single factor that compromises the quality of the HDV picture the most is the system's compression. It generates many more artifacts than HDTV, which you can clearly see, especially when the scene contains a high amount of small detail or a great deal of object and/or camera motion.

Nevertheless, you will find that in most situations your HDV camera will produce stunning images that come close in quality to those of the much more expensive HDTV systems.

Whatever camera you use, there is no better way to learn how it works than to use it for a while in a variety of production situations. You can, however, cut this learning process short and save nerves and equipment by first acquainting yourself with the major electronic and operational characteristics of various camera types.

ELECTRONIC CHARACTERISTICS

There are certain electronic characteristics common to all television cameras: (1) aspect ratio, (2) white balance, (3) resolution, (4) operating light level, (5) gain, (6) video

noise and signal-to-noise ratio, (7) image blur and electronic shutter, (8) smear and moiré, (9) contrast, and (10) shading. Most digital camcorders can be connected to a digital VTR or a computer via a FireWire (Apple) or an i-link (Sony), which is a cable that allows fast transport of digital data.

ASPECT RATIO

Most digital cameras allow you to switch electronically between the standard 4×3 aspect ratio and the horizontally stretched HDTV aspect ratio of 16×9 . This switchover occurs in the CCD imaging device (discussed later in this chapter). In low-end cameras such switchover inevitably reduces the image resolution, regardless of whether the transition is from 16×9 to 4×3 or from 4×3 to 16×9 . The more important facet of this aspect ratio change, however, is an aesthetic one, which we explore later in this chapter and in chapter 15.

WHITE BALANCE

To guarantee that a white object looks white under slightly reddish (low Kelvin degrees) or bluish (high Kelvin degrees) light, you need to tell the camera to compensate for the reddish or bluish light and to pretend that it is dealing with perfectly white light (see chapter 7). This compensation by the camera is called *white balance*. When a camera engages in white-balancing, it adjusts the RGB channels in such a way that the white object looks white on-screen regardless of whether it is illuminated by reddish or bluish light. **SEE 3.14**

In the studio the white-balancing is usually done by the VO, who adjusts the RGB channels at the CCU. When operating a studio camera, you will probably be asked by the VO to zoom in on a white card in the primary set area and remain on it until the white balance is accomplished.

ENG
All ENG/EFP cameras have semiautomatic white-balance controls, which means that you need to point the camera at something white and press the white-balance button. Instead of the VO, the electronic circuits

1. *Kelvin degrees* refer to the Kelvin temperature scale. In lighting, it is the specific measure of color temperature—the relative reddishness or bluishness of white light. The higher the K number, the more bluish the white light gets. The lower the K number, the more reddish the white light appears. (See chapter 7.)

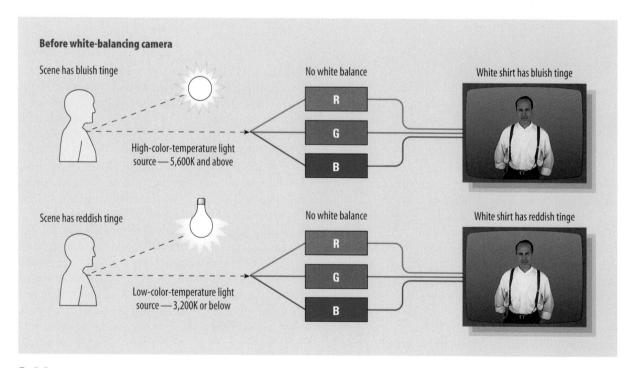

3.14 WHITE BALANCE

To counteract tinting caused by variations in color temperature of the prevailing light (reddish light and bluish light), it is necessary to white-balance the camera (figure continued on the following page).

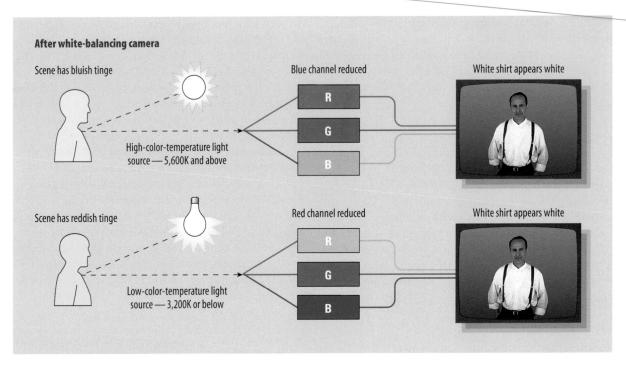

3.14 WHITE BALANCE (continued)

White-balancing the camera adjusts the RGB channels for the unwanted color cast and makes white look white under various lighting conditions.

in the camera will do the adjusting of the RGB channels to make the object look white under the current lighting conditions.

Most consumer camcorders have fully automated white-balance controls that adjust immediately to the general color temperature of the prevailing light environment. The camcorder does so by looking at the colors of a scene and calculating the white reference, that is, the color temperature of white even if there is no white object in the picture. Unfortunately, these calculations are not always accurate, especially when done under colored light. A professional camera therefore needs a more accurate reference that will tell it precisely what is supposed to look white under a specific lighting setup. Prosumer cameras give you a choice between automatic and manual white-balancing.

How to white-balance You white-balance a camera by focusing on a white card, a piece of foam core, or some other nonreflecting white object that is illuminated by the lighting in the performance area. Have someone hold a white card toward the camera. If, for example, the show has someone sitting behind a desk, have that person or the

floor manager face the camera and hold the white card in front of his or her face. Zoom in on the card until it fills the entire screen (viewfinder). Press the white-balance button (often located at the front of the camera) and wait until the viewfinder display (usually a flashing light) indicates a successful white balance.

If you don't have a white card, any white object will do, but be sure that the object fills the entire screen; otherwise, the camera will not know whether to white-balance on the foreground (the white object) or on the background, which may well have a different lighting setup. Most camera utility bags have a white flap that can be used for white-balancing. Will you need to white-balance again when you move from the desk area into the hallway that is illuminated by fluorescent lights? Absolutely. In fact, each time you encounter a different lighting situation, you need to white-balance again.

ZVL1 LIGHTS
Color temperature
white balance | controlling

RESOLUTION

Resolution refers to measuring detail in the picture and is the major factor that distinguishes standard television from

up the image.

Si

pi sł ir

ir Ci d

ta Si to

tl

b ti

produce a very detailed mosaic if you had only a few large

3.15 LOW-RESOLUTION IMAGE This low-resolution picture has relatively few pixels that make

HDTV pictures. Resolution is measured by numbers of pixels per screen area, much like in print, where resolution is often measured in dpi, which means dots (pixels) per inch. Because it plays such a big role in video equipment and production techniques, we summarize the major factors that contribute to higher resolution. SEE 3.15 AND 3.16 Figure 3.15 has considerably fewer pixels per image area than does figure 3.16. The latter therefore has the higher

resolution. As you recall, the quality of a television camera is determined primarily by the degree of resolution of the video it produces. High-quality cameras produce high-resolution pictures; lower-quality cameras produce lower-resolution pictures. The picture resolution a camera can deliver depends on various factors: (1) the quality of the lens, (2) the number pixels, (3) the number of scanning lines and the

Quality of lens The camera's electronic system is ultimately at the mercy of what the lens delivers. If the lens does not produce a high-resolution image, the rest of the camera functions will have a hard time producing a higher-resolution picture. Sometimes the signal processing can improve on picture resolution, but the average camera

must work with the picture the lens produces.

scanning system, and (4) the general signal processing.

Number of pixels Even if you have a high-quality lens, it is primarily the number of pixels in the camera's imaging device that determines the image resolution. CCDs are usually measured by total number of pixels. The CCDs in a good digital camera may have a half million or more pixels each, and those in a high-definition camera may have several million (megapixels). For example, you could not

pixels that make up the image.

ning line.

3.16 HIGH-RESOLUTION IMAGE This high-resolution picture has a relatively high number of

tiles to work with. For more detail in the mosaic, you need more (and smaller) tiles to increase the resolution of the

same-sized mosaic. The resolution of a video image can also be measured by how many pixels (dots) are used to make up a scan-

Number of scanning lines The picture resolution that a television camera or video monitor can deliver can be measured not only by the number of pixels but also by the number of lines that compose the image. You may have heard advertisements for a high-quality camera boasting more than 700 lines of resolution. But how is this possible if the standard NTSC system has only 525 scanning lines, of which we can see only 480? To explain this rather confusing

concept, let's take another close look at figure 3.15. Note that the dots in figure 3.15 form horizontal as well as vertical lines. Line up a piece of paper horizontally with the first row of dots: you perceive a horizontal line. To count the lines, slide the paper down toward the bottom of the simulated screen. You may have counted the horizontal lines in figure 3.15, but on the television screen you would have counted the vertical lines. Because, in the context of resolution, you moved the paper vertically to count the number of scanning lines, they are paradoxically called vertical lines of resolution. In effect, resolution is measured by the way the lines are stacked. Standard NTSC television has a vertical stack of 525 lines, of which 480 are visible. In HDTV the 1,080 active scanning lines increase the vertical resolution because the vertical stack comprises more than

twice the number of lines. SEE 3.17 When trying to count the horizontal television lines, you need to line up the piece of paper with the vertical rows of dots at the far left and slide it horizontally to

The camera is not fooled very easily, however. The higher the gain, the more the picture suffers from excessive video noise and color distortion—called artifacts. Nevertheless, because of improved low-noise CCDs, more and more ENG/EFP cameras follow the consumer camcorder's lead, enabling you to switch between the manual and the automatic gain controls. The advantage of an automatic gain control is that you can move from bright outdoor light to a dark interior or vice versa without having to activate the gain. Such a feature is especially welcome when covering a news story that involves people walking from a sunlit street into a dim hotel lobby or a dark corridor. The problem with automatic gain is obvious when focusing, for example, on a person in a dark suit standing in front of a fairly bright background: the automatic gain will not lighten up the dark suit but will reduce the brightness of the background. Thus, the dark suit will appear to be darker than before. When this happens you will be glad to switch back to manual gain so that you can adjust the gain for an optimal exposure.

VIDEO NOISE AND SIGNAL-TO-NOISE RATIO

You may have wondered what "noise" has to do with picture. The term *noise* is borrowed from the audio field and applied to unwanted interference in video. You can recognize "noisy" pictures quite readily by the amount of "snow"—white or colored vibrating spots or color-distorting artifacts—that appears throughout an image, causing it to be less crisp.

Technically, video noise works very much like audio noise. When playing regular (analog) audiotapes, you can hear the speakers hiss a little as soon as you turn on the system. But as soon as the music starts, you are no longer aware of the hiss. Only when the music is very soft do you again hear the hiss, hum, or rumble. So long as the signal (the music) is stronger than the noise (the hiss), you won't perceive the noise. The same is true of video noise. If the picture signal is strong (mainly because the imaging device receives adequate light), it will cover up the snow. This relationship between signal and noise is appropriately enough called *signal-to-noise* (*S/N*) *ratio*. It means that the signal is high (strong picture information) relative to the noise (picture interference) under normal operating conditions. A high number, such as 62 dB, is desirable.

IMAGE BLUR AND ELECTRONIC SHUTTER

One of the negative aspects of the CCD imaging device is that it tends to produce blur in pictures of fast-moving objects, very much like photos taken with a regular still camera at a slow shutter speed. For example, if a yellow tennis ball moves from camera-left to camera-right at high speed, the ball does not appear sharp and clear throughout its travel across the screen—it looks blurred and even leaves a trail. To avoid this blur and get a sharp image of a fast-moving object, CCD cameras are equipped with an electronic shutter.

Like the mechanical shutter on the still camera, the *electronic shutter* controls the amount of time that light is received by the chip. The slower the shutter speed, the longer the pixels of the CCD imaging surface are charged with the light of the traveling ball and the more the ball will blur. The higher the shutter speed, the less time the pixels are charged with the light of the moving ball, thus greatly reducing or eliminating the blur. But because the increased shutter speed reduces the light received by the CCD, the yellow ball will look considerably darker than without electronic shutter. As with a regular still camera, the faster the shutter speed, the more light the camera requires. Most professional CCD cameras (studio or ENG/EFP) have shutter speeds that range from ½00 to ½000 second. Some digital camcorders can go to ¼000 second or even higher.

Fortunately, most high-action events that require high shutter speeds occur in plenty of outdoor or indoor light.

SMEAR AND MOIRÉ

Both smear and moiré are specific forms of video noise. On occasion, extremely bright highlights or certain colors (especially bright reds) cause smears in the camera picture. *Smears* show up adjacent to highlights as dim bands that weave from the top of the picture to the bottom. The highly saturated color of a red dress may bleed into the background scenery, or the red lipstick color may extend beyond the mouth. Digital cameras with high-quality CCDs are practically smear-free.

Moiré interference shows up in the picture as vibrating patterns of rainbow colors. **SEE 3.20** You can see the *moiré effect* on a television screen when the camera shoots very narrow and highly contrasting patterns, such as the herringbone weave on a jacket. The rapid change of light and dark occurs at a frequency the camera uses for its color information, so it looks for the color that isn't there. It cycles through the entire color palette, causing the moving color patterns. Although the more expensive studio monitors have moiré compression circuits built-in, the ordinary television set does not. Obviously, you should avoid wearing anything with a narrow, contrasting pattern.

the recording, assuming that the VTR is also analog. In the digital camera, however, the analog RGB video signals are digitized and processed right after leaving the CCDs.

Although digital signals are much more robust than analog ones (that is, less prone to distortion), they are not automatically high-definition. Despite their superior picture quality, many digital cameras still operate on the traditional 480i (interlaced), 30-frames-per-second NTSC system and therefore are not considered high-definition. Sometimes you will hear the 480p system described as high-definition, which is not surprising when looking at its high-resolution pictures, but only the 720p and 1080i systems, or some variations thereof, are truly high-definition.

Despite the differences between analog and digital, standard or high-definition, high-end or low-end, television cameras fall into four groups: (1) studio cameras, (2) ENG/EFP cameras and camcorders, (3) consumer camcorders, and (4) prosumer camcorders. This classification is more useful because it is based on the primary production function of the camera, not on its electronic makeup. Some camera types are better suited for studio use, others for the coverage of a downtown fire or the production of a documentary on pollution, and still others for taking along on vacation to record the more memorable sights.

STUDIO CAMERAS

The term *studio camera* is generally used to describe high-quality cameras, including *high-definition television* (*HDTV*) *cameras*. They are so heavy they cannot be maneuvered properly without the aid of a pedestal or some other camera mount. **SEE 3.9** Studio cameras are used for various studio productions, such as news, interviews, and panel shows, and for daily serial dramas, situation comedies, and instructional shows that require high-quality video. But you can also see these cameras used in such "field" locations as concert and convention halls, football and baseball stadiums, tennis courts, and medical facilities.

The obvious difference between the standard studio camera and ENG/EFP and consumer cameras is that studio cameras can function only as part of a camera chain; all other camera types can be self-contained, capable of delivering a video signal to a recording device, such as a VTR, without any other peripheral control equipment. Because the picture quality of a studio camera is determined by the VO who is operating the CCU, there are relatively few buttons on studio cameras compared with ENG/EFP models.

Considering that you can get pretty good pictures from a camera that fits into your pocket, why bother with such

3.9 STUDIO CAMERA ON STUDIO PEDESTAL Studio cameras have high-quality lenses and CCDs. They are quality-controlled by the CCU. Studio cameras are too heavy to be carried and are mounted on a sturdy tripod or studio pedestal.

heavy cameras and the rest of the camera chain? As indicated, the overriding criteria for the use of studio cameras are picture quality and control. We usually judge picture quality by the amount of sharp picture detail the camera and the monitor can generate. The virtue of HDV and HDTV (480p, 720p, and 1080i) is that both systems can produce high-resolution pictures. But *quality* is a relative term. In many productions the extra quality and control achieved with studio cameras is not worth the additional time and expense necessary for operating such equipment. For example, if you are to get a picture of an approaching tornado, you are probably not thinking about optimum picture quality. Your attention is on getting the shot and then getting out of harm's way as quickly as possible. But

if picture quality is paramount, such as in the production of commercials, medical shows, or dramas, you would undoubtedly choose a high-end studio camera. Of course, picture quality is an important factor for most shows, even in everyday news coverage.

Besides the electronic system used in the camera, another major factor that affects picture quality is the lens. You will notice that the lens of a studio camera is as large as (or even larger than) the camera itself. When buying a medium-priced camera with a top-quality lens, you will spend quite a bit more money for the lens than for the camera. The HDTV cameras used for the creation of electronic cinema use special, high-quality lenses. (We elaborate on various lenses in chapter 4.)

ENG/EFP CAMERAS AND CAMCORDERS

As mentioned before, the cameras for *electronic news* gathering (ENG) and *electronic field production* (EFP) are portable, which means that they are usually carried by a camera operator or put on a tripod. They are also self-contained and hold the entire camera chain in the camera head. With their built-in control equipment, *ENG/EFP* cameras and camcorders are designed to produce high-quality pictures (video signals) that can be recorded on a separate VTR, on a small VTR or disk-recording device that is docked with the camera, or on a built-in VTR or disk recorder. As noted, when docked with a recording device, the camera forms a camcorder. SEE 3.10

ENG/EFP camcorders operate on the same basic principle as the smaller consumer models except that the

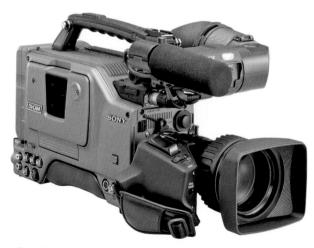

3.10 ENG/EFP CAMCORDER

This one-piece camcorder has its VTR permanently attached. Other models have a dockable VTR, which can be used independent of the camera.

CCDs, the video-recording device, and especially the lens are of much higher quality. Most newer digital camcorders use either the Sony DVCAM or the Panasonic DVCPRO system and record on ¼-inch (6.35mm) videocassettes. In conforming to a tapeless production environment, an everincreasing number of camcorders use small hard drives or optical discs as the recording device. (See chapter 12 for more information on video recording).

The ENG/EFP camera has many more buttons and switches than does a studio camera or a home camcorder mainly because the video control (CCU) functions, the VTR operation, and the audio control functions must be managed by the camera operator. Fortunately, you can preset many of these controls using an electronic menu or by switching to automatic, similar to the auto-controls on a consumer camcorder. These automatic features make it possible to produce acceptable pictures even under drastically changing conditions without having to manually readjust the camera.

The picture quality of the high-end ENG/EFP camera is so good that it is frequently used as a studio camera. To make it operationally compatible with regular studio cameras, the ENG/EFP model is placed in a specially made camera frame; a large external *tally light* is added; the small (1-inch) eyepiece viewfinder is replaced with a larger (5- or 7-inch) one; and zoom and focus controls that can be operated from the panning handles are added. The ENG/EFP lens, which offers a relatively wide-angle view, must be substituted with a zoom lens that is more suitable to the studio environment. **SEE 3.11** Other important conversion factors include an intercom system for the camera operator and a cable connection to the CCU that enables the VO to control the camera from a remote position just like a standard studio camera.

CONSUMER CAMCORDERS

Despite the dazzling variety advertised in the Sunday papers, most consumer cameras have a single-chip imaging device and a built-in VTR. All have automated features, such as *auto-focus*, which focuses on what the camera presumes to be the target object, and *auto-iris*, which regulates the incoming light. In addition to the regular eyepiece viewfinder, most consumer camcorders have a foldout screen on which you can see the picture you are taking without having to hold the camera close to your eye. **SEE 3.12**

Even very small digital camcorders produce astonishingly good pictures and, if everything is done correctly, acceptable sound. The VTR of the consumer camcorder

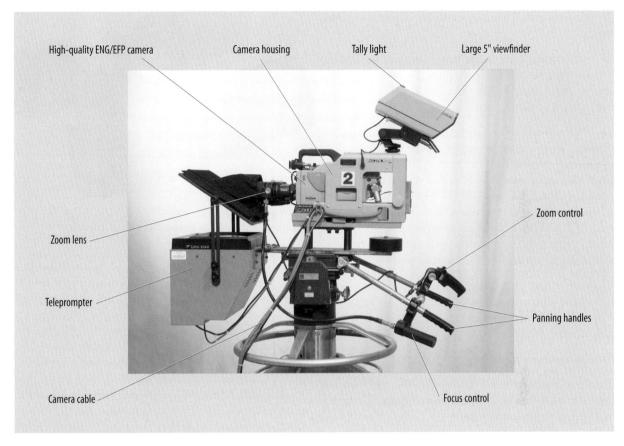

3.11 ENG/EFP CAMERA IN STUDIO CONFIGURATION

When converted for studio use, the high-quality ENG/EFP camera is mounted into a camera housing and equipped with a lens that is more suitable for studio operation, cable controls for zoom and focus, a large (5- or 7-inch) viewfinder, and an external tally light.

uses the digital video (DV) system, which records on a very compact (¼-inch, or 6.35mm) minitape cassette. Why, then, are professional ENG/EFP camcorders you see on the shoulders of news shooters so large compared with the consumer camcorder you can slip into your pocket? The reasons for their larger size are outlined here, as well as the various other advantages of professional camcorders over small consumer models:

- Professional camcorders have three high-resolution CCDs, whereas most consumer camcorders have only one. Each of the three CCDs is assigned to a specific color (red, green, or blue) as provided by the beam splitter. Three-CCD cameras produce truer colors than do cameras with a single CCD, especially in low light levels.
- Professional camcorders have larger and sturdier recording devices (VTRs or disks).

3.12 CONSUMER CAMCORDER

Small consumer camcorders have controls similar to those of professional models, with many of the functions fully automated. Most consumer camcorders have a single CCD imaging device.

- Professional camcorders use larger and better-quality lenses.
- Professional camcorders have better audio systems. The microphone inputs, preamplifiers, and sound controls are less noisy and more flexible than the simple camera microphone of the consumer camcorder.
- Professional camcorders have more operational controls that let you manually adjust the camera to a variety of production conditions. The automatic controls of the small camcorders may seem like an advantage over manual operation, but this is true only in ideal situations. If you shoot under adverse conditions, such as in dim light, extremely bright sunshine, or noisy surroundings, or if you want to achieve a certain mood, the automatic controls will no longer suffice for producing optimal images.
- Professional camcorders can transport their signals to an RCU. This transmission can be done through a thin cable or via a small transmitter attached to the back of the camera.
- Professional camcorders have larger batteries.
- Professional camcorders have smoother mechanisms for zooming in and out, better focus controls, and larger and higher-resolution viewfinders.

PROSUMER CAMCORDERS

Nevertheless, there are smaller camcorders on the market that incorporate many of the aforementioned features of professional camcorders. These high-end consumer models, called *prosumer camcorders*, are finding more and more acceptance in news and documentary productions. Some of the top documentaries shown in movie theaters are shot with such prosumer camcorders. **SEE 3.13**

HDV camcorders *High-definition video* (*HDV*) digital camcorders are the prosumer model for high-definition television. The HDV camcorder captures video with three fairly high-quality imaging devices. They can be the standard high-quality CCDs or high-resolution CMOS chips, which are similar to CCDs but draw less power. This is an important consideration when using a relatively small battery as the energy source. The HDV camcorder uses a high-definition VTR that records on ¼-inch full-sized or mini-cassettes just like other digital video prosumer camcorders. And, like the HDTV camcorder, the HDV camcorders use the 720p/30 (720 progressively scanned lines at 30 frames per second) or the 1080i (1080 interlaced

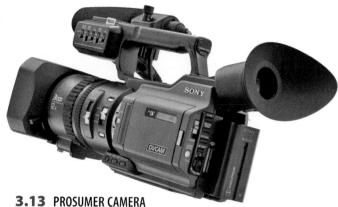

This high-end prosumer camera has three CCDs and can be used for on-the-air work.

scanning lines at 30 frames per second) system. Does this mean that the HDV pictures look as good as the HDTV ones? Yes and no. Under normal circumstances you will have a hard time seeing a big difference between the two, especially if the HDV images are displayed on a high-resolution monitor. Thanks to the signal processing of HDV, which detects and corrects many video signal errors, the HDV pictures look amazingly sharp.

The initial limiter for delivering pictures as good as or better than HDTV systems is the lens. An HDTV lens can cost thousands of dollars more than the entire HDV camcorder, which may not be a worthwhile investment for a slightly better picture. The single factor that compromises the quality of the HDV picture the most is the system's compression. It generates many more artifacts than HDTV, which you can clearly see, especially when the scene contains a high amount of small detail or a great deal of object and/or camera motion.

Nevertheless, you will find that in most situations your HDV camera will produce stunning images that come close in quality to those of the much more expensive HDTV systems.

Whatever camera you use, there is no better way to learn how it works than to use it for a while in a variety of production situations. You can, however, cut this learning process short and save nerves and equipment by first acquainting yourself with the major electronic and operational characteristics of various camera types.

ELECTRONIC CHARACTERISTICS

There are certain electronic characteristics common to all television cameras: (1) aspect ratio, (2) white balance, (3) resolution, (4) operating light level, (5) gain, (6) video

noise and signal-to-noise ratio, (7) image blur and electronic shutter, (8) smear and moiré, (9) contrast, and (10) shading. Most digital camcorders can be connected to a digital VTR or a computer via a FireWire (Apple) or an i-link (Sony), which is a cable that allows fast transport of digital data.

ASPECT RATIO

Most digital cameras allow you to switch electronically between the standard 4×3 aspect ratio and the horizontally stretched HDTV aspect ratio of 16×9 . This switchover occurs in the CCD imaging device (discussed later in this chapter). In low-end cameras such switchover inevitably reduces the image resolution, regardless of whether the transition is from 16×9 to 4×3 or from 4×3 to 16×9 . The more important facet of this aspect ratio change, however, is an aesthetic one, which we explore later in this chapter and in chapter 15.

WHITE BALANCE

To guarantee that a white object looks white under slightly reddish (low Kelvin degrees) or bluish (high Kelvin

degrees) light, you need to tell the camera to compensate for the reddish or bluish light and to pretend that it is dealing with perfectly white light (see chapter 7). This compensation by the camera is called *white balance*. When a camera engages in white-balancing, it adjusts the RGB channels in such a way that the white object looks white on-screen regardless of whether it is illuminated by reddish or bluish light. **SEE 3.14**

In the studio the white-balancing is usually done by the VO, who adjusts the RGB channels at the CCU. When operating a studio camera, you will probably be asked by the VO to zoom in on a white card in the primary set area and remain on it until the white balance is accomplished.

ENG/EFP cameras have semiautomatic white-balance controls, which means that you need to point the camera at something white and press the white-balance button. Instead of the VO, the electronic circuits

Kelvin degrees refer to the Kelvin temperature scale. In lighting, it is
the specific measure of color temperature—the relative reddishness or
bluishness of white light. The higher the K number, the more bluish
the white light gets. The lower the K number, the more reddish the
white light appears. (See chapter 7.)

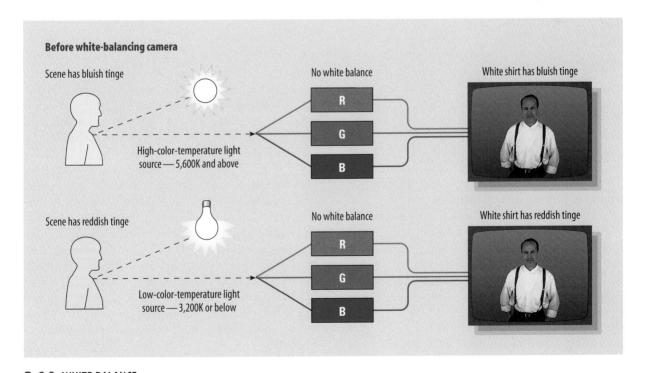

3.14 WHITE BALANCE

To counteract tinting caused by variations in color temperature of the prevailing light (reddish light and bluish light), it is necessary to white-balance the camera (figure continued on the following page).

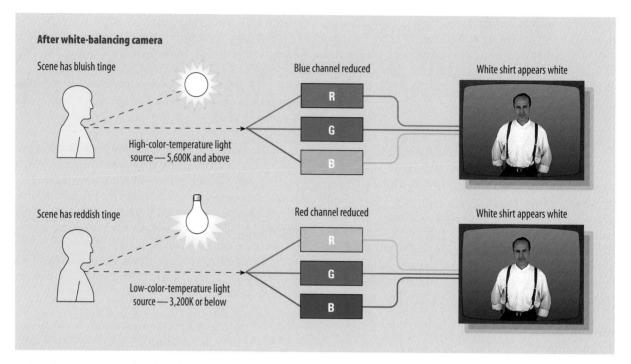

3.14 WHITE BALANCE (continued)

White-balancing the camera adjusts the RGB channels for the unwanted color cast and makes white look white under various lighting conditions.

in the camera will do the adjusting of the RGB channels to make the object look white under the current lighting conditions.

Most consumer camcorders have fully automated white-balance controls that adjust immediately to the general color temperature of the prevailing light environment. The camcorder does so by looking at the colors of a scene and calculating the white reference, that is, the color temperature of white even if there is no white object in the picture. Unfortunately, these calculations are not always accurate, especially when done under colored light. A professional camera therefore needs a more accurate reference that will tell it precisely what is supposed to look white under a specific lighting setup. Prosumer cameras give you a choice between automatic and manual white-balancing.

How to white-balance You white-balance a camera by focusing on a white card, a piece of foam core, or some other nonreflecting white object that is illuminated by the lighting in the performance area. Have someone hold a white card toward the camera. If, for example, the show has someone sitting behind a desk, have that person or the

floor manager face the camera and hold the white card in front of his or her face. Zoom in on the card until it fills the entire screen (viewfinder). Press the white-balance button (often located at the front of the camera) and wait until the viewfinder display (usually a flashing light) indicates a successful white balance.

If you don't have a white card, any white object will do, but be sure that the object fills the entire screen; otherwise, the camera will not know whether to white-balance on the foreground (the white object) or on the background, which may well have a different lighting setup. Most camera utility bags have a white flap that can be used for white-balancing. Will you need to white-balance again when you move from the desk area into the hallway that is illuminated by fluorescent lights? Absolutely. In fact, each time you encounter a different lighting situation, you need to white-balance again. ZVL1 LIGHTS Color temperature white balance | controlling

RESOLUTION

Resolution refers to measuring detail in the picture and is the major factor that distinguishes standard television from

3.15 LOW-RESOLUTION IMAGE

This low-resolution picture has relatively few pixels that make up the image.

HDTV pictures. Resolution is measured by numbers of pixels per screen area, much like in print, where resolution is often measured in dpi, which means dots (pixels) per inch. Because it plays such a big role in video equipment and production techniques, we summarize the major factors that contribute to higher resolution. **SEE 3.15 AND 3.16** Figure 3.15 has considerably fewer pixels per image area than does figure 3.16. The latter therefore has the higher resolution.

As you recall, the quality of a television camera is determined primarily by the degree of resolution of the video it produces. High-quality cameras produce high-resolution pictures; lower-quality cameras produce lower-resolution pictures. The picture resolution a camera can deliver depends on various factors: (1) the quality of the lens, (2) the number pixels, (3) the number of scanning lines and the scanning system, and (4) the general signal processing.

Quality of lens The camera's electronic system is ultimately at the mercy of what the lens delivers. If the lens does not produce a high-resolution image, the rest of the camera functions will have a hard time producing a higher-resolution picture. Sometimes the signal processing can improve on picture resolution, but the average camera must work with the picture the lens produces.

Number of pixels Even if you have a high-quality lens, it is primarily the number of pixels in the camera's imaging device that determines the image resolution. CCDs are usually measured by total number of pixels. The CCDs in a good digital camera may have a half million or more pixels each, and those in a high-definition camera may have several million (megapixels). For example, you could not produce a very detailed mosaic if you had only a few large

3.16 HIGH-RESOLUTION IMAGE

This high-resolution picture has a relatively high number of pixels that make up the image.

tiles to work with. For more detail in the mosaic, you need more (and smaller) tiles to increase the resolution of the same-sized mosaic.

The resolution of a video image can also be measured by how many pixels (dots) are used to make up a scanning line.

Number of scanning lines The picture resolution that a television camera or video monitor can deliver can be measured not only by the number of pixels but also by the number of lines that compose the image. You may have heard advertisements for a high-quality camera boasting more than 700 lines of resolution. But how is this possible if the standard NTSC system has only 525 scanning lines, of which we can see only 480? To explain this rather confusing concept, let's take another close look at figure 3.15.

Note that the dots in figure 3.15 form horizontal as well as vertical lines. Line up a piece of paper horizontally with the first row of dots: you perceive a horizontal line. To count the lines, slide the paper down toward the bottom of the simulated screen. You may have counted the horizontal lines in figure 3.15, but on the television screen you would have counted the vertical lines. Because, in the context of resolution, you moved the paper vertically to count the number of scanning lines, they are paradoxically called *vertical lines of resolution*. In effect, resolution is measured by the way the lines are *stacked*. Standard NTSC television has a vertical stack of 525 lines, of which 480 are visible. In HDTV the 1,080 active scanning lines increase the vertical resolution because the vertical stack comprises more than twice the number of lines. **SEE 3.17**

When trying to count the *horizontal* television lines, you need to line up the piece of paper with the vertical rows of dots at the far left and slide it horizontally to

3.17 VERTICAL DETAIL (LINES OF RESOLUTION)

To measure vertical detail, we count the vertical stack of horizontal (scanning) lines. The more lines the vertical stack contains, the higher the resolution. The number of lines is fixed by the system: the NTSC system has 525 lines, of which only 480 are visible on-screen; HDV and HDTV systems have 720 and 1,080 active (visible) lines, respectively.

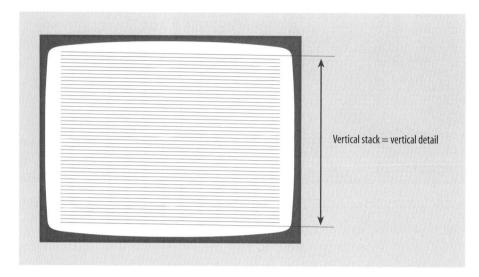

3.18 HORIZONTAL DETAIL (LINES OF RESOLUTION)

To measure horizontal detail, we count the dots (pixels) of each horizontal line and then connect these dots vertically, which yields a horizontal stack of vertical lines. The more lines the horizontal stack contains (reading from left to right), the higher the resolution. This horizontal stack can contain many more lines (such as 700) than can the vertical stack.

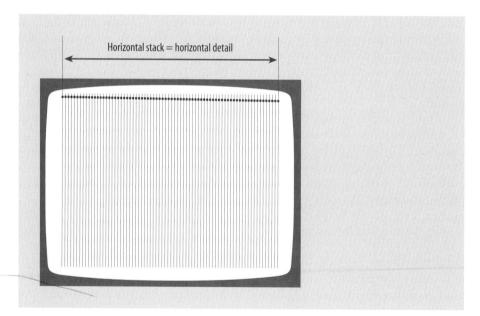

screen-right. As you can see, each dot forms the beginning of another line. Because the lines are stacked horizontally, they are called *horizontal lines of resolution*. If you count 700 dots (pixels) making up the horizontal line, it is a horizontal resolution of 700 lines, which, incidentally, is remarkably good for video. **SEE 3.18**

Because such a perceptual switch of horizontal and vertical in terms of resolution is confusing even for engineering experts, some authors suggest calling the dots that make up the resolution in the horizontal direction horizontal detail, and those that make up the resolution in the vertical direction, vertical detail.² As you can see, there can be many more dots horizontally than vertically; hence the horizontal resolution can have 700 or more "lines" even if the vertical detail is limited to 525 "lines."

As you already know, the scanning system also has a say in how sharp we perceive a picture to be. Generally,

^{2.} Arch C. Luther and Andrew F. Inglis, *Video Engineering*, 3rd ed. (New York: McGraw-Hill, 1999), p. 7.

progressive scanning, such as in a 480p system, produces sharper pictures than a 480i image. The progressive scanning system produces twice as many frames per second (60) than does the interlaced scanning system (30 fps). Hence with progressive scanning you perceive twice the picture information each second.

Signal processing Once the CCD has changed the light image into electrical video signals, these digitized signals can be manipulated considerably. This manipulation in digital cameras can enhance and even improve on the resolution. HDV uses such manipulation to great advantage. Most digital cameras use image enhancers. In this signal manipulation, the electronic circuits are designed to sharpen the contour of the picture information, but they do not increase the number of pixels. You will not see more picture detail but rather a sharper demarcation between one picture area and the next. Human perception translates this outline into a higher resolution and hence a sharper, higher-definition picture.

As you can see once again, television operates as a system in which most elements are dependent on the proper functioning of all the others.

OPERATING LIGHT LEVEL

Because it is the job of the camera's imaging device to transduce light into electricity, the camera obviously needs light to produce a video signal. But just how much light is required to produce an adequate signal? The answer depends again on a variety of interacting factors, such as the light sensitivity of the imaging device and how much light the lens transmits.

The operating light level, also called baselight level, is the amount of light needed by the camera to produce acceptable pictures ("acceptable" meaning a video image that is relatively free of color distortion and electronic noise, which shows up as black-and-white or colored dots in the dark picture areas). When looking at technical camera specifications, you may come across two terms that refer to operating light levels. Minimum illumination means that you get some kind of picture under very low light levels. These images are just one cut above the greenish, ghostlike pictures you get when switching your camcorder to the nightshot mode. The other operating light level specification is sensitivity, which describes the amount of light necessary to produce acceptable, if not optimal, pictures with good detail and color fidelity. To get this measurement, the object is illuminated by a standard amount of light (200 foot-candles, or approximately 2,000 lux) with an f-stop between f/5.6 and f/13) that allows optimal focus and a fairly great *depth of field*. (See chapter 7 for explanations of foot-candles and lux, and see chapter 4 for *f*-stop and depth of field).

The minimum operating light level under which cameras perform adequately is not always easy to define. It is determined by how much light the camera lens admits, the light sensitivity of the CCDs, and how much the video signal can be boosted electronically—a process called *gain*—before the picture begins to deteriorate. Some camera viewfinders can display a zebra-striped pattern that starts pulsating when the light level in parts of the picture is too high. You can then adjust the *f*-stop to limit the light transmitted by the lens.

GAIN

A video camera can produce pictures in extremely low light levels because it can boost the video signal electronically—a feature called *gain*. In effect, the electronic gain is fooling the camera into believing that it has adequate light. In studio cameras the gain is adjusted through the CCU.

In ENG/EFP cameras gain is manipulated by the gain control switch. In a consumer camcorder, you can use the gain switch or you can change to automatic gain. When operating an ENG/EFP camera, you can move the gain control switch to one of several boosting positions—marked by units of *dB* (decibels), such as a +6, +12, +18, or even +24 dB gain—to compensate for low light levels. When it is really dark and you can't worry about picture quality, you can switch to a hypergain position, which makes the camera "see" although you may stumble in the dark. **SEE 3.19**

3.19 MANUAL GAIN CONTROL

The gain control compensates for low light levels. The higher the gain, the lower the light level can be. High gain causes video noise.

The camera is not fooled very easily, however. The higher the gain, the more the picture suffers from excessive video noise and color distortion—called artifacts. Nevertheless, because of improved low-noise CCDs, more and more ENG/EFP cameras follow the consumer camcorder's lead, enabling you to switch between the manual and the automatic gain controls. The advantage of an automatic gain control is that you can move from bright outdoor light to a dark interior or vice versa without having to activate the gain. Such a feature is especially welcome when covering a news story that involves people walking from a sunlit street into a dim hotel lobby or a dark corridor. The problem with automatic gain is obvious when focusing, for example, on a person in a dark suit standing in front of a fairly bright background: the automatic gain will not lighten up the dark suit but will reduce the brightness of the background. Thus, the dark suit will appear to be darker than before. When this happens you will be glad to switch back to manual gain so that you can adjust the gain for an optimal exposure.

VIDEO NOISE AND SIGNAL-TO-NOISE RATIO

You may have wondered what "noise" has to do with picture. The term *noise* is borrowed from the audio field and applied to unwanted interference in video. You can recognize "noisy" pictures quite readily by the amount of "snow"—white or colored vibrating spots or color-distorting artifacts—that appears throughout an image, causing it to be less crisp.

Technically, video noise works very much like audio noise. When playing regular (analog) audiotapes, you can hear the speakers hiss a little as soon as you turn on the system. But as soon as the music starts, you are no longer aware of the hiss. Only when the music is very soft do you again hear the hiss, hum, or rumble. So long as the signal (the music) is stronger than the noise (the hiss), you won't perceive the noise. The same is true of video noise. If the picture signal is strong (mainly because the imaging device receives adequate light), it will cover up the snow. This relationship between signal and noise is appropriately enough called *signal-to-noise* (*S/N*) *ratio*. It means that the signal is high (strong picture information) relative to the noise (picture interference) under normal operating conditions. A high number, such as 62 dB, is desirable.

IMAGE BLUR AND ELECTRONIC SHUTTER

One of the negative aspects of the CCD imaging device is that it tends to produce blur in pictures of fast-moving objects, very much like photos taken with a regular still camera at a slow shutter speed. For example, if a yellow tennis ball moves from camera-left to camera-right at high speed, the ball does not appear sharp and clear throughout its travel across the screen—it looks blurred and even leaves a trail. To avoid this blur and get a sharp image of a fast-moving object, CCD cameras are equipped with an electronic shutter.

Like the mechanical shutter on the still camera, the *electronic shutter* controls the amount of time that light is received by the chip. The slower the shutter speed, the longer the pixels of the CCD imaging surface are charged with the light of the traveling ball and the more the ball will blur. The higher the shutter speed, the less time the pixels are charged with the light of the moving ball, thus greatly reducing or eliminating the blur. But because the increased shutter speed reduces the light received by the CCD, the yellow ball will look considerably darker than without electronic shutter. As with a regular still camera, the faster the shutter speed, the more light the camera requires. Most professional CCD cameras (studio or ENG/EFP) have shutter speeds that range from ½,000 second. Some digital camcorders can go to ½,000 second or even higher.

Fortunately, most high-action events that require high shutter speeds occur in plenty of outdoor or indoor light.

SMEAR AND MOIRÉ

Both smear and moiré are specific forms of video noise. On occasion, extremely bright highlights or certain colors (especially bright reds) cause smears in the camera picture. *Smears* show up adjacent to highlights as dim bands that weave from the top of the picture to the bottom. The highly saturated color of a red dress may bleed into the background scenery, or the red lipstick color may extend beyond the mouth. Digital cameras with high-quality CCDs are practically smear-free.

Moiré interference shows up in the picture as vibrating patterns of rainbow colors. **SEE 3.20** You can see the *moiré effect* on a television screen when the camera shoots very narrow and highly contrasting patterns, such as the herringbone weave on a jacket. The rapid change of light and dark occurs at a frequency the camera uses for its color information, so it looks for the color that isn't there. It cycles through the entire color palette, causing the moving color patterns. Although the more expensive studio monitors have moiré compression circuits built-in, the ordinary television set does not. Obviously, you should avoid wearing anything with a narrow, contrasting pattern.

3.20 MOIRÉ PATTERN

Moiré is a visual interference pattern that occurs when the color frequency of the color system approximates the frequency generated by the narrow and highly contrasting pattern on an object (usually clothing).

CONTRAST

The range of contrast between the brightest and the darkest picture areas that the video camera can accurately reproduce is limited. That limit, called contrast range, is expressed as a ratio. Despite their manufacturers' overly optimistic claims, even the better cameras have trouble handling high contrast in actual shooting conditions. You will run into this problem every time you videotape a scene in bright sunlight. When you adjust the camera for the extremely bright sunlit areas, the shadow become uniformly dark and dense. When you then adjust the lens (open its iris), you will promptly overexpose—or, in video lingo, "blow out"—the bright areas. It is best to limit the contrast and stay within a contrast ratio of about 50:1, meaning that for optimal pictures the brightest picture area can be only fifty times brighter than the darkest area. Digital cameras with high-quality CCDs can tolerate higher contrast ratios, but don't be misled by the camera's specifications. (How to control extremely high contrast and bring it within the range of tolerable limits is discussed in chapters 4 and 8.)

SHADING

By watching a waveform monitor, which graphically displays the white and black levels of a picture, the video operator adjusts the picture to the optimal contrast range, an activity generally called *shading*. **SEE 3.21** To adjust a less-than-ideal picture, the VO tries to "pull down" the excessively bright values to make them match the established white level (which represents a 100 percent video signal strength). But because the darkest value cannot get any blacker and move down with the bright areas, the darker

picture areas are "crushed" into a uniformly muddy, noisy dark color. If you insist on seeing detail in the dark picture areas, the video operator can "stretch the blacks" toward the white end, but, in all but the top-of-the-line cameras, that causes the bright areas to lose their definition and take on a uniformly white and strangely flat and washed-out color. In effect, the pictures look as though the contrast is set much too low with the brightness turned too high. Again, before the VO can produce optimal pictures through shading, you must try to reduce the contrast to tolerable limits.

OPERATIONAL CHARACTERISTICS

Knowing some of the operational elements and functions of studio and field cameras will help you greatly in preparing for a trouble-free, optimal camera performance.

OPERATIONAL ITEMS AND CONTROLS: STUDIO CAMERAS

This section focuses on the major operational items and controls of studio cameras: (1) power supply, (2) camera cable, (3) connectors, (4) filter wheel, (5) viewfinder, (6) tally light, and (7) intercom.

Power supply All studio cameras receive their power from a DC power supply, which is part of the camera chain. The power is supplied through the camera cable.

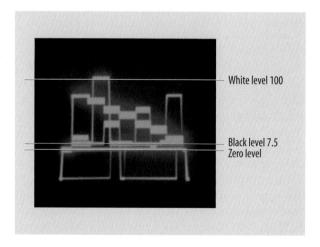

3.21 WAVEFORM MONITOR WITH WHITE AND BLACK LEVELS

The waveform monitor shows a graph of the luminance (blackand-white) portion of the video signal. It also shows the white level (the upper limit of the signal) and the black level (the lower limit of the signal). **Camera cable** Camera cables differ significantly in how they carry the various electronic signals to and from the camera. When requesting cable runs, you need to know which cable the camera can accept and, especially, how long a cable run you need.

Triaxial (triax) cables have one central wire surrounded by two concentric shields. Fiber-optic cables contain thin, flexible, glass strands instead of wires and are relatively thin, but they can transport a great amount of information over relatively long distances. A triax cable allows a maximum distance of almost 5,000 feet (about 1,500 meters), and a fiber-optic cable can reach twice as far, to almost 2 miles (up to 3,000 meters).3 Such a reach is adequate for most remote operations. Before planning a camera setup with triax or fiber-optic cables, check which cables the camera can accept and which adapters you may need. If you want to simply transport the video and audio signals from a consumer or prosumer camcorder to a digital VTR or computer hard drive, you can use a long FireWire (IEEE 1394). Some analog cameras use a multicore cable, which contains a great number of thin wires. Multicore cables are relatively heavy and have a limited reach, but they are extremely reliable.

Connectors When in the studio, the camera cable is generally left plugged into the camera and the camera wall jack (outlet). When using studio cameras in the field, however, you need to carefully check whether the cable connectors fit the jacks of the remote truck. Simple coaxial video lines all have BNC connectors (see figure 3.23 later in this chapter).

Filter wheel The *filter wheel* is located between the lens and the beam splitter. It normally holds two *neutral density filters* (*NDs*), referred to as ND-1 and ND-2, and some color-correction filters. The NDs reduce the amount of light transmitted to the imaging device without affecting the color of the scene. You use them when shooting in bright sunlight. The color-correction filters compensate for the relative bluishness of outdoor and fluorescent light and the relative reddishness of indoor and candlelight (see chapter 8). In some studio cameras, these filters can be operated from the CCU. In most others you can rotate the desired filter into position, usually with a small thumb wheel or with a switch that activates the filter wheel.

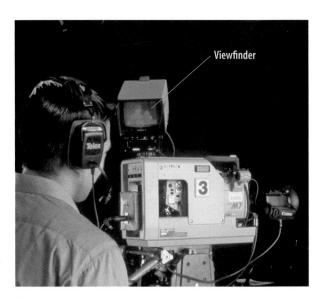

3.22 STUDIO CAMERA VIEWFINDER

The 7-inch studio camera viewfinder can be swiveled and tilted so that the screen faces the camera operator regardless of the camera position.

Viewfinder The *viewfinder* is a small television set that shows the picture the camera is getting. Studio cameras usually have a 5- or 7-inch viewfinder that can be swiveled and tilted so you can see what you are doing even when you're not standing directly behind the camera. SEE 3.22 Most viewfinders are monochrome, which means you see only a black-and-white picture of the scene you are shooting. Even HDTV cameras are not always equipped with a color viewfinder. This is somewhat unfortunate, especially for HDTV, where the stretched aspect ratio and usually large projections of its pictures make color an important compositional factor. The reason for using monochrome viewfinders is that the luminance (black-and-white) signal produces a higher-resolution image than the color channels. This feature is especially important for HDTV cameras, whose high-definition pictures are always difficult to focus.

Besides displaying the sometimes extensive electronic control menu, the camera viewfinder also acts as a small information center, indicating the following items and conditions:

- *Center marker.* This shows the exact center of the screen.
- Safe title area. A rectangle in the viewfinder within which you should keep all essential picture information.

^{3.} If the cable length is given in meters (m) and you want to find the equivalent in feet, simply divide the meters by 3. This is close enough to give you some idea of how far the cable will reach. For greater accuracy, 1 meter = 39.37 inches, or 3.28 feet.

- Electronic setup. This includes a variety of control functions, such as electronic gain, optimal video levels, electronic shutter, and so forth.
- *Lens extenders.* These are magnifying devices that extend the telephoto power of a lens (see chapter 4).
- Multiple views. The viewfinder of studio cameras allows you to see the pictures other studio cameras are taking as well as special effects. Viewing the picture of another camera helps you frame your shot so that it will complement the shot of the other camera and avoid meaningless duplication. When special effects are intended, the viewfinder displays the partial effect so that you can place your portion of the effect in the exact location within the overall screen area.

Tally light The *tally light* is the red light on top of a studio camera that signals which of the two or more cameras is "hot," that is, on the air. The light indicates that the other cameras are free to line up their next shots. It also helps the talent address the correct camera. There is also a small tally light inside the viewfinder hood that informs the camera operator when the camera is hot. When two cameras are used simultaneously, such as for a split-screen effect or a superimposition (see chapter 14), the tally lights of both cameras are on. When operating a studio camera, wait until your tally light is off before repositioning the camera. Consumer cameras usually do not have a tally light. When using prosumer camcorders for a multicamera production, you need to rig a tally light system that is activated by the switcher in the program control section.

Intercom The intercom, or intercommunication system, is especially important for multicamera productions because the director and the technical director have to coordinate the cameras' operations. All studio cameras and several high-end field cameras have at least two channels for intercommunication—one for the production crew and the other for the technical crew. Some studio cameras have a third channel that carries the program sound.

When ENG/EFP cameras are converted to the studio configuration, intercom adapters are an essential part of the conversion. As the camera operator, you can listen to the instructions of the director, producer, and technical director and talk to them as well as to the VO. When using ENG/EFP cameras in isolated (*iso*) positions, or prosumer cameras in a multicamera configuration, you need to provide for an intercom system. Sometimes it is easier to use walkie-talkies, which let you listen to the sound via small

earphones, than to string cables for intercom headsets. (The various intercom functions are discussed in depth in chapter 20.)

OPERATIONAL ITEMS: ENG/EFP CAMERAS AND CAMCORDERS

Although the operational features of ENG/EFP cameras are similar to those of studio cameras, they differ considerably in design and function. This section explains the operational items of field cameras and their functions: (1) power supply, (2) camera cable, (3) connectors, (4) interchangeable lenses, (5) filter wheel, and (6) viewfinder.

Power supply Most professional camcorders are powered by a 13-volt (13.2 V) or 14-volt (14.4 V) battery that is clipped on, or inserted in, the back of the camera. Consumer camcorders have lower-voltage batteries that are also clipped on the back of the camera-VTR unit. Substitute power supplies are household AC current and car batteries, both of which require adapters. Use a car battery only in an emergency; car batteries are hazardous to the operator as well as to the camera.

Depending on the power consumption of the camera or camcorder, most batteries can supply continuous power for up to two hours before they need recharging. If your camcorder has a low power consumption, you may be able to run it for four hours or more with a single battery charge.

Some older types of batteries for consumer video equipment develop a "memory" if they are recharged before they have completely run down. This means that the battery signals a full charge even if it is far from fully charged. To keep a battery from developing such a memory, run the battery until it has lost all of its power before recharging it, or discharge it purposely from time to time. Many battery rechargers have a discharge option, which will completely discharge a battery before recharging it. Newer batteries can be trained to develop no memory. Usually, you must drain the battery's initial charge and then fully recharge it. From then on you can recharge the battery anytime without having to discharge it completely.

When operating a professional camcorder, you should use a *digital battery*, which has a small built-in chip that communicates with the battery charger to receive a full charge. It also powers a gauge that indicates how much charge is left in the battery.

Ordinary batteries also let you know when their charge is running out, but this low-battery warning in the camera viewfinder often comes on just before the battery runs down completely. To avoid the risk of a camera shutdown in the middle of a shoot, always change the battery well before the period indicated by the manufacturer.

Camera cable When using an ENG/EFP camera rather than a camcorder, you may need to connect the camera to a videotape recorder or a remote control unit. Even a camcorder needs cables when connecting it to external equipment, such as monitor feeds, audio recorders, and so forth.

Connectors Before going to the field location, carefully check that the connectors on the various cables actually fit into the camera jacks (receptacles) and the jacks of the auxiliary equipment. Little is more annoying than having the whole production held up for an hour or more simply because a connector on a cable does not match the receptacle on the camera. Most professional video equipment uses BNC, S-video, or RCA phono connectors for video coaxial cables, and XLR or RCA phono plugs for audio cables. Some audio equipment requires cables with phone plugs. Consumer equipment usually uses RCA phono for video cables and mini plugs for audio. Although there are adapters for all plugs (so, for example, you can change a BNC connector into an RCA phono plug), try to stay away from them. Such makeshift connections are not reliable, and each adapter introduces a potential trouble spot. **SEE 3.23**

The regular 400 FireWire cable, which has a transfer speed of 400 MBps (megabytes per second), comes with a smaller 4-pin or a larger 6- pin connector. The faster 800 FireWire, with a transfer speed of 800 MBps, has a 9-pin connector and will not fit the regular 400 FireWire jacks. Cables are available that come with a different connector on each end to avoid the need for adapters.

Interchangeable lenses When using your home camcorder, you may have had trouble getting an overall shot of a birthday party in a small living room, even if zoomed out all the way. Some high-end consumer models allow you to exchange the standard zoom lens with a wide-angle one, but in most cases you can do so only with an adapter. Most professional ENG/EFP cameras let you attach the zoom lens that provides the necessary wide-angle view and a good zoom range.

Filter wheel Much like studio cameras, field cameras and camcorders have a filter wheel that contains at least two ND and a variety of color-correction filters. You can rotate the desired filter into position by activating a filter switch on the side of the camera or by selecting the appropriate filter position on the menu. The switch is sometimes labeled "color temperature."

Viewfinder Unless converted to the studio configuration, all ENG/EFP cameras and camcorders have a 1½-inch high-resolution monochrome viewfinder. It is shielded

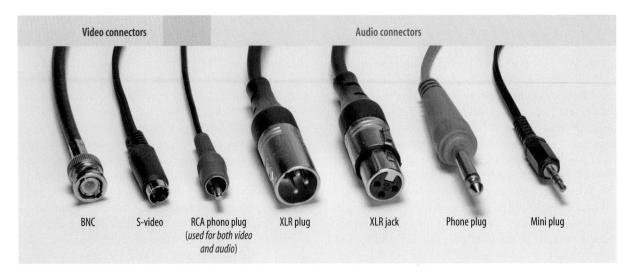

3.23 STANDARD VIDEO AND AUDIO CONNECTORS

Most professional video cables have BNC connectors. Video cables can also use S-video and RCA phono connectors. All professional microphones and three-wire cables use XLR connectors; some equipment uses the RCA phono plug or the two-wire phone plug; consumer equipment typically uses RCA phono or mini-plug connectors.

from outside reflections by a flexible rubber eyepiece that you can adjust to your eye. You can swivel the viewfinder in several directions—an important feature when the camera cannot be operated from the customary shoulder position. Most small ENG/EFP cameras and consumer camcorders have an additional foldout screen whose color image consists of a liquid crystal display (LCD) similar to that of a laptop computer. Most consumer and prosumer cameras display the electronic control menu on the foldout screen. The problem with such displays is that they are not always easy to read, especially when shooting in bright sunlight. The viewfinder also acts as an important communications system, showing the status of camera settings when the camera is in operation. Although the actual display modes vary from model to model, most studio and field camera viewfinders include the following indicators:

- VTR record. This indicates whether the videotape in the VTR is rolling and recording. This indicator is usually a steady or flashing red light, or letters such as REC keyed over the scene. When you use the foldout screen on a camcorder, it will display the same information but will deactivate the regular viewfinder.
- *End-of-tape warning*. The viewfinder may display a message of how much tape time remains.
- White balance. The white balance adjusts the colors to the relative reddishness or bluishness of the

- white light in which the camera is shooting so that a white card looks white when seen on a well-adjusted monitor. Color temperature controls are part of the white-balance adjustment.
- Battery status. This indicator shows the remaining charge or a small icon, such as a crossed-out battery or one that shows the "juice" level. Such warnings come only before the battery has lost its useful charge.
- Maximum and minimum light levels. The zebra pattern can be set for a particular maximum light level.
 When this level is exceeded, the pattern begins to flash or vibrate.
- Gain. In low-light conditions, the viewfinder indicates whether the gain is active and at what level it is set.
- Optical filter positions. The display tells you which specific filter is in place.
- Playback. The viewfinder or foldout screen can serve as a monitor when playing back from the camcorder's VTR the scenes you have just recorded. This playback feature allows you to immediately check whether the recording turned out all right technically as well as aesthetically. **SEE 3.24**

If all these indications are not enough for you, most camcorder viewfinders or display panels also show an

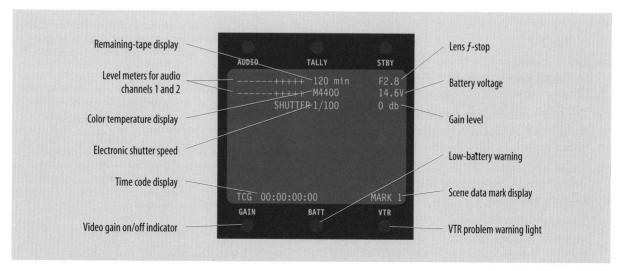

3.24 VIEWFINDER DISPLAY OF INDICATORS

The viewfinder of an ENG/EFP camera or camcorder acts as a small control center that displays a variety of status indicators. You can see these indicators without taking your eyes off the viewfinder. The operational menu can also be displayed on the foldout screen.

elaborate menu that allows a variety of camera adjustments. But, as mentioned before, such menus are hard to read in bright sunlight and are often difficult to activate in the field. This is why high-end prosumer camcorders and many ENG/EFP camcorders use external switches for the more important operational controls. <

EXTERNAL OPERATIONAL CONTROLS: ENG/EFP CAMERAS AND CAMCORDERS

Although the specific operational controls differ from one camcorder to another, you will find the following external switches on almost all camcorders.

- The power switch obviously turns the camera on and off. On a camcorder it turns on the whole system, including the camera and the VCR.
- The *standby switch* keeps the camera turned on at reduced power, therefore lessening the drain on the battery while keeping the camera ready to perform almost instantly. It is like idling a car engine before driving off. Having a camera in the standby mode rather than continually turning it on and off is also gentler on the camera's electronics and prolongs its life considerably. The standby mode also keeps the viewfinder warmed up and ready to go, which is especially important for ENG/EFP cameras.
- The *gain control* keeps the camera operational in low light levels.
- The *white-balance indicator* shows whether the camera is adjusted to the particular tint of the light (reddish or bluish) in which you are shooting (see chapter 8).
- The filter wheel enables you to select the appropriate color filter to facilitate a white balance or a neutral density filter to cut down excessive light.
- The VTR switch starts and stops the built-in or docked VTR or the one connected to the camera by cable.
- The shutter speed control lets you select the specific shutter speed necessary to avoid a blurred image of a rapidly moving object.
- The camera/bars selection switch lets you choose between the video (pictures the camera sees) and the color bars that serve as reference for the color monitors or the playback of the recording.
- The *audio level control* helps you adjust the volume of the connected audio sources.

- Sound volume and audio monitor controls let you set an optimal volume for monitoring incoming audio sources.
- *VTR controls* help you load and eject the videocassette and put the camcorder in the record mode.
- Various *jacks* enable you to connect camera, audio, intercom, and genlock cables, as well as the RCU and the setup equipment.

MAIN POINTS

- The television camera is one of the most important production elements. Other production equipment and techniques are influenced by what the camera can and cannot do.
- The major parts of the camera are the lens, the camera itself with the beam splitter and the CCD imaging device, and the viewfinder.
- The beam splitter separates the entering white light into the three additive light primaries: red, green, and blue (RGB).
- The imaging devices convert the light entering the camera into electric energy—the video signal. This is done by the charge-coupled device (CCD) or some variation of it, which is a solid-state chip containing rows of a great many lightsensitive pixels.
- The standard studio camera chain consists of the camera head (the actual camera), the CCU (camera control unit), the sync generator, and the power supply.
- The two major types of television cameras are the standard analog camera and the digital camera. Most cameras are digital, but some high-quality analog cameras are still in use.
- When classified by function, the four types of standard television cameras are the standard studio camera, the ENG/EFP camera and camcorder, the consumer camcorder, and the prosumer camcorder.
- The electronic characteristics include: aspect ratio, white balance, resolution, operating light level, gain, video noise and signal-to-noise ratio, image blur and electronic shutter, smear and moiré, contrast, and shading. The FireWire cable allows fast transport of digital data.
- The operational characteristics of studio and ENG/EFP cameras include: power supply, camera cable, connectors, filter wheel, viewfinder, tally light, and intercom.
- Because ENG/EFP cameras and camcorders have a built-in CCU—and, for camcorders, a built-in VTR—they have many more operational controls than do studio cameras.

SECTION

3.2

From Light to Video Image

Although you need not be an electronics expert to operate most television equipment, you should at least know how the light image that is captured by the lens is converted by the camera into a video picture. These basic principles will help you understand the reasons for using certain pieces of television equipment and how to use them effectively.

CCD PROCESS

The solid-state imaging device that converts light into the video signal

NATURE OF COLOR

Color attributes and additive and subtractive color mixing

CHROMINANCE AND LUMINANCE CHANNELS

The three color signals, the black-and-white signal, and how they are combined

ELECTRONIC CINEMA

The HDTV camera, frame rate, scanning, and the "film look"

CCD PROCESS

As you learned in section 3.1, a CCD (charge-coupled device) is a solid-state chip that has a small window (about the size of a telephone pushbutton) that receives the light from the beam splitter. This window contains a great number (from several thousand to several million) of horizontal and vertical rows of light-sensing pixels. Each of the pixels

can collect a certain amount of light—chrominance (color) and luminance (black-and-white) information—and transduce it into electric charges that make up part of the video signal. These charges are then temporarily stored in another layer of the chip so that the front window—the imaging, or target, area of the chip—is cleared to receive another frame of light information. The stored charges are then scanned and "clocked out" (transferred) at a particular speed and amplified to a workable signal voltage. The higher the light level a pixel receives, the stronger the signal output. SEE 3.25 There are variations of the standard CCD, such as the CMOS chip, which are designed to produce a higher-resolution image, make the chip more light sensitive, produce better colors, and all but eliminate such problems as smear and image blur.

Regardless of whether the camera is analog or digital, the entire transducing process from light to electrical signal is analog. The analog video signals are changed into digital ones only after this transduction from light to electricity.

In cameras that allow you to switch between the 4×3 and 16×9 aspect ratios, the CCDs can have a 4×3 or a 16×9 format. With 4×3 format CCDs, the top and bottom rows of pixel sensors are cut off to achieve the 16×9 aspect ratio. Because so many pixels are lost, the switch usually results in a lower-resolution image. With 16×9 format CCDs, however, the 4×3 scanning area is achieved by utilizing the center portion of the chip. Assuming that it

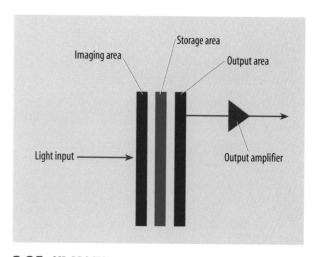

3.25 CCD PROCESS

The charge-coupled device consists of an imaging area (the window), a storage area, and an output area. The imaging area contains the pixels, the storage area stores the pixel charges, and the output area delivers them to the amplifier to form the video signal.

is a high-resolution chip (many rows of pixels), its center portion should deliver basically the same resolution as does the 16×9 format.

NATURE OF COLOR

When you look at a red ball, its color is not part of the ball, but simply light reflected off of it. The red paint of the ball acts as a color filter, absorbing all colors except red, which it bounces back. Thus the ball is stuck with the only color it has rejected: red.

COLOR ATTRIBUTES

When you look at colors, you can easily distinguish among three basic color sensations, called *attributes*: hue, saturation, and brightness or lightness. In television language *luminance* is yet another name for brightness. **SEE 3.26**

Hue describes the color itself, such as a red ball, a green apple, or a blue coat. Saturation indicates the richness or strength of a color. The bright red paint of a sports car is highly saturated, whereas the washed-out blue of your jeans or the beige of the sand on a beach are of low saturation. Brightness (lightness or luminance) is how dark or light a color appears on a black-and-white monitor or, roughly, how light or dark a color appears. The various brightness steps of a television image are usually shown as a grayscale

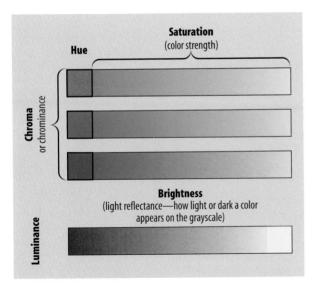

3.26 COLOR ATTRIBUTES

Hue is the term used for the base color—blue, green, yellow, and so on. Saturation refers to the purity and intensity of the color. Brightness, lightness, or luminance describes the degree of reflectance: how light or dark a color appears on the grayscale.

(see chapter 15). When you see black-and-white television pictures on-screen, you see brightness variations only; the pictures have no hue or saturation. In television the hue and saturation properties of color are sometimes named *chrominance* (from *chroma*, Greek for "color"), and the brightness properties are called *luminance* (from *lumen*, Latin for "light"). The chrominance, or *C*, channels and the luminance, or *Y*, channels are discussed later in this section.

COLOR MIXING

When you think back to your finger-painting days, you probably had three pots of paint: red, blue, and yellow. When mixing blue and yellow, you got green; when mixing red and blue, you got purple; and when smearing red and green together, you got, at best, a muddy brown. An expert finger painter could achieve almost all colors by simply mixing the primary paint colors of red, blue, and yellow. Not so when mixing colored light. The three primary light colors are not red, blue, and yellow, but rather *red*, *green*, and *blue*—in television language, *RGB*.

Additive mixing Assume that you have three individual slide projectors with a clear red slide (filter) in the first, a clear green one in the second, and a clear blue one in the third. Hook up each of the projectors to a separate dimmer. When the three dimmers are up full and you shine all three light beams together on the same spot of the screen, you get white light (assuming equal light transmission by all three slides and projector lamps). This is not surprising because we can split white light into these three primaries. When you turn off the blue projector and leave on the red and green ones, you get yellow. If you then dim the green projector somewhat, you get orange or brown. If you turn off the green one and turn on the blue one again, you get a reddish purple, called magenta. If you then dim the red projector, the purple becomes more bluish. Because you add various quantities of colored light in the process, it is called additive color mixing. SEE 3.27 Because the color camera works with light rather than finger paint, it needs the three additive color primaries (red, green, and blue) to produce all the colors you see on the television screen. You can make all other colors by adding the three light beams-primaries-in various proportions, that is, in various light intensities.

Subtractive mixing When using paint instead of colored light, your primary colors are red, blue, and yellow or, more accurately, magenta (a bluish red), cyan (a greenish blue), and yellow. In subtractive mixing, the colors

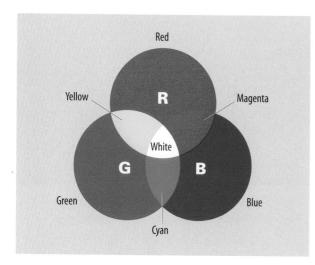

3.27 ADDITIVE COLOR MIXING

When mixing colored light, the additive primaries are red, green, and blue. All other colors can be achieved by mixing certain quantities of red, green, and blue light. For example, the additive mixture of red and green light produces yellow.

filter each other out. Because the television camera works with light rather than paint, we skip subtractive mixing at this point.

CHROMINANCE AND LUMINANCE CHANNELS

As stated earlier, chrominance deals with the hue and saturation attributes of a color, luminance with its brightness information. The chrominance channel in a camera deals with the color signals, and the luminance channel transports the black-and-white signal.

CHROMINANCE CHANNEL

The *chrominance channel*, or *C channel*, includes all hue attributes. It consists of the three "slide projectors" that produce red, green, and blue light beams of varying intensities, except that in the television camera the "slide projectors" consist of the CCDs that produce an electrical signal of varying intensity (voltage) for each of the three primary colors.

LUMINANCE CHANNEL

The *luminance channel*, or *Y channel*, is responsible for the brightness information of the color pictures. Its single luminance signal fulfills two basic functions: it translates the brightness variations of the colors in a scene into blackand-white pictures for black-and-white receivers, and it provides color pictures with the necessary crispness and definition, just like the black dots in a four-color print. Because it has such a great influence on the sharpness of the picture, the Y signal is very much favored in the digital domain. Even in high-end digital cameras, the color signals are sampled only half as often as the luminance signal, or only one-fourth as often for lower-end professional and high-end prosumer digital cameras.

Even if two hues differ considerably, such as red and blue, their brightness attributes may be so similar that they are difficult to distinguish on a monochrome monitor. For example, a red letter that looks quite prominent against a blue background may get lost in a black-and-white rendering. This problem occurs because the brightness attributes of the letter and the background are almost identical. Although the hues are contrasting considerably, their brightness values are the same. As a result, the letter is no longer legible in the black-and-white rendering. **SEE 3.28**

3.28 BRIGHTNESS: INSUFFICIENT CONTRAST

Although the hue is sufficiently different for this letter to show up on the blue background of the color television set, it is barely readable on a black-and-white receiver. The brightness contrast is insufficient for good monochrome reproduction.

3.29 BRIGHTNESS: GOOD CONTRAST

The hues in this picture have enough difference in brightness to show up equally well on both a color and a black-and-white receiver.

When the brightness attributes of the two different colors are sufficiently far apart, the letter shows up quite well in black-and-white. **SEE 3.29**

ENCODER

The encoder combines the three C (RGB) signals with the Y (luminance) signal so that they can be transported inside the camera and the VTR and transmitted and easily separated again by the color television receiver. This combined signal is called the *composite*, or *NTSC*, *signal*. If the Y signal and the C signals are kept separate, it is a *component signal*. (We revisit the composite and component signals in chapter 12.)

ELECTRONIC CINEMA

The long-anticipated time when television cameras are used to produce motion pictures intended for showing in theaters has finally arrived. Electronic cinema usually refers to a top-of-the-line HDTV camera that has been adapted for motion picture production. These cameras have CCDs, each of which has up to a megamillion pixels. These cameras have different frame rates that can be set to the 24 fps rate of motion pictures or to a much slower or faster rate. One of the most expensive parts of the camera is the lens, which is specially made for HDTV cameras. SEE 3.30 Some of these cameras have provisions for attaching a variety of primary lenses, which are similar to the various lenses you may use with your still camera. Additional items are a matte box (a lens attachment for optical special effects) and a high-resolution monochrome camera viewfinder. The images are then recorded on an HDTV recorder (see chapter 12).

Many film people complain about the "in-your-face" look of HDTV images and lament the loss of the mysterious

3.30 ELECTRONIC CINEMA CAMERA

This top-of-the-line DVCPRO HDTV 720p camera can be set at various frame rates, including the 24 fps rate to match the traditional frame rate of motion pictures. It is equipped with attachments borrowed from the traditional film camera.

"film look." The film look has been erroneously attributed to high-resolution images and is probably the result of the high contrast ratio and the blackouts that occur when one frame of the film changes over to the next. This constant going-to-black between frames makes us perceive a softer image. To copy this blackout sensation, some electronic cinema systems use filters, reintroduce a variety of artifacts, or manipulate the progressive scanning. Unfortunately, all such attempts result in a lower-quality image but not in the softer frame-by-frame cushions.

MAIN POINTS

- The solid-state charge-coupled device (CCD) consists of many (up to a megamillion) horizontal and vertical rows of pixels. Each of the pixels can collect a certain amount of light and transduce it into electric charges. The charges are then stored and read (clocked out) line-by-line and amplified into a workable video signal.
- Color attributes are hue, the color itself; saturation, the richness or strength of a color; and brightness, how dark or light a color appears.
- Color television operates on additive mixing of the three color primaries of light: red, green, and blue (RGB).
- Color cameras contain a chrominance and a luminance channel. The chrominance channel processes the color signals—the C signals—and the luminance channel processes the black-and-white (brightness) signal, called the Y signal. The two types of signals are combined by the encoder.
- Electronic cinema usually refers to a specially equipped, high-end HDTV camera for video capture.

ZETTL'S VIDEOLAB

For your reference, or to track your work, the *VideoLab* program cue in this chapter is listed here with its corresponding page number.

ZVL1

LIGHTS→ Color temperature→ white balance | controlling 52

4

Lenses

Lenses are used in all fields of photographic art. Their primary function is to project a small, clear image of the viewed scene on the film or, in the case of digital photography and television, on the electronic imaging device. As discussed in chapter 3, the lens is one of the three major parts of the camera. In studio cameras the lens is often considerably larger than the camera itself. Section 4.1, What Lenses Are, covers the basic optical characteristics of lenses and their primary operational controls. The performance characteristics of lenses, that is, how they see the world, are explored in section 4.2, What Lenses See.

KEY TERMS

- aperture Iris opening of a lens, usually measured in f-stops.
- **auto-focus** Automated feature whereby the camera focuses on what it senses to be your target object.
- calibrate To preset a zoom lens to remain in focus throughout the zoom.
- compression The crowding effect achieved by a narrow-angle (telephoto) lens wherein object proportions and relative distances seem shallower.
- **depth of field** The area in which all objects, located at different distances from the camera, appear in focus. Depth of field depends on the focal length of the lens, its *f*-stop, and the distance between the object and the camera.
- **digital zooming** Simulated zoom by cropping the center portion of an image and electronically enlarging the cropped portion. Digital zooms lose picture resolution.
- **digital zoom lens** A lens that can be programmed through a small built-in computer to repeat zoom positions and their corresponding focus settings.
- **fast lens** A lens that permits a relatively great amount of light to pass through at its maximum aperture (relatively low *f*-stop number at its lowest setting). Can be used in low-light conditions.
- **field of view** The portion of a scene visible through a particular lens; its vista. Expressed in symbols, such as *CU* for close-up.
- focal length The distance from the optical center of the lens to the front surface of the camera's imaging device at which the image appears in focus with the lens set at infinity. Focal lengths are measured in millimeters or inches. Shortfocal-length lenses have a wide angle of view (wide vista); long-focal-length (telephoto) lenses have a narrow angle of view (close-up). In a variable-focal-length (zoom) lens, the focal length can be changed continuously from wide-angle (zoomed out) to narrow-angle (zoomed in) and vice versa. A fixed-focal-length (or *prime*) lens has a single designated focal length.
- **focus** A picture is in focus when it appears sharp and clear onscreen (technically, the point where the light rays refracted by the lens converge).
- f-stop The calibration on the lens indicating the aperture, or iris opening (and therefore the amount of light transmitted through the lens). The larger the f-stop number, the smaller the aperture; the smaller the f-stop number, the larger the aperture.

- iris Adjustable lens-opening that controls the amount of light passing through the lens. Also called diaphragm or lens diaphragm.
- **macro position** A lens setting that allows it to be focused at very close distances from an object. Used for close-ups of small objects.
- **minimum object distance (MOD)** How close the camera can get to an object and still focus on it.
- **narrow-angle lens** Gives a close-up view of an event relatively far away from the camera. Also called *long-focal-length* or *telephoto lens*.
- **normal lens** A lens or zoom lens position with a focal length that approximates the spatial relationships of normal vision.
- **rack focus** To change focus from one object or person closer to the camera to one farther away or vice versa.
- **range extender** An optical attachment to the zoom lens that extends its focal length. Also called *extender*.
- **selective focus** Emphasizing an object in a shallow depth of field through focus while keeping its foreground and/or background out of focus.
- **servo zoom control** Zoom control that activates motor-driven mechanisms.
- slow lens A lens that permits a relatively small amount of light to pass through at its maximum aperture (relatively high f-stop number at its lowest setting). Can be used only in well-lighted areas.
- wide-angle lens A short-focal-length lens that provides a broad vista of a scene.
- **zoom lens** A variable-focal-length lens. It can gradually change from a wide shot to a close-up and vice versa in one continuous move.
- zoom range The degree to which the focal length can be changed from a wide shot to a close-up during a zoom. The zoom range is often stated as a ratio; a 20:1 zoom ratio means that the zoom lens can increase its shortest focal length twenty times.

4.1

What Lenses Are

The lens determines what the camera can see. One type of lens can provide a wide vista even though you may be relatively close to the scene; another type may provide a close view of an object that is quite far away. Different types of lenses also determine the basic visual perspective—whether you see an object as distorted or whether you perceive more or less distance between objects than there really is. They also contribute to a large extent to the quality of the picture and how much you can zoom in or out on an object without moving the camera. This section examines what lenses can do and how to use them.

- TYPES OF ZOOM LENSES

 Studio and field lenses, zoom range, and lens format
- OPTICAL CHARACTERISTICS OF LENSES

 Focal length, focus, light transmission (iris, aperture, and f-stop), and depth of field
- OPERATIONAL CONTROLS
 Zoom control, digital zoom lens, and focus control

TYPES OF ZOOM LENSES

When listening to production people talk about *zoom lenses*, you will most likely hear one person refer to a studio rather than a field zoom, another to a 20× lens, and yet another to a zoom lens that fits a ²/₃-inch image format.

And all may be talking about the same zoom lens. This section looks at these classifications.

STUDIO AND FIELD LENSES

As the name indicates, *studio zoom lenses* are normally used with studio cameras. *Field zooms* include large lenses mounted on high-quality cameras that are used for remote telecasts, such as sporting events, parades, and the like. They also include the zoom lenses attached to ENG/EFP cameras. The lenses of consumer camcorders usually come with the camera and cannot be exchanged. Some high-end prosumer models, however, allow you to attach a variety of zoom lenses. Because you can, of course, use a field lens in the studio and vice versa, a better and more accurate way to classify the various zoom lenses is by their zoom range and lens format, that is, what cameras they fit.

ZOOM RANGE

If a zoom lens provides an overview, for example, of the whole tennis court and part of the bleachers when zoomed all the way out and (without moving the camera closer to the court) a tight close-up of the player's tense expression when zoomed all the way in, the lens has a good zoom range. The *zoom range* is the degree to which you can change the focal length of the lens (and thereby the angle of view, or vista) during the zoom.

The zoom range of a lens is often stated as a ratio, such as 10:1 or 40:1. A 10:1 zoom means that you can increase the shortest focal length ten times; a 40:1, forty times. To make things easier, these ratios are usually listed as $10\times$ (ten times) or $40\times$ (forty times), referring to the maximum magnification of the image of which the lens is capable. **SEE 4.1**

The large (studio) cameras that are positioned on top of the bleachers for sports coverage may have zoom ranges of $40\times$ and even $70\times$. In the studio the cameras are well served by a $20\times$ zoom lens. The smaller and lighter ENG/EFP camera lenses rarely exceed a $15\times$ zoom range.

Optical and digital zoom ranges You may have noticed that the zoom range on a consumer camcorder is rather limited; an optical zoom range of 15× is considered excellent even for high-end consumer cameras. This is why consumer cameras offer the option of increasing the zoom range digitally. During an optical zoom to a tighter shot, the image magnification is achieved by moving elements within the lens. In effect, you are continually changing the focal length during the zoom-in or zoom-out. In *digital zooming* such a change in focal length does not take place.

4.1 MAXIMUM ZOOM POSITIONS OF A 10× LENS

The 10× zoom lens can increase its focal length ten times. It magnifies a portion of the scene and seems to bring it closer to the camera and ultimately the viewer.

For a zoom-in, the electronics of the camera simply select the center portion of the long shot and enlarge the cropped area to full-screen size. The problem with digital zooming is that the enlarged pixels noticeably reduce the resolution of the image (recall the mosaic tiles in chapter 3). At one point in digital zooming, the pixels can get so large that they look more like a special effect than a magnification of the original image. Higher-end camcorders, which have a digital zoom option, try to restore the full-pixel resolution of the original image by a process called *interpolation*. But

despite this digital wizardry, the digital zoom does not achieve the crispness of the optical zoom.

Studio, field, and ENG/EFP lenses are all detachable from the camera. Most consumer camcorders have a built-in lens that cannot be detached. **SEE 4.2 AND 4.3**

Studio and large field lenses Note that a 20× studio lens becomes a field lens if it is used "in the field," that is, for a production that happens outside the studio. Generally, however, field lenses have a much greater zoom

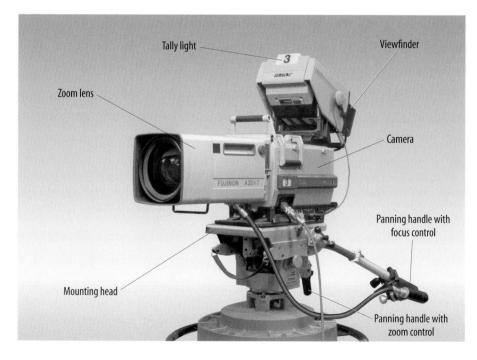

4.2 STUDIO ZOOM LENS High-quality studio lenses are quite heavy and often larger

quite heavy and often larger than the camera itself. They cannot be mounted on an ENG/EFP camera.

4.3 ENG/EFP ZOOM LENS

The ENG/EFP camera lens is considerably lighter and smaller than the studio zooms. Although these lenses are not as high quality as studio lenses, ENG/EFP lenses nevertheless have many of the studio zoom's features, such as servo and manual zoom controls, automatic iris control, and sometimes an autofocus feature.

range (from $40 \times$ to $70 \times$) than studio cameras. Some field lenses have even a greater zoom range, allowing the camera operator to zoom from a wide establishing shot of the football stadium to a tight close-up of the quarterback's face. Despite the great zoom range, these lenses deliver high-quality pictures even in relatively low light levels. For studio use such a zoom range would be unnecessary and often counterproductive.

ENG/EFP lenses These lenses are much smaller, to fit the portable cameras. Their normal zoom range varies between 11× and 20×. A 15× zoom lens would be sufficient for most ENG/EFP assignments, but sometimes you might want a closer view of an event that is relatively far away. You would then need to exchange the 15× zoom lens for one with a higher zoom range—such as 20× or even 30×. You can also use a *range extender* (discussed later in this chapter), which would let you zoom beyond the normal zoom range into a tighter shot.

A more important consideration for ENG/EFP lenses is whether they have a wide enough angle of view (a very short focal length), which would allow you to shoot in highly cramped quarters, such as in a car, a small room, or an airplane. Also, the wide-angle view is important for shooting in the wide-screen 16×9 format.

Many lenses have digital or mechanical stabilizers that absorb at least some of the picture wiggles resulting from

operating the camera, especially when in a narrow-angle (zoomed-in) position. Realize, however, that such stabilizers cause an additional drain on the battery. Use this feature only if you don't have a tripod or are unable to stabilize the camera in any other way.

Consumer camcorder lenses These zoom lenses generally have an optical zoom range of 10× to 18×. You may have noticed that the problem with zoom lenses on consumer camcorders is that the maximum wide-angle position is often not wide enough, despite their good zoom range. Most camcorders have some sort of image stabilization. Some high-end prosumer models, which have a built-in lens, let you attach elements that allow a wider angle or tighter close-ups.

Range extenders If a zoom lens does not get you close enough to a scene from where the camera is located, you can use an additional lens element called a range extender, or simply an extender. This optical element, usually available only for lenses on professional cameras, does not actually extend the range of the zoom but rather shifts the magnification—the telephoto power—of the lens toward the narrow-angle end of the zoom range. Most lenses have 2× extenders, which means that they double the zoom range in the narrow-angle position, but they also reduce the wide-angle lens position by two times. With such an extender, you can zoom in to a closer shot, but you cannot zoom back out as wide as you could without the extender. There is another disadvantage to range extenders: they cut down considerably the light entering the camera, which can be problematic in low-light conditions.

LENS FORMAT

Because camera lenses are designed to match the size of the CCD imaging device, you may hear about a *lens format* or *image format* of ½-inch, ½-inch, or ¾-inch. This means that you can use only a lens that fits the corresponding CCD image format. Like film, the larger CCDs produce better pictures. The term *lens format* may also refer to whether a lens is used for standard NTSC cameras or HDTV cameras.

OPTICAL CHARACTERISTICS OF LENSES

Effective use of a camera depends to a great extent on your understanding of four optical characteristics of lenses: (1) focal length; (2) focus; (3) light transmission—iris, aperture, and *f*-stop; and (4) depth of field.

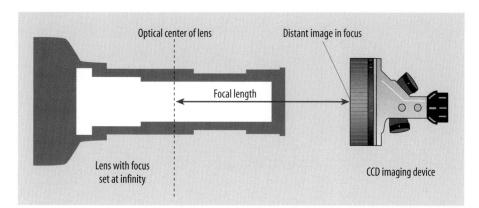

4.4 FOCAL LENGTHThe focal length is the distance from the optical center of the lens to the front surface of the imaging device.

FOCAL LENGTH

Technically, *focal length* refers to the distance from the optical center of the lens to the point where the image the lens sees is in focus. This point is the camera's imaging device. **SEE 4.4** Operationally, the focal length determines how wide or narrow a vista a particular camera has and how much and in what ways objects appear magnified.

When you zoom all the way *out*, the focal length of the lens is short and at the maximum wide-angle position; the camera will provide a wide vista. When you zoom all the way *in*, the focal length is long and at the maximum narrow-angle (telephoto) position; the camera will provide a narrow vista or field of view—a close-up view of the scene. **SEE 4.5** When you stop the zoom approximately halfway in between these extreme positions, the lens has the normal focal length. This means that you will get a "normal" vista that approximates your actually looking at the scene. Because the zoom lens can assume all focal lengths from its maximum wide-angle position (zoomed all the way out) to its maximum narrow-angle position (zoomed all the way in), it is called a *variable-focal-length lens*. **ZVL1** CAMERA > Zoom lens > normal | wide | narrow | try it

On the television screen, a zoom-in appears as though the object is gradually coming toward you. A zoom-out seems to make the object move away from you. Actually, all that the moving elements within the zoom lens do is gradually magnify (zoom-in) or reduce the magnification (zoom-out) of the object while keeping it in focus, but the camera remains stationary during both operations. **SEE 4.6**

Minimum object distance and macro position You will find that there is often a limit to how close you can move a camera (and lens) to the object to be photographed and still keep the picture in focus. This is especially

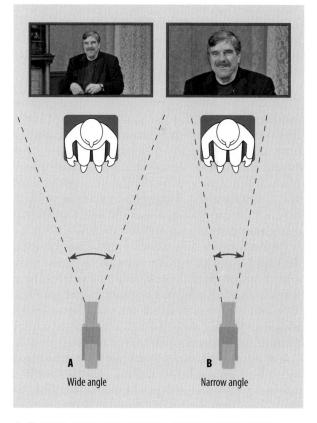

4.5 WIDE-ANGLE AND NARROW-ANGLE ZOOM POSITIONS **A** The wide-angle zoom position (zoomed out) has a wider vista (field of view) than **B**, the narrow-angle zoom position (zoomed in). Note that zooming in magnifies the subject.

4.6 ELEMENTS OF A ZOOM LENS

A zoom lens consists of many sliding and stationary lens elements that interact to maintain focus throughout the continuous change of focal length. The front elements control the focus; the middle elements control the zoom.

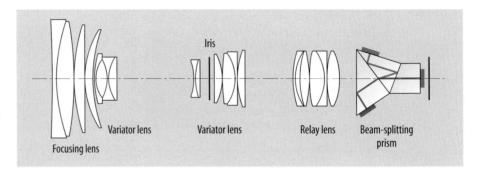

problematic when trying to get a close-up of a very small object. Even when zoomed in all the way, the shot may still look too wide. Moving the camera closer to the object will make the shot tighter, but you can no longer get the picture in focus. Range extenders help little, but while they provide you with a tighter close-up of the object, they force you to back off with the camera to get the shot in focus. One way to solve this problem is to zoom all the way out to a wide-angle position.

Contrary to normal expectations, the wide-angle zoom position often allows you to get a tighter close-up of a small object than does the extended narrow-angle zoom position (zoomed all the way in with a 2× extender). But even with the lens in the wide-angle position, there is usually a point at which the camera will no longer focus when moved too close to the object. The point where the camera is as close as it can get and still focus on the object is called the *minimum object distance* (*MOD*) of the lens.

Although there are zoom lenses that allow you, without extenders, to get extremely close to the object while still maintaining focus over the entire zoom range, most zoom lenses have a minimum object distance of 2 to 3 feet. High-ratio zoom lenses, such as 40× or 50×, have a much greater MOD than do lenses with a wide-angle starting position and a relatively low zoom ratio (such as 10×). This means that you can probably get closer to an object with a wide-angle field lens that can magnify the object only ten or twelve times than with a large field lens that starts with a narrower angle but can magnify the scene fifty or more times.

Despite the relative advantage of wide-angle field lenses, many field lenses on ENG/EFP cameras have a *macro position*, which lets you move the camera even closer to an object without losing focus. When the lens is in the macro position, you can almost touch the object with the lens and still retain focus; you can no longer zoom, however. The macro position changes the zoom lens from

a variable-focal-length lens to a fixed-focal-length, or *prime*, lens. The fixed focal length is not a big disadvantage because the macro position is used only in highly specific circumstances. For example, if you need to get a screenfilling close-up of a postage stamp, you would switch the camera to the macro position, but then you cannot use the camera for zooming until you switch back to the normal zoom mechanism.

FOCUS

A picture is "in focus" when the projected image is sharp and clear. The *focus* depends on the distance from the lens to the film (as in a still or movie camera) or from the lens to the camera's imaging device (beam splitter with CCDs). Simply adjusting the distance from the lens to the film or imaging device brings a picture into focus or takes it out of focus. In television zoom lenses, this adjustment is accomplished not by moving the lens or the prism block (beam splitter) but by moving certain lens elements relative to each other through the zoom focus control (see figure 4.6).

Focus controls come in various configurations. Portable cameras have a focus ring on the lens that you turn; studio cameras have a twist grip attached to the panning handle (see figure 4.18). Most consumer camcorders have an automatic focus feature, called *auto-focus*, which is discussed in the context of operational controls later in this section.

If properly preset, a zoom lens keeps in focus during the entire zoom range, assuming that neither the camera nor the object moves very much toward or away from the other. But because you walk and even run while carrying an ENG/EFP camera, you cannot always prefocus the zoom. In such cases you would do well by zooming all the way out to a wide-angle position, considerably reducing the need to focus. This is examined more thoroughly in the discussion on depth of field later in this section.

Presetting (calibrating) the zoom lens There is a standard procedure for *presetting*, or *calibrating*, the zoom lens so that the camera remains in focus throughout a zoom: Zoom all the way in on the target object, such as a newscaster on a news set. Focus on the newscaster's face (eyes or the bridge of her nose) by turning the focus control. When zooming back out to a long shot, you will notice that everything remains in focus. The same is true when you zoom in again. You should now be able to maintain focus over the entire zoom range. If you move the camera, however, or if the object moves after you preset the zoom lens, you need to calibrate the lens again.

For example, if you had preset the zoom on the news anchor but then the director instructed you to move the camera a little closer and to the left so that she could more easily read the teleprompter, you would not be able to maintain focus without presetting the zoom again from the new position. If, after presetting the zoom, you were asked to zoom in on the map behind the news anchor, you would have to adjust the focus while zooming past the anchor—not an easy task for even an experienced camera operator.

If the camera moves are predetermined and repeated from show to show, as in a daily newscast, you can use the preset features of the digital zoom lens. The lens then remembers the various zoom positions and performs them automatically with the push of a button.

Unless you have an automatic focus control, you must preset the zoom on an ENG/EFP camera even when covering a news event in the field. You may have noticed that unedited video of a disaster (such as a tornado or fire) often contains brief out-of-focus close-ups followed by focusing and quick zoom-outs. What the camera operator is doing is calibrating the zoom lens to stay in focus during subsequent zoom-ins.

LIGHT TRANSMISSION: IRIS, APERTURE, AND f-STOP

Like the pupil in the human eye, all lenses have a mechanism that controls how much light is admitted through them. This mechanism is called the *iris* or *lens diaphragm*. The iris consists of a series of thin metal blades that form a fairly round hole—the *aperture*, or lens opening—of variable size. **SEE 4.7**

If you "open up" the lens as wide as it will go, or, technically, if you set the lens to its maximum aperture, it admits the maximum amount of light. **SEE 4.8A** If you close the lens somewhat, the metal blades of the iris form a smaller hole and less light passes through the lens. If

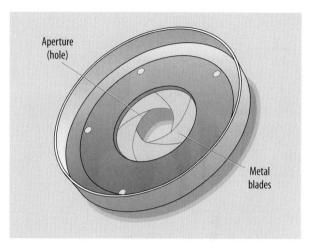

4.7 LENS IRIS

The iris, or lens diaphragm, consists of a series of thin metal blades that form, through partial overlapping, an aperture, or lens opening, of variable size.

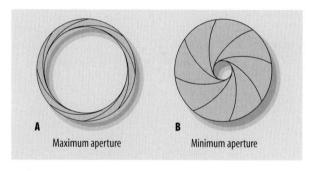

4.8 MAXIMUM AND MINIMUM APERTURES

A At the maximum aperture, the iris blades form a large opening, permitting a great amount of light to enter the lens. **B** At the minimum setting, the blades overlap to form a small hole, admitting only a small amount of light.

you close the lens all the way—that is, if you set it to its minimum aperture—very little light is admitted. **SEE 4.8B** Some irises can be closed entirely, which means that no light at all goes through the lens.

f-stop The standard scale that indicates how much light goes through a lens, regardless of the lens type, is the **f-stop**. **SEE 4.9** If, for example, you have two cameras—a camcorder with a $10 \times$ zoom lens and a field camera with a large $50 \times$ lens—and both lenses are set at f/5.6, the imaging devices in both cameras will receive an identical amount of light.

Regardless of camera type, f-stops are expressed in a series of numbers, such as f/1.7, f/2.8, f/4, f/5.6, f/8,

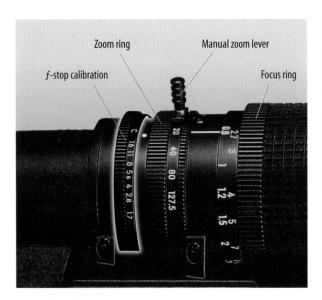

4.9 f-STOP SETTINGS

The f-stop is a calibration that indicates how large or small the aperture is.

f/11, and f/16 (see figure 4.9). The *lower* f-stop numbers indicate a relatively *large* aperture or iris opening (lens is relatively wide open). The *higher* f-stop numbers indicate a relatively *small* aperture (lens is closed down considerably). A lens that is set at f/1.7 has a much larger iris opening and therefore admits much more light than one that is set at f/16. (The reason why the low f-stop numbers indicate large iris openings and high f-stop numbers indicate relatively small iris openings, rather than the other way around, is that the f-stop numbers actually express a ratio. In this sense f/4 is actually f/1/4; that is, f one over four.) As mentioned, most lenses produce the sharpest pictures between f/5.6 and f/8. Some lenses extend the optimal focus to f/11.

Lens speed The "speed" of a lens has nothing to do with how fast it transmits light, but with how much light it lets through. A lens that allows a relatively great amount of light to enter is called a *fast lens*. Fast lenses go down to a small f-stop number (such as f/1.4). Most good studio zoom lenses open up to f/1.6, which is fast enough to make the camera work properly even in low-light conditions.

A lens that transmits relatively little light at the maximum iris aperture is called a *slow lens*. A studio lens whose lowest f-stop is f/2.8 is obviously slower than a lens that can open up to f/1.7. Range extenders render the zoom lens inevitably slower. A $2\times$ extender can reduce the lens speed by as much as two "stops" (higher f-stop numbers),

for instance, from f/1.7 to f/4 (see figure 4.9). This reduction in light transmission is not a big handicap, however, because range extenders are normally used outdoors, where there is enough light. The more serious problem is a slight deterioration of the original picture resolution.

Remote iris control Because the amount of light that strikes the camera's imaging device is so important for picture quality, the continuous adjustment of the iris is a fundamental function of video control. Studio cameras have a *remote iris control*, which means that the aperture can be continuously adjusted by the video operator (VO) from the camera control unit (CCU). If the set is properly lighted and the camera properly set up (electronically adjusted to the light/dark extremes of the scene), all that the VO has to do to maintain good pictures is work the remote iris control—open the iris in low-light conditions and close it down somewhat when there is more light than needed.

Auto-iris switch Most cameras, especially ENG/EFP and consumer camcorders, can be switched from the manual to the auto-iris mode. **SEE 4.10** The camera then senses the light entering the lens and automatically adjusts the iris for optimal camera performance. This auto-iris feature works well so long as the scene does not have too much contrast. There are circumstances, however, in which you may want to switch the camera over to manual iris control. For example, if you took a loose close-up shot of a woman wearing a white hat in bright sunlight, the automatic iris would adjust to the bright light of the white hat, not to the darker (shadowed) face under the hat. The auto-iris control would therefore give you a perfectly exposed hat but an underexposed face. In this case you would switch to manual iris control, zoom in on the face to eliminate most of the white hat, then adjust the iris to the light reflecting off the face rather than the hat. When switching to manual iris control, however, you will find that even a fairly good ENG/EFP camera can't handle such an extreme contrast. In this case you might try a neutral density (ND) filter, which would lower the extreme brightness without making the dense shadow areas any darker. (Other ways to handle extreme contrast are explained in chapter 8.) ZVL2 CAMERA→ Exposure control \rightarrow aperture | f-stop | auto iris | try it

DEPTH OF FIELD

If you place objects at different distances from the camera, some will be in focus and others will be out of focus. The area in which the objects are in focus is called *depth of field*. The depth of field can be shallow or great, but it is always greater behind the object than in front of it. **SEE 4.11**

Section 4.1 What Lenses Are 77

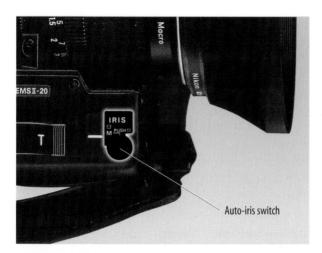

4.10 AUTO-IRIS SWITCH

The auto-iris switch lets you change the aperture control from manual to automatic. You can quickly change back to manual simply by pressing the auto-iris switch without interrupting your shot.

If you have a shallow depth of field and you focus on an object in the foreground, the middleground and background objects will be out of focus. **SEE 4.12** If the depth of field is great, all objects (foreground, middleground, and background) will be in focus, even though you focus on the middleground object only. **SEE 4.13**

With a great depth of field, there is a large "sharp zone" in which people or objects can move toward or away from the camera without going out of focus or without any need for adjusting the camera focus. If they move in a shallow depth of field, however, they can quickly become blurred unless you adjust the camera focus. A similar thing happens when you move the camera. A great depth of field makes it relatively easy to move the camera toward or away from the object because you do not have to work any controls to keep the picture in focus. If you move the camera similarly in a shallow depth of field, you must adjust the focus continuously to keep the target object sharp and clear.

Operationally, the depth of field depends on the coordination of three factors: (1) the focal length of the lens, (2) the aperture, and (3) the distance between the camera and the object.

Focal length The focal length of the lens is the factor that most influences the depth of field. In general, wide-angle lenses and, of course, wide-angle (short-focal-length) zoom positions (zoomed out) have a great depth of field. Narrow-angle lenses and narrow-angle (long-focal-length)

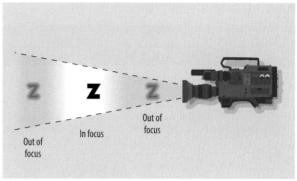

4.11 DEPTH OF FIELD

The depth of field is the area within which all objects, although located at different distances from the camera, are in focus.

4.12 SHALLOW DEPTH OF FIELD

With a shallow depth of field, the area in which an object is in focus is limited.

4.13 GREAT DEPTH OF FIELD

With a great depth of field, almost everything in the camera's field of view appears in focus.

4.14 DEPTH-OF-FIELD FACTORS

DEPTH OF FIELD	FOCAL LENGTH	APERTURE	f-STOP	LIGHT LEVEL	SUBJECT/CAMERA DISTANCE
Great	Short (wide-angle)	Small	Large f-stop number (f/22)	High (bright light)	Far
Shallow	Long (narrow-angle)	Large	Small <i>f</i> -stop number (<i>f</i> /1.4)	Low (dim light)	Near

This chart was prepared by Michael Hopkinson of Lane Community College.

zoom positions (zoomed in) have a shallow depth of field. You may want to remember a simple rule of thumb:

Depth of field increases as focal length decreases.

When running after a fast-moving news event, should you zoom all the way in or all the way out? All the way out. Why? Because, first, the wide-angle position of the zoom lens will at least show the viewer what is going on. Second, and most important, the resulting great depth of field will help keep most of your shots in focus, regardless of whether you are close to or far away from the event or whether you or the event is on the move.

Aperture Large iris openings cause a shallow depth of field; small iris openings cause a large depth of field. The rule of thumb for apertures is this:

Large f-stop numbers (such as f/16 or f/22) contribute to a great depth of field; small f-stop numbers (such as f/1.7 or f/2) contribute to a shallow depth of field.

Here is an example of how everything in television production seems to influence everything else: If you have to work in low-light conditions, you need to open up the iris and thereby increase its aperture to get enough light for the camera. But this large aperture (low f-stop number) reduces the depth of field. Thus, if you are to cover a news story when it is getting dark and you have no time or opportunity to use artificial lighting, focus becomes critical—you are working in a shallow depth of field. This problem is compounded when zooming in to tight closeups. On the other hand, in bright sunlight you can stop down (decrease the aperture) and thereby achieve a large depth of field. Now you can run with the camera or cover people who are moving toward or away from you without too much worry about staying in focus—provided the zoom lens is in a wide-angle position.

Camera-to-object distance The closer the camera is to the object, the shallower the depth of field. The farther the camera is from the object, the greater the depth of field. Camera-to-object distance also influences the focal-length effect on depth of field. For example, if you have a wideangle lens (zoom lens in a wide-angle position), the depth of field is great. But as soon as you move the camera close to the object, the depth of field becomes shallow. The same is true in reverse: If you work with the zoom lens in a narrow-angle position (zoomed in), you have a shallow depth of field. But if the camera is focused on an object relatively far away from the camera (such as a field camera located high in the stands to cover an automobile race), you work in a fairly great depth of field and do not have to worry too much about adjusting focus, unless you zoom in to an extreme close-up. SEE 4.14

Generally, the depth of field is shallow when you work with close-ups and low-light conditions. The depth of field is great when you work with long shots and high light levels. ZVL3 CAMERA→ Focusing→ focus ring | depth of field | great depth | shallow | rack focus | auto focus | try it

OPERATIONAL CONTROLS

You need two basic controls to operate a zoom lens: the *zoom control*, which lets you zoom out to a wide shot or zoom in to a close-up, and the *focus control*, which slides the lens elements that lie close to the front of the zoom lens back and forth until the image or a specific part of the image is sharp. Both controls can be operated manually or through a motor-driven servo control mechanism.

ZOOM CONTROL

Most zoom lenses of professional cameras are equipped with a servo mechanism whose motor activates the zoom,

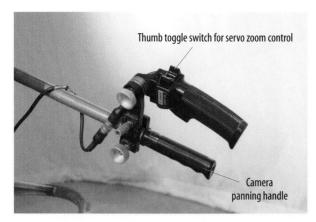

4.15 SERVO ZOOM CONTROL FOR STUDIO CAMERA

This zoom control is attached to the camera panning handle. By moving the rocker switch with your thumb to the right or left, you zoom in or out, respectively. The farther you move the lever from the central position, the faster the zoom will be.

but they also have a mechanical zoom control that can override the servo zoom at any time.

Servo zoom control All types of professional cameras (studio and ENG/EFP) have a *servo zoom control* for their lenses, usually called *servo zooms*. The servo zoom control for studio cameras is usually mounted on the right panning handle, and you zoom in and out by moving the thumb lever, similar to a rocker switch. When pressing the right side of the lever, you zoom in; when pressing the left side, you zoom out. The farther you move the lever from the central position, the faster the zoom will be. With the servo system, the zoom speed is automatically reduced as the zoom approaches either of the extreme zoom positions. This reduction prevents jerks and abrupt stops at the ends of the zoom range. **SEE 4.15**

The automation lets you execute extremely smooth zooms. Most servo mechanisms for studio cameras offer a choice of at least two zoom speeds: normal and fast. The fast zoom setting is used when fast zoom-ins are required for emphasis. For example, the director may call for a very fast zoom-in on a ringing telephone or a contestant's face. Normal zoom speeds are simply not fast enough to highlight such events.

The servo zoom control for ENG/EFP and prosumer cameras is directly attached to the lens; for consumer camcorders it is built into the camera housing. The rocker switch (similar to the thumb lever of studio cameras) is mounted on top of the box that surrounds the lens. It is usually marked with a W (for wide) and a T (for tight or telephoto). To zoom in press the T side of the switch; to

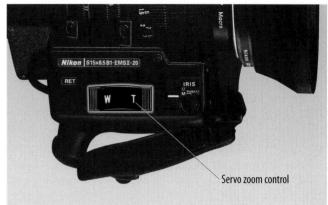

4.16 SERVO ZOOM CONTROL FOR ENG/EFP CAMERA

For ENG/EFP cameras and camcorders, the servo zoom control is part of the lens assembly.

zoom out press the *W* side. The servo control housing has a strap attached, which lets you support the shoulder-mounted or handheld camcorder while operating the zoom control. This way your left hand is free to operate the manual focus control. **SEE 4.16**

Manual zoom control ENG and EFP often require extremely fast zoom-ins to get fast close-ups or to calibrate the zoom lens as quickly as possible. Even fast servo settings are usually too slow for such maneuvers. ENG/EFP lenses (including the lenses on prosumer camcorders) therefore have an additional *manual zoom control*. The manual zoom is activated by a ring on the lens barrel. **SEE 4.17** By moving

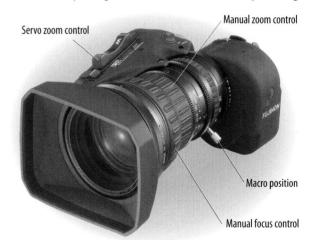

4.17 MANUAL ZOOM RING ON LENS

The ring behind the focus control on ENG/EFP and prosumer camera lenses activates a manual zoom control.

the ring clockwise (to zoom in) or counterclockwise (to zoom out), you can achieve extremely fast zooms not possible with the servo control. Some zoom rings have a small lever attached to facilitate mechanical zooming (see figure 4.9). In addition to news coverage, this manual zoom option is especially important for sports, where getting quick close-ups is the rule rather the exception.

Digital zooming In *digital zooming*, the magnification of the image is achieved not through optical means but by enlarging the image electronically. The gradual increase of image size in a digital zoom is similar to the gradual increase of the picture through the optical magnification of a normal zoom. As mentioned earlier, the problem with digital zooming is that the enlarged pixels noticeably reduce the resolution of the image and eventually show up as mosaic tiles. Professional cameras, which have a digital zoom option, add pixels during the zoom to avoid such negative pixalization of an image. If you have a choice, however, use the optical rather than the digital zoom. The optical zoom simply looks better.

DIGITAL ZOOM LENS

The *digital zoom lens* has digital controls that allow you to preset certain zoom positions and then trigger the operation with the push of a button. This preset device, which also remembers focus calibration, is highly accurate, provided the camera and the subject are in exactly the same positions as during setup. It is most practical when using *robotic cameras* (cameras whose movements are controlled by computer and not by an operator), such as during studio newscasts. Do not confuse the digital zoom lens with digital zooming: a digital zoom lens facilitates various preset zoom positions; digital zooming enlarges the pixels. Some lenses used for robotic cameras can also stay in focus by analyzing the camera's video signal. Obviously, such technology is helpful only when a specific sequence of shots is preset.

FOCUS CONTROL

The *focus control* activates the focus mechanism in a zoom lens. For studio cameras the focus control ordinarily consists of a twist grip similar to a motorcycle throttle, usually mounted on the left panning handle. Two or three turns are sufficient to achieve focus over the full zoom range. As with the servo zoom control, the focus operations are transferred by the drive cable from the panning-handle control to the lens, but the lens executes the focusing electronically. **SEE 4.18**

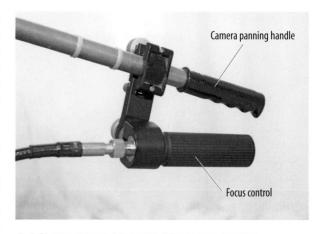

4.18 SERVO FOCUS CONTROL FOR STUDIO CAMERA

The twist grip of the servo focus control for a studio zoom lens turns clockwise and counterclockwise for focusing.

ENG/EFP cameras and all camcorders have a focus ring near the front of the zoom lens (see figure 4.9). You focus the lens by turning the focus ring clockwise or counterclockwise until the viewfinder shows the image sharply and clearly. You will notice when focusing this way that the front end of the lens, including its lens shade, rotates. This rotation is not problematic unless you want to attach a special-effects filter, such as a star filter that transforms light sources into starlike light beams. When focusing with the filter attached, the effect will rotate with the lens and may end up sideways when you have the picture in focus. *Internal*, or *inner*, *focus* (*I-F*) *lenses* do not rotate the front end when turning the focus ring. You can therefore focus I-F lenses without upsetting the filter effect.

Servo focus The *servo focus control* lets you preset the lens so that it keeps focus during carefully rehearsed camera and/or subject movements. Because even the smartest servo focus control will not help you stay in focus if the camera or subject movements have not been carefully rehearsed, most camera operators prefer to use the manual focus controls.

Auto-focus The problem with *auto-focus* is that the camera does not know exactly on which object in the frame to focus. It usually settles for the object that is more or less in the center of the frame and closest to the camera. If you want to focus on part of the scene that is farther in the background and off to one side, the auto-focus will

not comply. Also, if you do a fast zoom with a consumer camera, the automatic focus may not always be able to keep up; the picture will pop in and out of focus during the zoom. That is why manual focus devices are often preferred in critical camera work.

As mentioned previously, focusing an HDTV image is not always easy because the high resolution can fool you into believing that the picture is in focus. To help HDTV camera operators focus and stay in focus, some lenses have a built-in focus-assist feature. The camera operator can use a roller ball (similar to that of a computer mouse) to select the picture area that needs to be in sharp focus, and the focus system in the lens will do the rest. Obviously, this feature is not designed for the live HDTV coverage of sporting events.

MAIN POINTS

- There are various ways to classify zoom lenses: as studio and field lenses and according to zoom range and lens format.
- A range extender (an additional lens element) extends the telephoto power of the zoom lens (permits a closer shot) but reduces the range at the wide-angle end.
- The primary function of the lens is to produce a small, sharp optical image on the front surface of the camera's imaging device.
- All television cameras are equipped with zoom (variablefocal-length) lenses.
- The major optical characteristics of lenses are focal length, focus, light transmission (iris, aperture, and f-stop), and depth of field.
- The focal length of a lens determines how wide or narrow a vista the camera can show and how much and how close or far away the object seems to be from the camera (viewer). Zoom lenses have a variable focal length, whose major positions are wide-angle, normal, and narrow-angle (telephoto).

- A wide-angle lens (zoomed out) gives a wide vista. A narrow-angle lens (zoomed in) gives a narrow vista but magnifies the object so that it appears closer to the camera than it actually is. A normal lens (zoom position toward the midrange of the zoom) approximates the angle of human vision.
- A picture is in focus when the projected image is sharp and clear. The lens needs to be preset (calibrated) so that focus is maintained over the zoom range. If the lens is properly focused when zoomed in, it should remain in focus when zoomed out and in again.
- The lens iris, or diaphragm, controls the amount of light passing through the lens. It consists of a series of thin metal plates that form a hole known as the aperture, or lens opening.
- The f-stop is a standard scale indicating how much light passes through the lens. Low f-stop numbers indicate large apertures; high f-stop numbers indicate small apertures.
- Studio cameras have a remote iris control, which is operated by the VO (video operator) from the CCU (camera control unit). ENG/EFP cameras and consumer camcorders can be switched from manual to auto-iris control, whereby the lens adjusts itself for optimal exposure (amount of light reaching the imaging device).
- ◆ The area in which objects at different distances from the camera are seen in focus is called depth of field. The depth of field depends on the focal length of the lens, the aperture (f-stop), and the distance from camera to object.
- The two basic operational controls for the zoom lens are the zoom control and the focus control. On ENG/EFP cameras and camcorders, both can be operated either manually or automatically by servo control.
- A digital zoom lens can be programmed to repeat zoom positions and their corresponding focus settings.
- Digital zooming refers to the gradual enlarging of the center portion of the image. It usually extends the optical zoom.
- Auto-focus is an automated feature whereby the camera focuses on what it senses to be the target area. HDTV lenses have a focus-assist feature whereby the camera operator selects the target area.

4.2

What Lenses See

The performance characteristics of a lens refer to its vista, what it can and cannot do, and how it generally behaves in common production practice. Because the camera normally processes only visual information that the lens can see, knowledge of the performance characteristics—how it sees the world and how it influences the aesthetic elements of a picture—will aid you greatly in composing effective shots and in many other production tasks. This section explores these concepts.

► HOW LENSES SEE THE WORLD

Field of view, distortion of objects and perceived distance, movement, and depth of field of wide-angle, normal, and narrow-angle lenses

HOW LENSES SEE THE WORLD

Although all television cameras use zoom lenses, it might be easier for you to learn how various zoom positions influence what you see in the viewfinder by describing three zoom positions as though they were fixed-focal-length lenses. Fixed-focal-length lenses (also called prime lenses) have a specific focal length that cannot be changed. They are normally classified as (1) wide-angle, or short-focal-length, lenses; (2) normal, or medium-focal-length, lenses; and (3) narrow-angle, or long-focal-length, lenses, also called telephoto lenses.¹

Now let's adjust a zoom lens to correspond to the wideangle, normal, and narrow-angle focal lengths and observe their performance characteristics. These include (1) field of view, (2) object and distance distortion, (3) movement, and (4) depth of field.

WIDE-ANGLE LENS

As you recall, you need to zoom all the way out to achieve the maximum short focal length, or wide angle, of the zoom lens.

Field of view The *wide-angle lens* affords a wide vista. You can have a relatively wide *field of view*—the portion of a scene visible through the lens—with the camera rather close to the scene. When you need a wide vista (long shot) or, for example, when you need to see all five people on a panel and the studio is relatively small, a wide-angle lens (wide-angle zoom position) is mandatory. The wide-angle lens is also well suited to provide pictures that fit the horizontally stretched 16×9 HDTV aspect ratio.

Object and distance distortion A wide-angle lens makes objects relatively close to the camera look large and objects only a short distance away look quite small. This distortion—large foreground objects, small middleground, and even smaller background objects—helps increase the illusion of depth. The wide-angle lens also influences our perception of perspective. Because parallel lines seem to converge faster with this lens than you ordinarily perceive, it gives a forced perspective that aids the illusion of exaggerated distance and depth. With a wide-angle lens, you can make a small room appear spacious or a hallway seem much longer than it really is. **SEE 4.19-4.23** Such distortions can also work against you. If you take a close-up of a face with a wide-angle lens, the nose, or whatever is closest to the lens, will look unusually large compared with the other parts of the face. Such distortions are often used purposely, however, for emphasizing stress or psychological conditions or for stylistic special effects. SEE 4.24

Movement The wide-angle lens is also a good dolly lens. Its wide field of view de-emphasizes camera wobbles and bumps during dollies, trucks, and arcs (see chapter 5); but because the zoom lens makes it so easy to move from a long shot to a close-up and vice versa, dollying with a zoom lens has almost become a lost art.

Most of the time, a zoom will be perfectly acceptable as a means of changing the field of view (moving to a wider or closer shot). You should be aware, however, that

When HDTV cameras are used for electronic filmmaking, the director
of photography sometimes uses prime lenses instead of zoom lenses
to ensure maximum picture resolution.

4.19 WIDE-ANGLE LONG SHOT

The wide-angle lens (zoom position) gives you a wide vista. Although the camera is relatively close to the news set, we can see the whole set.

4.20 WIDE-ANGLE DISTORTION: TRUCK

The wide-angle lens intensifies the raw power of this truck. Note that the apparent size of the front grill is greatly exaggerated through the wide-angle lens.

4.21 WIDE-ANGLE DISTORTION: EMPHASIS ON FOREGROUND OBJECT

Shot with a wide-angle lens, the telephone and the right hand appear unusually large.

4.22 WIDE-ANGLE DISTORTION: DEPTH ARTICULATION

Shooting through a permanent foreground piece with the wide-angle lens creates a spatially articulated, forceful picture.

4.23 WIDE-ANGLE DISTORTION: LINEAR PERSPECTIVE

The length of this hallway is greatly exaggerated.

4.24 WIDE-ANGLE DISTORTION: FACE

This face is greatly distorted because the shot was taken with a wide-angle lens at a close distance.

there is a significant aesthetic difference between a zoom and a dolly. Whereas the *zoom* seems to bring the scene to the viewer, a *dolly* seems to take the viewer into the scene. Because the camera does not move during the zoom, the spatial relationship among objects remains constant. The objects appear to be glued into position—they simply get bigger (zoom-in) or smaller (zoom-out). In a dolly, however, the relationships among objects change constantly. You seem to move past them when dollying in or out.² Be sure to recalibrate the zoom when you reach the end of the dolly so you can zoom in and out from the new position without losing focus. ZVL4 CAMERA→ Camera moves→ dolly | zoom | try it

When people or objects move toward or away from the camera, their speed appears greatly accelerated by the wide-angle lens. The wide-angle zoom position is often used to accelerate the speed of a car or a dancer moving toward or away from the camera.

When covering a news event that exhibits a great deal of movement or that requires you to move rapidly, you should put the zoom lens in its extreme wideangle position. As you recall, the wide-angle position will reduce camera wobbles to a great extent and make it much easier to keep the event in the viewfinder. Also, the great depth of field helps you to keep the pictures in focus. The disadvantage of the extreme wide-angle position is that you need to move the camera quite close to the action if you want a closer look.

Depth of field The wide-angle lens generally has a great depth of field. When zoomed all the way out, you should have few focus problems, unless you work in low-light conditions (which requires a large aperture) or are extremely close to the object.

NORMAL LENS

The zoom position for a normal focal length lies somewhere in the midrange of a zoom lens, perhaps a little more toward the wide-angle position.

Field of view The *normal lens* offers a field of view (focal length) that approximates that of normal vision. It gives you the perspective between foreground and middleground that you actually see.

Object and distance distortion Whereas the wideangle lens makes objects seem farther apart and rooms

4.25 NORMAL LENS FIELD OF VIEW AND PERSPECTIVE The normal lens gives a field of view that approximates normal vision.

seem larger than they actually are, the normal lens or the midrange zoom positions make objects and their spatial relationships appear more like our normal vision. **SEE 4.25**

When shooting graphics such as charts that are positioned on an easel, you should put the zoom lens in the midrange position. These are the main advantages: (1) You can quickly correct the framing on the card by zooming in or out slightly or by dollying in or out without undue focus change. (2) You are far enough away from the easel to avoid camera shadows yet close enough so that the danger of someone's walking in front of the camera is minimal. (3) By placing the easel at a standard distance from the camera, a floor person can help you frame and focus on the card with minimal time and effort.

Movement With the normal lens (midrange zoom positions), you have a much more difficult time keeping the picture in focus and avoiding camera wobbles, even when the camera is mounted on a studio pedestal. When carrying an ENG/EFP camera or camcorder, this lens position makes it hard to avoid camera wobbles even when standing still. If you must have such a field of view, put the camera on a tripod.

Because the distance and the object proportions approximate our normal vision, the dolly speed and the speed of objects moving toward or away from the camera also appear normal. But again, such movement may cause focus problems, especially when the object gets fairly close to the camera.

Depth of field The normal lens has a considerably shallower depth of field than the wide-angle lens under similar conditions (same f-stop and object-to-camera distance). You might think that a very great depth of field would be the most desirable condition in studio operations because

See Herbert Zettl, Sight Sound Motion, 4th ed. (Belmont, Calif.: Thomson Wadsworth, 2005), pp. 272–74.

it shows everything in focus. But a medium depth of field is often preferred in studio work and EFP because the in-focus objects are set off against a slightly out-of-focus background. The objects are emphasized, and a busy background or the inevitable smudges on the television scenery receive less attention. Most important, foreground, middleground, and background are better defined.³

Of course, a large depth of field is necessary when there is considerable movement of camera and/or subjects. Also, when two objects are located at widely different distances from the camera, a great depth of field enables you to keep both in focus simultaneously. Most outdoor telecasts, such as sports remotes, require a large depth of field, the principal objective being to help the viewer see as much and as well as possible.

NARROW-ANGLE, OR TELEPHOTO, LENS

When you zoom all the way in, the lens is in the maximum narrow-angle, long-focal-length, or telephoto, position.

Field of view The *narrow-angle lens* not only reduces the vista but also magnifies the background objects. Actually, when you zoom in, all the zoom lens does is magnify the image. You get a view as though you were looking through binoculars, which, in effect, act as telephoto lenses. **SEE 4.26**

Object and distance distortion Because the enlarged background objects look big in comparison with the foreground objects, an illusion is created that the distance between foreground, middleground, and background has decreased. The long lens seems to compress the space between the objects, in direct contrast to the effect created by the wide-angle lens, which exaggerates object proportions and therefore seems to increase relative distance between objects. A narrow-angle lens, or telephoto zoom position, crowds objects on-screen. This crowding effect, called aesthetic compression, can be positive or negative. If you want to show how crowded the freeways are during rush hour, for example, use the zoom lens in the telephoto position. The long focal length shrinks the perceived distance between the cars and makes them appear to be bumperto-bumper. SEE 4.27

But such depth distortions by the narrow-angle lens also work to a disadvantage. You are certainly familiar with the deceptive closeness of the pitcher to home plate on the television screen. Because television cameras must remain

4.26 NARROW-ANGLE LENS FIELD OF VIEW AND PERSPECTIVE The narrow-angle (telephoto) lens compresses space.

4.27 POSITIVE AESTHETIC COMPRESSION WITH NARROW-ANGLE LENS

With a narrow-angle lens, the background is greatly enlarged and the distance between the cars seems reduced. The feeling of a traffic jam is heightened.

at a considerable distance from the action in most sporting events, the zoom lenses usually operate at their extreme telephoto positions or with powerful range extenders. The resulting compression effect makes it difficult for viewers to judge actual distances. **SEE 4.28**

Movement The narrow-angle lens gives the illusion of *reduced speed* of an object moving toward or away from the camera. Because the narrow-angle lens changes the size of an object moving toward or away from the camera much more gradually than does the wide-angle lens, the object seems to move more slowly than it actually does; in fact, an extreme narrow-angle lens virtually eliminates such movement. The object does not seem to change size perceptibly even when traveling a considerable distance relative to the camera. Such a slowdown is especially

^{3.} Zettl, Sight Sound Motion, pp. 165-67.

4.28 NEGATIVE AESTHETIC COMPRESSION WITH NARROW-ANGLE LENS

This shot was taken with a zoom lens in an extreme long-focal-length position. Note how the pitcher, batter, catcher, and umpire all seem to stand only a few feet apart from one another. The actual distance between the pitcher and the batter is $60\frac{1}{2}$ feet.

effective if you want to emphasize the frustration of someone running but not getting anywhere. Added to the compression effect (shown in figure 4.27), the drastic reduction of the perceived speed of traffic will certainly emphasize the congestion.

ZVL5 CAMERA→ Picture depth→ perspective and distortion | try it

You cannot dolly with a narrow-angle lens or with a zoom lens in the telephoto position (zoomed in); its magnifying power makes any movement of the camera impossible. If you work outdoors, even wind can be a problem. A stiff breeze may shake the camera to such a degree that the greatly magnified vibrations become clearly visible on-screen.

In the studio the telephoto position may present another problem. The director may have you zoom in on part of an event, such as the lead guitarist in a rock performance, and then, after you have zoomed in, ask you to *truck* (move the camera sideways) past the other members of the band. But this movement is extremely difficult to do in the telephoto position. What you can do is zoom out before trucking to minimize the wobbles.

Image stabilization As you recall, to control the slight image jitter caused by narrow-angle zoom positions, some professional cameras have an image stabilization device built-in, very much like the ones in most consumer camcorders. Some lenses have optical stabilizers; others correct the problem electronically. Both systems reduce

and often eliminate subtle image shifts caused by minor camera shakes.

When you have to walk, or perhaps even run, with the portable camera for a news story or other type of electronic field production, however, put the zoom lens in the wide-angle position. Even with the best image stabilizers, the pictures will be rendered useless by the inevitable camera wobbles when moving the camera in the telephoto position.

Depth of field Unless the object is far away from the camera, long-focal-length lenses have a shallow depth of field. Like the compression effect, a shallow depth of field can have advantages and disadvantages. Let's assume that you are about to take a quick close-up of a medium-sized object, such as a can of soup. You do not have to bother putting up a background for it—all you need to do is move the camera back and zoom in on the display. With the zoom lens in a telephoto (narrow-angle) position, decreasing the depth of field to a large extent, the background is sufficiently out of focus to prevent undesirable distractions. This technique is called *selective focus*, meaning you can focus either on the foreground, with the middleground and the background out of focus; on the middleground, with the foreground and the background out of focus; or on the background, with the foreground and the middleground out of focus. SEE 4.29 AND 4.30

You can also shift emphasis easily from one object to another with the help of selective focus. For example, you can zoom in on a foreground object, thus reducing the depth of field, and focus on it with the zoom lens in the telephoto position. Then, by refocusing on the person behind it, you can quickly shift the emphasis from the foreground object to the person (middleground). This technique is called *racking focus* or, simply, *rack focus*.

ZVL6 CAMERA → Focusing → rack focus | try it

The advantage of a shallow depth of field also applies to unwanted foreground objects. In a high-school baseball pickup, for example, the camera behind home plate may have to shoot through the chain-link backstop. But because the camera is most likely zoomed in on the pitcher, or on other players performing at a considerable distance from the camera, you work with a relatively shallow depth of field. Consequently, everything fairly close to the camera, such as the chain-link fence, is so out of focus that it becomes virtually invisible. The same principle works for shooting through birdcages, prison bars, or similar foreground objects.

What Lenses See 87

4.29 SELECTIVE FOCUS: FOREGROUND IN FOCUS

In this shot the camera-near person is in focus, drawing attention away from the two people in the background.

4.30 SELECTIVE FOCUS: BACKGROUND IN FOCUS

Here the focus and attention are shifted from the camera-near person (foreground) to the two people farther away.

MAIN POINTS

- The performance characteristics of wide-angle, normal, and narrow-angle lenses (zoom lenses adjusted to these focal lengths) include field of view, object and distance distortion, movement, and depth of field.
- A wide-angle lens (zoom lens in the wide-angle position) offers a wide vista. It gives a wide field of view with the camera relatively close to the scene.
- ♦ A wide-angle lens distorts objects close to the lens and exaggerates proportions. Objects relatively close to the lens look large, and those only a short distance away look quite small. The lens makes objects seem farther apart and makes rooms look larger than they actually are.
- A wide-angle lens is ideal for camera movement. It minimizes camera wobbles and makes it easy to keep the picture in focus during camera movement. It also exaggerates the perception of object speed toward and away from the camera.
- The normal lens gives a field of view that approximates that of normal vision. The normal lens (zoom lens in the midrange position) does not distort objects or the perception of distance. It is used when a normal perspective is desired.
- When a camera is moved with the lens in the midrange (normal lens) zoom position, camera wobbles are emphasized considerably more than with a wide-angle lens. The shallower depth of field makes it harder to keep the picture in focus.
- A narrow-angle lens (zoom lens in the telephoto position)
 has a narrow field of view and enlarges the objects in the
 background. Exactly opposite of the wide-angle lens, which

increases the perceived distance between objects, the narrow-angle lens seems to compress the space between objects at different distances from the camera. It slows the perception of object speed toward and away from the camera.

 The magnifying power of a narrow-angle lens prevents any camera movement while on the air. Narrow-angle lenses have a shallow depth of field, which makes keeping in focus more difficult but allows for selective focus.

ZETTL'S VIDEOLAB

For your reference, or to track your work, each *Video-Lab* program cue in this chapter is listed here with its corresponding page number.

ZVL1 CAMERA → Zoom lens → normal | wide | narrow | try it 73

ZVL2 CAMERA \rightarrow Exposure control \rightarrow aperture | f-stop | auto iris | try it 76

CAMERA→ Focusing→ focus ring |
depth of field | great depth | shallow |
rack focus | auto focus | try it 78

ZVL4 CAMERA→ Camera moves→ dolly | zoom | try it 84

ZVL5 CAMERA→ Picture depth→ perspective and distortion | try it 86

86

ZVL6 CAMERA→ Focusing→ rack focus | try it

5

Camera Mounting Equipment

Because television cameras differ considerably in size and weight, various camera mounts are needed for ease and efficiency of operation. For example, you may find that a camera mount for the studio has to support not only a heavy camera with its large zoom lens but also the added weight of a bulky teleprompting device. In contrast, most ENG/EFP cameras are designed to be carried on the operator's shoulder. And, as you know, some camcorders are so small that you can hold and operate them with one hand. But there are many production situations in which the ENG/EFP camera and the small camcorder should be mounted on a tripod rather than carried by the operator. Section 5.1, Standard Camera Mounts and Movements, examines the basics of camera mounts; section 5.2, Special Camera Mounts, discusses other mounting devices.

KEY TERMS

- arc To move the camera in a slightly curved dolly or truck.
- **cam head** A camera mounting head for heavy cameras that permits extremely smooth tilts and pans.
- cant Tilting the shoulder-mounted or handheld camera sideways.
- crab Sideways motion of the camera crane dolly base.
- **crane** (1) Motion picture camera support that resembles an actual crane in both appearance and operation. The crane can lift the camera from close to the studio floor to more than 10 feet above it. (2) To move the boom of the camera crane up or down. Also called *boom*.
- **dolly** (1) Camera support that enables the camera to move in all horizontal directions. (2) To move the camera toward (dolly in) or away from (dolly out or back) the object.
- **fluid head** Most popular mounting head for lightweight ENG/ EFP cameras. Balance is provided by springs. Because its moving parts operate in a heavy fluid, it allows very smooth pans and tilts.
- high hat Cylindrical camera mount that can be bolted to a dolly or scenery to permit panning and tilting the camera without a tripod or pedestal.
- **jib arm** Similar to a camera crane. Permits the jib arm operator to raise, lower, and tongue (move sideways) the jib arm while titling and panning the camera.
- monopod A single pole onto which you can mount a camera.
- pan To turn the camera horizontally.
- **pedestal** (1) Heavy camera dolly that permits raising and lowering the camera while on the air. (2) To move the camera up and down via a studio pedestal.

- **quick-release plate** Mounting plate used to attach camcorders and ENG/EFP cameras to the fluid head.
- robotic pedestal Motor-driven studio pedestal and mounting head. It is guided by a computerized system that can store and execute a great number of camera moves. Also called robotic.
- spreader A triangular base mount that provides stability and locks the tripod tips in place to prevent the legs from spreading.
- **Steadicam** Camera mount whose built-in springs hold the camera steady while the operator moves.
- tilt To point the camera up or down.
- **tongue** To move the boom or jib arm with the camera from left to right or right to left.
- track Another name for truck (lateral camera movement).
- **tripod** A three-legged camera mount. Can be connected to a dolly for easy maneuverability.
- **truck** To move the camera laterally by means of a mobile camera mount. Also called *track*.
- wedge mount Wedge-shaped plate attached to the bottom of a studio camera; used to attach the heavier cameras to the cam head.
- zoom To change the lens gradually to a narrow-angle position (zoom-in) or to a wide-angle position (zoom-out) while the camera remains stationary.

5.1

Standard Camera Mounts and Movements

Even if your camera is small and light enough to carry in your hands, you should mount it on a camera support whenever possible. Using a camera support will reduce fatigue and especially prevent unnecessary and distracting camera motion. This section discusses the more common camera mounts and the basic camera movements.

▶ BASIC CAMERA MOUNTS

The handheld and shoulder-mounted camera, the monopod and the tripod, and the studio pedestal

► CAMERA MOUNTING (PAN-AND-TILT) HEADS

Fluid heads, cam heads, and the plate and the wedge mount

CAMERA MOVEMENTS

Standard camera movements: pan, tilt, pedestal, tongue, crane or boom, dolly, truck or track, crab, arc, cant, and zoom

BASIC CAMERA MOUNTS

When using a camcorder on vacation or when running after a news story, you will probably carry it with your hands or on your shoulder. But when more-precise camera work is required, you need to support the camera with a tripod. Studio cameras that have large studio lenses and teleprompters attached are so heavy that they are usually mounted on, and moved with, a heavy-duty tripod or studio pedestal.

The most common camera mounts are the tripod, the tripod dolly, and the studio pedestal. The more elaborate camera mounts, such as jib arms, studio cranes, body mounts, and robotic devices are discussed in section 5.2. You will find that many gadgets are available to help you get good shots and to generally make your life as a camera operator easier. For example, you can clip on a flexible arm with a small plastic plate that shields your viewfinder from sunlight. Because they change from year to year—and sometimes disappear from the market altogether—we ignore such novelties here, but you should certainly make an effort to find out what is currently available from catalogs and Web sites.

HANDHELD AND SHOULDER-MOUNTED CAMERA

If the camera is lightweight enough, the most flexible camera mount is your arms or shoulder. You can lift and lower the camera, tilt it up or down, swing it around, cant it (tilt it sideways), and walk or run with it. So why bother with a tripod? First, with a tripod you will be able to operate the camera much longer without getting fatigued; even a small camcorder can get awfully heavy when shooting over a period of several hours. Second, and probably more important, using some kind of camera support prevents unmotivated camera motion—swinging and weaving it back and forth not unlike a firefighter using a fire hose to put out a fire. Unless motivated, as in some commercials and MTV shows, wild and rapid camera movement draws too much attention to itself and is one of the sure signs of amateur camera handling. Third, even if you are exceptionally well coordinated, the tripod makes for smoother moves. Nevertheless, there are some techniques that professional camera operators have developed to keep the handheld or shoulder-mounted camera as steady as possible. These are explored in chapter 6.

MONOPOD AND TRIPOD

You will find that even a relatively light ENG/EFP camera can get awfully heavy during long shoots. Using a portable camera support, such as a monopod or tripod, will get the camera off your hands or back, and keep you from making unnecessary or distracting camera movements.

Monopod The *monopod* is a single pole, or a single "pod," onto which you can mount a camera. When using a monopod, you still need to balance the camera on the pole as you would on your shoulder, but at least you are relieved

5.1 MONOPOD

The monopod is designed to take the weight off your shoulders by letting you balance a small to medium-sized camcorder on a single pole.

of the camera's weight. Some monopod supports have a fold-out extension that you step on to steady the pole so that you can work the camera with both hands. The advantages of such a camera support are that it is easy to carry and can be set up in less than a minute. Such monopods are by no means perfect, but they offer a welcome relief during a long shoot, not unlike finding a log or rock to sit on after a long hike. **SEE 5.1**

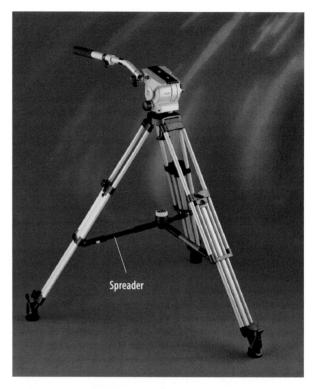

5.2 TRIPOD WITH BUILT-IN SPREADER

The tripod is one of the most basic camera supports and is used extensively in field productions. This tripod has a built-in spreader at midlevel.

Tripod and tripod dolly The *tripod* is used extensively for all types of fieldwork. Regardless of whether you use a heavy tripod for the support of a studio camera or a lightweight one for a field camera or camcorder, all tripods work on a similar principle: they have three collapsible legs (pods) that can be individually extended so that the camera is level, even on an irregular surface such as a steep driveway, bleachers, or stairs. The tips of the legs are equipped with spikes and/or rubber cups that keep the tripod from slipping. Most tripods can be adjusted to specific heights (usually from about 16 to 60 inches) and have a built-in *spreader* that prevents the tripod legs from spreading and collapsing under a heavy load. **SEE 5.2**

For tripods that do not have a spreader built-in, there are auxiliary spreaders that you can place on the ground and then fasten to the three tips of the tripod. These spreaders can be adjusted to accommodate a small or large triangular base. The disadvantage of a separate spreader is that you can use it only when the ground is relatively level. **SEE 5.3**

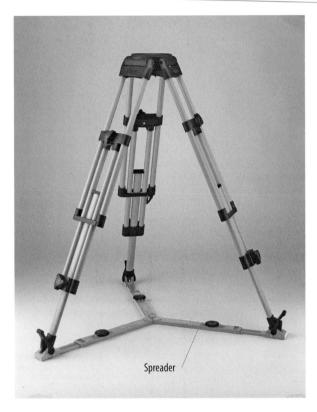

5.3 TRIPOD MOUNTED ON SPREADER

Tripods designed for heavy camera loads have a separate spreader that can be put on the level floor. The tips of the tripod are anchored by the spreader.

When setting up a tripod, you must take particular care that the tripod, and with it the camera, is level. Such a setup is especially difficult when working on steps or uneven ground. **SEE 5.4** Fortunately, most high-quality tripods have a *leveling bowl* as a platform, which can accept a ball-like device attached to the bottom of the fluid head. This simple device, which can be adjusted by a twist grip, allows you to level the camera without having to adjust the length of each leg on uneven ground. Most pan-and-tilt heads have a built-in air bubble that indicates when the camera is level.

You can also place a tripod on a three-caster *dolly*, which is simply a spreader with wheels. Because the tripod and the dolly are collapsible, they are ideal for fieldwork. You will find tripod dollies used even in studios equipped with studio-converted ENG/EFP cameras. The dolly base should be adjustable so that you can maneuver it through various-sized doors, and it should have *cable guards* that prevent the camera cable from getting caught under the dolly base or run over by the dolly wheels. **SEE 5.5**

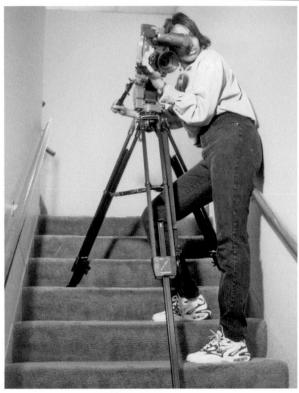

5.4 TRIPOD ON STEPS

Because each pod can be adjusted individually, the tripod can be leveled on extremely uneven ground.

STUDIO PEDESTAL

With a studio *pedestal*, you can move a camera in all directions (assuming there is a smooth floor) and elevate and lower the camera while on the air. This up-and-down movement adds an important dimension to the art of television photography. You can not only adjust the camera to a comfortable working height but also change the eye level from which you look at an event. For example, if you are in danger of overshooting the set, you can always *pedestal up* (raise the camera) and look down on the scene. Or you can *pedestal down* (lower the camera) and look up at the scene, such as at the lead singer of a rock group. Some pedestals use counterweights to balance the weight of the camera in its up-and-down movement; others use pneumatic pressure or both weights and pneumatic pressure.

Regardless of the specific balancing mechanism, all studio pedestals have similar operating features. You can steer the pedestal smoothly in any direction with a large horizontal steering ring or steering wheel. By pulling up on the steering ring, you move the camera higher, or pedestal

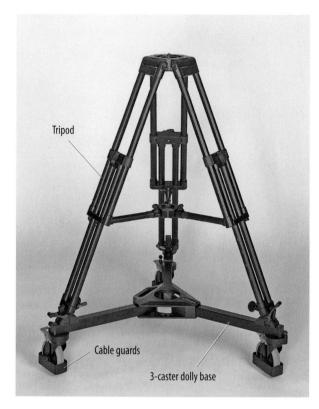

5.5 COLLAPSIBLE TRIPOD MOUNTED ON DOLLY BASEThe tripod can be mounted on a dolly, which permits quick repositioning of the camera. This is called a tripod dolly.

up. By pressing down on it, you lower the camera, or pedestal down. Pedestals are not necessarily judged by how high they can elevate the cameras but often by how low they can move the camera relative to the floor. The more the pedestal column *telescopes*, the better it is. The telescoping pedestal column can be locked at any horizontal position.

Like tripod dollies, studio pedestals need a cable guard to keep from running over cables. Always check that the adjustable skirt of the pedestal base is low enough to push the cable out of the way rather than roll over it. **SEE 5.6**

Generally, you work the pedestal in the parallel, or *crab*, steering position, which means that all three casters point in the same direction. **SEE 5.7A** If, however, you want to rotate the pedestal itself, to move it closer to a wall or piece of scenery, for example, you can switch it from the crab to the *tricycle* steering position. **SEE 5.7B**

There are also lighter pneumatic pedestals that can be adjusted to the lightweight ENG/EFP cameras. These can be taken on remote locations and used when smooth dollies, trucks, and camera elevations are required. You can

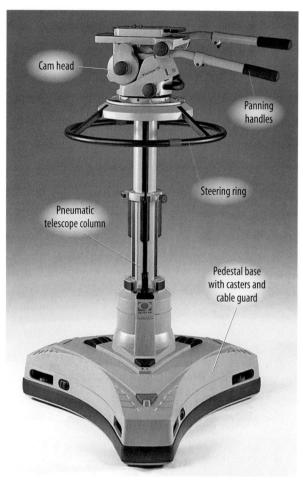

5.6 STUDIO PEDESTAL

The studio pedestal permits smooth dollies and trucks and has a telescoping center column that pedestals the camera from a low of 2 feet to a maximum height of about 6 feet above the studio floor.

5.7 PARALLEL (CRAB) AND TRICYCLE STEERING

A In the parallel, or crab, position, all three casters point in the same direction. **B** In the tricycle position, only one wheel is steerable. A foot pedal allows a quick change from parallel to tricycle steering.

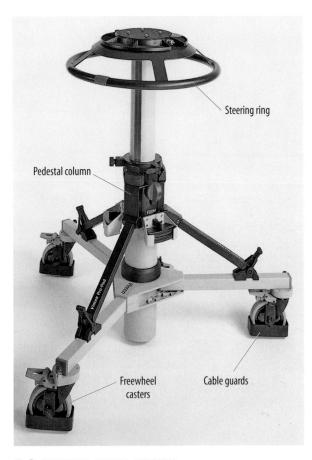

5.8 PORTABLE CAMERA PEDESTAL

These pedestals are much lighter than the studio pedestals and can be disassembled and transported to various (usually indoor) field locations.

disassemble such pedestals for transport and, as with tripod dollies, adjust the width of the dolly base to fit through doors. **SEE 5.8**

CAMERA MOUNTING (PAN-AND-TILT) HEADS

The camera mounting head connects the camera to the tripod or studio pedestal. The mounting head (not to be confused with the camera head, which represents the actual camera) allows you to tilt (point the camera up and down) and pan (turn it horizontally) extremely smoothly. The mounting devices for the lighter tripod-supported cameras are fluid heads; the heavier field and studio cameras use cam heads.

FLUID HEADS

ENG Fluid heads are normally used for ENG/EFP cameras or consumer camcorders that weigh less than 30

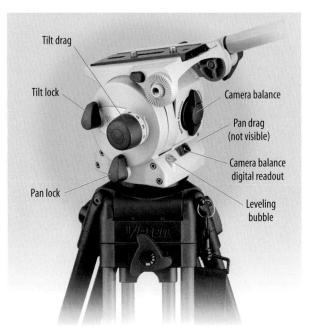

5.9 FLUID HEAD

Fluid heads are designed for mounting and operating ENG/EFP cameras and camcorders on tripods. They have a limited weight capacity.

pounds. There are heavy-duty fluid heads that can operate with heavier loads, which may come from a teleprompter or transmission equipment attached to the ENG/EFP camcorders.

Fluid heads contain a spring-loaded counterbalancing mechanism that is encased in thick oil, which supplies the drag necessary for smooth pans and tilts. Most professional fluid heads have four controls: a tilt and pan drag and a tilt and pan lock. The drag controls give various degrees of resistance to panning and tilting to make the camera movements optimally smooth. The lock controls immobilize the pan-and-tilt mechanism to keep the camera from moving when left unattended. **SEE 5.9** Never use the drag controls to lock the mounting head, or the lock controls to assist the drag. Neither practice will work very well and will eventually wreck the mounting head.

The fluid head attaches to the leveling ball, which attaches to the tripod platform with the leveling bowl. As stated, the leveling ball enables you to level the camera without adjusting the tripod legs, assuming the tripod is relatively level already. The actual panning and tilting are done with a single panning handle or double panning handles that are attached to the mounting head. By moving the panning handle up and down, you tilt the camera; by moving it left and right, you pan the camera.

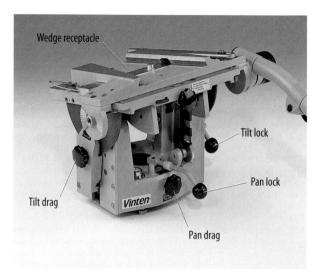

5.10 CAM HEAD

The cam head is designed for heavier cameras. It is normally used for mounting studio cameras with teleprompters onto studio pedestals.

CAM HEADS

Cam heads are designed to connect heavy studio or field cameras to studio or field pedestals. Like fluid heads, cam heads have separate drag and lock mechanisms. Be sure to find out exactly which knob adjusts the friction (to make your tilt and pan movements somewhat looser or tighter) and which one locks the camera mounting head. SEE 5.10 As with fluid heads, never use the drag control to lock the cam head, or the lock control to adjust the drag. Using the drag control to lock the camera will ruin the cam head in a very short time, and trying to use the locking device for tilt and pan drag controls will almost always result in jerky and uneven camera movements.

PLATE AND WEDGE MOUNT

How do you attach the camera to the fluid head so that the camera is fairly well balanced during tilts? This is done with an attachment mechanism called a *quick-release plate*. You attach a metal plate to the bottom of the camera (with one or two bolts) and then simply slide the plate (with the camera attached) onto its receptacle on the fluid head. A simple lever holds the camera in the preset balanced position.

The problem is how far forward or backward to slide the plate so that the camera is indeed balanced. Digital technology has again come to the rescue. High-end fluid heads now have a digital readout that tells you just where to place the quick-release plate for optimal balance. Many field productions require that you take the camera off the tripod, run to a new position for a few quick shots, and

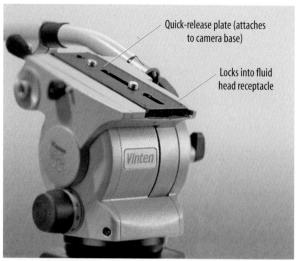

5.11 QUICK-RELEASE PLATE

The quick-release plate enables you to reattach the camera to the mounting head in a balanced position without time-consuming readjustment.

then return to the tripod position. The quick-release plate makes it possible to detach the camera and put it back again in a perfectly balanced position in seconds. **SEE 5.11**

Many cam heads use a similar device, called a *wedge mount*—a wedge-shaped plate attached to the bottom of the studio camera. All you have to do is slip the camera with the wedge plate onto the cam head receptacle; the camera is then securely attached to the cam head, balanced, and ready to go. **SEE 5.12**

CAMERA MOVEMENTS

Before learning to operate a camera, you should become familiar with the most common camera movements. *Left* and *right* always refer to the *camera's* point of view. The camera mounting equipment has been designed solely to help you move the camera smoothly and efficiently in various ways. The major camera movements are pan, tilt, pedestal, tongue, crane or boom, dolly, truck or track, crab, arc, cant, and zoom. **SEE 5.13**

Pan means turn the camera horizontally, from left to right or from right to left. When the director tells you to "pan right," which means point the lens and the camera to the right (clockwise), you must push the panning handles to the left. To "pan left," which means swivel the lens and the camera to the left (counterclockwise), you push the panning handles to the right.

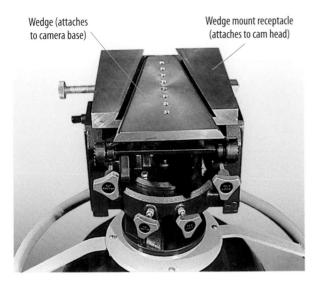

5.12 WEDGE MOUNT

The wedge mount makes it easy to connect the studio camera to the cam head in a balanced position.

- Tilt means point the camera up or down. When you "tilt up," you make the camera point up gradually. When you "tilt down," you make the camera point down gradually.
- Pedestal means elevate or lower the camera on a studio pedestal. To "pedestal up," you raise the camera; to "pedestal down," you lower the camera.
- Tongue means move the whole camera from left to right or from right to left with the boom of a camera crane. When you tongue left or right, the camera usually points in the same general direction, with only the boom moving left (counterclockwise) or right (clockwise).
- Crane or boom means move the whole camera up or down on a camera crane or jib arm. The effect is somewhat similar to an up or down pedestal except that the camera swoops over a much greater vertical distance. You either "crane [or boom] up" or "crane [or boom] down."
- **Dolly** means move the camera toward or away from the scene in more or less a straight line by means of a mobile camera mount. When you "dolly in," you move the camera closer to the scene; when you "dolly out" or "dolly back," you move the camera farther away from the scene.
- Truck or track means move the camera laterally by means of a mobile camera mount. To "truck left" means to move the camera mount to the left with the camera

pointing at a right angle to the direction of travel. To "truck right" means to move the camera mount to the right with the camera pointing at a right angle to the direction of travel.

- Crab means any sideways motion of the crane dolly. A crab is similar to a truck except that the camera mount does not have to stay lateral to the action the whole time; it can move toward or away from the action as well. Crabbing is used more in film than in television. The term is sometimes used to mean trucking.
- Arc means move the camera in a slightly curved dolly or truck movement with a mobile camera mount. To "arc left" means to dolly in or out in a camera-left curve or to truck left in a curve around the object; to "arc right" means to dolly in or out in a camera-right curve or to truck right in a curve around the object.
- Cant means tilting the shoulder-mounted or handheld camera sideways. The result, called a *canting effect*, is a slanted horizon line, which puts the scene on a tilt. Through the skewed horizon line, you can achieve a highly dynamic scene.
- Zoom means change the focal length of the lens through the use of a zoom control while the camera remains stationary. To "zoom in" means to change the lens gradually to a narrow-angle position, thereby making the scene appear to move closer to the viewer; to "zoom out" means to change the lens gradually to a wide-angle position, thereby making the scene appear to move farther away from the viewer. Although not a camera movement per se, the zoom effect looks similar to that of a moving camera and is therefore classified as such. ZVL1 CAMERA→ Camera moves→ dolly | zoom | truck | pan | tilt | pedestal | try it

MAIN POINTS

- The basic camera mounts are handheld and shouldermounted, the monopod, the tripod and the tripod dolly, and the studio pedestal.
- A monopod is a single pole upon which a small camcorder is mounted. Tripods are used extensively for supporting ENG/EFP cameras or smaller camcorders in field productions. The tripod can be mounted on a three-caster dolly base.
- Studio pedestals can support heavy studio cameras and permit extremely smooth camera movements, such as dollies, trucks, and arcs. The camera can also be raised and lowered while on the air.

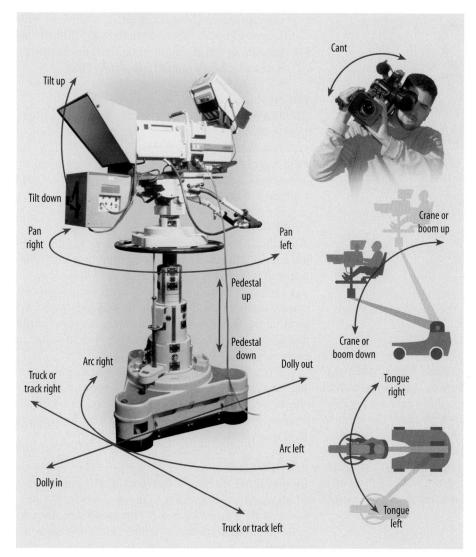

5.13 CAMERA MOVEMENTS

Major camera movements include pan, tilt, pedestal, tongue, crane or boom, dolly, truck or track, arc, and cant.

- The camera mounting head connects the camera to the camera mount and allows the camera to be smoothly tilted up and down and panned horizontally. There are two types of mounting heads: fluid heads, used for consumer camcorders and ENG/EFP cameras; and cam heads, designed for use with studio cameras or heavy camcorders with teleprompters or transmission equipment.
- The quick-release mounting plate is used to attach camcorders and ENG/EFP cameras to the fluid head. The wedge mount attaches the heavier cameras to the cam head.
- The most common camera movements are pan, turning the camera horizontally; tilt, pointing the camera up or down; pedestal, lowering or elevating the camera on a studio pedestal; tongue, moving the whole camera from

left to right or from right to left with the boom of a camera crane or jib arm; crane or boom, moving the whole camera up or down on a camera crane or jib arm; dolly, moving the camera toward or away from the scene; truck or track, moving the camera laterally; crab, moving the whole base of a camera crane sideways; arc, moving the camera in a slightly curved dolly or truck movement; cant, tilting the camera sideways; and zoom, changing the focal length of the lens while the camera is stationary.

5.2

Special Camera Mounts

Nonconventional camera mounts are designed to help you operate a camera in unusual shooting conditions, such as when covering a scene in a cramped living room or field position, swooping from a view high above the event to below eye level, running up a flight of stairs, or shooting from the perspective of a speeding car. Some pedestals are designed to do without you; their movements are controlled not by the camera operator but by a computer. This section examines such nonstandard camera mounting devices.

SPECIAL MOUNTING DEVICES

The high hat, the beanbag and other car mounts, the Steadicam, short and long jibs, and the studio crane

ROBOTIC CAMERA MOUNTS

Used for shows with rigid production formats, such as newscasts

SPECIAL MOUNTING DEVICES

Despite their flexibility the tripod and the studio pedestal cannot always facilitate the required camera movements. If during a field production, for example, the director wanted you to follow the main character from the car through the front door and down the hall with great fluidity, and then follow the character running up a flight of stairs without any distracting camera wiggles, you'd need a special mounting device. If the director then asked you to attach the camera to a moving car without resorting to extremely

expensive equipment, how would you do it? Here are some of the more accessible mounting devices: (1) the high hat, (2) the beanbag and other car mounts, (3) the Steadicam, (4) short and long jibs, and (5) the studio crane.

HIGH HAT

The *high hat* is a short (about 6 inches) cylinder-shaped or three-legged metal mount that accepts the usual fluid or cam mounting head. You can bolt or clamp the high hat onto part of the scenery, on the bleachers of a stadium, on a fence post, or, for low-angle shots, on a piece of plywood fastened to a tripod dolly. **SEE 5.14**

BEANBAG AND OTHER CAR MOUNTS

No kidding! The beanbag has its place as an effective camera mount. It is simply a canvas bag filled not with beans but with high-tech foam that molds itself to the shape of any ENG/EFP camera or camcorder. All you do is set the camera on the bag and then strap the bag with the camera to the object that acts as a camera mount. You can use this bag mount on cars, boats, mountain ledges, bicycles, or ladders. **SEE 5.15**

If you have a big budget, you can rent shock-absorbing car mounts that are specially designed for attaching the camera to a car. The spring-loaded devices are usually attached to the hood or the sides of the car by means of large suction cups.

STEADICAM

Just as we use the term *Xerox* to mean any kind of photocopier, we use *Steadicam* to mean any camera mount worn by the camera operator. This camera mount uses various springs to absorb the wobbles and jitters while you run with the camera. During the take, you can watch the scene in a small viewfinder mounted below the camera. The counterbalance mechanism keeps the camera so steady that even when you run upstairs or on a mountain trail the camera shots will come out as though you had used a large camera crane. The Steadicam harness and mount for motion picture cameras and large ENG/EFP camcorders are relatively heavy, and only experienced operators can wear them and the camera/monitor combination for an extended period. **SEE 5.16**

There are, however, more-compact spring-loaded camera mounts that support lighter (from 8 to 17 pounds) ENG/EFP cameras or small (2- to 6-pound) digital or consumer camcorders. The camera mounts for such lightweight cameras do not need a body brace. You simply grab the whole unit with both hands and run with it, similar to carrying a small flag. **SEE 5.17** Unless you are a

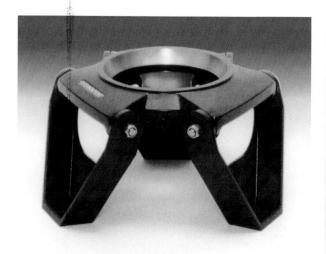

5.14 HIGH HAT

The high hat can be bolted or clamped to scenery, bleachers, or a fence post. You can use it with a fluid head or even a cam head.

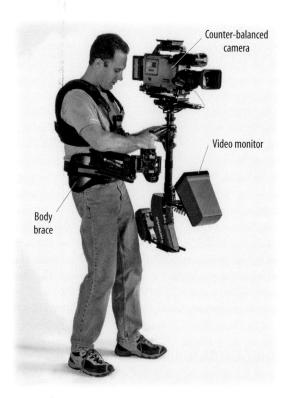

5.16 CAMERA STABILIZING SYSTEM

This type of stabilizing system, generically called a Steadicam, allows you to walk or run with the camera while keeping the pictures perfectly steady. The rather heavy spring-balanced mechanism is connected to a body harness.

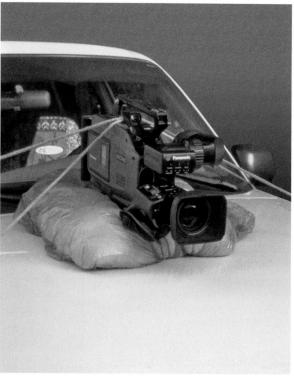

5.15 BEANBAG

This canvas bag filled with synthetic material adjusts to any camera and any object on which the camera is mounted. Both bag and camera can be easily secured with nylon rope.

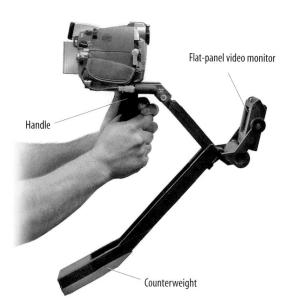

5.17 STEADICAM MOUNT FOR LIGHTWEIGHT CAMCORDERS

The Steadicam JR mount is designed for lightweight consumer camcorders, such as the Hi8 or DTV models.

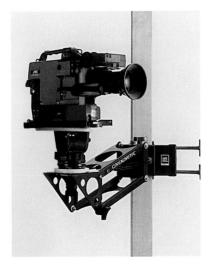

5.18 SHORT JIB

This lightweight, counterbalanced jib arm can be clamped onto any suitable surface. It is especially useful when working in cramped quarters.

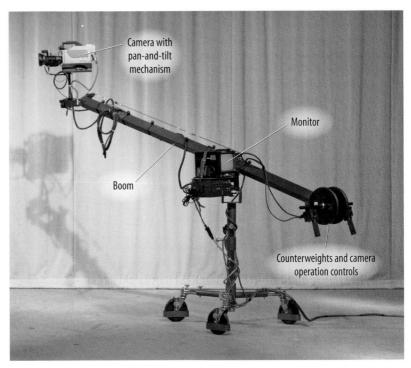

5.19 LONG JIB

With the long jib, the camera operator can dolly, truck, and boom the camera up and down and simultaneously pan, tilt, focus, and zoom.

weightlifter, however, even a lightweight camera seems to get heavy when carried this way for a prolonged period. There are small body braces available even for relatively light prosumer and consumer camcorders.

SHORT AND LONG JIBS

The short *jib arm* is a counterbalanced camera mount designed for shooting on location. You can clamp it onto a doorframe, a chair, a deck railing, or a car window and then tongue the camera sideways and boom it up and down. **SEE 5.18** That way you can not only perform smooth camera movements but also pay full attention to panning and zooming and the general composition of your shots.

The long jib or long jib arm is a cranelike device that lets you—by yourself—lower the camera practically to the studio floor, raise it 12 feet or even higher, tongue the jib arm and swing it a full 360 degrees, dolly or truck the whole assembly, and, at the same time, tilt, pan, focus, and zoom the camera. Obviously, all of these movements require practice if they are to look smooth on the air. The camera and the jib arm are balanced by a monitor, the battery pack, remote camera controls, and, for good measure, actual counterweights. **SEE 5.19**

Some jib arm camera mounts are specially designed for fieldwork. You can quickly and easily collapse the whole jib and carry it in a single 6-foot bag. Once at the remote location, you can have the 12-foot jib assembled and operational in less than five minutes. **SEE 5.20**

STUDIO CRANE

Although a crane is desirable for creative camera work, it is used in very few television studios. In most cases the long jib arm is preferred over a crane because it is lighter and can perform almost all the functions of a crane. The studio crane is used more frequently in film work or with an HDTV camera for electronic cinema production. **SEE 5.21**

ROBOTIC CAMERA MOUNTS

Automated pedestals and mounting heads, sometimes called *robotics*, are used more and more for shows with rigid production formats, such as newscasts, teleconferences, and certain instructional programs. There are basically three types of robotics: (1) the robotic pedestal, (2) the stationary robotic camera mount, and (3) the rail system.

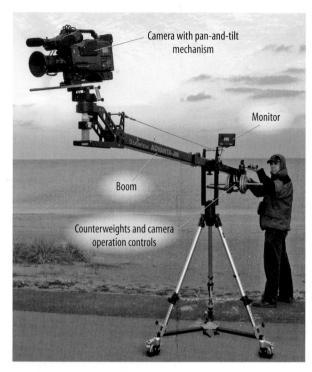

5.20 FIELD JIB

This field jib can be easily disassembled, carried in a canvas bag, and reassembled in minutes.

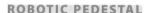

The *robotic pedestal* consists of a motor-driven studio pedestal and a mounting head. The robotic pedestal and the remote zoom and focus controls are guided by a computerized system that can store up to 800 camera moves. **SEE 5.22**

For example, the computer list for a portion of a news show may display and eventually activate the following scenario: while cameras 2 and 3 are still on the news anchor, camera 1 relocates to the weather set and sets up the opening shot by tilting up and zooming out to a long shot of the weatherperson and the map; camera 1 is then joined by camera 2 for close-ups of the weather map; in the meantime camera 3 trucks to the center of the set and zooms out for a cover shot—and all this without a camera operator in sight on the studio floor. The only human beings in the studio are the news anchor, the weatherperson, the sportscaster, and sometimes a lonely floor manager. Even the director no longer gives any camera instruction but simply checks the computer list in the news script against the actual robotic execution of camera shots in the preview monitors.

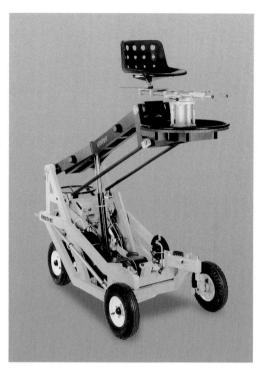

5.21 STUDIO CRANE

Studio cranes are used for elaborate productions. Besides the camera operator, cranes need one or two extra people to operate the crane dolly and boom.

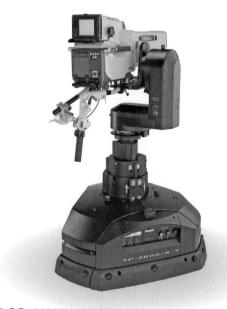

5.22 ROBOTIC PEDESTAL

The robotic pedestal is fully automated and needs no camera operator. All necessary camera movements and functions are computer-controlled.

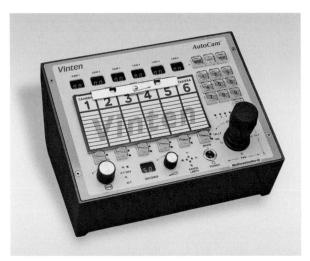

5.23 OPERATOR CONTROL PANEL FOR ROBOTIC PEDESTAL With such computer control panels, an individual can operate several cameras by remote control.

Because a small error in setting the pedestal wheels on long dollies can cause the camera to end up in the wrong place, some systems use aluminum tape on the studio floor to guide accurate camera travel. An *operator control panel* in the studio control room allows for remote control of the camera movements that have not been stored in the computer. **SEE 5.23** But what happens if the computer fails? You must have somebody ready to override the automatic system, run into the studio, grab the nearest camera, and zoom out to a long shot of the news set.

STATIONARY ROBOTIC CAMERA MOUNT

Thanks to smaller and lighter-weight cameras, some news stations use small stationary mounts. These mounts are in a fixed position but allow the camera to be panned and tilted from a remotely controlled joystick panel. This remote control can also activate the zoom lens for closer or wider shots. Some robotic systems used primarily for news have computer programs that control a variety of additional event functions, such as switching from camera to camera, opening and closing microphones, and controlling the teleprompter. These small stationary systems are also popular in classrooms and teleconferences, where the camera action can be precisely preset. **SEE 5.24**

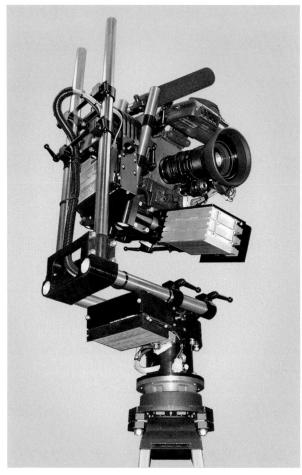

5.24 STATIONARY ROBOTIC MOUNTS

The stationary robotic mounts enable an ENG/EFP camera or a prosumer camera to pan, tilt, and zoom. It is normally attached to a standard tripod. It is controlled by a joystick panel and can be interfaced with a laptop computer for storing and executing predetermined camera moves.

RAIL SYSTEM

You have undoubtedly seen a rail system in action. The camera that follows sprinters or speed skaters around the racetrack or ice rink is mounted on a cart that resembles a small railroad car. It runs on rails that are laid parallel to the track or rink. The speed of the cart and all customary camera functions are remotely controlled via a joystick panel.

MAIN POINTS

- The high hat is a short (about 6 inches) cylinder-shaped or three-legged metal mount that accepts the usual fluid or cam mounting head.
- The beanbag is a canvas bag filled with synthetic foam that molds itself to the shape of any ENG/EFP camera or camcorder. It can be tied to the hood of a car. Spring-loaded, shock-absorbing car mounts are usually attached with suction cups.
- The Steadicam is a spring-loaded device that keeps the camera steady even if the operator, who wears a harness and a mount, runs with the camera. Steadicam JR mounts are available for lightweight consumer camcorders; these are handheld by the operator or attached to a body harness.
- The short jib arm is a camera mount that can be attached to furniture or scenery. The long jib has a longer arm that allows a single camera operator to simultaneously dolly, pan and tilt, move the camera up and down, and activate the zoom.
- The studio crane is larger than the jib arm and can support a heavy camera. It is usually used in film or electronic cinema productions.

- The robotic pedestal, or robotic, consists of a motor-driven studio pedestal and a mounting head. The robotic pedestal and the remote zoom and focus controls are guided by a computerized system that can store and execute a great number of camera moves. The stationary robotic mount usually allows pans, tilts, and zooms of small cameras from a fixed position.
- Some robotic news systems include software that also controls a variety of additional event functions, such as switching among cameras, opening and closing microphones, and controlling the teleprompter.
- The rail system consists of a small cart that runs on rails that are laid parallel to a racetrack or ice rink.

ZETTL'S VIDEOLAB

For your reference, or to track your work, the *VideoLab* program cue in this chapter is listed here with its corresponding page number.

ZVLT

CAMERA→ Camera moves→ dolly | zoom | truck | pan | tilt | pedestal | try it 96 6

Camera Operation and Picture Composition

Although television cameras are getting more complex so far as digital electronics are concerned, they are also becoming more user-friendly. The automation of some camera functions cannot make you an expert camera operator overnight, however. Even the smartest automated camera has no way of knowing what part of the event you consider important and how best to clarify and intensify the selected event details through maximally effective shots. Nor can it exercise aesthetic judgment—how to frame an extreme close-up, for example. This is why it is important to learn as much as possible about camera operation before trying to do your blockbuster documentary. Section 6.1, Working the Camera, discusses the basic do's and don'ts of camera operation. Section 6.2, Framing Effective Shots, focuses on some of the aesthetic aspects of picture composition.

KEY TERMS

- **automatic gain control (AGC)** Regulates the volume of the audio or video level automatically, without using manual controls.
- **bust shot** Framing of a person from the upper torso to the top of the head.
- close-up (CU) Object or any part of it seen at close range and framed tightly. The close-up can be extreme (extreme or big close-up—ECU) or rather loose (medium closeup—MCU).
- **closure** Short for *psychological closure*. Mentally filling in spaces of an incomplete picture.
- cross-shot (X/S) Similar to the over-the-shoulder shot except that the camera-near person is completely out of the shot.
- extreme close-up (ECU) Shows the object with very tight framing.
- **extreme long shot (ELS)** Shows the object from a great distance. Also called *establishing shot*.
- **follow focus** Maintaining the focus of the lens in a shallow depth of field so that the image of an object is continuously kept sharp and clear even when the camera or object moves.
- **headroom** The space left between the top of the head and the upper screen edge.

- **knee shot** Framing of a person from approximately the knees up.
- **leadroom** The space left in front of a person or an object moving toward the edge of the screen.
- **long shot (LS)** Object seen from far away or framed loosely. Also called *establishing shot* or *full shot*.
- **medium shot (MS)** Object seen from a medium distance. Covers any framing between a long shot and a close-up. Also called *waist shot*.
- **noseroom** The space left in front of a person looking or pointing toward the edge of the screen.
- over-the-shoulder shot (O/S) Camera looks over a person's shoulder (shoulder and back of head included in shot) at another person.
- **shot sheet** A list of every shot a particular camera has to get. It is attached to the camera to help the camera operator remember the shot sequence. Also called *shot list*.
- three-shot Framing of three people.
- two-shot Framing of two people.
- **z-axis** Line representing an extension of the lens from the camera to the horizon—the depth dimension.

6.1

Working the Camera

When reading about all the details of setting up and operating a camera or camcorder, you may feel overwhelmed. Don't worry. After you have studied and understood the procedures and practiced with the camera a few times, such operational details become routine, very much like driving a car. Section 6.1 helps clarify studio and portable camera operation by laying out the sequential steps that you—the camera operator—need to follow before, during, and after a production. Once you are familiar with the technical details of camera operation, you can turn your attention to how to get effective, dynamic shots.

■ WORKING THE CAMCORDER AND THE EFP CAMERA

Some basic camera "don'ts"; and camera setup, operation, and care—the basic operational steps before, during, and after a field production

▶ WORKING THE STUDIO CAMERA

Camera setup, operation, and care—the basic operational steps before, during, and after a studio production

WORKING THE CAMCORDER AND THE EFP CAMERA

Whether you are working with a small consumer camcorder, a large professional ENG/EFP camcorder, or a high-end EFP camera with a separate VTR, you should know something about how to check it before the shoot and what to do with it during and after the production. Many

of the operational steps are similar or identical regardless of the type of camera, except that during EFP you normally have a few more people helping you.

When caught up in a large studio production or covering a hot news story, it's easy to forget that the camera is an extremely complex piece of machinery. Although it may not be as precious or fragile as your grandmother's china, it still needs careful handling and a measure of respect. Here are some "don'ts" you should know before learning the "do's" of camera operation. These early warnings may well prevent you from damaging or losing the equipment before you ever get to use it. In this light these taboos represent a rather positive beginning.

SOME BASIC CAMERA "DON'TS"

- Don't leave a camcorder in a car—even in the trunk—for an extended period of time unless the car is safely locked in a garage. Like people and animals, electronic equipment tends to suffer from excessive heat. More important, keeping the camera gear with you as much as possible is a fairly simple way of preventing theft.
- Do not leave a camcorder unprotected in the rain, hot sun, or extreme cold or, worse, exposed in a car on a hot day. When you must use a camcorder in the rain, protect it with a "raincoat"—a prefabricated plastic hood—or at least a plastic sheet. A simple but effective means of keeping rain away from a camera is a large umbrella. Some zoom lenses stick in extremely wet or cold weather. Test the lens before using it on location. Prevent the videocassettes or optical discs from getting wet, and never use wet tapes. A wet tape may get sticky and ruin the drive motor in the VTR. Moisture is a major hazard to all electronic equipment.
- Do not point the lens for an extended period of time at the midday sun. Although the CCDs will not be damaged by the intensity of the sunlight, they may suffer from the heat generated by the focused rays. The same goes for the viewfinder: don't leave it pointed at the sun for an extended period of time; the viewfinder's magnifying lens can collect the sun's rays, melting its housing and electronics.
- Do not leave camcorder batteries in the sun or, worse, drop them. Although a battery may look rugged from the outside, it is actually quite sensitive to heat and shock. Some batteries should not be charged in extremely cold temperatures.
- Do not lay a camcorder on its side. You run the risk of damaging the viewfinder or the clipped-on microphone on the other side. When finished shooting, cap the camera

with the external lens cover and, just to make sure, close the aperture to the C (cap) position.

Given these important warnings, you can now relax and devote your full attention to learning what to do before, during, and after the shoot.

BEFORE THE SHOOT

- Before doing anything else, count all the pieces of equipment and mark them on your checklist (see chapter 20). If you need auxiliary equipment, such as external microphones, camera lights, a power supply, or field monitors, make sure you have the right connectors and cables. Recall that BNC and S-video are the standard connectors for professional video cables, and RCA phono is the standard video connector for consumer equipment. The RCA phono connector is also used for consumer audio equipment (see figure 3.23). Take some extra adapters along just in case you need to connect a BNC cable to an RCA phono jack.
- Unless you are running after hot news, first set up the tripod and check whether the camera plate fits the receptacle on the fluid head and balances the camera when locked in place. Do some panning and tilting to determine the optimal pan and tilt drag. Check the pan and tilt locks. Insert the battery or connect the camcorder to its alternate power supply (AC/DC converter and transformer) and do a brief test recording before taking the camcorder into the field. Check that the camcorder records video as well as audio.
- If you are engaged in more-elaborate field productions using high-quality EFP cameras and separate VTRs, check the connecting cables and the various power supplies (usually batteries). You may need a video feed from the camera (or VTR) to a battery-powered field monitor for the director. Be especially aware of connectors. In EFP a loose connector can mean a lost production day. As with the camcorder, *hook up all the equipment you will use in the field and do a test recording before going on location.* Never assume that everything will work merely because it worked in the past.
- Check that the external microphone (usually a hand mic) and the camera mic are working properly. Most camera mics need to be switched on before they become operational. Is there sufficient cable for the external mic so that the reporter can work far enough away from the camera? If you are primarily doing news that requires an

external mic for the field reporter, you may want to keep the external mic plugged in to save time and minimize costly mistakes. You can coil the mic cable and bow-tie it with a string or shoelace—one tug, and the cable is uncoiled with the mic.

- Does the portable camera light work? Don't just look at the lamp. Turn on the light to verify that it works. When using a separate battery for the light, make sure that the battery is fully charged. If you have additional lights, are they all operational? Do you have enough AC extension cords to power the additional lights? Although most households have three-prong receptacles, you should still carry some three-prong to two-prong adapters to fit older household outlets.
- When using a separate VTR for EFP, do a test recording to ensure that the VTR is in good working order. (See chapter 12 for details on VTR operation.)
- Open the videocassette box and verify that it contains the cassette that fits the VTR or camcorder and that it matches the tape length indicated on the box (normally given in standard-speed playing time, such as 60 minutes, 120 minutes, or 180 minutes). Check that the cassette's supply reel has enough tape to justify the indicated playing time. Even if you can't be sure about the exact length, a 180-minute cassette will obviously have a fuller supply reel than a 120-minute tape. Check whether the camera accepts a mini-cassette or a DVCPRO or DVCAM tape. Some relatively large prosumer cameras cannot accept the larger tapes and use only mini-cassettes. Check that the safety tab is in place. If it has been removed, you cannot record on that tape (see chapter 12).
- Always take along a few more cassettes or other storage media than you think you will need.
- Although you are not a maintenance engineer, carry some spare fuses for the principal equipment. Some ENG/EFP cameras and professional camcorders have a spare fuse right next to the active one. Note, however, that a blown fuse indicates a malfunction in the equipment. Even if the camcorder works again with the new fuse, have it checked when you return from the shoot.
- Like carrying a medical first-aid kit, you should always have a *field production kit* that contains the following items: several videocassettes or appropriate storage media, an audiocassette recorder and several audiocassettes, an additional microphone and a small microphone stand,

one or more portable lights and stands, additional lamps for all lighting instruments, AC cords, spares for all types of batteries, various clips or wooden clothespins, gaffer's tape, a small reflector, a roll of aluminum foil, a small white card for white-balancing, light-diffusing material, various effects filters, a can of compressed air for cleaning lenses, and a camera raincoat. You should also carry such personal survival items as a working flashlight, an umbrella, some spare clothes, and, yes, toilet paper. Once you have worked in the field a few times, you will know how to put together your own field production kit.

DURING THE SHOOT

After some field production experience, you will probably develop your own techniques for carrying and operating a camcorder or ENG/EFP camera. Nevertheless, there are some well-established basics that will help you when starting out.

Handheld camcorder operating techniques You may think that the small, handheld camcorder is much easier to operate than its heavier cousin. This may be true if all you do with the camcorder is shoot vacation pictures. The small camcorder is lightweight enough to be tilted, held in one hand, and moved freely through the air. Although such wild camera movement may, on occasion, fit the style of the event, it usually reflects the inexperience of the operator or disrespect for the audience. In most production situations, the camcorder's small size and light weight require steady hands and smooth movements.

- To avoid jittery pictures, you must keep the camera as steady as possible. This is especially important when the zoom lens is in the telephoto position. Support the small camcorder in the palm of your hand and use the other hand to support the "camera arm" or the camcorder itself. **SEE 6.1** Whenever possible, press your elbows against your body, inhale, and hold your breath during the shot. Bend your knees slightly when shooting, or lean against a sturdy support to increase the stability of the camera. **SEE 6.2** Such camera handling is recommended even if you have the image stabilizer turned on. Note that image stabilizers drain the battery relatively quickly, unless you have an optical one built into the lens.
- Whenever possible, use the viewfinder rather than the foldout screen to compose your shots. The viewfinder makes focusing more accurate (you get a sharper image) and is a better guide to proper exposure (*f*-stop) than the flat screen. When shooting outdoors, you will find that the

6.1 HOLDING THE SMALL CAMCORDER
Steady the camcorder with both hands, with your elbows pressed against your body.

foldout screen is often rendered useless by the sun shining on it, obliterating the image. Use the foldout screen only if your camera is in the automatic mode and you need only a rough guide to framing a shot.

- When moving the camera, should you be zoomed in or out? Zoomed out, of course. By zooming out all the way, you put the zoom lens in the wide-angle position, which is very forgiving and does not show minor camera wobbles. Also, because of the great depth of field, you have fewer problems keeping the event in focus, even if you or the subject moves. But even in the wide-angle position, you should move the camera as smoothly as possible.
- To pan the camera (point it sideways), move it with your whole body rather than just your arms. First, point your knees in the direction of the end of the pan. Then twist your body with the camera aimed toward the beginning of the pan. During the pan you are like a spring that is uncoiling from the start of the action to the finish. This position is much smoother than if your knees are pointed

6.2 STEADYING THE CAMERA OPERATOR
Lean against a tree or wall to steady yourself and the camcorder.

6.3 PANNING THE CAMCORDER

Before panning, point your knees in the direction of the end of the pan, then uncoil your upper body during the pan.

toward the start of the action and you are forced to wind up your body during the pan. Always bend your knees slightly when shooting; as in skiing, your knees act as shock absorbers. Don't panic if you lose the subject temporarily in the viewfinder. Keep the camera steady, look up to see where the subject is, and aim the camera smoothly in the new direction. **SEE 6.3**

When moving with people who are walking, get in front of them with the camera and walk backward at the same speed. This way you can see their faces rather than their backs. Moving backward also forces you to walk on the balls of your feet, which are better shock absorbers than your heels. **SEE 6.4** Watch that you do not bump into or stumble over something while walking backward. A quick check of your proposed route can prevent unexpected mishaps. With the zoom lens in the wide-angle position,

you are often closer to the object than the viewfinder image indicates. Be careful not to hit something or someone with the camera, especially if you walk forward with it into a crowd.

ENG/EFP camera or camcorder operating techniques When operating the larger and heavier prosumer or shoulder-mounted ENG/EFP camcorder, many of the rules for small camcorders still apply.

- First and foremost, put the camera on a tripod whenever possible. You will have more control over framing and steadying the shot. You will also get less tired during a long shoot.
- All large ENG/EFP cameras or camcorders are designed to be carried on the operator's shoulder. There are shoulder pods available for the larger prosumer cameras.

6.4 WALKING BACKWARD

When moving with something or somebody, walk backward rather than forward. The balls of your feet act like shock absorbers.

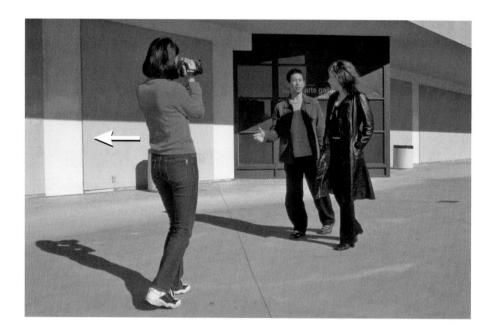

Assuming that you are right-handed, carry the camera on your right shoulder and slip your right hand through the support strap on the zoom lens. This helps you steady the camera while allowing you to operate the zoom and autofocus controls. Your left hand is free to operate the manual focus ring. If you are left-handed, reverse the procedures. You can also switch the viewfinder to the other side so that you can watch the scene with your left rather than your right eye. **SEE 6.5**

- Meep your body and, with it, the camera as steady as possible. Put the zoom lens in the wide-angle position when moving. Preset your knees during a pan, and walk backward rather than forward when moving with the event.
- Unless the camera has a fully automated white balance (as do most consumer camcorders), you must white-balance it before starting to shoot. Be sure to white-balance the camera in the same light that illuminates the scene you are shooting. If you don't have a white card, focus the camera on anything white, such as somebody's shirt or the back of a script. Most camera utility bags have a white sheet sewn into the flap for white-balancing. Repeat the white balance each time you encounter new lighting conditions, such as when moving from an interview on a street corner to the interior of a new restaurant. Careful white-balancing may save you hours of color correction in postproduction.

6.5 SHOULDER-MOUNTED ENG/EFP CAMERA

Carry the larger professional camcorder on your shoulder. One hand slips through the strap on the lens to steady the camcorder and to operate the zoom. Your other hand is free to operate the focus ring at the front of the zoom lens and to provide further support for the camcorder.

- Under normal conditions put the camera in the autoiris mode. *Normal conditions* means that you don't have to reveal picture detail in a dense shadow area or struggle with extreme contrast problems, such as when trying to get a decent exposure of somebody standing in the bright sun or in front of a brightly lit wall. Despite the objections of some especially critical camera operators, using the camcorder in the auto-iris mode on an overcast day will often yield better-exposed video than doing it manually, especially during ENG.
- Try to *calibrate* (preset) the zoom lens as much as possible, even when on the run during ENG. More often than not, such a routine will pay off with good, in-focus pictures. Just as a reminder: you calibrate a zoom lens by zooming in on the target object, such as the limousine carrying the celebrities, focusing the camera, and zooming back out again to the opening shot. When you then zoom in on the people getting out of the car, the camera will remain in focus even for the close-ups. Or, better yet, start with a focused close-up and then zoom back to a wider shot. In effect, what you are doing is presetting the zoom while on the air.

If you haven't calibrated the zoom lens and need to zoom in from a wide shot, you need to *follow focus* as well as you can. This means that you have to turn the focus ring to keep the picture sharp and clear while zooming in—not an easy task by any means. The focus becomes more critical when you shoot under low-light conditions. Recall that low light levels necessitate a large lens aperture (iris opening), which in turn reduces the depth of field. Unless you're shooting vacation pictures or for an HDV focus check, putting a camera in the auto-focus mode is not recommended; the camera frequently gets confused about just what it is you intend to focus on, and fast zooms are frequently out of focus with consumer camcorders.

Achieving optimal focus is especially difficult with HDV and HDTV because the high-resolution picture looks in focus even if it is slightly out of focus. If the scene is rather steady, put the camera in the auto-focus mode if available. Otherwise, rack through the focus a few times to see where the optimal focus lies. Look through the view-finder rather than at the foldout screen when focusing.

All ENG/EFP and most prosumer camcorders display audio levels of the two audio channels. Some ENG/EFP cameras and camcorders have a small speaker attached to their side, in which case you listen to the audio with your right ear resting against the speaker. Usually, camera operators hear the audio through headsets or a molded earpiece

that fits the ear. Whenever possible, check the audio level before and during recording. When working in relatively quiet surroundings, record with the *automatic gain control* (*AGC*). Otherwise, you need to switch to manual gain control, take a sound level, and record. (See chapters 9 and 10 for more information on ENG sound.)

- Whenever videotaping, record sound with the camera mic regardless of whether somebody is talking. This ambient sound is important to achieve continuity in postproduction editing. When the reporter is holding the external mic, do not start to run away from him or her to get a better shot of the event. Either you both run together, or you must stay put.
- Heed the warning signals in the viewfinder display or foldout screen. It is usually the equipment, not the warning display, that is malfunctioning.
- In EFP you usually work with other crewmembers. Even with a small production team, you must assign each member specific functions. For example, assuming that you work with a separate VTR, you might run the camera, with somebody else taking care of all VTR functions. A third person might do the lighting and work the external microphone. When your ENG/EFP camera is part of a multicamera shoot, you need a good *cable puller* who will anticipate your moves and feed the cable so that you can walk or run freely to the next shooting position.
- Above all, *use common sense*. Always be mindful of your and other people's safety. Use sound judgment in determining whether the risk is worth the story. In ENG reliability and consistency are more important than sporadic feats, however spectacular. Do not risk your neck and the equipment to get a shot that would simply embellish a story already on tape. Leave that type of shooting to the gifted amateurs.

AFTER THE SHOOT

- Unless you have just shot a really hot story that must air immediately, even unedited, take care of the equipment before delivering the tape. If you are properly organized, it should take just a few minutes.
- Take the full videocassette or other media out of the VTR and immediately replace it with a new one. Label all cassettes or discs right away.
- Put all the switches in the *off* position, unless you are heading for another assignment, in which case put the camera in the *standby* position.

- Cap the camera by closing the iris all the way and snapping on the lens cover.
- Roll up the mic cable and bow-tie it with a string or shoelace.
- Immediately put everything back into its designated box or bag. Don't leave it for the next day because you may find yourself having to cover an important news story on your way home.
- Recharge all batteries as soon as you return from the assignment.
- If the camcorder got wet, wait until everything has dried out before putting the camera back into its case. Most camera operators and ENG/EFP crews carry a battery-powered hair dryer or fan that will accelerate the drying. Moisture is one of the most serious threats to camcorder VTRs.
- If you have time, check all the portable lights so they will work for the next assignment. Coil all AC extension cords—you will not have time to untangle them during an ongoing event. ◀

WORKING THE STUDIO CAMERA

The big difference between operating an ENG/EFP camcorder and a studio camera is that the latter is always mounted on some kind of camera support—usually a studio pedestal. In one way the studio camera is easier to operate than the portable camera: all electronic adjustments are performed for you by the video operator (VO), who "shades" the camera at the CCU (camera control unit). In another way, however, you may find that operating the studio camera is more difficult because you have to steer the pedestal (or other camera mount) and adjust the focus while composing effective pictures. Here are the important steps to observe before, during, and after a show or rehearsal.

BEFORE THE SHOW

- Put on your headset and check that the intercom system is functioning. You should hear at least the director, the technical director (TD), and the video operator.
- Unlock the pan-and-tilt mechanism on the camera mounting head and adjust the horizontal and vertical drag, if necessary. Check that the camera is balanced on the mounting head. Unlock the pedestal, then pedestal up and down. Check that the pedestal is correctly counterweighted. A properly balanced camera remains put in any

- given vertical position. If it drops down or moves up by itself, the pedestal is not properly counterweighted.
- See how much camera cable you have and whether there are any obstacles that may interfere with the cable run. Check that the pedestal skirt or other type of cable guard is low enough to move the cable out of the way rather than roll over it.
- Ask the VO to uncap the camera from the CCU, and ask if you can remove the lens cap. You can then see in the viewfinder the pictures the camera actually takes. Is the viewfinder properly adjusted? Like a home television set, the viewfinder can be adjusted for brightness and contrast. If you need framing guides, flip the switch that shows the *essential area* and the screen-center mark (see chapter 15).
- Check the zoom lens. Zoom in and out. Does the lens stick, or does it move smoothly throughout the zoom range? What exactly is the range? Get a feel for how close you can get to the main event from a certain position. If you work with a digital zoom lens, check whether the lens returns to the designated position (focal length) in subsequent zooms. Is the lens clean? If it is dusty, use a fine camel-hair brush and carefully clean off the larger dust particles. With a small rubber bulb or a can of compressed air, blow off the finer dust. Do not blow on the lens with your mouth: the moisture will fog it up and get it even dirtier.
- Rack through focus—that is, move the focus control from one extreme position to the other. Can you move easily and smoothly into and out of focus, especially when in a narrow-angle, zoomed-in position?
- Calibrate the zoom lens. Zoom all the way in on the target object in the zoom range, such as the newscaster or the door on the far wall of the living room set. Focus on this far object. Now zoom all the way back to the widest-angle setting. You should now remain in focus throughout the zoom, provided neither the object nor the camera moves.
- If you have a shot sheet (also called a *shot list*), this is a good time to practice the more complicated zoom and dolly or truck shots. A *shot sheet* is a list of every shot a particular camera has to get. It is attached to the camera to help the camera operator remember the shot sequence.
- If a teleprompter is attached to the camera, check all the connections.
- Lock the camera again (the pedestal and the pan-and-tilt mechanism) before leaving it. *Don't ever leave a camera*

unlocked, *even for a short while*. Some of the newer pedestals have a parking brake. Set the brake(s) on the pedestal before leaving the camera.

Cap the camera if you leave it for a prolonged period of time.

DURING THE SHOW

Section 6.1

- Put on the headset and establish contact with the director, technical director, and video operator. Unlock the camera and recheck the pan and tilt drag and the pedestal movement.
- Calibrate the zoom at each new camera position. See whether you can stay in focus over the entire zoom range.
- When checking the focus between shots, rack through focus a few times to determine at which position the picture is the sharpest. When focusing on a person, the hairline usually gives you enough detail to determine the sharpest focus, or you may focus on eyes. In *extreme close-ups* (*ECUs*), focus on the bridge of the nose. As mentioned, you will probably find that achieving and remaining in proper focus is more difficult with an HDTV camera. Because the HDTV picture detail looks so sharp in the viewfinder even if you are slightly out of focus, you may not notice the problem until your video is played back on a larger monitor. After some practice, however, you will be able to read the HDTV image for proper focus.

As you learned in the section on lenses, some have a built-in focus-assist mechanism: you select the critical area of the image with a roller ball (similar to that of a computer mouse) and tell the lens that this is the area that needs to be in sharp focus. The lens will then try to comply. Such maneuvers are obviously possible only with a static scene and plenty of production time.

- If you anticipate a dolly, set the zoom lens to the wide-angle position. Preset the focus at the approximate midpoint of the dolly distance. With the zoom lens in the extreme wide-angle position, the depth of field should be large enough so that you need to adjust focus only when you are very close to the object or event.
- Although a camera pedestal allows you to dolly extremely smoothly, you may have some difficulty moving or stopping it without jerking the camera. Start slowly to overcome the inertia, and slow down just before the end of the dolly or truck. If you have a difficult truck or arc to perform, have a floor person help you move and steer the camera. You can then concentrate on the camera operation.

In a straight dolly, you can keep both hands on the panning handles. If you have to steer the camera, steer with your right hand, keeping your left hand on the focus control.

- If you pedestal up or down, try to brake the camera before it hits the stops at the extreme pedestal positions. Generally, keep your shots at the talent's eye level unless the director instructs you to shoot from either a high (pedestal up and look down) or a low (pedestal down and look up) angle.
- When you operate a freewheel camera dolly, always preset the wheels toward the intended camera movement to prevent the dolly from starting off in the wrong direction. Check that the cable guards are low enough to prevent the camera from running over the cables on the studio floor instead of pushing them out of the way.
- Determine the approximate reach of the camera cable. In a long dolly, the cable may tug annoyingly at the camera. Do not try to pull the cable along with your hand. To ease the tension, loop it over your shoulder or tie it to the pedestal base, leaving enough slack so that you can freely pan, tilt, and pedestal. On complicated camera movements, have a floor person help you with the cable; otherwise, the microphone may pick up the dragging sound. If the cable gets twisted during a dolly, do not drag the whole mess along; have a floor person untangle it.
- At all times during the show, be aware of the activity around you. Where are the other cameras? The microphone boom? The floor monitor? It is your responsibility to keep out of the view of the other cameras and not hit anything (including floor personnel or talent) during your moves. Watch especially for obstacles in your dolly path, such as scenery, properties, and floor lights. Rugs are a constant hazard to camera movement. When dollying into a set that has a rug, watch the floor so that you do not suddenly dolly up onto the rug. Better yet, have a floor person warn you when you come close to the rug. Be particularly careful when dollying back. A good floor manager will help clear the way and tap you on the shoulder to prevent you from backing into something.
- In general, keep your eyes on the viewfinder. If the format allows, look around for something interesting to shoot between shots. The director will appreciate good visuals in an ad-lib show (in which the shots have not been rehearsed). If you have a shot sheet, though, stick to it, however tempting the shot possibilities may be. Do not try to outdirect the director.

- Watch for the tally light to go out before calibrating the zoom or moving the camera into a new shooting position. This is especially important if your camera is engaged in special effects. With some effects the tally lights of both cameras involved are on (see chapter 11).
- During rehearsal inform the floor manager or the director of unusual production problems, such as an inability to prevent a camera shadow. The director will decide whether to change the camera position or the lighting. The camera may be too close to the object to keep it in focus, or the director may not give you enough time to preset the zoom again after you move into a new shooting position. Alert the director if he or she has told you to move the camera while on the air and your zoom lens is in a narrow-angle position. Sometimes it is hard for the director to tell from the preview monitor the exact zoom position of a lens. Mark all shot changes on the shot sheet.
- Use masking tape on the studio floor to mark the critical camera positions. Line up exactly on these marks during the actual show. If you don't have a shot sheet, make one on your own. Mark particularly the camera movements (dollies, trucks, and the like) so that you can set the zoom in a wide-angle position.
- If you work without shot sheets, try to remember the type and the sequence of shots from the rehearsal. A good camera operator has the next shot lined up before the director calls for it. If you work from a shot sheet, go to the next shot immediately after the preceding one—don't wait until the last minute. The director may have to "punch up" your camera (put it on the air) much sooner than you remember from rehearsal. Do not zoom in or out needlessly during shots unless you are calibrating the zoom lens.
- Listen carefully to what the director tells all the camera operators (not just you) so that you can coordinate your shots with those of the other cameras. Also, you can avoid wasteful duplication of shots by knowing approximately what the other cameras are doing.
- Avoid unnecessary chatter on the intercom.

AFTER THE SHOW

- At the end of the show, wait for the "all clear" signal before you lock the camera.
- Ask the VO whether you can cap the lens with the lens cap.
- Lock the camera mounting head and the pedestal and push the camera to its designated "parking place" in the studio. If the camera is so equipped, set the brake. Do not leave the camera in the middle of the studio, where it can easily be damaged by a piece of scenery being moved or by other studio traffic.
- Coil the cable as neatly as possible in the customary figure-eight loops.

MAIN POINTS

- When working a camcorder or portable camera, be sure to handle it with the utmost care. Do not leave it unprotected in the sun or uncovered in the rain.
- Before using a camcorder, check that the batteries are fully charged and that you have enough videotape or other recording media for the assignment. Do an audio check with the camera mic and the external mic.
- When shooting pay particular attention at all times to white balance, presetting the zoom, and recording ambient sound. If the lighting is fairly even, you can switch to autoiris control. Respond immediately to any warning signals in the viewfinder or foldout screen.
- After the production put everything back carefully so that the equipment is ready for the next assignment.
- Before operating the studio camera, check the headset, the camera mount (tripod dolly, pedestal, or crane), and the zoom and focus mechanisms.
- During the show pay particular attention to calibrating the zoom, smooth camera movements, the camera cable's reach and travel, and focus.
- After the show lock the camera mounting head, cap the camera, and move it to its designated place in the studio. If available, set the parking brake.

SECTION

6.2

Framing Effective Shots

The basic purpose of framing a shot is to show images as clearly as possible and to present them so that they convey meaning and energy. Essentially, you clarify and intensify the event before you. When working a camcorder, you are the only one who sees the television pictures before they are videotaped. You therefore cannot rely on a director to tell you how to frame every picture for maximum effectiveness.

The more you know about picture composition, the more effective your clarification and intensification of the event will be. But even if you are working as a camera operator during a multicamera studio show or a large remote where the director can preview all the camera pictures, you still need to know how to compose effective shots. The director might be able to correct some of your shots, but he or she will certainly not have time to teach you the fundamentals of good composition.

This section describes the major compositional principles and explains how to frame a shot for maximum clarity and impact.

SCREEN SIZE AND FIELD OF VIEW

Operating with close-ups and medium shots rather than long shots and extreme long shots

FRAMING A SHOT: STANDARD TV AND HDTV ASPECT RATIOS

Dealing with height and width, framing close-ups, headroom, noseroom and leadroom, and closure

DEPTH

Creating the illusion of a third dimension in both aspect ratios: choice of lens, positioning of objects, depth of field, and lighting and color

SCREEN MOTION

Z-axis motion (movement toward and away from the camera) and lateral movement in both aspect ratios¹

SCREEN SIZE AND FIELD OF VIEW

Screen size and field of view are closely related. On the large movie screen, you can show a relatively large vista with a great amount of event detail. When the same scene is shown on television, however, you will not only have difficulty making out the smaller event details but, more important, you will lose the aesthetic impact of the shot. This is why some film critics suggest seeing a particular film "on the big screen."

SCREEN SIZE

Most television sets have a relatively small screen, especially when compared with the average movie screen. To reveal event details, you must show them in close-ups rather than long shots. In other words, your field of view must generally be tighter on television than on the motion picture screen. Such a close-up approach necessitates choosing and emphasizing those details that contribute most effectively to the overall event.

FIELD OF VIEW

Field of view refers to how wide or how close the object appears relative to the camera, that is, how close it will appear to the viewer. It is basically organized into five steps: (1) extreme long shot (ELS), also called establishing shot; (2) long shot (LS), also called full shot or establishing shot; (3) medium shot (MS), also called waist shot; (4) close-up (CU); and (5) extreme close-up (ECU). SEE 6.6 ZVL1 CAMERA \rightarrow Composition \rightarrow field of view

Four other ways of designating conventional shots are: bust shot, which frames the subject from the upper torso to the top of the head; knee shot, which frames the subject from just above or below the knees; two-shot, with two people or objects in the frame; and three-shot, with three people or objects in the frame. Although more a blocking arrangement than a field of view, you should also know two additional shots: the over-the-shoulder shot and the

For an extensive discussion of screen forces and how they can be used for effective picture composition, see Herbert Zettl, Sight Sound Motion, 4th ed. (Belmont, Calif.: Thomson Wadsworth, 2005), pp. 93–194.

6.6 FIELD-OF-VIEW STEPS

The shot designations range from ELS (extreme long shot) to ECU (extreme close-up).

Extreme long shot (ELS), or establishing shot

Long shot (LS), or full shot

Medium shot (MS), or waist shot

Close-up (CU)

Extreme close-up (ECU)

cross-shot. In the *over-the-shoulder shot* (O/S), the camera looks at someone over the shoulder of the camera-near person. In a *cross-shot* (X/S), the camera looks alternately at one or the other person, with the camera-near person completely out of the shot. **SEE 6.7**

Of course, exactly how to frame such shots depends not only on your sensitivity to composition but also on the director's preference.

FRAMING A SHOT: STANDARD TV AND HDTV ASPECT RATIOS

Many high-end studio cameras, ENG/EFP cameras, and even some high-quality consumer camcorders have a switch for changing the aspect ratio from the standard 4×3 format to the HDTV 16×9 . Although the aspect

ratios of standard television and HDTV are quite different and require different technical manipulations, many of the aesthetic principles of good picture composition apply to both. Nevertheless, in framing effective shots some aesthetic principles need to be adjusted to the specific requirements of the aspect ratio. This section takes a closer look at (1) dealing with height and width, (2) framing close-ups, (3) headroom, (4) noseroom and leadroom, and (5) closure.

DEALING WITH HEIGHT AND WIDTH

You will find that the 4×3 aspect ratio is well suited to framing a vertical scene, such as a high-rise building, as well as a horizontally oriented vista. **SEE 6.8 AND 6.9** It is also relatively easy to accommodate a scene that has both wide and high elements. **SEE 6.10**

6.7 OTHER SHOT DESIGNATIONS

Other common shot designations are the bust shot, knee shot, two-shot, three-shot, over-the-shoulder shot, and cross-shot. Note that the bust shot is similar to the MS and that the knee shot is similar to the LS.

Bust shot

Knee shot

Two-shot (two persons or objects in frame)

Three-shot (three persons or objects in frame)

Over-the-shoulder shot (O/S)

Cross-shot (X/S)

6.8 FRAMING A VERTICAL VIEW
The 4 × 3 aspect ratio allows you to frame a vertical scene without having to use extreme camera distance or angles.

6.9 FRAMING A HORIZONTAL VIEW The 4×3 aspect ratio readily accommodates a horizontal vista.

6.10 FRAMING HEIGHT
AND WIDTH IN A SINGLE SHOT
The 4 × 3 aspect ratio easily accommodates both horizontal and vertical vistas.

6.11 FRAMING A HORIZONTAL VIEW IN THE HDTV ASPECT RATIO

The 16×9 format is ideal for framing wide horizontal vistas.

6.12 FRAMING A VERTICAL VIEW IN THE HDTV ASPECT RATIO The 16×9 format makes it quite difficult to frame a vertical object. One way to frame a tall object is to shoot it from below and cant the camera.

Although the horizontally stretched 16 × 9 aspect ratio makes horizontal scenes look quite spectacular, it presents a formidable obstacle to framing a vertical view. **SEE 6.11** You can either tilt the camera up to reveal the height of the object or shoot from below and *cant* the camera to make the subject fit into the diagonal screen space. **SEE 6.12** Another frequently used film technique for dealing with vertical objects is to have other picture elements block the sides of the screen and, in effect, give you a vertical aspect ratio in which to frame the shot. **SEE 6.13**

FRAMING CLOSE-UPS

Close-ups (CUs) and extreme close-ups (ECUs) are common elements in the visual language of television because, compared with the large motion picture screen, even large television screens are relatively small. The 4×3 aspect ratio and the small screen of the standard television receiver are

6.13 NATURAL MASKING OF THE SCREEN SIDES IN THE HDTV ASPECT RATIO

You can use parts of the natural environment to block the sides of the wide 16×9 screen to create a vertical space in which to frame the vertical object. In this shot the foreground buildings create a vertical aspect ratio for the high-rise building.

6.14 FRAMING A CLOSE-UP
The normal close-up shows the head of the person and part of the shoulders.

6.15 FRAMING AN EXTREME CLOSE-UP In an extreme close-up, you should crop the top of the head while keeping the upper part of the shoulders in the shot.

the ideal combination for close-ups and extreme close-ups of people's heads. **SEE 6.14**

As you can see, the normal close-up shows the customary headroom and part of the upper body. The ECU is somewhat trickier to frame: the top screen edge cuts across the top part of the head, and the lower edge cuts just below the top part of the shoulders. SEE 6.15 ZVL2 CAMERA > Composition > close-ups

When you try to frame the same shot in the HDTV 16×9 aspect ratio, however, you are left with a great amount of leftover space on both sides of the subject's face. The close-up looks somewhat lost in the widescreen format, and the extreme close-up looks as though it is squeezed between the top and bottom screen edges. **SEE 6.16 AND 6.17** You can solve this problem relatively easily

by including some visual elements in the shot that fill the empty spaces on either side. **SEE 6.18** Some directors simply tilt the camera or the talent somewhat so that the shot occupies more of the horizontal space. On the other hand, the HDTV aspect ratio lets you easily frame close-ups of two people face-to-face. Such an arrangement is quite difficult in the traditional format because the two dialogue partners must stand uncomfortably close together. **SEE 6.19**

HEADROOM

Because the edges of the television frame seem to attract like magnets whatever is close to them, leave some space above people's heads—called *headroom*—in normal long shots, medium shots, and close-ups. **SEE 6.20** Avoid having the head "glued" to the upper edge of the frame.

6.16 FRAMING A CLOSE-UP IN THE HDTV ASPECT RATIO When framing the same close-up in the 16×9 format, both screen sides look conspicuously empty.

6.17 FRAMING AN EXTREME CLOSE-UP IN THE HDTV ASPECT RATIO

In the 16×9 format, the ECU of the person seems oddly squeezed between the upper and lower screen edges.

6.18 NATURAL MASKING OF A CLOSE-UP IN THE HDTV ASPECT RATIO

To avoid excessive empty space when framing a screencenter close-up of a person in the 16×9 format, you can mask the sides with objects from the actual environment.

6.19 FACE-TO-FACE CLOSE-UPS IN THE HDTV ASPECT RATIO

The 16×9 format makes it relatively easy to have two people face each other on a close-up without having to stand uncomfortably close together.

6.20 NORMAL HEADROOM
Headroom counters the magnetic pull of the upper frame. The person appears comfortably placed in the frame.

6.21 TOO LITTLE HEADROOMWith no, or too little, headroom, the person looks cramped in the frame. The head seems to be glued to the upper screen edge.

6.22 TOO MUCH HEADROOMWith too much headroom, the pull of the bottom edge makes the picture bottomheavy and strangely unbalanced.

SEE 6.21 Because you lose a certain amount of picture area in videotaping and transmission, you need to leave a little more headroom than feels comfortable. Leaving too much headroom, however, is just as bad as too little. SEE 6.22 If your camera is so equipped, you can use the frame guide in the viewfinder to see the picture area that actually appears on the television screen. The headroom rule applies equally to both aspect ratios. ZVL3 CAMERA→ Composition→ headroom

NOSEROOM AND LEADROOM

Somebody looking or pointing in a particular direction other than straight into the camera creates a screen force called an *index vector*. You must compensate for this force by leaving some space in front of the vector. When someone looks or points screen-left or screen-right, the index vector needs to be balanced with *noseroom*. A lack of noseroom or leadroom makes the picture look oddly out

6.23 PROPER NOSEROOM

To absorb the force of the strong index vector created by the person's looking toward the screen edge, you need to leave some noseroom.

6.24 LACK OF NOSEROOM

Without noseroom the person seems to be blocked by the screen edge, and the picture looks unbalanced.

6.25 PROPER LEADROOM

Assuming that the cyclist is actually moving, his motion vector is properly neutralized by the screen space in front of him. We like to see where the person is heading, not where he has been. Note that a still picture cannot show a motion vector. What you see here is an index vector.

6.26 LACK OF LEADROOM

Without leadroom the moving person or object seems to be hindered or stopped by the screen edge.

of balance; the person seems to be blocked by the screen edge. **SEE 6.23 AND 6.24**

Screen motion creates a *motion vector*. When someone or something moves in a screen-right or screen-left direction, you must leave *leadroom* to balance the force of the motion vector. **SEE 6.25** Even in a still photo you can see that without proper leadroom the cyclist seems to be crashing into right screen border. **SEE 6.26** To avoid such crashes, you must always lead the moving object with the camera rather than follow it. After all, we want to see where the moving object is going, not where it has been. Note, however, that neither of the leadroom examples here represent actual motion vectors because they are still pictures; because they

don't move but simply point in a specific direction, they are index vectors. ZVL4 CAMERA→ Composition→ leadroom

CLOSURE

Closure, short for psychological closure, is the process by which our minds fill in information that we cannot actually see on-screen. Take a look around you: you see only parts of the objects that lie in your field of vision. There is no way you can ever see an object in its entirety unless the object moves around you or you move around the object. Through experience we have learned to mentally supply the missing parts, which allows us to perceive a whole world

6.27 FACILITATING CLOSURE BEYOND THE FRAME

In this shot we perceive the whole figure of the person and her guitar although we see only part of them. This shot gives us sufficient clues to project the figure beyond the frame and apply psychological closure in the off-screen space.

6.28 TRIANGLE CLOSURE

We tend to organize things into easily recognizable patterns. This group of similar objects forms a triangle.

6.29 SEMICIRCLE CLOSURE

These objects organize the screen space into a semicircle.

although we actually see only a fraction of it. Because closeups usually show only part of an object, your psychological closure mechanism must work overtime.

Positive closure To facilitate closure you should always frame a shot in such a way that the viewer can easily extend

the figure beyond the screen edges and perceive a sensible whole. **SEE 6.27** To organize the visual world around us, we also automatically group things together so that they form a sensible pattern. **SEE 6.28 AND 6.29** You would be hard-pressed *not* to perceive figure 6.28 as a triangular pattern and figure 6.29 as a semicircle.

6.30 UNDESIRABLE CLOSURE WITHIN THE FRAME
This shot is badly framed because we apply closure within the frame without projecting the rest of the person into off-screen space.

6.31 DESIRABLE CLOSURE IN OFF-SCREEN SPACEIn this ECU there are enough on-screen clues to project the rest of the person's head and body into off-screen space, thus applying closure to the total figure.

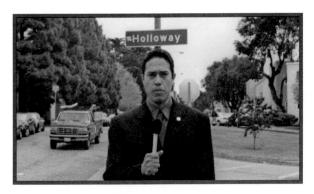

6.32 ILLOGICAL CLOSURE
Although we know better, we perceive this reporter as balancing a street sign on his head.

Negative closure This closure automation can also work *against* good composition. For example, when framing a close-up of a face without giving prominent visual clues to help viewers project the image beyond the screen edges, the head seems oddly cut off from its body. **SEE 6.30** You therefore need to provide enough visual clues to lead the viewers' eyes beyond the frame so they can apply closure and perceive the complete person in off-screen space. **SEE 6.31**

Our mechanism to organize our environment into simple patterns is so strong that it often works against reason. In the excitement of getting a good story and an interesting shot, it is easy to forget to look *behind* the object of attention, but it is often the background that spoils a good picture composition. **SEE 6.32** As you can see in figure 6.32, we tend to perceive the background as part of the foreground. The reporter seems to be balancing a street sign

on his head. Most often you must guard against compositions wherein background objects seem to be growing out of the foreground people's heads. A slightly tilted horizon line is another common compositional problem. Once you are aware of the background, it is relatively easy to avoid illogical closure. ZVL5 CAMERA > Composition > closure

DEPTH

Because the television screen is a flat, two-dimensional piece of glass upon which the image appears, we must create the illusion of a third dimension. Fortunately, the principles for creating the illusion of depth on a two-dimensional surface have been amply explored and established by painters and photographers over the years. For creating and intensifying the illusion of depth on the most basic level, try to establish a clear division of the image into foreground, middleground, and background. To do this you need to consider the following factors:

- Choice of lens. A wide-angle zoom position exaggerates depth. Narrow-angle positions reduce the illusion of a third dimension.
- *Positioning of objects.* The *z-axis*—the line representing an extension of the lens from the camera to the horizon—has significant bearing on perceiving depth. Anything positioned along the *z-axis* relative to the camera will create the illusion of depth.
- Depth of field. A slightly shallow depth of field is usually more effective to define depth because the in-focus foreground object is more clearly set off against the out-of-focus background.
- Lighting and color. A brightly lighted object with strong (highly saturated) color seems closer than one that is dimly lighted and has washed-out (lowsaturation) colors. SEE 6.33 ZVL6 CAMERA→ Picture depth→ z-axis | lens choice | perspective and distortion

SCREEN MOTION

Contrary to the painter or the still photographer, who deals with the organization of static images within the picture frame, the television camera operator must almost always cope with framing images in motion. Composing

6.33 FOREGROUND, MIDDLEGROUND, AND BACKGROUND In general, try to divide the z-axis (depth dimension) into a prominent foreground (dead tree), middleground (pine trees), and background (ski run). Such a division helps create the illusion of screen depth.

moving images requires quick reactions and full attention throughout the telecast. The study of the moving image is an important part of learning the fine art of television and film production; here we look at some of its most basic principles.

When framing for the traditional 4×3 aspect ratio and small screen, movements along the z-axis (toward or away from the camera) are stronger than any type of lateral motion (from one screen edge to the other). Fortunately, they are also the easiest to frame: you simply keep the camera as steady as possible and make sure that the moving object does not go out of focus as it approaches the camera. Remember that a wide-angle zoom lens position gives the impression of accelerated motion along the z-axis, whereas a narrow-angle position slows z-axis motion for the viewer.

When working in the 16×9 HDTV aspect ratio, however, lateral movement takes on more prominence. Although the stretched screen width gives you a little more breathing room, you must still have proper leadroom during the entire pan. As mentioned, the viewer wants to know where the object is going, not where it has been.

If you are on a close-up and the subject shifts back and forth, don't try to follow each minor wiggle. You might run the risk of making viewers seasick; at the very least, they will not be able to concentrate on the subject for very long. Keep the camera pointed at the major action area or zoom out (or pull back) to a slightly wider shot.

6.34 TWO PERSONS SAYING GOOD-BYE

If in a two-shot the people walk away from each other toward the screen edges, don't try to keep both people in the shot.

If even after extensive rehearsals you find that in an over-the-shoulder shot the person closer to the camera blocks the other person, who is farther away from the camera, you can solve the problem by trucking or arcing to the right or left. **SEE 6.36 AND 6.37**

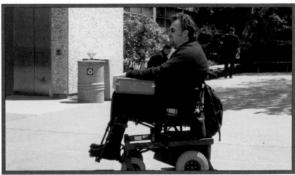

6.35 CAMERA STAYS WITH ONE OF THEM

You must decide which person you will keep in the frame and let the other move off-camera.

Whatever you do to organize screen motion, do it *smoothly*. Try to move the camera as little as possible unless you need to follow a moving object or dramatize a shot through motion. Because you can move a camcorder so easily, it may be tempting to "animate" a basically static scene by moving the camera with great fervor. Don't do it. Excessive camera motion is a telltale sign of an amateur camera operator.

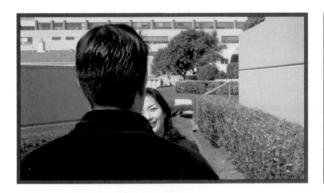

6.36 CAMERA-FAR PERSON BLOCKED

In an over-the-shoulder shot, you may find that the cameranear person blocks the camera-far person.

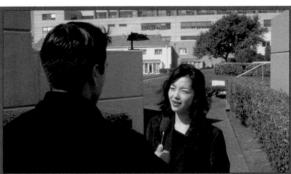

6.37 CAMERA TRUCKS TO CORRECT

To correct this over-the-shoulder shot so that the camera-far person can be seen, simply truck or arc the camera to the right.

MAIN POINTS

- Because the television screen size is relatively small, we use more close-ups and medium shots than long shots. When shooting for wide-aspect-ratio, large-screen HDTV, you can use more medium shots and long shots.
- Field of view refers to how much of a scene you show in the viewfinder, that is, how close the object appears relative to the viewer. The field of view is organized into five steps: ESL (extreme long shot, or establishing shot), LS (long shot, or full shot), MS (medium shot, or waist shot), CU (close-up), and ECU (extreme close-up).
- Alternate shot designations include the bust shot, the knee shot, the two-shot, the three-shot, the over-the-shoulder shot (O/S), and the cross-shot (X/S).
- In organizing the screen area for the traditional 4 × 3 and the HDTV 16 × 9 aspect ratios, the major considerations are: dealing with height and width, framing close-ups, headroom, noseroom and leadroom, and closure.
- In organizing screen depth, a simple and effective way is to establish a distinct foreground, middleground, and background.
- In creating the illusion of a third dimension (depth), you need to consider the choice of lens, positioning of objects, depth of field, and lighting and color.
- ◆ In organizing screen motion for the 4 × 3 aspect ratio, z-axis motion (movement toward or away from the camera) is stronger than lateral movement (from one side of the screen to the other). When working in the 16 × 9 aspect ratio, lateral movement becomes more prominent.

ZETTL'S VIDEOLAB

For your reference, or to track your work, each *Video-Lab* program cue in this chapter is listed here with its corresponding page number.

ZVL1 CAMERA→ Composition→ field of view 115

ZVL2 CAMERA→ Composition→ close-ups 118

ZVL3 CAMERA → Composition → headroom 119

ZVL4 CAMERA→ Composition→ leadroom 120

ZVL5 CAMERA→ Composition→ closure 123

ZVL6 CAMERA→ Picture depth→ z-axis | lens choice | perspective and distortion 123

ZVL7 CAMERA→ Screen motion→ z-axis | lateral | close-ups 124

7

Lighting

Lighting means to control light and shadows for three principal reasons: (1) to help the television camera see well, that is, produce technically optimal pictures; (2) to help the viewer see well—to recognize what things and people look like and where they are in relation to one another and to their immediate environment; and (3) to establish for the viewer a specific mood that helps intensify the feeling about the event.

Section 7.1, Lighting Instruments and Lighting Controls, describes the tools you need to accomplish these lighting objectives. Section 7.2, Light Intensity, Lamps, and Color Media, introduces a few more elements about light, how to control and measure it, and how to use colored light.

KEY TERMS

- barn doors Metal flaps mounted in front of a lighting instrument that control the spread of the light beam.
- **baselight** Even, nondirectional (diffused) light necessary for the camera to operate optimally. Normal baselight levels are 150 to 200 foot-candles (1,500 to 2,000 lux) at f/8 to f/16. Also called *base*.
- **broad** A floodlight with a broadside, panlike reflector.
- **clip light** Small internal reflector spotlight that is clipped to pieces of scenery or furniture with a gator clip. Also called *PAR* (parabolic aluminized reflector) lamp.
- cookie A popularization of the original term cucoloris or cucaloris. Any pattern cut out of thin metal that, when placed inside or in front of an ellipsoidal spotlight (pattern projector), produces a shadow pattern. Also called gobo.
- **dimmer** A device that controls the intensity of light by throttling the electric current flowing to the lamp.
- **ellipsoidal spotlight** Spotlight producing a very defined beam, which can be shaped further by metal shutters.
- **flag** A thin, rectangular sheet of metal, plastic, or cloth used to block light from falling on specific areas. Also called *gobo*.
- **floodlight** Lighting instrument that produces diffused light with a relatively undefined beam edge.
- **fluorescent** Lamps that generate light by activating a gas-filled tube to give off ultraviolet radiation, which lights up the phosphorous coating inside the tubes.
- **follow spot** Powerful special-effects spotlight used primarily to simulate theater stage effects. It generally follows action, such as dancers, ice skaters, or single performers moving in front of a stage curtain.
- foot-candle (fc) The American unit of measurement of illumination, or the amount of light that falls on an object. One foot-candle is the amount of light from a single candle that falls on a 1-square-foot area located 1 foot away from the light source.
- Fresnel spotlight One of the most common spotlights, named after the inventor of its lens. Its lens has steplike concentric rings.
- **gel** Generic term for color filters put in front of spotlights or floodlights to give the light beam a specific hue. *Gel* comes from *gelatin*, the filter material used before the invention of more-durable plastics. Also called *color media*.

- **HMI light** Stands for *hydragyrum medium arc-length iodide.*Uses a high-intensity lamp that produces light by passing electricity through a specific type of gas. Needs a separate ballast. Similar to the HID light.
- incandescent The light produced by the hot tungsten filament of ordinary glass-globe or quartz-iodine light bulbs (in contrast to fluorescent light).
- incident light Light that strikes the object directly from its source. An incident-light reading is the measure of light in foot-candles (or lux) from the object to the light source. The light meter is pointed directly into the light source or toward the camera.
- **lumen** The light intensity power of one candle (light source radiating isotropically, i.e., in all directions).
- luminaire Technical term for lighting instrument.
- luminant Lamp that produces the light; the light source.
- lux European standard unit for measuring light intensity. 10.75 lux = 1 fc; usually roughly translated as 10 lux = 1 fc.
- **neutral density (ND) filter** Filter that reduces the incoming light without distorting the color of the scene.
- **patchboard** A device that connects various inputs with specific outputs. Also called *patchbay*.
- pattern projector An ellipsoidal spotlight with a cookie (cucoloris) insert, which projects the cookie's pattern as a cast shadow.
- **quartz** A high-intensity incandescent light whose lamp consists of a quartz or silica housing (instead of the customary glass) that contains halogen gas and a tungsten filament. Produces a very bright light of stable color temperature (3,200K). Also called *TH* (tungsten-halogen) lamp.
- **reflected light** Light that is bounced off the illuminated object. A reflected-light reading is done with a light meter held close to the illuminated object.
- scoop A scooplike television floodlight.
- **scrim** A spun-glass material that is put in front of a lighting instrument as an additional light diffuser or intensity reducer.
- softlight Television floodlight that produces extremely diffused light.
- spotlight A lighting instrument that produces directional, relatively undiffused light with a relatively well-defined beam edge.

7.1

Lighting Instruments and **Lighting Controls**

When you turn on the light in your room, you are concerned primarily with having enough illumination to see well and get around. Contrary to the lighting in your home, however, television lighting must also please the television camera and fulfill certain aesthetic functions, such as simulating outdoor or indoor lighting or creating a happy or sinister mood. Studio lighting requires instruments that can simulate bright sunlight, a street lamp at a lonely bus stop, the efficiency of a hospital operating room, or the horror of a medieval dungeon. It must also reflect the credibility of a news anchor, the high energy of a game show, or the romantic mood in a soap opera scene.

When in the field, you need lighting instruments that are easy to transport and set up and flexible enough to work in a great variety of environments for a multitude of lighting tasks. This section describes the major studio and field lighting instruments and the various types of lighting controls. Section 7.2 provides information about light intensity, various types of lamps, and color media. The techniques of lighting are discussed in chapter 8.

STUDIO LIGHTING INSTRUMENTS

Spotlights and floodlights

- FIELD LIGHTING INSTRUMENTS

 Portable spotlights, portable floodlights, and camera lights
- LIGHTING CONTROL EQUIPMENT

 Mounting devices, directional controls, and intensity controls

STUDIO LIGHTING INSTRUMENTS

All studio lighting is accomplished with a variety of spotlights and floodlights. These instruments, technically called *luminaires*, are designed to operate from the studio ceiling or from floor stands.

SPOTLIGHTS

Spotlights produce directional, well-defined light whose beam can be adjusted from a sharp light beam like the one from a focused flashlight or a car headlight to a softer beam that is still highly directional but that lights up a larger area. All studio spotlights have a lens that helps sharpen the beam. Most studio lighting uses three basic types of spotlights: the Fresnel, the ellipsoidal, and the follow spot.

Fresnel spotlight Named for the early-nineteenth-century French physicist Augustin Fresnel (pronounced "franel") who invented the lens used in it, the *Fresnel spotlight* is widely used in television studio production. **SEE 7.1** It is relatively lightweight and flexible and has a high output. The spotlight can be adjusted to a "flood" beam position, which gives off a widespread light beam; or it can be "spotted," or focused to a sharp, clearly defined beam.

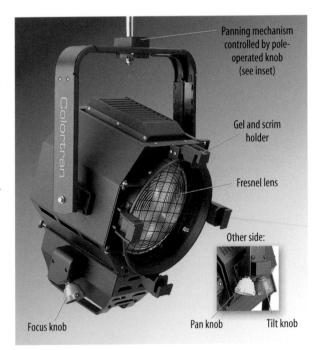

7.1 FRESNEL SPOTLIGHT

This spotlight is one of the most useful lighting instruments in the studio.

You manipulate the relative spread of the beam with a beam control that changes the distance between the light bulb and the lens. Most Fresnel spotlights have a lampreflector unit inside the lighting instrument that slides toward or away from the lens. Some instruments have a spindle that you crank and thereby move the lamp-reflector unit toward or away from the lens; others have a ring or knob that can be turned by hand or from the studio floor with a small hook on top of a long pole, called a *lighting* pole. Whatever the mechanism, the result is the same: To spot, or focus, the beam, turn the control so that the lamp-reflector unit moves away from the lens. To flood, or spread, the beam, turn the control so that the lampreflector unit moves toward the lens. Even in the flood position, the beam of the spotlight is still directional and much sharper than that of a floodlight. The flood position merely softens the beam (and with it the shadows) and simultaneously reduces the amount of light falling on the object. Always adjust the beam gently. When the bulb is turned on, its hot filament is highly sensitive to shock. SEE 7.2

Some Fresnel spots have additional external knobs with which you can also control the pan and the tilt of the instrument without climbing a ladder and doing it manually (see figure 7.1).

Fresnel spotlights come in different sizes, depending on how much light they produce. Obviously, the larger instruments produce more light than the smaller ones. The size of Fresnel spotlights is normally given in the wattage of the lamp. For example, you might be asked to rehang the 1kW (1 kilowatt = 1,000 watts) Fresnel or change the lamp in the 2kW Fresnel.

The size of lighting instrument to use depends on several factors: (1) the type of camera and the sensitivity of the imaging device; (2) the distance of the lighting instrument from the object or scene to be illuminated; (3) the reflectance of the scenery, objects, clothing, and studio floor; and, of course (4) the mood you want to convey.

In most television studios, the most common Fresnels are the 1kW and the 2kW instruments. For maximum lighting control, technicians usually prefer to operate with as few (yet adequately powerful) lighting instruments as possible. The increased sensitivity of cameras has made the 1kW Fresnel the workhorse in average-sized studios.

Ellipsoidal spotlight The *ellipsoidal spotlight* produces a sharp, highly defined beam. Even when in a flood position, the ellipsoidal beam is still sharper than the focused beam of a Fresnel spot. Ellipsoidal spots are generally used when specific, precise lighting tasks are necessary. For ex-

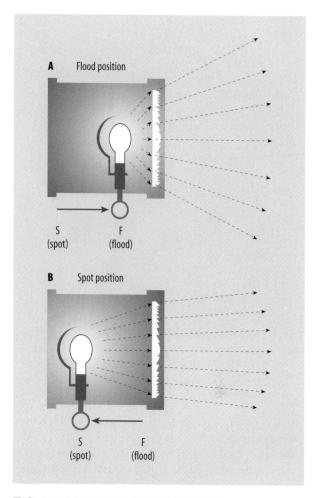

7.2 BEAM CONTROL OF FRESNEL SPOTLIGHT

A To flood (or spread) the beam, turn the focus spindle, ring, or knob so that the lamp-reflector unit moves toward the lens. **B** To spot (or focus) the beam, turn the focus spindle, ring, or knob so that the lamp-reflector unit moves away from the lens.

ample, if you want to create pools of light reflecting off the studio floor, the ellipsoidal spot is the instrument to use.

As with the Fresnel, you can spot and flood the light beam of the ellipsoidal. Instead of sliding the lamp inside the instrument, however, you focus the ellipsoidal spot by moving its lens in and out. Because of the peculiarity of the ellipsoidal reflector (which has two focal points), you can even shape the beam into a triangle or rectangle by adjusting the four metal shutters inside the instrument. **SEE 7.3**

Ellipsoidal spotlights come in sizes from 500W to 2,000W, but the most common is 750W. Some ellipsoidal spotlights can also be used as *pattern projectors*. These

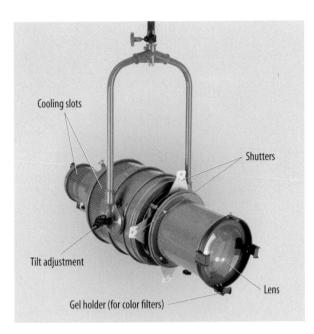

7.3 ELLIPSOIDAL SPOTLIGHT

The highly focused beam of the ellipsoidal spotlight can be further shaped by shutters. It produces the most directional beam of all spotlights.

instruments are equipped with a slot next to the beam-shaping shutters, which can hold a metal pattern called a *cucoloris*, or *cookie* for short. The ellipsoidal spot projects the cookie as a shadow pattern on any surface. Most often it is used to break up flat surfaces, such as the *cyclorama* (large cloth drape used for backing of scenery) or the studio floor. **SEE 7.4**

7.4 COOKIE PATTERN ON CYCLORAMA

The cookie pattern is projected by an ellipsoidal spotlight (pattern projector) in which you can insert a variety of metal templates. Because the spotlight can be focused, you can make the projected pattern look sharp or soft.

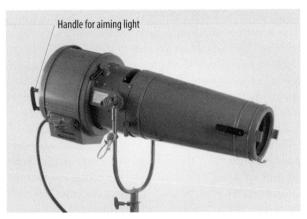

7.5 FOLLOW SPOT

The follow spot allows you to follow action and simultaneously adjust the light beam.

To make lighting terminology a little more confusing, some lighting people call these patterns *gobos*. Unfortunately, *gobo* seems to have as ambiguous a meaning as the word *spring*. If a lighting director (LD) asked you to fetch a gobo, he or she could mean a cookie; a *flag*, which is a rectangular piece of plastic or metal to keep light from falling onto certain areas; or even a freestanding piece of scenery, such as prison bars or a picture frame, through which the camera can shoot a related scene.

Follow spot Sometimes you may find that a television show requires a *follow spot*, a powerful special-effects spotlight used primarily to simulate theater stage effects. The follow spot generally follows action, such as dancers, ice skaters, or single performers moving in front of a stage curtain. **SEE 7.5** In smaller studios, you can use an ellipsoidal spotlight to simulate a follow spot.

FLOODLIGHTS

Floodlights are designed to produce great amounts of highly diffused light. They are often used as principal sources of light (key lights) in situations where shadows are to be kept to a minimum, such as news sets and product displays; to slow down falloff (reduce contrast between light and shadow areas); and to provide baselight. With some floodlights, as with some spotlights, you can adjust the spread of the beam so that undue spill into other set areas can be minimized. You can also create a floodlight effect by flooding the beam of a spotlight and diffusing it further with a scrim—a spun-glass material held in a metal frame—in front of the instrument.

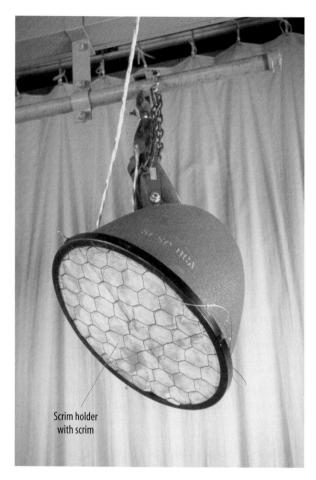

7.6 SCOOP

The scoop is a rugged, all-purpose floodlight. Its scooplike reflector gives its beam some directionality. This scoop has a scrim attached to soften the beam.

There are four basic types of studio floodlights: (1) the scoop, (2) the softlight and the broad, (3) the fluorescent floodlight bank, and (4) the strip, or cyc, light.

Scoop Named for its peculiar scooplike reflector, the *scoop* is one of the more popular floodlights. Although it has no lens, it nevertheless produces a fairly directional but diffused light beam. **SEE 7.6**

There are two types of scoops: fixed-focus and adjust-able-focus. The *fixed-focus scoop* permits no simple adjustment of its light beam. You can increase the diffusion of the beam by attaching a scrim (see figure 7.6). Although the light output through the scrim is considerably reduced, some lighting people put scrims on *all* scoops, not only to produce highly diffused light but also to protect studio personnel in case the hot lamp inside the scoop shatters.

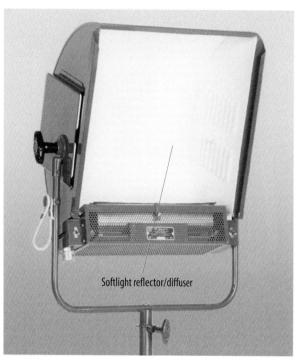

7.7 INCANDESCENT SOFTLIGHT

The softlight produces extremely diffused light and is used for illumination with slow falloff. It renders a scene almost shadow-less.

Adjustable-focus scoops have adjustable beams, from medium-spread positions to full flood. You may use the adjustable scoops as key lights and fill in the resulting shadows with other floodlights that emit a more highly diffused light. Most scoops range from 1kW to 2kW (1,000W to 2,000W), with the 1,500W scoop being the most popular.

ZVL1 LIGHTS→ Instruments→ studio | field

Softlight and broad *Softlights* are used for even, extremely diffused lighting. They have large tubelike lamps, a diffusing reflector in the back of the large housing, and a diffusing material covering the front opening to further diffuse the light. Softlights are often used for *flat* (virtually shadowless) lighting setups. You can also use softlights to increase the baselight level without affecting specific lighting where highlights and shadow areas are carefully controlled. For example, if a scene calls for a hallway with alternating bright and dark areas, you can lighten up the dark areas with softlights to provide enough baselight for the camera to see well even in the dark areas. Softlights come in various sizes and use incandescent or HMI lamps, which are discussed in section 7.2. **SEE 7.7**

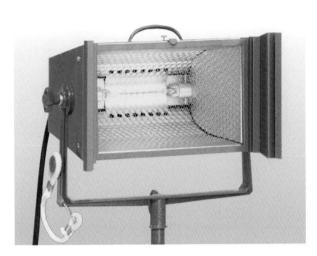

7.8 LARGE BROAD

This instrument illuminates a fairly large area with diffused light. Its light output is normally greater than that of a softlight of equal size.

The *broad* (from *broadside*) is similar to a softlight except that it has a higher light output that causes more-distinct shadows. Broads also have some provision for beam control. They are generally used to evenly illuminate large areas with diffused light. **SEE7.8** Smaller broads emit a more directional light beam than do the larger types, for evenly illuminating smaller areas. To permit some directional control over the beam, some broads have *barn doors*—movable metal flaps—to block gross light spill into other set areas.

Fluorescent floodlight bank The fluorescent floodlight bank goes back to the early days of television lighting. In those days the banks were large, heavy, and not very efficient. Today's fluorescent banks are relatively lightweight, much more efficient, and can burn close to the standard indoor color temperature (3,200K) or even a lower one (giving off more-reddish light). By simply changing the tubes, you can approximate the standard outdoor color temperature (5,600K) or achieve even higher ones (morebluish light) that resemble the extremely bluish midday sunlight filtered by a hazy sky. (Color temperature is explained in detail in chapter 8. For now it should suffice to know that a high color temperature refers to white light with a slight bluish tint, and a low color temperature to white light with a slight reddish tint. Color temperature has nothing to do with how hot a lamp gets.)

Other advantages of fluorescent banks are that they use less power than incandescent lamps and they burn

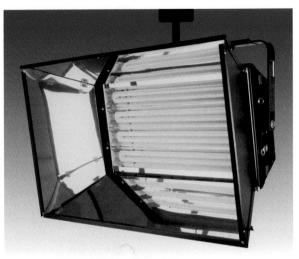

7.9 FLUORESCENT FLOODLIGHT BANK

These floodlight banks act like softlights except that they do not get as hot as incandescent floodlights of equal output. Some floodlight banks use lamps that operate on various fluorescent-like principles.

much more coolly—a definite advantage when lighting interiors with poor ventilation. The disadvantages are that fluorescent banks are still quite large and bulky and their color spectrum is sometimes uneven. This means that the light emitted does not reproduce all colors faithfully. Some instruments cause a persistent and noticeable greenish sheen.

Floodlight banks have rows of low-powered fluorescent lamps inside a housing that looks similar to a soft-light. These lamps look much like the fluorescent bulbs you can now buy to replace normal incandescent bulbs. **SEE 7.9** Some fluorescent studio lighting fixtures have a gridlike contraption, called an *egg crate*, attached to make the light beam more directional without losing its softness. **SEE 7.10**

Strip, or cyc, light This type of instrument is commonly used to achieve even illumination of large set areas, such as the *cyc* (*cyclorama*) or some other uninterrupted background. Similar to the border, or cyc, lights of the theater, television *strip lights* consist of rows of three to twelve quartz lamps mounted in long, boxlike reflectors. The more sophisticated strip lights have, like theater border lights, colored-glass frames for each of the reflector units so that the cyc can be illuminated in different colors. **SEE 7.11**

You can also use strip lights as general floodlights by suspending them from the studio ceiling, or you can place

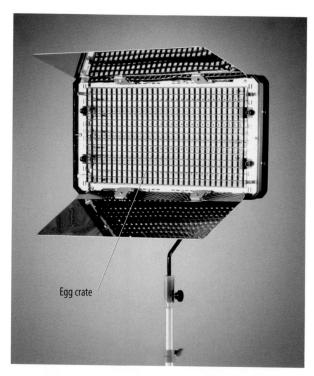

7.10 EGG CRATE ON FLUORESCENT FIXTURE

The egg crate makes the floodlight from a fluorescent fixture more directional without influencing the light's softness.

7.11 STRIP, OR CYC, LIGHT

Strip lights are used to illuminate cycloramas and other large areas that need even illumination.

them on the studio floor to separate pillars and other set pieces from the lighted background. Strip lights are sometimes used for *silhouette lighting* (where the background is evenly illuminated and the foreground objects remain unlit) and special-effects *chroma-key lighting* (see chapter 8). **ZVL2** LIGHTS → Design → silhouette

For relatively static scenes, such as news or interviews, you will find that it is often easier to use the much lighter and more flexible field lighting instruments, even if there's a great variety of studio lights hanging from the lighting

grid. There are several advantages to using these lighter instruments instead of those on the grid: (1) you can place the small instruments anywhere in the studio with a minimum of effort, (2) they can be repositioned quite easily to get the desired lighting effect, (3) they draw considerably less power than the larger instruments, and (4) they generate less heat. The following section highlights some of the major portable field lighting instruments.

FIELD LIGHTING INSTRUMENTS

ENG You can use studio lighting instruments on remote locations, but you'll find that most of them are too bulky to move around easily, their large plugs do not fit the normal household receptacles, and they draw too much power. Once in place and operating, they may not provide the amount or type of illumination you need for good field lighting. Besides, most studio lights are suspended on an overhead lighting grid. To take them down each time you have to light a remote telecast not only wastes valuable production time but, more important, robs the studio of the lighting instruments. Unless you do big remotes where the lighting requirements rival studio lighting, you need instruments that are easy to transport and quick to set up and that give you the lighting flexibility needed in the field.

Although many portable lighting instruments fulfill dual spotlight and floodlight functions, you may still find it useful to group them, like studio lights, into those categories. Note, however, that by bouncing a spotlight beam off the ceiling or the wall or by putting some kind of diffuser in front of the lens, the spotlight will take on the function of a floodlight. On the other hand, you can use a small floodlight and control its beam with barn doors so that it illuminates a relatively limited area, operating as a spot.

PORTABLE SPOTLIGHTS

Portable spotlights are designed to be lightweight, rugged, efficient (which means that the light output is great relative to the size of the instrument), easy to set up and transport, and small enough to be effectively hidden from camera view even in cramped interiors. The most frequently used spotlights are (1) the small Fresnel spot, (2) the HMI light, (3) the small focusable spot, (4) the open-face spot, and (5) the internal reflector spot.

Small Fresnel spot If you need precise lighting for EFP, such as for a scene that takes place in an actual living room rather than on a studio set, you may want to use low-powered (300W to 650W) Fresnel spotlights. They have all the features of the larger Fresnel spots, but they are smaller and

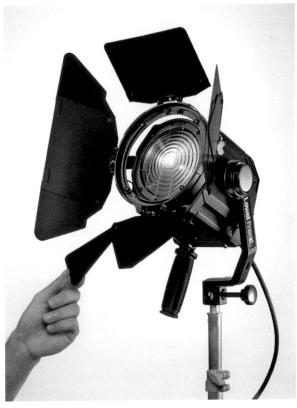

7.12 SMALL FRESNEL SPOTLIGHT
This low-powered (300W to 650W) Fresnel spotlight is especially effective in EFP lighting. You can focus or diffuse its beam and attach four-way barn doors and color media (gels).

lighter weight. You can mount them on light stands or even clip them on various braces or hangers. **SEE 7.12**

HMI light The *HMI light* is a Fresnel spotlight that has proved highly successful in elaborate EFP, large remotes, and film productions. **SEE 7.13** It has a lamp that delivers from three to five times the illumination of an incandescent quartz instrument of the same wattage. This means that you can get the same level of illumination with a 500W HMI Fresnel as with a 2,500W incandescent Fresnel. The HMI lamp also generates considerably less heat than does an incandescent lamp of the same wattage. To perform such miracles, each instrument needs its own starter and ballast units to power the lamp. It is used primarily for simulating or supplementing outdoor light. (See section 7.2 for more-technical details about how the various lamps work.)

For normal EFP work, you may find that the 200W, 575W, and 1,200W instruments are the most useful. HMI lights are designed for location shooting and burn with

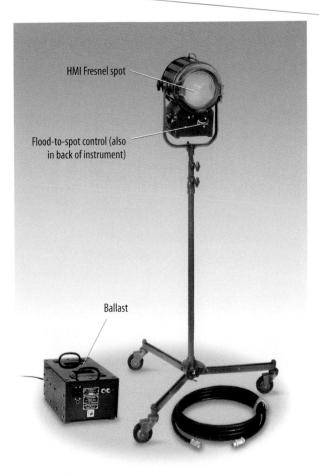

7.13 PORTABLE HMI FRESNEL SPOT WITH BALLAST

The HMI Fresnel spotlight burns with the daylight standard (5,600K). It needs considerably less power than does an incandescent light of equal intensity.

the photographic daylight (outdoor) standard of 5,600K. You can use them as the principal light source or to fill in shadows when shooting outdoors. You can also use them indoors to fill in shadows caused by daylight streaming through a window.

One of the major advantages of these superefficient HMI lights is that you can use up to five 200W instruments simultaneously without overloading a single circuit, assuming that nothing else is plugged into the same circuit. Because you plug most of the lights into household outlets, you can light most interiors with a minimum of time and effort. All you actually need are plenty of extension cords and power strips. As mentioned before, the HMI lamps don't generate much heat, which keeps interiors relatively cool even when several instruments are aimed at a small action area.

Chapter 7

advantage of using the lantern as a principal light source is that you can follow the subject as you would with a microphone (but you have to secure the lantern to the pole so that it doesn't swing). Because the lantern has an opening on the bottom to vent the heat, keep the bright spot coming from this hole out of your picture. For brief takes, covering it with a light scrim works well. There are huge Chinese lanterns available that are used primarily for providing even light for large, reflective objects, such as automobiles or large appliances.

Portable fluorescent bank Even small portable fluorescent floodlights are considerably bulkier and heavier than comparable incandescent instruments. But because fluorescent floodlights use much less power and generate practically no heat, they are frequently used for indoor EFP lighting. As mentioned, the problem with fluorescent lights is that they do not accurately reproduce all colors, even if the camera has been properly white-balanced. If highly accurate color reproduction is not a major concern, however, the small fluorescent unit is a valuable EFP lighting tool.

When lighting for EFP in relatively cramped quarters, you can use some of the smaller, lightweight fluorescent banks and mount them on light stands. **SEE 7.21** Because fluorescent instruments do not always burn at the standard Kelvin ratings of 3,200K and 5,600K, pay particular attention to white-balancing the cameras. Check the colors and especially the skin tones on a well-adjusted field monitor before starting to videotape.

LED light LED lights are like small computer screens or a stretched foldout viewfinder, but instead of displaying an image, they simply show white light. The *LEDs* (lightemitting diodes) of these small panels (about 7 inches wide) put out enough light to illuminate an object sufficiently for acceptable video images, provided the panel is fairly close to the object. The battery-powered (12V to 24V) panel produces light with the 5,600K daylight color temperature that can be dimmed with a knob on its topside. It is an ideal camera light because you can get fairly close to the subject without causing a hot spot. When it's not mounted on the camera, you can use it to light up small areas, such as a car interior.

DIFFUSING PORTABLE SPOTLIGHTS

The open-face instruments (discussed at the beginning of this section) can also be used as floodlights—just change the light from a spot to a flood position. You will find that despite the flood control, however, you will not always get the even diffusion you may need. Fortunately, there are

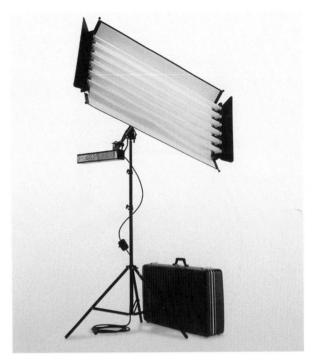

7.21 PORTABLE FLUORESCENT BANK

The portable fluorescent bank can be mounted on a light stand. It has great light output and emits no heat.

several ways to achieve a more diffused light with these instruments.

Bouncing the light The simplest way to diffuse the light is to bounce it off the wall or ceiling. Unfortunately, bouncing light drastically reduces its intensity, even if the walls are painted a light color. To salvage maximum light intensity, try to get the instrument as close to the wall or ceiling as possible without charring the paint.

Attaching a scrim The most popular diffusers are scrims and frosted gels. As mentioned, scrims are spunglass diffusers that you can put in front of small spotlights, floodlights, or open-face spots to achieve maximum diffusion of the light. The simplest way to attach a scrim to an open-face instrument is to clip it on the barn doors with wooden clothespins. Don't use plastic ones: open-face lights get very hot and will melt plastic within a few minutes. SEE7.22

Scrims come in various thicknesses; the thinner ones absorb less light, and the thicker ones absorb more light. You can also convert a scoop into a softlight by attaching a scrim that is trimmed to fit a scrim holder (see figure 7.6).

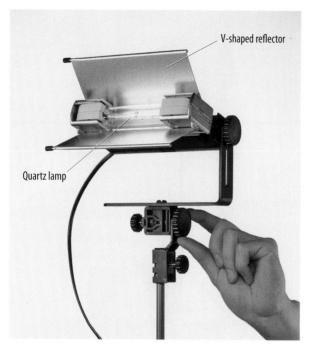

7.18 V-LIGHT
This small lighting instrument is popular in field productions because of its light weight and high output.

small instrument that consists of a large (500W to 750W) incandescent quartz lamp wedged into a V-shaped metal reflector. **SEE 7.18** The V-light is highly portable and easy to set up and can light up large areas relatively evenly. Be careful when handling such lights—they get very hot. Don't touch them when they are switched on, and keep them away from combustible materials.

Portable softlight Portable softlights consist of a high-intensity (250W to 1,000W) lamp that is placed into a *soft-box*, also called a *diffusion tent*, which is nothing but a black heat-resistant cloth bag with a scrim at its opening. (Diffusion tents that can be attached to a variety of portable lights are discussed in section 7.2.) **SEE 7.19**

A highly effective portable softlight is the *Chinese lantern*. This softlight is a more durable version of an actual round or bulb-shaped Chinese lantern. It is usually suspended from a mic stand or a microphone fish pole (see chapter 9). You can put various kinds of low-powered lamps inside the same lantern, such as a 250W clip light, a 200W household light bulb, or even a daylight (5,600K) lamp if you want to match outdoor light. **SEE 7.20**

The Chinese lantern gives off a very soft yet noticeable light that is especially useful for close-up shots. The

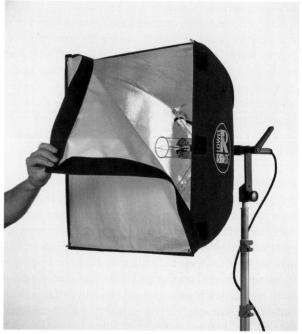

7.19 ENG/EFP PORTABLE SOFTLIGHT
The softlight comes as a single unit of lamp and diffusion tent. It can be folded up for easy transport.

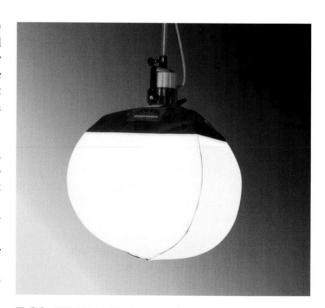

7.20 CHINESE LANTERNThis floodlight is modeled after a Chinese lantern. It can be suspended from a pole and illuminates a relatively large area with extremely soft light.

front of the spotlight, you can usually correct the problem. In fact, when using a spot for general indoor lighting, you should routinely place a scrim or similar light-diffusing material in front of the instrument.

Most open-face spots use 500W to 1,000W lamps and can therefore be plugged into a regular household receptacle without risking a circuit overload. Most of these instruments have a power switch close to the lamp, so to extend the life of the lamp you can turn the instrument off anytime it is not in use. All of these small spotlights come as part of a *lighting kit*—a suitcase containing several such instruments and light stands.

You may find that sometimes the relatively inexpensive 500W "utility lights" you can buy in any hardware store will do the same job as the more expensive instruments in lighting kits. Note, however, that utility lights are much better suited for general-area rather than specific lighting. They also get extremely hot: don't touch the front of the instrument when handling it, and place it far enough away from curtains and other combustible materials to prevent fires.

With any lighting instrument, always be careful not to overload the circuit; that is, do not exceed the circuit's rated amperage by plugging in more than one instrument per outlet. Extension cords also add their own resistance to that of the lamp, especially when they get warm. Ordinary household outlets can tolerate a load of up to 1,200 watts. You can therefore plug two 500W spots or one 1,000W instrument into a single circuit without risking an overload (see chapter 8).

Internal reflector spot This spotlight is also known as a *clip light* because it is usually clipped onto things. It looks like an overgrown, slightly squashed household bulb. You have most likely used it already in still photography or to light up your driveway. These lamps are often called *PAR lamps* for their parabolic aluminized reflector, which is the inside coating of the lamp. **SEE 7.16**

The clip light is easy to use and can provide additional subtle highlights and accents in hard-to-reach areas. Internal reflector spots come in a variety of beam spreads, from a soft, diffused beam to a hard, precisely shaped beam (often called *PAR 38 lamp*). For even better beam control, as well as for the protection of the internal reflector bulb, the lamp can be used in a metal housing with barn doors attached. **SEE 7.17**

PORTABLE FLOODLIGHTS

Most ENG/EFP lighting requires a maximum amount of even illumination with a minimum of instruments and

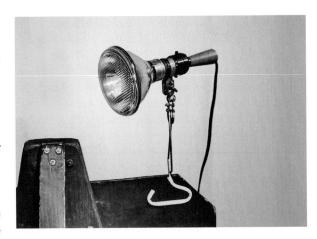

7.16 CLIP LIGHT

The clip light, or PAR lamp, consists of a normal internal reflector bulb (such as a PAR 38), a socket with an on/off switch, and a clip for fastening the lamp to a support.

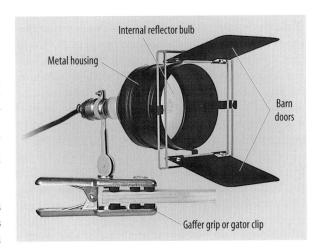

7.17 CLIP LIGHT WITH METAL HOUSING AND BARN DOORS The metal housing and the barn doors help control the beam.

power requirements. Floodlights are therefore preferred over highly directional spotlights. We look first at the more popular portable floodlights: (1) the V-light, (2) the portable softlight, (3) the portable fluorescent bank, and (4) the LED light. We then discuss how you can change portable open-face, and even Fresnel, spots into effective floodlights.

V-light One of the more popular floodlights is the *V-light*. Although the V-light was originally a specific floodlight manufactured by the Lowel-Light Manufacturing company, it has become the generic name for any

But there is a downside to these miracle lights. The ballast box of the HMI light is relatively heavy, can get quite warm, and occasionally hums. Even the lamp can emit a high-frequency noise. When switched on, the lamp takes anywhere from one to three minutes to reach full illumination power. HMI lights can also cause flicker in the video image under certain circumstances (high shutter speeds). You cannot dim the lights without a noticeable color shift (change in color temperature). All HMI lights are expensive, and even the smaller 500W instruments are bulky compared with their incandescent cousins.

Small focusable spot This small, low-powered (125W to 200W) spotlight functions much like a Fresnel except that it has a different lens. Because of its efficient reflector and lens, it gives off more light than a Fresnel of equal wattage. Its beam can be focused or spread, much like that of a Fresnel. It is especially effective when highlighting small areas. **SEE 7.14**

Open-face spot Mainly because of weight considerations and light efficiency, the *open-face spotlight* has no lens. This permits a higher light output, but the beam is less even and precise than that of the Fresnel. In most remote lighting tasks, however, a highly defined beam offers no particular advantage. Because you usually have to work with a minimum of lighting instruments, a fairly general illumination is often better than a highly defined one.

Even in the field, you should try to achieve the lighting that best fits the communication purpose. For example, if you light a simple interview in a hotel room, flat lighting for optimal visibility is all you need. But if you do a documentary on big-city slums, don't light up a dark tenement as though it were an elegant department store. Such a situation requires more-careful lighting that will retain the actual lighting conditions of the scene while still providing enough light to satisfy the needs of the camera.

The open-face spot can serve both of these requirements. You can spot or spread the beam of the high-efficiency quartz lamp through a focus control lever or knob on the back. SEE7.15 Unfortunately, the focused beam is not always even. When you place the spot close to the object, you may notice (and the camera surely will) that the rim of the beam is intense and "hot" while the center of the beam has a *hole*—a low-intensity dark spot. If you place the instrument too close when lighting a face, for example, the *hot spot* may cause a glowing white area surrounded by red on the lighted face or, at best, a distinct color distortion. But by spreading the beam a little and pulling the instrument farther away from the person, or by placing a scrim in

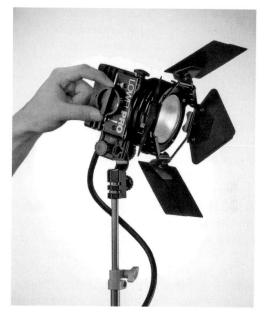

7.14 SMALL SPOTLIGHT

This small, low-powered (125W to 200W) spotlight has an efficient reflector and lens (not a Fresnel) that, despite its small size, make it into a highly effective lighting instrument. It is primarily used for ENG and EFP.

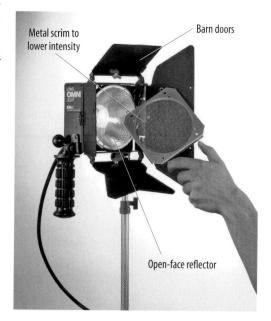

7.15 OPEN-FACE SPOT

The open-face (external reflector) spot has no lens. Its beam spread can be adjusted to a spot or moderate flood position. It is one of the most versatile lighting instruments in field production.

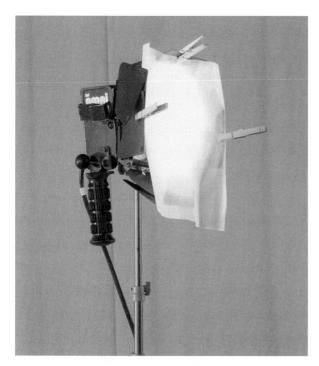

7.22 SCRIM ATTACHED TO BARN DOORS

To further diffuse the beam of an open-face instrument, you can attach a scrim to the barn doors with wooden clothespins.

Some lighting people prefer frosted gels as diffusers. *Frosted gels* are white translucent sheets of plastic that have a semiopaque surface. Like scrims, they come in different densities that diffuse and therefore reduce the intensity of the light beam by varying degrees.

Using a diffusion umbrella Another highly effective diffusion device is the *umbrella*. The small, silvery, heatresistant umbrella is not to protect you from the rain but to reflect and diffuse the light source that shines into it. You can attach the scooplike umbrella to the lighting instrument and/or the light stand and then aim the umbrella's opening in the general direction of illumination. You need to shine the light into the umbrella opening, not on the rounded surface. **SEE 7.23**

Attaching a tent As mentioned earlier you can use a diffusion tent rather than a tentlike softlight unit to change an incandescent spotlight into an effective softlight. Most Fresnel spots can be changed into softlights by attaching a diffusion tent to the front of the instrument. You need the ring attachment that connects the tent to the spotlight. SEE 7.24 ▼VL3 ►LIGHTS → Instruments → field

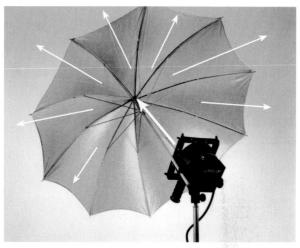

7.23 DIFFUSION UMBRELLA

The umbrella reflector is a popular diffusion device. Note that the lighting instrument shines into, not away from, the inside of the umbrella.

Note, however, that anytime you put the spotlight in the flood position, or put a diffuser in front of the lens, you reduce the light output. Here's a good rule of thumb: the more you diffuse the light, the weaker it gets.

When doing elaborate field productions, such as covering a high-school basketball game, you can try to use high-powered V-lights and umbrellas, but you may need larger floodlights, such as scoops, or floodlight banks. If available, HMI floodlights would probably be the most efficient instruments. A few 1kWs or even 575W instruments in the flood position are all you need to light up a gymnasium.

CAMERA LIGHTS

Electronic news gathering requires yet another type of light, which can be mounted on top of the camera or handheld by the camera operator or an assistant. **SEE 7.25** Camera lights have a high light output. They are open-faced and relatively small and have an assortment of diffusion filters and a daylight filter (5,600K), which you can flip over the opening of the small light. Camera lights draw their power either from the camera battery or from a larger battery that can be attached to a tripod or carried by the camera operator.

If you detach the light from the camera, avoid shining it directly on the scene right away—it is often annoying to a person to have a high-powered light pop into his or her eyes without at least a little warning. First point the camera light toward the ceiling and then tilt it down gradually.

This also gives the auto-iris on the camera sufficient time to adjust to the new lighting conditions without noticeable brightness and color changes. When you have an assistant to handle the light, he or she can direct its beam so that it strikes the on-camera person at a slight angle rather than directly from the front.

Lighting kits Standard lighting kits contain a variety of spot and flood instruments, light stands, barn doors, various diffusion materials, cables, and extra lamps. These

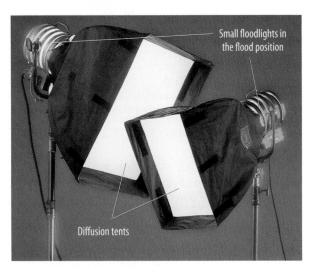

7.24 DIFFUSION TENT ON FRESNEL SPOTLIGHT

You can turn a small Fresnel spot into a softlight by diffusing its beam with a portable diffusion tent.

7.25 CAMERA LIGHT

This small light is mounted on the camera and powered by the camcorder battery or a separate battery pack. Its beam is further diffused by a small diffusion tent. kits help you keep track of the various instruments and accessories and facilitate their transport, setup, and storage. **SEE 7.26**

LIGHTING CONTROL EQUIPMENT

To understand lighting control, you need to be familiar with some specific equipment: (1) mounting devices, (2) directional controls, and (3) intensity controls.

MOUNTING DEVICES

Mounting devices let you safely support a variety of lighting instruments and aim them in the desired direction. Good mounting devices are as important as the instruments themselves. The major devices specially designed and intended for studio lights are: (1) the pipe grid and the counterweight battens, (2) the C-clamp, (3) the sliding rod and the pantograph, and (4) a variety of floor stands. Portable lights are mounted primarily on collapsible stands

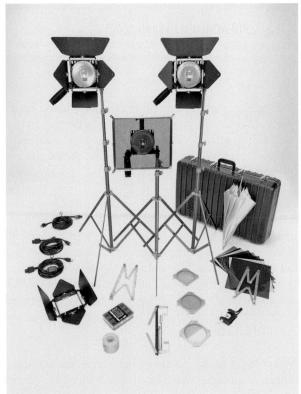

7.26 LIGHTING KIT

A typical EFP lighting kit contains a variety of floodlights and spotlights and such accessories as light stands, barn doors, and diffusers.

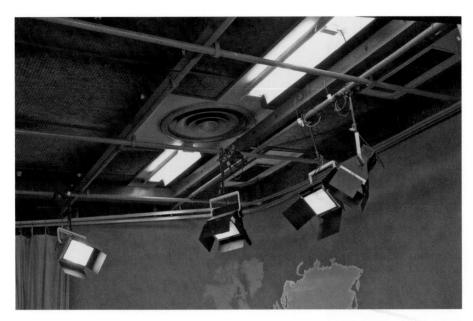

7.27 PIPE GRID

This simple pipe grid supports all the lighting necessary for a small performance area, such as a news, interview, or kitchen set.

that are typically part of a lighting kit. For on-location lighting, there is a variety of mounting devices available, such as small booms, cross braces, and braces that fit over doors or furniture.

Pipe grid and counterweight battens Studio lights are hung either from a fixed pipe grid or from counterweight battens. The *pipe grid* consists of heavy steel pipe strung either crosswise or parallel and mounted 12 to 18 feet above the studio floor. The height of the grid is determined by the height of the studio ceiling; but even in rooms with low ceilings, the pipe should be mounted approximately 2 feet below the ceiling so that the lighting instruments or hanging devices can be easily attached. The space above the grid is also necessary to dissipate the heat generated by the lights. **SEE 7.27**

Unlike the pipe grid, which is permanently mounted below the ceiling, the *counterweight battens* can be raised and lowered to any desired position and locked firmly in place. **SEE 7.28** The battens and the instruments are counterweighted by heavy iron weights and moved by means of a rope-and-pulley system or by individual motors. **SEE 7.29** Before unlocking a counterweight rope to move the batten up or down, always check that the batten is properly weighted. You can do this by counting the weights and comparing them with the type and number of instruments mounted on the batten. The counterweights and the instruments should roughly balance each other. Such rope-and-pulley systems should have a sign posted that

tells how many weights are necessary to balance each type of instrument, plus the weight of the empty batten.

The obvious advantage of the counterweight battens over the pipe grid system is that the instruments can be hung, adjusted, and maintained from the studio floor. You will find, however, that you cannot do entirely without a ladder. First, although you can initially adjust the instruments to a rough operating position, you need to re-aim them once the battens are locked at the optimal height.

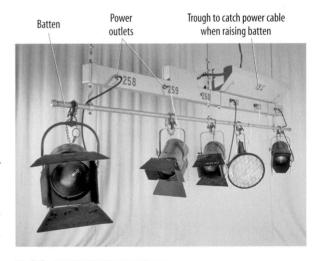

7.28 COUNTERWEIGHT BATTEN

The counterweight batten can be raised and lowered and locked at a specific operating height.

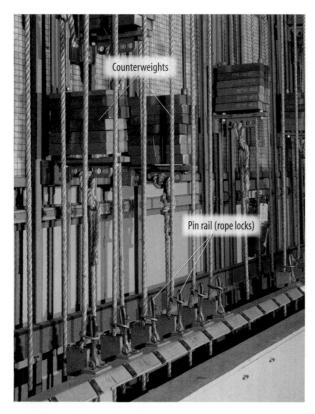

7.29 COUNTERWEIGHT RAIL

The battens and the lighting instruments attached to them are counterweighted by heavy iron weights and moved up and down by a rope-and-pulley system from a common rail.

Second, by the time you need to *trim*, or fine-tune, the lights, the studio floor is generally crowded with sets, cameras, and microphones, which prevent lowering the battens to a comfortable working height. You can then squeeze the ladder into the set or use a lighting pole to do the final trimming. As you recall, high-end Fresnel spots have knobs that allow you to tilt, pan, and focus the instrument from the studio floor with a lighting pole (see figure 7.1).

C-clamp The lighting instruments are directly attached either to the batten by a large *C-clamp* or to hanging devices (discussed next). You need a wrench or key to securely fasten the C-clamp to the round metal batten. The lighting instrument is attached to the C-clamp and can be swiveled horizontally without loosening the bolt that holds it to the batten. Although the C-clamp will support the lighting instrument and not fall off the batten even if the large bolt is loose, you should nevertheless check that all C-clamps on the grid are securely tightened. As an added safety measure,

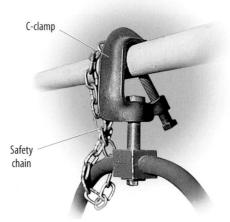

7.30 C-CLAMP

The C-clamp is the connection between the lighting instrument and the batten. Even when the C-clamp is securely tightened to the batten, you can swivel the instrument as necessary.

all lighting instruments should be chained or secured to the batten itself by a strong steel cable loop. Similarly, the barn doors must be secured to the lighting instruments. Even if you are under severe time pressure when rehanging lights, do not neglect to secure each instrument with the safety chain or cable. **SEE 7.30**

Sliding rod and pantograph If the studio has a fixed pipe grid, or if you need to raise or lower individual instruments without moving an entire batten, you can use sliding rods. A *sliding rod* consists of a sturdy pipe attached to the batten by a modified C-clamp; it can be moved and locked into a specific vertical position. For additional flexibility, the more expensive sliding rods have telescopic extensions. **SEE 7.31** More-elaborate lighting systems have motor-driven sliding rods whose vertical movement can be remotely activated from the studio lighting control.

Some studios use the *pantograph*, a spring-loaded hanging device that can be adjusted from the studio floor to any vertical position within its 12-foot range. **SEE 7.32** Pantographs are most useful for adjusting the height of scoops and other floodlights. The advantage of a pantograph is that you can adjust it from the studio floor without affecting the height of spotlights that may be hung on the same batten. The disadvantages are that the pantograph is bulky and that the counterbalancing springs get out of adjustment and, worse, wear out from extended use.

Floor stand Not all studio lights are mounted on the pipe grid or battens. Some are mounted on roller-caster *floor stands* that can be rolled around the studio and vertically extended. **SEE 7.33** Such stands can hold all types of

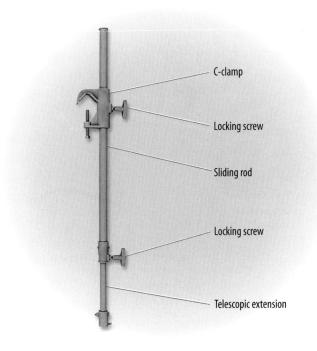

7.31 SLIDING ROD (TELESCOPE HANGER)

This sliding rod, called a telescope hanger, allows you to move the instrument up and down and lock it into position. It is used primarily on lighting grids but also on counterweight systems when more vertical control is needed.

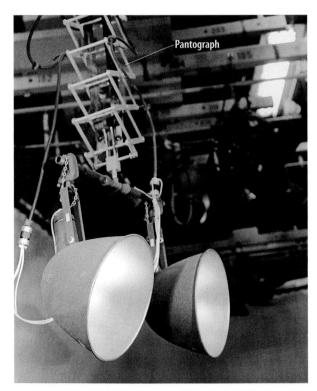

7.32 PANTOGRAPH

You can adjust this spring-loaded pantograph quickly and easily by pushing it up or pulling it down with a lighting pole. The springs act as a counterweight for the lights attached to it.

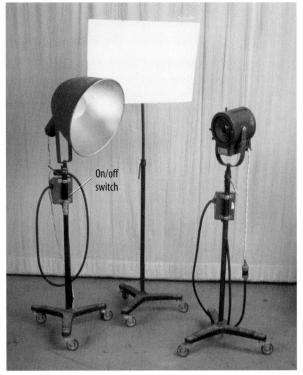

7.33 FLOOR STANDS

The floor stand can support a variety of lighting instruments and can be adapted for an easel or for large reflectors.

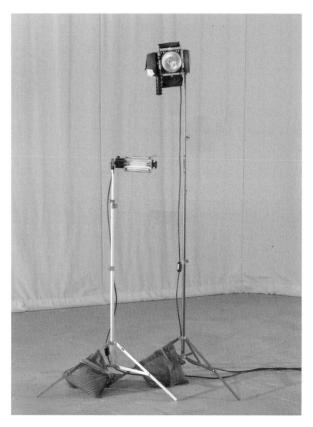

7.34 PORTABLE LIGHT STANDS

These light stands are designed for relatively light-weight portable instruments and can be extended to a height of 8 to 10 feet. Because light stands tend to tip over when fully extended, always secure them with sandbags.

instruments: scoops, broads, spots, and even strip lights. The stands usually have a switch to turn the light on and off. Floor stands are especially important if you light for film-style shooting, which means that you adjust the lighting, or light separately, for each take.

Portable light stand Because you won't find battens or grids conveniently installed at field locations, you need to carry the lighting supports with you. A large variety of lightweight and durable mounting devices is available, and all of them consist basically of collapsible stands and extendible poles. **SEE 7.34**

You can attach to the stands and poles a wide array of portable lighting instruments and other devices, such as reflectors, scrims, and flags (see figures 7.37–7.39). In more-elaborate productions, you can use a portable boom

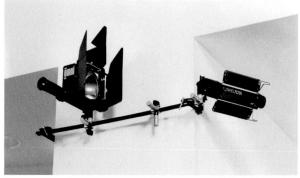

7.35 CROSS BRACE

This extendible cross brace can be clamped to scenery or furniture as a battenlike support for portable lighting instruments.

specifically designed to hold small lighting instruments. The advantage of such a boom is that you can suspend the light over the scene out of camera range and easily relocate it as necessary. The disadvantages are that booms are quite expensive and that even a small one takes up more space than is often available.

Many ingenious mounting devices are available, such as cross braces and braces that fit conveniently over doors, and others that let you attach small lighting instruments to scenery, desks, furniture, trashcans, or any other convenient object in the remote location. **SEE 7.35** You can also make a simple lighting bridge out of 1×3 lumber that will hold one or two portable spotlights for back-lighting. Whatever mounting devices you use—including your own contraptions—see to it that the lighting instrument is securely fastened and sufficiently far from curtains, upholstery, or other ignitable materials. Light stands that are fully extended tend to topple at the slightest pull on the power cable or even in a strong breeze. *Always put a sandbag on the light stand to prevent it from tipping over.*

DIRECTIONAL CONTROLS

You are familiar with the spot and flood beam control on spotlights. Several other devices can help you control the direction of the beam, such as barn doors, flags, and reflectors. You can use reflectors for intensity as well as directional control. Most of the time, however, reflectors are used for shadow control.

Barn doors This admittedly crude beam control method is very effective for blocking certain set areas partially or totally from illumination. *Barn doors* consist of two or four metal flaps that you can fold over the lens of the

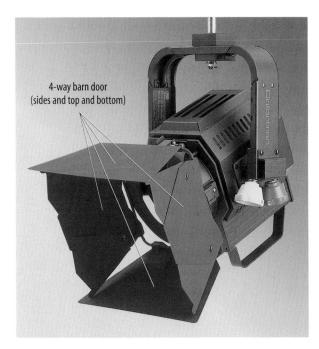

7.36 FOUR-WAY BARN DOOR

This four-way barn door allows you to control the beam spread on all four sides—top and bottom, and left and right.

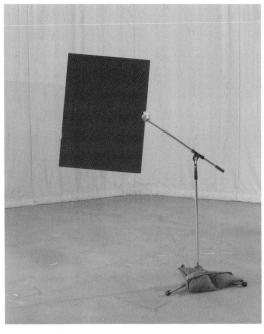

7.37 FLAG

Flags come in various sizes and densities. You use them to prevent light from hitting specific set areas.

lighting instrument to prevent the light from falling on certain areas. For example, if you want to keep the upper part of the scenery dark without sacrificing illumination of the lower part, you simply block off the upper part of the beam with a barn door. Or if you want to eliminate a boom shadow, you can partially close a barn door. SEE 7.36 ∠VL4→LIGHTS→ Instruments→ beam control

Barn doors are also effective for preventing the *back light* from shining into the camera lens, which can cause *lens flare* (an uncontrolled light reflection inside the lens that shows up as superimposed rays of light circles). Because barn doors slide into their holders easily, they have a tendency to slide out of them just as readily. Always secure all barn doors to their instruments with the safety chain or cable. Barn doors also get very hot: wear protective gloves while adjusting them when the instrument is turned on.

Flags Rectangular metal frames with heat-resistant cloth or thin metal sheets of various sizes, *flags* act very much like barn doors except that you don't place them directly on the lighting instrument. Flags are mounted on light stands and put anywhere they're needed to block the light from falling on a specific area without being seen by the

camera. In movie lingo, flags are also called gobos. Yes, this is yet another definition of *gobo*; this time it refers to a flag and not to a cookie—the metal template that is inserted into an ellipsoidal spotlight to produce a shadow pattern (see figure 7.4). Obviously, you can use flags only if the camera and talent movements have been carefully rehearsed. **SEE 7.37**

Reflectors Mirrors are the most efficient reflectors. You can position them to redirect a light source (often the sun) into areas that are too small or narrow for setting up lighting instruments. For example, if you had to light up a long, dark hallway that has an exterior door, you could use mirrors to redirect the sunlight into the hall and reflect it off the wall. This technique would save you setup time, equipment, and electricity. Most often, however, you use reflectors to produce highly diffused light to lighten up dense shadows (in media aesthetic language, to *slow down falloff*) on someone's face or on an object. You don't use mirrors to slow down falloff; rather, you use material that will reflect only a portion of the light and diffuse it at the same time. Most LDs prefer a large sheet of white foam core; it is lightweight, quite sturdy, simple to set up, and

7.38 FOIL REFLECTOR

This homemade but highly efficient reflector uses crumpled aluminum foil taped to a piece of cardboard.

easily replaced if it gets dirty or broken. Any large white cardboard will do almost as well. If you need a more efficient reflector (one that reflects more light), you can crumple up some aluminum foil to get an uneven surface (for a more diffused reflection) and then tape it to a piece of cardboard. **SEE 7.38 ZVL5** LIGHTS → Field → use of reflectors

Commercial reflectors come in white, silver, and gold and can be folded up for easy transport and setup. **SEE 7.39** The silver and white models reflect a higher-color-temperature light than do the gold-colored ones.

INTENSITY CONTROLS: INSTRUMENT SIZE, DISTANCE, AND BEAM

There are three basic methods of controlling the intensity of light without the use of dimmers: (1) selecting an instrument of the proper size, (2) adjusting the distance of lighting instrument to object, and (3) focusing or diffusing the light beam.

Instrument size The simplest way to control light intensity is obviously to turn on only a certain number of instruments of a specific size (wattage). Because of the light sensitivity of modern cameras and the high light output

7.39 PORTABLE REFLECTOR

Small portable reflectors are round and can be folded up for easy transport. Most of them have a silver-colored reflector on one side and a warmer, gold-colored reflector on the other.

of incandescent and fluorescent lamps, you don't need the large instruments you may still see in motion picture production. The largest instrument used in most television studios is a 2kW Fresnel spotlight. The lights for EFP/ENG rarely exceed 650 watts.

Distance When you move the lighting instrument closer to the object, the intensity of the light increases; if you move it farther away, the intensity decreases. You can apply this principle easily so long as the instruments are mounted on light stands and you can move them without too much effort. In many cases this is the most efficient way of controlling light intensity on an ENG/EFP shoot. You can also apply this principle in the studio if the lights are mounted on a movable batten. In general, try to position the instruments as low as possible without getting them into camera range. This way you achieve maximum light intensity with minimal power.

▼VLLG→LIGHTS→Instruments→ field

Beam The more focused the light beam, the higher its intensity. The more diffused the light beam is, the less intensity it has. You have already learned about the various methods of diffusing the beam using the focus control in

the instrument and with various scrims and reflectors. You can also use a specially designed *wire-mesh screen* to diffuse and block a certain amount of light. You simply slide the metal screen directly in front of the instrument, much like scrims and frosted gels. Depending on the fineness of the mesh, the screen dims the light without influencing its color temperature. The problem with wire-mesh screens is that the heat of the quartz lamp tends to burn up the fine metal wires within a relatively short time; the screens become brittle and eventually disintegrate (see figure 7.13).

INTENSITY CONTROLS:

The most precise light control is the electronic dimmer. With a *dimmer* you can easily manipulate each light, or a group of lights, to burn at a given intensity, from 0 (*off* position) to full strength.

Although dimmers are technically complex, their basic operational principle is simple: by allowing more or less voltage to flow to the lamp, the lamp burns with a higher or lower intensity. If you want the lighting instrument to burn at full intensity, the dimmer lets all the voltage flow to the lamp. If you want it to burn at a lesser intensity, the dimmer reduces the voltage. To dim the light completely—called a *blackout*—the dimmer permits no voltage (or at least an inadequate voltage) to reach the lamp.

Individual dimmers A useful dimmer system should have a fair number of individual dimmers (twenty or more), each with an intensity calibration. The usual calibration is normally in increments up to 10, with 0 preventing any voltage from reaching the instrument (the light is off) and 10 allowing the full voltage to flow to the lamp (the lamp burns at full intensity). Although most studios' dimmers are computer-controlled, it is easier to learn the principle of dimmers by looking at a manual system. The computer does not change the basic principle of dimming; it simply facilitates the storage and retrieval of the various dimming commands, provides a wide variety of dimming options, and activates the actual dimming process at precise moments in the production.

On manual dimmers you push the control lever to the desired setting between 0 and 10. Such calibrations are necessary not only to set the initial light intensity but also to record the exact settings so that they can be stored and recalled with minimal effort. **SEE 7.40** Computerized dimmers have similar slide faders that can be manually or automatically controlled. A variety of controls lets you combine a great number of dimming functions and

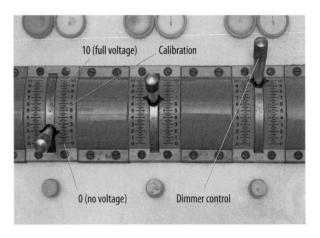

7.40 MANUAL DIMMER CALIBRATION

The higher you push the lever on this manual dimmer, the more voltage flows to the lamp. At the 0 setting, no voltage flows to the lamp; at a setting of 10, the lamp burns at full intensity.

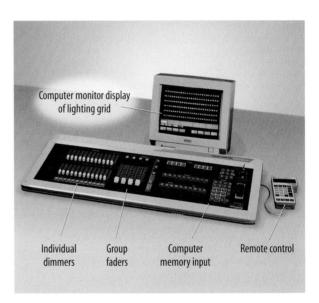

7.41 COMPUTERIZED DIMMER CONTROL

The computerized dimmer can store, recall, and execute a wide variety of dimming functions. You can also switch it to manual control.

store and recall them either automatically or by pushing a single button. It is not uncommon for a computerized dimmer to offer hundreds of individual functions that you can store on disk. Most computer dimmers keep your input in short-term memory, even if you have switched them off. **SEE 7.41**

148 Chapter 7 LIGHTING

7.42 MANUAL PATCHBOARD

The patchboard enables you to establish power connections between specific lighting instruments and specific dimmers.

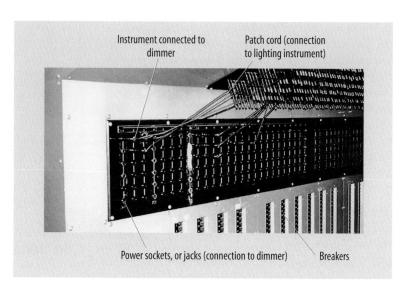

The downside of dimming is that lowering the voltage will cause incandescent lamps to lower their color temperature to a more reddish light. (We discuss this problem in more detail in chapter 8.)

Patchboard The *patchboard*, or *patchbay*, makes it possible to connect each lighting instrument to a specific dimmer. Let's assume that you have one lamp in your study and another lamp in your bedroom but only one dimmer. Because you can't be in the study and the bedroom at the same time, you can plug lamp 1 into the dimmer when in the study, and lamp 2 when in the bedroom. What you have done is *patched* different lighting instruments to a single dimmer. If you had twenty lights that you wanted to dim at different times, you could select any one of them and patch it into the single dimmer. The patchboard of an actual dimmer system works in the same way.

To patch a specific lighting instrument into a specific dimmer, you select its designated patch cord and plug it into the dimmer receptacle (called a *jack*). **SEE 7.42**

Just for practice let's do some patching. You are asked to patch instrument 5 (a spotlight plugged into the #5 batten outlet) and instrument 27 (a scoop plugged into the #27 batten outlet at the other end of the studio) to dimmer 1. At the patchboard you look for the patch cords #5 and #27 and plug them into the jacks for dimmer 1. When you bring up dimmer 1 at the patchboard, both instruments—spotlight 5 and scoop 27—should light up simultaneously and be dimmed at equal intensity. **SEE 7.43** If you want to control them separately, you would plug spotlight 5 into dimmer 1 and scoop 27 into dimmer 2.

The patchboard thus allows for many combinations of specific lighting instruments from different studio areas and lets you control their intensity either individually or in groups. As a safety measure, all patchboards have circuit breakers for each power connection to the dimmer. Do not turn on the breaker before plugging the patch cord into the appropriate dimmer jack. If the breaker is on, you are hotpatching, a practice that can damage both the equipment and—especially—you.

The software program in a computer-assisted dimming system will record your patching decisions and trigger the actual patches on command. For example, if you want to turn up all the fill lights while turning off all the spotlights or vice versa, you simply type the numbers of the various instruments and tell the computer which ones to combine for a specific group function. Then all you need to do is press the group button at the specific time, and the computer will take care of the rest. What formerly required cumbersome repatching can now be accomplished with a single computer command. The computer-assisted system, however, does not change the simple principle of patching that you used with your study and bedroom lights.

There are many types of dimmers on the market, ranging from simple rheostats to sophisticated computer-driven models. Regardless of the electronics involved, the dimmer systems used in television studios have two basic features: a series of individual dimmers that control the current flowing to the lighting instruments, and a patchboard and other grouping devices with the necessary storage and retrieval equipment.

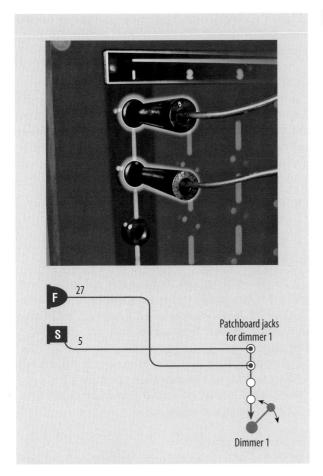

7.43 MANUAL PATCHING

As you can see, the patches for the lighting instruments (spotlight 5 and scoop 27) are both patched to dimmer 1. Consequently, both lighting instruments respond identically to any dimmer 1 setting.

Besides controlling the intensity of the light, dimmers enable you to quickly and easily change from one type of lighting in a particular area to another. For example, you may change a dining room set from day to night by simply dimming one lighting setup and bringing up another. You also can light several studio areas at once, store the lighting setup in the dimmer's memory, and activate part or all of the stored information whenever necessary. Some shows may require that you go from one background color to another, such as from a red to a blue one. With the dimmer you can simply fade down all instruments that throw red light onto the background while at the same time bringing up the blue lights.

MAIN POINTS

- All studio lighting is accomplished by a variety of spotlights and floodlights.
- Studio spotlights include the Fresnel spot, the ellipsoidal spot, and the follow spot. Ellipsoidal and follow spots are for special lighting effects.
- Studio floodlights include the scoop, the softlight and the broad, the fluorescent floodlight bank, and the strip, or cyc, light.
- Field lighting uses the small Fresnel spot, the HMI light, the small focusable spot, the open-face spot, and the internal reflector spot (clip light or PAR lamp).
- Most portable floodlights are open-faced, which means that they have no lens. Small fluorescent banks are also used as portable floodlights. Diffusers can turn a spotlight into a floodlight.
- ENG lighting is often done with small, versatile lights that are mounted on the camera or handheld.
- Lighting kits contain a variety of field lighting equipment.
- Lighting control equipment includes a variety of mounting devices, directional controls, and intensity controls.
- Major mounting devices are the pipe grid and the counterweight battens, the C-clamp, the sliding rod and the pantograph, and a variety of floor stands.
- Directional controls include barn doors, flags, and reflectors.
- Intensity controls are the size of the instrument (lamp wattage), the relative distance of lighting instrument to target object, and the relative focus or diffusion of the beam.
- With an electronic dimmer, you can easily manipulate a light, or a group of lights, to burn at a given intensity. The patchboard, or patchbay, makes it possible to connect each lighting instrument to a specific dimmer.

7.2

Light Intensity, Lamps, and Color Media

Before learning to do actual lighting in the studio and the field, you need to study a few more elements about light, how to control and measure it, and how to produce colored light. This section adds to the technical details given in section 7.1.

► LIGHT INTENSITY

Incident and reflected light measured in foot-candles and lux

► CALCULATING LIGHT INTENSITY

The lumen and the inverse square law

OPERATING LIGHT LEVEL: BASELIGHT

Providing the optimal operating light level, or baselight

TYPES OF LAMPS

The basic luminants: incandescent, fluorescent, and HMI

COLOR MEDIA

Plastic sheets (gels) that change the color of light

LIGHT INTENSITY

Although there are video cameras that can produce pictures in almost total darkness, most standard cameras need a certain amount of light for optimal performance. As sensitive as our eyes are, they cannot always tell accurately just how much light an instrument produces, how much light is actually on the set or on location, how much light

an object actually reflects, and how much light the camera lens actually receives. A *light meter* gives us a more accurate reading of light intensity.

FOOT-CANDLES AND LUX

The standard units of measuring light intensity are the American *foot-candle* (*fc*) and the European *lux*. Because ordinary television lighting doesn't require extremely precise units of intensity, you can simply figure lux by multiplying foot-candles by a factor of ten, or you can figure foot-candles by dividing lux by ten:

- To find lux when given foot-candles, multiply footcandles by ten.
- To find foot-candles when given lux, divide lux by ten.

As an example, 100 foot-candles are about 1,000 lux (100×10) , and 2,000 lux are about 200 foot-candles $(2,000 \div 10)$. If you want to be more accurate, use a factor of 10.75 to calculate foot-candles from lux, or lux from foot-candles.

Equipped with foot-candles or lux as the unit of light intensity, you can now measure either of the two types of light intensity: *incident light* and *reflected light*.

ZVL7 LIGHTS-> Measurement-> meters

INCIDENT LIGHT

The reading of *incident light* gives you some idea of how much light reaches a specific set area. When measuring incident light, you are actually measuring the amount of light that falls on a subject or a performance area but not what is reflected by it. To measure incident light, you must stand in the lighted area or next to the subject and point the incident-light meter *toward the camera lens*. The meter will give a quick reading of the overall light level that reaches the particular set area. This general light level is also called *baselight*. But incident light can also refer to the light that comes to you from a specific instrument. If you want a reading of the intensity of the light coming from particular instruments, you should point the foot-candle (or lux) meter *into* the lights. **SEE 7.44**

Such measurements may come in handy, especially when you need to duplicate the illumination for a scene shot on the same set over a period of several days. For some reason duplicating the exact lighting from one day to the next is difficult to do, even when your computer-assisted patchboard faithfully duplicates the dimmer settings of the previous day. An incident-light check, however, guarantees identical or fairly close intensities.

7.44 INCIDENT-LIGHT READING

To read incident light, you point the light meter at the camera or into the lights while standing next to the lighted subject or performance area.

To discover possible holes in the lighting (unlighted or underlighted areas), walk around the set with the light meter pointed at the major camera positions. Watch the light meter: whenever the needle dips way down, it is indicating a hole.

REFLECTED LIGHT

The reading of *reflected light* gives you an idea of how much light is bounced off the various objects. It is primarily used to measure *contrast*.

To measure reflected light, you must use a reflected-light meter (most common photographic light meters measure reflected light). Point it closely at the lighted object—such as the performer's face or white blouse or the dark blue background curtain—from the direction of the camera (the back of the meter should face the principal camera position). **SEE 7.45** Do not stand between the light source and the subject when taking this reading or you will measure your shadow instead of the light actually reflecting off the subject. To measure contrast, point the meter first at the lighted side of the object and then move it to the shadow side. The difference between the two readings gives you the *contrast ratio*. (Chapter 8 describes contrast ratio and its importance in television lighting.)

Do not be a slave to all these measurements and ratios, however. A quick check of the baselight is all that is generally needed for most lighting situations. In especially critical situations, you may want to check the reflectance of faces or exceptionally bright objects. Some people get so involved in reading light meters and oscilloscopes that

7.45 REFLECTED-LIGHT READING

To measure reflected light, you point the reflected-light meter (used in normal still photography) close to the lighted subject or object.

visually display the light levels against camera tolerances that they forget to look at the monitor to see whether the lighting looks the way it was intended. If you combine your knowledge of how the camera works with artistic sensitivity and, especially, common sense, you will not let the light meter tell you how to light but rather use it as a guide to make your job more efficient.

CALCULATING LIGHT INTENSITY

Light intensity measures how much light strikes an object. One foot-candle is the amount of light of a single candle that falls on a 1-by-1 foot surface located 1 foot away from the candle. One lux is the light that falls on a surface of 1 square meter (about 3 by 3 feet) generated by a single candle that burns at a distance of 1 meter (roughly 3 feet). The norm for the light intensity of one candle is 1 *lumen*.

Light intensity is subject to the *inverse square law*. This law states that if a light source radiates *isotropically* (uniformly in all directions), such as a candle or a single light bulb burning in the middle of a room, the light intensity falls off (gets weaker) as $1/d^2$ where d is the distance from the source. For example, if the intensity of a light is 1 fc at a distance of 1 foot from the source, its intensity at a distance of 2 feet is $\frac{1}{4}$ fc. **SEE 7.46**

The inverse square law also applies to lux. In this case the light intensity is measured off a surface of $1 \, m^2$ located 1 meter from the light source of 1 lumen.

This formula tells you that light intensity decreases the farther away you move the lighting instrument from 152 Chapter 7 LIGHTING

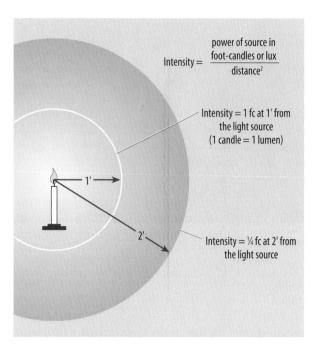

7.46 INVERSE SQUARE LAW

Note that the inverse square law applies only to light sources that radiate isotropically (uniformly in all directions). This law applies equally to lux.

the object, and increases if you move the light closer. Otherwise, the formula does little to make television lighting more accurate. The beams of a searchlight, a flashlight, car headlights, and a Fresnel or an ellipsoidal spotlight do not radiate light isotropically but are collimated (the light rays are made to run parallel as much as possible) and, therefore, do not obey the inverse square law. Even floodlights radiate their light more in the direction of the reflector opening than its back. The more collimated the light—that is, the more focused its beam—the slower its intensity decreases with distance. This is why we "focus" a spotlight when we want more light on an object and "flood" its beam when we want less light, without changing the distance between the lighting instrument and the object. An example of an extremely well-collimated light is a laser beam, which, as you know, maintains its intensity over a great distance.

OPERATING LIGHT LEVEL: BASELIGHT

To make the camera "see well" so that the pictures are relatively free of video *noise* (artifacts in the picture, or "snow"), you must establish a minimum operating light

level, called *baselight* or *base*. As you recall, baselight is the general, overall light level on a scene.

BASELIGHT LEVELS

Many an argument has been raised concerning adequate minimum baselight levels for various cameras. The problem is that baselight levels do not represent absolute values but are dependent on other production factors, such as the sensitivity of the camera, the desired lighting contrast, the general reflectance of the scenery, and, of course, the aperture of the lens (*f*-stop). When shooting outdoors on an ENG assignment, you do not have much control over baselight levels; you must accept whatever light there is. But even there you might be able to use sunlight reflectors to lighten up shadow areas, or additional lighting instruments to boost available light. Most often the problem is inadequate baselight. But there are also situations in which you struggle with controlling too much light.

Not enough baselight Although you often hear that consumer camcorders can operate in light levels as low as 0.1 fc or even 0.02 fc (10 or even 2 lux), the light levels for optimal camera performance are much higher. Professional ENG/EFP and studio cameras normally need about 150 fc, or approximately 1,500 lux, for optimal picture quality at an aperture setting of f/5.6 to f/8.0. These f-stops produce the highest-resolution images. You will probably read camera specifications that use 200 fc (2,000 lux) as the standard illumination and then give the highest f-stop, such as f/11, at which the camera still delivers optimal pictures.

Most video cameras can work at baselight levels that are considerably lower, without noticeable loss of picture quality. By switching to a low gain setting (which, as you recall, will electronically boost the video signal), you may get an acceptable image even in low-light conditions. Despite manufacturers' claims to the contrary, high gain can cause increased video noise and occasional color distortion. For home video or even ENG, video quality may be secondary to picture content, but it is of major concern for EFP and studio shows that must tolerate many copies and picture manipulations in postproduction editing. In general, digital cameras tolerate higher gain than do analog cameras, without noticeable picture deterioration.

If you work with sets or costumes whose colors and textures absorb a great amount of light, you obviously need higher baselight levels than with a set whose brightly painted surface reflects a moderate amount of light.

Another problem with shooting in inadequate baselight is the resulting shallow depth of field. In low-light Section 7.2

conditions, the iris must be fairly wide open (low *f*-stop number) to allow as much light as possible to strike the camera pickup device. But, as you recall, a lens whose iris is set at its maximum aperture gives a fairly shallow depth of field. Consequently, focusing becomes a problem, and, if there is a great deal of object and/or camera movement, you may experience noticeable *lag* (smear that follows the moving object).

Here is the rule of thumb: in general, a camera has less trouble producing high-quality, crisp pictures when the light level is fairly high and the contrast limited than under very low levels with high-contrast lighting.

Too much baselight Despite the validity of this general rule for baselight and picture quality, there will be instances when there is simply too much light for the camera to operate properly. You can cope with too much light by reducing the lens aperture, which translates into setting the *f*-stop to a higher number, such as *f*/22, or using an ND filter that is part of the filter wheel inside the camera. Much like a small aperture, *neutral density* (*ND*) *filters* reduce the amount of light falling on a scene or entering the beam splitter in the camera without changing the color temperature of the light. (Color temperature is explained in detail in chapter 8.) Such ND filters will also help you control the extreme contrast between light and shadows when shooting outdoors on a sunny day.

ZVLB LIGHTS→ Measurement→ baselight

TYPES OF LAMPS

Lighting instruments are classified not only by function (spotlight or floodlight) but also by the lamp (bulb) they use. When classifying instruments by type of lamp, we can refer to the power rating, such as 12V or 30V for battery-powered lamps or 1kW or 2kW (1,000W or 2,000W) lamps for studio lighting, or to a specific way of generating a light output—the *luminant*. Obviously, you should not use a 12V lamp with a 30V battery or put a 2kW lamp in an instrument that is rated for only a 1kW.

Television lighting generally uses three basic types of luminants: (1) incandescent, (2) fluorescent, and (3) HMI.

INCANDESCENT

The *incandescent* lamp operates on the same principle as the ordinary household light bulb. It generates light by heating up a filament with electricity. The incandescent lamps used in television resemble the ones in your

home fixtures except that they usually have more wattage and therefore produce higher-intensity light. They also include the smaller but hotter *quartz* lamps. The major disadvantages of regular incandescent lamps are that the higher-wattage lamps are quite large, the color temperature becomes progressively lower (more reddish) as the lamp ages, and they have a relatively short life.

Quartz The quartz lamp has a filament that is encased in a quartz bulb filled with halogen gas. The advantages of a quartz lamp over regular incandescent systems are that it is smaller and maintains its color temperature over its entire life. The disadvantage is that it burns at an extremely hot temperature. When changing quartz lights, do not touch the lamp with your fingers. The old lamp may still be hot enough to burn your skin, and your finger-prints will cause the new one to have a much shorter life span. Always use gloves, a paper towel, or a clean rag when handling lamps.

FLUORESCENT

Fluorescent tubes generate light by activating a gas-filled tube to give off ultraviolet radiation. This radiation in turn lights up the phosphorous coating inside the tubes, similar to the way the electron beam lights up the television screen. Despite improved fluorescent lamps that produce a fairly even white light, many fluorescent tubes have a tendency to give off a slightly greenish light or, at best, a color temperature that makes it difficult to blend with other indoor or outdoor light sources.

HMI

HMI (which stands for hydragyrum medium arc-length iodide) lamps generate light by moving electricity through various types of gases. This creates a sort of lightning inside the bulb, which is the discharge that creates the light. To create the lightning inside the lamp, you need a ballast—a fairly heavy transformer. HMI lamps produce light with a color temperature of 5,600K, the outdoor standard. (See section 7.1 for the advantages and disadvantages of the HMI when used in production.) As with quartz bulbs, do not touch HMI lamps with your hands: your fingerprints will weaken the quartz housing and cause the lamp to burn out in a relatively short time.

COLOR MEDIA

You can produce a great variety of colored light simply by putting different color media, or gels, in front of the

7.47 COLOR MEDIA

Color media, or gels, are colored filters that are put in front of lighting instruments to produce colored light.

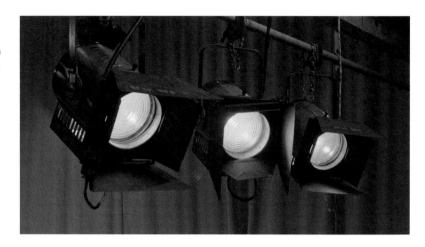

lighting instrument. (*Gel* is short for *gelatin*, which was the color medium used before the more heat- and moisture-resistant plastic was developed.) Color media are sheets of highly heat-resistant plastic that act as color filters. They are used extensively to color-tint scenic backgrounds or to create color special effects, such as in dance programs, rock concerts, or some mystery or outer-space adventure shows. **SEE 7.47**

HOW TO USE COLOR MEDIA

You can cut the color media sheet to fit the frame of the gel holder of the lighting instrument. You then slip the gel holder into brackets in front of the lens of the lighting instrument. If the colored lighting does not have to be too precise, you can use wooden clothespins (plastic ones melt) to hang the color sheets from the barn doors like laundry on a clothesline. The advantages of this method are that it saves you from having to cut the expensive gels and they are farther away from the heat generated by the lamp. Highly focused instruments generate so much heat that they may burn out the center of even the most heat-resistant gels. You can avoid such burns by putting the instrument into more of a flood position (by moving the lamp-reflector unit toward the lens), thereby dissipating somewhat the heat of the beam.

MIXING COLOR GELS

When using gels the colors can mix *additively* or *subtractively*. For example, if you put a red gel in one instrument and a green gel in the other and then partially overlap their beams, you get yellow in the overlap. Because you added one light on top of the other, this is *additive mixing*. If, however, you were to put both gels—the red and

the green—in front of the same instrument, you would get no light from the instrument. This is because the red gel blocks (subtracts) all the green light, and the green gel negates all the red light.

A similar problem occurs if you shine colored lights on colored objects. We see an apple as red because the color filters in the apple absorb all colors of white light except red, which is reflected back to our eyes. A green apple absorbs all colors except green, which is reflected back and makes the apple look green. What would happen if you shined a red light on a green apple? Would it turn yellow? No, the apple would look dark brown or black. Why? Because the red light that shines on the green apple contains no green. The apple, which absorbs all or most of the red light, has no or very little red to reflect back. In the same way, you may have a problem using yellow objects under blue "night" illumination: the blue light contains no yellow, and the objects therefore have no yellow to reflect, so they turn dark gray or black.

Most lighting experts advise against using colored lights to illuminate talent and performance areas unless, of course, it's for special effect, such as the greenish tint on crime shows or the multicolored lights on a rock music scene. If colors are critical, try to keep the colored light away from the faces.

You may have heard about the tedious but important job of color correction in postproduction editing (explored in depth in chapter 13). Although this has nothing to do with using color media in studio lighting, it nevertheless is based on electronically remixing the RGB quantities and qualities of the RGB light primaries. This procedure is a special skill, however, and its techniques far exceed the scope of this handbook.

MAIN POINTS

- Light intensity is measured in foot-candles (fc) or lux. To find lux when given foot-candles, multiply foot-candles by ten. To find foot-candles when given lux, divide lux by ten.
- Although the general conversion factor of foot-candles into lux is 10, the more accurate conversion factor is 10.75; thus, 1 fc = 10.75 lux, and 10.75 lux = 1 fc.
- To measure incident light (the light that falls on the scene), point the light meter away from the lighted scene toward the camera or into the lights that are illuminating the subject.
- To measure reflected light, use a reflected (standard) light meter and point it closely at various areas of the lighted subject or object. Reflected-light readings measure primarily contrast.
- ◆ The inverse square law in illumination applies only if the light source radiates isotropically (uniformly in all directions), such as a bare light bulb or a candle. Because most television lighting instruments collimate the light (focus the light rays), the inverse square law does not apply to the same degree. The general principle, however, still holds true: the farther away the light source is from the object, the less intense the light; the closer the light is to the object, the more intense the light.
- Baselight is the overall light level on a scene. Cameras require a minimum baselight level for optimal operation.
- Lamps are rated by the voltage they need to operate—their power rating. They are also labeled by the type of luminant: (1) incandescent, including quartz, (2) fluorescent, and (3) HMI. Incandescent lamps include regular household bulbs and the more efficient quartz lamps. Fluorescent lamps produce ultraviolet rays that light up the phosphorous layer inside the tube. The HMI lamp generates light by discharging electricity through various gases.
- Color media, normally called gels, are colored plastic filters that, when put in front of the lens of a lighting instrument, give the light beam the color of the gel.
- Colored light beams mix additively, but overlaying filters mix subtractively.

ZETTL'S VIDEOLAB

For your reference, or to track your work, each *Video-Lab* program cue in this chapter is listed here with its corresponding page number.

ZVL1 LIGHTS→ Instruments→ studio | field 131

ZVL2 LIGHTS→ Design→ silhouette 133

ZVL3 LIGHTS→ Instruments→ field 139

ZVL4 LIGHTS→ Instruments→ beam control 145

ZVI_5 LIGHTS → Field → use of reflectors 146

ZVL6 LIGHTS→ Instruments→ field 146

ZVL7 LIGHTS→ Measurement→ meters 150

ZVL8 LIGHTS→ Measurement→ baselight 153

8

Techniques of Television Lighting

When watching television, you will probably notice that people and sometimes the entire scenes in newscasts, situation comedies, and game shows are brightly lit with a minimum of shadows on their faces. But when watching crime shows or soap operas, there are often more deep shadows on the actors' faces than light, and even the colors are sometimes distorted. The techniques of television lighting suggest how to achieve such different lighting effects and more.

In most video production situations, especially EFP, available space, time, and people are insufficient for you to accomplish motion picture—quality lighting. You may find, for instance, that the time allotted to lighting is so short that all you can do is flood the studio or location site with highly diffused light, regardless of the nature of the event to be illuminated. Although such a technique may please the camera and probably the video operator (who because of the uniform light levels has little shading to do), it does not always fulfill the aesthetic requirements of the production. For example, a dramatic scene that is supposed to play on a dark street corner will not look convincing if everything is brightly and evenly illuminated by softlights. On the other hand, there is no reason to spend a great deal of time on dramatic lighting for such events as newscasts, interviews, or the corporate manager's telling her employees about recent sales. Even lighting will do just fine.

The ever-present time limitation should not preclude good and creative television lighting, but it does call for a high degree of efficiency. Without a thorough understanding of the basic lighting principles, you can easily spend all your allotted time, and part of the rehearsal time, on trying to achieve a specific lighting effect that, in the end, might look out of place. Efficiency in lighting also means careful preparation.

This chapter will help you with such preparations. Section 8.1, Lighting in the Studio, covers basic and special-effects studio lighting techniques and principles; section 8.2, Lighting in the Field, addresses lighting techniques for ENG and EFP.

KEY TERMS

- **background light** Illumination of the set, set pieces, and backdrops. Also called *set light*.
- back light Illumination from behind the subject and opposite the camera.
- **cameo lighting** Foreground figures are lighted with highly directional light, with the background remaining dark.
- chroma keying Effect that uses color (usually blue or green) for the backdrop, which is replaced by the background image during a key.
- **color temperature** The standard by which we measure the relative reddishness or bluishness of white light. It is measured on the Kelvin (K) scale. The standard color temperature for indoor light is 3,200K, for outdoor light, 5,600K. Technically, the numbers express Kelvin degrees.
- contrast ratio The difference between the brightest and the darkest portions in the picture (often measured by reflected light in foot-candles). The contrast ratio for most cameras is normally 40:1 to 50:1, which means that the brightest spot in the picture should not be more than forty or fifty times brighter than the darkest portion without causing loss of detail in the dark or light areas. High-end digital cameras can exceed this ratio.
- **cross-keying** The crossing of key lights for two people facing each other.
- diffused light Light that illuminates a relatively large area with an indistinct light beam. Diffused light, created by floodlights, produces soft shadows.
- **directional light** Light that illuminates a relatively small area with a distinct light beam. Directional light, produced by spotlights, creates harsh, clearly defined shadows.
- **falloff** (1) The speed with which light intensity decays. (2) The speed (degree) with which a light picture portion turns into shadow area. *Fast falloff* means that the light areas turn abruptly into shadow areas and there is a great brightness difference between light and shadow areas. *Slow falloff* indicates a very gradual change from light to dark and a minimal brightness difference between light and shadow areas.

- **fill light** Additional light on the opposite side of the camera from the key light to illuminate shadow areas and thereby reduce falloff. Usually done with floodlights.
- **floor plan** A diagram of scenery and properties drawn onto a grid pattern. Can also refer to *floor plan pattern*.
- **high-key** Light background and ample light on the scene. Has nothing to do with the vertical positioning of the key light.
- **Kelvin (K)** Refers to the Kelvin temperature scale. In lighting it is the specific measure of color temperature—the relative reddishness or bluishness of white light. The higher the K number, the more bluish the white light. The lower the K number, the more reddish the white light.
- key light Principal source of illumination.
- **kicker light** Usually directional light that is positioned low and from the side and the back of the subject.
- **light plot** A plan, similar to a floor plan, that shows the type, size (wattage), and location of the lighting instruments relative to the scene to be illuminated and the general direction of the beams.
- **location survey** Written assessment, usually in the form of a checklist, of the production requirements for a remote.
- **low-key** Dark background and illumination of selected areas. Has nothing to do with the vertical positioning of the key light.
- photographic lighting principle The triangular arrangement of key, back, and fill lights, with the back light opposite the camera and directly behind the object, and the key and fill lights on opposite sides of the camera and to the front and the side of the object. Also called triangle lighting.
- side light Usually directional light coming from the side of an object. Acts as additional fill light or a second key light and provides contour.
- **silhouette lighting** Unlighted objects or people in front of a brightly illuminated background.

8.1

Lighting in the Studio

Lighting means the control of light and shadows. Both are necessary to show the shape and the texture of a face or an object, to suggest a particular environment, and, like music, to create a specific mood. Regardless of whether you do lighting for dramatic or nondramatic productions, you will find that there are usually many solutions to any one problem. And though there is no universal recipe that works for every possible lighting situation, there are some basic principles that you can easily adapt to a great variety of specific requirements. When faced with a lighting task, do not start with anticipated limitations. Start with how you would like the lighting to look and then adapt to the existing technical facilities and especially the available time.

Section 8.1 covers the following lighting techniques:

OUALITY OF LIGHT

Directional and diffused

COLOR TEMPERATURE

The reddishness and bluishness of white light and how to control it

LIGHTING FUNCTIONS

Terminology and specific functions of the main light sources

SPECIFIC LIGHTING TECHNIQUES

Flat, continuous-action, large-area, high-contrast, cameo, silhouette, and chroma-key area lighting, and controlling eye and boom shadows

CONTRAST

Contrast ratio, measuring contrast, and controlling contrast

▶ BALANCING LIGHT INTENSITIES

Key-to-back-light ratio and key-to-fill-light ratio

▶ LIGHT PLOT

Indicating the location of instruments and their beams

▶ OPERATION OF STUDIO LIGHTS

Safety, preserving lamps and power, and using a studio monitor

OUALITY OF LIGHT

Whatever your lighting objective, you will be working with two types of light: directional and diffused. Normal white light, which you get from the sun or the light you use while reading, is never pure white but has a slight reddish or bluish tinge. Technically, white light has a certain *color temperature*.

DIRECTIONAL LIGHT AND DIFFUSED LIGHT

Directional light, produced by spotlights, illuminates a relatively small area with a distinct light beam and produces dense, well-defined shadows. The sun on a cloudless day acts like a giant spotlight, producing dense and distinct shadows.

Diffused light illuminates a relatively large area with a wide, indistinct beam. It is produced by floodlights and creates soft, transparent shadows. The sun on a cloudy or foggy day acts like an ideal floodlight because the overcast transforms the harsh light beams of the sun into highly diffused light.

Actually, it is the density of the shadows and their falloff that indicates whether the light is directional or diffused. If you looked only at the illuminated side, you would have a hard time telling whether it was directional or diffused light.

COLOR TEMPERATURE

You may have noticed that a fluorescent tube gives off a different "white" light than does a candle. The fluorescent tube actually emits a white light that has a bluish-green tinge, whereas the candle produces a more reddish white light. The setting sun gives off a much more reddish light than does the midday sun, which is more bluish. These color variations in light are called *color temperature*. Note that color temperature has nothing to do with physical

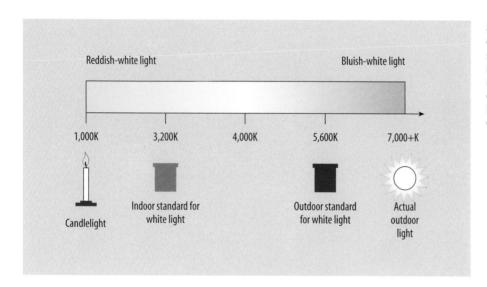

8.1 COLOR TEMPERATURE

Color temperature is measured on the Kelvin (K) scale. It measures the relative reddishness or bluishness of white light. The norm for indoor light is 3,200K; for outdoor light, 5,600K.

temperature, that is, how hot the light bulb actually gets; it is strictly a measure of the relative reddishness or bluishness of white light.

This reddishness and bluishness of white light can be precisely measured and are expressed in degrees of color temperature, or *Kelvin* (*K*) degrees. In lighting lingo the degrees are dropped and a specific color temperature is referred to only as a certain amount of K.

The color temperature standard for indoor illumination is 3,200K, which is a fairly white light with just a little reddish (warm) tinge. All studio lighting instruments and portable lights intended for indoor illumination are rated at 3,200K, assuming they receive full voltage. Lighting instruments used to augment or simulate outdoor light have lamps that emit a 5,600K light. They approximate more the bluish light of the outdoors. **SEE 8.1**

When you dim a lamp that is rated at 3,200K, the light becomes progressively more reddish, similar to sunlight at sunset. The color camera, when adjusted to seeing white in 3,200K light, will faithfully show this increasing reddishness. For example, the white shirt of a performer will gradually turn orange or pink, and the skin tones will take on an unnatural red glow. Some lighting experts therefore warn against *any* dimming of lights that illuminate performers or performance areas. The skin tones are, after all, the only real standard viewers have by which to judge the accuracy of the television color scheme. If the skin colors are distorted, how can we trust the other colors to be true? So goes the argument. Practice has shown, however, that you can dim a light by 10 percent or even a little more

without the color change becoming too noticeable on a color monitor. Incidentally, dimming the lights by at least 10 percent will not only reduce power consumption but just about double the life of the bulbs. ▼VLI→LIGHTS→ Color temperature→ white balance | controlling | try it

HOW TO CONTROL COLOR TEMPERATURE

As you learned in chapter 3, you need to white-balance the camera to ensure the correct color reproduction even if the illumination has different color temperatures. You may find, however, that occasionally the camera will refuse to white-balance although you follow exactly the procedures outlined here. This difficulty may be caused by a color temperature that is too low (light is too reddish) or too high (light is too bluish) for the automatic white balance to handle. In this case you need to choose one of the color filters on the filter wheel inside the camera (see chapter 3). Light-blue filters compensate for the reddishness of low-color-temperature light, and amber or light-orange filters compensate for the bluishness of high-color-temperature light.

Most professional ENG/EFP cameras remember some of these setups, so you can go back to the previous lighting environment and recall the appropriate white balance automatically. Experienced camerapersons, however, prefer to white-balance from scratch to be sure that the actual colors as seen by the camera, including white, are as true as possible.

Another way to raise the color temperature of the reddish light (to make it more bluish) is by putting a light-

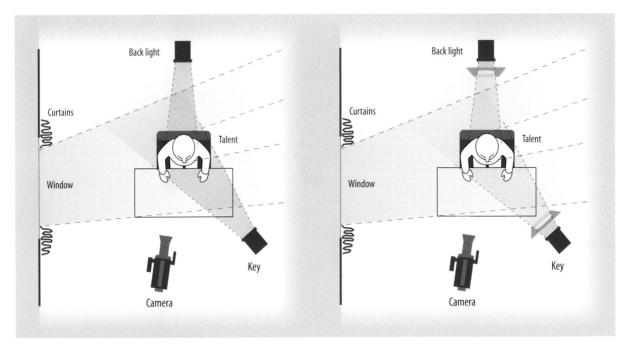

8.2 MATCHING COLOR TEMPERATURES OF DIFFERENT LIGHT SOURCES

A When illuminating an object with indoor light mixed with outdoor light coming through a window, you need to equalize the color temperatures of both light sources to ensure proper white-balancing.

B To equalize the color temperatures, you can put light-blue gels on the indoor lighting instruments to raise their 3,200K color temperature to the more prominent 5,600K daylight coming through the window.

blue *gel* (sheet of colored plastic) in front of the lighting instrument's lens; or you can lower the color temperature (to make it more reddish) by placing a light-orange gel in front of the lighting instrument.

When shooting an indoor scene that is partially illuminated by outdoor (5,600K) light coming through a window and by portable indoor (3,200K) lighting instruments, you have two choices: either lower the high outdoor color temperature (bluish light) or raise the indoor color temperature (reddish light) to match the daylight streaming through the window. In elaborate field productions, the usual way is to cover the entire window with amber plastic sheets that act like gigantic filters, lowering the high outdoor color temperature to the lower indoor standard. The advantage of this method is that the whole interior is adjusted to the 3,200K standard. A quicker and cheaper way is to let the high-color-temperature outdoor light stream through the window and put bluish filters in front of the indoor lighting instruments to raise their light to the outdoor standard. SEE 8.2 ZVL2 LIGHTS -> Color temperature > light sources

In certain circumstances you can get away with mixing lights of different color temperatures so long as one or the other dominates the illumination. For example, if you are in an office that is illuminated by overhead fluorescent tubes and you need to add key and back lights (see the following discussion) to provide more sparkle and dimension to the performer, you can most likely use normal portable lighting instruments that burn at the indoor color temperature standard (3,200K). Why? Because the portable instruments provide the dominant light, overpowering the overhead lights that now act as rather weak fill lights. The camera will have little trouble white-balancing on the strong indoor lights while more or less ignoring the higher color temperature of the overhead fluorescent lights.

LIGHTING FUNCTIONS

You will notice that lighting terminology is based not so much on whether the instruments are spotlights or floodlights but rather on their functions and their position relative to the object to be lighted.

TERMINOLOGY

Although there are variations for the following terms, most lighting people in the photographic arts (including video) use this standard terminology.

- The *key light* is the apparent principal source of directional illumination falling on a subject or an area; it reveals the basic shape of the object.
- The back light produces illumination from behind the subject and opposite the camera; it distinguishes the shadow of the object from the background and emphasizes the object's outline.
- The fill light provides generally diffused illumination to reduce shadow or contrast range (to slow falloff). It can be directional if the area to be "filled in" is rather limited.
- The background light, or set light, is used specifically
 to illuminate the background or the set and is separate from the light provided for the performers or
 performance area.
- The *side light* is placed directly to the side of the subject, usually on the opposite side of the camera from the key light. Sometimes two side lights are used opposite each other, acting as two keys for special-effects lighting of a face.
- The *kicker light* is a directional illumination from the back, off to one side of the subject, usually from a low angle opposite the key light. Whereas the back light merely highlights the back of the head and the shoulders, the kicker light highlights and defines the entire side of the person, separating him or her from the background.

SPECIFIC FUNCTIONS OF MAIN LIGHT SOURCES

How do these lights now function in basic lighting tasks? Let's take a look.

Key light As the principal source of illumination, the major function of the *key light* is to reveal the basic shape of the subject. **SEE 8.3** To achieve this the key light must produce some shadows. Fresnel spotlights, medium spread, are normally used for key illumination. But you can use a scoop, a broad, or even a softlight for a key if you want softer shadows or, technically, slower falloff. In the absence of expensive softlights, some lighting directors (LDs) take

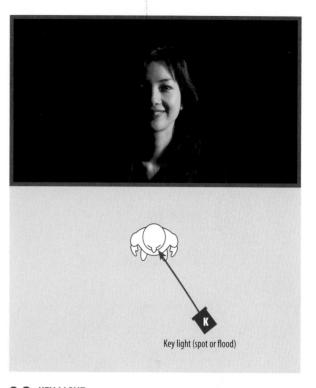

8.3 KEY LIGHT The key light represents the principal light source and reveals the basic shape of the object or person.

a cue from filmmakers and still photographers and use reflectors as key and fill lights. Instead of diffusing the key and fill lights with diffusion material, such as scrims or frosted gels, you do not aim the key light (a Fresnel spot) directly at the subject but rather bounce it off white foam core or a large white posterboard. The reflected, highly diffused light nevertheless produces distinct, yet extremely soft, slow-falloff shadows. Some LDs prefer this method over key-lighting directly with a softlight, claiming that it gives them more gradual (slower) falloff.

Because during the day we see the principal light source—the sun—coming from above, the key light is normally placed above and to the right or left front side of the object, from the camera's point of view. Look again at figure 8.3, which shows the woman illuminated with the key light only, and notice that the falloff is very fast, blending part of her hair and shoulder with the background. To help clarify the outline and the texture of the woman's right (camera-left) side, you obviously need light sources other than the single key light.

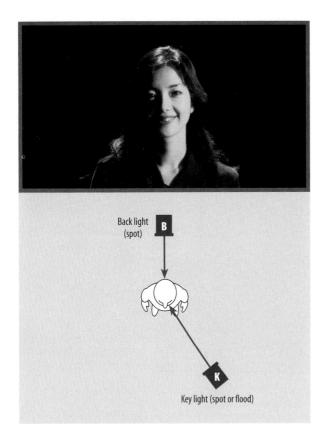

8.4 KEY AND BACK LIGHTS

The back light provides more definition to the actual shape of the subject (her hair on camera-left), separates her from the background, and gives her hair sparkle and highlights.

Back light Adding illumination from behind helps separate the subject from the background. **SEE 8.4** Note how the *back light* helps distinguish between the shadow side of the woman and the dark background, emphasizing the outline—the contour—of her hair and shoulders. We have now established a clear *figure/ground* relationship, which means that we can easily perceive a figure (the woman) in front of a (dark) background. Besides providing spatial definition, the back light adds sparkle and professional polish.

In general, try to position the back light as directly behind the subject (opposite the camera) as possible; there is no inherent virtue in placing it somewhat to one side or the other unless it is in the camera's view. A more critical problem is controlling the vertical angle at which the back light strikes the subject. If it is positioned directly above the person, or somewhere in that neighborhood, the back light becomes an undesirable top light. Instead of revealing the subject's contour to make her stand out from the

background and giving the hair sparkle, the light simply brightens the top of her head, causing dense shadows below her eyes and chin. On the other hand, if the back light is positioned too low, it shines into the camera.

To get good back lighting on a set, you need a generous space between the performance areas (the areas in which the talent move) and the background scenery. Therefore you must place "active" furniture, such as chairs, tables, sofas, or beds actually used by the performers, at least 8 to 10 feet away from the walls toward the center of the set. If the talent works too close to the scenery, the back lights must be tilted at very steep angles to reach over the *flats*, and such steep angles inevitably cause undesirable top light.

Fill light Now take another look at figure 8.4. Despite the back light, the difference between the light and shadow sides is still rather extreme, and the light side of the face still changes abruptly to a dense shadow. This change is called falloff. *Falloff* means the speed (degree) to which a light picture portion turns into shadow area. If the change is sudden, as in figure 8.4, it is *fast falloff*. With fast falloff the shadow side of the subject's face is very dense; the camera sees no shadow detail. To slow down the falloff, that is, to make the shadow less prominent and more transparent, you need some *fill light*. **SEE 8.5**

Not surprisingly, you place the fill light on the opposite side of the camera from the key light. A highly diffused floodlight or reflected light is generally used as fill. The more fill light you use, the slower the falloff becomes. When the intensity of the fill light approaches or even matches that of the key light, the shadows, and with them the falloff, are virtually eliminated. This gives the subject a flat look—shadows no longer help define shape and texture.

When doing critical lighting in a specific area and you don't want the fill light to spill over too much into the other set areas, you can use a Fresnel spotlight as fill by spreading the beam as much as possible or by putting a scrim in front of the lens. You can then use the barn doors to further control the spill.

The photographic principle, or triangle light-

ing With the three main light sources (key, fill, and back) in the triangle setup, you have established the basic *photographic lighting principle*, or *triangle lighting* (see figure 8.5). But you are not done yet! You must now fine-tune this lighting arrangement. Take a good hard look at the lighted object or, if possible, the studio monitor to see whether the scene (in our case, the close-up of the woman) needs some further adjustment for optimal lighting. Are there any undesirable shadows? Are there shadows that distort

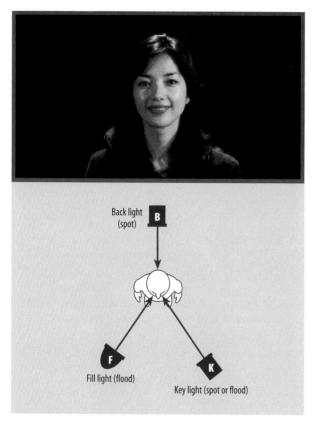

8.5 KEY, BACK, AND FILL LIGHTS

The fill light slows falloff, making the shadow side (camera-left) more transparent and revealing details without erasing the form-revealing shadows altogether.

rather than reveal the face? How is the light balance? Does the fill light wash out all the necessary shadows, or are the shadows still too dense? Is the back light too strong for the key/fill combination?

Background, or set, light To illuminate the background (walls or cyclorama) of the set or portions of the set that are not a direct part of the principal performance area, you use the *background light*, or, as it is frequently called, the *set light*. To keep the shadows of the background on the same side as those of the person or object in front of it, the background light must strike the background from the same direction as the key light. **SEE 8.6** As you can see in the figure, the key light is placed on the cameraright side, causing the shadows on the subject to fall on the camera-left side. Consequently, the background light is also placed on camera-right to make the shadows on camera-left correspond with those of the foreground. If you place the background light on the opposite side from

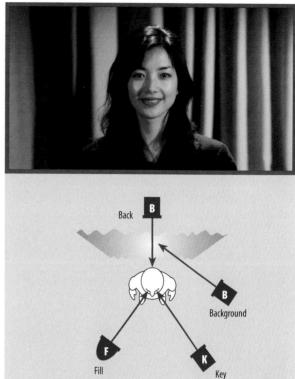

8.6 BACKGROUND LIGHT

The background light illuminates the background area. It must be on the same side of the camera as the key light to keep the background shadows (curtain) on the same side as the foreground shadows (woman).

the key, the viewer may assume that there are two separate light sources illuminating the scene or, worse, that there are two suns in our solar system. ZVL3 LIGHTS→ Triangle lighting→ key | back | fill | background | try it

Background light frequently goes beyond its mere supporting role to become a major production element. Besides accentuating an otherwise dull, monotonous background with a slice of light or an interesting cookie, the background light can be a major indicator of the show's locale, time of day, and mood. **SEE 8.7** A cookie projection of prison bars on the wall, in connection with the clanging of cell doors, immediately places the event in a prison. **SEE 8.8**

A long slice of light or long shadows falling across the back wall of an interior set suggests, in connection with other congruent production clues, late afternoon or evening. Dark backgrounds and distinct shadows generally suggest a *low-key* scene (dark background with selective fast-falloff lighting) and a dramatic or mysterious mood.

8.7 SETTING MOOD WITH BACKGROUND LIGHTING

The colorful background lighting in this set suggests a trendy environment and an upbeat mood.

8.8 SETTING LOCALE WITH BACKGROUND LIGHTING

Background lighting can place an event in a specific locale or environment. Here the background light produces barlike shadows, suggesting that the scene takes place in a prison.

A light background and a generally high baselight level are usually regarded as a *high-key* scene with an upbeat, happy mood. That is why situation comedies and game shows are much more brightly lighted (higher baselight level and less contrast) than are mystery and police dramas (lower baselight level and more contrast). Do not confuse *high-key* and *low-key* with high and low vertical hanging positions of the key light or with the intensity with which it burns.

In normal background lighting of an interior setting, try to keep the upper portions of the set relatively dark, with only the middle and lower portions (such as the walls) illuminated. There are three main reasons for this common lighting practice: (1) Most indoor lighting is designed to illuminate low work areas rather than the upper portions of walls. (2) The performer's head is more pleasingly contrasted against a slightly darker background. Too much light at that height might cause a *silhouette* effect, rendering the face unusually dark. On the other hand, furniture and

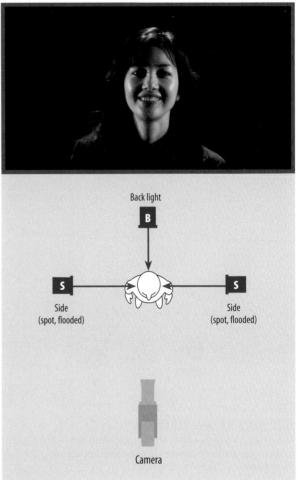

8.9 SIDE LIGHT

The side light strikes the subject from the side. It can act as key and/or fill light. In this case two opposing side lights are used as two keys.

medium- and dark-colored clothing are nicely set off by the lighter lower portions of the set. (3) The dark upper portions suggest a ceiling. You can darken the upper portions of the set easily by using barn doors to block off any spotlight (including the background lights) that would hit those areas.

Side light Usually placed directly to the side of the subject, the *side light* can function as a key or fill light. When used as a key, it produces fast falloff, leaving half of the face in dense shadow. When used as a fill, it lightens up the whole shadow side of the face. When you place side lights on opposite sides of the person, the sides of the face are bright, with the front of the face remaining shadowed. **SEE 8.9** The side light becomes a major light source if the

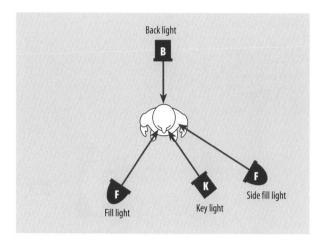

8.10 SIDE FILL-LIGHT SETUP

The side fill light provides soft illumination, with the key (spot) adding sparkle. When the key is turned off, the side fill takes over the function of the key light.

camera's shooting arc is exceptionally wide. If, for instance, the camera moves around the subject from a 6 o'clock to an 8 o'clock position, the side light takes on the function of the key light and provides essential modeling (lighting for three-dimensional effect). Although Fresnel spots at a wide-beam setting are generally used for side lighting, using scoops or broads as side lights can produce interesting lighting effects.

For extrabrilliant high-key lighting, you can support the key light with side fill light. The fill light gives the key side of the subject basic illumination, with the key light providing the necessary sparkle and accent. **SEE 8.10**

Kicker light Generally a sharply focused Fresnel spot, the *kicker light* strikes the subject from behind and on the opposite side of the camera from the key light (the fill-light side). Its main purpose is to highlight the subject's contour at a place where key-light falloff is the densest and where the dense shadow of the subject opposite the key-lighted side tends to merge with the dark background. The function of the kicker is similar to that of the back light, except that the kicker "rims" the subject not at the top-back but at the lower side-back. It usually strikes the subject from below eye level. Kicker lights are especially useful for creating the illusion of moonlight. **SEE 8.11**

SPECIFIC LIGHTING TECHNIQUES

Once you are familiar with how to apply the photographic principle in a variety of lighting situations, you can move on to a few specific lighting techniques. These include:

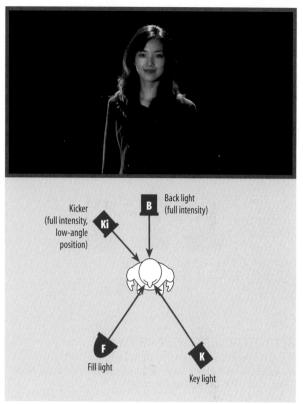

8.11 KICKER LIGHT

The kicker light rims the subject opposite the key, emphasizing contour. Like the back light, the kicker helps separate the foreground subject from the background.

- (1) flat lighting, (2) continuous-action lighting, (3) large-area lighting, (4) high-contrast lighting, (5) cameo lighting,
- (6) silhouette lighting, (7) chroma-key area lighting, and
- (8) controlling eye and boom shadows.

FLAT LIGHTING

Flat lighting means that you light for optimal visibility with minimal shadows. Most flat-lighting setups use floodlights (softlights or fluorescent banks) for front lighting and background lighting and more-focused instruments (Fresnel spots or small broads) for back lights. This setup is the favorite lighting technique for more or less permanently installed news sets and interview areas. **SEEB.12** As you can see in the figure, the basic lighting triangle is preserved. In effect, you have three key lights, or, if you wish, three fill lights, evenly illuminating the front area. The back lights add the sparkle and make the flatness of the lighting setup less noticeable. The additional background lights illuminate the set. The flat lighting of such permanent performance

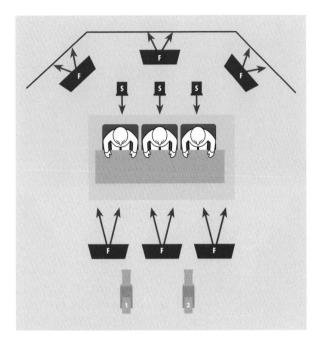

8.12 FLAT-LIGHTING SETUP FOR NEWS

This flat-lighting setup consists of three frontal softlights that act as key and fill lights, three spots or spotted floods for back lights, and three background floodlights.

areas has several advantages: (1) It is quick—all you need to do is turn on one switch and your lighting is done. (2) It is flexible—two or more newspeople can join the news anchor without your having to reset any lights. (3) It is flattering—the virtually shadowless lighting hides any wrinkles that may have survived the makeup. (4) The cameras can maintain their original setup and don't have to be white-balanced for every show.

The major disadvantage is that it looks like what it is: flat.

CONTINUOUS-ACTION LIGHTING

When watching dramas or soap operas on television, you probably notice that many of them have fast-falloff, low-key lighting, which means prominent shadows and relatively dark backgrounds. In such multicamera productions, the cameras look at a scene from different points of view, and people and cameras are always on the move. Wouldn't it be easier to light "flat," that is, to flood the whole performance area with flat light rather than with spotlights? Yes, but then the lighting would not contribute to the mood of the scene or how we feel about the persons acting in it. Fortunately, the basic lighting triangle of key, back, and fill lights can

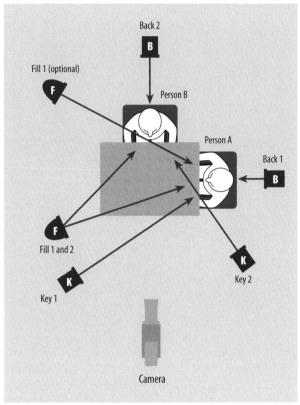

8.13 MULTIPLE-TRIANGLE APPLICATION

In this lighting setup, a separate lighting triangle with its own key, back, and fill light is used for each of the two persons (performance areas). If floodlights are used for the keys, you can probably dispense with the fill lights.

be multiplied and overlapped for each set or performance area for *continuous-action lighting*. Even if there are only two people sitting at a table, you have to use a multiple application of the basic lighting triangle. **SEE 8.13**

To compensate for the movement of the performers, you should illuminate all adjacent performance areas so that the basic triangle-lighted areas overlap. The purpose of overlapping is to give the performers continuous lighting as they move from one area to another. It is all too easy to concentrate only on the major performance areas and to neglect the small, seemingly insignificant areas in between. You may not even notice the unevenness of such lighting until the performers move across the set and all of a sudden they seem to be playing a "now you see me, now you don't" game, popping alternately from a well-lighted area into dense shadow. In such situations a light meter comes in handy to pinpoint the "black holes."

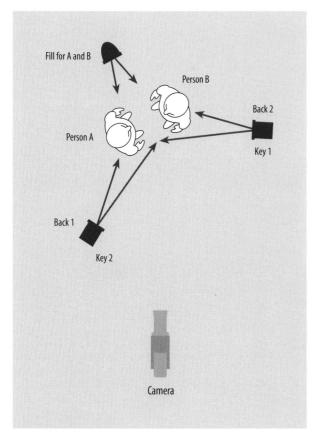

8.14 CROSS-KEYING

In this lighting setup, the key light for person A (the camera-near person) also functions as a back light for person B (the camera-far person), and the back light for person A is the key for person B.

If you do not have enough instruments to apply multiple-triangle lighting for several performance areas when lighting for continuous action, you must place the instruments so that each can serve two or more functions. In reverse-angle shooting, for instance, the key light for one performer may become the back light for the other and vice versa. This technique is generally called *cross-keying*. Or you may have to use a key light to serve also as directional fill in another area. Because fill lights have a diffused beam, you can use a single fill light to lighten up dense shadows in more than one area. **SEE 8.14**

Of course, the application of lighting instruments for multiple functions requires exact positioning of set pieces such as tables and chairs, clearly defined performance areas, and *blocking* (movements of performers). Directors who decide to change blocking or move set pieces after the set has been precisely lighted are not very popular with the lighting crew.

Accurate lighting is always done with basic camera positions and points of view in mind. It therefore helps immensely to know at least the basic camera positions and the range of all major camera viewpoints before starting with the lighting (see figures 8.27 and 8.28). For example, an object that appears perfectly well lighted from a 6 o'clock camera position may look woefully unlit from a 10 o'clock position. Sometimes, as in dramas, variety shows, or rock concerts, "unlighted" shots from shooting angles that lie outside the lighted parameters may look quite startling; in most other shows of less flexible lighting formats, such as news features or instructional programs, these shots simply look bad.

LARGE-AREA LIGHTING

For *large-area lighting*, such as for an audience or orchestra, the basic photographic principle still holds: all you do is partially overlap one triangle on another until you have adequately covered the entire area. Instead of key-lighting from just one side of the camera and fill-lighting from the other, however, key-light from both sides of the camera with Fresnel spots in the flood position. The key lights from one side act as fill for the other side. If the area is really big, you can have additional sets of Fresnel spots positioned closer to the center.

The back lights are strung out in a row or a semicircle opposite the main camera position. The fill lights (broads or scoops) usually come directly from the front. If the cameras move to the side, some of the key lights also function as back lights. You can also use broads or fluorescent banks instead of Fresnel spots for this type of area lighting. **SEE 8.15**

For some assignments, such as lighting a school gym for a basketball game, all you need is enough light for the cameras to see the players and at least some of the spectators. In this case simply flood the gym with highly diffused light. As mentioned, one possibility is to use fairly high-powered open-face instruments with light-diffusing umbrellas.

HIGH-CONTRAST LIGHTING

The opposite of flat lighting is *high-contrast lighting*, much of which mirrors motion picture lighting techniques. Because of the increased tolerance of today's video cameras to low light levels and higher-contrast lighting, many television plays make extensive use of fast-falloff lighting. You may have noticed that some series, such as crime or medical

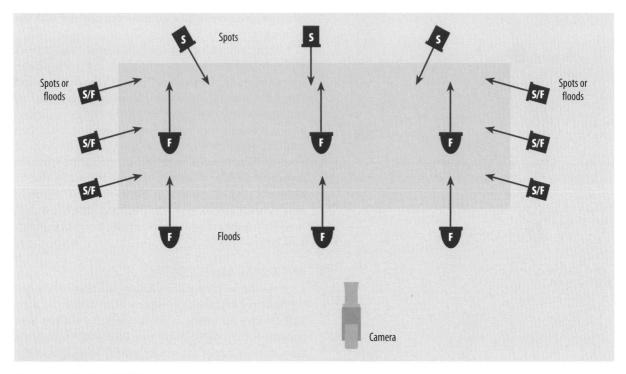

8.15 LARGE-AREA KEYING

In this lighting setup, the Fresnel spots at the left and right sides function as keys and directional fill lights. Fresnel spots are also strung out as regular back lights behind the main action area. If necessary, scoops provide additional fill light from the front.

8.16 FAST-FALLOFF LIGHTING ON FACE The fast-falloff lighting increases the dramatic impact of this close-up.

shows, use not only extremely fast-falloff lighting (harsh shadows) but also color distortion to intensify the scenes. For example, extremely fast falloff on a face inevitably looks more dramatic than if it were lighted with slow falloff.

SEE 8.16 ZVL4 LIGHTS → Design → high key | low key

Prominent side lighting and fast-falloff lighting can be combined for dramatic effect. **SEE 8.17** And instead of always having the key-lighted side face the camera, you may show the shadow side to establish a certain mood. **SEE 8.18**

In addition to fast-falloff lighting, color distortion can add dramatic impact. In this example the scene is purposely given a green tint. **SEE 8.19**

Realize that such lighting effects require not only skill but also a lot of production time. That said, you should still try to apply some of these lighting techniques whenever possible—and when appropriate to the show. If your lighting time is limited, however, stay away from such precision lighting and stick to the classic triangle-lighting approach. You might be pleasantly surprised to find that by turning

8.17 HARSH SIDE LIGHT
The fast falloff and prominent side lighting intensify the mysterious mood of the scene.

8.18 SHADOW SIDE TOWARD CAMERA The camera-far person is lighted so that his shadow side, rather than key side, is seen by the camera. This shadow reversal has dramatic impact.

8.19 COLOR DISTORTIONIn addition to fast-falloff lighting, the precariousness of this scene is further emphasized by the green tint.

on a few Fresnel spots and fill lights, your lighting will look quite acceptable.

CAMEO LIGHTING

Certain television shows, especially those of a dramatic nature, are staged in the middle of an empty studio against an unlighted background. This technique, where the performers are highlighted against a plain dark background, is commonly known as *cameo lighting* (from the cameo art form in which a light relief figure is set against a darker

background). **SEE 8.20** Like the close-up, cameo lighting concentrates on the talent and not the environment.

All cameo lighting is highly directional and is achieved most effectively using spotlights with barn-doors. In small studios the background areas are carefully shielded from any kind of distracting spill light with black, light-absorbing draperies. One of the problems with cameo lighting is that it often exceeds the acceptable *contrast ratio* between the darkest and brightest spots in the picture, which may lead to overexposed bright areas and loss of detail, as well as

8.20 CAMEO LIGHTING

In cameo lighting, the background is kept dark, with only the foreground person illuminated by highly directional spotlights.

possible color distortion in the dark areas. Also, because the lighting is highly directional, the talent must meticulously adhere to the rehearsed blocking. A slight deviation means that the talent steps out of the light and, for all practical purposes, disappears from the screen. Finally, if a microphone boom is used for sound pickup, its distinct shadows present a constant hazard. Some production people use the term *cameo lighting* even when showing part of a set in the scene.

SILHOUETTE LIGHTING

Lighting for a silhouette effect is the opposite of cameo lighting. In *silhouette lighting* you light the background but leave the figures in front unlighted. This way you see only the contour of objects and people but not their volume and texture. To achieve silhouette lighting, use highly diffused light, usually from softlights, cyc lights, or scoops with scrims, to evenly illuminate the background. Obviously, you light in silhouette only those scenes that gain by emphasizing contour. **See 8.21** You can also use silhouette lighting to conceal the identity of a person appearing oncamera. **ZVL5** LIGHTS Design silhouette

CHROMA-KEY AREA LIGHTING

The chroma-key set area normally consists of a plain blue or green backdrop. It is used to provide a variety of backgrounds that are electronically generated, replacing the blue or green areas during the key—a process called *chroma keying*. A popular use of the chroma key is a weather report. Although the weathercaster seems to be standing in front of a large weather map, she is in fact standing in front of an empty, evenly lighted blue or green backdrop. When the blue or green areas are electronically replaced by the weather map during the key, the weathercaster must look

8.21 SILHOUETTE LIGHTING

In silhouette lighting, only the background is lighted, with the figure in front remaining unlighted. It emphasizes contour.

into a monitor to see the map. **SEE 8.22** (See chapter 14 for an in-depth explanation of the chroma-key process.)

The most important aspect of lighting the chroma-key set area is even background illumination, which means that the blue or green backdrop must be lighted with highly diffused instruments, such as softlights or floodlight banks. If there are unusually dark areas or hot spots (undesirable concentrations of light in one area), the electronically supplied background image looks discolored or, worse, breaks up. When lighting the weathercaster in the foreground, prevent any of the lights used for the foreground from hitting the backdrop. Such spill would upset the evenness of the chroma-key background illumination and lead to keying problems. In practice this means that the key and directional fill light (a Fresnel in the flood position) must strike the subject from a steeper-than-normal angle. You may find that using softlights for the key and fill lights on the weathercaster will not affect the chroma key even if they spill onto the backdrop.

Sometimes the outline of a weathercaster looks out of focus or seems to vibrate during the chroma key. One of the reasons for such vibrations is that especially dark colors or shadows at the contour line take on a blue or green tinge, caused by a reflection from the colored backdrop. During the chroma key, these blue or green spots become transparent and let the background picture show through. To counteract a blue reflection, try putting a light-yellow or amber gel on all the back lights or kicker lights. For green reflections, use a light-magenta or soft-pink gel. The back lights then not only separate the foreground subject from the background picture through contour illumination but also neutralize the blue or green shadows with the complementary yellow or pink filters. As a result, the outline of the weathercaster will remain relatively sharp even during

8.22 CHROMA-KEY EFFECT: WEATHERCAST

A In this weathercast, the blue background is evenly lighted with floodlights. The weathercaster is lighted with the standard triangle arrangement of key, back, and fill lights.

B During the chroma key, the weathercaster seems to stand in front of the satellite view.

the chroma key. Be careful, however, not to let any of the colored back light hit the arms or hands of the person standing in the chroma-key area.

Because the blue reflections from the sky are hard to control outdoors, in EFP green is the preferred color for a chroma-key backdrop. You can also use green as the chroma-key color in the studio, especially if the talent likes to wear blue.

CONTROLLING EYE AND BOOM SHADOWS

Two fairly persistent problems in studio lighting are the shadows caused by eyeglasses and microphone booms. Depending on the specific lighting setup, such unwanted shadows can present a formidable challenge to the lighting crew. Most often, however, you will be able to correct such problems rather quickly.

Key light and eye shadows The key light's striking the subject from a steep angle will cause large dark shadows in any indentation and under any protrusion, such as in the eye sockets and under the nose and chin. If the subject wears glasses, the shadow of the upper rim of the frames may fall directly across the eyes, preventing the camera (and the viewer) from seeing them clearly. **SEE 8.23**

There are several ways to reduce these undesirable shadows. First, try to lower the vertical position of the light itself or use a key light farther away from the subject. When you lower it (with a movable batten or a rod), notice that the eye shadows seem to move farther up the face. As soon as the shadows are hidden behind the upper rim of the glasses, lock the key light in position. Such a technique works well so long as the subject does not move around too much. **SEE 8.24** Second, you can try to reduce

8.23 SHADOW CAUSED BY GLASSES

The steep angle of the key light causes the shadow of the woman's glasses to fall right across her eyes.

8.24 KEY LIGHT LOWERED

By lowering the key light, the shadow moves up and is hidden behind the glasses.

eye shadows by illuminating the person from both sides with similar instruments. You can also reposition the fill light so that it strikes the subject directly from the front and from a lower angle, thus placing the shadows upward, away from the eyes. Annoying reflections from eyeglasses can be eliminated with the same recipe.

Boom shadows Although you may not normally use a large microphone boom in the studio except for some dramatic productions, the principles of dealing with boom shadows also apply to handheld microphone booms, such as fishpoles and even handheld shotgun mics.

When you move a boom mic in front of a lighted scene—in this case a single person—and move the boom around a little, you may notice shadows on the actor or on the background whenever the mic or boom passes through a spotlight beam. (You can easily test for shadows by substituting a broomstick or the lighting pole.) Such shadows are especially distracting when they move in and out during a highly dramatic scene. You can deal with boom shadows in two ways: move the lights and/or the mic boom so that the shadow falls out of camera range, or use such highly diffused lighting that the shadow becomes all but invisible.

First of all, you need to find the light that is causing the boom shadow. As simple as this may seem, it is not always so easy to spot the troublemaking instrument, especially if several spotlights are illuminating various adjacent areas on the set. The easiest way to locate the light is to move your head directly in front of the boom shadow and look at the microphone suspended from the boom. The shadow-causing light will now inevitably shine into your eyes. Be careful not to stare into the light for any prolonged period. More precisely, the instrument lies at the extension of a line drawn from the shadow to the microphone causing it. **SEE 8.25**

To get rid of the shadow, simply turn off the offending instrument. You may be pleasantly surprised to find that you have eliminated the shadow without impeding the overall lighting. If such a drastic step seriously weakens the lighting setup, try to position the boom so that it does not have to travel through this light. If you use a handheld fishpole boom, walk around the set while pointing the mic toward the sound source. Watch the shadow move on the background wall until it is out of camera range. If the microphone is still in a position for optimal sound pickup, you have solved the problem. You may locate such a shadow-safe spot more readily when holding or placing the boom parallel to the key-light beam rather than when crossing it. Some LDs use the key and fill lights close to side-light positions to provide a "corridor" in which to operate the boom.

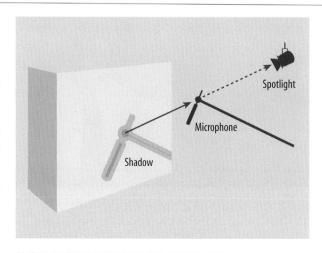

8.25 LOCATING THE SHADOW-CAUSING LIGHT

The instrument that causes the undesirable boom shadow lies at the extension of a line drawn from the shadow to the microphone causing it.

Another simple way to avoid boom shadows is to light more steeply than usual. You do this by moving the key light closer to the set area. The closer the lights are to the performance area, the steeper they will have to be angled to hit the target. The boom will now cast its shadow on the studio floor rather than on the talent's face or background scenery and thus be out of camera range. The downside to this technique is that the steep key lights produce dense and prominent shadows under the eyes, nose, and chin.

You can also try to use barn doors to block off the part of the spotlight that causes the boom shadow. Such a technique is especially useful when the shadow appears in the upper part of the background scenery.

CONTRAST

In chapter 3 you learned about contrast ratio and the way television cameras react to it. In this segment you get acquainted with how lighting affects contrast and how to keep it within tolerable limits (40:1 to 50:1). Contrast does not depend so much on how much light comes from the lighting instruments (incident-light reading) as on how much light is *reflected* by the illuminated objects (reflected-light reading). For example, a white refrigerator, a yellow plastic raincoat, and a polished brass plate reflect much more light than does a dark-blue velvet cloth, even if they are illuminated by the very same source. If you place the brass plate on the velvet cloth, there may be too much contrast for the television camera to handle properly—and you have not even begun with the lighting.

What you have to consider when dealing with contrast is a constant relationship among various factors, such as how much light falls on the subject, how much light is reflected, and how much difference there is between the foreground and the background or the lightest and darkest spots in the same picture. Because we deal with relationships rather than absolute values, we express the camera's contrast limit as a ratio.

CONTRAST RATIO

As stated in chapter 3, *contrast ratio* is the difference between the brightest and the darkest spots in the picture (often measured by reflected light in foot-candles). The brightest spot, that is, the area reflecting the greatest amount of light, is called the *reference white*, and it determines the "white level." The area reflecting the least amount of light is the *reference black*, which determines the "black level." With a contrast limit of 40:1 or 50:1, the reference white should not reflect more than forty or fifty times the light of the reference black. Remember that the contrast is determined not necessarily by the amount of light generated by the lamps but by how much light the objects reflect back to the camera lens.

MEASURING CONTRAST

You measure contrast with a reflected-light reading—by first pointing the light meter close to the brightest spot (often a small white card on the set, which serves as the reference white) and then to the darkest spot (serving as the reference black). Even if you don't have a light meter or waveform monitor for checking the contrast ratio, you can tell by looking at the monitor. When the white areas, such as the white tablecloths in a restaurant set, look awfully bright, or the black clothing of the people sitting at the tables awfully black without any detail, the contrast is obviously great and probably exceeds the optimal ratio. With a little practice, squinting your eyes when taking a brief look at the set will give you a good idea about the contrast ratio even without using the light meter. A look at the camera viewfinder or studio monitor is, of course, a more accurate and reliable measuring tool. ZVL6 LIGHTS→ Measurement → contrast

CONTROLLING CONTRAST

If you feel that the contrast ratio is too high, think about what you can do to reduce it before fussing with the lighting. For example, changing the white tablecloth to a pink or light-blue one will help eliminate the contrast more readily than dimming some of the lights or asking the talent to change into slightly lighter-colored clothes.

Such help is much appreciated by the video operator (VO), also called the *shader*, who is ultimately responsible for controlling contrast. If there is too much contrast, however, even the best VOs have difficulty unless you're working with top-of-the-line cameras. By "pulling down," or clipping, the brightest areas of the scene, the VO causes the dark areas in the picture to also become compressed, and they are often rendered uniformly black. This is why you do not see much detail in the shadows of a high-contrast scene. For example, it is difficult for the camera to reproduce true skin color if the talent is wearing a highly reflective starched white shirt and a light-absorbing black jacket. If the camera adjusts for the white shirt by clipping the white level, the talent's face will go dark. If the camera tries to bring up the black level (making the black areas in the picture light enough to distinguish shadow detail), the face will wash out.

Does this mean that you have to measure all items to see whether they exceed the acceptable contrast ratio when seen together? Not at all. A few small, shiny items in the picture will not upset a limited contrast ratio, especially when using high-quality cameras. Rhinestones on a dress, for example, make the picture come alive and give it sparkle. In fact, video operators like to have something white and something black on the set so that they can set the appropriate video levels. But avoid having relatively large, extremely bright areas and extremely dark ones right next to each other.

One big advantage of shooting in the studio is that you can control the light intensity and, with it, the contrast. Even if the talent wear contrasting clothes, you can always reduce the contrast by adjusting the key and fill lights so that the differences between light and dark areas are somewhat reduced.

Here are a few tips for preventing an overly high contrast ratio.

- Be aware of the general reflectance of the objects.
 A highly reflective object obviously needs less illumination than does a highly light-absorbing one.
- Avoid extreme brightness contrasts in the same shot.
 For example, if you need to show a new line of white china, do not put it on a dark-purple tablecloth. By displaying it on a lighter, more light-reflecting cloth, you can limit the amount of light falling on the porcelain without making the tablecloth appear too dark and muddy.
- Have the talent avoid clothes whose colors are too contrasting (such as a starched white shirt with a black suit).

Many contrast problems, however, occur when shooting outdoors on a sunny day. These problems and how to solve them are explored in section 8.2.

BALANCING LIGHT INTENSITIES

Even if you have carefully adjusted the position and the beam of the key, back, and fill lights, you still need to balance their relative intensities. For example, it is not only the direction of the lights that orients the viewer in time but also their relative intensities. A strong back light with high-key, slow-falloff front lighting can suggest the early-morning sun; a generous amount of strong back light and low-key, very low-intensity front lighting can suggest moonlight.¹

There is some argument about whether to first balance the key and back lights, or the key and fill lights. Actually, it matters little which you do first so long as the end effect is a well-balanced picture. Because balancing the three lights of the lighting triangle depends on what you intend to convey to the viewer, you can't use precise intensity ratios among key, back, and fill lights as an absolute guide for effective lighting. Nevertheless, there are some ratios that have proved beneficial for a number of routine lighting assignments. You can always start with these ratios and then adjust them to your specific lighting task.

KEY-TO-BACK-LIGHT RATIO

In normal conditions back lights have approximately the same intensity as key lights. An unusually intense back light tends to glamorize people; a back light with an intensity much lower than that of the key tends to get lost on the monitor. A television performer with blond hair and a light-colored suit will need considerably less back light than will a dark-haired performer in a dark suit. The 1:1 key-to-back-light ratio (key and back lights have equal intensities) can go as high as 1:1.5 (the back light has one and a half times the intensity of the key) if you need a fair amount of sparkle or if the talent has dark, light-absorbing textured hair.

KEY-TO-FILL-LIGHT RATIO

The fill-light intensity depends on how fast a falloff you want. If you want fast falloff for dramatic effect, little fill is needed. If you want very slow falloff, higher-intensity fill is needed. As you can see, there is no single key-to-fill-

light ratio, but for starters you may want to try a fill-light intensity that is half that of the key and go from there. Remember that the more fill light you use, the less modeling the key light is doing but the smoother the texture (such as of a person's face) becomes. If you use almost no fill light, the dense shadows reveal no picture detail and you run the risk of some color distortion in the shadow areas. If, for example, a detective refers to a small scar on the left side of a woman's face and a close-up of her face shows nothing but a dense shadow where the scar should be, or when the shadow hides an important detail in a product demonstration, the key-to-fill-light ratio is obviously wrong.

If you are asked to light for a high-baselight, low-contrast scene (high-key lighting), you may want to use floodlights for both the key and the fill, with the fill burning at almost the same intensity as the key. As you know by now, *high-key* has nothing to do with the actual positioning of the key light but rather the intensity of the overall light level. The back light should probably burn with a higher intensity than the key or the fill light to provide the necessary sparkle. In a low-key scene, the back light is often considerably brighter than the key and fill lights. **SEE 8.26**

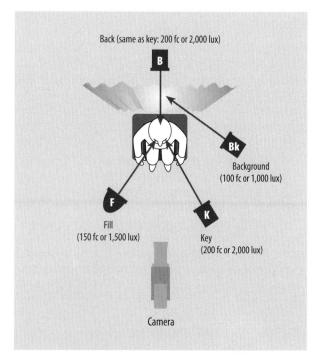

8.26 LIGHTING RATIOS

Lighting ratios differ, depending on the specific lighting task. These ratios are a good starting point.

^{1.} See Herbert Zettl, *Sight Sound Motion*, 4th ed. (Belmont, Calif.: Thomson Wadsworth, 2005), pp. 28–30.

Again, as helpful as light meters are in establishing rough lighting ratios, do not rely solely on them. Your final criterion is how the picture looks on a well-adjusted monitor.

LIGHT PLOT

The *light plot* shows: (1) the location of the lighting instruments relative to the set and the illuminated objects and areas; (2) the principal directions of the beams; and, ideally (3) the type and the size of the instruments used.

In drawing a successful light plot, you need an accurate *floor plan* that shows the scenery and the stage props, the principal talent positions, and the major camera positions and shooting angles (see section 15.2). Most routine shows, such as news, interviews, or panel shows, are relatively easy to light and do not change their lighting setup from show to show, so you don't need a light plot. If you have to light an atypical show, however, such as a graduate dance project or an interview with the university president and members of the board of trustees, a light plot makes the lighting less

arbitrary and saves the crew considerable time and energy. You can also use it again later for similar setups.

An easy way to make a light plot is to put a transparency over a copy of the floor plan and draw the lighting information on the transparency. Use different icons for spotlights and floodlights, drawing arrows to indicate the main directions of the beams. **SEE 8.27 AND 8.28** Some LDs use small cutouts of their spotlights and floodlights, which they then lay on the floor plan and move into the appropriate positions.

Try to work with the set designer (usually the art director) or the floor manager (who is responsible for putting up the set) as much as possible to have them place the set in the studio where you won't have to move any, or only a few, instruments to achieve the desired lighting. Placing the small set to suit the available lighting positions is much easier than moving the lights to suit the location of a small set.

Studio lighting is successful when you get it done on time. With due respect to creative lighting, don't fuss over a single dense shadow somewhere on the background while neglecting to light the rest of the set. If you are really

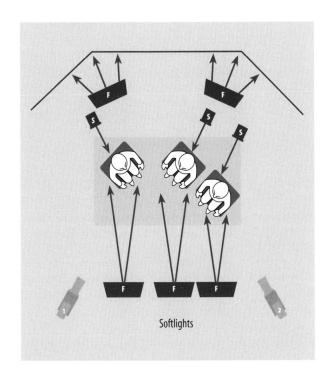

8.27 LIGHT PLOT FOR FLAT LIGHTING OF INTERVIEW

This light plot shows the slow-falloff (flat) lighting setup for a simple interview. Ordinarily, such a simple setup would not require a light plot. Note that the sketch is not to scale.

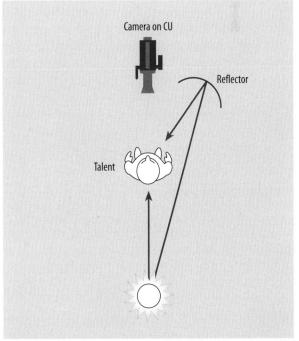

8.28 LIGHT PLOT FOR INTERVIEW, USING FLOODS AND SPOTS This interview is lighted for faster falloff. It uses spots for key and back lights, and scoops for fill and background lights.

pressed for time, turn on some floodlights and back lights that hang in approximate positions and hope for the best. More often than not, the lighting will look acceptable.

OPERATION OF STUDIO LIGHTS

When initially hanging lights, divide the studio into major performance areas and hang the appropriate instruments (spotlights and floodlights) in the triangular arrangements of the basic photographic principle. Try to position the instruments so that they can serve multiple functions, that is, light more than one person or several parts of the set. This will help you illuminate all major performance areas adequately with minimum effort and instruments.

SAFETY

In the actual operation of lighting instruments and the associated control equipment, you should heed the rule for all production activities: *safety first*.

- As mentioned in chapter 7, always wear gloves when working with active lighting instruments. The gloves will protect you from burns when touching hot barn doors or lamps and will give you some protection from electric shock.
- Always secure the lighting instruments to the battens with safety chains or cables and attach the barn doors and scrims to the lighting instruments. Check all C-clamps periodically, especially the bolts that connect the lighting instruments to the hanging device.
- Be careful when plugging in lights and when moving active (switched-on) instruments. Because the hot lamps are especially vulnerable to physical shock, try not to jolt the instrument; move it gently.
- When replacing lamps, wait until the instrument has cooled somewhat. Always turn off the instrument before reaching in to remove a burned-out lamp. As a double protection, unplug the light at the batten. *Do not touch the new quartz lamp with your fingers.* Fingerprints, or any other stuff clinging to the quartz housing of the lamp, cause the lamp to overheat and burn out. Wear gloves or, if you have nothing else, use a tissue or even your shirttail when handling the lamp.
- Watch for obstacles above and below when moving ladders. Do not take any chances by leaning way out to reach an instrument. Position the ladder so that you can work from behind, rather than in front of, the instrument. When adjusting a light, try not to look directly into it; look instead at the object to be lighted and see how the beam

strikes it. If you must look into the light, wear dark glasses and do so only briefly.

Before you start patching (assuming that you use a physical patchboard) have all dimmers and breakers in the off position. Do not "hot-patch" by connecting the power cord of the instrument to the power outlet on the batten with the breaker switched on. Hot-patching can burn your hand and also pit the patches so that they no longer make the proper connection.

PRESERVING LAMPS AND POWER

Try to warm up large instruments through reduced power by keeping the dimmer low for a short while before supplying full power. This will prolong the lamp life and the Fresnel lenses, which occasionally crack when warmed up too fast. This warm-up period (about one to three minutes) is essential for getting HMI lights up to full operation. Do not overload a circuit: it may hold during rehearsal but then go out just at the wrong time during the actual show. If extension cords start to get hot, unplug and replace them immediately with lower-gauge (thicker wire, such as 14-gauge) cables.

Do not waste energy. Dry runs (without cameras) can be done just as efficiently when illuminated by work lights as by full studio lighting. If you have movable battens, telescope hangers, or pantographs, try to bring the lights down as close as possible to the object or scene to be illuminated. As you know, light intensity drops off considerably the farther the light moves from the object. Bring the lights up full only when necessary.

USING A STUDIO MONITOR

If you intend to use a well-adjusted color monitor as a guide for lighting, you must be ready for some compromise. As noted, the lighting is correct if the studio monitor shows what you want the viewer to perceive. To get to this point, you should use the *monitor* as a guide to lighting, rather than the less direct light meter. But you may run into difficulties. The video operator may tell you that she cannot set up the cameras (adjust them for an optimal video signal) before you have finished the lighting. And your argument probably is (and should be) that you cannot finish the lighting without checking it on the monitor.

Approach this argument with a readiness for compromise because both parties have a valid point. You can do the basic lighting without the camera. An incident-light reading (foot-candle or lux) can help you detect gross inadequacies, such as insufficient baselight levels, extremely uneven illumination, or too high a contrast. With some

experience you can also tell whether a shadow is too dense for adequate reproduction of color and detail. But for the fine trimming, you need at least one camera. Ask the VO to work with you; after all, it is also the VO's responsibility to deliver optimal pictures. The single camera can be roughly set up to the existing illumination and pointed at the set. With the direct feedback of the picture on the studio monitor, you can proceed to correct glaring discrepancies or simply touch up some of the lighting as to beam direction and intensity. After this fine trimming, all cameras can be set up and balanced for optimal performance.

MAIN POINTS

- All lighting uses directional and/or diffused light.
- The key light is the principal source of illumination and reveals the basic shape of the object.
- The back light provides more definition to the object's outline, separates it from the background, and gives it sparkle.
- The fill light reduces falloff and makes the shadows less dense.
- Most television lighting setups use the basic photographic principle, or triangle lighting, of key, back, and fill lights.
- The background, or set, light illuminates the background of the scene and the set. The side light acts as additional fill or a side key. The kicker light is used to outline the contour of an object that would otherwise blend in with the background.

- Specific lighting techniques include flat lighting, continuous-action lighting, large-area lighting, high-contrast lighting, cameo lighting, silhouette lighting, chroma-key area lighting, and controlling eye and boom shadows.
- Falloff indicates how fast the lighted side of a subject changes to shadow and how dense the shadows are. Fast falloff means that the light and shadow areas are distinct and that the shadows are dense. Slow falloff means that the transition from light to shadow is more gradual and that the shadows are transparent. Generally, fast falloff means high-contrast lighting; slow fall-off means low-contrast, or flat, lighting.
- A low-key scene has a dark background with selective fast-falloff lighting and a dramatic or mysterious mood.
 A high-key scene has a light background, a generally high baselight level, and usually an upbeat, happy mood.
- Contrast is the difference between the lightest and the darkest areas in a picture as measured by reflected light.
- The contrast ratio is the contrast as measured by reflected light. The normal optimal contrast ratio is 40:1 to 50:1. It can be higher for digital cameras, which means that they can tolerate a higher contrast.
- Balancing the intensities of the various lights depends largely on the desired effect.
- The light plot indicates the location of the lighting instruments, the principal direction of their light beams, and sometimes the type and size of the instruments used.
- Exercise caution during all lighting operations. Do not look directly into the instruments, and wear gloves when handling the hot lights.

8.2

Lighting in the Field

When lighting field productions, you are not working in the studio, where all the lighting equipment is in place and ready to go. Every piece of equipment, however large or small, must be hauled to the remote location and set up in places that always seem either too small or too large for good television lighting. Also, you never seem to get enough time to experiment with various lighting setups to find the most effective one. Whatever the remote lighting task, you need to be especially efficient in the choice of instruments and their use. This section explains the techniques of field lighting and describes some of its essential requirements.

SAFETY

Primary safety concerns: electric shock, cables, and fires

■ ENG/EFP LIGHTING

Shooting in bright sunlight, in overcast daylight, in indoor light, and at night

► LOCATION SURVEY

Survey checklists and power supply

SAFETY

As in the studio, safety is a primary concern when lighting in the field. In fact, there are more safety hazards in the field than in the studio. No production, however exciting or difficult, excuses you from abandoning safety for expediency or effect.

ELECTRIC SHOCK

Be especially careful with electric power when on location. A charge of 110 volts can be deadly. Secure cables so that people do not trip over them. Every connection—from cable to power outlet, from cable to cable, and from cable to lighting instrument—can cause an electric shock if not properly joined and secured.

CABLES

String the cables above doorways or tape them to the floor and cover them with a rubber mat or flattened cardboard at points of heavy foot traffic. A loose cable not only can trip somebody but may also topple a lighting instrument and start a fire. See that all light stands are secured with sandbags.

FIRE HAZARD

As discussed in chapter 7, portable incandescent lighting instruments get very hot when turned on for only brief periods of time. Place them as far away as possible from combustible materials, such as drapes, books, tablecloths, wood ceilings, and walls. It pays to double-check. If they must be close to walls or other combustibles, insulate them with aluminum foil.

ENG/EFP LIGHTING

There is no clear-cut division between lighting for ENG and EFP, except that in electronic news gathering you often have to shoot in whatever light there is or as supplied by the camera light. But when called upon to do an interview in a hotel room or in the office of a CEO, or when covering a ceremony at the entrance to city hall, ENG and EFP lighting techniques are pretty much the same. The big difference is that in EFP you have enough lead time to survey the lighting requirements before the event is taking place; but then you may be expected to make the office of a corporate president look like the best Hollywood can muster or to illuminate the hearing room of the board of supervisors so that it rivals a courtroom scene in the latest blockbuster movie—all without adequate time or equipment.

When engaged in field lighting, you will find yourself confronted with problems both indoors and out. When outdoors you have to work with available light—the illumination already present at the scene. At night you must supplement available light or provide the entire illumination. Although you have a little more time in EFP than in ENG, you must still work quickly and efficiently to obtain

not only adequate lighting but also the most effective lighting possible under the circumstances.

SHOOTING IN BRIGHT SUNLIGHT

Most lighting problems occur when you have to shoot in bright sunlight. A shooter's nightmare is having to cover a mixed choir, with the women dressed in starched white blouses and the men in white shirts and black jackets, with half of them standing in the sun and the rest of them in a deep shadow against a sun-flooded white building. Even a good digital ENG/EFP camcorder would have trouble handling such high contrast.

If you put the camera in the auto-iris mode, it will faithfully read the bright light of the shirts and the light background and close its iris for optimal exposure. The problem is that the drastic reduction of light coming through the lens will darken equally drastically the shadow area and the people standing in it. The black jackets will turn into a dull black and lose all detail. If you switch to manual iris to open the aperture somewhat to achieve some transparency in the shadows and the black jackets, the white shirts and the sunlit background will be overexposed. Worse, the highlights on the perspiring foreheads and occasional bald spots of the choir members will begin to "bloom," turning the skin color into strangely luminescent white spots surrounded by a pinkish rim.

Should you give up? No, even though your options are somewhat limited, here are some potential remedies:

- Whenever possible, try to position the talent in a shadow area, away from a bright background. You could probably move the whole choir in the shadow and away from the sunlit building. For a single on-camera person, you can always create a shadow area with a large umbrella.
- Ask whether the male choir members can take off their black jackets. This is worth a try, even though you will probably be turned down.
- Shoot from an angle that avoids the white building in the background.
- Use a reflector to slow down falloff. **SEE 8.29 AND 8.30**
- Control the aperture. Once the talent is in the shadow area, you can put the camera back in auto-iris mode for an appropriate exposure. If this fails to correct the problem, switch the iris back to manual and see whether you can get the right exposure.
- Use a neutral-density filter. The *neutral density* (ND) filters act like sunglasses of varying densities, reducing the

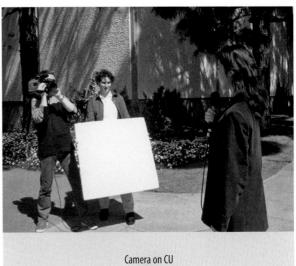

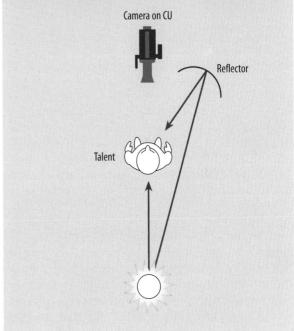

8.29 USING A REFLECTOR: SHOOTING AGAINST THE SUN When shooting against the sun, reflect as much sunlight as possible back to the talent with a simple reflector (in this case a white card).

amount of light that falls on the pickup device without distorting the actual colors of the scene. In fact, the ND filter seems to reduce extreme brightness while still revealing detail in the shadow areas. It will certainly eliminate the red-rimmed flares on the shirts and the perspiring foreheads of the choir, without rendering the rest of the people invisible.

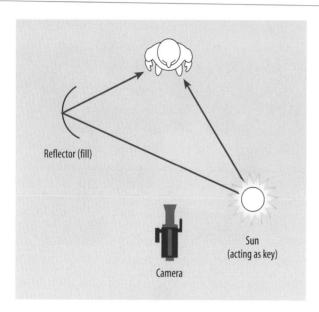

8.30 USING A REFLECTOR: SHOOTING WITH THE SUN When shooting in bright sunlight, the dark shadows can be easily lightened with a reflector.

What if you are running after a news story and have no time for any of these remedies? Put the camera in autoiris mode—or, if you have time, pop in a neutral density filter—and hope for the best.

ZVL7 ➤ LIGHTS → Field → outdoor | indoor | mixed | try it

SHOOTING IN OVERCAST DAYLIGHT

The ideal light for outdoor shooting is an overcast day: the clouds or fog act as diffusers for the harsh sunlight, providing an even illumination similar to that of softlights. Do not be surprised if you have to use an ND and/or color-correction filter. The light of a cloudy day is often surprisingly bright and usually has a high color temperature.

Even in diffused lighting, try to avoid an overly bright background. If you have to shoot against a light background, zoom in on the person (thereby avoiding as much of the background as possible). Be sure that you have manual iris control, and adjust the iris to meet the light requirements of the person rather than the background. It is better to have an overexposed background than an underexposed person. Despite the highly diffused light, try to use a reflector on the person.

SHOOTING IN INDOOR LIGHT

You encounter various amounts and types of light when shooting indoors. Some interiors are illumi-

nated by the daylight that comes through large windows, others by high-color temperature fluorescent banks that make up a light ceiling. Still others, such as windowless hotel rooms, have desk and floor lighting that provide a romantic mood but hardly the proper illumination for good television pictures. The major problem here is not so much how to supply additional light, but how to place the instruments for optimal aesthetic effect and how to match the various color temperatures. In all cases try first to maintain the photographic principle of key, fill, and back lights. If this isn't possible, try to adjust the setup so that you maintain at least the effect of triangle lighting. Whenever possible try to maintain a back-light effect; it is the back light that distinguishes good lighting from mere illumination.

Let's assume that you are lighting an interview of the CEO of a software company. Except for some cutaway close-ups of the interviewer at the end of the show, the CEO is seen in a close-up for most of the interview. Let's put her in three different environments: (1) in a windowless hotel room, (2) in a hotel room with a window, and (3) in her office with a large picture window behind her desk.

Windowless room In a room with no windows, you can simply set up portable, open-face lights in a typical triangle fashion. Use a diffused key light, a more focused back light of the same kind, and a reflector or softlight (or a diffusion tent) for the fill (see figure 8.5). If you have a fourth instrument, you can use it as a background light. If only two instruments are available, use an open-face spot as a back light and use a diffused light (open-face spot with scrim, tent, or umbrella) as a key, placed so that most of the face is illuminated. The spill of the key will also take care of the background lighting. **SEE 8.31**

If the director insists on cross shooting with two cameras to catch the immediacy of the interviewer's asking questions or reacting to the CEO, you can still get by with two or three instruments. Place two open-face spots or small Fresnel spots with tents, scrims, or umbrella reflectors so that they shine over the shoulder of the participants sitting opposite each other. In this cross-keying, the two lights now serve as multifunction key and back lights. You can use the third instrument as general fill light. This lighting setup can also be used for an interview in a hallway, living room, or any other such location. **SEE 8.32**

Room with window When there is a window in the room, you can use it as a key or even a back light. If you use the window as a key, you need a reflector or a fill light on the opposite side. In any case you need a strong back light. To

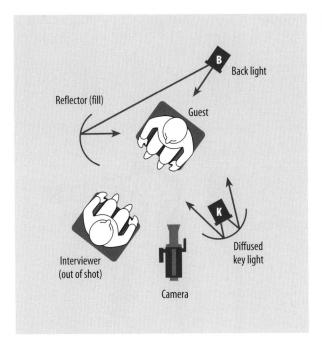

8.31 TRIANGLE INTERVIEW LIGHTING

Section 8.2

This one-person lighting setup uses two instruments. The diffused key light is an open-face spot with a scrim, a tent, or an umbrella. The back light is a spread or focused open-face spot. If fill light is necessary, it can be created with a softlight or a reflector. You can use an additional softlight as a background light. Note that the interviewee is looking at the interviewer, who is sitting or standing next to the camera, out of the shot.

match the outdoor color temperature of the window light, both the fill and back lights need either 5,600K lamps or 3,200K lamps with blue gels to raise their color temperature. **SEE 8.33** The better way of lighting is to position the CEO so that the window acts as a back light—without letting it get into the shot. You can then use a single diffused 5,600K key light (an open-face spot with 5,600K lamp or a 3,200K lamp with a blue gel) to illuminate most of her face, eliminating the need for a fill light. **SEE 8.34**

Panoramic office window A typical problem is having to shoot against a large window. If, for example, the CEO insists on making her statement from behind her desk that is located in front of a large picture window, your lighting problem is identical with that of a person standing in front of a bright background: If you set the iris according to the background brightness, the person in front tends to appear in silhouette. If you adjust the iris for the person in front, the background is overexposed. Here are some possible solutions:

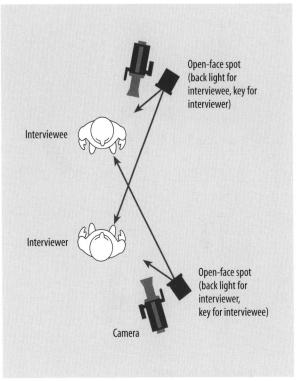

8.32 CROSS KEYING FOR INTERVIEW

The two portable lights serve multiple functions: key and back lights for the interviewer and the interviewee. If you have a third light, use it as fill.

- Draw the drapes or the blinds and light the person with portable instruments. Or go to a tight close-up and cut out as much background as possible. Unfortunately, many windows do not have drapes or blinds, and not all company officials look good in extreme close-up.
- Move the camera to the side of the desk and have the person face the camera. You can then shoot parallel to the window. You can use the light from the window as key, and fill with a large reflector or an additional light on a stand (see figure 8.33).
- If the person insists on having the window in the background, you must cover it with large color temperature filters and/or ND filters (plastic sheets) of varying densities. Use two strong but diffused open-face instruments (5,600K) as key and fill, or use a large, highly efficient reflector that bounces the light from the window onto the CEO's face. Bear in mind that these procedures take up a great amount of time and are generally left to EFP.

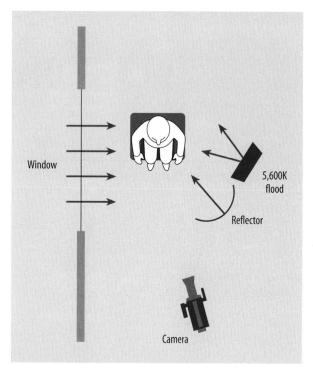

8.33 WINDOW AS KEY LIGHT

The daylight shining through a window can serve as the key light, and a reflector as the fill light. If you use a portable light as fill and/or back light, you need to bring its color temperature up to the 5,600K daylight standard.

Take a picture of the window view and use it as a chroma-key video source (see chapter 14).

Large-area indoor lighting Sometimes you have to deal with groups of people who are gathered in locations with inadequate illumination. Typical examples are meeting rooms, hotel lobbies, and hallways. Most of the time, a camera light provides enough illumination to cover the speaker and individual audience members. If you are to do extensive coverage of such an event, however, you need additional illumination.

The quickest and most efficient way to light such a location is to establish a general, nondirectional baselight level. Use two or three open-face spots or V-lights and bounce the light off the ceiling or walls. If you have light-reflecting umbrellas, direct the lights into the umbrellas and place them so that you can cover the event area. You will be surprised by how much illumination you can get out of a single V-light when diffused by an umbrella. If that is not possible, direct the lights on the group, but diffuse the

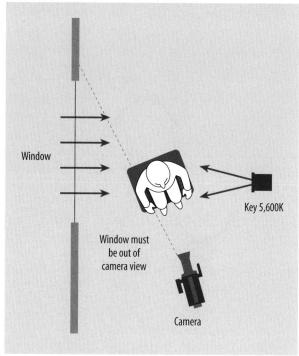

8.34 WINDOW AS BACK LIGHT

You can use a window as back light so long as you place the talent with the window out of the shot. The key light can be a diffused open-face spot that burns at 5,600K.

light beam with scrims. The most effective method is to use portable HMI, quartz, or fluorescent softlights and flood the active area. Always be sure to white-balance the camera for the light in which the event actually takes place.

As you probably noticed, all these lighting techniques aim to establish a high baselight level. Even when pressed for time, try to place one or two diffused back lights out of camera range. They will provide sparkle and professional polish to an otherwise flat scene. **SEE 8.35**

Working with fluorescents The basic problem of working with the fluorescent lights used in stores, offices, and public buildings is their color temperature. It is usually higher than the 3,200K indoor standard of incandescent lights. Even if some fluorescent tubes burn at the warmer indoor color temperature, they have a strange greenish blue tint. So if you turn on the camera light for additional illumination, you are confronted with two color temperatures. Some lighting people advise turning off the fluorescents altogether when working with quartz lights (3,200K), but

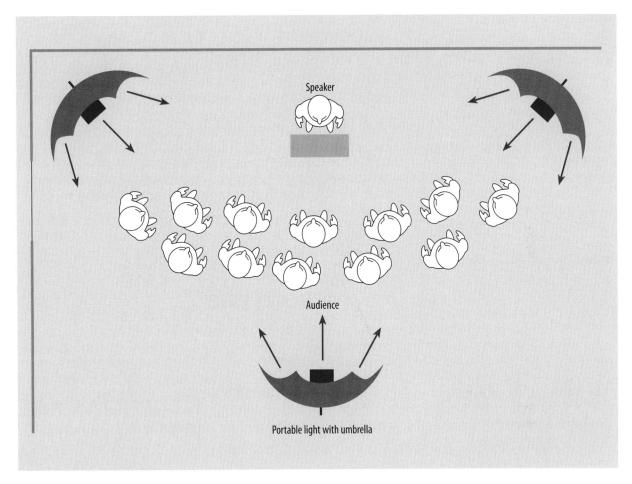

8.35 LARGE-AREA LIGHTING

To establish sufficient baselight over a large area, you need highly diffused light. Here three portable incandescent lights and light-diffusing umbrellas provide maximally diffused light over the entire area. You can, of course, use fluorescent or HMI lights in place of the quartz lights.

this is unrealistic. If you need to get a fast-breaking story and you shoot in a hallway that is illuminated by fluorescent lights, you certainly do not have time to locate and persuade the building manager to turn off the lights and then to relight the scene before starting to shoot.

If the fluorescent lights give enough illumination, simply select the appropriate color temperature filter in the camera (to bring down the high color temperature of the fluorescents) and white-balance the camera with the available light. If you have to use a camera light for additional illumination, either boost the color temperature of the camera light (by inserting a dichroic filter that often comes with the camera light) or white-balance the camera with the illumination provided by the camera light (3,200K).

As mentioned in chapter 7, the portable incandescent lights—including the camera light—are strong enough to wash out the fluorescent baselight. If available, the better solution, of course, is to use floodlights that burn at the outdoor color temperature of 5,600K or floodlights whose color temperature is raised by light-blue gels.

One word of caution: Despite all the praise for fluorescent field lights, stay away from them if color reproduction is critical. Even the best fluorescent lamps do not give you the color mix for white light that you get from incandescent and HMI lamps. Careful white-balancing will help, but you may still discover a greenish or bluish tint to your pictures that is difficult, if possible at all, to correct in post-production.

SHOOTING AT NIGHT

When covering a nighttime news event, you will most often use the camera light or a single light that is operated by the camera assistant. Here are some points to consider:

- Assuming that you have only one camera light and no assistant, use the camera light and aim it straight at the field reporter. The closer the reporter is to the camera, the stronger the illumination. You can change the light intensity by moving just one or two steps toward or away from the reporter and zoom in or out to compensate for your repositioning. Almost all professional camera lights have diffusion filters that you can use to soften the shadow on the reporter's face.
- If you have an assistant, he or she can hold the light somewhat above camera level (to avoid shining the light directly into the reporter's eyes) and a little to the side of the camera so that the single camera light acts as a key light. If you are fairly close to the event, put this single light into a semiflood position to avoid hot spots. Take advantage of any additional light source, such as a lighted store window or a street lamp, as fill by positioning the subject appropriately. Don't worry about mixing color temperatures; viewers readily accept color distortions when seeing events shot at night. You could also use the store window as a key light and have your assistant hold a reflector on

the opposite side to generate some fill. Once again, avoid shooting against a brightly lighted background.

- If you are to cover a brief feature report outside the county hospital, for example, and you are not under great time pressure, use a portable light mounted on a light stand as a key. Use the lighted hospital door or a window as fill or back light. In this case position the field reporter so that he or she is not directly in front of the door or window but off to one side and out of camera range (see figure 8.34). Whenever possible, plug the lights into regular household outlets rather than using batteries as a power source.
- If the reporter needs a remote teleprompter, check that the prompting device is working before the reporter goes on the air. As a reporter, ask the production person in charge to run the first few lines for you.

LOCATION SURVEY

One of the most important aspects of lighting for EFP is a thorough *location survey* of the remote site. **SEE 8.36** The survey checklists in figure 8.36 are intended for relatively simple productions, as are all other discussions of EFP. (For more-detailed information on location surveys, see the remote survey section in chapter 20). The lighting for large and complex electronic field productions is more closely related to motion picture techniques and is

8.36 EFP LOCATION SURVEY

INDOORS OUTDOORS AVAILABLE LIGHT Is the available light sufficient? If not, what additional lights Do you need any additional lights? Where is the sun in relation do you need? What type of available light do you have? to the planned action? Is there enough room to place the Incandescent? Fluorescent? Daylight coming through windows? necessary reflectors? PRINCIPAL BACKGROUND Is there any action planned against a white wall? Are there How bright is the background? Even if the sun is not hitting the windows in the background? If so, do they have curtains, drapes, background at the time of the survey, will it be there when the or venetian blinds that can be drawn? If you want to use the actual production takes place? When shooting at the beach, daylight from the window, do you have lights that match the does the director plan to have people perform with the ocean as color temperature of the daylight (5,600K)? If the window is the background? You will need reflectors and/or additional lights too bright, or if you have to reduce the color temperature coming (HMIs) to prevent the people from turning into silhouettes, through the window, do you have the appropriate ND or color unless the director plans on ECUs most of the time. filters to attach to the window? You will certainly need some reflectors or other type of fill-light illumination.

8.36 EFP LOCATION SURVEY (continued)

OUTDOORS INDOORS CONTRAST If there are dense shadows or if the event takes place in Does the production take place in bright sunlight? Can the scene high-contrast areas (sunlight and shadows), you need extra fill be moved into the shadow area? If not, you must then provide for a generous amount of fill light (reflectors and/or HMI spotlights) light and/or ND filters to reduce the contrast. to render the shadows transparent, or ND filters to reduce the glare of overly bright areas. LIGHT POSITIONS Can you place the lights out of camera range? What lighting If you need reflectors or additional lights on stands, is the supports do you need (light stands, gaffer grip, clamps)? Do you ground level enough for the stands to be securely placed? If outneed special mounting devices, such as battens or cross braces? doors, will you need to take extra precautions because of wind? (Take plenty of sandbags along, or even some tent stakes and Are the lighting instruments far enough away from combustible rope, so that you can secure the light stands in case of wind.) materials? Are the lights positioned so that they do not interfere with the event? People who are not used to television complain mostly about the brightness of the lights. POWER REQUIREMENTS Your main concern will be power and how to get it to the lighting You do not need to use lighting instruments very often when instruments. Is the necessary power available nearby? Do you need shooting outdoors unless you shoot at night or need to fill in particularly dense shadows that cannot be reached with a generator? If you can tap available power, make sure you can tell the engineer in charge the approximate power requirement a simple reflector. for all lights. (Simply add up the wattage of all the lights you plan to use, plus another 10 percent to ensure enough power.) Do you have enough extension cords to reach all the lighting instruments? Do you know exactly where the outlets are, what the rating of the circuits is, and which outlets are on the same circuit? Make a rough sketch of all outlets and indicate the distance to the corresponding light or lights. What adapters do you need to plug lights into the available outlets? Do you have the necessary cables, extension cords, and power strips so that you can get by with a minimum of cable runs? In the projected cable runs, have you taken all

not addressed here. But even in a relatively simple EFP, you will find that the power supply is one of the key elements for good remote lighting.

POWER SUPPLY

possible safety precautions?

In EFP you have to work with three types of power for lighting instruments: household current (usually from 110 to 120 volts), generators, and 12V or 30V batteries.

The most frequently used power supply is household current. When using regular wall outlets, be aware of the power rating of the circuits, which is usually 15 or 20 amps (amperes) per circuit. This rating means that you can theoretically plug in a 1,500W (or 2,000W) instrument, or any combination of lights that does not exceed 1,500 (or 2,000) watts, without overloading the circuit, provided nothing else is on the same circuit. But that is not always wise to

8.37 (ALCULATING	ELECTRIC POWER	REQUIREMENTS
---------------	------------	----------------	--------------

	WATTAGE OF LAMP	NUMBER OF INSTRUMENTS PER 15-AMP CIRCUIT
To find the maximum load (watts) for a single circuit, use the following	100	15
formula: amperes × volts = watts	150	10
The ampere rating of a standard household circuit is 15 amps (normally	175	9
stamped on the circuit breaker). This means that the circuit can theoretically hold a maximum load of 15 amps \times 110 volts = 1,650 watts.	200	7
To be safe always figure 100 volts instead of 110 volts:	350	4
15 amps × 100 = 1,500 watts	500	3
To calculate how many instruments to plug into a single circuit, divide	750	2
their total wattage into 1,500 watts (maximum load). The table lists the number of instruments of a certain wattage that you can safely	1,000	1
plug into a single 15-amp circuit.	1,500	1

do. Recall the discussion about extension cords that build up additional resistance, especially when warm. To be on the safe side, *do not load up a single circuit to full capacity*. Otherwise, you may find that the lights go out just at the most important part of the shoot.

You can find the capacity of the circuit by checking its fuse or breaker. Each breaker is labeled with the number of amps it can handle. You can now figure the total wattage capacity of each circuit: simply multiply the number of amps of the circuit (15 or 20 amps) by 100 (assuming the household current rates between 110 and 120 volts). This gives you an upper limit: 1,500 watts for a 15-amp breaker (100 volts \times 15 amps = 1,500 total wattage) or 2,000 watts for a 20-amp breaker (100V = 2,000W). But don't press your luck. Try to use lower-wattage instruments per circuit to ensure that the lights will work properly during the entire production. **SEE 8.37**

If you need to power more lights than a single circuit can handle, plug them into different circuits. But how do you know which outlets are on separate circuits?

Determining the circuits Normally, several double wall outlets are connected to a single circuit. You can determine which outlets are on the same circuit by plugging one low-powered lamp into a particular outlet. Find the specific circuit breaker that turns off the lamp. Switch the breaker on again. The light should light up again. Now plug the light into the next convenient outlet and switch off the

same circuit breaker or fuse. If the light goes out, the plugs are on the same circuit. If the light stays on, it's a different circuit and you are safe to use it.

Safe power extensions Obviously, you need enough extension cords to get from the outlets to the lighting instruments. You can minimize cable runs by using power strips (multiple-outlet boxes), especially if you use low-wattage instruments. The larger the wires in the extension cords (lower gauge ratings), the more wattage they can handle without getting unduly hot. Have enough and various kinds of adapters available so that lights can be plugged into the existing outlets.

Whenever there is doubt about the availability or reliability of power, use a generator, the responsibility of which falls to the engineering crew. The circuit ratings and the allowable combined wattage of the lights per circuit still apply.

For relatively simple on-location productions, you may power the lights with batteries. First check whether the lamps in the portable lights are appropriate for the voltage of the battery. Obviously, you cannot use a 12-volt lamp with a 30-volt battery. Then check that the batteries are properly charged and that there are enough spares for the duration of the production. Turning off the lights whenever possible saves battery power and greatly extends the life of the lamps.

MAIN POINTS

- When shooting in bright sunlight, try to place the talent in the shade rather than the sun. If you must shoot in the sun, use a reflector and/or a neutral density (ND) filter to reduce contrast.
- The best outdoor shooting light is an overcast day. The clouds act as a giant diffusion filter.
- Use the basic photographic principle when lighting a single-person interview in a windowless room. If you have only two instruments, use a softlight from the front as key and fill and use a second instrument as a back light. When cross shooting use two instruments to fulfill key- and backlight functions.
- When a window is present, use it for fill or back light. Any indoor lights must then burn at 5,600K. Gel your 3,200K indoor lights with light-blue media, or use 5,600K lamps. Use a large panoramic window for the key light or cover it with a curtain and use a triangle lighting setup. If the window is in the shot, filter the intensity of the light and lower the color temperature with gels on the window, and add 3,200K key and fill lights.
- When shooting in fluorescent light, use 5,600K lights for additional key and back lights, or "wash out" the fluorescent ceiling lights with incandescent key, back, and fill lights.
- When shooting at night, use the camera light as the principal light source if no other light is available. Use a diffusion filter on the camera light and any other available light or a reflector for fill.
- Before doing any EFP lighting, conduct a location survey.
- The formula for figuring the electric power rating is watt = volt × ampere.
- When powering portable lights with household current, check the capacity of the circuits and do not overload them.

ZETTL'S VIDEOLAB

For your reference, or to track your work, each *Video-Lab* program cue in this chapter is listed here with its corresponding page number.

ZVL1 LIGHTS→ Color temperature→ white balance | controlling | try it 159

ZVL2 LIGHTS→ Color temperature→ light sources 160

ZVL3 LIGHTS→ Triangle lighting→ key | back | fill | background | try it 163

ZVL4 LIGHTS→ Design→ high key | low key 168

ZVL5 LIGHTS→ Design→ silhouette 170

ZVL6 LIGHTS→ Measurement→ contrast 173

ZVL7 LIGHTS→ Field→ outdoor | indoor | mixed | try it 180

9

Audio: Sound Pickup

We are usually so engrossed in the barrage of colorful pictures when watching television that we are often totally unaware of the sound—unless there is an audio problem. All of a sudden we realize that without sound we have a hard time following what is going on. But so long as we can hear the sound track, we can turn away from the TV and still know pretty much what's happening on-screen. But isn't a picture worth a thousand words? Apparently not in television. Because so much information is transmitted by someone talking, the infamous "talking head" is not such a bad production technique after all, provided the person talking has something worthwhile to say.

Sound is important for establishing mood and intensifying an event. A good chase sequence invariably has a barrage of sounds, including agitated music and squealing tires. The sound track also helps us connect the visual fragments of the relatively small, low-definition television image to form a meaningful whole.

If sound is, indeed, such an important production element, why do we fail to have better sound on television? Even when you produce a short scene as an exercise in the studio, you will probably notice that although the pictures may look acceptable, it is usually the sound portion that could stand some improvement. It is often assumed, unfortunately, that by sticking a microphone into a scene at the last minute the audio requirements

have been satisfied. Don't believe it. Good television audio needs at least as much preparation and attention as the video portion. And, like any other production element, television audio should not simply be added—it should be *integrated* into the production planning from the very beginning.

Section 9.1, How Microphones Hear, covers the sound pickup portion of *audio* (from the Latin verb *audire*, "to hear"), including the electronic and operational characteristics of microphones. In Section 9.2, How Microphones Work, you learn about the more technical aspects of sound-generating elements and the various microphone uses in ENG/EFP.

KEY TERMS

- **audio** The sound portion of television and its production. Technically, the electronic reproduction of audible sound.
- cardioid Heart-shaped pickup pattern of a unidirectional microphone.
- **condenser microphone** A microphone whose diaphragm consists of a condenser plate that vibrates with the sound pressure against another fixed condenser plate, called the *backplate*. Also called *electret* or *capacitor microphone*.
- **direct insertion** Recording technique wherein the sound signals of electric instruments are fed directly to the mixing console without the use of speaker and microphone. Also called *direct input*.
- **dynamic microphone** A microphone whose sound pickup device consists of a diaphragm that is attached to a movable coil. As the diaphragm vibrates with the air pressure from the sound, the coil moves within a magnetic field, generating an electric current. Also called *moving-coil microphone*.
- **fishpole** A suspension device for a microphone; the mic is attached to a pole and held over the scene for brief periods.
- flat response Measure of a microphone's ability to hear equally well over its entire frequency range. Is also used as a measure for devices that record and play back a specific frequency range.
- **foldback** The return of the total or partial audio mix to the talent through headsets or I.F.B. channels. Also called *cuesend*.
- **frequency response** Measure of the range of frequencies a microphone can hear and reproduce.
- **headset microphone** Small but good-quality omni- or unidirectional mic attached to padded earphones; similar to a telephone headset but with a higher-quality mic.

- **impedance** Type of resistance to the signal flow. Important especially in matching high- or low-impedance microphones with high- or low-impedance recorders.
- **lavaliere microphone** A small microphone that can be clipped onto clothing.
- **omnidirectional** Pickup pattern in which the microphone can pick up sounds equally well from all directions.
- phantom power The power for preamplification in a condenser microphone, supplied by the audio console rather than a battery.
- **pickup pattern** The territory around the microphone within which the microphone can "hear equally well," that is, has optimal sound pickup.
- **polar pattern** The two-dimensional representation of a microphone pickup pattern.
- **ribbon microphone** A microphone whose sound pickup device consists of a ribbon that vibrates with the sound pressures within a magnetic field. Also called *velocity mic*.
- **shotgun microphone** A highly directional microphone for picking up sounds from a relatively great distance.
- **system microphone** Microphone consisting of a base upon which several heads can be attached that change its sound pickup characteristic.
- unidirectional Pickup pattern in which the microphone can pick up sounds better from the front than from the sides or back.
- wireless microphone A system that transmits audio signals over the air rather than through microphone cables. The mic is attached to a small transmitter, and the signals are received by a small receiver connected to the audio console or recording device. Also called RF (radio frequency) mic or radio mic.

9.1

How Microphones Hear

The *pickup* of live sounds is done through a variety of microphones. How good or bad a particular microphone is depends not only on how it is built but especially on how it is used. Section 9.1 focuses on the specific make and use of microphones.

► ELECTRONIC CHARACTERISTICS OF MICROPHONES

Sound-generating elements (dynamic, condenser, and ribbon),
pickup patterns (omnidirectional and unidirectional), polar
patterns, pop filter, windscreen, and system microphones

OPERATIONAL CHARACTERISTICS OF MICROPHONES Mobile microphones (lavaliere, hand, boom, headset, and wireless) and stationary microphones (desk, stand, hanging, hidden, and long-distance)

ELECTRONIC CHARACTERISTICS OF MICROPHONES

Choosing the most appropriate microphone, or mic (pronounced "mike"), and operating it for optimal sound pickup requires that you know about three basic electronic characteristics: (1) sound-generating elements, (2) pickup patterns, and (3) microphone features.

SOUND-GENERATING ELEMENTS

All microphones *transduce* (convert) sound waves into electric energy, which is amplified and reconverted into sound waves by the loudspeaker. The initial conversion is accomplished by the *generating element* of the microphone.

There are three major types of sound-converting systems, which are used to classify microphones: *dynamic, condenser*, and *ribbon*. Section 9.2 explores how the various types of microphones transduce sound into electrical signals.

Dynamic microphones These are the most rugged. *Dynamic microphones*, also called *moving-coil microphones*, can tolerate reasonably well the rough handling that television microphones frequently (though unintentionally) receive. They can be worked close to the sound source and still withstand high sound levels without damage to the microphone or excessive *input overload* (distortion of very high-volume sounds). They can also withstand fairly extreme temperatures. As you can probably guess, they are an ideal outdoor mic.

Condenser microphones Compared with dynamic mics, *condenser microphones* are much more sensitive to physical shock, temperature change, and input overload, but they usually produce higher-quality sound when used at greater distances from the sound source. Unlike dynamic mics, the condenser mic (or, more precisely, the *electret condenser*) needs a small battery to power its built-in preamplifier. Although these batteries last for about a thousand hours, you should always keep spares on hand, especially if you are using condenser mics for ENG or EFP. Many times condenser mic failures can be traced to a dead or wrongly inserted battery. **SEE 9.1**

Condenser mics can also be powered through the appropriate voltage supplied by the audio console or mixer

9.1 POWER SUPPLY BATTERY FOR CONDENSER MICROPHONE

Many condenser microphones are powered by a battery rather than from the console (phantom power); be sure to observe the + and – poles as indicated on the battery housing.

through the audio cable. This method of supplying power to the mic's preamplifier is called *phantom power*.

Ribbon microphones Similar in sensitivity and quality to the condenser mics, *ribbon microphones* produce a warmer sound, frequently preferred by singers. Unlike condenser mics, which you may use outdoors under certain circumstances, ribbon mics are strictly for indoor use. They are also called *velocity microphones*. **ZVL1** AUDIO→ Microphones→ mic choice | transducer

PICKUP PATTERNS

Whereas some microphones, like our ears, hear sounds from all directions equally well, others hear sounds better when they come from a specific direction. The territory within which a microphone can hear equally well is called its *pickup pattern*; its two-dimensional representation is called the *polar pattern*, as shown in figures 9.2 through 9.4.

In television production you need to use both omnidirectional and unidirectional microphones, depending on what and how you want to hear. The *omnidirectional* microphone hears sounds from all (*omnis* in Latin) directions more or less equally well. **SEE 9.2** The *unidirectional* microphone hears better in one (*unus* in Latin) direction—the front of the mic—than from its sides or back. Because the polar patterns of unidirectional microphones are roughly heart-shaped, they are called *cardioid*. **SEE 9.3**

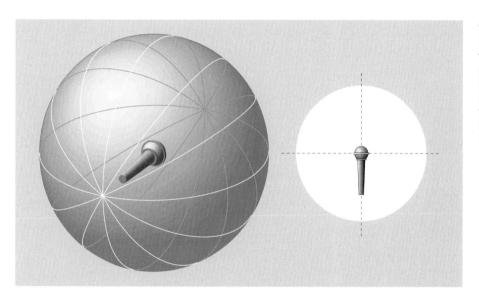

9.2 OMNIDIRECTIONAL PICKUP AND POLAR PATTERNS

The omnidirectional pickup pattern is like a small rubber ball with the mic in its center. All sounds that originate within its pickup pattern are heard by the mic without marked difference.

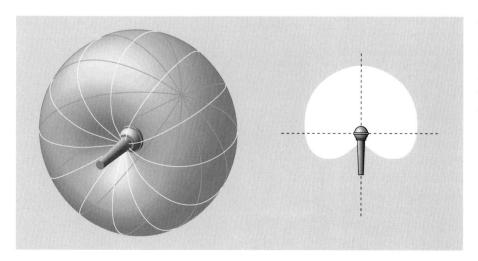

9.3 CARDIOID PICKUP AND POLAR PATTERNS

The heart-shaped pickup pattern makes the mic hear better from the front than from the sides. Sounds to its rear are suppressed.

9.4 HYPERCARDIOID PICKUP AND POLAR PATTERNS

The supercardioid and hypercardioid pickup patterns narrow the sound pickup. They have a long but narrow reach in front and eliminate most sounds coming from the sides. They also hear sounds coming from the back.

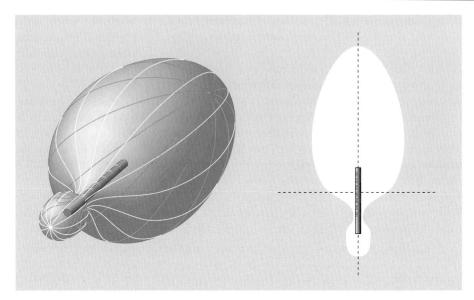

The *supercardioid, hypercardioid,* and *ultracardioid* microphones have progressively narrower pickup patterns, which means that their hearing is more and more concentrated in the front. Their claim to fame is that they can hear sounds from far away and make them appear to be relatively close. These mics also hear sounds that are in back of them; but because they excel on hearing in one direction (a narrow path in front), they still belong to the unidirectional group. **SEE 9.4**

Which type you use depends primarily on the production situation and the sound quality required. If you are doing a stand-up report (standing in front of the actual scene) on conditions at the local zoo, you would want a rugged, omnidirectional mic that not only favors speech but also picks up some of the animal sounds for authenticity. If, on the other hand, you are videotaping a singer in the studio, you should probably choose a high-quality mic with a more directional cardioid pickup pattern. To record an intimate conversation between two soap opera characters, a hypercardioid shotgun mic is probably your best bet. Unlike the omnidirectional mic, the shotgun mic can pick up their conversation from relatively far away without losing sound presence (the closeness of the sound), while ignoring to a large extent many of the other studio noises, such as people and cameras moving about, the humming of lights, or the rumble of air conditioning. A table of the most common microphones and their characteristics is included in section 9.2 (see figure 9.34). ZVL2 AUDIO→ Microphones → pickup patterns

MICROPHONE FEATURES

Microphones that are held close to the mouth have a built-in *pop filter*, which eliminates the sudden breath pops that might occur when someone speaks directly into the mic. **SEE 9.5** When used outside, all types of microphones are susceptible to wind, which they reproduce as low rumbling noises. To reduce wind noise, put a *windscreen* made of acoustic foam rubber over the microphone. The popular name is *zeppelin* because it resembles an airship. **SEE 9.6** To cut the wind noise even more, you need to pull a *windsock*,

9.5 POP FILTER
The built-in pop filter eliminates breath pops.

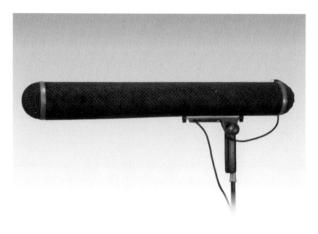

9.6 WINDSCREEN

The windscreen, normally made of acoustic foam rubber, covers the whole microphone to reduce the low rumble of wind noise.

or *wind jammer*, over the windscreen. The wind jammer is made from synthetic material and resembles more a mop than a sophisticated audio device (see figure 9.15). Whatever you use, bear in mind that the rumble of wind noise cannot be eliminated totally. The only way to have no wind noise on the videotape is to shoot when there is no wind. You can, however, use certain filters in postproduction that can reduce or eliminate some wind noise.

To reduce the need for microphones with various pickup patterns, you can use a *system microphone*, which consists of a base upon which several "heads" can be attached. These heads change the pickup pattern from omnidirectional to hypercardioid. As convenient as this may be, you will find that most audio engineers favor the individual mics built for specific applications.

OPERATIONAL CHARACTERISTICS OF MICROPHONES

Some microphones are designed and used primarily for sound sources that are moving, whereas others are used more for stationary sound sources. When grouped according to their actual operation, there are *mobile* and *stationary* microphones (see figure 9.34). Of course, any of the mobile mics can be used in a stationary position, and the stationary mics can be moved about if the production situation so requires.

The mobile microphones include (1) lavaliere, (2) hand, (3) boom, (4) headset, and (5) wireless mics.

The stationary microphones include (1) desk, (2) stand, (3) hanging, (4) hidden, and (5) long-distance mics.

LAVALIERE MICROPHONES

The first of the mobile type, the *lavaliere microphone*, usually referred to as a *lav*, is probably the most frequently used on-camera microphone in television. The high-quality lavalieres, which range in size from a small pushbutton on your home telephone to the eraser section on the back of your pencil, can be fastened to clothing with a small clip. Because of their size, they are unobtrusive and look more like jewelry than a technical device. **SEE 9.7**

Lavaliere microphones are omnidirectional or unidirectional, with a dynamic or condenser sound-generating element. They are designed primarily for voice pickup. The quality of even the smallest one is amazingly high. Once the lav is properly attached to the performer (approximately 5 to 8 inches below the chin, on top of the clothes, and away from anything that could rub or bang against it), the sound pickup is no longer a worry. The audio engineer also has less difficulty *riding the gain* (adjusting the volume) of the lavaliere than the boom mic or hand mic. Because the distance between the mic and the sound source does not change during the performance, an even sound level can be achieved more easily than with other mobile microphones.

The use of lavaliere microphones frees the lighting people from "lighting around the boom" to avoid shadows. They can concentrate more on the aesthetic subtleties of lighting as required by the scene.

Although the action radius of performers is still limited by the lavaliere cable, the cable is flexible enough that they can move quickly and relatively unrestricted in a limited studio area. For greater mobility you can plug the lavaliere into a small transmitter, which you can clip on a

9.7 LAVALIERE MICROPHONE

This lavaliere mic is properly attached for optimal sound pickup.

belt or put in a coat pocket, and use it as a wireless mic (see figure 9.23). Despite their small size and high-quality sound pickup characteristics, lavs are durable and relatively immune to physical shock. Because they are so small and lightweight, some production people unfortunately take much less care when handling a lav than with other, larger mics. If you happen to drop a lavaliere, or any other mic, check it immediately to see if it is still operational.

When to use lavaliere microphones Here are some typical productions that use lavs as the primary microphone:

News The lavaliere is the most efficacious sound pickup device for all types of indoor news shows and interviews. You can also use it outdoors with a small windscreen attached for ENG/EFP.

Interviews So long as the interview takes place in one location, the wearing of lavaliere mics by the interviewer and each guest ensures good, consistent voice pickup.

Panel shows Rather than use desk mics, which are apt to pick up the unavoidable banging on the table, you can achieve good audio with individual lavalieres. But note that each panel member needs his or her own lavaliere mic.

Instructional shows In shows with a principal performer or television teacher, the lavaliere is ideal. The sound pickup is the same whether the instructor speaks to the class or turns to the blackboard.

Dramas Some multicamera studio productions, such as soap operas, use wireless lavalieres for audio pickup. In such productions the lavs are hidden from camera view. If properly attached to the talent's clothing so that the voices do not sound muffled, a lavaliere mic seems the ideal solution to a traditionally difficult sound pickup problem. Once the levels are set, the audio engineer need do very little to keep the voices balanced. More important, the lighting director (LD) can design the lighting without worrying about boom or camera shadows.

The main problem with using lavs for drama is not operational but aesthetic. Because the lavaliere mic is always at the same distance from its sound source, long shots sound exactly the same as close-ups. The unchanging presence does not contribute to a credible *sound perspective* (close-ups sound closer and long shots sound farther away). This is why most productions of television dramas use a boom mic rather than a lavaliere (see chapter 10). Wireless mics are discussed in more detail later in this chapter.

Music The lavaliere mic has been successfully used for singers (even when accompanying themselves on guitar) and for the pickup of certain instruments, such as a string bass, with the mic taped below the fingerboard. In the realm of music, there is always room for experimentation; do not be too limited by convention. If the lavaliere sounds as good as or better than a larger, more expensive mic, stick to the lavaliere.

ENG/EFP The lav is often used for field reports, in which case you need to attach the little windscreen. Wireless lavs are used when the field reporter needs a great deal of mobility. For example, if you talk with a farmer about the drought while walking with him in the parched field, two wireless lavs will solve the audio problem. Wireless lavs can also save you many headaches when picking up the principal's comments while conducting a tour through the newly completed computer lab.

Disadvantages of lavaliere mics There are also some disadvantages to the lavaliere:

- The wearer cannot move the mic any closer to his mouth; consequently, if there is extraneous noise, it is easily picked up by an omnidirectional mic, although a unidirectional lavaliere will usually take care of this problem.
- The lavaliere can be used for only one sound source at a time—that of the wearer. Even for a simple interview, each participant must wear his or her own mic.
- Although the lavaliere mic allows considerable mobility, a wired lavaliere can limit the performer's action radius.
- Because it is attached to clothing, the lavaliere tends to pick up occasional rubbing noises, especially if the performer moves around a great deal. This noise is emphasized when the microphone is concealed underneath a blouse or jacket.
- If the performer's clothes generate static electricity, the discharge may be picked up by the mic as loud, sharp pops.
- If two lavalieres are at a certain distance from each other, they may cancel out some frequencies and make the voices sound strangely "thin" (see figure 9.28).

How to use lavaliere microphones Lavalieres are easy to use, but there are some points you need to consider:

- Be sure to put it on. You would not be the first performer to be discovered sitting on, rather than wearing, the microphone by airtime.
- To put on the microphone, bring it up underneath the blouse or jacket and then attach it on the outside. Clip it firmly to the clothing so that it does not rub against anything. Do not wear jewelry in proximity to the mic. If you get rubbing noises, put a piece of foam rubber between the mic and the clothing.
- Thread the mic cable underneath the clothing and secure the cable so that it cannot pull the microphone sideways.
- Loop the cable or even make a loose knot in it just below the clip to block some unwanted pops and rubbing noises.
- If you encounter electrostatic pops, try to treat the clothes with antistatic laundry spray, available at supermarkets.
- If you must conceal the mic, do not bury it under layers of clothing; keep it as close to the surface as possible.
- If you use the *dual-redundancy* microphone system (which uses two identical microphones for the sound pickup in case one fails), fasten both mics securely and use a clip designed to hold two lavalieres so that they do not touch each other.
- Avoid hitting the microphone with any object you may be demonstrating on-camera.
- If the lavaliere is a wireless and/or condenser mic, check that the battery is in good condition and installed correctly.
- Double-check that the transmitter is turned on (there are normally two switches—one for power and one for the mic) and that it is turned off when leaving the set.
- If your lavaliere was used as a wireless mic, don't walk off with the mic still clipped to your clothing. Turn off the transmitter, take off the microphone, and remove the cable from under the clothing before leaving the set. Put the mic down gently.
- When using a lavaliere outdoors, attach the windscreen. You can also make a windscreen by taping a small piece of acoustic foam or cheesecloth over the mic. Experienced EFP people claim that by wrapping the mic in cheesecloth and covering it with the tip of a child's woolen glove, the wind noise is virtually eliminated.

HAND MICROPHONES

As the name implies, the *hand microphone* is handled by the performer. It is used in all production situations in which it is most practical, if not imperative, that the performer exercise some control over the sound pickup. Hand mics are used extensively in ENG, where the reporter often works in the midst of much commotion and noise. In the studio or on-stage, hand mics are used by singers and by performers who do audience participation shows. With the hand mic, the performer can approach and talk at random to anyone in the audience.

For singers the hand mic is part of the act. They switch the mic from one hand to the other to visually support a transition in the song, or they caress it during an especially tender passage. Most important, however, the hand mic enables singers to exercise sound control. First, they can choose a mic whose sound reproduction suits their voice quality and style of singing. Second, they can "work" the mic during a song, holding it close to the mouth to increase the intimacy during soft passages or farther away during louder, more external ones. Third, the hand mic gives them freedom of movement, especially if it is wireless.

The wide variety of uses makes heavy demands on the performance characteristics of a hand mic. Because it is handled so much, it must be rugged and capable of withstanding physical shock. And because it is often used extremely close to the sound source, it must be insensitive to plosive breath pops and input overload distortion (see section 9.2). When used outdoors on remote locations, it must withstand rain, snow, humidity, heat, and extreme temperature changes and yet be sensitive enough to pick up the full range and subtle tone qualities of a singer's voice. Finally, it must be small enough to be handled comfortably by the performer.

Of course, no single mic can fulfill all these requirements equally, which is why some hand mics are built for outdoor use, whereas others work best in the controlled studio environment. Normally, you should use dynamic mics for outdoor productions. Their built-in pop filter and sometimes even built-in windscreen produce acceptable audio even in bad weather conditions. **SEE 9.8** Condenser or ribbon mics do not fare as well outdoors but are excellent for more-demanding sound pickup, such as of singers. **SEE 9.9**

The major disadvantage of the hand mic is what we just listed as one of its advantages: the sound control by the performer. If a performer is inexperienced in using a hand mic, he or she might produce more pops and bangs than intelligible sounds, or may, much to the dismay of the camera operator, cover the mouth or part of the face with

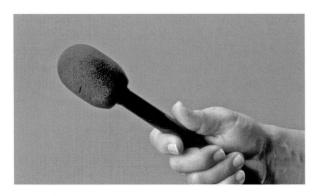

9.8 DYNAMIC HAND MICROPHONE FOR OUTDOOR USEThe hand mic is rugged, has a built-in windscreen, and is insulated to prevent rubbing sounds from the talent's hands.

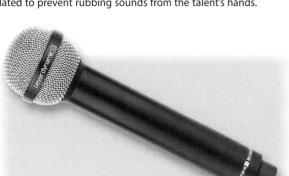

9.9 RIBBON MICROPHONE FOR HIGH-QUALITY SOUND PICKUP This ribbon mic (Beyerdynamic 500) has a built-in pop filter and an excellent frequency response. Because of its warm tone, it is a favorite with singers. (*Note: Beyerdynamic* is a trade name—not the type of microphone. The mic pictured here is a ribbon microphone.)

the mic. Another disadvantage of most hand mics is that their cables can restrict movement somewhat, especially in ENG, when a field reporter is tied to the camcorder. Although wireless hand mics are successfully used in the studio, stay away from them when working outdoors. A cable is still the most reliable connection between the mic and the audio mixer or camcorder.

How to use hand microphones Working with the hand mic requires dexterity and foresight. Here are some hints:

Although the hand mic is fairly rugged, treat it gently. If you need both hands during a performance, do not just drop the mic; put it down gently or wedge it under your arm. If you want to impress on the performer the sensitivity of a microphone, especially that of the hand mic, turn up

9.10 POSITION OF DIRECTIONAL HAND MIC DURING SONG For optimal sound pickup, the singer holds the microphone close to her mouth, at approximately a 45-degree angle.

the volume level and feed the clanks and bangs back out into the studio for the performer to hear.

- Before the telecast check your action radius to see if the mic cable is long enough for your actions and laid out for maximum mic mobility. The action radius is especially important in ENG, where the reporter is closely tied to the camcorder. If you have to move about a great deal, use a wireless hand mic or lavaliere.
- Always test the microphone before the show or news report by speaking into it or lightly scratching the pop filter or windscreen. Do not blow into it. Have the audio engineer or the camcorder operator confirm that the mic is working properly.
- When using an omnidirectional mic, speak *across* rather than into it. With a directional hand mic, hold it close to your mouth at approximately a 45-degree angle to achieve optimal sound pickup. Unlike the reporter, who speaks *across* the omnidirectional hand mic, the singer sings *into* the directional mic. **SEE 9.10**
- If the mic cable gets tangled, do not yank on it. Stop and try to get the attention of the floor manager.
- When walking a considerable distance, do not pull the cable with the mic. Tug the cable gently with one hand while holding the microphone with the other.

When in the field, always test the microphone before the show or news report by having the camcorder operator record some of your opening remarks and then play them back for an audio check. Insist on a mic check, especially if the crew tells you not to worry because they've "done it a thousand times before"!

9.11 HAND MIC POSITION: CHEST

When used in a fairly quiet environment, the hand mic should be held chest high, parallel to the body.

- When doing a stand-up news report in the field under normal conditions (no excessively loud environment, no strong wind), hold the microphone at chest level. **SEE 9.11** Speak toward the camera, across the microphone. If the background noise is high, raise the mic closer to your mouth while still speaking across it. **SEE 9.12**
- When interviewing someone, hold the microphone to your mouth whenever you speak and to the guest's whenever he or she answers. Unfortunately, this obvious procedure is sometimes reversed by many novice performers.
- Do not remain standing when interviewing a child. Crouch down so that you are at the child's eye level; you can then keep the microphone close to the child in a natural way. You become a psychological equal to the child and also help the camera operator frame an acceptable picture. **SEE 9.13**
- Always coil the mic cables immediately after use to protect the cables and have them ready for the next project.

BOOM MICROPHONES

When a production, such as a dramatic scene, requires that you keep the microphone out of camera range, you need

9.12 HAND MIC POSITION: MOUTH

In a noisy environment, the hand mic must be held closer to the mouth. Note that the talent is still speaking across the mic, rather than into it.

9.13 USE OF HAND MIC WITH CHILD

When interviewing a child, crouch down to the child's eye level. The child is more at ease, and the camera operator is able to frame a better shot.

a mic that can pick up sound over a fairly great distance while making it seem to come from close up (presence) and which keeps out most of the extraneous noises surrounding the scene. The *shotgun microphone* fills that bill. It is highly directional (supercardioid or hypercardioid) and has a far reach with little loss of presence. **SEE 9.14** Because it is usually suspended from some kind of boom, or is handheld with your arms acting as a boom, we call it a *boom microphone*.

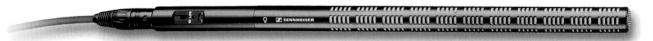

9.14 SHOTGUN MIC

The shotgun mic has a highly directional (super- or hypercardioid) pickup pattern and a far reach, permitting the pickup of sounds that are relatively far away.

198 Chapter 9 AUDIO: SOUND PICKUP

This section examines the following boom operations: (1) the handheld shotgun, (2) the fishpole boom, (3) the giraffe, or tripod, boom, and (4) the big, or perambulator, boom.

Handheld shotgun The most common ways of using the shotgun mic in EFP or small studio productions are to hold it by hand or to suspend it from a *fishpole* boom. Both methods work fairly well for short scenes, where the microphone is to be kept out of camera range. The advantages of holding it or suspending it from a fishpole boom are: (1) the microphone is extremely flexible—you can carry it into the scene and aim it in any direction without any extraneous equipment; (2) by holding the shotgun, or by working the fishpole, you take up very little production space; and (3) you can easily work around the existing lighting setup to keep the mic shadows outside camera range.

The disadvantages are: (1) you can cover only relatively short scenes without getting tired; (2) you have to be relatively close to the scene to get good sound pickup, which is often difficult, especially if the set is crowded; (3) if the scene is shot with multiple cameras (as in a studio production), you are often in danger of getting in the wide-shot camera view; and (4) when you are holding it, the mic is apt to pick up some handling noises, even if you carry it by the *shock mount* (a suspension device that prevents transmitting handling noises to the mic).

ENGHow to use shotgun microphones When holding the shotgun mic during a production, pay particular attention to the following points:

- Always carry the shotgun mic by the shock mount. Do not carry it directly or you'll end up with more handling noises than actors' dialogue. **SEE 9.15**
- Do not cover the *ports* (openings) at the sides of the shotgun with anything but the windscreen. These ports must be able to receive sounds to keep the pickup pattern directional. Holding the mic by the shock mount minimizes the danger of covering the ports.
- Watch that you do not hit anything with the mic and that you do not drop it.
- Aim it as much as possible toward whoever is speaking, especially if you are close to the sound source.
- Always wear earphones so that you can hear what the mic is actually picking up. Listen not only to the sound quality of the dialogue but also for unwanted noise. If you

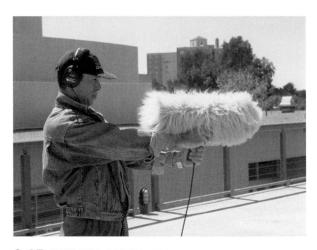

9.15 HANDHELD SHOTGUN MIC

Always hold the shotgun mic by its shock mount. When outdoors a windscreen is mandatory. This mic has an additional wind jammer attached.

hear sounds that are not supposed to be there, tell the director about the interference immediately after the *take* (from start to stop of the show segment being videotaped).

Watch for unwanted mic shadows.

Fishpole boom An extendible metal pole that lets you mount a shotgun mic, a *fishpole* is used mostly outdoors for ENG/EFP but can, of course, be used for brief scenes in the studio in place of the big perambulator boom. You will find that a short fishpole is relatively easy to handle, whereas working a long or fully extended fishpole can be quite tiring, especially during long, uninterrupted takes.

How to use fishpole microphones When using the fishpole, many of the foregoing points apply. Here are some more:

- Check that the mic is properly shock-mounted so that it does not touch the pole or the mic cable.
- Fasten the mic cable to the pole. Some commercially available fishpoles double as a conduit for the cable.
- Hold the fishpole from either above or below the sound source. **SEE 9.16 AND 9.17** If you are recording two people talking to each other, point the mic at whoever is speaking.
- If the actors speak while walking, walk with them at exactly the same speed, holding the mic in front of them during the entire take.

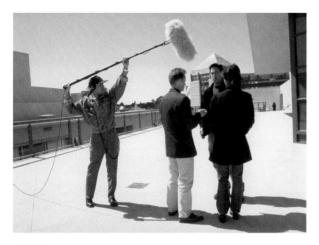

9.16 FROM-ABOVE MIC POSITION

The short fishpole is usually held as high as possible and dipped into the scene from above.

- Watch for obstacles that may block your way, such as cables, lights, cameras, pieces of scenery, or trees. Because you usually walk backward while watching the actors, rehearse your route a few times.
- Before each take check that you have enough mic cable for the entire walk.
- If you have a long fishpole, anchor it in your belt and lower it into the scene as though you were "fishing" for the appropriate sound. **SEE 9.18**

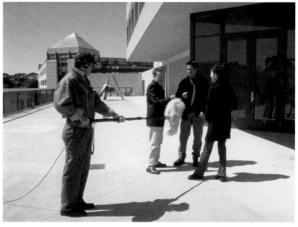

9.17 FROM-BELOW MIC POSITION

The fishpole can also be held low, with the mic aimed at the sound source from below.

Giraffe, or tripod, boom Many studios use a small boom, called a *giraffe*, or *tripod, boom*. The giraffe consists of an extendible horizontal boom arm that is mounted on a tripod dolly. **SEE 9.19**

You can tilt the boom up and down and simultaneously rotate the mic in the desired direction. And you can reposition the entire boom assembly by simply pushing it. The advantages of the giraffe boom for studio work are: (1) unlike the fishpole, you do not have to hold the boom assembly with the mic; (2) the giraffe takes up relatively

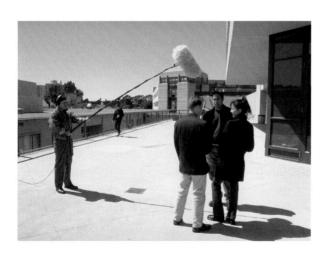

9.18 HANDLING THE LONG FISHPOLE BOOM

The long fishpole can be anchored in the belt and raised and lowered similar to an actual fishing pole.

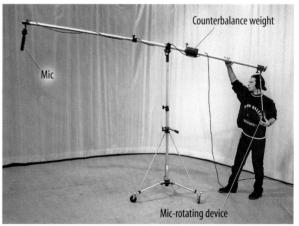

9.19 GIRAFFE, OR TRIPOD, BOOM

The small giraffe boom can be repositioned with its tripod dolly. The boom can be tilted up and down and panned horizontally. The mic can be rotated to the exact pickup position.

9.20 BIG, OR PERAMBULATOR, BOOM

The big boom can extend to a 20-foot reach, pan 360 degrees, and tilt up and down. The microphone itself can be rotated by about 300 degrees—almost a full circle.

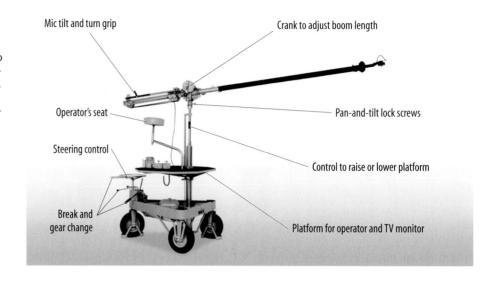

little studio space; (3) because of its low height and narrow wheelbase, you can move it easily through narrow doorways or hallways; and (4) it can be disassembled quickly and taken to remote locations if necessary.

Unfortunately, even the giraffe is not without serious operational disadvantages: (1) The lighting must be carefully adjusted so that the boom shadows fall outside of camera view (see chapter 8). (2) The extension of the relatively light giraffe boom is limited. It requires that the boom operator stand closer to the sound source, a position that tends to increase the general noise level. (3) Because the boom has to remain relatively low during operation, the risk of getting the boom or the mic in the picture is increased considerably. (4) Because of its light weight, the boom is subject to shock and vibrations, which, despite its shock mounts, can be transferred to the microphone.

The big, or perambulator, boom When working with large, multicamera studio productions, such as situation comedies and soap operas, you will find that despite the presence of lavaliere mics, the big perambulator boom is very much alive and well. In the controlled environment of the studio, the big boom is still one of the most effective ways of getting a high-quality mic close to the talent while keeping it out of camera view. **SEE 9.20**

There are several reasons why the big boom has not achieved great popularity in routine studio productions:

 Using the big boom usually requires two operators: the boom operator, who works the microphone boom, and the dolly operator, who helps reposition the whole boom assembly whenever necessary.

- The floor space that the boom takes up may, in a small studio, cut down considerably the maneuverability of the cameras.
- Like the giraffe boom, the big boom requires a manipulation of the lighting so that its shadow falls outside of camera range. Even in larger studios, the lighting problems often preclude the use of a boom, available personnel and space notwithstanding.
- The boom is difficult to operate, especially when the actors are moving about.

The big boom nevertheless has several advantages, especially when used for multicamera shows that are done live-on-tape or contain fairly long, uninterrupted takes:

- It allows smooth and rapid movement of the microphone above and in front of the sound sources and from one spot to another anywhere in the studio within its extended range. You can extend or retract the mic, simultaneously pan the boom horizontally, move it up and down vertically, and rotate and tilt the mic to allow for directional sound pickup. During all these operations, the boom assembly can be moved to various locations, in case the boom cannot reach the sound source when fully extended.
- It can ride high enough to keep the boom and its mic out of camera view.
- It permits the mounting of high-quality shotgun mics.
- It can reach into performance areas without the boom assembly's moving too close to the scene.

The operation of the big boom is similar to that of the giraffe (see figure 9.19). The major operational difference between the giraffe and the big boom is that the latter allows better sound pickup: you can move the mic much more quickly and smoothly and can extend it much farther into a scene than with the giraffe. Once properly mounted, the boom noise is not transferred to the mic.

How to use boom microphones The following tips apply to operating both the small giraffe boom and the big perambulator boom:

- Try to keep the mic in front of the sound source and as low as possible without getting it in the picture. Do not ride the mic directly above the talent's head—the performer speaks from the mouth, not the top of the head.
- Watch the studio line monitor (which shows the picture that goes on the air or is videotaped). Try to ascertain during rehearsal how far you can dip the mic toward the sound source without getting it or the boom in the picture. The closer the mic, the better the sound. (In boom mic operation, you can never get close enough to violate the minimum distance required of cardioid mics to avoid breath pops or similar sound distortions.)
- The optimum distance for boom mics is when the talent can almost touch the mic by reaching up at about a 45-degree angle.
- If the boom gets in the picture, it is better to pull it back than to raise it. By retracting the boom, you pull the microphone out of the camera's view and at the same time keep the mic in front of, rather than above, the sound source.
- Watch for shadows. Even the best LD cannot avoid shadows but can only redirect them. If the major boom positions are known before the show, work with the LD to light around them. You may sometimes have to sacrifice audio quality to avoid boom shadows.

If you discover a boom shadow when the camera is already on the air, do not suddenly move the mic—everyone will see the shadow travel across the screen. Try to sneak it out of the picture very slowly or, better, just keep the mic and the shadow as steady as possible until a relief shot permits you to move into a more advantageous position.

Anticipate the movements of performers so that you can lead them with the mic rather than frantically follow them. Unless the show is very well rehearsed, do not lock the pan-and-tilt devices on the boom. If the performers rise unexpectedly, they may bump their heads on the locked microphone.

Listen for good audio balance. If you have to cover two people who are fairly close together and stationary, you may achieve good audio balance by simply positioning the mic between them and keeping it there until someone moves. Favor the weaker voice by pointing the mic more toward it. More often, however, you will find that you must rotate the unidirectional mic toward whoever is talking. In fully scripted shows, the audio engineer in the booth may follow the scripted dialogue and signal the boom operator whenever the mic needs to be rotated from one actor to the other. **ZVL3** AUDIO Microphones mic types | placement

HEADSET MICROPHONES

The *headset microphone* consists of a small but good-quality omni- or unidirectional mic attached to earphones. One of the earphones carries the program sound (whatever sounds the headset mic picks up or is fed from the station), and the other carries the *I.F.B.* (interruptible foldback or feedback) cues and instructions of the director or producer. Headset mics are used in certain EFP situations, such as sports reporting, or in ENG from a helicopter or convention floor. The headset mic isolates you sufficiently from the outside world so that you can concentrate on your specific reporting job in the midst of much noise and commotion while at the same time keeping your hands free to shuffle papers with players' statistics or buttonhole someone for an interview. **SEE 9.21**

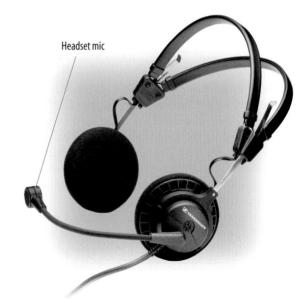

9.21 HEADSET MICROPHONE

The headset mic is similar to an ordinary telephone headset except that it has bigger, padded earphones and a higher-quality microphone.

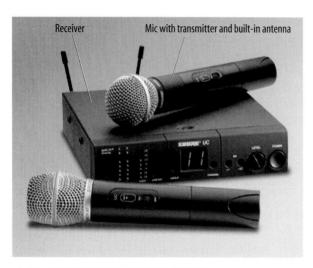

9.22 WIRELESS HAND MIC AND RECEIVER

The wireless hand mic normally has the transmitter built into the housing. The antenna either is built into the mic or sticks out at the bottom. The receiver, which is tuned to the frequency of the hand mic's transmitter, picks up the signal and sends it via ordinary mic cable to the audio console or camcorder.

WIRELESS MICROPHONES

In production situations in which complete and unrestricted mobility of the sound source is required, wireless microphones are used. If, for example, you are recording a group of singers who are also dancing, or if you are asked to pick up a skier's grunts and the clatter of the skis on a downhill course, the wireless mic is the obvious choice. Wireless mics are also used extensively for newscasts, for EFP, and occasionally for multicamera studio productions of dramatic shows. Wireless mics actually broadcast their signals. They are therefore also called *RF* (radio frequency) mics or radio mics. Most wireless microphones are used as either hand or lavaliere mics.

In wireless hand mics, the battery-powered transmitter is built into the microphone itself. Some models have a short antenna protruding from the bottom of the mic, but in most the antenna is incorporated into the microphone housing or cable. **SEE 9.22**

The wireless lavaliere mic is connected to a small battery-powered transmitter that is either worn in the hip pocket or taped to the body. The antenna is usually tucked into the pocket or strung inside the clothing. SEE 9.23

The other important element of the wireless microphone system is the receiver (see figure 9.22). The receiver tunes in to the frequency of the wireless transmitter and can receive the signal from as far as 1,000 feet (approximately 330 meters) under favorable conditions. When conditions

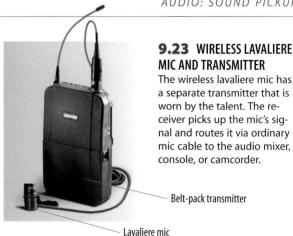

are more adverse, the range may shrink to about 100 feet (about 33 meters). To ensure optimal signal reception, you can set up several receiving stations in the studio as well as in the field. When tuned to the same frequency, the receiver will switch to a more favorable frequency or have another receiver take over when the signal gets too weak. This is called diversity reception.

The wireless mic works best in the controlled environment of a studio or stage, where you can determine the precise range of the performer's movements and find the optimal position for the receiver(s). Most singers prefer working with the wireless hand mic because it affords them unrestricted movement. It is also useful in audience participation shows, where the performer walks into the audience for brief, unplanned interviews. The wireless lavaliere mic has been used successfully for musicals and dramatic shows and, of course, in many ENG/EFP situations.

Despite the obvious advantages of using wireless mics, there are also some major disadvantages:

- The signal pickup can be uneven, especially if the sound source moves over a fairly great distance and through hilly terrain—a skier, for example. If you do not have line of sight between the transmitter (on the performer) and the receiver, you may encounter fades and even occasional dropouts. Diversity reception, which uses multiple receivers, is a must in such situations.
- If the transmitter is taped to the body, the performer's perspiration can reduce signal strength, as does, of course, the increasing distance from transmitter to receiver.
- Large metal objects, high-voltage lines and transformers, X-ray machines, microwave transmissions, and cellular phones can all interfere with the proper reception of the wireless mic signal.
- Although most wireless equipment offers several frequency channels, there is still some danger of picking up

extraneous signals, especially if the receiver is not tuned accurately or if it operates in the proximity of someone else's wireless signals or other strong radio signals. Interference is evident by pops, thumps, signal dropouts, and even the pickup of police band transmissions.

If you use several wireless mics, they need to be fed into a mixer for proper audio control.

How to use wireless microphones The basic operational techniques of the wireless mic are identical to those of the wired lavaliere and hand mics, but here are some additional points to consider:

- Always install new batteries before each shoot—and carry plenty of spares. The upper frequencies sound thin when the mic has a weak battery.
- If the receiver is fairly far from the wireless transmitter that is worn by the talent, the transmitter antenna must be fully extended. You can tie one end of a rubber band to the tip of the antenna and tape the other end to the performer's clothing. That will keep the antenna fully extended while preventing it from being snapped off its connector when the talent moves.
- If you must tape the transmitter to the body, avoid attaching the tape directly to skin because excessive moisture can interfere with the signal.
- Position the receiver(s) so that there are no blind spots (ideally in line of sight with the transmitter at all times).
- Always test the sound pickup over the entire range of the sound source. Watch for possible interfering signals or objects.

DESK MICROPHONES

As the name implies, *desk microphones* are usually put on tables or desks. These stationary mics are widely used in panel shows, public hearings, speeches, press conferences, and other programs where the performer is speaking from behind a desk, table, or lectern. These mics are used for voice pickup only. Because the performer is usually doing something—shuffling papers, putting things on the desk, accidentally bumping the desk with feet or knees—desk microphones must be rugged and able to withstand physical shock. Dynamic, omnidirectional mics are generally used. If a high separation of sound sources is desired, however, unidirectional mics are another option. Generally, most hand mics double as desk mics—all you do is place them in a desk stand and position them for optimal sound pickup. **SEE 9.24**

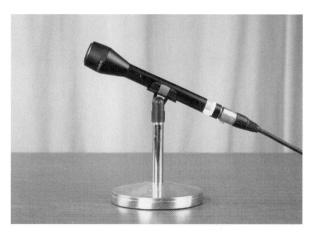

9.24 DESK MICROPHONE ON DESK STANDIn television production desk mics are usually hand mics clipped to a desk stand.

9.25 BOUNDARY MICROPHONE

This mic must be mounted or put on a reflecting surface to build up the "pressure zone" at which all sound waves reach the mic at the same time.

Boundary microphone One type of desk mic is the *boundary microphone* or, as it is commonly called, the *pressure zone microphone* (*PZM*). These mics look different from ordinary microphones and operate on a different principle. **SEE 9.25**

The boundary microphone is mounted or positioned close to a reflecting surface, such as a table or a plastic plate accessory. **SEE 9.26** When placed into this sound "pressure zone," the mic receives both the direct and the reflected

^{1.} PZM is a trademark of Crown International, Inc.

204 Chapter 9 AUDIO: SOUND PICKUP

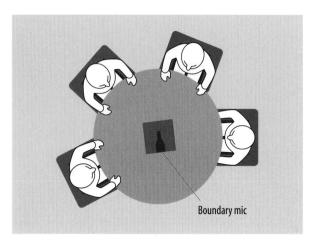

9.26 BOUNDARY MICROPHONE USED FOR MULTIPLE-VOICE PICKUP

With the boundary mic in the middle of the table, the sound pickup is equal for all people sitting around it.

sounds at the same time. Under optimal conditions the boundary microphone produces a clearer sound than do ordinary mics. Its chief advantage is that it can be used for the simultaneous voice pickup of several people with equal fidelity. Boundary mics have a wide, hemispheric pickup pattern and are therefore well suited for large group discussions and audience reactions. You can, for example, simply place this mic on a table and achieve a remarkably good pickup of the people sitting around it. Unfortunately, when used as a table mic, the boundary mic also picks up paper rustling, finger tapping, and the thumps of people knocking against the table, but pads for the mic minimize or virtually eliminate such problems.

How to use desk microphones Desk mics, like peanuts, seem to be irresistible—not that performers want to eat them, but when sitting or standing behind a desk mic they feel compelled to grab it and pull it toward them, no matter how carefully you might have positioned it. Polite or not-so-polite requests not to touch the mic seem futile. Sooner or later the talent will move the mic. To counter this compulsion, consider taping the mic stand to the table, or at least tape the microphone cable securely and unobtrusively so that the mic can be moved only a short distance.

As with the hand mic, no attempt is made to conceal the desk mic from the viewer. Nevertheless, when placing it on a desktop or lectern, consider the camera picture as well as optimal sound pickup. Performers certainly appreciate it if the camera shows more of them than the microphone. If the camera shoots from straight on, place the mic some-

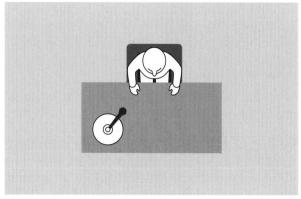

9.27 DESK MICROPHONE PLACEMENT FOR SINGLE PERFORMER

The desk mic should be placed to the side of the talent and aimed at the talent's collarbone so that he or she speaks across, rather than into, it. If the talent uses a monitor, put the mic on the monitor side.

what to the side of the performer and point it at his or her collarbone rather than mouth, giving a reasonably good sound pickup while allowing the camera a clear shot of the performer's face. **SEE 9.27**

When integrating the mic unobtrusively in the picture, do not forget about the mic cable. Even if the director assures you that the mic cable on the floor will never be seen, don't bet on it. Try to string the cable as neatly as possible and use gaffer's or black masking tape to secure it to the desk and floor. The viewer inevitably interprets a shot that shows cable "spaghetti" as inefficient and sloppy, regardless of the overall quality of the show.

Here are a few more tips on using a desk mic:

- When using two desk mics for the same speaker as a dual-redundancy precaution, use identical mics and place them as close together as possible. As noted, *dual-redundancy* is the rather clumsy term for using two mics for a single sound source so that you can switch from one to the other in case one fails. Do not activate them at the same time unless you are feeding separate audio channels. If both mics are on at the same time, you may experience *multiple-microphone interference*: when two mics are close to each other yet far enough apart that they pick up the identical sound source at slightly different times, they can cancel out certain frequencies, giving the sound a strangely thin quality. If you must activate both mics at the same time, place them as close to each other as possible so that they receive the sound simultaneously.
- When using desk mics for a panel discussion, do not give each member a separate mic unless they sit far apart.

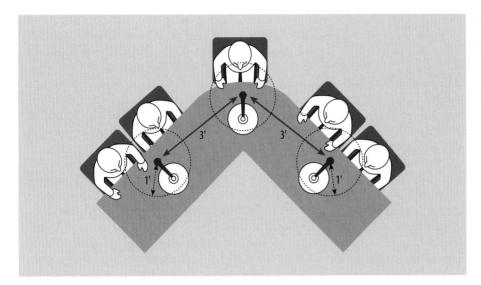

9.28 MULTIPLE-MICROPHONE SETUP

How Microphones Hear

When using a multiplemicrophone setup, keep the individual mics at least three times as far apart as the distance any mic is from its user.

Using one mic for two panel members not only saves mics and setup time but also minimizes multiple-microphone interference. Place the mics so that they are at least three times as far apart as any mic is from its user. **SEE 9.28**

- Position the microphones to achieve optimal sound pickup from all participants. Finalize the mic positions only after having seen the total panel setup and the interaction of the members. Participants will not only respond to the moderator but also talk among themselves, turning in opposite directions.
- Although almost a lost cause, remind the panel members—or anyone working with a desk mic—not to reposition it once it is set and to avoid banging on the table or kicking the lectern, even if the discussion gets lively. Tell participants not to lean into the mics when speaking.
- When two people sit opposite each other, give each one a mic.

When on an ENG assignment, always bring along a small collapsible desk stand. You can then use the hand mic (or even the shotgun mic), usually clipped to the camera, as a desk mic. A clamp-on mic holder with a gooseneck is very handy, especially when adding your mic to a cluster of other mics on a speaker's lectern during a news conference.

STAND MICROPHONES

Stand microphones are used whenever the sound source is fixed and the type of programming permits them to be seen. For example, there is no need to conceal the mics

of a rock group; on the contrary, they are an important show element. You are certainly familiar with the great many ways rock performers handle the stand mic. Some tilt it, lift it, lean against it, hold themselves up by it, and, when the music rocks with especially high intensity, even swing it through the air like a sword (not recommended, by the way).

The quality of stand mics ranges from dynamic hand mics clipped to a stand to highly sensitive ribbon or condenser mics used exclusively for music recording sessions.

How to use stand microphones Stand mics are usually placed in front of the sound source, regardless of whether it is a singer or the speaker of an amplified electric guitar. **SEE 9.29** In some cases, such as for the pickup

9.29 STAND MIC FOR SINGER

The singer stands in front of the stand mic and sings directly into it.

of a singer using an acoustic guitar, you may attach two microphones to a single stand.

HANGING MICROPHONES

Hanging microphones are used whenever any other concealed-microphone method (boom or fishpole) is impractical. You can hang the mics (high-quality cardioid, but also lavalieres) by their cables over any fairly stationary sound source. Most often, hanging mics are used in dramatic presentations where the action is fully blocked so that the actors are in a precise location for each delivery of lines. A favorite spot for hanging mics is the upstage door (at the back of the set), from which the actors deliver their hellos and good-byes when entering or leaving the major performance area. The boom can generally not reach that far to adequately pick up voices. The actors have to take care to speak only within the "audio pool" of the hanging mic. Similar to the spotlight pool, where the actors are visible only so long as they move within the limited circle of light, they are heard only when they are within the limited range of the audio pool. SEE 9.30

The sound quality from hanging mics is not always the best. The sound source is always relatively far away from the mic; and if the performer is not precisely within the audio pool, his or her voice is off-mic. In the case of the upstage door, such quality loss is actually an asset because it underscores the physical and psychological distance of the departing person. Unfortunately, hanging mics have the

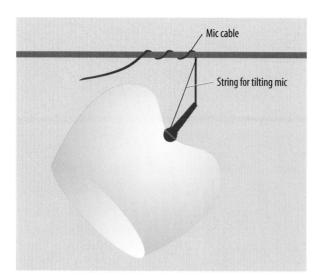

9.30 AUDIO POOL OF HANGING MICROPHONE

Hanging microphones are high-quality unidirectional mics that are normally suspended by their cables from the lighting grid. The talent must remain in the "audio pool" to be properly heard.

annoying tendency to pick up the shuffling of feet and the rumbling of moving camera pedestals almost as well as the voices. A further disadvantage is that when positioned close to the studio lights, the hanging mic might pick up and amplify their hum.

Hanging mics are nevertheless popular in dramas, studio productions, and audience participation shows. They are easy to set up and take down and, when in the right positions, produce acceptable sound.

You may find that a single suspended boundary mic will meet the audio requirements better than several regular hanging mics. Mount the boundary mic on a sound-reflecting board (such as 3-by-4-foot Plexiglas or plywood), suspend it above and in front of the general sound-generating area (such as an audience area), and angle the reflecting board for optimal pickup. **SEE 9.31** Regardless of whether the sound source is near the mic or farther away, the sounds still have good presence. This positive aspect turns negative in dramatic productions, where sound perspective is an important factor. This is one of the reasons why in complex productions the boom is still preferred over the boundary mic.

How to use hanging microphones Although no particular skill is required for hanging a mic, here are some tips:

- Hang the mic as low as possible to get reasonably good presence. Use tape or fishing line to tilt the mic toward speakers or musicians (see figure 9.30).
- If necessary, mark the studio floor for the talent at the spot of the best sound pickup.
- Secure the mic cable sufficiently so that the mic does not come crashing down. A small piece of gaffer's tape will do the trick.
- Separate the mic cables from the studio lights or the AC cables to minimize electronic interference. If that is not possible, cross the mic and power cables at right angles rather than having them run parallel.
- Do not place the mic next to a hot lighting instrument.
- Be especially careful when *striking* (taking down) hanging microphones. Do not drop the mic or the cable connectors onto the studio floor or, worse, somebody's head.
- Do not inadvertently hit hanging mics against ladders, lighting poles, or lighting instruments.

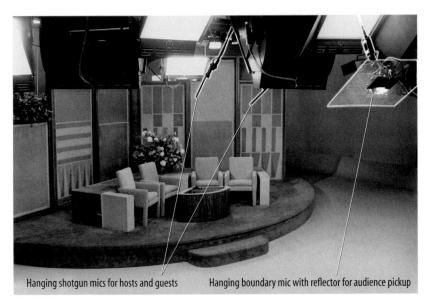

9.31 BOUNDARY MIC USED AS HANGING MICROPHONE

When using a boundary mic as a hanging microphone, mount it on an additional sound-reflecting board and angle it toward the sound source for optimal pickup. The shotgun mics are for the host and guests' audio pickup.

HIDDEN MICROPHONES

You may sometimes find that you need to hide a small lavaliere microphone in a bouquet of flowers, behind a centerpiece, or in a car to pick up a conversation during studio productions or in EFP where microphones should be out of camera range. **SEE 9.32** Realize that it is time-consuming to place a hidden mic so that it yields a satisfactory pickup. Often you get a marvelous pickup of various noises caused by people hitting the table or moving their chairs but only a poor pickup of their conversation.

Again, the boundary mic can serve as an efficient "hidden" mic. Especially because it looks nothing like an ordinary mic, you may get away with not hiding it at all; simply place it on a table among other eclectic objects.

How to use hidden microphones Hiding mics seems to present unexpected problems. These tips may minimize or eliminate some of them:

- Try to shock-mount the lavaliere so that it does not transfer unintentional banging noises. Use the lavaliere clip or put some foam rubber between the mic and the object to which it is attached.
- Do not try to conceal the mic completely, unless there is an extreme close-up of the object to which it is attached.
- Realize that you must hide not only the microphone but also the cable. If you use a wireless setup, you must hide the transmitter as well.

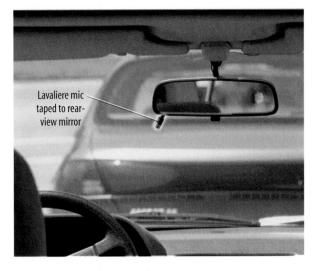

9.32 LAVALIERE AS HIDDEN MIC

This "hidden" lavaliere microphone is attached to the rear-view mirror to pick up the conversation inside the car. Note that the mic is not covered, to ensure optimal sound pickup.

- Secure the microphone and the cable with tape so that they do not come loose. The setup must withstand the rigors of the rehearsals and the videotaping sessions.
- Do not hide a mic in such enclosed spaces as empty drawers or boxes. The highly reflecting enclosure will act as a reverberation chamber and make the voices sound as though the actors themselves were trapped in the drawer.

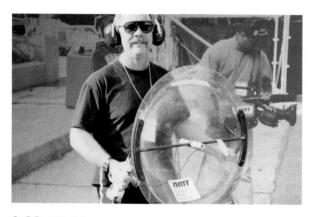

9.33 PARABOLIC REFLECTOR MICROPHONE

The parabolic reflector mic is used primarily for sound pickup over long distances, such as crowd noises in a stadium.

LONG-DISTANCE MICROPHONES

We have finally realized that it is often the sounds more than the pictures that carry and communicate the energy of an event. The simplest way to pick up the sound of a sporting event, for example, is to place normal shotgun (hypercardioid) mics at strategic positions and aim them at the main action. The sounds of the spectators are picked up by additional omnidirectional mics. Coverage of a single tennis match may involve six or more microphones to pick up the sounds of the players, the judges, and the crowd. Place a fairly dense windscreen on every mic to eliminate wind noise as much as possible.²

An old-fashioned but successful means of picking up distant sounds is the parabolic reflector microphone, which consists of a parabolic dish (similar to a small satellite dish) that has an omnidirectional microphone facing inward at its focal point. All incoming sounds are reflected toward and concentrated at the mic. SEE 9.33 A popular use of the parabolic mic is to pick up the sounds of the bands during a parade, the collisions of football players, or the enthusiastic chanting of a group of home-team fans. Because the parabolic reflector directs the higher sound frequencies to the mic better than the lower ones, the sounds take on a slight telephonic-like tone. We tend to ignore this impaired sound quality, however, when the mic is used primarily for ambient (environmental) sounds that communicate the feel of an event (such as a football game) rather than precise information.

MAIN POINTS

- Audio is the sound portion of a television show. It transmits information (such as a news story), helps establish the specific time and locale of the action, contributes to the mood, and provides continuity for the various picture portions.
- The three major types of microphones are dynamic, condenser, and ribbon. Each type has a different soundgenerating element that converts sound waves into electric energy—the audio signal.
- Some microphones can hear sounds equally well from all directions (omnidirectional); others hear better from a specific direction (unidirectional or cardioid).
- Microphones are classified according to their operation and are either mobile or stationary. The mobile types include lavaliere, hand, boom, headset, and wireless microphones. The stationary types are desk, stand, hanging, hidden, and long-distance mics.
- The lavaliere microphone, or lav for short, is most common in small studio operations. It is usually clipped to clothing. Although it is extremely small, it provides high-quality sound reproduction.
- Hand microphones are used when the performer needs to exercise some control over the sound pickup.
- When the microphone must be kept out of camera range, it is usually mounted on and operated from a fishpole or microphone boom. All boom mics are highly directional.
- The headset microphone is used when the talent needs both hands free to take notes or work with scripts. Headset microphones are especially practical for sportscasting or for ENG from a helicopter or convention floor.
- When unrestricted mobility of the sound source is required, a wireless, or RF (radio frequency), microphone is used.
 Wireless mics need a transmitter and a receiver.
- Desk microphones are simply hand mics clipped to a desk stand. They are often used for panel discussions.
- Stand microphones are employed whenever the sound source is fixed and the type of programming permits the mics to be seen by the camera, such as in rock concerts.
- Hanging microphones are popular in some studio productions because the mics are kept out of camera range without using booms.
- Hidden microphones are small lavalieres concealed behind or within set dressings.
- Long-distance mics are shotgun or parabolic reflector mics that pick up sound over relatively great distances.

^{2.} You will find highly useful suggestions on how to mic a variety of sports for ambient sound in Stanley R. Alten, *Audio in Media*, 7th ed. (Belmont, Calif.: Thomson Wadsworth, 2005), pp. 259–74. Note that wireless mics play an important role in miking some indoor sporting events.

9.2

How Microphones Work

Section 9.1 examined sound pickup and the electronic and operational characteristics of microphones. This section takes a closer look at how sound-generating elements work. It includes a list of popular mics and their primary use and looks at mic and line inputs and what connectors to use. It also explores further considerations of microphone use in ENG/EFP.

SOUND-GENERATING ELEMENTS

The diaphragm and the sound-generating element—and sound quality—of dynamic, condenser, and ribbon microphones

SPECIFIC MICROPHONE FEATURES

High and low impedance, frequency response, flat response, balanced and unbalanced mics and cables, and audio connectors

MIC SETUPS FOR MUSIC PICKUP

Possible setups for various musical events

► MICROPHONE USE SPECIFIC TO ENG/EFP

Ambient sounds and line-out tie-in

SOUND-GENERATING ELEMENTS

Simply speaking, microphones convert one type of energy—sound waves—to another—electric energy. All microphones have a *diaphragm*, which vibrates with the sound pressures, and a *sound-generating element*, which transduces (changes) the physical vibrations of the

diaphragm into electric energy, but the particular process each mic uses to accomplish this conversion determines its quality and use.

DYNAMIC MICROPHONES

In the *dynamic* microphone, the diaphragm is attached to a coil—the *voice coil*. When someone speaks into the mic, the diaphragm vibrates with the air pressure from the sound and makes the voice coil move back and forth within a magnetic field. This action produces a fluctuating electric current which, when amplified, transmits the vibrations to the cone of a speaker, making the sound audible again. Because of this physical process, dynamic mics are sometimes called *moving-coil* microphones.

Because the diaphragm-voice coil element is physically rugged, the mic can withstand and accurately translate high sound levels or other air blasts close to it with little or no sound distortion. It can also tolerate fairly extreme outdoor temperatures and seems immune to rain and snow.

CONDENSER MICROPHONES

In the condenser microphone, also called electret or capacitor microphone, the movable diaphragm constitutes one of the two plates necessary for a condenser to function; the other, called the backplate, is fixed. Because the diaphragm moves with the air vibrations against the fixed backplate, the capacitance of this condenser is continuously changed, thus modulating the electric current. The major advantage of the condenser microphone over other types is its extremely wide frequency response and pickup sensitivity. But this sensitivity is also one of its disadvantages. If placed close to high-intensity sound sources, such as the high-output speakers of a rock band, it overloads and distorts the incoming sound—a condition known as input overload distortion. The condenser is a superior recording mic, however, especially when used under the highly controlled conditions of the studio. You will find that most high-quality lavalieres and shotguns are condenser rather than dynamic mics.

RIBBON MICROPHONES

In the *ribbon* or *velocity* microphone, a very thin metal ribbon vibrates within a magnetic field. The ribbon is so fragile that even moderate physical shocks to the mic, or sharp air blasts close to it, can damage and even destroy the instrument. When it is used outdoors, even a light breeze moves the ribbon and thus produces a great amount of noise. You should not use this kind of mic outdoors or in production situations that require its frequent movement. A good ribbon mic is nevertheless an excellent recording

mic, even in television productions. Singers like the ribbon mic because of its rich, warm sound. Because of this warm sound quality, some talk-show hosts use it as a desk mic. Although it has a low tolerance of high sound levels, the delicate ribbon responds well to a wide frequency range and reproduces with great fidelity the subtle nuances of tone color, especially in the bass range.

SOUND QUALITY

Semiprofessional mics do not have as wide a frequency response as do high-quality microphones, which means that high-quality mics can better hear higher and lower sounds than can the less expensive models. (Frequency response is discussed in depth later in this section.) Other, less definable quality factors are whether a mic produces especially warm or crisp sounds, but don't be misled by specifications, "professional" and "semiprofessional" labels, or the personal preferences of singers or sound engineers. If you can, try out several different mics, listen carefully, and choose whichever produces the sound you want.

The type of mic to use for various music recordings depends on such a variety of factors that specific suggestions would probably be more confusing than helpful at this stage. Studio acoustics, the type and combination of instruments used, and the aesthetic quality of the desired sound—all play important parts in the choice and the placement of microphones. In general, rugged dynamic—omnidirectional or cardioid—mics are used for high-volume sound sources such as drums, electric guitars, and some singers, whereas condenser or ribbon mics are used for the more-gentle sound sources, such as strings and acoustic guitars. Figures 9.36 through 9.38 show common mic setups. The microphone table lists some of the more popular mics and their most common use. **SEE 9.34**

SPECIFIC MICROPHONE FEATURES

When working with audio equipment, you will probably hear some terms that are not self-explanatory: *high*- and *low-impedance* mics, *flat response*, and *balanced* and *unbalanced* mics and cables. Although these features are quite technical in nature, you need to know at least their operational requirements.

IMPEDANCE

When working with sound equipment, you have to watch that the impedance of the microphone and the recorder match. *Impedance* is a type of resistance to the signal flow. You can have high-impedance (sometimes abbreviated *high-Z*) and low-impedance (*low-Z*) microphones. A high-impedance mic (usually the less expensive and lower-quality mics) works only with a relatively short cable (a longer cable has too much resistance), whereas a low-impedance mic (all high-quality professional mics) can be used with several hundred feet of cable.

If you must feed a low-impedance recorder with a high-impedance mic or vice versa, you need an *impedance transformer*. Many electric instruments, such as electric guitars, have a high-impedance output. For them to match up with low-impedance equipment, they have to be routed through a *direct box*—a box containing the transformer-like electronics that adjust the high-impedance signal to a low-impedance one. You will find, however, that new equipment is much more tolerant than older equipment to impedance differences and will often match impedances without a transformer.

FREQUENCY RESPONSE

The ability of a microphone to hear extremely high and low sounds is known as the *frequency response*. A good microphone hears better than most humans and has a frequency range of 20 to 20,000 Hz (*hertz*, which measures cycles per second). Many high-quality mics are built to hear equally well over the entire frequency range, a feature called *flat response*. High-quality mics should therefore have a great frequency range and a relatively flat response.

BALANCED AND UNBALANCED MICS AND CABLES, AND AUDIO CONNECTORS

All professional microphones have a *balanced* output that is connected by three-wire microphone cables to a balanced input at recorders and mixers. Two of the wires carry the audio signal, and the third wire is a shield that acts as a ground. The balanced line rejects hum and other electronic interference. All balanced (three-wire) microphones and mic cables use three-pronged connectors, called *XLR connectors*.

When working with semiprofessional equipment, you may come across *unbalanced* mics and cables that use only two wires to carry the signals: one for the audio signal and the other for the ground. These unbalanced lines use a variety of two-wire connectors: the *phone plug*, the *RCA phono plug*, and the *mini plug*. **SEE 9.35 ZVL4** AUDIO > Connectors > overview

The problem with unbalanced (two-wire) mics and lines is that they are much more susceptible to hum and

9.34 TABLE OF MICROPHONES

MICROPHONE	ELEMENT TYPE PICKUP PATTERN	CHARACTERISTICS	USE
HOTGUN MIC -	— LONG		
ennheiser MKH 70	Condenser	Excellent reach and presence, there- fore excellent distance mic. Extremely	Boom, fishpole, handheld. Best for EFP and sports remotes to capture
	Supercardioid	directional. Quite heavy when held on extended fishpole.	sounds over considerable distances.
HOTGUN MICS	— SHORT		
ennheiser MKH 60	Condenser	Good reach and wider pickup pattern than long shotguns. Less presence	Boom, fishpole, handheld. Especially good for
	Supercardioid	over long distances but requires less precise aiming at sound source. Lighter and easier to handle than long shotgun mics.	EFP indoor use.
Neumann KMR 81i	Condenser	Slightly less reach than the MKH 60 but has warmer sound.	Boom, fishpole, handheld. Especially good for EFP.
	Supercardioid	but has waither sound.	Excellent dialogue mic.
Sony ECM 672	Condenser	Highly focused but slightly less presence	Boom, fishpole, handheld. Especially good for
	Supercardioid	than long shotguns.	EFP indoor use.
HAND, DESK, A	ND STAND MIC	S	
Electro-Voice 635N/D	Dynamic	An improved version of the classic 635A. Has good voice pickup that	Excellent mic (and therefore standard) for all-weather ENG
	Omnidirectional	seems to know how to differentiate between voice and ambience. Extremely rugged. Can tolerate rough handling and extreme outdoor conditions.	and EFP reporting assignments.

9.34 TABLE OF MICROPHONES (continued)

MICROPHONE	ELEMENT TYPE PICKUP PATTERN	CHARACTERISTICS	USE
HAND, DESK, A	ND STAND MICS	(continued)	
Electro-Voice RE50	Dynamic Omnidirectional	Similar to the E-V 635N/D. Rugged. Internal shock mount and blast filter.	Good, reliable desk and stand mic. Good for music pickup, such as vocals, guitar, and drums.
Beyerdynamic M58	Dynamic Omnidirectional	Smooth frequency response, bright sound. Rugged. Internal shock mount. Low handling noise.	Good ENG/EFP mic. Especially designed as an easy-to-use hand mic.
Shure SM57	Dynamic Cardioid	Good-quality frequency response. Can stand fairly high input volume.	Good for music, vocals, electric guitars, keyboard instruments, and even drums.
hure SM58	Dynamic Cardioid	Rugged. Good for indoors and outdoors.	Standard for vocals and speech.
hure SM81	Dynamic Cardioid	Wide frequency response. Also good for outdoors.	Excellent for miking acoustic instruments.
Seyerdynamic M160	Double ribbon Hypercardioid	Sensitive mic with excellent frequency response. Can tolerate fairly high input volume.	Especially good for all sorts of music pickup, such as strings, brass, and piano. Also works well as a stand mic for voice pickup.
seyerdynamic M500	Dynamic Hypercardioid	Classic ribbon mic.	Good vocal mic. Very good for a variety of music and voice recordings. Warm sound.

9.34 TABLE OF MICROPHONES (continued)

MICROPHONE	ELEMENT TYPE PICKUP PATTERN	CHARACTERISTICS	USE
	ND STAND MICS	(continued)	
AKG D112	Dynamic	Rugged. Specially built for high-energy	For close miking of kick drum.
7	Cardioid	percussive sound.	
LAVALIERE MIC	S		
Sony ECM 55	Condenser	Excellent presence. Produces close-up sounds. But, because of this excellent	Excellent for voice pickup in a controlled environment (studio
	Omnidirectional	presence, does not mix well with boom mics, which are normally farther away from the sound source.	interviews, studio news, and presentations).
Sennheiser MKE 102	Condenser	Mixes well with boom mics. Excellent, smooth overall sound pickup.	Excellent for most lavaliere uses. Works well as a concealed mic.
	Omnidirectional	Very sensitive to clothes noise and even rubbing of cable, however. Must be securely fastened to avoid rubbing noises.	
Sony ECM 77	Condenser	Highly directional. Isolates most ambient noise when used for speech	Excellent pickup of all sounds. Good for concealed mic use
	Omnidirectional	pickup in noisy surroundings. High directionality can be a problem when mic shifts from original point. Blends well with boom mic. Mic and cable are sensitive to rubbing on clothes. Must be securely fastened.	and even for the pickup of some musical instruments.
Professional Sound PSC MilliMic	Condenser	Extremely small yet has excellent pickup quality. Blends well with boom	Excellent as a concealed mic for interviews, dramas, and documen-
- SCMIIIIWIC	Omnidirectional	mics. Well shielded against electro- magnetic interference.	taries. Works well outdoors.

9.35 AUDIO CONNECTORS

Balanced audio cables use XLR connectors (**A** and **B**); unbalanced cables use the phone plug (**C**), the RCA phono plug (**D**), and the mini plug (**E**).

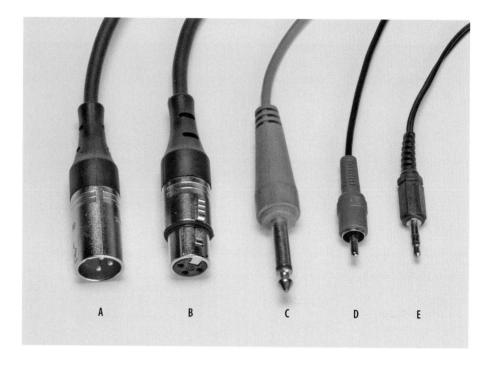

other electronic noise than are balanced mics and lines. With adapters you can connect an XLR to the unbalanced connectors and vice versa. Note, however, that every adapter is a potential trouble spot. If at all possible, try to find a mic cable with the appropriate connector already attached.

MIC SETUPS FOR MUSIC PICKUP

The following suggestions of how to mike musical events should be taken with a grain of salt. Any two audio experts would rarely agree on just how a musical event should be milked and what mics to use. Nevertheless, the suggested setups will help you get started.

The sound pickup of an instrumental group, such as a rock band, is normally accomplished with several stand mics. These are placed in front of each speaker that emits the amplified sound of a particular instrument as well as in front of unamplified sound sources, such as singers and drums. The mic to use depends on such factors as studio acoustics, the type and combination of instruments, and the aesthetic quality of the desired sound.³

Generally, the rugged dynamic, omnidirectional, or cardioid mics are used for high-volume sound sources,

pointing just below the mouth, and another pointing at the guitar. **SEE 9.36** Of course, you can also use two stands, but they usually get in the way of good shots.

you have in mind.

MICROPHONE SETUP FOR SINGER AND PIANO

MICROPHONE SETUP FOR

SINGER AND ACOUSTIC GUITAR

If the concert is formal, with the vocalist singing classical songs, you should keep the mics out of the pictures. You may want to try a Beyerdynamic M160 mic suspended from a small giraffe boom. For the piano tape a boundary

such as drums, electric guitar speakers, and some singers.

whereas ribbon or condenser mics are used for such sound

sources as singers, strings, and acoustic guitars. Although

many factors influence the type of microphone used and its

placement, the figures in this section give some idea of how

three different yet typical musical events may be miked. Again, the final criterion is not what everybody tells you

but whether the playback loudspeakers reflect the sounds

For a singer accompanying himself or herself on an acoustic

guitar, you may try to attach two microphones on a single

mic stand, such as a Beyerdynamic M160 for the singer,

^{3.} See Alten, Audio in Media, pp. 316-21.

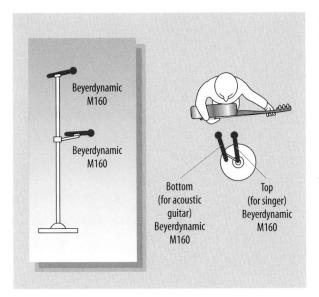

9.36 MICROPHONE SETUP FOR SINGER AND ACOUSTIC GUITAR The mic setup for a singer with an acoustic guitar is to have one mic for the voice and another lower on the same mic stand for the guitar.

mic on the lid in the low-peg position or directly on the sound board. **SEE 9.37** Another way of miking a piano is to have one Shure SM81 mic pointing at the lower half of the strings and another at the upper half. Good results have also been achieved by putting the mic underneath the piano close to the sound board and about a foot behind the pedals.

If the recital consists of popular songs, such as light classics or rock, a hand mic, such as a Beyerdynamic M500 or a Shure SM58, may be the more appropriate choice for the singer. The miking of the piano does not change.

MICROPHONE SETUP FOR SMALL ROCK GROUP AND DIRECT INSERTION

When setting up for a rock group, you need microphones for the singers, drums, and other direct sound-emitting instruments, such as saxophones and pianos, as well as for the speakers that carry the sound of amplified instruments, such as electric guitars and keyboards. The sound signals of electric instruments, such as the bass, are often fed directly to the mixing console without the use of a speaker and a microphone. This technique is called *direct insertion* or *direct input*. Because most electric instruments are high impedance and all other professional sound equipment is

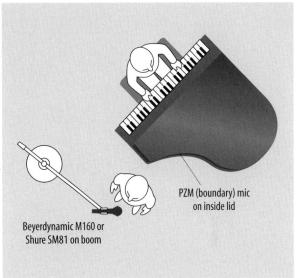

9.37 MICROPHONE SETUP FOR SINGER AND PIANO If the singer's mic is to be out of camera view, it should be suspended from a boom. The piano is miked separately. For an on-camera mic, the singer can use a hand mic.

low impedance, you need to match impedances through the direct box, unless the input equipment does it for you.

When setting up mics and speakers, watch for multiple feedback or microphone interference. For the band members to hear themselves, you must supply the foldback sound mix through either earphones or speakers. *Foldback*, also called *cue-send*, is the return of the total or partial audio mix from the mixing console to the musicians. **SEE 9.38**

MICROPHONE USE SPECIFIC TO ENG/EFP

The sound pickup requirements in ENG/EFP do not differ significantly from those in studio operation. In the field as in the studio, your ultimate objective is optimal sound. You will find, however, that sound pickup in the field is much more challenging than in the studio. When outdoors there is the ever-present problem of wind noise and other unwanted sounds, such as airplanes or trucks passing by during a critical scene. The best way to combat wind noise is to use a highly directional mic, cover it with an effective windscreen and wind jammer, and hold it as close to the sound source as possible. But contrary to most studio shows, ambient (environmental) sounds are often needed to support the video. When indoors you need to

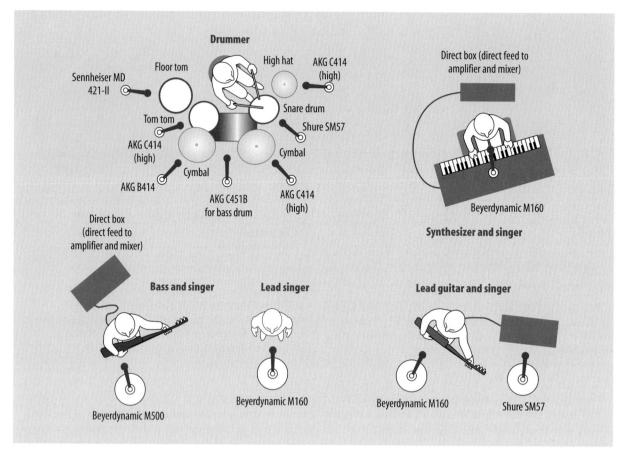

9.38 MICROPHONE SETUP FOR SMALL ROCK BAND

The types and the placement of microphones in this illustration are merely a suggestion for how you may start with the mic setup. The final criterion for a successful setup is when the sounds coming out of the control room speakers are satisfactory.

record *room tone*—the "silence" of an empty room without speaker or audience and the ambient sounds of the room with the audience present but without the speaker's voice. These ambient sounds are essential for masking the various cuts in postproduction.

When on an ENG assignment, always have a microphone open to record ambient sounds, even when shooting "silent" footage. In fact, when using a hand mic for a stand-up report (with the reporter telling about a news event while standing in a particular location), you should also turn on the camera mic (the shotgun mic, which is built into, or clipped to, the camera) for the ambient sounds. Feed each of the two mics into a separate VTR audio track. As with room tone, such ambient sounds are essential for sound continuity in postproduction editing. The split tracks allow the video editor to control the mix between the reporter's voice and the ambient sounds.

If you have only one microphone, which you must use for voice pickup, record the ambient sounds on a small, portable audiocassette recorder or on videotape after finishing the voice work. Again, the editor will appreciate some authentic sounds with which to bridge the edits.

You may find that a seemingly simple audio pickup, such as a speech in a large conference room, can pose a formidable audio problem especially if you cannot get close enough in the crowded and noisy room for a clean voice pickup. In this case it may be easier to ask the engineer in charge (usually the audiovisual manager of the hotel or conference room) to assist you with a *line-out tie-in*. In such a setup, you do not need a microphone to pick up the speaker's sound but simply a direct feed from the audio control board of the in-house audio system to the audio input of your camcorder. In effect, you "tie in" to the audio feed from the audio system of the conference room.

MAIN POINTS

- All microphones have a diaphragm, which vibrates with sound pressure, and a generating element, which transduces the physical vibrations of the diaphragm into electric energy.
- In the dynamic, or moving coil, mic, the diaphragm is attached to the voice coil. The air pressure moves the voice coil back and forth within a magnetic field. This type of generating element is quite rugged.
- ◆ The condenser, or electret, mic has a condenser-like generating element. The movable diaphragm constitutes one of the two condenser plates; a fixed backplate is the other. The varying air pressure of the incoming sounds moves the diaphragm plate against the fixed backplate, thus continuously changing the capacitance of the condenser and modulating the current of the audio signal. Condenser mics have a wide frequency response.
- In the ribbon, or velocity, mic, a thin metal ribbon vibrates within a magnetic field. Because the ribbon is fragile, the mics are generally used indoors under controlled conditions.
- ◆ Impedance, usually expressed as high-Z or low-Z, is a type of resistance to the signal flow. The impedances of mics and electric instruments must be matched with that of the other electronic audio equipment. When using the direct-insertion (direct-input) method, whereby the output of electric instruments is patched directly into the mixing console, the high-Z instruments must first be routed through a direct box, which changes the signal to a low-Z impedance. Most modern equipment will match impedances automatically.
- High-quality microphones pick up sounds equally well over a wide frequency range. They can better hear higher and

- lower sounds without distortion—called a flat response—than can low-quality mics.
- Microphones can be balanced or unbalanced. Most professional mics have a balanced output. Balanced microphone cables have two wires for the audio signal and a third wire as a ground shield. The balanced audio cable prevents external signals from causing a hum in the audio track. Unbalanced cables have only a single wire for the audio signal and a second wire as a ground. They cannot be as long as unbalanced cables and are more vulnerable to signal interference.
- All professional microphones and audio equipment use the three-pronged XLR connectors for balanced cables. Unbalanced connectors include the phone plug, the RCA phono plug, and the mini plug.
- Foldback is the return of the total or partial audio mix from the mixing console to the musicians.

ZETTL'S VIDEOLAB

For your reference, or to track your work, each *Video-Lab* program cue in this chapter is listed here with its corresponding page number.

ZVL1 AUDIO→ Microphones→ mic choice | transducer 191

ZVI_2 AUDIO→ Microphones→ pickup patterns 192

AUDIO→ Microphones→
mic types | placement 201

ZVL4 AUDIO→ Connectors→ overview 210

10

Audio: Sound Control

The previous chapter dealt mostly with sound pickup—the types of microphones and their uses. This chapter explores the equipment and the techniques of controlling sound and sound recording in television studio and field production. Section 10.1, Sound Controls and Recording for Studio and Field Operations, identifies the major equipment and production techniques for mixing and recording sound in the studio and the field. Section 10.2, Postproduction and Sound Aesthetics, familiarizes you with basic information on analog and digital audio postproduction equipment and their primary uses. It also highlights the principal aesthetic factors of sound.

You should realize that audio production is a highly specialized field in its own right and that that this chapter is limited to the major equipment, the basic production techniques, and some fundamental aesthetic considerations. Even if you don't intend to become a sound designer, you need to know what good audio is all about. Whatever you do, the most important prerequisite to successful audio for television is, and will always be, a good pair of ears. **ZVL1** AUDIO> Audio introduction

KEY TERMS

- ambience Background sounds.
- audio control booth Houses the audio, or mixing, console; analog and digital playback machines; a turntable; a patchbay; computer(s); speakers; intercom systems; a clock; and a line monitor.
- **audio postproduction room** For postproduction activities such as sweetening; composing music tracks; adding music, sound effects, or laugh tracks; and assembling music bridges and announcements.
- **automatic dialogue replacement (ADR)** The synchronization of speech with the lip movements of the speaker in post-production. Not really automatic.
- **automatic gain control (AGC)** Regulates the volume of the audio or video level automatically, without using manual controls.
- calibrate To make all VU meters (usually of the audio console and the record VTR) respond in the same way to a specific audio signal.
- **cassette** A video- or audiotape recording or playback device that uses tape cassettes. A cassette is a plastic case containing two reels—a supply reel and a takeup reel.
- compact disc (CD) A small, shiny disc that contains information (usually sound signals) in digital form. A CD player reads the encoded digital information using a laser beam.
- digital audiotape (DAT) The sound signals are encoded on audiotape in digital form. Includes digital recorders as well as digital recording processes.
- digital cart system A digital audio system that uses built-in hard drives, removable high-capacity disks, or read/write optical discs to store and access almost instantaneously a great amount of audio information. It is normally used for the playback of brief announcements and music bridges.
- digital versatile disc (DVD) The standard DVD is a read-only, high-capacity (4.7 gigabytes or more) storage device of digital audio and video information. Also called digital videodisc.
- **equalization** Controlling the quality of sound by emphasizing certain frequencies while de-emphasizing others.

- **figure/ground** Emphasizing the most important sound source over the general background sounds.
- **flash memory device** A small read/write portable storage device that can download, store, and upload very fast (in a flash) a fairly large amount (1 gigabyte or more) of digital information. Also called *flash drive*, stick flash, flash stick, or flash memory card.
- mini disc (MD) Optical 2½-inch-wide disc that can store one hour of CD-quality audio.
- mixing Combining two or more sounds in specific proportions (volume variations) as determined by the event (show)
- **mix-minus** Type of multiple audio feed missing the part that is being recorded, such as an orchestra feed with the solo instrument being recorded. Also refers to program sound feed without the portion supplied by the source that is receiving the feed.
- MP3 A widely used compression system for digital audio. Most Internet-distributed audio is compressed in the MP3 format.
- musical instrument digital interface (MIDI) A standardized protocol that allows the connection and interaction of various digital audio equipment and computers.
- peak program meter (PPM) Meter in audio console that measures loudness. Especially sensitive to volume peaks, it indicates overmodulation.
- **sound perspective** Distant sound must go with a long shot, close sound with a close-up.
- surround sound Sound that produces a soundfield in front of, to the sides of, and behind the listener by positioning loudspeakers either to the front and rear or to the front, sides, and rear of the listener.
- **sweetening** Variety of quality adjustments of recorded sound in postproduction.
- **volume unit (VU) meter** Measures volume units, the relative loudness of amplified sound.

10.1

Sound Controls and Recording for Studio and Field Operations

When watching a television program, we are generally not aware of sound as a separate medium. Somehow it seems to belong to the pictures, and we become aware of the audio portion only when it is unexpectedly interrupted. But in your own videotapes, you probably notice that there are always some minor or even major audio problems that tend to draw attention away from your beautiful shots. Although audio is often treated casually, you quickly realize that the sound portion is, indeed, a critical production element that requires your full attention.

▶ PRODUCTION EQUIPMENT FOR STUDIO AUDIO

The audio console, the patchbay, and analog and digital tapebased and tapeless audio-recording systems

► AUDIO CONTROL IN THE STUDIO

The audio control booth and basic audio operation

PRODUCTION EQUIPMENT AND BASIC OPERATION FOR FIELD AUDIO

Keeping sounds separate and the audio mixer

► AUDIO CONTROL IN THE FIELD

Using the automatic gain control in ENG and EFP, and EFP mixing

PRODUCTION EQUIPMENT FOR STUDIO AUDIO

The major components of audio equipment are (1) the audio console, (2) the patchbay, and (3) analog and digital tape-based and tapeless audio-recording systems.

AUDIO CONSOLE

Regardless of individual designs—analog or digital—all *audio consoles*, or audio control boards, are built to perform five major functions:

- Input: to preamplify and control the volume of the various incoming signals
- Mix: to combine and balance two or more incoming signals
- Quality control: to manipulate the sound characteristics
- Output: to route the combined signals to a specific output
- Monitor: to listen to the sounds before or as their signals are actually recorded or broadcast. SEE 10.1

Input Studio consoles have multiple inputs to accept a variety of sound sources. Even small studio consoles may have sixteen or more inputs. Although that many inputs are rarely used in the average in-house production or broadcast day, they must nevertheless be available for the program you may have to do the next day.

Each input module requires that you select either the *mic* or the *line* input. *Mic-level inputs* are for sound sources that need to be preamplified before they are sent to the various input controls. All microphones need such preamplification and are therefore routed to the mic input. *Line-level inputs*, such as CD players, DVD players, or DAT recorders, have a strong enough signal to be routed to the

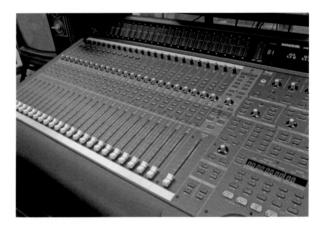

10.1 AUDIO CONSOLE

Each module of this audio console contains a volume control (slide fader), various quality controls, and assignment switches. It can route several mixes to various destinations.

line input without preamplification. All incoming audio signals must reach line-level strength before they can be further adjusted or mixed at the audio console.

Because not all input levels of microphones or line signals are the same, they run the risk of becoming overamplified. To prevent this from occurring, you can manipulate the signals individually with the *trim control*, which adjusts the input strength of the microphone signals so that they won't become distorted during further amplification.

Regardless of input, the audio signals are then routed to the volume control, a variety of quality controls, switches (mute or solo) that silence all the other inputs when you want to listen to a specific one, and assignment switches that route the signal to certain parts of the audio console and to signal outputs. **SEE 10.2**

Volume control All sounds fluctuate in *volume* (loudness). Some sounds are relatively weak, so you have to increase their volume to make them perceptible. Other sounds come in so loud that they overload the audio system and become distorted or they outweigh the weaker ones so much that there is no longer proper balance between the two. The volume control that helps you adjust the incoming sound signals to their proper levels is usually called a *pot* (short for *potentiometer*) or a *fader* (also called *attenuator* or *gain control*).

To increase the volume, turn the knob clockwise or push the fader up, away from you. To decrease the volume, turn the knob counterclockwise or pull the fader down, toward you. **SEE 10.3**

Mix The audio console lets you combine, or *mix*, the signals from various inputs, such as two lavaliere mics, the background music, and the sound effect of a phone ring. The *mix bus* combines these various audio signals with the specific volume that you assign. Without the mixing capability of the board, you could control only one input at a time. The completed mix is then fed to the line-out.

A mix bus is like a riverbed that receives the water (signals) from several different streams (inputs). These streams (various sound signals) converge (mixed sound signal) and finally flow downstream along the riverbed (mix bus) to their destination (recorder). **ZVL2** AUDIO Consoles and mixers parts | signals | control | try it

Quality control All audio consoles have various controls that let you shape the character of a sound (see figure 10.2). Among the most important are equalization, filters, and reverberation (reverb) controls.

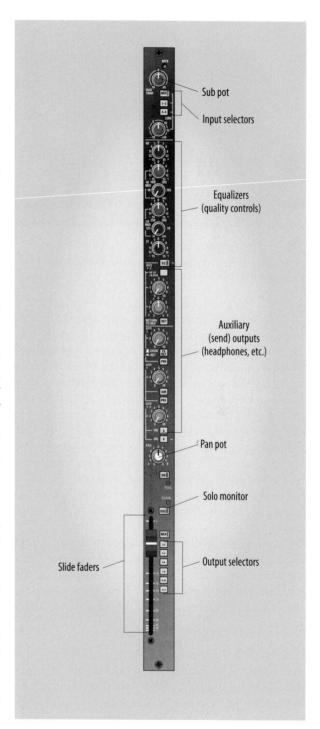

10.2 AUDIO CONSOLE MODULE

The major controls on this module are the slide fader volume control, equalizers, assignment switches, the mute switch (silences this input), the pan pot (moves the sound horizontally from one stereo speaker to the next), and various other quality controls.

10.3 SLIDE FADERS

Pushing the fader up increases the volume; pulling it down decreases the volume.

The process of controlling the audio signal by emphasizing certain frequencies and de-emphasizing or eliminating others is called *equalization*. It can be accomplished manually or automatically through an *equalizer*, which works like the tone control on your home stereo receiver. It can boost or reduce selected frequencies and thereby influence the character of the sound. For example, you can make a sound more brilliant by boosting the high frequencies or more solid by boosting the lows, or you can eliminate a low-frequency hum or a high-frequency hiss. *Filters* eliminate automatically all frequencies above or below a certain point. The *reverb* controls can add an increasing amount of reverberation to each of the selected inputs.

Among the additional quality controls on large consoles are switches that allow you to accommodate the relative strengths of incoming sound signals or that prevent input overloads, and others that let you "pan" the stereo sound to a particular spot between the two stereo speakers.

Output The mixed and quality-processed signal is then routed to the output, called the *line-out*. To ensure that the mixed signals stay within the acceptable volume limits, they are regulated by final volume controls—the master pots—and metered by volume indicators, the most common of which is the *volume unit (VU) meter*. As the volume varies, the needle of the VU meter oscillates back and forth along a calibrated scale. **SEE 10.4**

If the volume is so low that the needle barely moves from the extreme left, you are riding the gain (or volume)

10.4 ANALOG VU METER

The VU meter indicates the relative loudness of a sound. The upper figures ranging from –20 to +3 are the volume units (decibels). The lower figures represent a percentage scale, ranging from 0 to 100 percent signal modulation (signal amplification). Overmodulation (too much signal amplification) is indicated by the red line on the right (0 to +3 VU).

"in the mud." If the needle oscillates around the middle of the scale and peaks at, or occasionally over, the red line on the right, you are riding the gain correctly. If the needle swings almost exclusively in the red on the right side of the scale, and even occasionally hits the right edge of the meter, the volume is too high—you are "bending the needle," "spilling over," or "riding in the red."

Much like the volume indicator amplifier of a home stereo system, the VU meter in some audio consoles consists of *light-emitting diodes* (*LEDs*), which show up as thin, colored light columns that fluctuate up and down a scale. When you ride the gain too high, the column shoots up on the scale and changes color. **SEE 10.5**

Some audio consoles have an additional *peak program meter* (*PPM*), which measures loudness peaks. A PPM reacts more quickly to the volume peaks than does the needle of the VU meter and clearly shows when you are overmodulating (riding the gain too high).

Output channels We often classify audio consoles by the number of output channels. Older television consoles had several input channels but only one output channel because television sound was monophonic. Today, however, even small television consoles have at least two output channels to handle stereophonic sound or to feed two pieces of equipment (such as headphones and a videotape recorder) simultaneously with two independent signals. With high-definition television (HDTV), the sound requirements also change. Very much like motion pictures, large-screen TV displays will require *surround sound*, which involves

10.5 LED VU METER

The LED (light-emitting diode) VU meters indicate overmodulation by lighting up in a different color (usually red).

multiple discrete output channels and a variety of speakers that are strategically placed in front and in back of the display screen (see figure 10.22). This increasing demand for high-quality audio has led to greater use of multichannel (output) consoles in the audio control booth and especially in the audio production room (which is explored in section 10.2).

To identify how many inputs and outputs a specific console has, they are labeled with the number of input and output channels, such as an 8×1 or a 32×4 console. This means that the small 8×1 console has eight inputs and one output; the larger 32×4 console has thirty-two inputs and four outputs. With a single output channel, the 8×1 board obviously is monophonic.

Most larger television audio consoles have eight or more output channels (with eight master pots and eight VU meters), each of which can carry a discrete sound signal or mix. The advantage of multiple outputs is that you can feed the individual signals onto a multitrack audiotape recorder for postproduction mixing.

If, for example, there are twenty-four inputs but only two outputs, you need to mix the various input signals down to two, which you can then feed to the left and right channels of a stereo recorder. But if you want to keep the various sounds separated to exercise more control in the final postproduction mix, or if you want to feed separate surround-sound speakers, you need more outputs. Even when covering a straightforward rock concert, for example, you may have to provide one mix for the musicians, another for the audience, one for the videotape recorder (VTR), and yet another for the multitrack audiotape recorder (ATR). You will be surprised by how fast you run out of available inputs and outputs even on a big console.

In-line consoles Some of the more elaborate consoles, called in-line consoles, have input/output, or I/O, modules, which means that each input has its own output. If, for example, there are twenty-four inputs and each one receives a different sound signal, you could send each of them directly to the separate tracks of a twenty-fourtrack recorder without feeding them through any of the mix buses. That way you use the console to control the volume of each input, but the console does not function as a mixing or quality-control device. In fact, the sound is sent to the tape recorder in its raw state. The mixing and quality control of the various sounds are all done in the postproduction and mixdown sessions. The I/O circuits let you try out and listen to all sorts of mixes and sound manipulations without affecting the original signal sent to the recorder.

Phantom power Don't let the name scare you: As mentioned before, the "phantom" in *phantom power* is more like "virtual." All it means is that the audio console or some other source, rather than a battery, supplies the preamplification power to some condenser mics.

Monitor and cue All consoles have a monitor system, which lets you hear the final sound mix or allows you to listen to and adjust the mix before switching it to the lineout. A separate audition or cue return system lets you hear a particular sound source without routing it to the mix bus. This system is especially important when you want to cue a digital audiotape (DAT) or a cassette or you want to check the beginning sounds of a compact disc (CD) or a digital versatile disc (DVD) track while on the air with the rest of the sound sources.

Computer-assisted consoles Almost all newer consoles contain a computer through which you can preset, store, recall, and activate many of the audio control functions. For example, you can try out a particular mix with

specific volume, equalization, and reverberation values for each of the individual sounds, store it all in the computer's memory, try something else, and then recall the original setup with the press of a button.

Digital consoles These consoles look like their analog cousins except that they have centralized controls that trigger various sound control and routing functions for each input module. These controls are not unlike the delegation controls of a video switcher (see figure 11.4). The advantage is that this routing architecture keeps the console relatively small and workable.

PATCHBAY

The primary function of the *patchbay*, or patch panel, is connecting and routing audio signals to and from various pieces of equipment. You can accomplish this by using actual wires that establish specific connections, or with a computer that rearranges the signals and sends them according to your instructions. Whatever method you use, the principle of patching is the same. Here we use wires, called *patch cords*, to explain a simple patching procedure.

Assume that you want to have two microphones, a remote feed from a field reporter, and a CD operating during a newscast. Lav 1 and 2 are the newscasters' lavalieres. The remote feed comes from the field reporter with a live story. The CD contains the opening and closing theme music for the newscast.

Just as the individual lighting instruments can be patched into any of the dimmers, any one of these audio sources can be patched to individual volume controls (pots or faders) in any desired order. Suppose you want to operate the volume controls in the following order, from left to right: CD, lavaliere 1, lavaliere 2, remote feed. You can easily patch these inputs to the audio console in that order. If you want the inputs in a different order, you need not unplug the equipment; all you do is pull the patch cords and repatch the inputs in the different order. **SEE 10.6**

Wired patchbay All wired patch panels contain rows of holes, called *jacks*, which represent the various outputs and inputs. The upper rows of jacks are normally the outputs (which carry the signals from mics, CDs, and so forth). The rows of jacks immediately below the output jacks are the input jacks, which are connected to the audio console. The connection between output and input is made with the patch cord.

To accomplish a proper patch, you must plug the patch cord from one of the upper output jacks into one of the lower input jacks. **SEE 10.7** Patching output to output (up-

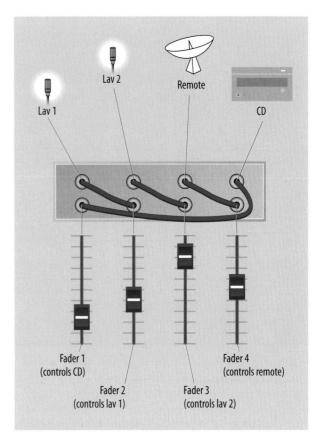

10.6 PATCHING

This patching shows that the signal outputs (audio sources) of two microphones, a remote feed, and a CD are grouped in the following order of fader inputs: CD, lavaliere 1, lavaliere 2, remote feed.

per-row jack to another upper-row jack) or input to input (lower-row jack to lower-row jack) will give you nothing but headaches.

To reduce the number of patch cords, certain frequently used connections between outputs (a specific mic, DAT machine, or CD) and inputs (specific volume controls assigned to them) are directly wired, or *normaled*, to one another. This means that the output and the input of a circuit are connected without a patch cord. By inserting a patch cord into one of the jacks of a normaled circuit, you *break*, rather than establish, the connection.

Although patching helps make the routing of an audio signal more flexible, it can also cause some problems. Patching takes time; patch cords and jacks get worn out after frequent use, which can cause a hum or an intermittent connection; and many patch cords crisscrossing each other are confusing and look more like spaghetti than orderly

10.7 PATCHBAY WITH PATCHES

All patchbays connect the signal outputs (mics, CDs, VTRs) to specific input modules of the audio console. The patching is accomplished by connecting the audio outputs (top row) to the inputs (bottom row) with patch cords.

connections, making individual patches difficult to trace. Also, when patching with a corresponding fader still set at a reasonably high volume, the pop caused by plugging or unplugging the patch cord can blow even the most robust speaker. Once again, although physical connections are important because you can see which signal goes where, the computer can perform many of the routine patching functions more efficiently.

Computer patching In computer patching, the sound signals from the various sources, such as mics, direct boxes, CDs, DVDs, or videotapes, are routed to the patch panel programmer, which assigns the multiple signals to specific fader modules of the audio console for further processing. To route lavaliere 1 to pot 2, and the CD to pot 1, for example, you don't need any physical patches; you simply enter the routing information into the computer (patch panel programmer), which tells the electronic patch panel to connect the inputs to the desired faders on the console, show the information on the display screen, and store your patching commands on a disk for future use. Patching is now as easy as pasting words with a word processor.

AUDIO-RECORDING SYSTEMS

The sound of routine television productions is usually recorded simultaneously with the pictures on one of the audio tracks of the videotape recorder. There are occasions, however, when you need to back up your sound recording

with a separate audio recording, or record the audio on a separate system for high-end postproduction. Even if you don't intend to become an audio expert, you need to know what systems are available to you.

In general, audio-recording systems can record audio signals in analog or digital form. As explained in chapter 2, analog means that the signal fluctuates exactly like the original stimulus; digital means that the signal is translated into many discrete digits (on/off pulses). Almost all audio recording in professional television is done digitally. As with video, digital audio recordings excel not only in sound quality but also in maintaining that quality in extensive postproduction editing. Because digital systems allow you to see a visual display of the recorded sounds, they make editing much more precise than with the analog methods. But don't dismiss analog audio just yet. Many older camcorders and VHS recorders are still analog, and there are extensive analog sound archives that will most likely remain analog even in the digital age. You may still have a collection of analog equipment that most likely includes an analog cassette machine. Some audio purists have returned to analog sound systems because, according to them, analog recordings have a warmer sound than digital ones.

ANALOG RECORDING SYSTEMS

All analog recording systems are tape-based. Here we briefly touch on the two analog audio systems that are still in use: the open-reel audiotape recorder and the audiocassette recorder. The operational features of analog ATRs have been inherited by the digital recorders.

Open-reel audiotape recorder The *open-reel*, formerly called reel-to-reel, *audiotape recorder* is generally used for multitrack recording or for playing back longer pieces of audio material. For example, the background music and the sound effects, such as traffic noise, are generally premixed (prerecorded) on audiotape and then played back and mixed again with the dialogue during an actual production. The ATR is also used to record material for archival purposes. Although a great variety of ATRs are used in television production, they all operate on common principles and with similar controls.

All professional ATRs, analog and digital, have, in addition to the switch for the various recording speeds, five control buttons that regulate the tape motion: (1) *play*, which moves the tape at the designated recording speed; (2) *fast-forward*, which advances the tape at high speed; (3) *stop*, which brakes the reels to a stop; (4) *rewind*, which rewinds the tape at high speed; and (5) *record*, which activates both the erase and the record heads. **SEE 10.8** Many

10.8 OPEN-REEL ANALOG AUDIOTAPE RECORDER

This open-reel ATR can record up to eight separate audio tracks on a ¼-inch audiotape and can locate certain cue points automatically. It can interface with the SMPTE time code for audio/video synchronization. All of the controls—including the standard operational controls of play, fast-forward, stop, rewind, and record—are on a panel that can be used from a remote location.

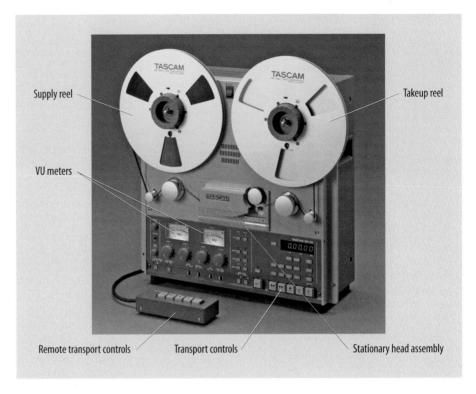

tape recorders also have a *cue* control, which enables you to hear the sound on a tape even when running at fast-forward or rewind speeds.

The tape moves from a *supply reel* to a *takeup reel* over at least three heads: the erase head, the record head, and the playback head. **SEE 10.9** This head assembly arrangement is standard for all analog tape recorders. When the ATR is being used for recording, the erase head clears the portions of the tape that receive the recording (tracks) of all audio material that might have been left on the tape from a previous recording; the record head then puts the

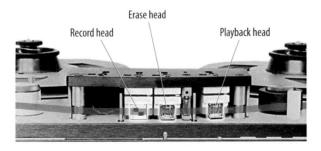

10.9 ANALOG AUDIOTAPE HEAD ASSEMBLY

The head assembly of an analog reel-to-reel ATR consists of an erase head, a record head, and a playback head.

new audio material on the tape. When the tape is played back, the playback head reproduces the audio material previously recorded. The erase and record heads are not activated during playback.

Some audio production rooms in large stations have multitrack recorders that use wider formats than the standard ¼-inch (such as ½-, 1-, or 2-inch) to accommodate the multiple (up to twenty-four) tracks. High-quality four-track machines use ½- or 1-inch tape. The 2-inch tape is used for sixteen or more analog tracks.

Audiocassette recorder Professional *cassette* systems are similar to the one you have at home or carry around except that they have more-sophisticated electronics to reduce noise and more-durable tape transports that allow faster and smoother fast-forward and rewind speeds.

As you know from experience, cassettes are easy to store and handle and can play up to 120 minutes of audio material. Despite the narrow tape, cassettes produce good sound, especially if they are the newer, metal-particle-coated variety. Despite the digital revolution, analog cassettes are still popular in television production. If you want superior audio quality from cassettes, however, you should use a DAT recorder.

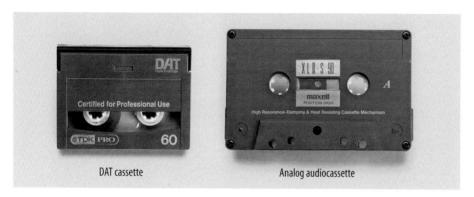

10.10 ANALOG AND DAT CASSETTES

The DAT cassette is considerably smaller than the regular analog audiocassette.

Digital recording is done with either tape-based systems or a variety of tapeless devices.

TAPE-BASED DIGITAL RECORDING SYSTEMS

The tape-based systems include videotape used by the stand-alone or camcorder VTRs, and DAT recorders. Some postproduction rooms have larger digital multitrack recorders that use S-VHS or Hi8 videotape, but the more flexible and efficient hard disk recorders have made these modular digital multitrack (MDM) recorders and digital tape recording systems (DTRSs) all but obsolete.

Videotape recorders Most digital audio recording for video is done simultaneously with the video on one or both tracks of the videotape (see figure 12.6). Some prosumer and professional camcorders let you choose between high-quality (16-bit) and a somewhat lower-quality (12-bit) recording mode.

DAT recorders *Digital audiotape* (*DAT*) recorders can use open-reel tape or cassettes. The digital open-reel machines look and operate much like the analog open-reel recorders—they have a supply and a takeup reel—but the head assembly is more like that of a VTR. Its recording and playback heads rotate at high speed while the audiotape passes by them. Because the recording and playback heads rotate, these machines are also called *R-DAT recorders*.

Normally, a DAT recorder refers to a digital cassette recorder. These machines operate more like videocassette recorders than audiocassette recorders. As with open-reel DAT recorders, the heads of the cassette recorders rotate at high speed. Because of the rotating heads, the cassettes can be smaller than analog cassettes, but at their slowest speed they still record up to four hours of high-quality audio. As with videotape, however, the slower tape speeds produce lower-quality recordings. **SEE 10.10**

Besides recording sound with the customary digital, virtually noise-free high fidelity, high-end DAT recorders include the following features that are especially important for video production:

- High-speed search and extremely accurate cueing
- Verbal slating (identifying a scene or take) through a built-in microphone
- Time code recording simultaneously with the audio material, for cueing and for matching sound and pictures in postproduction
- Display that shows the time remaining on the tape
- Synchronization, if desired, of its internal time code with an external time code (such as the one supplied by or to the cameras)
- Recording and display of the current date and time SEE 10.11

10.11 PORTABLE DAT RECORDER

This portable DAT recorder can record up to two hours on a single battery charge. It has one balanced stereo input (two XLR jacks) and four unbalanced inputs (RCA phono jacks). Its excellent frequency response lets you make high-fidelity recordings of speech and music.

But these wonder machines are not problem-free. The high-speed rotary heads are subject to wear and tear, especially if not properly maintained, and the recorders are sensitive to moisture. DAT cassettes cannot have any flaws, or the recording will be equally flawed. Finally, DAT recorders are quite expensive, which is why tapeless recorders are becoming more popular.

TAPELESS RECORDING SYSTEMS

High-capacity, rugged hard drives coupled with efficient compression systems such as *MP3* make disk-based systems the prime audio-recording medium in television production. The more popular systems include: (1) the digital cart system, (2) mini disks and flash memory devices, (3) hard drives with removable or fixed disks, and (4) optical disc systems with a variety of CD and DVD formats.

Digital cart system The digital recorder/players that constitute a *digital cart system* use regular high-capacity removable computer disks, such as the 250-megabyte Zip disks, for recording and playback, or read/write optical discs or mini discs. These digital systems operate very much like a home CD player. You can select a particular cut and start the audio track instantly. You can also interface the digital cart with a desktop computer that lets you assemble a playlist, which will automatically cue and start various audio segments. **SEE 10.12**

Mini discs and flash memory devices The mini disc (MD) is a small (about 2½-inch) read-only or read/write optical disc that can store more than an hour of high-quality digital stereo audio. Its small size, large storage

10.12 DIGITAL CART RECORDER/PLAYER

This digital cart system uses a removable high-density computer disk and allows random and instant cueing and playback via remote control.

capacity, and easy cueing make it a useful playback device for television production.

The *flash memory device*, or *flash drive*, is a small memory stick, very much like the one you might be using in your digital still camera or prosumer camcorder. It has no moving parts but can store 1 gigabyte of information. This means that the flash drive can hold approximately one hour of high-quality audio. It plugs right into the USB port on your computer.

Hard drives There are large-capacity systems built specifically for audio production and postproduction that store audio information just like you would on your computer hard drive. **SEE 10.13** Despite its diminutive size,

10.13 DIGITAL MULTITRACK RECORDER/PLAYER

This digital recorder can record twenty-four tracks on two high-capacity hard drives. Both hard disks (10 megabytes each) are removable and can be swapped from bay to bay.

the ubiquitous Apple iPod has a 20-gigabyte hard drive that you can connect to your computer via USB cable or FireWire (IEEE 1394) for storing audio files and other data. You can then transfer these files to a digital editing system. **SEE 10.14** Some have built-in hard drives; others have removable disks that can be exchanged from one recorder/player to another.

CD and **DVD** The professional *compact disc* (*CD*) and *digital versatile disc* (*DVD*) players are often used in television (and radio) stations for playing back commercially produced music and other audio material. The rewritable CDs and DVDs are used for multiple recording and playback. There are several different CD and DVD formats on the market, all of which perform similar production functions: the storage and playback of a variety of audio material. SEE 10.15

Professional CD and DVD players allow random access of a specific track; let you enter, store, and activate various play sequences; and display, among other things, the menu of the playlist, what the disc is playing, and how much of the segment time is remaining.

Although CDs and DVDs can theoretically withstand an unlimited amount of playbacks without deterioration, they are nevertheless quite vulnerable. If you scratch the shiny side or even the label side, the disc won't play past the scratch. And if there are fingerprints on the disc, the laser may try to read the fingerprints instead of the imprinted digits. When handling CDs and DVDs, try to keep your hands off the surface and always put down the disc on its label side—not its shiny side.

AUDIO CONTROL IN THE STUDIO

Recall from chapter 1 that most audio booths are separate from the program control section yet in close proximity to

10.14 APPLE IPOD DIGITAL MUSIC PLAYER

This tiny player can store a great amount of music and other data on its 20-megabyte hard drive.

it. Some provide visual access to the studio or, at least, to the program control room. When walking into the audio booth, you will probably be surprised by the variety and the complexity of audio equipment, especially because we are generally unaware of the audio aspect of television unless something goes wrong.

AUDIO CONTROL BOOTH

The *audio control booth* houses the audio, or mixing, console; analog and digital recording and playback equipment,

10.15 PROFESSIONAL CD PLAYER

Professional CD and DVD players allow instant random access to various tracks. The play sequence can be stored and displayed on playback.

^{1.} Stanley R. Alten, *Audio in Media*, 7th ed. (Belmont, Calif.: Thomson Wadsworth, 2005), pp. 122–29.

10.16 AUDIO CONTROL BOOTH

The television audio control booth contains a variety of audio control equipment, such as the control console with computer display, patchbay, CD and DVD players, DAT machines, loudspeakers, intercom systems, and a video line monitor.

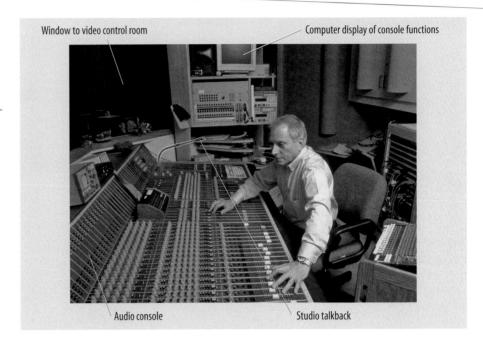

such as cassette recorders, a reel-to-reel analog ATR, DAT recorders, an MD player, CD and/or DVD machines; and, largely for nostalgic reasons, a turntable. There is also a physical patchbay despite the presence of computer patching, and one or more desktop computers fulfilling various functions. You will also find cue and program speakers, intercom systems, a clock, and a line monitor. One audio engineer (or audio operator or audio technician) operates the audio controls during a show. **SEE 10.16**

BASIC AUDIO OPERATION

Learning to operate all this equipment takes time and practice. Fortunately, in most studio productions your audio tasks consist mostly of making sure that the voices of the news anchors or panel guests have acceptable volume levels and are relatively free of extraneous noise and that the sound appears with the pictures when video recordings are played. Most likely you will not be asked to do intricate sound manipulations during complex recording sessions—at least not right away. Consequently, the focus here is on the basic audio control factors: (1) audio system calibration, (2) volume control, and (3) live studio mixing.

Audio system calibration Before doing any serious volume adjustment or mixing, you need to make sure that the audio console and the VTR or any other device on which you are recording the audio "hear" in the same way, that is, that the VTR input volume (recording level)

matches the console output (line-out signal). This process is called audio system calibration or simply *calibration*. To *calibrate* a system is to make all the VU meters (usually of the audio console and the record VTR) respond in the same way to a specific audio signal—the *control tone*. (Note that audio calibration has nothing to do with the zoom lens calibration, whereby you adjust the zoom lens so that it stays in focus during the entire zoom range.)

Here are the basic steps of audio calibration:

- With all faders on the console or mixer turned all the way down, activate the control tone, which is either a continuous tone or an intermittent beep. Most professional audio consoles and mixers have such a tone generator built-in.
- 2. Bring up the master (line-out) fader on the console or mixer to the 0 VU mark.
- 3. Bring up the fader for the control tone until the master (line-out) VU meter reads 0 VU. While bringing up the fader, you should hear the sound becoming progressively louder until it has reached the 0 VU level.
- 4. Now turn up the incoming volume control on the VTR until its VU meter also reads 0 VU. When both the master VU meter of the console or mixer and the VU meter of the VTR read the same 0 VU level, the system has been calibrated.

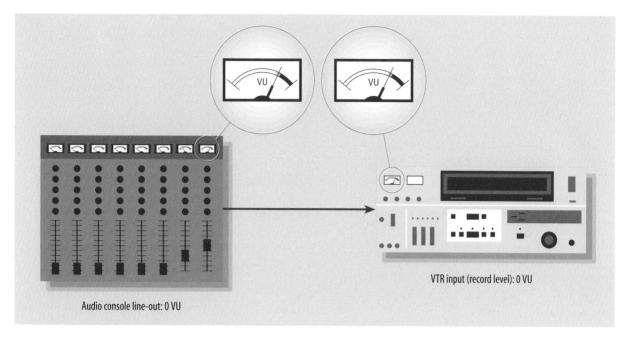

10.17 AUDIO SYSTEM CALIBRATION

An audio system is calibrated when all VU meters respond in the same way to a specific audio signal. Here the line-out of the audio mixer is calibrated with the input (record level) of the VTR. Both VU meters show the same value.

From this point on throughout the recording, the VTR operator should not touch the audio input level, even if the VU meter indicates low volume levels. It is up to you—the console operator—to maintain proper audio levels.

Because the VTR is now receiving exactly what you send from the console or mixer, you can confidently engage in some serious volume control. SEE 10.17 ZVL3 AUDIO→ Consoles and mixers→ calibration

Volume control Once the system is calibrated, you can pay attention to the finer points of adjusting the volume of the incoming sound sources.

Taking a level Except when literally running after a story on an ENG assignment, before starting the videotape recording you should always *take a level*—that is, adjust the input level so that the talent's speech falls more or less within the tolerable volume range (not riding in the mud and not bending the needle). Ask the talent to talk long enough for you to see where the lower and upper limits of the speech volume are, then place the fader between these two extremes. An experienced performer will stay within this volume range even in subsequent takes.

Unfortunately, when asked to give a level, most performers consider it an intrusion on their concentration and simply count rapidly to three or four; then, when they are on the air, their voices rise to the occasion—and also in volume. Always be prepared for this sudden volume increase. Experienced performers give a few of their opening remarks in about as loud a voice as they will use when on the air.

When overmodulating speech (riding the gain consistently at too high a level), you end up not with a recording that is slightly too loud but with distorted sound. Although it is relatively easy to boost sound that was recorded at a slightly lower-than-normal level (even at the risk of amplifying some of the noise with the low-level sounds), it is very difficult and often impossible to fix overmodulated, distorted sound in postproduction. Digital sound is especially susceptible to overmodulation.

Live studio mixing *Live mixing* means that you combine and balance sounds while the production is in progress. Studio mixing may range from the relatively simple task of riding gain for the newscaster's lavaliere mic or balancing the voices of several panel members during a discussion, to the more complicated job of switching among various audio sources during a newscast or recording a rock band or even a dramatic scene for an interactive multimedia program on how to recognize potential shoplifters.

As with the setup of mics for a complex production, there is no formula for how an optimal mix is achieved. When riding gain for the single mic of the news anchor, simply keep his or her level within the acceptable audio range and watch that the anchor is clearly heard. When controlling the audio of the panel discussion, riding gain is easiest if every member wears a lavaliere. Once the levels are set, you have little to do except bring down the fader somewhat if one of the members gets excited and starts talking much louder than normal, or bring it up when somebody drifts off mumbling.

When using desk mics, the most important audio job is before the show even starts—the mic setup. Remember to place the mics at least three times as far apart as the distance of any mic to the panel member (as described in chapter 9) to eliminate possible multiple-microphone interference. After taking preliminary levels, adjust the mics for optimal positions and tape them down. Take another level, adjust the faders for all mics, and hope that the panel members' kicking and banging on the table will be kept to a minimum.

The multisource newscast is more challenging. For example, you may need to switch quickly from the anchor's introduction to *SOT* (*sound on tape*), and from there to the co-anchor, to the guest in London (remote source), back to the co-anchor, to another VTR, back to the anchor, to a commercial, and so forth. You will find that labeling each audio input will greatly facilitate your audio control: simply put a strip of masking tape below the faders and mark them with a grease pencil. As for volume control, you have to watch the remote sources and the SOT segments more than the mics of the anchors and weathercaster (whose voice levels you have set before the newscast).

The mixing for the rock band or dramatic scene for the multimedia project can be quite complicated and is best left to an audio expert. Again, the initial choice of mics and their proper placement are more challenging than the mixing itself. You may also have to patch the mics for various audio feeds, such as foldback, mix-minus, audience feed, or videotape feed. A *mix-minus* feed is a type of foldback in which you send into the studio a complete mix (usually the band or orchestra) minus the sound generated in the studio (such as the singer's voice). Regardless of the complexity of the setup, there are some basic steps to follow:

- 1. Label each input.
- 2. Calibrate the audio system.
- 3. Check the mics individually by having an assistant lightly scratch the surface of each mic. This will

identify the specific mic whose input you are trying to locate. Having someone talk in the vicinity of the mic is not as accurate—you may well think you are testing one mic while actually receiving sound from another.

- If foldback is required, check the foldback levels in the studio.
- 5. Do a brief test recording and listen to the play-back mix.
- 6. Adjust the necessary quality controls until the singer's voice sounds the way you like it to sound. Check with the band's manager or producer, who usually likes to listen to the rehearsal in the audio control booth, before deciding on the final recording setup.
- 7. Try to record major sound sources (voice and instruments, dialogue and sound effects, guitar, bass, and keyboard) on separate tracks. Such separation makes postproduction mixing much easier than if you mix everything live on a single track.
- 8. Anticipate the director's cues. For example, be prepared to open (activate) a specific person's mic so that you can react immediately to the director's cue.
- 9. Do not panic and lose your temper if you hear some accidental noise, such as a door slamming or something being dropped. Although such noise may sound to you like irreparable damage at the time, most viewers will not even be aware of it. Don't take this friendly advice as an invitation to sloppy sound control but rather as an appeal to common sense. If, however, you are doing a recording meant for postproduction, alert the director of such incidents and let him or her decide whether to do a retake.

PRODUCTION EQUIPMENT AND BASIC OPERATION FOR FIELD AUDIO

As with all audio, the better the sound pickup, the easier the sound control during the production or in postproduction. (Refer to chapter 9 for information and advice on what mics to use outdoors and how to achieve optimal sound under various field conditions.)

Unless you are engaged in a big remote (see chapter 20), the audio equipment in the field is much less elaborate than its studio counterparts. This is not because you don't need to produce optimal audio in the field but simply because in ENG the audio requirements are usually more

modest. Similarly, in EFP most of the quality control is done in postproduction in the studio. But don't be fooled into thinking that field audio is somehow easier than studio audio. On the contrary—sound pickup and recording in the field are actually more difficult. In the field you have to worry about wind noise, barking dogs, traffic sounds, airplanes overhead, chattering onlookers, or rooms that produce the dreaded inside-a-barrel sounds.

KEEPING SOUNDS SEPARATE

The key to good field audio is keeping the primary sounds as separate from the environmental sounds as possible. For example, you usually want to record the reporter's mic input on one audio track and the camera mic's input of primarily ambient sounds on the second audio track. There will nevertheless be circumstances in which you need to mix and balance several sound sources in the field. For example, if you have to cover an interview of several people in somebody's living room, you should balance their voices right then and there. This is where the field mixer comes in.

AUDIO MIXER

An audio mixer differs from a console in that it normally serves only the input (volume control) and the *mixing* (combining two or more signals) functions. **SEE 10.18**

Most portable mixers have only three or four input channels and one or two outputs. Even then the small mixers require that you distinguish between low-level and high-level input sources. A switch above or below each sound input must be set either to *mic* for low-level inputs,

10.18 PORTABLE MIXER

This portable mixer has three inputs and two outputs. The volume controls are rotary knobs. Such big knobs and switches are especially convenient in the field, where digital menus are often hard to see and activate.

such as all microphones, or to *line* for high-level sources, such as the output of a CD player. Because most of the time you will use the field mixer for mixing microphones, double-check that the input switch is set to *mic*. If you are not sure whether a particular piece of audio equipment produces a mic-level or a line-level signal, do a brief test recording. Don't rely on the VU meter when playing back the test recording—you should actually listen to it with headphones. The VU meter might show the recording to be in the acceptable volume range, but it will not reflect sound distortions.

Even though some digital mixers have more inputs as well as some quality controls, elaborate mixing in the field is not recommended unless you're doing a live telecast.

AUDIO CONTROL IN THE FIELD

You usually do not need a mixer when doing ENG. You can plug the external mic into one of the camcorder audio inputs and plug the camera shotgun mic into the other audio input.

USING THE AGC IN ENG AND EFP

Be especially conscious of the overmodulation problem during ENG or EFP. When you are on an ENG assignment and cannot watch the VU meter on the camcorder. switch on the *automatic gain control* (AGC), which boosts low sounds and reduces high-volume sounds so that they conform to the acceptable volume range. The AGC does not discriminate between wanted and unwanted sounds, however; it faithfully boosts the sound of the passing truck and the coughing crewmember and even the noise of the pauses when the field reporter is thinking of something clever to say. But whenever possible, and especially when in noisy surroundings, switch off the AGC, take a level, and try to watch the audio levels. When using DAT, turn down the pot (volume control) a bit from where you had it while taking a level. This way you can be pretty sure not to overmodulate once you are on the air.

EFP MIXING

In EFP mixing there are always assignments for which you have to control more audio sources than the two microphones. Even a simple assignment such as covering the opening of the local elementary school's new gym will most likely require that you mix at least three microphones: the field reporter's mic, the lectern mic for the speeches, and a mic to pick up the school choir. If you run out of mic inputs on the mixer, you can always cover the choir with the camera mic.

Despite the number of mics, the mixing itself is fairly simple. Once you have set the level for each input, you probably need to ride gain only for the reporter's mic during interviews and for the various speakers at the lectern. You may also want to bring up (increase the gain of) the choir mic during the performance. Although in an emergency you could try to pick up most of these sounds with the camera mic or by pointing a shotgun mic at the various areas, the multiple-mic setup and the portable mixer afford you better control.

Here are a few basic guidelines for live ENG/EFP mixing:

- Even if you have only a few inputs, label each one with what it controls, such as field reporter's mic, audience mic, and so forth. You would be surprised at how quickly you forget whose mic corresponds to which pot. In case you have to turn over the audio control to someone else, he or she can take over without long explanations.
- If you work with a separate VTR, calibrate the audio output of the camera with the audio input of the VTR.
- If you do a complicated mix in the field, protect yourself by feeding it not only to the camcorder and the VTR but also to a separate audio recorder for probable remixing in postproduction.
- If you feed the mixer line-out to the camcorder and a backup audio recorder, you must calibrate all of the equipment.
- Double-check all inputs from wireless mic systems—they have a tendency to malfunction just before the start of an event.
- If recording for postproduction, try to put distinctly different sound sources on separate audio tracks of the videotape, such as the reporter's and guests' voices on one track and the speaker's lectern mic and the choir on the other. That way it will be easier during postproduction *sweetening* (getting rid of unwanted noises and improving the sound quality) to balance the reporter's voice with the other sounds.

It is usually easier to do complicated and subtle mixing in postproduction rather than live in the field. This does not mean that you should forgo filtering out as much unwanted sound as possible during the on-location pickup, assuming that the mixer has some basic quality controls available. If it doesn't, don't worry. If any sweetening is to be done, do it in postproduction. Remember that the more attention you pay to good sound pickup in the field, the less time you need in postproduction.

MAIN POINTS

- The major production equipment for studio audio includes the audio console, the patchbay, analog and digital tapebased recording systems (VTR, ATR, and DAT), and tapeless recording systems (digital cart, mini disc and flash memory devices, hard drives with removable or fixed disks, and optical disc systems, such as CDs and DVDs).
- Audio consoles perform five major functions: input—select, preamplify, and control the volume of the various incoming signals; mix—combine and balance two or more incoming signals; quality control—manipulate the sound characteristics; output—route the combined signal to a specific output; and monitor—route the output or specific sounds to a speaker or headphones so that they can be heard.
- The audio control area of a television studio includes the basic audio control booth, which is used for the sound control of daily broadcasts. It houses the audio console, the patchbay, various recording and playback systems, high-quality speakers, a video monitor, and at least one computer that carries the essential in-house information.
- The basic audio operation includes: the audio system calibration, which means that all VU meters in the system must respond in the same way to a specific audio signal (control tone); volume control; and live studio mixing.
- Live studio mixing usually involves combining and balancing sounds while the production is in progress.
- In EFP the key to good field audio is keeping the various sound sources reasonably separate so that they can be properly mixed in postproduction.
- The automatic gain control (AGC) is a convenient means of keeping the volume within acceptable limits, but in its automatic amplification it will not distinguish between important sounds and unwanted sounds.

10.2

Postproduction and Sound Aesthetics

If you want to replace an existing sound track on a videotape, add music or sound effects to an edited videotape, get rid of some noise or other audio interference, or premix a sound track to serve as a guide for video editing, you are engaged in *audio postproduction*. This section touches on some fundamental postproduction activities, basic postproduction equipment, and major aesthetic considerations.

AUDIO POSTPRODUCTION ACTIVITIES

Linear and nonlinear sound editing, correcting audio problems, postproduction mixing, and controlling sound quality

AUDIO POSTPRODUCTION ROOM

The digital audio workstation, analog audio synchronizer, keyboards and sampler, and automatic dialogue replacement

SOUND AESTHETICS

Environment, figure/ground, perspective, continuity, and energy

STEREO AND SURROUND SOUND

Horizontal positioning and creating the soundfield

AUDIO POSTPRODUCTION ACTIVITIES

Because of the sophisticated video-editing techniques and large-screen, high-definition video displays, the quality of television audio has become of primary importance. Consequently, complex audio postproduction is no longer left

to the video editor but has become a demanding field in its own right. That said, you will find that you don't have to be an audiophile to accomplish basic audio postproduction tasks, and you need to know at least the potential of digital audio postproduction. Without this knowledge you will be unsure of yourself and either fall for the excuses of a sound editor or become unreasonably demanding.

LINEAR AND NONLINEAR SOUND EDITING

You will find that the most common postproduction task is managing the sound track during video editing. In a news story about a political candidate, you probably see and hear her make a brief but especially striking statement, but then you hear the reporter summarize the rest of her comments. During her brief statement—the *sound bite*—the audio is synchronized with the picture, but when the reporter's summary comes in, the new sound track is obviously edited in later to the existing video. But even editing a videotape for significant sound bites by cutting out extraneous information takes practice.

Linear audio editing When editing the audio track of a videotape, you need to select the video and audio portions from the source VTR that contains the original footage, then copy the video and the audio (or the audio only) onto the *edit master tape* of the record VTR. You can adjust the record VTR or the video *edit controller* so that it reads the audio track independent of the video track. To accomplish this split, the video-editing system must be in the *insert mode*. If you want to add audio that is not on the source tape, you need to feed the new audio to the record VTR via a small mixer. (These features and operations are explained in detail in chapter 13.)

Nonlinear audio editing If you work with a nonlinear video-editing system, all of the video and audio information is stored as computer files on a high-capacity hard drive. Audio editing then resembles cutting and pasting words and sentences with a word-processing program. The great advantage of nonlinear audio editing is that you can not only hear the sounds but also see them as a graphic on-screen. Such a visual representation of sound helps make audio editing extremely precise, especially when you work with several sound tracks. Another advantage is that you can synchronize specific sounds with the selected video or move them from place to place with relative ease.² SEE 10.19

^{2.} For an excellent and detailed discussion of nonlinear audio editing, see Alten, *Audio in Media*, pp. 372–97.

10.19 VISUAL REPRESENTATION OF SOUND

All nonlinear audio-editing systems show a visual representation of various sound tracks.

Editing video to audio and transcribing audio

When doing a brief news feature or segments of a documentary, it is often easier to edit the sound track first and then "drop in," or match, the appropriate video to the edited audio track. You will soon discover, however, that editing audio involves playing the source audio (or a copy thereof) over and over again to find the right edit points; this can be extremely wearing on the equipment as well as on you, so regardless of whether you edit on a linear or a nonlinear system, you must transcribe the audio track, that is, play back the track in segments and type out every spoken word. But isn't this procedure more time-consuming than editing the sound track right away? Yes, if you have only a few sound bites to edit—but not if you have to edit longer or more complex speeches. The big advantage of transcribing the dialogue is that you can locate the editing cues—and change them much more readily—when looking at the typed page than when listening to the taped audio. ZVL4 EDITING→ Postproduction guidelines → audio transcript

CORRECTING AUDIO PROBLEMS

Fixing a seemingly simple mistake, such as the talent's mispronouncing a word or giving the wrong address, can become a formidable if not impossible postproduction task. When a politician says "I am not a *cook*" instead of "*crook*" in the middle of videotaping his defense, "fixing it in post" can be very labor-intensive. It is much easier to correct the problem right away and have the politician repeat his comments a few sentences before he made the mistake. Such problems become almost impossible to fix

if you have to try to lip-sync the new word or words in postproduction. ZVL5 EDITING→ Functions→ correct

Filtering out the low rumble of wind during an outdoor shoot or the hum of a lighting instrument in the studio is possible with sophisticated equipment but is nevertheless difficult and time-consuming. Even experienced audio production people labor long hours correcting what may seem like a relatively simple audio problem. The more care you take during the audio acquisition, the more time you save in the long run.

POSTPRODUCTION MIXING

Postproduction mixing is not much different from live mixing except that you remix separately recorded sound tracks instead of live inputs. Because you mix recorded sound tracks, you can be much more discriminating in how to combine the various sounds for optimal quality. In a critical production such as the HDTV recording of a play, sound designers and engineers can spend weeks, if not months, on audio postproduction. But don't worry—nobody will ask you to do complicated audio postproduction for video production unless you have had a great deal of experience.

Mixdowns—during which a multitude of discrete audio tracks are combined and reduced to stereo or surround-sound tracks—are even more complicated and should definitely be left to the experts. Mixing surround sound is especially complicated because you must deal not only with intricate aural mixes but with complex spatial relationships as well.

CONTROLLING SOUND QUALITY

The management of sound quality is probably the most difficult aspect of audio control. You must be thoroughly familiar with the various types of signal-processing equipment (such as equalizers, reverberation controls, and filters), and you especially need a trained ear. As with the volume control in live mixing, you must be careful how you use these quality controls. If there is an obvious hum or hiss that you can filter out, by all means do so; but do not try to adjust the quality of each input before you've done at least a preliminary mix.

For example, you may decide that the sound effect of a police siren sounds much too thin; but when mixed with the traffic sounds, the thin and piercing siren may be perfect for communicating mounting tension. Before making any final quality judgments, listen to the audio track in relation to the video. An audio mix that sounds warm and rich by itself may lose those qualities when juxtaposed with a high-impact video scene. As in all other aspects of

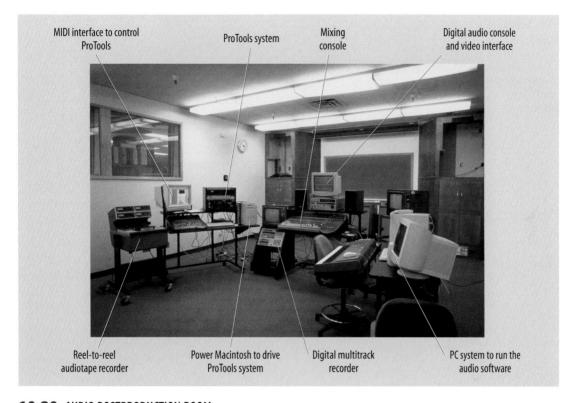

10.20 AUDIO POSTPRODUCTION ROOM

The audio postproduction room is equipped to handle most postproduction tasks. It typically contains a digital audio console, a patchbay, a digital audio workstation, a reel-to-reel audiotape recorder, digital cart players, a MIDI interface, and DAT recorders.

television production, the communication goal and your aesthetic sensitivity, not the availability and production capacity of the equipment, should determine what you want the audience to hear. No volume meter in the world or the best computer audio display can substitute for aesthetic judgment.

AUDIO POSTPRODUCTION ROOM

The equipment to perform all the postproduction miracles is usually housed in an *audio postproduction room*. The specific machinery that is installed in such a room, or production studio, depends entirely on the sound designer or sound editor, but generally you will find the same basic equipment as in the audio control booth: elaborate audio consoles, a patchbay, analog and digital audio-recording systems, and several VTRs.

Additional audio equipment, which you rarely see in the audio control booth, includes: (1) a digital audio workstation, (2) an analog audio synchronizer, and (3) keyboards and a sampler; larger production centers even sport (4) an automatic dialogue replacement room. **SEE 10.20**

DIGITAL AUDIO WORKSTATION

The digital audio workstation (DAW) is designed for editing the sound tracks and synchronizing them with the video tracks. The DAW is a sophisticated computer-driven system that facilitates sound editing, signal processing, mixing, and synchronizing video and audio. With the musical instrument digital interface (MIDI) standardization device (a specific cable), you can connect the DAW with a variety of other audio equipment for additional manipulation of the audio track. The DAW screen displays a variety of graphs, including the editing time line, indicating the length of audio segments from a great many sound tracks; the time code for edit-in and edit-out points; various graphics of selected sound tracks and their audio content; and so forth. Don't be surprised when you see a physical mixing board moving its faders all by itself, dutifully following the commands of the DAW software. **SEE 10.21** The digital

10.21 DIGITAL AUDIO WORKSTATION DISPLAY

There are several computer programs that facilitate audio editing, audio quality control, audio effects, and audio/video synchronization.

audio information can even be sent via telephone line to DAW stations located in different cities or even other countries.

ANALOG AUDIO SYNCHRONIZER

When using analog video- and audiotape, you need a machine called a *synchronizer* for matching each video frame with its appropriate audio. Most audio synchronizers use the *SMPTE time code*, which divides the audiotape into imaginary "frames." These frames correspond with those of the videotape and provide a mutual "time address" as specified by hours, minutes, seconds, and frames (30 frames make up 1 second). (For more information on time code, see chapter 13.) But you will find that most audio/video matching is now done digitally, using a DAW.

KEYBOARDS AND SAMPLER

If the sound designer is also a practicing musician, the postproduction rooms are usually equipped with various keyboards and a sampler. As you undoubtedly know, a keyboard can re-create percussion sounds, ready-made chords for accompaniment, and the sounds of many instruments. Most have a built-in recording device so you can save and play back your musical inspirations. A *sampler* is actually

an electronic sound-shaping device that can take a specific sound, such as a door closing, and morph it into the sounds of an earthquake, a thunderstorm, or an explosion.

AUTOMATIC DIALOGUE REPLACEMENT

Some large postproduction houses have a room specifically for *automatic dialogue replacement* (*ADR*). Technically, *ADR* means the postdubbing of dialogue, but it sometimes refers to the synchronization of sound effects as well. This audio-dubbing process is borrowed directly from motion pictures. Many sounds, including dialogue, that are recorded simultaneously with pictures do not always live up to the expected sound quality, so they are replaced by dialogue and sounds re-created in the studio. Most of the time, the ADR is anything but automatic and requires painstaking re-creations and mixing of dialogue, sound effects, and ambient sounds.

Elaborate ADR has the actors repeat their lines while watching footage of themselves on a large-screen projection. Recording sound effects is usually done with the *Foley stage*, which consists of a variety of equipment that is set up in a recording studio to produce common sound effects, such as footsteps, opening and closing of doors, and so forth. The Foley stage uses sound-effects equipment much

like that of traditional radio and film productions, which includes different types of floor sections, little doors with numerous locks and squeaks, or boxes with different types of gravel. The Foley artists step on the various surfaces to produce the desired sound effects of someone walking in a hallway or on a driveway. Foley offers this equipment in efficiently packaged boxes so that it can be transported by truck, sound-effect artists included.

SOUND AESTHETICS

As reiterated throughout this chapter, the bewildering array of audio equipment is of little use if you cannot exercise some aesthetic judgment—make decisions about how to work with television sound artistically rather than just technically. Yet aesthetic judgment is not arbitrary or totally personal; there are some common aesthetic factors to which we all react similarly.

When dealing with television sound, you should pay particular attention to five basic aesthetic factors: (1) environment, (2) the figure/ground principle, (3) perspective, (4) continuity, and (5) energy.

ENVIRONMENT

In most studio recordings, we try to eliminate as much ambient sound as possible. In the field these sounds, when heard in the background of the main sound source, are often important indicators of where the event takes place or even how it feels. Such sounds help establish the general environment of the event.

For example, when covering a downtown fire, the sirens, the crackling of the fire, the noise of the fire engines and the pumps, the tense commands of the firefighters, and the agitated voices of onlookers are significant in communicating to the television viewer some of the excitement and apprehension. Now consider the recording of a small orchestra. In a studio recording, the coughing of a crewmember or musician would, during an especially soft passage, certainly prompt a retake. Not so in a live concert. We have learned to identify occasional coughing and other such environmental sounds as important indicators of the immediacy of the event.

Environmental sounds are especially important in ENG. By using an omnidirectional mic, you pick up the ambient sounds automatically with the main audio source. But, as mentioned before, if you intend to do some post-production, try to use one mic and one audio track of the videotape for the recording of the main sound source, such

as the reporter or the guest, and the other mic (usually the camera mic) and the second audio track for the recording of the ambient sounds. Separating the sounds facilitates mixing them in the proper proportions in postproduction.

FIGURE/GROUND

One important perceptual factor is the *figure/ground* principle, whereby we tend to organize our visual environment into a relatively mobile figure (a person or a car) and a relatively stable background (a wall, houses, or mountains). If we expand this principle a little, we can say that we single out an event that is important to us and make it the foreground while relegating all other events to the background—the environment.

For example, if you are looking for someone and finally discover her in a crowd, she immediately becomes the focus of your attention—the foreground—while the rest of the people become the background. The same happens in the field of sound. We have the ability to perceive, within limits, the sounds we want or need to hear (the figure) while ignoring to a large extent all other sounds (the ground), even if the background sounds are relatively louder.

When showing a close-up of someone in a noisy environment, you should make the figure (CU of the person talking) louder and the background sounds softer. When showing the person in a long shot, however, you should increase the volume of the environmental sounds so that the figure/ground relationship is more equal. When emphasizing the foreground, the sounds must not only be louder but also have more *presence* (explained in the following section).

You can now see why it is so important to separate sounds as much as possible during the recording. If you record background and foreground all on one track, you have to live with whatever the mic picked up; manipulating the individual sounds would be very difficult, if possible at all. With the figure sounds on one track and the background sounds on the other, the manipulation is relatively easy.

PERSPECTIVE

Sound perspective means that close-up pictures are matched with relatively nearby sounds, and long shots correspond with sounds that seem to come from farther away. Close sounds have more presence than distant sounds—a sound quality that makes us feel in proximity to the sound source. Generally, background sounds have less presence, and close-ups have more presence. Experienced singers

hold their mics close to the mouth during intimate passages but pull them back a little when the song becomes less personal.

Such a desirable variation of sound presence is virtually eliminated when using lavaliere mics in a drama. Because the distance between mic and mouth is about the same for each actor, their voices exhibit the same presence regardless of whether they are seen in a close-up or a long shot. The necessary presence must then be achieved in time-consuming and costly postproduction. This is why boom mics are still preferred in many multicamera productions of television plays such as soap operas. The boom mic can be close to an actor during a close-up and moved somewhat farther away during a long shot to stay out of the picture—a simple solution to a big problem.

CONTINUITY

Sound continuity is especially important in postproduction. You may have noticed the sound quality of a reporter's voice change depending on whether he was speaking on- or off-camera. When on-camera the reporter used one type of microphone and was speaking from a remote location, then he returned to the acoustically treated studio to narrate the off-camera segments of the videotaped story, using a high-quality mic. The change in microphones and locales gave the recordings distinctly different qualities. This difference may not be too noticeable during the actual recordings, but it becomes obvious when they are edited together in the final show.

How can you avoid such continuity problems? First, have the reporter record the narration on-site. Second, use identical mics, or mics that produce a similar sound quality, for the on- and off-camera narrations. Third, if you have time for a sweetening session, try to match the on-camera sound quality through equalization and reverberation. Fourth, if you recorded some *ambience* at the on-camera location, mix it with the off-camera narration. When producing this mix, feed the ambient sounds to the reporter through earphones while he is doing the voice-over narration; this will help him recapture the on-site energy.

Sometimes you may hear the ambience punctured by brief silences at the edit points. The effect is as startling as when an airplane engine changes its pitch unexpectedly. The easiest way to restore the background continuity is to cover up these silences with prerecorded ambience. Always record a few minutes of "silence" (room tone or background sounds) before and after videotaping or

whenever the ambience changes decisively (such as a concert hall with and without an audience). ZVL6 EDITING→ Continuity→ sound

Sound is also a chief element in establishing *visual continuity*. A rhythmically precise piece of music can help a disparate series of pictures seem continuous. Music and sound are often the important connecting link among abruptly changing visual sequences.

ENERGY

Unless you want to achieve a special effect through contradiction, you should match the general energy of the pictures with a similar sound intensity. *Energy* refers to all the factors in a scene that communicate a certain degree of aesthetic force and power. Obviously, high-energy scenes, such as a series of close-ups of an ice-hockey game or a rock band in action, can stand higher-energy sounds than can a more tranquil scene, such as lovers walking through a meadow. Good television audio depends a great deal on your ability to sense the general energy of the pictures or sequences and to adjust the volume and sound presence accordingly. ZVLT AUDIO Aesthetics continuity environment | sound perspective | try it

STEREO AND SURROUND SOUND

As you read this brief discussion of stereo and surround sound, apply it to the context of video—either film or standard-sized and large-screen television.

STEREO SOUND

Stereo sound, which defines especially the horizontal audio field (left-right or right-left positioning of the major audio source) is of little use when playing it back on a standard-sized television set. Because the horizontal dimension of the screen is so small, any panning (horizontal positioning) of sound will inevitably lead to off-screen space, even if you sit in the sweet spot (the center where you perceive the two channels as one). At best, stereo for television will enrich the general shape of the sound, that is, make it more spacious.

With large-screen, home-theater HDTV video projections, however, stereo sound becomes extremely important for keeping up with and balancing the high-energy video. In fact, the movielike experience when watching large-screen video projections will be greatly intensified by a surround-sound system.

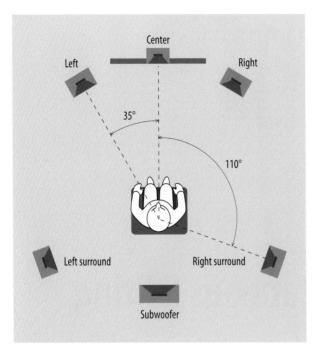

10.22 SURROUND SOUND

The 5.1 Dolby surround-sound system uses six speakers—three in front and three in back. The rear-center speaker is a subwoofer for very low sounds.

SURROUND SOUND

Surround sound is a technology that produces a soundfield in front of, to the sides of, and behind the listener, enabling one to hear sounds from the front, sides, and back. Developed originally for film reproduction, it is now used for HDTV and other large-screen home-theater arrangements. The most prevalent surround-sound system is Dolby 5.1, which positions three speakers in front and two in the back for sound reproduction. These five speakers are supported by an additional subwoofer that is usually positioned between the two rear speakers. This .1 speaker can reproduce especially low-frequency, thunderous sounds. **SEE 10.22**

Good surround-sound mixing generally restricts onscreen dialogue to the center-front speaker and laterally spreads action to all three front speakers. But if the video shows the hero standing amid downtown traffic, playing in an orchestra, or dodging bombs, all five speakers are active, as well as the "thunder box" at rear-center.³

MAIN POINTS

- Most audio postproduction involves linear or nonlinear editing of the sound tracks of video recordings.
- When editing the audio track to serve as a guide for subsequent video editing, you must transcribe all spoken material on the source tapes.
- Postproduction mixing means "sweetening" or mixing recorded sound tracks for optimal quality.
- When engaged in mixdowns (reducing the various sound tracks to stereo or surround sound) of the audio portion of a video production, always judge the audio mix relative to the video.
- The audio postproduction room contains the equipment of a television audio control booth, plus a digital audio workstation (DAW), an analog audio synchronizer, keyboards and a sampler, and sometimes an automatic dialogue replacement (ADR) room.
- The five major aesthetic factors in sound control are: environment—sharpening an event through ambient sounds; figure/ground—emphasizing the most important sound source over the general background sounds; perspective—matching close-up pictures with nearby sounds, and long shots with distant sounds; continuity—maintaining the quality of sound when combining various takes; and energy—matching the force and the power of the pictures with a similar intensity of sound.
- Surround-sound technology uses three speakers placed in front of the listener and three in back to produce a sound field that surrounds the listener.

ZETTL' S VIDEOLAB

For your reference, or to track your work, each *Video-Lab* program cue in this chapter is listed here with its corresponding page number.

ZVI-1 AUDIO→ Audio introduction 218

AUDIO→ Consoles and mixers→ parts | signals | control | try it 221

ZVL3 AUDIO→ Consoles and mixers→ calibration 231

ZVL4 EDITING→ Postproduction guidelines→ audio transcript 236

ZVL5 EDITING→ Functions→ correct 236

ZVL6 EDITING→ Continuity→ sound 240

AUDIO→ Aesthetics→ continuity | environment | sound perspective | try it 240

^{3.} See Alten, Audio in Media, pp. 413-24.

11

Switching, or Instantaneous Editing

When watching a television director during a live multicamera show, such as a newscast or a basketball game, you might be surprised to find that the primary activity of the director is not telling the camerapersons what to do but rather selecting the most effective shots from the variety of video sources displayed on a row of preview monitors. In fact, the director is engaged in a sort of editing, except that it's the selection of shots during rather than after the production. Cutting from one video source to another or calling for other transitions, such as dissolves, wipes, and fades, while a show is in progress is known as **switching** or *instantaneous editing*.

Unlike postproduction editing, in which you have the time to deliberate exactly which shots and transitions to use, switching demands snap decisions. Although the aesthetic principles of switching are identical to those used in postproduction, the technology involved is quite different. Instead of various linear and nonlinear editing systems, the major editing tool is the video switcher or a computer that performs the switcher functions.

Section 11.1, How Switchers Work, acquaints you with the basic functions, layout, and operation of a production switcher in a television control room. Section 11.2, What Switchers Do, looks at some specific switching systems and features.

KEY TERMS

- **auto transition** An electronic device that functions like a fader bar.
- bus A row of buttons on the switcher.
- **delegation controls** Controls on the switcher that assign specific functions to a bus.
- downstream keyer (DSK) A control that allows a title to be keyed (cut in) over the picture (line-out signal) as it leaves the switcher.
- **effects buses** Program and preview buses on the switcher, assigned to perform effects transitions.
- **fader bar** A lever on the switcher that activates preset transitions, such as dissolves, fades, and wipes, at different speeds. It is also used to create superimpositions.
- **key bus** A row of buttons on the switcher, used to select the video source to be inserted into a background image.
- **key-level control** Switcher control that adjusts the key signal so that the title to be keyed appears sharp and clear. Also called *clip control* or *clipper*.

- **layering** Combining two or more key effects for a more complex effect.
- **M/E bus** Short for *mix/effects bus*. A row of buttons on the switcher that can serve a mix or an effects function.
- **mix bus** Rows of buttons on the switcher that permit the mixing of video sources, as in a dissolve or a super.
- **preview/preset bus** Rows of buttons on the switcher used to select the upcoming video (preset function) and route it to the preview monitor (preview function) independent of the line-out video. Also called *preset/background*.
- **program bus** The bus on a switcher whose inputs are directly switched to the line-out. Also allows cuts-only switching. Also called *direct bus* or *program/background*.
- **switching** A change from one video source to another during a show or show segment with the aid of a switcher. Also called *instantaneous editing*.

11.1

How Switchers Work

When you look at a large production switcher with all the different-colored rows of buttons and various levers, you may feel as intimidated as when looking into the cockpit of an airliner. But once you understand the basic principles and functions of a switcher, you can learn to operate it faster than running a new computer program. Even the most elaborate digital video-switching system performs the same basic functions as a simple production switcher, except that large switchers have more video inputs and can perform more visual tricks.

This section explores what a production switcher does and how it basically works.

▶ BASIC SWITCHER FUNCTIONS

Selecting video sources, performing transitions between them, and creating special effects

SIMPLE SWITCHER LAYOUT

Program bus, mix buses, preview bus, effects buses, and multifunction switchers and additional switcher controls

BASIC SWITCHER OPERATION

Cut or take, dissolve, super, fade, and additional special-effects controls

BASIC SWITCHER FUNCTIONS

The basic functions of a production switcher are (1) to select an appropriate video source from several inputs, (2) to perform basic transitions between two video sources, and

(3) to create or access special effects. Some switchers can automatically switch the program audio with the video.

As introduced in chapter 1, each video input on a switcher has a corresponding button. If you have only two cameras and all you want to do is cut from one to the other. two buttons (one for camera 1 and the other for camera 2) are sufficient. By pressing the camera 1 button, you put camera 1 "on the air," that is, route its video to the line-out, which carries it to the transmitter or the video recorder. Pressing the camera 2 button will put camera 2 on the air. What if you wanted to expand your switching to include a video recorder, a character generator (C.G.), and a remote feed? You would need three additional buttons-one for the video recorder, one for the C.G., and one for the remote feed. When you want the screen in black before switching to one of the video sources and then go to black again at the end of the show, you need an additional BLK (black) button. The row of buttons, called a bus, has increased to six inputs. Production switchers have not only many more buttons but several buses as well. Let's find out why. ZVL1 SWITCHING→ Switching functions→ select | connect

SIMPLE SWITCHER LAYOUT

It may be easier to understand the parts of a switcher by constructing one that fulfills the basic switcher functions: cuts, dissolves, supers, and fades.¹ This switcher should also let you see the selected video inputs or effects before you punch them up on the air. While building a switcher, you will realize that even a simple switcher can get quite complicated and that we need to combine several functions to keep it manageable.

PROGRAM BUS

If all you wanted to do is *cut* (switch instantaneously) from one video source to another without previewing them, you could do it with a single row of buttons, each one representing a different video input. **SEE 11.1** This row of buttons, which sends everything you punch up directly to the lineout (and from there to the transmitter or video recorder), is called the *program bus*. Also called *program/background*, the program bus represents, in effect, a selector switch for the line-out. It is a direct input/output link and therefore is also called the *direct bus*. Note that there is an additional button at the beginning of the program bus, labeled *BLK*

See Stuart W. Hyde, *Television and Radio Announcing*, 4th ed. (Boston: Houghton Mifflin, 1983), pp. 226–35. He explains the workings of an audio console by building one. I am using his construction metaphor with his permission.

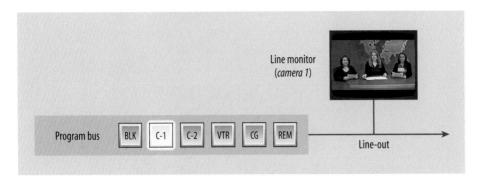

11.1 PROGRAM BUS

Whatever source is punched up on the program bus goes directly to the line-out.

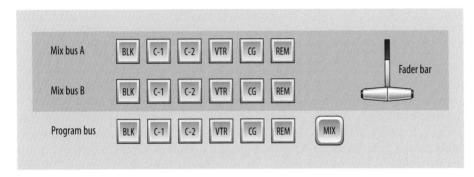

11.2 PROGRAM BUS WITH MIX BUSES AND FADER BAR

The mix buses A and B enable the mixing of two video sources.

or *BLACK*. Instead of calling up a specific picture, the *BLK* button puts the screen to black.

MIX BUSES

If you want the switcher to do *dissolves* (during which one image gradually replaces the other through a temporary double exposure), *supers* (a double exposure of two images, with the top one letting the bottom one show through), and *fades* (the gradual appearance of an image from black or disappearance to black) in addition to simple cuts, you need two more buses—the *mix buses*—and a lever, called the *fader bar*, that controls the speed of the mix (dissolves and fades) and the nature of the super. **SEE 11.2**

When moving the fader bar to the full extent of travel, the picture of one bus is faded in while the picture of the other bus is faded out. The actual dissolve happens when the video images of the two buses temporarily mix. When you stop the fader bar somewhat in the middle, you arrest the dissolve and create a *superimposition* of the two video sources.

How does the program bus get this "mix" to the lineout? You must add still another button to the program bus that can transfer to the line-out the video generated by the mix buses. This *MIX* button is at the far right of the program bus.

PREVIEW BUS

The preview bus is identical to the program bus in the number, type, and arrangement of buttons. The functions of the buttons are also similar, except that the "line-out" of the preview bus does not go on the air or to a recording device but simply to a preview (P/V) monitor. If, for example, you press the camera 1 (C-1) button on the preview bus, camera 1's picture appears on the preview monitor without affecting the output of the program bus, such as the C.G. text. If you don't like camera 1's picture and want to switch to camera 2, you simply press the C-2 button on the preview bus. The program bus will still display the C.G. text on the line monitor and will not switch to camera 2. The preview bus is also called the preset bus if it also functions as a monitor that shows various preset effects. (The preview/preset bus is explored further later in this section.)

Like the two-screen computer display on a postproduction editing unit, the preview and line monitors are usually side-by-side to show whether two succeeding shots will cut together well, that is, preserve vector continuity and mental map positions (see chapter 13).

As you can see, our simple switcher has grown to twenty-six buttons, arranged in four buses, and has a fader bar added. **SEE 11.3**

11.3 BASIC PRODUCTION SWITCHER WITH PREVIEW BUS

This basic production switcher has a program bus, two mix buses, and a preview bus. Note that the preview bus is identical to the program bus except that its output is routed to the preview monitor rather than to the line-out.

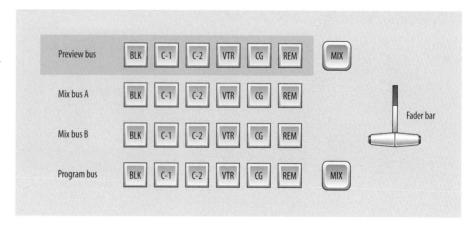

EFFECTS BUSES

If you now wanted your switcher to perform some special effects, such as a variety of *wipes* (one image framed in a geometrical shape gradually replacing the other), title *keys* (lettering inserted into a background picture), and other image manipulations (shape and/or color transformations), the basic design would have to include at least two or more *effects buses* and one additional fader bar. You would probably then want to expand the other video inputs to accommodate several more cameras, two or three VTRs, an *electronic still store* (*ESS*) *system*, a graphics generator, and remote feeds. In no time your switcher would have so many buttons and levers that operating them would require roller skates to get to all of them in a hurry.

MULTIFUNCTION SWITCHERS

To keep switchers manageable, manufacturers have designed buses that perform multiple functions. Rather than have separate program, mix, effects, and preview buses, you can assign a minimum of buses various *mix/effects* (*M/E*) functions. When you assign two *M/E buses* (A and B) to the mix mode, you can *dissolve* from A to B or even do a super (by stopping the dissolve midway). By assigning them to the effects mode, you can achieve special effects, such as a variety of wipes from A to B. You can even assign the program and preview buses various M/E functions while still preserving their original functions. The buttons with which you delegate what a bus is to do are, logically enough, called *delegation controls*. The following discussion identifies the various buses and how they interact on a simple multifunction switcher. **SEE 11.4**

Major buses As you can see, the switcher in figure 11.4 has only three buses: a preview/preset bus (lower row of

buttons), a program bus (middle row), and a key bus (upper row). It also has a number of button groups that let you create certain effects.

Let's briefly review the functions of the various buses. The program bus always directs its output to the line-out. If, for example, you press the *C-1* button on the program bus, camera 1 is on the air. If you then press the *VTR* button, you cut from camera 1 to the VTR video. If you don't need to preview the upcoming pictures and your switching is "cuts-only," you can do it all on the program bus. When assigned a mix or an effects function, it becomes M/E bus A. **SEE 11.5**

The *preview/preset bus*, also called *preset/background*, lets you preview the video source that you selected as your next shot. Whenever you press the corresponding button on the preset bus, the selected shot will automatically appear on the preview/preset monitor. As soon as you activate a certain transition (cut, dissolve, or wipe), this preview picture will replace the on-the-air picture as shown on the line monitor. As you can see, this preview/preset bus now functions as M/E bus B. You can now understand why this is called a preview/preset bus: it is a preview bus because it lets you preview the upcoming source; it is a preset bus because it lets you preset the upcoming effect. Despite its dual function, this bus is generally known as the preview bus.

Complicating the terminology a little more, both the program and the preview/preset buses are sometimes called "background" buses because they can serve as background for various effects. Let's assume that you have camera 1 punched up on the program bus (M/E bus A), showing a CU (close-up) of the latest computer model. When you insert the name of the computer over this shot, the program bus supplies the background image (the CU of the computer) for this title key.

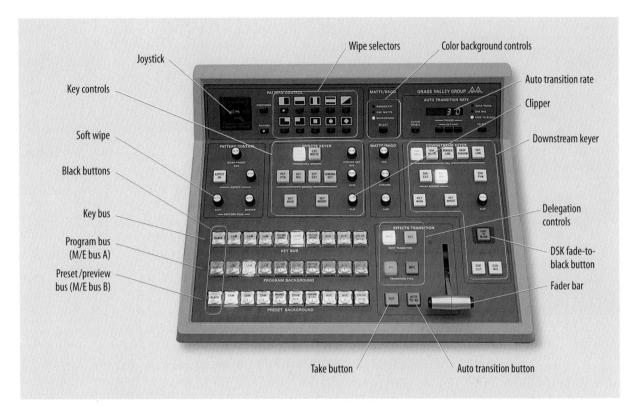

11.4 MULTIFUNCTION SWITCHER

This multifunction switcher (Grass Valley 100) has only three buses: a preview/preset bus, a program bus, and a key bus. You can delegate the program and preview/preset buses M/E functions.

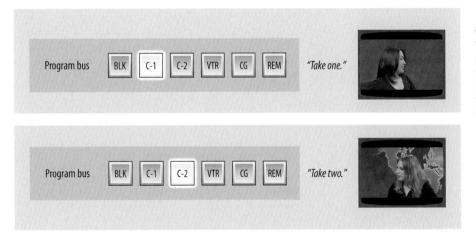

11.5 SWITCHING ON THE PROGRAM BUS

When switching on the program bus, the transitions will be cuts-only. With camera 1 on the air, you can cut to camera 2 by pressing the *C-2* button.

The third (top) row of buttons is the *key bus*. It lets you select the video sources, such as lettering supplied by the C.G., to be inserted into the background image, supplied by the program bus. ZVL2 SWITCHING→ Architecture→ program bus | preview bus | mix buses | fader bar automatic transition | try it

Delegation controls These controls let you choose a transition or an effect. On this multifunction switcher, they are located to the immediate left of the fader bar. **SEE 11.6**

By pressing the background button (*BKGD*), you put the program and preview/preset (A and B) buses in mix

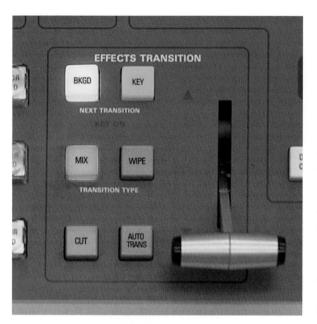

11.6 DELEGATION CONTROLS

The delegation controls assign the function of the buses and the specific transition mode.

mode. Whatever you punch up on the program bus (A) will go on the air and, therefore, show up on the line monitor. Whatever you press on the preview/preset bus (B) will show up on the preview monitor, ready to replace—through a cut—the picture from bus A currently on the air.

By additionally pressing the red *MIX* button in the delegation controls section of the switcher, you have expanded the transitions from cuts-only to include dissolves as well. You can now cut from one video source to another or dissolve between them. When you press the red *WIPE* button instead of the *MIX* button, the transition will be a wipe instead of a dissolve (see chapter 14).

By pressing the KEY button, you activate the top (key) bus. On this bus you can select a proper key source, such as the C.G., that is to be inserted into the background picture currently activated on the program bus (A) and, therefore, on the air. Going back to our computer example, the C-1 button on the program bus (A) would provide the background image of the computer, and the CG button on the key bus would provide the name of the computer.

The advantage of a multifunction switcher is that you can achieve all of these effects with only three buses. If you had continued the *architecture*—the electronic design logic—of the switcher we were building, you would have needed at least five buses, two fader bars, and several addi-

tional buttons to achieve the same key effect. ZVL3 SWITCH-ING→ Switching functions→ transitions | create effects

Before moving on to some other major switcher controls, let's put some of the theory into practice and do some simple switching.

BASIC SWITCHER OPERATION

Although you are now working with a specific analog switcher (Grass Valley 100)² whose controls are arranged in a particular way, most multifunction switchers operate on a similar switcher architecture. Once you know how to operate a specific production switcher, you can readily transfer those skills to another one.

Look again at the switcher in figure 11.4. How would you achieve a cut, a dissolve, a super, a fade from black, and a fade to black?

CUT OR TAKE

As you recall, the program bus (A) lets you cut from one source to another by simply pressing the corresponding button. If you want camera 1 on the air, press the *C-1* button; to cut to camera 2, press the *C-2* button. The problem with such direct switching is that the next shot will not appear on the preview monitor. Although each video input shows up on a designated monitor in the control room, you will have a difficult time seeing whether the new shot (camera 2) will cut together well (provide visual continuity) with the one already on the air (camera 1). With a preview/preset monitor positioned next to the line monitor, you can judge whether camera 2's image will provide the necessary continuity when cut with the image on camera 1. To effect such a preview, you have to punch up camera 2 on the preset/preview bus.

But wait! You first need to tell the program and preview buses that they are supposed to interact as a pair of M/E buses. Pressing the *BKGD* delegation control button will accomplish this assignment. M/E bus A (also the program bus) is now feeding camera 1's picture to the line monitor (and to the line-out), and M/E bus B (also the preset bus) is feeding camera 2's picture to the preview monitor, ready to replace camera 1's picture. **SEE 11.7**

^{2.} The GV 100 switcher is a classic that you still find in many smaller professional and educational television studios. Whereas more-modern digital switchers have greater effects capabilities, which allow the layering of a variety of effects through multiple keys, a high-capacity effects memory, and two or more downstream channels to provide separate video feeds, they still operate on the principal M/E architecture of the GV 100.

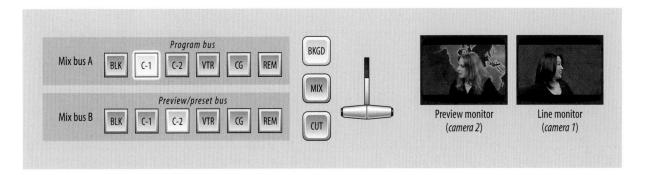

11.7 DUAL FUNCTION OF PROGRAM AND PRESET BUSES

When delegated a background and mix function, the program bus becomes M/E bus A and the preview/preset bus becomes M/E bus B. Here camera 1 is punched up on bus A and is on the air. Camera 2 is preset to replace camera 1 as soon as you press the CUT button.

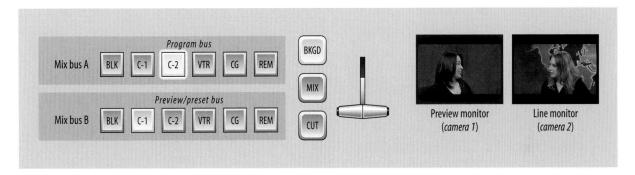

11.8 IMAGE CHANGE AFTER CUT

When the cut is completed, the program bus shows camera 2 on the air, and the preview/preset bus switches automatically to camera 1.

To perform the actual cut from camera 1 to camera 2, you must press the CUT button right below the MIX button (see figure 11.6). The picture on the line monitor will instantly switch from camera 1 to camera 2, and the picture on the preview monitor will switch from camera 2 to camera 1. The light of the *C-1* button on the program bus (indicating that its video source is on the air) will dim, and the *C-2* button will light (indicating that camera 2 is now on the air). The opposite will happen on the preset bus: the C-2 button will dim (indicating that its source is no longer previewed), and the C-1 button will light (indicating that its source is now fed to the preview monitor). By pressing the CUT button, you have, in effect, transferred the output of the preview bus to the program bus and transferred the former output of the program bus back to the preview bus. This maneuver is also called flip-flop switching. SEE 11.8

What if you were to press the *CUT* button again? Would you get the same flip-flop effect between the preview

bus (which now shows camera 1) and program bus (which has camera 2 on the air)? Yes. This toggle feature of the *CUT* button is helpful whenever you have to switch quickly and repeatedly between the same two video sources. For example, in switching an interview, the single *CUT* button lets you react quickly to what is being said and perform with great accuracy repeated cuts between the close-ups of the host and the guest.

DISSOLVE

To achieve a dissolve, you must now press the *MIX* button in addition to the *BKGD* button to delegate the mix function to both buses. If for some reason the *BKGD* button has been turned off, you need to also press this button again. When both the *BKGD* and the *MIX* buttons are lighted, the switcher is in the correct mix mode.

To dissolve from camera 1 to camera 2, you need to first punch up camera 1 on the program bus (A) to put

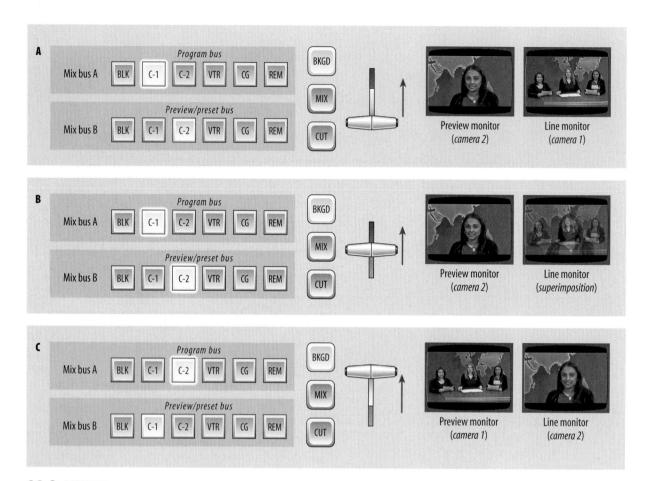

11.9 DISSOLVE

Once assigned the mix function through the mix delegation control, you can dissolve from camera 1 to camera 2. Assuming that camera 1 is on the air on bus A, you need to preset camera 2 on bus B. By moving the fader bar to the full extent of travel (in this case, up), you activate the dissolve from camera 1 to camera 2. Once the dissolve is completed, camera 2 will replace camera 1 on the program bus. Note that you can move the fader bar either up or down for the dissolve.

camera 1 on the air. Now punch up camera 2 on the preview bus (B). As soon as you press the *C-2* button on the preset bus, it will light up and route camera 2's video to the preview monitor. But instead of pressing the *CUT* button as you would during a take, you move the fader bar all the way up (away from you) or down (toward you) to the full extent of travel. The speed of the dissolve depends on how fast you move the fader bar. When you have reached the limit of travel with the fader bar, the dissolve is complete and camera 2's picture will have replaced camera 1's picture. **SEE 11.9**

You can watch the dissolve on the line monitor, which displays camera 1's picture at the start of the dissolve and camera 2's picture at the end of it. Although you had both buses act temporarily as M/E buses A and B, they quickly

revert to their program and preview functions. Because the program bus has command over what picture is on the air, the preset bus transfers camera 2's video input to the program bus and camera 1's picture to its own bus just in case you want to dissolve back to camera 1 at the end of the dissolve.

You can also use the *auto transition* device to execute the dissolve. Instead of moving the fader bar up or down, you can press the *AUTO TRANS* button (next to the *TAKE* button—see figure 11.4), which then takes over the fader bar function. The rate of the dissolve is determined by the number of frames you punch up in the auto transition section. Because our television system operates with 30 frames per second, a frame rate of 60 would give you a 2-second dissolve. Sound complicated? Yes, but once you've

How Switchers Work

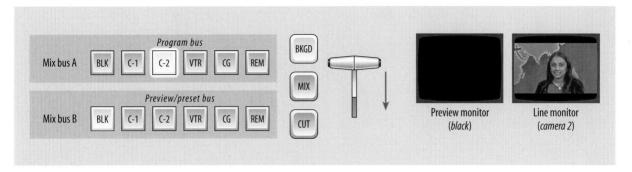

11.10 FADE

When fading to black from camera 2, you need to punch up the *BLK* button on bus B (preview/preset) and then dissolve into it by moving the fader bar to the full extent of travel (in this case, down).

done it a few times, punching all these buttons becomes as much a routine as using a computer keyboard with a word-processing program.

SUPER

If you were to stop the dissolve halfway between the program (A) and preset (B) buses, you would have a superimposition, or *super* (see figure 11.9b). Both buses will be activated, each delivering a picture with exactly one-half video (signal strength). If you want to favor the picture from bus A (make the "old" video source stronger), simply stop the travel of the fader bar before it reaches midpoint. To favor the source from bus B (the "new" image), move the fader bar past the midpoint.

FADE

A *fade-in* is a dissolve from black to a picture; to "fade to black" or "go to black" is a dissolve from the on-the-air picture to black. Using our switcher, how would you fade in camera 2 from black? Here is the switching sequence for doing so:

- 1. Press the *BLK* button on the program bus. Because the program bus delivers its picture to the line-out, the line monitor shows black video.
- 2. Press both the *BKGD* and the *MIX* buttons. As you recall, these delegation controls assign the program and preset buses' mix/effects functions.
- 3. Press the *C*-2 button on the preset bus.
- 4. Move the fader bar to the opposite position. The speed of the fade-in is determined by how fast you move the fader bar. The camera 2 picture "develops" on the line-out monitor.

To fade to black from camera 2 (which has been transferred to the program bus and is therefore on the air) you press the *BLK* button on the preset bus and move the fader bar to the opposite limit of travel. **SEE 11.10** Because you literally dissolve from an image to black, you can also use the auto transition control for the fade to black. **ZVL4** SWITCH-ING→ Transitions→ cut | mix/dissolve | wipe | fade | try it

ADDITIONAL SPECIAL-EFFECTS CONTROLS

Because you have become so proficient in performing simple switcher operations, you can work with a few more controls to create a variety of special effects. These include: (1) wipe controls and wipe patterns, (2) key and clip controls, (3) the downstream keyer, and (4) color background controls. At this point don't worry about exactly how these controls are operated. Although all professional production switchers have these additional controls, they often require different means of operation. To become efficient in using a particular switcher, you need to study its operations manual and, above all, practice, as you would when learning to play a musical instrument.

Realize that these controls do not by themselves create the effect; rather, it is the *special-effects generator* (*SEG*) that performs this task (see chapter 14). All production switchers have a built-in SEG. In fact, you will find that the manufacturers of most digital production switchers pride themselves not so much on operational ease but on the many visual tricks their SEGs can perform. The buzzword is *layering*, which means combining several key effects into a more complex one. When doing complicated postproduction editing, you will find that the standard switcher SEG will not give you enough variety. In this case you need to use a postproduction switcher or a computer with special-effects software.

11.11 WIPE MODE SELECTORS

The wipe mode selectors offer a choice of geometrical wipe patterns. The configurations can be placed in a specific screen position using the joystick.

Wipe controls and wipe patterns When pressing the WIPE button in the delegation controls section in addition to the BKGD button, all transitions will be wipes. During a wipe the source video is gradually replaced by the second image that is framed in a geometrical shape (see chapter 14). You can select the specific pattern in the group of buttons called wipe mode or pattern selectors. Common wipe patterns are expanding diamonds, boxes, or circles. **SEE 11.11** On large switchers these controls can be extended to nearly 100 different patterns by inputting a code into the switcher. You can also control the direction of the wipe (whether a horizontal wipe, for example, starts from screen-left or screen-right during the transition). The joystick positioner lets you move patterns on the screen. Other controls give the wipes a soft or hard edge and give letters different borders and shadows.

Key and clip controls *Keying* lets you insert lettering or other picture elements into the existing, or background, scene. The most common use of keys is to put lettering over people or scenes, or the familiar box over the newscaster's shoulder. The key bus lets you select the particular video source to insert into the background scene, such as the titles from the C.G. The *key-level control*, also called the *clip control* or *clipper*, adjusts the key signal so that the letters appear sharp and clear during the key. On the Grass Valley 100 switcher, you would use the following steps to achieve a key:

- 1. On the preset bus, select the background into which you want to insert a key.
- 2. On the key bus, select the video source to be keyed (normally the C.G.).

- 3. In the delegation controls section (effects/transition group), press the *KEY* and *MIX* buttons.
- 4. In the key controls, press the *KEY BUS* button, which will make the key source appear on the preview monitor.
- 5. Adjust the clipper and the gain control (turn clockwise or counterclockwise) until the key looks sharp. If the key does not appear as indicated in step 4, adjust the clip control until it does.
- 6. Press the *CUT* button to activate the key. The background image and the key should both appear on the line monitor.

Note that various switcher models require different sequences to achieve a key effect. Whatever the steps, you need to select the background image (the main image into which you want to insert the title) and the key source (the title) and then work with the clip control so that the key has sharp and clear edges. (For more information about how a key works, as well as an additional form of keying called the *chroma key*, see chapter 14.)

Downstream keyer The "downstream" in *downstream keyer* (*DSK*) refers to the manipulation of the signal at the line-out (downstream), rather than at the M/E (upstream) stage. With a downstream keyer, you can insert (key) a title or other graphic over the signal as it leaves the switcher. This last-minute maneuver, which is totally independent of any of the controls on the buses, is done to keep as many M/E buses as possible available for the other switching and effects functions. Most switchers with a DSK have a *master fader*, which consists of an additional fader bar or, more common, a fade-to-black *AUTO TRANS* button, with which you can fade-to-black the base picture together with the downstream key effect (see figure 11.4).

You may ask why this fade-to-black control is necessary when, as just demonstrated, you can fade to black by simply dissolving to black on the program bus. The reason for the extra fade control is that the effect produced by the DSK is totally independent of the rest of the (upstream) switcher controls. The *BLK* button on the program bus will eliminate the background but not the key itself. Only the *BLK* button in the downstream keyer section (to the right of the fader bar) will fade the entire screen to black.

ZVL5 SWITCHING→ Effects→ keys | key types | downstream keyer | special effects

As an example, let's set up a simple DSK effect at the end of a product demonstration of the latest computer

model and then fade to black. The final scene shows a CU of the computer as the background, with the name of the computer inserted by the DSK. Recall that one way to fade to black is to press the *BLK* button on the preset bus and then dissolve into it by moving the fader bar or pressing the *AUTO TRANS* button. But when you look at the line monitor, the background image (CU of the computer) has been replaced by black as it should, but the name of the computer remains on-screen. You now know why. The downstream keyer is unaffected by what you do in the upstream part of the switcher—such as going to black on the M/E bus. Totally independent of the rest of the switcher controls, the DSK obeys only those controls in its own (downstream) territory, hence the need for its own black controls.

Color background controls Most switchers have controls with which you can provide color backgrounds to keys and even give the lettering of titles and other written information various colors or colored outlines. Color generators built into the switcher consist of dials that you can use to adjust *hue* (the color itself), *saturation* (the color strength), and *brightness* or *luminance* (the relative darkness and lightness of the color) (see figure 11.4). On large production switchers, these color controls are repeated on each M/E bus.

MAIN POINTS

- Instantaneous editing is the switching from one video source to another, or the combining of two or more sources while the show, or show segment, is in progress.
- All switchers, simple or complex, perform the same basic functions: selecting an appropriate video source from several inputs, performing basic transitions between two video sources, and creating or accessing special effects.
- The switcher has a separate button for each video input. There is a button for each camera, VTR, C.G., and other video sources, such as a remote input. The buttons are arranged in rows, called buses.
- The basic multifunction switcher has a preset bus for selecting and previewing the upcoming shot; a program bus that sends its video input to the line-out; a key bus for selecting the video to be inserted over a background picture; a fader bar to activate mix effects; and various special-effects controls.
- The program bus is a direct input/output (I/O) link and is therefore also called the direct bus. Whatever is punched up on the program bus goes directly to the line-out. It can also serve as a mix/effects (M/E) bus.
- The preview/preset bus is used to select the upcoming video (preset function) and route it to the preview monitor (preview function). It also serves as an M/E bus.
- The M/E bus can serve a mix (dissolve, super, or fade) or an effects function.
- The key bus is used to select the video source to be inserted (keyed) into a background image.
- Delegation controls are used to assign the buses specific functions.
- The actual transition is activated by moving the fader bar from one limit of travel to the other, or by an AUTO TRANS button that takes on the functions of the fader bar.
- Most switchers offer additional effects, such as a variety of wipe patterns, borders, and background colors, and the possibility of effects layering.

11.2

What Switchers Do

This section gives a brief overview of analog and digital switchers and switching software. Virtually all new switchers are digital in design and partially or fully computer-driven. With the predominance of component video recorders, the electronic design of switchers has changed accordingly.

SWITCHER TYPES AND FUNCTIONS

Production and postproduction switchers, master control switchers, and routing switchers

▶ ELECTRONIC DESIGNS

Composite and component switchers, analog and digital switchers, and audio-follow-video switchers

SWITCHER TYPES AND FUNCTIONS

When looking more carefully at switchers, and especially when you begin to operate them, you will notice that they are designed to fulfill specific production functions. The major types of switchers are: (1) production switchers, (2) postproduction switchers, (3) master control switchers, and (4) routing switchers. Most switchers are built to fulfill both production and postproduction functions.

PRODUCTION SWITCHERS

Production switchers are used in multicamera studio or field productions. You will find them in studio control rooms and remote trucks. Their primary purpose is to select specific video sources to go on the air; to connect the selected video through cuts, dissolves, or wipes; and to create and apply keys and other effects. Production switchers must let you perform these tasks reliably and with relative ease. When switching a live football game, there is no room for error.

Production switchers must offer enough inputs to accommodate the various video sources available. Even a small studio production may require inputs from three cameras, a C.G., two or three VTRs, an ESS (electronic still store) system, and two or three remote feeds (such as a mobile ENG truck, network program, or satellite hookup). Because each button on a switcher can handle only a single input, this production would require a bus with a minimum of ten buttons, counting the BLK button as a black video input. Despite the fact that large production switchers have thirty or more inputs, there are occasions when a TD (technical director) feels strapped for more, especially during live coverage of international news or large sporting events. You may then have to press into service an additional switcher that can take over a specific assignment, such as the instant replays.

Yet in many cases you don't need a large thirty-input switcher and a remote truck to do a live or live-on-tape pickup of a variety of multicamera events, such as a wedding, basketball game, rock show, classical concert, or graduation ceremony. For example, the PixBox features a complete audio/video switching system, including a variety of transitions and special effects—all packed into a small suitcase. You can connect up to ten video inputs—any four of which are switchable—and a number of stereo line- and mic-level audio sources. It also has efficient two-way intercom and tally light systems. Much like a laptop computer, the lid of the suitcase serves as the source monitors and the larger preview and line monitor pair. **SEE 11.12**

Although the primary function of production switchers is to facilitate instantaneous editing—selecting various video sources and sequencing them through transitions—they are expected to perform more and more complex effects that rival those of postproduction editing. Are such effects necessary or even appropriate when switching a live or live-on-tape show? Isn't the primary task of live switching to select shots and sequence them properly through a variety of transitions? Yes. But because audiences have become so accustomed to the visual razzledazzle of postproduction effects, live shows (such as news and sports) cannot afford to look any less exciting. At least so goes the argument.

11.12 PORTABLE SWITCHING SYSTEM

This portable production switching system (PixBox2) is designed for multicamera live and live-on-tape productions. It has eight video and six audio inputs, a tally light, an intercom hookup, and a rich transition menu. The LCD panel displays all video inputs and simulates a larger preview and line monitor. All this technology is contained in a relatively small suitcase.

A more persuasive argument is that expensive switchers cannot be limited to the few live or live-on-tape productions done in most television stations; they must be able to perform the more complex postproduction tasks as well. Fortunately, all production switchers have a considerable number of digital effects built-in, and they can be easily hooked up to complex digital effects equipment to be used as postproduction switchers. Because switchers are basically computer-driven, they allow you to store a great number of preproduced special effects and recall them instantly by pressing a single button, without having to climb all over the panel to reach the necessary buttons and levers.

POSTPRODUCTION SWITCHERS

The switcher in postproduction is used for instantaneous editing rather than for creating transitions and special effects. A good *postproduction switcher* is not necessarily the one with the most video inputs but rather the one that offers the greatest number of key effects and other multilevel

equipment that can build, step-by-step, a highly complex effect. For example, the small postproduction switcher in figure 11.13 can produce 1,600 different effects—more than enough for even the most ardent special-effects fanatic. And just in case you want even more effects, you can hook up via USB or FireWire cable to a computer with special-effects software. **SEE 11.13**

Some postproduction switchers have a small audio mixer built-in, which for routine audio postproduction jobs makes patching to an external mixer unnecessary.

Postproduction switchers are basically menu-driven: you activate the major functions not by pressing buttons on the switcher panel but by choosing options on pull-down menus in a software program. The computer responds to the commands, activating the switcher buttons and, if everything goes right, delivering the specified effect or transition.

Because such switchers are computer-driven, couldn't we do away with the actual switcher and simply use computer software to execute the various transitions? Yes. There

11.13 SMALL DIGITAL PRODUCTION SWITCHER

This postproduction switcher (Panasonic AG-MX70) can create 600 effects, which, with a special-effects board, can be expanded to 1,600 two- and three-dimensional effects. It has a built-in audio mixer with six inputs. Its large control panel displays operation and monitoring information, and, like all postproduction switchers, it can also be used for simple live switching.

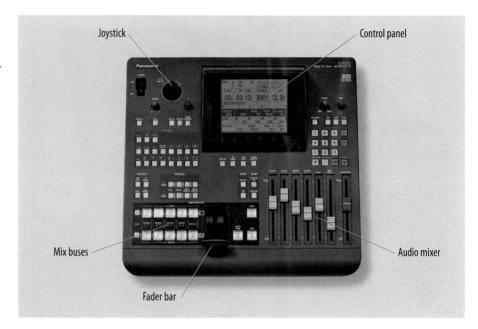

are software programs for both Windows and Macintosh platforms that function as basic switchers. Instead of pressing a button, you click a mouse. **SEE 11.14** There are also computer programs that have a whole switching sequence programmed for highly predictable show formats, such as a single-anchor news or weather program. Such software not only takes care of the switching from camera to camera but also tells the robotic cameras what to do.

Computer technology notwithstanding, the switcher as you know it will have its place for some time. Even the most sophisticated computer switchers are simply not as flexible and functional as the actual switcher panel with its buttons and levers. A TD pressing buttons on a switcher panel is still the most effective means of instantaneous editing, provided he or she presses the right buttons at the right time.

MASTER CONTROL SWITCHERS

Computer-assisted switching is especially helpful in master control. In fact, the computer is so important in master control operation that often the engineer assists the computer rather than the other way around. The computerized *master control switcher* retrieves all the program material stored in the program server (an extralarge computer storage device) according to the program log time line; it cues, rolls, and stops VTRs and video cart machines; it calls up any number of still shots from the ESS system; it activates any number of transition sequences; and it switches auto-

matically to remote feeds, such as a network program or live event. **SEE 11.15**

ROUTING SWITCHERS

Routing switchers route video signals to specific destinations. For example, you should use a routing switcher to feed various monitors with the line-out video, then switch to the preview video, and then to the satellite video. Or you may assign the line-out signal to the video server instead of VTR 2 because VTR 2 is involved in editing. The buttons on a routing switcher are usually arranged in rows that look very much like the program bus on a production switcher or part of a computer-controlled system.

ELECTRONIC DESIGNS

Although the ability to operate a switcher does not hinge on an intimate knowledge of its electronic design, you should have some idea of the major electronic characteristics of switchers: (1) composite and component, (2) analog and digital, and (3) audio-follow-video.

COMPOSITE AND COMPONENT SWITCHERS

The *composite switcher* is built to transport and process the *NTSC signal* that combines the luminance (Y) and color (C) video signals into a single one. Composite switchers need only a single wire to transport the video signal. If you use the switcher strictly for multicamera live switching,

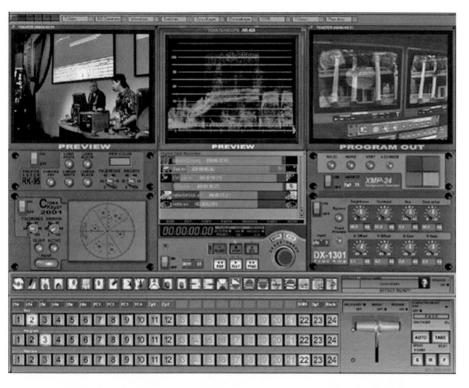

11.14 COMPUTER SWITCHER INTERFACE

This software program of the NewTek switcher VT[4] displays and activates all basic production and postproduction switcher functions. It has an amazing array of built-in test and video-quality equipment, as well as a multitrack audio console. This switcher can be used for live switching or postproduction work.

257

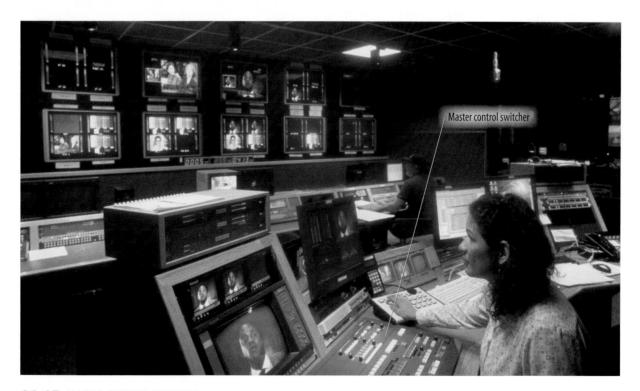

11.15 MASTER CONTROL SWITCHER

The computerized master control switcher switches specific video and audio sources automatically.

such as a studio show or a sports remote, the composite switcher is perfectly adequate because you deal only with NTSC signals. For high-quality postproduction, however, you need a switcher that allows Y/C component, Y/color difference component, or RGB component signal processing (see figures 12.1–12.4).

Component switchers process the video signal in either the Y/C or the Y/color difference configuration. In the Y/C component switcher, the luminance and color information are processed separately and transported via two wires. In the Y/color difference component switcher, three signals (a luminance and two color signals, or RGB) are transported separately by three wires throughout the switcher and processed separately. Most digital switchers are built to adapt to either composite or component signals or to accept either configuration. (These systems are explained in depth in chapter 12.)

ANALOG AND DIGITAL SWITCHERS

Although most *analog switchers* have a digital device for *digital video effects* (*DVE*) or the storage of such effects, they basically process the analog video signals as supplied by analog cameras or VTRs in their original analog form. *Digital switchers*, on the other hand, process all incoming video signals digitally. Most digital switchers are component systems, but they let you change from the component to the composite configuration.

One advantage of digital switchers is that you can use as the video source signals that come directly from digital equipment, such as digital cameras, digital editing systems, servers, computer hard drives, read/write optical discs, and any number of digital storage devices.

Fortunately, digital switchers have maintained the architecture of their analog cousins, which for our purposes means that the digital switcher panel still has M/E, program, preview/preset, and key buses and fader bars much like an analog switcher. In fact, the appearance of a switcher alone will not tell you whether it is analog or digital. More important, there is much similarity in the operation of the two types. **SEE 11.16**

AUDIO-FOLLOW-VIDEO SWITCHERS

Audio-follow-video switchers switch the audio with the pictures that go with it. For example, when switching a scene in which two people are talking on the phone, a telephone-quality audio filter cuts in every time you switch

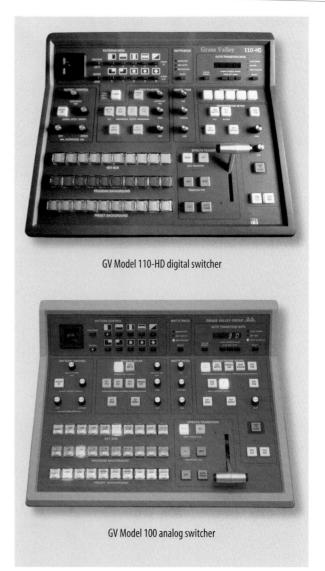

11.16 ANALOG AND DIGITAL SWITCHERS

The appearance and operational functions of the digital switcher are very similar to those of its analog cousin.

to the person on the far end of the conversation. When switching back to the "close" person, the switcher cuts out the audio filter and you hear the regular audio.

Master control switchers are audio-follow-video switchers—they automatically change the accompanying audio along with the video source.

MAIN POINTS

- Production switchers are used to facilitate instantaneous editing during multicamera productions. They must have enough video inputs to accommodate the number of video sources used during the production.
- Postproduction switchers are used primarily for creating transitions and special effects rather than for instantaneous editing.
- Master control switchers are computer-driven. They not only switch from one program source to the next but also roll VTRs and video cart machines and call up DVE (digital video effects), ESS (electronic still store) video, or material stored on video servers.
- Routing switchers simply direct a video signal to a specific destination.
- Composite switchers are built to transport and process NTSC video signals.
- Component switchers are built to handle Y/C component, Y/color difference, or RGB video signals. Most digital switchers can handle both composite and component signals.
- Analog switchers process analog video inputs throughout the switching operation, although they often treat special effects digitally.
- Digital switchers are mainly component switchers, processing the video inputs exclusively in digital form. They normally maintain the switcher architecture (switching logic and the arrangement and functions of buses) in a similar way to analog switchers.
- Audio-follow-video switchers switch the audio with the pictures that go with it.

ZETTL'S VIDEOLAR

For your reference, or to track your work, each *Video-Lab* program cue in this chapter is listed here with its corresponding page number.

SWITCHING→ Switching functions→ select | connect 244

ZVL2> SWITCHING→ Architecture→ program bus | preview bus | mix buses | fader bar automatic transition | try it 247

ZVL3 SWITCHING→ Switching functions→ transitions | create effects 248

SWITCHING→ Transitions→ cut | mix/dissolve | wipe | fade | try it 251

ZVL5 SWITCHING→ Effects→ keys | key types | downstream keyer | special effects 252

12

Video-recording and Storage Systems

Although one of television's great assets is its capability to transmit an event "live," that is, while the event is in progress, most programs have been prerecorded on some kind of video-recording device. Even live newscasts contain a preponderance of prerecorded material. In corporate video and in independent production houses, almost all program material originates from some kind of video recording.

Because of the importance of video recording, manufacturers are constantly striving to compress more and more video and audio information onto ever smaller storage devices while making the retrieval of program material as quick and simple as possible. Section 12.1, How Video Recording Works, acquaints you with the major tape-based and tapeless video-recording and storage systems. A tape-based system uses videotape as the storage medium for analog or digital video and audio signals. Tapeless systems store only digital video and audio signals on computer hard disks, read/write optical discs, or large-capacity flash memory devices. Because today almost all video footage is captured with digital cameras, great strides have been made toward tapeless recording, editing, and playback.

Section 12.2, How Video Recording Is Done, introduces you to some of the operational uses of video recording and the major studio and ENG/EFP recording procedures.

KEY TERMS

- analog recording systems Record the continually fluctuating video and audio signals generated by the video and/or audio source.
- **composite system** A process in which the luminance (Y, or black-and-white) signal and the chrominance (C, or red, green, and blue) signal as well as sync information are encoded into a single video signal and transported via a single wire. Also called *NTSC signal*.
- **compression** Reducing the amount of data to be stored or transmitted by using coding schemes that pack all original data into less space (*lossless* compression) or by throwing away some of the least important data (*lossy* compression).
- control track The area of the videotape used for recording the synchronization information (sync pulse). Provides reference for the running speed of the VTR, for the placing and reading of the video tracks, and for counting the number of frames.
- **digital recording systems** Sample the analog video and audio signals and convert them into discrete on/off pulses. These digits are recorded as 0's and 1's.
- **disk-based video recorder** All digital video recorders that record or store information on a hard disk or read/write optical disc. All disk-based systems are nonlinear.
- electronic still store (ESS) system An electronic device that can grab a single frame from any video source and store it in digital form. It can retrieve the frame randomly in a fraction of a second.
- field log A record of each take during the videotaping.
- **flash memory device** A small read/write portable storage device that can download, store, and upload very fast (in a flash) a fairly large amount (1 gigabyte or more) of digital information. Also called *flash drive*, stick flash, flash stick, or flash memory card.
- **framestore synchronizer** Image stabilization and synchronization system that stores and reads out one complete video frame. Used to synchronize signals from a variety of video sources that are not genlocked.

- JPEG A video compression method mostly for still pictures, developed by the Joint Photographic Experts Group.
- **MPEG** A compression technique for moving pictures, developed by the Moving Picture Experts Group.
- MPEG-2 The compression standard for motion video.
- MPEG-4 The compression standard for Internet streaming.
- **RGB component system** Analog video-recording system wherein the red, green, and blue signals are kept separate throughout the entire recording and storage process and are transported via three separate wires.
- **tape-based video recorder** All video recorders (analog and digital) that record or store information on videotape. All tape-based systems are linear.
- **time base corrector (TBC)** Electronic accessory to a video recorder that helps make playbacks or transfers electronically stable.
- video leader Visual material and a control tone recorded ahead of the program material. Serves as a technical guide for playback.
- videotape recorder (VTR) Electronic recording device that records video and audio signals on videotape for later playback or postproduction editing.
- videotape tracks Most videotape systems have a video track, two or more audio tracks, a control track, and sometimes a separate time code track.
- Y/C component system Analog video-recording system wherein the luminance (Y) and chrominance (C) signals are kept separate during signal encoding and transport but are combined and occupy the same track when actually laid down on videotape. The Y/C component signal is transported via two wires. Also called *S-video*.
- Y/color difference component system Video-recording system in which three signals—the luminance (Y) signal, the red signal minus its luminance (R–Y) signal, and the blue signal minus its luminance (B–Y)—are kept separate throughout the recording and storage process.

12.1

How Video Recording Works

Despite the great variety of video recording devices, there are basically two types of systems: tape-based and tapeless. Tape-based systems can record analog or digital signals; tapeless systems can record only digital information. The operational advantages of a tapeless system are that it is generally faster and it allows random access of information.

To help you make sense of the various systems, this section gives an overview of some important recording systems and technology and a more detailed description of the various tape-based and tapeless recording devices.

RECORDING SYSTEMS AND TECHNOLOGY

Analog and digital systems, linear and nonlinear systems, composite and component systems, sampling, and compression

► TAPED-BASED RECORDING AND STORAGE SYSTEMS

How videotape recording works, operational VTR controls, electronic features, and major analog and digital systems

► TAPELESS RECORDING AND STORAGE SYSTEMS

Hard disk systems, read/write optical discs, flash memory devices, and data transfer

RECORDING SYSTEMS AND TECHNOLOGY

This section examines the following recording systems and technology: (1) analog and digital systems, (2) linear and nonlinear systems, (3) composite and component systems, (4) sampling, and (5) compression.

ANALOG AND DIGITAL SYSTEMS

Although digital video is firmly established as the professional system of choice, you will also find that the high-end Betacam recording systems are very much alive and well in many professional operations.

Analog videotape recording Analog videotaping is similar to the analog audiotape-recording process. With *analog recording systems*, the electronic impulses of television pictures (the video signal) and sound (the audio signal) are recorded and stored on the plastic videotape by magnetizing its iron-oxide coating. During playback the stored information is reconverted into video and audio signals and translated by the television set into television pictures and sound. The amount of electronic information is many times greater for video than for audio recording.

Not surprisingly, not all analog systems are the same. Some, such as your VHS recorder, are designed for cost-effective home use and operational ease. Its picture and sound quality is not great, but it's sufficient for a reasonably good recording of a football game or soap opera segment you missed. But as soon as you start making copies for your friends, the quality deteriorates even after the first dub. The *S-video* system is similar to the VHS system but is designed for professional use. The initial recording will have considerably higher image and audio quality that will not deteriorate from dub to dub as quickly as the VHS copies.

High-quality analog systems, such as the *Betacam SP*, produce pictures as good as the best digital systems. Although these recordings deteriorate relatively little in a limited amount of postproduction dubs, they do show noticeable quality loss after about ten generations. (A *generation* is the number of dubs away from the original recording.)

Digital video recording The advantage of *digital recording systems* over analog is that digital systems can use recording media other than videotape, which do not sustain quality loss even after a great number of generations. For all practical purposes, the fiftieth generation looks the same as the original recording. Besides videotape, digital video and audio signals can be recorded on, and played back from, computer hard drives, optical discs (CDs and DVDs), and flash memory devices. (The specifics of these recording devices are explored later in this section.) Note that computer hard disks are spelled with a k, and optical discs with a c.

LINEAR AND NONLINEAR SYSTEMS

Although the terms *linear* and *nonlinear* apply more to the way the recorded information is retrieved rather than stored, you may also hear tape-based systems described as linear recording devices, and disk-based systems as nonlinear ones.

Linear systems All *tape-based video recorders* are linear, regardless of whether the signals recorded are analog or digital. Linear systems record their information serially, which means that during retrieval you need to roll through shots 1 and 2 before reaching shot 3. Even if a tape-based system records the information digitally rather than in analog, it is linear and does not allow random access. You can't call up shot 3 without first rolling through shots 1 and 2.

Nonlinear systems All *disk-based video recorders* (including optical discs and flash memory devices) are nonlinear, which means that you can randomly access any shot without having to roll through the previous material. For example, you can access shot 3 directly by simply calling up the shot 3 file. Of course you can also watch the recording in linear fashion, starting with shot 1 and then watching shot 2, shot 3, and so on.

Random access is especially important when editing because it lets you call up instantaneously any video frame or audio file regardless of where it may be buried on the disk. (The difference between linear and nonlinear systems is explored further in the context of postproduction editing in chapter 13.)

COMPOSITE AND COMPONENT SYSTEMS

The division of video recorders into *composite* and *component* systems is significant because the two systems are not compatible and they differ in production application. Analog and digital recording systems can treat their signals in one of four basic ways: (1) composite, (2) Y/C component, (3) Y/color difference component, and (4) RGB component.

Composite system The *composite system* combines the color (C, or chrominance) and the brightness (Y, or luminance) information into a single (composite) signal. Only one wire is necessary to transport the composite signal. Because this electronic combination was standardized some time ago by the National Television System Committee (NTSC), the composite signal is also called the *NTSC signal* or, simply, *NTSC*. The NTSC system is different from other composite systems, such as the European PAL system. A standard conversion is necessary when systems don't match. Most such standard conversions are done in the satellite that distributes the signals.

The major disadvantage of the composite signal is that there usually is some interference between chrominance and luminance information that gets worse and therefore more noticeable with each videotape generation. **SEE 12.1**

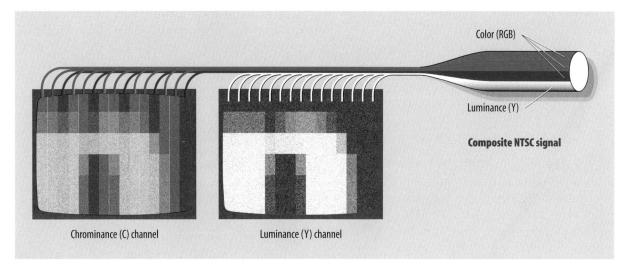

12.1 COMPOSITE SYSTEM

The composite system uses a video signal that combines the luminance (Y, or brightness) and color (C) information. It needs a single wire to be transported and recorded on videotape as a single signal. It is the standard NTSC system.

Y/C component system In the analog *Y/C component system*, also called *S-video*, the luminance (Y) and chrominance (C) signals are kept separate during the encoding ("write") and the decoding ("read") processes. During the recording process, however, the two signals are combined and occupy the same track when stored, that is, when actually laid down on the videotape. The Y/C configuration requires two wires to transport the Y/C component signal. **SEE 12.2**

To maintain the advantages of Y/C component recording, other equipment used in the system, such as monitors, must also keep the Y and C signals separate. This means that you cannot play a Y/C component videotape on a regular VHS recorder but only on an S-VHS recorder. The advantage of the Y/C component system is that it produces higher-quality pictures that will suffer less in subsequent tape generations than do composite tapes.

Y/color difference component system In the analog *Y/color difference component system*, the luminance signal, the red signal minus its luminance (R–Y), and the blue signal minus its luminance (B–Y) are transported and stored as three separate signals. The green signal is regenerated (matrixed) from these three signals. This system needs three wires to transport the three separate signals. **SEE 12.3**

RGB component system In the *RGB component system*, the red, green, and blue signals are kept separate and treated as separate components throughout the recording and storage process. Each of the three signals remains separate even when laid down on the videotape. Because the RGB system needs three wires to transport the component signal, all other associated equipment, such as switchers, editors, and monitors, must also be capable of processing the three separate RGB signal components. This means that they all must have "three wires" to handle the video signal instead of the single wire of the normal composite system—all in all a rather expensive requirement. **SEE 12.4**

The big advantage of the three-signal component system is that even its analog recordings maintain much of their original quality through many tape generations. Such a feature is especially important if a production requires many special effects, such as animation scenes, that need to be built up through several recordings.

Obviously, the Y/C, Y/color difference, and RGB component systems eventually must combine the separate parts of their video signals into a single NTSC composite signal for traditional analog broadcast or tape distribution.

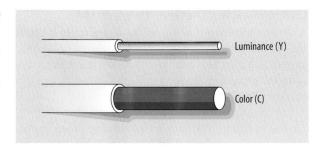

12.2 Y/C COMPONENT SYSTEM

The Y/C component system separates the Y (luminance) and C (color) information during signal encoding and transport, but it combines the two signals on the videotape. It needs two wires to transport the separate signals.

12.3 Y/COLOR DIFFERENCE COMPONENT SYSTEM

The Y/color difference component system separates the three RGB signals throughout the recording process. It needs three wires to transport the three component signals: the Y (luminance) signal, the R–Y (red minus luminance) signal, and the B–Y (blue minus luminance) signal. The green signal is then matrixed (regenerated) from these signals.

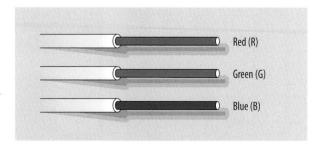

12.4 RGB COMPONENT SYSTEM

Like the Y/color difference system, the RGB component system (also called the RGB system) separates the three RGB signals throughout the recording process. It needs three wires to transport the signals. It provides the greatest color quality but takes up an inordinate amount of frequency space.

SAMPLING

You will undoubtedly hear people talk about the relative benefits of 4:2:2 over 4:1:1 sampling ratios in all forms of video recording. All that this means is that in the digitizing process, the C (color) signals are sampled less frequently than the Y (luminance, or black-and-white) signal. In fact, in 4:1:1 sampling the Y signal is sampled four times, whereas the C signals are sampled only once. In 4:2:2 sampling the Y signal is sampled twice as often as the C signals: the Y signal is sampled four times, but the C signals only twice during a certain period of time. The luminance signal receives such privileged treatment because it is a major contributor to picture sharpness.

Most normal productions look stunning with 4:1:1 sampling. If, however, you require high-quality color that must withstand a variety of special effects, such as various blue-screen or chroma-key effects (see chapter 14) or a great number of key layers, you will do well to use equipment that employs the higher 4:2:2 sampling ratio.

Confused? Don't worry. The most important things to remember about these systems are that, in comparison, the video signal of the NTSC composite system is of lower quality than that of the Y/C component system, which is somewhat inferior to the Y/color difference component system or the RGB component system. A 4:2:2 sampling ratio produces better pictures than does a 4:1:1 ratio, although the latter certainly produces good images. In fact, you would notice the difference between the two sampling ratios only when building complex effects or when recording under extreme (high-contrast) lighting conditions.

Other important points to remember are that some of these systems are incompatible with the others, and all need their own recording and playback equipment. Also, contrary to analog ones, digital recordings show no noticeable deterioration even after many generations.

COMPRESSION

As you recall from chapter 2, *compression* refers to the rearrangement or elimination of redundant picture information for more-efficient storage and signal transport. *Lossless compression* means that we rearrange the data so that they take up less space. This technique is similar to repacking a suitcase to make all the stuff fit into it. In *lossy compression* we throw away some of the unnecessary items and therefore can use a much smaller suitcase.

Digital pictures require a great amount of time for transport and considerable disk space for storage. Because it is much easier to store and travel with a smaller digital "suitcase," most compression systems are the lossy kind—they throw away redundant data. When dealing with video compression, there are two basic systems: intraframe and interframe.

Intraframe compression This compression system is designed primarily for still images, but it can also be applied to individual video frames. *Intraframe compression* looks at each frame and throws away all video information that is unnecessary to perceiving pretty much the same picture as the original. In technical terms it eliminates *spatial redundancy*.

Let's consider our overstuffed suitcase again. To save some space, we must look at each part of the packed suitcase and ask whether we can get along with two shirts instead of six; then we move to the sweater section and take out five of the six sweaters we packed, especially since we are going to go to a warm, sunny location. We continue to check all the spaces in the suitcase to see what we can leave behind. Pretty soon we will have discarded enough unnecessary clothing (redundant pixels) to get by with a much smaller suitcase. The *JPEG* system—a video compression method used mostly for still pictures—employs this intraframe compression technique.

Interframe compression This system was developed for moving video images. Rather than compress each frame independent of all the others, *interframe compression* looks for redundancies from one frame to the next. Basically, the system compares each frame with the preceding one and keeps only the pixels that constitute a change. For example, if you see a cyclist moving against a cloudless blue sky, the system will not bother with repeating all the information that makes up the blue sky but only with the position change of the cyclist. As you can see, interframe compression looks for *temporal redundancy* (change from frame to frame) rather than spatial redundancy within a single frame.

Let's use the suitcase example one last time. We now have two people with suitcases. John has already packed his big suitcase, and Ellen is ready to begin packing. Before she starts, however, she checks with John to see what he has packed (full video frame 1). To her delight he has packed a lot of stuff she wanted to take along, so she needs to fit only a few more items into a very small suitcase (interframe compressed frame 2). *MPEG-2*, the compression standard for motion video, uses the interframe technique. (*MPEG* is a compression technique for moving pictures, developed by the Moving Picture Experts Group.)

The problem with this system is in editing. Because some of the compressed frames are very lossy, they can't be used as the starting or end point of an edit. The system therefore periodically sends a full *reference frame* (say, every fifth or tenth frame) that is independent and not the result of a comparison with the previous one. The editor can then go to the full frame to do the actual cut. Being restricted to every fifth or tenth frame for a cut does not please an editor who may need to match each frame of lip movement with the corresponding sound, but in most cases a five-frame cutting restriction is not too much of a handicap. This is why systems designed for editing include these reference frames as often as feasible. Some more-sophisticated MPEG-2 editing systems can recalculate a complete frame anywhere in the compressed video.

Regardless of the compression technique, you can always apply a simple compression/quality formula: *the less compression, the better the image quality.* But then there is another, not so happy, formula: *the less compression, the more unwieldy the huge amount of information becomes.*

TAPE-BASED RECORDING AND STORAGE SYSTEMS

This section explores (1) how videotape recording works, (2) the operational VTR controls, (3) their electronic features and how they function, and (4) the major analog and digital VTRs currently in use.

HOW VIDEOTAPE RECORDING WORKS

Generally speaking, a videotape recorder (VTR) is any electronic recording device that records video and audio signals on videotape for later playback or postproduction editing. During video recording, the videotape moves past a rotating head assembly that "writes" the video and audio signals on the tape during the recording process and "reads" the magnetically stored information off the tape during playback. Some VTRs use two or four heads for the record/play (write/read) functions. Some digital VTRs have even more read/write heads for various video, audio, and control tracks. In the play mode on some VTRs, the same heads used for recording are also used to read the information off the tracks and convert it back into video signals. Others use different heads for the record and playback functions. For a simple explanation of how video recording works, the following discussion uses an analog VTR with only two record/playback heads.

Record/playback heads The two heads are mounted opposite each other either on a rapidly spinning head drum or on a bar that spins inside a stationary head drum, in

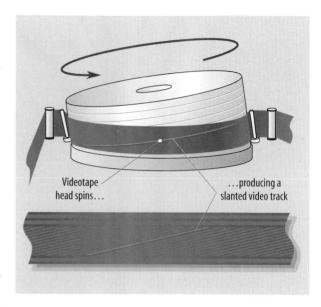

12.5 HELICAL SCAN, OR SLANT-TRACK, SYSTEM

The video track is slanted to gain a sufficient amount of area on a narrow tape.

which case they make contact with the tape through a slot in the drum. To gain as much tape space as possible for the large amount of video information without undue tape or drum speed, the tape is wound around the head drum in a slanted, spiral-like configuration. Based on *helix*—the Greek word for "spiral"—we call this tape wrap, and often the whole video-recording system, the *helical scan*, or *slant-track*, system. **SEE 12.5**

Videotape tracks The standard VHS recorder puts four separate *videotape tracks* on the tape: the *video track* containing the picture information, two *audio tracks* containing all sound information, and a *control track* that regulates the videotape and rotation speed of the VTR heads. **SEE 12.6** As we shall soon see, digital VTRs operate with a totally different track arrangement. **ZVL1** EDITING→ Postproduction guidelines→ tape basics

Analog video track When you record the video signal in the normal NTSC composite configuration, one pass of the head records a complete field of video information (Y + C). The next pass of the head—or, with a two-head machine, the second head—lays down the second field right next to it, thus completing a single video frame. Because two fields make up a single frame, the two heads must write 60 tracks for 60 fields, or 30 frames, for each second of NTSC video.

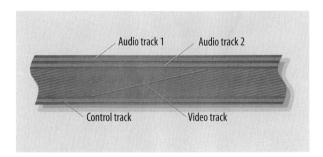

12.6 BASIC VIDEOTAPE TRACK SYSTEM

The basic videotape track system consists of a slanted video track, two or more audio tracks, and a control track.

In Y/C component VTRs, the separate luminance and chrominance signals are combined and laid down on a single track with each pass of the record head. In the RGB and Y/color difference component systems, three passes are required to lay the three signals next to each other.

Audio tracks Analog audio information is generally recorded on longitudinal tracks near the edge of the tape. Because of the demand for stereo audio and for keeping certain sounds separate even in monophonic sound, all VTR systems (even VHS recorders) provide at least two audio tracks.

Control track The *control track* contains evenly spaced blips or spikes, called the *sync pulse*, which mark each complete television frame. These pulses synchronize the tape speed (the speed with which the tape passes from the supply reel to the takeup reel in the cassette) and the rotation speed of the record heads so that a tape made

on a similar machine can be played back without picture breakups. As explained in chapter 13, the control track is also essential for precise videotape editing. Some VTRs have a *sync track* (reserving the control track for editing purposes) and still another track for additional data, such as the *SMPTE time code*. Because space is so scarce in a small videocassette, some systems squeeze the time code and other data between the video and audio portions of a single track.

Digital systems Rather than a video or audio signal, digital systems record on/off pulses that are usually coded as 0's and 1's. Some digital systems, such as the DVCPRO and the DVCAM systems, use very small (¼-inch) cassette tapes for their high-quality recording. Instead of using just two tracks for recording a full frame of video, these systems use as many as ten or more tracks to record a single video frame. For example, the high-quality DVCPRO 50 system uses twenty tracks for each complete frame. Extremely high record-head speeds make up for the lack of tape width. The audio tracks are embedded in the video track. The control track and cue tracks (for the time code) are longitudinal, which means that they run along the edge of the tape. **SEE 12.7**

OPERATIONAL VTR CONTROLS

The basic operational controls and features of VTRs are similar, regardless of whether the information they record is analog or digital. A typical VTR has the same controls as on your home VCR, except that the professional models have a few additional shuttle and edit controls. Each of these buttons or knobs lets you control a specific VTR function.

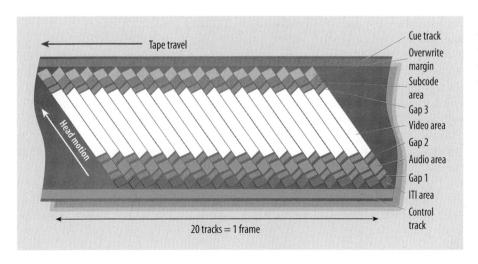

12.7 DVCPRO 50 TRACK PATTERN

The digital DVCPRO 50 system writes twenty tracks to record a single video frame.

12.8 BASIC VTR CONTROLS

Standard VTR controls are similar to those on a home videocassette recorder.

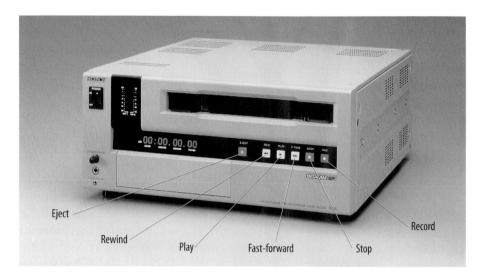

The most basic controls on any VTR—regardless of type or sophistication, analog or digital—are the *play*, *stop*, *record*, *fast-forward*, *rewind*, and *eject* buttons and the audio volume controls. **SEE 12.8** The more sophisticated VTRs have these additional functions: (1) standby, (2) pause or still, (3) search or shuttle, (4) audio controls, and (5) tracking.

Standby In the *standby* mode, the VTR threads the tape and rotates the video heads, but the tape is still stationary. The rotating video heads are disengaged and not in contact with the tape.

Pause or still The *pause* control will stop the tape with the heads still moving. In this mode the rotating video heads are in contact with the tape and will continuously scan the adjacent video fields and produce a still—or freeze—frame on the video monitor or in the camera viewfinder. But do not keep the machine in pause too long—the heads are apt to scrape the iron-oxide coating off the tape and leave you with nothing but clogged heads and video noise on the monitor.

Most home VCRs switch out of pause mode if the tape has had enough abuse. Some professional recorders, however, will not do this automatically, to avoid interfering with the creative process. Don't leave a tape too long in pause mode, especially if you want to use it for editing.

Search or shuttle This control lets you advance or reverse the tape at variable speeds that may be much higher

or lower than the normal record/play speed. The *shuttle* feature is especially important when searching for a particular shot or scene on the videotape. You can advance the video frame-by-frame or rattle through a whole scene until you find the right picture. You can also slow down the shuttle enough to get a jogging effect, which shows a frame-by-frame advancement of the videotape.

Some elaborate recorders have separate shuttle and jog controls. You should note that in the search or shuttle mode, the heads are still engaged and in contact with the tape. If you have a rough idea of where a particular scene is located, use the fast-forward or rewind controls instead of search. The fast-forward and rewind modes disengage the heads, thus preventing excessive tape and head wear; but because you can no longer see the pictures, you have to watch the tape counter.

Audio The main audio controls are the volume control and VU monitoring for each audio channel. Some recorders have separate volume controls for sound recording and playback. The *audio dub* control lets you record sound information without erasing the pictures already recorded on the video track. Most professional VTRs give you a choice of selecting regular (analog) and hi-fi (digital) audio. Depending on how the sound on the videotape was recorded, you may have to switch to or from hi-fi audio. If the audio doesn't play back properly, try the other mode.

Tracking *Tracking* errors usually show up as a jittery picture. It happens when the playback head of the playback

VTR is not exactly aligned with the heads of the VTR on which the program was recorded. Most professional VTRs do this alignment automatically, but some lower-end machines have manual controls.

ELECTRONIC FEATURES

The major electronic features that you need to know to operate a VTR are: (1) input and output jacks, (2) the time base corrector, (3) the framestore synchronizer, and (4) the automatic moisture shutdown.

Input and output jacks The most important jacks (receptacles) are the *video input* (camera or any other video feed, such as the signal from a television set) and *video output* (to other VTRs for editing and to monitors or television sets). Digital recorders have standard analog SMPTE composite and component video as well as S-video output jacks. Most consumer VTRs have in and out *RF* (*radio frequency*) jacks, which let you use a regular television set as a monitor. You simply connect the coaxial cable from the RF output of the VTR to the antenna input of the television set and switch the set to a particular channel (usually channel 3 or 4). The RF signal also carries the audio.

Besides the RF connection, the VTR has separate video and audio output jacks that operate independent of the RF. They are designed for RCA phono plugs and are normally color-coded white and red for audio and yellow for video. Good television receivers have similar video and audio input jacks.

Time base corrector All good-quality videotape systems need some device that stabilizes the picture and eliminates jitter during playback. Two of the most common are the time base corrector (TBC) and the more versatile digital framestore synchronizer. Both electronic devices adjust the scanning of the source signal to that of the playback device to keep both scanning "clocks" in step. This synchronization of the scanning of both video sources allows you to interface VTRs with a variety of video equipment without temporary picture breakup. Normally, you need to provide the same synchronization information—called house sync—to all video sources if you expect to switch among them without picture glitches. When you import a video source without such genlock, that is, without supplying house sync to all video sources, the TBC will help prevent picture breakup when switching from one video source to the other. Most high-end VTRs have a built-in TBC to prevent picture breakup and ensure jitter-free pictures.

Framestore synchronizer The digital *framestore synchronizer* is a more sophisticated digital version of a TBC. The framestore synchronizer grabs each digitized frame of the video signal and stores it momentarily until its scanning is synchronized with that of another video source. This system is so efficient that you can switch among various independent video sources that are not *genlocked*. You may have seen a picture freeze momentarily when watching a live report from a different city: when the signal is temporarily interrupted, the framestore synchronizer holds everything until the video is in sync again.

Automatic moisture shutdown This feature can prevent you from losing a hard day's work or it can drive you crazy. Because the tape heads and the videotape itself are especially sensitive to moisture, stand-alone VTRs and those in camcorders shut down automatically if they get too damp. When in the field, such a shutdown can be frustrating and time-consuming. Experienced VTR operators, or "shooters," therefore carry a battery-powered hair dryer to dry out the VTR and get it up and running again.

ANALOG VIDEOTAPE RECORDERS

Professional VTR models are as varied and ever-changing as consumer models. Rather than concentrate on specific makes, this overview looks at the quality differences and the specific functions of tape-based analog and digital recording systems.

You can accomplish many production tasks with less-than-top-of-the-line VTRs. Even home VCRs are sufficient if all you want to do is look for a particular shot or scene. The more popular analog VTRs in television stations and production centers, in descending order of quality, include (1) Betacam SP, (2) S-VHS, and—yes—even (3) VHS models.

Betacam SP The SP of this system stands, quite aptly, for superior performance. This is the improved version of the original Betacam recording process. Despite the digital revolution, Betacam SP is still used in quite a few broadcast stations, independent production companies, and corporate video operations. This is because it captures high-quality video and audio and because it is hard to retire such a good and initially very expensive piece of equipment. The Betacam SP keeps the Y (luminance) signal and the Y/color difference signals (R–Y and B–Y) separate throughout the recording process and is, therefore, a Y/color difference component system. Two of its

12.9 BETACAM SP STUDIO VTR

This high-quality Betacam SP VTR has all the controls of a standard VTR plus additional audio, shuttle, and editing controls.

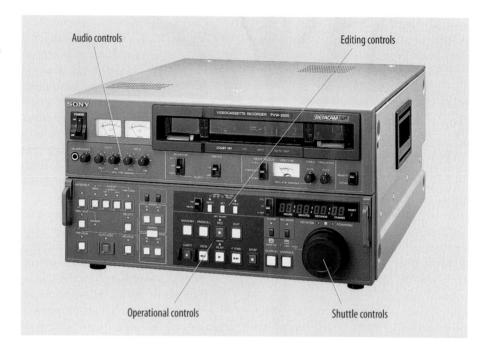

four audio tracks produce high-fidelity sound. This VTR, which can also be attached to a camcorder, is used mainly for capturing video. **SEE 12.9 AND 12.10**

5-VHS The S-VHS videotape recorder is a greatly improved version of the well-known consumer VHS recorders. You can find S-VHS systems in television newsrooms, in editing suites of corporate production houses, and especially in schools that teach video production or that produce programs for a local cable station. Some are used for viewing footage that has been shot with S-VHS cameras or dubbed from digital tape. **SEE 12.11**

The S-VHS system records video information as Y/C component signals. High-end models have a built-in TBC that ensures picture stability during playback and editing. The S-VHS recorders provide four sound tracks (two of which are for high-fidelity sound) and a separate control track.

VHS The VHS system, which you undoubtedly have in your home, records the video signals in the NTSC composite format. Its pictures and sound are noticeably inferior to other analog and especially digital systems, but don't throw away your VHS recorder just yet. The VHS system still serves important production functions. You can use these inexpensive machines for basic program screening, previewing and logging of scenes shot for postproduction

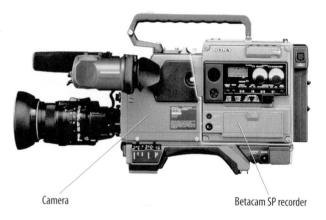

12.10 BETACAM SP VTR DOCKED WITH CAMERA

Many professional camcorders can be docked with a variety of VTRs. This camera is docked with a Betacam SP VTR.

editing, documenting shows for tape archives, and even off-line editing. (Logging and editing procedures are explored in chapter 13.)

DIGITAL VIDEOTAPE RECORDERS

At this point you may wonder why we bother with digital recording systems when the analog VTRs described produce perfectly acceptable pictures and sound. The major advantages of digital VTRs are that they are more compact

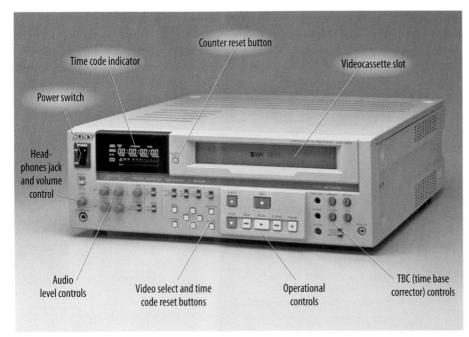

12.11 S-VHS STUDIO VTR This S-VHS studio VTR uses ½-inch cassettes to record Y/C component video and four separate audio tracks. Two of the audio tracks are for high-

fidelity sound.

and that even inexpensive models produce high-quality pictures and sound that maintain their quality through repeated dubs. Digital recordings also do not need to be converted—unlike analog recordings—for computer storage on a hard disk for nonlinear editing and special-effects manipulation.

When operating a VTR, it doesn't really matter what system you are using so long as you use the proper tape and

press the right buttons. Nevertheless, to operate a specific VTR reliably and efficiently, you need to be familiar with at least some of the major digital systems and their basic features: (1) DV, (2) DVCAM, (3) DVCPRO, (4) Betacam SX, (5) HDV, and (6) HDTV. **SEE 12.12**

DV All small digital consumer camcorders use the *DV* system, but it quickly found its way into newsrooms and

12.12 DIGITAL RECORDING SYSTEMS

This table lists the most widespread digital video systems.

SYSTEM	CASSETTE	PRODUCTION CHARACTERISTICS		
DV	1/4-inch (6.35mm) mini-cassette	Good digital quality.		
DVCAM	1/4-inch (6.35mm) full-sized cassette	Excellent quality. Cassette not compatible with DVCPRO.		
DVCPRO	½-inch (12.65mm) full-sized cassette	Excellent quality. Cassette not compatible with DVCAM.		
Betacam SX	½-inch (12.65mm) full-sized cassette	Excellent quality. Bulky.		
HDV	1/4-inch (6.35mm) mini-cassette	Excellent quality. Superior resolution. Records only half the video information of HDTV.		
HDTV	1/4-inch (6.35mm) full-sized cassette	Superior resolution and color.		

12.13 DVCAM DESKTOP VTR

This DVCAM digital VTR can record high-quality digital video and high-fidelity audio on a ¼-inch cassette as well as on DV mini-cassettes. It can be connected directly to a computer via a FireWire (i-link or IEEE 1394) interface cable.

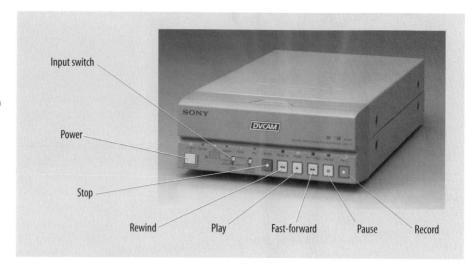

independent production houses because of the astonishingly good quality and small size of its camcorder and VTR. In fact, the DV recording method is the forerunner of the DVCPRO and DVCAM systems, and several prosumer cameras use DV recording. The mini-cassette used in the DV system can record up to an hour of continuous programming. Note, however, that extensive editing with the DV system is not recommended; in the DV mode, the audio/video synchronization is not "locked," which means that it is not frame-accurate.

DVCAM The Sony *DVCAM* VTR has a 4:1:1 sampling ratio when recording Y/color difference component signals. It uses intraframe compression and the ¼-inch (6.35mm) cassette, which is a little larger than the mini-cassette. The cassettes contain various tape lengths capable of recording up to three hours of programming. Besides the DVCAM's small size and excellent audio and video quality, the recordings suffer virtually no deterioration during postproduction because they stay compressed through the entire editing process. **SEE 12.13**

DVCPRO This Panasonic *DVCPRO* uses a ½-inch (6.35mm) cassette that can record about two hours of programming. It is similar to the DVCAM cassette but uses a videotape with a different coating. Like the DVCAM system, the DVCPRO uses Y/color difference component signals, a 4:1:1 sampling ratio, and intraframe compression. As you recall, this means that you can use any frame for an edit-in or edit-out point.

The DVCPRO 50 system, for high-end VTRs and camcorders, uses twice as many tracks for each video frame

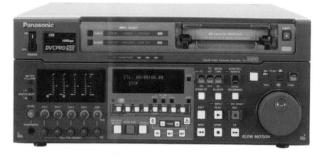

12.14 DVCPRO 50 STUDIO VTR

This recorder uses twenty tracks on a ¼-inch (6.35mm) tape for each frame—twice as many tracks as the standard DVCPRO VTR. It can record ninety minutes of program material.

(twenty instead of ten), a higher sampling ratio (4:2:2 for interlaced formats instead of 4:1:1), and a lower compression rate than the standard DVCPRO system. **SEE 12.14**

Betacam SX The digital *Betacam SX* system uses a Y/color difference component signal and has a 4:2:2 sampling ratio. It uses ½-inch tape cassettes that can record continuously for about three hours. This system never achieved the popularity of its analog counterpart, Betacam SP, mainly because it was upstaged by the lighter and more flexible DVCAM and DVCPRO systems.

HDV High-definition video (HDV) is a prosumer format that makes high-definition television accessible to production companies that cannot spend tens of thousands of dollars on a camcorder. As can be expected, the various

formats on the market have their own recording systems and are not compatible, except for one thing: they all record on standard DV mini-cassettes. Some operational systems (JVC and Panasonic) record with a 720p (progressive) scanning standard; Sony with a 1080i (interlaced) one (see chapter 2). All use MPEG-2 compression. Although properly produced HDV has the same picture resolution as HDTV, purists insist that HDV's colors and grayscale are still a far cry from those of HDTV.

You will find that the real problems of prosumer HDV are not only the lack of color information but also a lower-quality lens and playback equipment. When played back on standard television equipment, you obviously lose the resolution advantage you gained with HDV recording. Much like HDTV, HDV requires large-capacity hard drives to import the massive amount of digital information. You will also find that your favorite editing software may still not support HDV without first having to decompress and reconfigure the stored HDV data.

HDTV The ultimate in image quality is *high-definition television* (*HDTV*). Of the many recording systems, two are considered standard: VTRs that use the 1080i or the 720p system. As discussed in chapter 2, the 1080i is an interlaced system that produces 60 fields, or 30 frames, per second. The 720p system produces 720 visible lines, which are scanned progressively to produce 30 frames per second. Like DTV, HDTV needs not only HDTV cameras or camcorders with high-quality HDTV lenses and HDTV recorders but also HDTV playback and display equipment.

Although many television operations are producing shows in HDTV, it is still much too expensive for most smaller production houses and individual video producers. This is one of the reasons for the development of HDV.

TAPELESS RECORDING AND STORAGE SYSTEMS

The basis for nonlinear postproduction editing is the development of large-capacity hard disks and read/write optical discs with fast access times. All tapeless digital video-recording systems operate on the same principle: they store digital data in computer files that can be identified and randomly retrieved. If that sounds familiar, it's because disk-based systems are, indeed, specialized computers. This is why you can use a desktop computer and appropriate software as the key elements for a disk-based editing system. This overview looks at (1) hard disk systems, (2) read/write optical discs, (3) flash memory devices, and (4) data transfer.

HARD DISK SYSTEMS

These video-recording systems include: (1) large-capacity hard disks, (2) portable hard drives, and (3) electronic still store (ESS) systems.

Large-capacity hard disks The simplest way to store and retrieve digital video and audio information for post-production editing is with *large-capacity hard disks*. Accelerated hard-drive speeds and highly efficient compression techniques enable you to store hours of video and audio information and call up any frame in a fraction of a second. Unlike videotape, which inevitably degrades after repeated use, the hard disk has no such problem—it remains like new even after a great many recordings and erasures.

In the ongoing move to an entirely tapeless operation, many television stations use *video servers*, which are very large-capacity disk systems that can record, store, and play many hours of television programming. These servers are controlled by computers that tell them what to play at a particular time. Servers are also used in newsrooms so that editors, writers, and producers have instant access to the news material stored on them. **SEE 12.15**

12.15 VIDEO SERVER

The video server consists of large-capacity computer disks that can store a great number of brief program segments, such as commercials and promotional announcements.

ENG. Portable hard drives These small hard drives, sometimes called fieldpacks, are designed to be docked with ENG/EFP cameras. The Ikegami Editcam camcorder, for example, has an 80-gigabyte fieldpack and is about the size of a dockable VTR, yet it can store up to six hours of DV video and audio. Such portable hard drives record high-quality digital video, time code, and two- or four-channel audio. They all have in/out FireWire connections, which greatly facilitates transferring the captured video and audio to the editing computer. There are portable drives that can be connected via FireWire to prosumer DV camcorders. Some portable hard drives allow you to do editing in the field with an externally connected laptop—a big advantage in ENG. Some camcorders have a tape-based as well as a disk-based recording system. You can use both simultaneously for recording, or use the tape as a backup in case the hard drive crashes.

Chapter 12

Electronic still store systems In effect a large slide collection that allows you to access any slide in about a tenth of a second, the *electronic still store (ESS) system* can grab any frame from various video sources (camera, videotape, or computer) and store it in digital form on a hard disk. It is not unusual to find ESS systems that hold several thousand images. Each still has its own filename (address) and can therefore be accessed randomly and almost instantaneously during production or in postproduction editing. Large-capacity graphics generators work similarly with titles and a limited amount of stills, such as the vital statistics of sports figures or people in the news. Some of the smaller ESS systems use regular Zip disks. Even a tiny 2-inch floppy can hold up to 200 frames. **SEE 12.16**

READ/WRITE OPTICAL DISCS

There is a variety of *read/write optical discs* that can record and play back a great amount of digital information. The optical discs most often used are CDs and DVDs, although true to the nature of digital recording, you may not be able to play back your video masterpiece from a DVD unless you used certain authoring software for the recording. **SEE 12.17**

Some camcorders use read/write optical discs rather than hard disks as their recording media. The great advantages of such optical discs are that they are easy to store and they permit extremely fast access time. The disadvantage is that, despite various compression techniques, the storage capacity is rather limited.

FLASH MEMORY DEVICES

Flash memory devices, which are basically solid-state digital storage devices, are sometimes used in DV recorders instead of hard disks. The advantages of flash drives are that they are small, lightweight, and extremely fast in capturing digital information. The downside is that their storage capacity is relatively limited, especially in the arena of video capture, which gives you only about four minutes of video per gigabyte. Flash memory devices that can record longer events can be quite costly, especially when compared with the cost-per-megabyte of a hard drive.

DATA TRANSFER

The transfer of digital data is important enough to recap here. When capturing digital video on analog videotape, you don't need to digitize the video and audio information for storage. Although this is a great timesaver, you still

12.16 SMALL DISK USED FOR ESS

This tiny floppy disk, a little larger than a postage stamp, stores up to 200 still pictures (video frames), which can be randomly accessed by the ESS system.

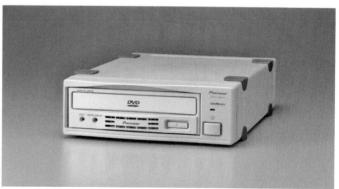

12.17 DVD RECORDER

This relatively small DVD unit records and plays a great amount of video and audio information. It operates with a laser beam, similar to the CD system.

need to transfer the data recorded by the digital camcorder to a temporary digital storage device, such as the editing computer's hard disk, for postproduction editing.

FireWire (Apple) or i-link (Sony) cables let you transfer digital data directly from storage (like the camcorder VTR) to a desktop computer. The more formal name for this transfer standard is *IEEE 1394*. Because this cable transfers about 400 megabytes per second, it is commonly referred to as FireWire 400. The faster FireWire 800 transfers information in half the time, but not all computers have FireWire 800 ports. Assuming that the connectors fit both the camcorder and the computer ports, these *IEEE 1394* cables let you transfer all your camcorder footage much faster than digitizing analog tape footage before storing it on the hard disk of the editing computer.

Similar to streaming audio, *streaming video* is an Internet delivery system that sends compressed data as a continuous stream. It updates the video continuously as you are watching it. The usual compression standard for streaming video is *MPEG-4*. The more efficient the compression systems are, the more video you will be able to store on the receiving end on conventional storage media.

MAIN POINTS

- Recording systems can be analog or digital, linear or nonlinear, composite or component.
- All analog recording systems use videotape as the recording medium. Analog recordings can be high-quality, but they deteriorate quickly from generation to generation.
 Digital recordings are virtually immune to deterioration in subsequent dubs.
- All tape-based systems are linear, regardless of whether the recorded signals are analog or digital.
- Video recorders treat their signals in one of four basic ways: composite, Y/C component, Y/color difference component, and RGB component.
- Tapeless, disk-based systems are nonlinear and allow random access.
- Video recorders are also classified by how they transport and record the video signal. Recorders that operate with the NTSC composite system combine the luminance (blackand-white, or Y) information and the chrominance (C, or red, green, and blue) information in a single signal. Y/C component recorders transport the Y and C signals separately but combine them on the videotape. The Y/color difference component system consists of Y, R-Y, and B-Y

- signals, which are kept separate throughout the recording process. In the RGB component system, the red, green, and blue signals are kept separate throughout the transport as well as on the videotape. None of these systems is compatible with the others, and all need their own recording and playback equipment.
- Component systems deliver better-quality video than do composite systems, especially after multiple generations.
- When sampling an analog color signal, the Y (luminance, or black-and-white) signal is sampled more often than the color signal because the luminance signal provides more resolution.
- A 4:2:2 sampling ratio results in a high-quality signal. It samples the luminance signal twice as often as the color signals. A 4:1:1 ratio reduces the color information somewhat. The Y signal is sampled four times as often as the C signals.
- Intraframe compression means that every frame is examined for, and purged of, redundant data. It eliminates spatial redundancy.
- Interframe compression compares each frame to the previous one and keeps only information that is new. It eliminates temporal (sequential) redundancy.
- All tape-based systems use the helical scan, or slant-track, recording method. One or more heads rotate with, or through, the head drum to put the video tracks on the tape that moves past the rotating heads.
- The time base corrector (TBC) and the framestore synchronizer are electronic devices that help stabilize the playback of video recorders and synchronize the scanning sync from remote sources so that you can switch among them without temporary picture breakup.
- Analog VTRs include, in descending order of quality, Betacam SP, S-VHS, and VHS.
- Digital VTRs have various recording systems: DV, DVCAM, DVCPRO, Betacam SX, HDV, and HDTV.
- Tapeless recording systems use large-capacity hard disks and read/write optical discs. Flash memory devices are used for low-capacity storage.
- Hard disk systems include large-capacity hard disks, portable hard drives, and the electronic still store (ESS) system.
 Large-capacity disk systems are used as video servers for programming automation and multiple users.
- Read/write optical discs include a variety of CD and DVD formats.
- Data transfer methods include IEEE 1394 cables such as the FireWire and the i-link as well as streaming video via the Internet.

12.2

How Video Recording Is Done

Now that you know all about the various video-recording systems, you need to know what to do with them. This section introduces you to the major operational uses of video recording and the video-recording procedures in studio production and ENG/EFP.

USES OF VIDEO RECORDING AND STORAGE

Building a show, time delay, program duplication and distribution, and record protection and reference

VIDEO-RECORDING PRODUCTION FACTORS

Preproduction (schedule, equipment, and preparation for postproduction editing) and production (video leader, recording checks, time code, recordkeeping, and specific aspects of disk-based video recording)

USES OF VIDEO RECORDING AND STORAGE

Video recording is primarily used for (1) building a show, (2) time delay, (3) program duplication and distribution, and (4) the creation of a protection copy of a video recording for reference and study.

BUILDING A SHOW

One of the major uses of videotape is to build a television show from previously recorded tape segments. This building process is done through *postproduction editing*. The building process may include assembling multiple segments shot at different times and locations, or it may

simply involve condensing a news story by cutting out the nonessential parts. It also includes stringing together longer multicamera scenes that were switched (instantaneously edited) and recorded on videotape. A good example of this technique is the recording of relatively long and uninterrupted studio segments of soap operas and then editing them together in a postproduction session.

TIME DELAY

Through video recording an event can be stored and played back immediately or hours, days, or even years after its occurrence. In sports many key plays are recorded and shown right after they occur. Because the playback of the recording happens so quickly after the actual event, they are called *instant replays*. Network shows that you can watch at the same schedule time in each time zone are time delayed through videotape. For example, through video recording you can delay the airtime so that the same awards show broadcast at 6 p.m. in New York is seen at 6 p.m. in San Francisco.

PROGRAM DUPLICATION AND DISTRIBUTION

Video recordings can be easily duplicated and distributed to a variety of television outlets by mail, courier, cable, telephone line, coax or fiber-optic cable, satellite, or Internet streaming. With satellite or Internet streaming, a single video recording can be distributed simultaneously to multiple destinations around the world with minimal effort.

RECORD PROTECTION AND REFERENCE

To protect the recordings of important events, make protection copies right after the actual taping. Make these dubs with equipment that has the same or better recording quality as that which you used to shoot the original footage. DVDs are an excellent archival recording device. They take up very little space, and the playback equipment is small and readily available.

The problem with digital recordkeeping is the rapidly changing technology that makes one recording device obsolete in just a few years. You have probably run into this problem with floppy disks or with the ever-changing systems software. Unless you transferred your digital records periodically to the latest system, your archives are worthless.

VIDEO-RECORDING PRODUCTION FACTORS

There are certain operational steps in video recording that are necessary for effective preproduction, production,

and postproduction activities. Because postproduction is explored extensively in chapter 13, this discussion focuses on the major preproduction and production factors of video recording.

PREPRODUCTION

Production efficiency is determined to a large extent by how well prepared you are. This production preparation is called *preproduction*. Its steps include: (1) preparing the schedule, (2) making an equipment checklist, and (3) edit preparation.

Unless you are working in news, where the equipment and the people are scheduled to respond immediately to unexpected situations, you need to follow some procedures that will guarantee you the availability of the equipment and the time you need to get your video-recording project done. But even the most careful scheduling will not help if the camcorder battery is dead or you forget to bring the right connecting cable for the external mics during a field production.

Schedule Is the videotaping equipment actually available for the studio production or remote shoot? Most likely, your operation will have more than one type of video recorder available. Which VTR do you need? Be reasonable in your request. You will find that recording equipment is usually available for the actual studio or field production but not always for your playback demands.

If you need a VTR simply for reviewing the scenes shot on location or for timing purposes, have the material dubbed down to a regular ½-inch VHS format and watch it on your home VCR. That way you free the high-quality machines for more important tasks and you are not tied to a precise schedule when reviewing your tapes.

Unless you use the camcorder as the source VTR when doing any dubbing, you must schedule not only the record VTR (the machine doing the dub) but also the VTR that plays the source tapes. Always try to use a regular standalone VTR and not the VTR of your camcorder when viewing the source footage. The studio VTRs are obviously much more rugged than the smaller camcorder VTRs. Couldn't you import the footage from the camcorder to the hard drive of your computer without making a preview dub? Yes, this is a good idea but only if you have relatively brief footage or unlimited storage on your hard drive—even a brief scene takes up a generous amount of gigabytes.

In all of your time and equipment requests, be sensitive to the other production people who need to work with the same machines you do.

- through a checklist Like a pilot who goes through a checklist before every flight, you should have your own equipment checklist every time you do a production. Such a list is especially important in field productions. This brief checklist is limited to video recording and uses the generic term *VTR* throughout, referring to tape-based as well as disk-based systems.
- *VTR status.* Does the VTR actually work? If at all possible, do a brief test recording to ensure that it functions properly.
- Power supply. If you use a VTR in the field, or if you use a camcorder, do you have enough batteries for the entire shoot? Are they fully charged? When using household current for the power supply, you need the appropriate transformer/adapter. Before leaving for the field location, check that the connecting cable from the power supply fits the jack on the VTR or camcorder. Do not try to make a connector fit if it is not designed for that jack. You may blow more than a fuse if you do.
- Correct tape. Do you have the correct tape, that is, the cassette format that fits the camcorder or VTR? Although the difference between a 1/2-inch mini-cassette and a 1/4-inch DVCPRO cassette is obvious, you may not see quite as readily the difference between a DVCAM and a DVCPRO full-sized cassette. Videotapes can look similar or even identical when you're in a hurry. Also check that the various boxes contain the correct tapes. For example, the Sony DVCAM VTRs and the Panasonic DVCPRO systems use different-sized cassettes that may not fit the camcorder you are using. Because even same-sized cassettes can be loaded with various lengths of tape, check the supply reel to see if it contains the amount of tape indicated on the label. If, for example, the box says that it contains a 184-minute tape but your check shows only a relatively small amount of tape on the supply reel, the box is obviously mislabeled.
- Enough tapes. Do you have enough tapes for the proposed production? This is especially important when you record a multicamera live event in its entirety for a live-on-tape production or for playback at a later time. If the largest cassette does not hold enough tape for the entire event, you need to schedule two machines or you will lose a few minutes during the tape change. Especially when doing multiple recordings for instant replay, you need three or four times the normal tape supply. Tapes do not take up much room and, compared with other production costs, are relatively inexpensive. Always take along more than you think you'll need.

12.18 VHS CASSETTE TAB REMOVED

To protect VHS and S-VHS cassettes from erasure. you need to break off the record-protect tab. To reuse the cassette for recording, put a small piece of masking tape over the hole.

Record protection. If a VTR refuses to record despite a careful check of the connecting cables, remove the cassette and see whether its recording is enabled. All cassettes have a device, sometimes called the record inhibitor, to protect the videotape from accidental erasure. VHS and S-VHS ½-inch cassettes have a small record-protect tab on the back edge at the lower left. When this tab is broken off, the cassette is record-protected. **SEE 12.18** Is the cassette now permanently disabled for future recordings? Not at all: to restore its recording capability, simply put a small piece of masking tape or even gaffer's tape over the tab opening.

Similar to computer floppy disks, most digital videocassettes have a tab that you can move into or out of a record-protect position. **SEE 12.19** Some, such as Zip disks, can be protected through software by clicking the appropriate command. Routinely check the record-protect tab before using a cassette for recording. Although you cannot record on a record-protected tape, any cassette will play back with or without a record-protect device in place.

Edit preparation Before starting your postproduction activities, you may need to prepare the videotapes ahead of time for certain types of editing. If, for example, you want to do analog insert editing and the record (edit) VTR uses a control track for recording the synchronization information (sync pulse), you need to record a continuous control track on the edit master tape (the tape onto which you copy the selected portions of the source tapes) before you can do any insert editing.

The easiest way to lay down the control track is to "record black," that is, a black video signal. This "blacking"

12.19 DIGITAL VIDEOCASSETTE IN RECORD-PROTECT POSITION

Record-protect tab

Digital videocassettes have a movable tab that prevents accidental erasure. To record on the cassette, the tab must be in the closed position.

of an edit master tape takes as much time as you would need to record regular scenes instead of black: laying a 60-minute control track takes 60 minutes. Note, however, that you need to blacken a tape only if you intend to use it as an edit master and then only if you intend to do insert editing. If you edit in the assemble mode, or if the VTR does not need a control track, such previous blacking of the edit master tape is unnecessary. (See chapter 13 for an in-depth discussion of postproduction editing.)

Unless you use digital camcorders whose VTRs allow limited editing in the field, all digital videotapes—regardless of whether they store analog or digital information—must be transferred to the hard disk of the nonlinear

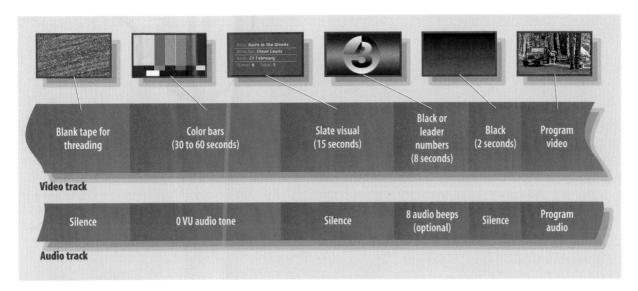

12.20 VIDEO LEADER

The video leader helps adjust the playback and record machines to standard audio and video levels.

editing system. This process, called *capturing*, is always time-consuming, as is the identification of the captured files. You may find that if you are in a hurry and your transitions are only cuts, a linear editor (see figure 13.4) may be the better choice. The upside of nonlinear editing is not necessarily that you will save time but that you can randomly access each frame or sequence, that you have any number of transitions and effects at your fingertips, and that you can view and save multiple versions of a scene before committing yourself to the final edit.

When using tape for editing or on-the-air playback, preview a minute or so of each tape to verify that the label on the box matches the one on the tape and that the tape label matches its content. Though you may consider such procedures redundant and a waste of time, they are not. A habit of triple-checking will not only prevent costly production errors but also save time, energy, and, ultimately, nerves.

PRODUCTION

If you have followed the basic preproduction steps, you should have little trouble during the actual recording, although the following elements still need attention: (1) the video leader, (2) recording checks, (3) time code, (4) recordkeeping, and (5) specific aspects of disk-based video recording.

Video leader When playing back a properly executed video recording, you will notice some front matter at the head of the recording: color bars, a steady tone, an iden-

tification slate, and perhaps some numbers flashing by with accompanying audio beeps. These items, collectively called the *video leader*, help adjust the playback and record machines to standard audio and video levels. **SEE 12.20** Let us look at them one by one. **ZVL2** EDITING > Postproduction guidelines > leader

Color bars help the videotape operator match the colors of the playback machine with those of the record machine. It is therefore important that you record the color bars (fed by color-bar generators located in master control or built into ENG/EFP cameras) for a minimum of thirty seconds each time you use a new videotape or begin a new taping session. Some VOs (video operators) prefer to have the color bars run for a full minute or more so that they do not have to rerun the bars if the equipment requires further adjustment.

Most audio consoles and even some field mixers can generate a *test tone* that you need in calibrating the line-out level of the audio console or mixer with the input (record) level of the VTR (see chapter 10). You should record this 0 VU test tone along with the color bars. Obviously, these test signals should be recorded with the equipment that you use for the subsequent videotaping. Otherwise, the playback will be referenced to the recorded color bars and test tone but not to the videotaped material. The director refers to these test signals as "bars and tone." When doing a studio show, you will hear the director call for bars and tone right after the videotape roll. In EFP the camera or VTR operator will, hopefully, take care of this reference recording.

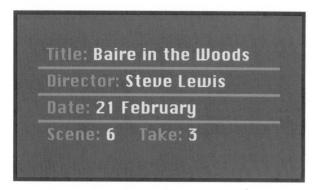

12.21 CHARACTER-GENERATED SLATE

The slate gives pertinent information about the production. It is recorded at the beginning of each take.

The *slate* gives pertinent production information along with some technical details. Normally, the slate indicates the following identification data:

- Show title
- Scene number (corresponding to that in the script)
- Take number (how often you record the same thing)
- Recording date

Some slates also list the director, the location (especially for EFP), and additional in-house information, such as reel numbers, editing instructions, name of producer, and so on. The essential information is the name of the show and the scene and take numbers.

In the studio the slate is usually generated by the C.G. (character generator) and recorded right after the color bars. **SEE 12.21** In the absence of a C.G., you can use a small whiteboard with a 4×3 aspect ratio (4 units wide by 3 units high). Because the information on the slate changes from take to take, the slate surface should be easily cleaned (chalk or dry-erase markers work well). The slate identifies the scene as well as the take, so you must use it every time you record a new take, regardless of how short or how complete the take may be. **ZVL3** EDITING \rightarrow Production guidelines \rightarrow slate

Assume that you are the director of the weekly *President's Chat* production. You have just recorded about ten seconds of the first take when the college president stumbles over the name of the new dean. You stop the tape, keep calm, roll the tape again, and wait for the "in-record" confirmation from the VTR operator. Before repeating the president's introduction, you need to record the slate

again. It reads: scene 1, take 1. But shouldn't the slate read: scene 1, take 2? Yes—the C.G. operator obviously forgot to change the slate. Should you go on, or stop the tape again to correct the slate? In this case you might as well keep going. The VTR operator, who keeps the field log, can note the false 10-second start and record the second take as take 1. If, however, you are breaking up the president's "chat" into several short takes to be assembled in postproduction, the slate numbers must be accurate.

Leader numbers are used for the accurate cueing of the videotape during playback. The leader numbers flash at 1-second intervals from 10 to 3 or from 5 to 3 and are usually synchronized with short audio beeps. The last two seconds are normally kept in black and silent so that they do not accidentally appear on the air if the videotape is punched up early (sometimes the numbers go down to the last second). The first frame of recorded program material should appear at the zero countdown. When cueing a videotape for playback, you can stop the tape at a particular leader number, say, 4; or you can advance the tape right to the first video frame. When you stop the tape at the last leader number, 4, you must preroll the tape exactly 4 seconds before the program material is to appear on the air. If, after starting the tape on leader number 4, there is a longer interval between the leader number 4 and the first video frame, the TD (technical director) will not know exactly when to punch up the videotape and almost certainly will miss the first second of the playback. If you start the tape on leader number 4, the first video frame should come up after exactly 4 seconds.

Recording checks As the VTR operator, you are responsible for seeing that the pictures and the sound are actually recorded on the videotape. Here are some checkpoints that greatly reduce recording problems:

- Always do a brief test recording, then play back the tape to ensure that the whole system works properly. Just because you see a picture on the VTR monitor and see the VU meter fluctuate during the test recording, it does not mean that the video and audio signals are actually recorded on tape. But once the test recording plays back all right, you can trust that the subsequent video and audio feeds will be recorded.
- Reset the tape counter on the VTR before starting the actual program recording. If you need to record time code at the actual videotaping, make sure it is recorded with the picture.

- Wait until the VTR has reached operating speed and has stabilized before starting to record. This *lockup time* may take anywhere from one-half to four seconds. The VTR has a control light that flashes during the lockup period and remains steady once the system is locked, that is, sufficiently stabilized for recording. As the VTR operator, you should watch the flashing light and, when you see a steady light, call out, "speed" or "in record." The director will then proceed with the actual recording.
- Watch the audio and video levels during the recording. If you do not have a separate audio setup but instead feed the mic directly to the VTR, pay particular attention to the audio portion. You may find that a director becomes so captivated by the beautiful camera shots that he or she does not even hear, for example, the talent giving an African country the wrong name, an airplane noise interrupting the medieval scene shot on location, or the wireless mic cutting out briefly during an especially moving moment of a song.
- When recording for postproduction, record enough of each segment so that the action overlaps the preceding and following scenes. At the end of each take, record a few seconds of black before stopping the tape. This *run-out* signal acts as a pad and greatly facilitates editing.

Ask the director whether you should videotape the camera rehearsals. Sometimes you get a better performance during rehearsal than during the actual take. The camera rehearsals (when run like full dress rehearsal) can then be edited into the rest of the production.

- Again, be sure to slate every take you have on tape, rehearsal or not. When you are in a hurry, *audio-slate* each take by having the audio operator use the console mic. When in the field, have the floor manager read the brief slate information into the talent's lavaliere or fishpole shotgun mic: "President's Chat, take 12." Some directors like an additional brief verbal countdown, such as "five, four, three" with the last two seconds silent before the cue to the talent. Many field productions are slated more extensively only at the beginning of the video recording, with subsequent takes being only verbally slated.
- Do not waste time between takes. If you are properly prepared, you can keep the intervals to a minimum. Although the playback of each take may occasionally improve the subsequent performance by cast and crew, it often does not justify the time it takes away from the actual production. If you pay close attention during the videotaping, you do not need to review each take.

Long interruptions not only waste time but also lower the energy level of the production team and talent. On the other hand, do not rush through taping sessions at a frenetic pace. If you feel that another take is warranted, do it right then and there. It is far less expensive and timeconsuming to repeat a take immediately than to re-create a whole scene later simply because one of your takes turned out to be unusable.

Time code The *time*, or *address*, *code* is an electronic mark that provides each frame with a unique address (frame number). If you need to record time code simultaneously with each take, verify that the time code is recorded on its designated address track or, if necessary, on a free audio track. Unless the camera or VTR has a built-in time code generator, you need a separate time code generator for the address system. Time code can also be laid down later in postproduction (as explained in chapter 13). **ZVL4** EDIT-ING→ Postproduction guidelines→ time code

Recordkeeping Keeping accurate records of what you videotape and the proper labeling of videotapes may seem insignificant while in the middle of a production, but they are critical when you want to locate a particular scene or a specific tape among the various tape boxes. You will be surprised at how quickly you can forget the "unforgettable" scene and especially the number and the sequence of takes.

Keeping accurate records during the taping saves much time in postproduction editing. Although you will most likely log the various takes and scenes when reviewing the videotape after the production, you are still greatly aided by a rough record kept *during* the production, called a *field log*. As a VTR operator, you should keep a field log even when recording in the studio. A field log is especially useful in more-complex field productions (hence its name) that involve a number of locations. Mark the good takes (usually with a circle) and identify especially those takes that seem unusable at that time. Label each videotape and box, and mark the field log with the corresponding information. **SEE 12.22**

Specific aspects of disk-based video recording The preproduction and production elements discussed here apply equally whether you record with an analog or a digital VTR or some tapeless recording device. There are, of course, some different production requirements when you use the disk-based system for editing, which is the subject of chapter 13.

PRODUCTION TITLE: "impre			essions" PRODUCER		DIRECTOR: Haurid Khani	
TAPING DAT	E: 4/	15		LOCATION:	BECA (leusroom
CASSETTE NUMBER	SCENE	TAKE	OK or NO GOOD	IN	CODE	EVENT / REMARKS
C-005	2	1	NG	01:57:25	02:07:24	Student looks into Camera CU - Zaxis
		(2)	OK	02:09:04	02:14:27	Monitor + L new ander MS getting ready
		3	OK	02:14:28	02:34:22	Pan R to reveal anchor in news set
		4	NG	02:34:.22	02:45:18	Rack Locus from Floor Mgr To Lauchor-OUTOFFOCE
		5	NG	02:48:05	02:55:12	Rack locus Both out of focus
		6	NG	02:58:13	03:05:11	LOST Audio
		(7)	OK	03:12:02	03:46:24	Hurrah ! Rackok
	3		OK	04:16:03	04:28:11	op from behind
		2	NG	04:35:13	04:49:05	CUMR andror Lost audio
		(3)	OK	05:50:00	06:01:24	CU of Randor
		4	NG	06:03:10	06:30:17	andio problem
		5	NG	06:40:07	07:04:08	LS of both andros floor Maga Halks throughshor
		(b)	OK	07:07:15	07:28:05	Good! Floor Mgr silhouthe against Set
		(7)	OK	07:30:29	07:45:12	slow pullout
C-006	4		04	49:48:28	51:12:08	MCU Marky talks to audiors
		2	NG	51:35:17	51:42:01	Lav comes off Randor

12.22 FIELD LOG

The field log is kept by the VTR operator during the taping. It normally indicates the tape or reel number, scene and take numbers, approximately where the take is located on the tape, and other information useful in postproduction editing.

MAIN POINTS

- Video recording is primarily used for building a whole show by assembling parts that have been recorded at different times and/or locations; time delay; duplication and distribution of programs; and records for protection, reference, and study.
- The production purpose should determine the type of video recorder used. Simple material destined for home consumption does not need top-of-the-line videotape recorders (VTRs). High-quality VTRs are necessary for productions that require a great amount of color fidelity and resolution and for material requiring extensive postproduction.
- The important preproduction steps for video recording include scheduling, equipment checklists, and specific edit preparations. Take along enough tape and be sure that it fits the specific camcorder or VTR. Check that none of the cassettes used for recording is record-protected.
- The major production factors in video recording are the video leader (color bars, test tone, slate information, and leader numbers and beeps), recording checks, time code, accurate recordkeeping, and specific aspects of disk-based operations. Slate all takes, either visually and/or verbally.
- The field log is kept during the actual studio or field production. It lists all tape numbers, scenes, takes, and comments about shots and audio.

ZETTL'S VIDEOLAB

For your reference, or to track your work, each *Video-Lab* program cue in this chapter is listed here with its corresponding page number.

ZVL1 EDITING→ Postproduction guidelines→ tape basics **266**

ZVL2 EDITING→ Postproduction guidelines→ leader 279

ZVL3 EDITING→ Production guidelines→ slate 280

ZVL4 EDITING→ Postproduction guidelines→ time code **281**

13

Postproduction Editing

Almost all programs you see on television have been edited in some way, either during or after the actual production. When editing is done after (*post* in Latin), it is known as *postproduction editing*. Its processes differ considerably from *switching*, the instantaneous editing done during production.

Today most postproduction editing is done with disk-based nonlinear systems rather than tape-based linear equipment. This development has a profound influence on how we edit. *Nonlinear editing* resembles more the cut-and-paste approach of word processing; in *linear editing* you select portions from one tape and copy them onto another. Despite the dramatic evolution of editing equipment and techniques, however, you, as the editor, remain unquestionably in charge of aesthetic decisions. **ZVL1** EDITING

Editing introduction

Section 13.1, How Postproduction Editing Works, examines the basic editing functions and the major editing systems. Section 13.2, Making Editing Decisions, helps you sharpen your aesthetic judgment about why and how to assemble shots. Despite the predominance of nonlinear editing, tape-based linear editing is discussed first because knowing how linear editing works will help you understand nonlinear editing and how to apply it with maximum efficiency.

KEY TERMS

- AB-roll editing Creating an edit master tape from two source VTRs, one containing the A-roll, the other the B-roll. The editing is initiated by the edit controller rather than through switching.
- **AB rolling** The simultaneous and synchronized feed from two source VTRs (one supplying the A-roll, the other the B-roll) to the switcher for instantaneous editing as though they were live sources.
- **assemble editing** Adding shots in linear editing on videotape in consecutive order without first recording a control track on the edit master tape.
- **capture** Transferring video and audio information to a computer hard drive for nonlinear editing.
- complexity editing The juxtaposition of shots that primarily, though not exclusively, helps intensify the screen event. Editing conventions as advocated in continuity editing are often purposely violated.
- **continuity editing** The preservation of visual continuity from shot to shot.
- control track system An editing system that counts the control track pulses and translates this count into elapsed time and frame numbers. It is not frame-accurate. Also called *pulse-count system*.
- **cutaway** A shot of an object or event that is peripherally connected with the overall event and that is often neutral as to its screen direction (such as a straight-on shot). Used to intercut between shots to facilitate continuity.
- edit controller Machine that assists in various editing functions, such as marking edit-in and edit-out points, rolling source and record VTRs, and activating effects equipment. Often a desktop computer with specialized software. Also called editing control unit.
- edit decision list (EDL) Consists of edit-in and edit-out points, expressed in time code numbers, and the nature of transitions between shots.
- **edit master tape** The videotape on which the selected portions of the source tapes are edited. Used with the record VTR.
- **insert editing** Requires the prior laying of a control track on the edit master tape. The shots are edited in sequence or inserted into an already existing recording. Necessary mode for editing audio and video tracks separately.
- **linear editing** Analog or digital editing that uses tape-based systems. Selection of shots is nonrandom.

- **mental map** Tells viewers where things are or are supposed to be in on- and off-screen space.
- nonlinear editing (NLE) Allows instant random access to shots and sequences and easy rearrangement. The video and audio information is stored in digital form on computer hard disks or read/write optical discs. Uses disk-based computer systems.
- **off-line editing** In linear editing it produces an edit decision list or a videotape not intended for broadcast. In nonlinear editing the selected shots are captured in low resolution to save computer storage space.
- on-line editing In linear editing it produces the final highquality edit master tape for broadcast or program duplication. In nonlinear editing it requires recapturing the selected shots at a higher resolution.
- **record VTR** The videotape recorder that edits the program segments as supplied by the source VTR(s) into the final edit master tape. Also called *edit VTR*.
- slate (1) Visual and/or verbal identification of each videotaped segment. (2) A small blackboard or whiteboard upon which essential production information is written. It is recorded at the beginning of each take.
- **source tape** The videotape with the original footage.
- source VTR The videotape recorder that supplies the program segments to be assembled by the record VTR. Also called play VTR.
- **time code** Gives each television frame a specific address (number that shows hours, minutes, seconds, and frames of elapsed tape). It is frame-accurate.
- vector Refers to a force with a direction. Graphic vectors suggest a direction through lines or a series of objects that form a line. Index vectors point unquestionably in a specific direction, such as an arrow. Motion vectors are created by an object or a screen image in motion.
- VTR log A list of all takes on the source videotapes compiled during the screening (logging) of the source material. It lists all takes—both good (acceptable) and no good (unacceptable)—in consecutive order by time code address. Often done with computerized logging programs. A vector column facilitates shot selection.
- **window dub** A "bumped-down" copy of all source tapes that has the time code keyed over each frame.

ECTION

13.1

How Postproduction Editing Works

Although editing equipment changes almost from day to day, the basic editing functions remain the same—to combine, shorten, correct, and build. How you do this depends a great deal on just what the editing job involves, how much postproduction time you have, and what equipment is available. If, for example, you need to edit an MTV segment that consists of many complex effects that have to match the music track exactly, you cannot use a simple, tape-based cuts-only editor no matter how hard you try. On the other hand, a simple cuts-only tape editing system is perfectly adequate if all you have to do is select one or two sound bites from a brief speech.

Section 13.1 explains the major editing procedures and systems and what they do best. Although editing, like bicycling, is difficult to learn from a book, this section will at least make you comfortable when you are finally called upon to do it.

- ► EDITING MODES: OFF- AND ON-LINE

 Linear and nonlinear on- and off-line editing—defined by quality and editing intent
- BASIC EDITING SYSTEMS
 Basic linear and nonlinear systems and their corresponding operational principles
- LINEAR EDITING SYSTEMS

 Single-source, expanded single-source, and multiple-source systems

- ► CONTROL TRACK AND TIME CODE EDITING

 Using the control track (pulse count) and time code systems
- LINEAR EDITING FEATURES AND TECHNIQUES

 Assemble and insert editing
- ► AB ROLLING AND AB-ROLL EDITING

 Creating an edit master tape from two source VTRs
- NONLINEAR EDITING SYSTEMS

 Basic desktop systems
- NONLINEAR EDITING FEATURES AND TECHNIQUES

 Capture, compression, and storage of information, and shot juxtaposition and rearrangement
- ► PRE-EDITING PHASES

 The shooting, review, and preparation phases
- ► EDITING PROCEDURES

 Shot selection, shot sequencing, audio sweetening, creating the final edit master tape, and operational hints

EDITING MODES: OFF- AND ON-LINE

Unless you edit news footage for an upcoming newscast or a short, basically cuts-only piece, you will probably engage in off-line and on-line editing procedures. *Off-line editing* results in a *rough-cut*. It will produce a low-quality picture series that serves as a guide for the final edit. *On-line editing* produces the final edit master tape or disc. Although similar in intent, the procedures for these two modes of editing are different for linear and nonlinear editing.

LINEAR OFF- AND ON-LINE EDITING

Linear off-line editing is done to give you a rough idea of how the intended shot sequence looks and feels. It is a sketch, not the final painting. Even skilled editors like to do an off-line edit to check the rhythm of the shot sequence, decide on various transitions and effects, and get some idea of the audio requirements. Linear off-line editing is usually done with low-end equipment. You could even use two VHS recorders for an off-line rough-cut; one feeds the source tapes, the other records the selected shots in the desired sequence (see figure 13.2). Never mind the sloppy transitions or audio—all you want to see is whether the sequences make sense, that is, tell the intended story. If you do a preliminary edit for a client, of course, the off-line edit should look as good as you can possibly make it, so VHS machines will no longer suffice. The most valuable by-product of off-line editing is a final edit decision list (EDL) that you can then use for on-line editing.

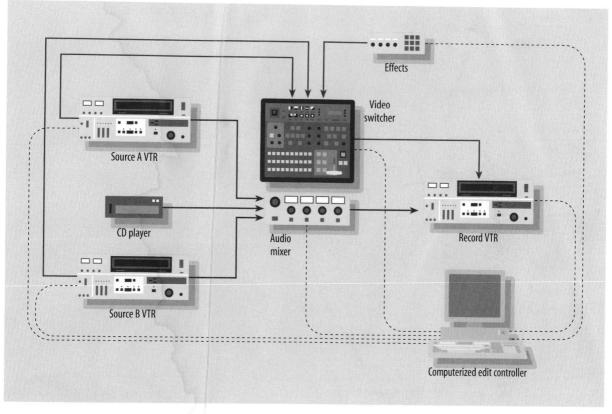

13.6 MULTIPLE-SOURCE EDITING SYSTEM

The multiple-source linear editing system has two or more source VTRs (A and B) and interfaces special effects, audio, and switcher equipment or functions.

a great variety of transitions (such as cuts, dissolves, and wipes) and allows the mixing of audio tracks from two or more source tapes. Another advantage is that you can arrange all even-numbered shots on the *A-roll* (the tape used for the source A VTR) and all odd-numbered shots on the *B-roll* (the videotape for the source B VTR). By switching from the A-roll to the B-roll during editing, you can quickly assemble the "pre-edited" shots, as explained later in this section.

CONTROL TRACK AND TIME CODE EDITING

All linear editing systems are guided by the control track or a specific address code. The *control track system* counts the control track pulses and translates this count into elapsed time and frame numbers, which you use to find specific shots on the source tapes and determine the editin and edit-out points on the record VTR. Also known as the *pulse-count system*, this method is not frame-accurate,

which means that the actual edit points may be a few frames off from the ones you chose.

The more sophisticated and more accurate linear systems use time code to accomplish these tasks. *Time code* gives each television frame a unique address—a number that shows hours, minutes, seconds, and frames. The time code system is frame-accurate.

CONTROL TRACK, OR PULSE-COUNT, EDITING

As you now know, the control track on a videotape marks each frame of recorded material. It therefore takes thirty control track "spikes" to mark each second of tape play. **SEE 13.7** Any one of the individual spikes, or *sync pulses*, of the control track can become an actual edit-in or edit-out point (frame). By counting the number of control track pulses, you can, for example, locate specific edit-in and edit-out points with greater accuracy than by simply looking at the video pictures. *Control track editing* is also called

13.7 CONTROL TRACK PULSES

The control track, or pulsecount, system counts the control track pulses to mark a specific spot on the videotape. Every thirty pulses mark one second of elapsed tape time.

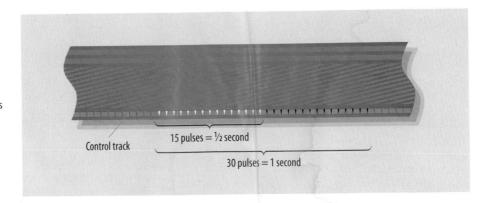

13.8 PULSE-COUNT OR TIME CODE DISPLAY

This display shows elapsed hours, minutes, seconds, and frames. The frames roll over (into seconds) after 29, the seconds to minutes, and the minutes to hours after 59; the hours are reset to 0 after 24.

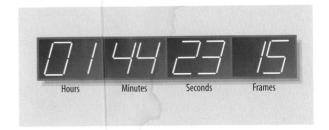

pulse-count editing because the edit controller counts the number of control track pulses. ZVL3 EDITING→ Postproduction quidelines→ tape basics

The edit controller counts the pulses of both the source and the edit master tapes from the beginning and displays the count as elapsed time—hours, minutes, seconds, and number of frames. Because there are 30 frames per second, the seconds are advanced by one digit after 29 frames (with the thirtieth frame making up the next second). The seconds and minutes roll over to the next after 59.¹ SEE 13.8

Finding the right address Although the pulse-count system can identify a specific frame with a pulse-count number, it is not frame-accurate. This drawback means that you may get different frames when advancing repeatedly to the same pulse-count number.

Imagine that you need to find a specific address in a long row of identical houses—but there are no house numbers on any of them. If you are told to find the tenth house on the left, you should have no trouble. You simply start at the beginning of the row and count the houses until you reach the tenth house. The task gets more dif-

 In countries that use a 25-frame-per-second system, the rollover occurs, of course, after the twenty-fourth frame instead of the twentyninth as in the 30-frame NTSC system. ficult when you have to find house number 110. And what if you have to find house number 1,010? You are sure to miscount somewhere along the line and arrive at the wrong address. What if you were to start counting somewhere in the middle of the block instead of at the beginning? Counting to ten would definitely take you to a different house than the one originally intended.

The pulse-count system has similar difficulties. The control track pulses do not have specific addresses but are simply counted by the edit controller and, as you have seen, translated into temporary time and frame addresses. Assuming that you have reset the pulse counter to 0 and have rolled the tape from its very beginning, the first second on the counter should show the number 01 in the seconds column of the tape counter and 00 in the frames column (the frame numbers roll over to the first second after frame 29). Let's assume that this first-second frame shows a glass of milk almost touching a child's lips. If you rewind the tape to 0 and run it again to the first-second mark, you will most likely get the same frame—but it might instead show the glass already touching the lips. The tape has moved one frame too far. Just as with counting houses, the edit controller has a tendency to get even more off-track when counting thousands of pulses repeatedly, particularly at high speed.

Realize that when you advance the tape by only 2 minutes, the edit controller must count 3,600 pulses. So if you

were to back up the tape to the beginning and run it again for 2 minutes, you would probably end up with a different frame, even if you started the tape at 0 as displayed by the edit controller and stopped it when it indicated exactly 2 minutes. Why? Because during high-speed shuttles or repeated threading and unthreading, the tape may stretch or slip, or the unit may simply skip some pulses when counting thousands of them. Fortunately, many editing jobs do not have to be frame-accurate; unless you have to match the lip movement to the words uttered, being a few frames off does not present a serious handicap.

Finding the right starting point Another potential problem of the control track system is that it begins counting from whatever starting point you assign. If, for example, you forget to reset the counter to 0 at the beginning of the tape, or if you have not rewound the tape completely when resetting the counter to 0, the count will be off. Because the addresses given to frames by the pulsecount system are temporary and, in effect, arbitrary, the pulse-count system is not an address code.

When editing with the pulse-count system, always reset the counter to 0 at the beginning of the tape and not somewhere in the middle of it.

TIME CODE EDITING

When more-precise editing is required, such as when editing video to the beat of music or when synchronizing dialogue or specific sound effects to the video track, you need to edit with a system that uses precise frame addresses. *Time code* is an electronic signal that provides a specific and unique address for each electronic frame. The address is usually recorded on a dedicated address code track of the videotape, on an available audio track, or integrated into, or recorded alongside, the video signal. From there it can be visually displayed, as in the pulse-count system (see figure 13.8). With time code each of the houses in our example now has its own house number affixed, so you no longer have to count the houses to find a specific one; you can simply look for its address and drive to house number 1,010 directly.

Because each frame has its own address, you can locate a specific frame relatively quickly and reliably, even if it is buried in hours of recorded program material or despite occasional tape slippage during repeated high-speed shuttles. Once the edit controller is told which frame to use as an edit point, it will find it again no matter how many times you shuttle the tape back and forth and will not initiate an edit until the right address is located.

Several time code systems are available. Even some small consumer camcorders can generate their own time code. Most professional editing equipment is built to read the *SMPTE/EBU time code*. *SMPTE* (pronounced "sempty") stands for Society of Motion Picture and Television Engineers. *EBU* is short for European Broadcasting Union. Both organizations set and track technical standards.

Time code read/write mechanisms Many studio VTRs, portable professional VTRs, and camcorders have a built-in time code generator for writing time code during the production and reading it during playback. Most others have jacks for attaching a separate time code generator.

ZVL4 EDITING→ Postproduction guidelines→ time code

Time code recording In larger studio productions, the time code is routinely recorded with the program. High-quality camcorders produce their own time code and lay it on a designated track during videotaping. If time code is needed for EFP productions, or when the camcorder you are using does not have a built-in time code generator, you can add the time code after the program has already been recorded on videotape. For example, when you "dub down" (make a lower-quality copy) for a *workprint*, or you "bump up" (make a higher-quality copy) for the actual editing copy, you can lay down the time code on the source tape and on its copy simultaneously.

You can set the code to correspond with the actual time of day or, more common, to simply start from 0 regardless of time of day. You will find that some videographers use the hour number to indicate the tape (reel) number. For example, you would mark the first tape with 01/00/00/00 and the second tape with 02, and continue on the 02 tape with the time code that was recorded at the end of tape 01. The third tape would show 03 in the hour column and so forth. Actually, you can start anywhere with the time code so long as it continues within the source tape and from tape to tape.

If you use three camcorders for a synchronized pickup—for example, one is on a continuous long shot, another is on continuous medium shot, and the third is on a continuous close-up—you can synchronize the cameras by having them start with the same time code. This is tricky in practice, however, and it takes time to get all the camcorders exactly time-code synchronized. Fortunately, there is an easy method for synchronizing cameras that we learned from film: start all the cameras more or less at the same time and have them focus on somebody who triggers the flash of a still camera. The overexposed frame will be the starting point for all time code synchronization.

Non-drop frame and drop frame modes Although we always figure that the NTSC system operates at 30 frames per second, this is not quite accurate. In fact, each frame takes just a little bit less than 1/30 second. This difference is so minute that for most editing projects you can simply ignore it. But when you have to be absolutely frame-accurate, such as when trying to maintain lip sync over a long period of time, you will find that the time code is somewhat off. In fact, when a stopwatch reads exactly one hour of elapsed recording time, the time code displays 1:00:03:18, which is 3.6 seconds longer. If this difference is not crucial to your editing, you can keep the camcorder in non-drop frame mode, assuming that it gives you the choice. If you must be perfectly in sync with the actual event time, you need to work in drop frame mode. This means that the time code skips some frames from time to time when keeping count. You will usually do just fine in the non-drop frame mode, at least most of the time.

Audio/video synchronizing Time code lets you run in sync not only several VTRs but also video- and audiotape recorders. Because the synchronization is frame-accurate, you can match video and audio tracks frame-by-frame in postproduction. You can, for example, strip low-quality speech sounds and other sound effects off the videotape and replace them frame-by-frame with new dialogue and sound effects from an audiotape. As explained in chapter 10, this process is called *automatic dialogue replacement* (*ADR*).

LINEAR EDITING FEATURES AND TECHNIQUES

Most professional VTRs let you switch between two major editing modes: *assemble editing* and *insert editing*.

ASSEMBLE EDITING

When in the assemble mode, the record VTR erases everything on its tape (video, audio, control, and address tracks) just ahead of copying the material supplied by the source VTR. When you use a tape that has last year's vacation pictures on it to chronicle your new adventures, the camcorder will, in effect, use *assemble editing* every time you shoot a new scene: it will simply erase what was there before and replace it with the new video and audio.

The same thing happens in a more sophisticated editing system. Even if the edit master tape has a previous recording on it, the assemble mode will clear the portion of the tape that is needed for the new first shot. When editing shot 2 onto shot 1, the record VTR will erase everything on the edit master tape following shot 1 to make room for copying the new video and audio information. The record VTR will then supply a new control track that is modeled exactly after the control track information contained in shot 2 of the source tape. The same happens when you assemble the subsequent shots. **SEE 13.9**

The problem with assemble editing is that the control track on the edit master tape, as reconstructed by the record VTR from the bits and pieces of the source tapes, is not always smooth and evenly spaced. For example, the record

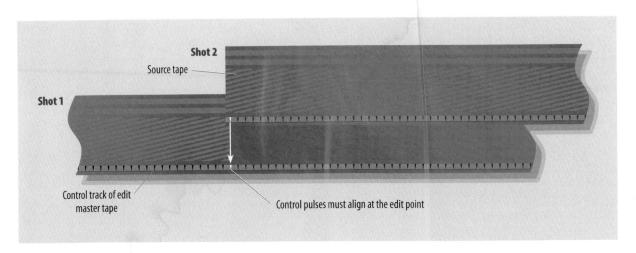

13.9 ASSEMBLE EDITING

In assemble editing, the record VTR produces the control track in bits and pieces. The record VTR copies from the source VTR all video and audio information of shot 2. The control track for shot 2 stays with the source VTR but is regenerated and attached to the shot 1 control track by the record VTR.

13.10 SYNC ROLL

Even a slight misalignment of the control tracks from shots 1 and 2 will cause a sync roll—a momentary breakup of the picture at the edit point.

VTR is expected to make a perfectly continuous control track out of the fragments from shots 1, 7, and 11. Even the best VTRs do not always succeed at this. A slight mismatch of sync pulses will cause some edits to "tear," causing a *sync roll*, which means that the picture will break up or roll momentarily at the edit point during playback. **SEE 13.10**

The primary advantage of assemble editing is that it is fast. You do not have to first lay down on the edit master tape a black video signal with its continuous control track before you begin editing. In fact, you can use any tape for the edit master, regardless of whether it contains previous video material (not recommended for use as an edit master in any case) or has a control track already recorded on it. Because you don't have to first record a continuous control track on the edit master tape, some "hot news" editing is done in the assemble, rather than the insert, mode. A camcorder edits in the assemble mode each time you press the *record* button.

INSERT EDITING

Wouldn't it be sensible to lay down a continuous control track on the edit master tape without trying to match up all the control track bits and pieces from the various source tape selections? You could then instruct the record VTR to yield to the continuous control track on the edit master. As you probably guessed, this is indeed possible. The process of using a continuous control track is called *insert editing*. But here is the rub: to prepare the edit master tape for insert editing, you need to first record a continuous control track on it. The simplest way to do this is to record "black," with the video and audio inputs in the *off* position. Some editors prefer to record color bars as a continuous

color reference. As though it were recording an important event, the VTR faithfully lays down a control track in the process. The "blackened" tape has now become an empty edit master, ready to receive the momentous scenes from your source tapes.

The recording of black or color bars (and thereby laying a control track) happens in *real time*, which means that you cannot speed up the process but must take 30 minutes to lay a 30-minute control track. Though this may seem like wasted time, it has the following advantages:

- All edits are roll-free and tear-free.
- You can easily insert new video and/or audio material anywhere in the tape without affecting anything preceding or following the insert (hence the name).
- You can edit the video without affecting the sound track, or you can edit the audio without affecting the pictures (called a *split edit*). This is especially important when you want to insert some shots without disturbing the continuity of the original sound track. In fact, the most efficient way of editing documentaries or music programs is to lay down the audio track first and then insert-edit the video to match the audio. **SEE 13.11**

AB ROLLING AND AB-ROLL EDITING

Although both of these techniques are admittedly crude and mostly rendered obsolete by nonlinear editing, they nevertheless have their place in television production. These methods are useful not for their accuracy but for their speed. Both techniques resemble instantaneous editing (switching) more than postproduction editing.

In a nutshell the difference between AB rolling and AB-roll editing is that in *AB rolling* you switch (do instantaneous editing via the switcher) between the two source VTRs as though they were live video sources; in *AB-roll editing* you use the edit controller to set up the transitions between the source A VTR and the source B VTR.

AB ROLLING

Because two separate sources supply visual material simultaneously in AB rolling, you can switch at any given point from the material on the A-roll (source A VTR) to that on the B-roll (source B VTR), and vice versa, and combine them with various transition devices or effects available in the switcher. **SEE 13.12**

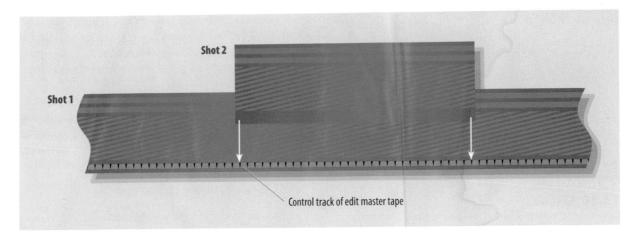

13.11 INSERT EDITING

In insert editing, the source material is transferred without its control track and placed according to the prerecorded continuous control track of the edit master tape.

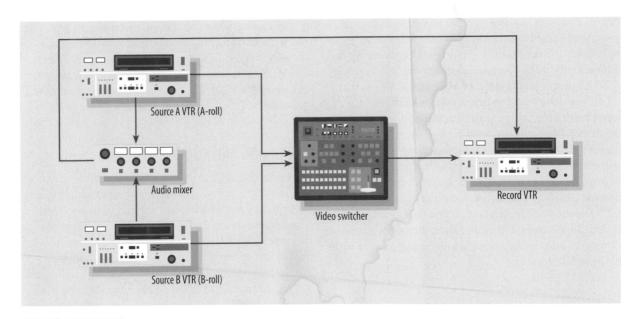

13.12 AB ROLLING

In AB rolling, the source A VTR supplies the A-roll and the source B VTR supplies the B-roll. Both machines are synchronized and feed their video material to the switcher. Because they represent two simultaneous video feeds, they can be switched (instantaneously edited) as though they were two live sources.

The advantages of AB rolling are that it can greatly speed up the editing process and it allows you to redo the editing a number of times until you are satisfied with the shot sequence. If you don't like the editing you have just done, you can rewind the source VTRs and cut the production again. Even the most experienced postproduction editors using conventional linear editing equipment

can't match the speed of AB rolling. But what you gain in speed, you lose in accuracy. AB rolling works best when the edit points between the A and B rolls do not have to be too precise.

Here is an example of an editing assignment that lends itself well to AB rolling: Assume that one of the source tapes—the A-roll—contains primarily long and

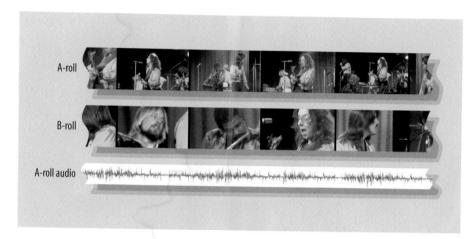

13.13 AB ROLLING TO COMMON SOUND TRACK

In this AB-roll editing example, the A-roll consists of long and medium shots of the band; the B-roll contains CUs of the individual members. Because both source VTRs are synchronized, you can use the A-roll sound track to insert the B-roll video.

medium shots of a rock band. The second source tape—the B-roll—has various CUs (close-ups) of the band members. Assuming that the source tapes have a common time code and, in this case, a common audio track (the band playing), you can roll both tapes simultaneously and keep them in sync; feed them to the switcher as two separate video sources; cut, dissolve, or wipe between the long and medium shots on the A-roll and the close-ups on the B-roll as though they were live sources; and record the switcher's line-out signal on the record VTR. Because the two source tapes are synchronized by their time code, you can feed the sound track from only one source tape to the record VTR and still maintain lip-sync for the A-roll and B-roll video. **SEE 13.13**

AB-ROLL EDITING

If you now substitute the edit controller for the switcher, you are engaged in AB-roll editing. Let's edit the rock video again but this time with the edit controller. You can first lay down the entire sound track on the edit master tape while recording black. The simultaneous recording of the sound track and black video will also establish the control track necessary for insert editing.

Now you can use the sound track as a guide and insert-edit into the long shots of the A-roll the various close-ups on the B-roll, with a variety of transitions. By running the two source VTRs in sync, you do not have to engage in time-consuming shuttles to search for the appropriate CU—you can simply choose between the A- and B-roll shots at any given moment. Although this method is considerably slower than AB rolling, it is more precise. For example, if you want a close-up of the lead guitarist at the exact moment when he begins his solo, the edit controller can locate the starting frame with precision and ease. To

attempt a similarly precise cut during AB rolling would probably require several retakes.

The advantage of AB-roll editing is that you can access the source material from two sources rather than just one, which allows a great variety of transitions. The A and B rolls do not have to run in sync from beginning to end, and you can advance either tape to a specific edit point and copy the material over to the record VTR without having to change videotapes on the source machine.

In AB-roll editing the edit controller has its hands full: it must respond to edit-in and -out points for the source A VTR, the source B VTR, and the record VTR; initiate prerolls for all three machines; and tell the record VTR when to start recording and the switcher what transition to perform. Fortunately, the computer can handle these control functions with ease and efficiency. Once you have entered your EDL into the editing program, it will seek out the listed time code numbers specifying the edit points and faithfully initiate the various transitions as stipulated by the EDL—assuming that everything works right.

NONLINEAR EDITING SYSTEMS

All nonlinear editing systems are basically computers that store digital video and audio information on high-capacity hard disks or read/write optical discs. Besides the computer and a high-capacity hard drive, the normal NLE system contains a VTR to play the source tapes, or some other digital device that holds the original footage (external hard drive or server), a small audio mixer, a large monitor that displays the editing interface, and a second monitor that plays back the edited sequences. **SEE 13.14**

Recall that the fundamental difference between linear and nonlinear editing systems is that linear systems copy

13.14 BASIC NONLINEAR EDITING SYSTEM

The basic nonlinear editing system consists of a computer with large-capacity storage devices and editing/effects software. The output of this editing system is an EDL as well as high-quality on-line video and audio material.

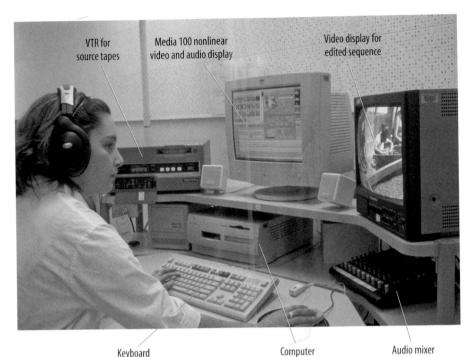

information from one videotape to another whereas non-linear systems allow random access of shots and sequences and enable their playback in a particular order. Instead of editing one shot next to another, with NLE you are basically engaged in *file management*. Nonlinear editing allows you to try, compare, and keep as many editing versions as you like, without being committed to any one. All you actually do is create various EDLs, that is, mark certain files to play back in various lengths and sequences. Once you decide on a particular arrangement, you tell the computer that this version is your final editing choice and to export it to

another digital storage device, such as a DVD.

The other big advantage of NLE is the ease with which you can integrate a great number of *digital video effects* (*DVE*). You can build these effects in real time—the rendering time has been drastically reduced; what used to take hours can now be done in minutes. But the ease with which you can create DVE might tempt you to pay more attention to the effects than to the story. Use such "knockyour-socks-off" effects only if they fit the content of the story and help energize the message.

the edit master tape or, with proper authoring software, to

Because of improved hardware, software, and compression methods, combined with high-capacity hard disks and optical discs, desktop software can produce high-quality video and CD-quality audio in the editing process. High-end NLE systems run on both PC and Macintosh

platforms and offer a greater number of transitions and special effects.

Thanks to readily available and sophisticated editing software, even your notebook computer can be turned quite easily into a powerful nonlinear editing system. Giving you even more options (and headaches), most nonlinear systems can be linked as networks for sharing video and audio data files, for audio sweetening, or for sending rough-cuts to a client for final approval. ZVL5 EDITING > Nonlinear editing > system

NONLINEAR EDITING FEATURES AND TECHNIQUES

Nonlinear editing systems are as varied as desktop computers and word-processing programs. Their features, software, and techniques are varied and often quite intricate. Even if you have some experience in nonlinear editing, you will need the operating manual close by. Despite the different models, there are features and techniques common to all NLE systems: (1) capturing, compressing, and storing information; and (2) juxtaposing and rearranging the video and audio files.

CAPTURE

You may be surprised to hear that one of the real bottlenecks in nonlinear editing is getting the analog or digital video and audio information into the computer, a process called *capture*. If you have ever backed up material from a hard disk, you know that it can try your patience. Transferring analog videotapes to digital storage devices is always quite time-consuming. Even if the footage was recorded on a digital camcorder or VTR, transferring it from tape to hard disk takes time. Some NLE systems, designed primarily for news, load the digital source video faster than real time (the time it would take for a straight dub). Nevertheless, all such transfers take longer than you think.

This is where a good *field log* comes in handy. You can check the field log and import only the good takes. Such a procedure may not always save you time, but it will certainly save you a fair amount of disk space.

COMPRESSION

There are high-end proprietary editing systems that capture and process all source material without any compression, but such systems must rely on high-capacity storage devices and high-speed computers to deal with the huge amount of digital information. To speed up the capture and editing process, many nonlinear systems therefore operate with some kind of compression. Recall from chapter 12 the detailed discussion of compression—that it's like trying to put half your wardrobe into a carry-on suitcase. Sometimes you succeed by refolding your clothes and by using all the available space; this is the lossless kind of compression. Most compression is the *lossy* kind, which means that you need to leave some clothing behind. Do you really need three sweaters or can you get by with one? Obviously, the less you discard, the more complete your wardrobe will be. In compression terms, the less compression there is, the higher the video and sound quality will be.

The bigger problem for you as a postproduction editor is that the generally accepted MPEG-2 *interframe* compression standard makes it difficult to do precise frame-accurate editing. As you recall, to save "suitcase space," not all frames contain the complete video information. For frame-accurate editing, you need MPEG-2 systems that use frequent reference frames or that can calculate the full frame wherever you want to cut. The advantage of the *intraframe* technique, in which each frame undergoes its own compression, is that you can use any given frame as an edit point without additional decoding software.

STORAGE

The greatest library in the world is useless if the books are not cataloged so that you can easily find them. The same is true of video material, regardless of whether it is stored on videotape or a hard disk. You already know about the SMPTE time code that gives a unique address to each

frame, but the "house number" does not tell you what the house *looks* like. Similarly, the time code reveals nothing about the nature of the shot it is identifying. What you need is a list that tells you what is actually stored. Computerized logging systems can create file menus, or shot lists, and transfer to a data file the SMPTE time code addresses of the scenes you want. There is also software that helps you create a list of stored files. Such lists show the in- and outnumbers for each shot as well as information like the name of the shot, its content, and so forth. A shot list, or rather an editing file menu, is similar to a regular VTR log.

JUXTAPOSING AND REARRANGING VIDEO AND AUDIO FILES

Now you are finally ready to do some editing, or, rather, juxtapose images and rearrange video and audio files. Because you have fast and easy access to each of the stored frames, you have the ultimate multiple-source editing system at your disposal. To duplicate the same feat with a taped-based system, you would need a separate source VTR for each single frame recorded on the source tapes. As pointed out earlier, nonlinear editing is comparable to rearranging letters, words, sentences, and paragraphs with a word-processing program.

Because the stored information allows random access, you can call up any frame, or video and audio sequence, in a fraction of a second and display it as a series of still images on the computer screen. Such access speed comes as a great relief to videotape editors who were used to waiting anxiously for a particular shot that was buried somewhere toward the end of the source tape. Now you simply click the mouse or press a button, and the next frame or series of frames, called a *clip*, appears on-screen.

Besides having almost instant access to any frame of the stored video and audio data, you can juxtapose two frames or clips to see how well they cut together. The side-by-side display consists, in effect, of the last frame of the previous shot and the first frame of the following shot. **SEE 13.15**

By running the newly "edited" sequence, you can see whether it fulfills your story continuity and aesthetic requirements. If it doesn't, you can call up another frame or sequence and try out a new arrangement. You can also test a number of transitions and effects. Once you are satisfied, you can tell the computer to record and remember the inand out-numbers for each of the selected sequences. The complete list of such in- and out-numbers constitutes the final edit decision list. From now on this EDL serves as the guide for the final editing procedure.

13.15 NONLINEAR EDITING DISPLAY

This shot display shows the last frames of the previous shot and the first frames of the new shot.

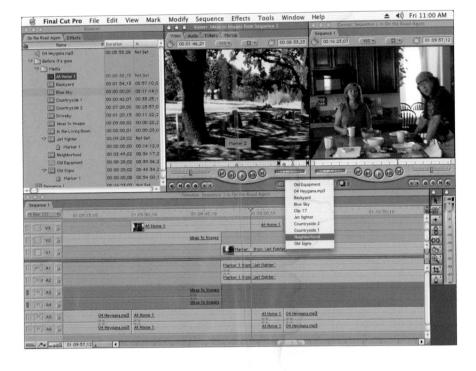

PRE-EDITING PHASE

While shooting video and recording audio during a production, experienced production people are already thinking of postproduction editing. The actual editing will also be greatly facilitated if you spend some time looking over and keeping accurate records of what you have shot. Finally, you have to select the most effective shots and decide how to put them together to give the video program clarity and impact. The pre-editing phase includes: (1) the shooting phase, (2) the review phase, and (3) the preparation phase.

SHOOTING PHASE

Much of the editing is predetermined by the way the material is shot. Some novice directors or camera operators stop one shot or scene and begin the next without any pads (overlapping action) or consideration for continuity. Others have the ability and foresight to visualize transitions between shots and scenes and to provide images that cut together well in postproduction. The key here is to visualize not just individual shots but a shot sequence. Imagining a shot sequence will help you compose shots that can be joined together to form seamless transitions.

When recording videotape do not stop exactly at the end of a scene—record a few more seconds before stopping

the tape. For example, if the field reporter has just ended the introduction to a story, have him or her remain silent and in place for a few more seconds. This pause will give you a video pad, called *trim handles*, in case the end of the actual report and the beginning of the following scene do not provide proper video or audio continuity. For the same reason, roll the tape for several seconds before beginning an action that will be used in the edited version. A change in the angle and field of view (moving the camera nearer or farther away from the event) between shots will also help make the cuts look organic and smooth. **ZVL6** EDITING→ Production quidelines→ pickup

Always get some cutaway shots. A *cutaway* is a brief shot that establishes continuity between two shots; provides the necessary video pad when editing according to sound bites (portion of videotaped interview in which we see and hear the person talk); and, in more-ambitious productions, helps bridge jumps in time and/or location. The cutaway may or may not be part of the principal action, but it must be thematically related to the actual event. Good cutaways are relatively static and neutral as to screen direction. Examples are straight-on shots of onlookers, reporters with still cameras or camcorders, buildings that show the location, house numbers, or objects that are part of the story (such as the book the guest has written). ZVLT EDITING-> Production guidelines-> cutaways

When on an ENG assignment, try to get some cutaway shots that identify the location of the event. For example, after covering the downtown fire, get a shot of the street signs of the nearest intersection, the traffic that has backed up because of the fire, and some close-ups of onlookers and exhausted firefighters. For good measure also get several wide shots of the event location. You will then have cutaways that not only facilitate transitions but also show exactly where the fire took place. Always record the ambient sound with the cutaways. The sound is often as important as the pictures for smooth transitions. The continuity of ambient (background) sound can also help immensely in preserving shot continuity, even if the visuals do not cut together too well.

- Always record a minute or two of "room tone" or any other kind of environmental sound, even if the camera has nothing interesting to shoot.
- Whenever possible during ENG, verbally *slate* (identify) the various takes or at least the shot series. You can do this by simply calling out the name of the event and the take number, such as: "Market Street police station, take 2." You can do the slating on the camera mic or the portable (reporter's) mic. After saying the take number, count backward from five or three to one. This counting is similar to the beeper after the slate in studio productions. Although not essential, it helps locate the take and cue it up during editing, especially if no address code is used.

REVIEW PHASE

Unless you deal with news footage that must be edited for the upcoming newscast, you need to make copies of all the source tapes. This is especially important for linear editing because you can now preserve the original source tapes for the actual editing while reviewing the tape copies.

When transferring the analog or digital source tapes to the hard disk of the editing system, back up the hard disk immediately. You may think that backing up is overkill and basically a waste of time; this is true—until your superdependable computer crashes or somebody else erases your hard drive to make room for a new project.

Reviewing Before you can make decisions about what to include and what to cut, you need to know what you've got. Regardless of whether you are editing a brief news story or a play that was shot film-style, you must look at everything on the source tape or, more likely, on the stack of videotapes that contain the bits and pieces of the source material. This way you get an overall impression of what you have to work with. Repeated screening of the source

tapes will reveal new things every time you play them and will suggest optimal ways of sequencing.

Even if you have not taken part in the actual production, this preview should give you (the editor) an idea of what the story is all about. When you work in corporate television, where many of the productions have specific instructional objectives, you need to know what those objectives are. If you cannot deduce story or objectives from the first preview, ask someone who knows. After all, the story and communication objective will greatly influence your selection of shots or scenes and their sequencing. Read the script and discuss the communication objectives with the writer or producer/director. Discussions about overall story, mood, and style are especially important when editing documentaries or plays.

When editing someone else's ENG footage, however, you rarely get a chance to learn enough about the total event. Worse, you have to keep to a rigid time frame ("Be sure to keep this story to twenty seconds!") and work with limited footage ("Sorry, I just couldn't get close enough to get good shots" or "The mic was working when I checked it"). Also, you have precious little time to get the job done ("Aren't you finished yet? We go on the air in forty-five minutes!"). Very much like a reporter, an ENG camera operator, or an emergency-room doctor, the ENG editor has to work quickly yet accurately and with little preproduction preparation.

Get as much information as you can about the story before you start editing. Ask the reporter, the camera operator, or the producer to fill you in. After some practice you will be able to sense the story contained on the tape and edit it accordingly. You will also find that you often get a better idea about the story by listening to the sound track than by looking at the pictures.

PREPARATION PHASE

Before you can engage in actual editing, you still have to take care of a few operational procedures: (1) time code and window dubbing and (2) logging.

Time code and window dub All critical editing requires time code. Unless you recorded the time code during the videotaping, you need to add it to all the source tapes. Like "blackening" the edit master tape for insert editing, laying the time code takes place in real time—adding 30 minutes of time code takes 30 minutes of recording time.

But while you are laying the time code, you can simultaneously make a *window dub*—a "bumped-down" (lower-quality, such as VHS) copy of all source tapes that has the time code keyed in a window over each frame. **SEE 13.16**

13.16 TIME CODE DISPLAY IN WINDOW DUB

The window dub shows the unique time code number keyed over each frame.

When working with tape-based systems, a window dub is necessary for creating an accurate VTR log during the preview phase. It will also help you compile a preliminary EDL without having to touch the original source tapes. As pointed out before, avoid using the original source tapes for previewing and logging unless you are working with news footage. Each pass will diminish the quality of the original material; and each time you play the tapes, you run the risk of damaging them.

Logging With the exception of editing for news or other such events that go on the air right after they occur, you should make a list of every take on the source tapes, regardless of whether it is usable or properly slated. This list, called the *VTR log*, represents a much more precise record of what is on the source tapes than the field log kept by the VTR operator during the production. (Note that we call it "VTR log" even if the camcorder captures the original footage on disc rather than tape.) The purpose of the VTR log is to help you locate specific shots on the source tapes without having to preview them over and over again, or to make the capturing process for nonlinear editing more efficient.

If you have an accurate VTR long, you can eliminate right away most of the shots labeled "NG." When preparing a VTR log, the field logs will be invaluable in helping you quick locate a particular tape or shot sequence. This may not seem a big deal when you have only two tapes to review, but it is a lifesaver when you must log a stack of twenty or more source tapes.

The following is the basic information a VTR \log should contain. **SEE 13.17**

Tape (or reel) numbers. These refer to the number the VTR operator has given the tape during production. He or she should have labeled not only the box but also

the cassette with a number and the title of what the tape contains. If the VTR log format has no place for the show title, put it in the *Remarks* column. If you recorded time code in the field, the *Hour* column on the field log usually indicates the tape number.

- Scene and take numbers. Use these only if they are useful in locating the material on the source tape. If you have properly slated the scenes and takes, copy the numbers from the slates. Otherwise, simply list all shots as they appear on the source tape in ascending order.
- Time code. Enter the time code number of the first frame of the shot in the *In* column and the last frame of the shot in the *Out* column, regardless of whether the shot is OK or no good.
- OK or no good. Mark the acceptable shots by circling the shot number or by writing "OK" or "NG" (no good) in the appropriate column. Unless you have already eliminated all shots that were labeled "NG" on the field log, you can now see if you agree with previous determinations of whether or not a take was OK.

When evaluating shots look for obvious mistakes—but also look for whether the shot is suitable in the context of the defined communication purpose and/or overall story. An out-of-focus shot may be unusable in one context but quite appropriate if you try to demonstrate impaired vision. Look behind the principal action: Is the background appropriate? Too busy or cluttered? It is often the background rather than the foreground that provides the necessary visual continuity. Will the backgrounds facilitate continuity when the shots are edited together?

Sound. Here you note in- and out-cues for dialogue and sound effects that need attention during editing. Listen carefully not only to the foreground sounds but also to the background sounds. Is there too much ambience? Not

PRODUCTION TITLE: Traffic Safety						PRODUCTION	NO:114	OFF-LINE DATE: 07/15	
PRODUCER: Hamid Khani			Hamid Khan	i DIRECTOR:		Elan F	rank ON-LINE DATE: 07	ON-LINE DATE:07/21	
NO.	SCENE/ SHOT	TAKE NO.	IN	OUT	OK/ NG	SOUND	REMARKS	VECTORS	
4	2	١	04 44 21 14	04 44 23 12	NS		mic problem	m	
		0	04 44 42 06	04 47 41 29	OK'	car sound	car A moving Through stop sign	m	
		(3)	04 48 01 29	04 50 49 17	OK.	brakes	car B putting on brakes (Toward camera)	om	
		(4)	04 51 02 13	04 51 42 08	OK,	reaction	pedestrian reaction	->;	
5	5	l	05 03 49 18	05 04 02 07	NS	car brakes ped.yelling	ball not in front of car	m ball	
		2	05 05 02 29	05 06 51 11	NS	11	Again, ball problem	m ball	
		3	05 07 40 02	05 09 12 13	OK	car brakes ped.yelling	car swerves To avoid ball	on -m ball	
	6		05 12 03 28	05 14 12 01	OK.	ped.yelling		→i child	
		0	05 17 08 16	05 21 11 19	OK.	car	cuTaways car moving	2 5	
		3	05 22 15 03	05 26 28 00	NG	street	lines o€ sidewalk	(9)	

13.17 VTR LOG

The VTR log contains all the necessary information about the video and audio recorded on the source tapes. Notice the notations in the *Vectors* column: g, i, and m refer to graphic, index, and motion vectors. The arrows show the principal direction of the index and motion vectors. Z-axis index and motion vectors are labeled with \odot (toward the camera) or \bullet (away from the camera).

enough? Note any obvious audio problems, such as trucks going by, somebody hitting the microphone or kicking the table, intercom chatter of the crew, or talent flubs in an otherwise good take. Write down the nature of the sound problem and its time code address.

- Remarks. Use this column to indicate what the shot is all about, such as "CU of watch," and to record the audio cues (unless you have a designated audio column).

 ZVL3 EDITING→ Postproduction guidelines→ VTR log
- Vectors. Vectors indicate the major directions of lines or motions within a shot. Noting such directional vectors will help you locate specific shots that continue or purposely oppose a principal direction.

There are three types of vectors: graphic, index, and motion. A *graphic vector* is created by stationary elements that guide our eyes in a specific direction, such as a line formed by the window frame or the edge of a book. An *index vector* is created by something that points unquestion-

ably in a specific direction, such as an arrow or a person's gaze. A *motion vector* is brought about by something moving. Take another look at the *Vectors* column in figure 13.17. The g, i, and m refer to the vector type (graphic, index, or motion); the arrows indicate the principal direction. The circled-dot symbol indicates movement or pointing toward the camera; the dot alone indicates movement or pointing away from the camera. **ZVL9 EDITING** \rightarrow Continuity \rightarrow vectors

For the actual logging, you can take the window dubs home and view them on your home VCR. Although the VCR will not show the high-quality pictures of the source tapes, it is certainly sufficient for giving you an idea of what video and audio material you have. It also lets you freeze the starting and ending frames of each shot so you can read and log their respective time code numbers.

If you shot the material yourself, you are probably familiar with most takes. You can therefore get by with a rather sketchy VTR log that indicates reel and take numbers

and some shot identification. But if you are given material that was shot by someone else, you should log as much about it as possible so that you will not have to go back to the source tapes to look for appropriate shots. The more careful and accurate your logging, the more time, money, and nerves you will save during the actual editing.

There are several good computerized logging programs available. Because the computer can display each frame with its time code address, you can use the clips you imported from the source tapes. Such logging software provides space for the name of the scene or shot and for identifying certain audio segments. Note, however, that the computer will not do the logging all by itself. It cannot tell how you want to name a particular shot, for example, or whether you consider a take acceptable or unacceptable.

EDITING PROCEDURES

Now you are finally ready to do some editing. What does *editing* actually mean? In video and film production, it is the selecting and assembling of shots in a seamless sequence that tells the story most effectively. Editing requires a sense for how a story develops, a good eye and ear, and patience. But before you turn on the equipment and start with editing, you should pay special attention to these major editing steps: (1) shot selection, (2) shot sequencing, (3) audio sweetening, (4) creating the final edit master tape, and (5) operational hints.

SHOT SELECTION

In this decision-making phase you must first be guided by the context of the total story and its overriding communication intent. Another important selection criterion is whether the shots contribute to a smooth, seamless sequence. Good editing should go unnoticed by the viewer.

Choosing shots Select only those shots that are essential to tell the story. Don't use ten shots if you can do the job with three. This is especially true when editing news. It is not uncommon to cut to about seven seconds of visuals a story the ENG camera/reporter team may have spent a whole day risking their lives to get.

ENG Editing news footage does not allow you the luxury of pondering over a shot sequence or trying out several different ways before settling on the most appropriate one. In fact, many ENG stories are edited in the ENG van in the field or on the way back to the station. If the news event is big enough, the footage may even be sent up to the satellite unedited.

The extreme time restrictions in ENG require that you tell the stories as economically as possible. When looking at the footage, the highlights of the event usually reveal themselves quite readily. The reporter or producer will occasionally select the *sound bite*—a brief memorable phrase—that drives the story. ZVL10 EDITING→ Continuity→ quiz

Nevertheless, under normal circumstances, ENG editing requires that you look at the source material repeatedly to see what you have to work with. After a few such screenings, the story should pretty much reveal itself. All the previewing and editing is done with the actual source tapes or footage imported from other recorded media.

All other postproduction editing requires a careful and deliberate selection of shots that help clarify, intensify, and interpret the intended message. Sometimes your job is made relatively easy because you can work from a detailed script or storyboard (see section 18.2). For example, most commercials are carefully designed, with every shot and the shot sequence sketched out in preproduction. Assuming that the director followed the storyboard in the production phase, all you need to do is look for the shots that best represent the storyboard sketch and clip them together. At other times you need to view the material repeatedly before you can select the most effective shots.

Because the audio track is often used as guide for editing the corresponding video, the transcribed audio track is edited first, then the video is "dropped in" according to the edited audio track (see section 10.2).

Preparing a paper-and-pencil EDL When you edit a longer and more complex production, such as a documentary or drama, your main concern is picking the shots that most effectively fulfill the story and contribute to a smooth shot sequence (see chapters 14 and 18). You can save a great amount of actual editing time by simply watching the window dubs (in linear editing) or the clips (in nonlinear editing) and making a list of the edit-in and -out points for each selected shot. This list will be your preliminary EDL. Because this list is usually written by hand, this decision-making activity is called *paper-and-pencil editing*, or *paper editing* for short. **SEE 13.18 ZVL11** EDITING→ Linear editing→ paper edit

When using a computer-assisted logging system, the computer will store your decisions and print out the preliminary EDL. Most high-end editing software will give you an option to display simultaneously a certain number of video and audio tracks. The tracks, stacked underneath the source and record monitors, display the video and audio tracks with their time code numbers. Such displays can greatly facilitate building your preliminary EDL.

			Traffic Safety			PRODUCTION NO: 114	
PRODUCER:			Hamid Khani DIRECTO		OR:	Elan Frank	ON-LINE DATE:07/21
TAPE NO.	SCENE/ SHOT	TAKE NO.	IN	OUT	TRANSITION	SOUND	REMARKS
1	2	2	01 46 13 14	01 46 15 02	cUT	car	
		3	01 51 10 29	01511121	cUT	car	
	3	4	02 05 55 17	02 05 56 02	cUT	ped.yelling—brakes	
		5	02 07 43 17	02084601	cUT	brakes	
		6	02 51 40 02	02514107	cUT	ped.yelling—brakes	

13.18 HANDWRITTEN EDIT DECISION LIST

Paper-and-pencil off-line editing normally produces a handwritten EDL containing information similar to that generated by a computerized system.

SHOT SEQUENCING

Once you have a preliminary EDL, you can proceed to the first tentative sequencing of shots—the rough cut. With a linear system, you insert the various tapes indicated on the preliminary EDL, tell the edit controller to search for the selected shots, and copy them over to the record VTR. With a nonlinear system, you simply tell the computer to run the selected sequence.

When looking at the rough cut, you will undoubtedly see some shots that don't make sense (despite their artistic value) or that interrupt the continuity. This is the time to eliminate redundant shots or look for similar shots in the VTR log that facilitate continuity.

Adding transitions Once satisfied with the rough cut, you can move to the next stage of deciding transitions and special effects. Again, don't go overboard with dissolves, wipes, and flips. Because they are so readily available in NLE, they are especially tempting. Even if you see an excess of effects on the air every day, don't try to compete. A clean cut is still one of the most effective and unobtrusive ways of combining shots.

AUDIO SWEETENING

In relatively simple editing projects, the sound editing will consist mainly of combining the sound tracks of the shots so that no words are lost or mangled, and adding some music or sound effects. In linear editing you can match the sound track with the corresponding video via time code. This is by no means an easy job, and it takes practice, but this is where the advantage of nonlinear editing comes in. Even the simplest editing software allows you to mix at least two sound tracks, and more-sophisticated programs let you manipulate close to a hundred tracks. Because sounds in NLE are treated as clips, much like video, you can call up the sound files in random order, look at them in addition to hearing them, scrub through them (move through the sound sequence using the mouse) to find a particular point or frame, and manipulate and combine them in any number of ways. Note, however, that more complicated sound work takes an additional set of skills and is best left to the sound designer or sound editor.2

Once you have completed the final shot sequencing, you can print out the final EDL that eventually triggers all the commands for the final edit, or tell the computer to run the final editing sequence. **SEE 13.19**

At this point even minor editing changes are quite time-consuming in linear editing and may even require that you redo all the edits that follow the point of change.

See Stanley R. Alten, Audio in Media, 7th ed. (Belmont, Calif.: Thomson Wadsworth, 2005), pp. 135–44.

13.19 COMPUTER-GENERATED EDL

The computer-generated EDL is similar to the handwritten one. It contains in- and outnumbers for both the source and record VTRs and the nature of the transitions.

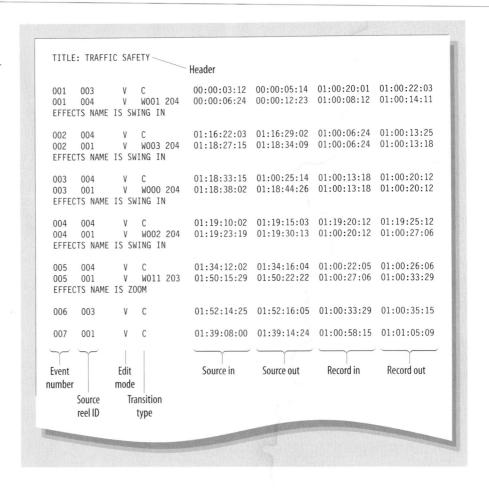

The same change can be done much more quickly with the NLE system. What you see and hear during the playback is simply video and audio data files arranged in a particular order. All you do to make an editing change is rearrange some computer files and generate a new play order—a new EDL. Obviously, this takes considerably less time than reediting tape.

CREATING THE FINAL EDIT MASTER TAPE

All that's left for you to do is to create a final edit master tape. In linear editing the creation of the final edit master depends on the relative sophistication of the system. Some edit controllers can use the final EDL to select the proper shots from the source VTRs and instruct the record VTR to record them according to the in- and out numbers indicated. If you work with a nonlinear system, you tell the computer to run the entire sequence and export the selected video and audio files in the specified sequence for recording on the edit master tape or disc.

OPERATIONAL HINTS

Now you have to sit down and practice. You cannot learn editing simply by reading a book—even this one. There are also so many linear and nonlinear editing systems on the market that it would be impossible to list them all. The variety of editing equipment places more and more importance on the aesthetic principles—how to achieve a shot sequence that looks seamless or that purposely jolts viewers out of their perceptual complacency (such principles are the focus of section 13.2). Here are some basic operational steps for editing on either tape-based or disk-based systems:

- If you share editing facilities, double-check on their availability. Have you requested additional equipment you may need to interface, such as a C.G., a switcher, audio equipment, or DVE?
- If working with a tape-based system, check the tapes that you intend to use for edit masters. Use only new tapes for the record VTR. When doing insert editing, the edit

master tapes must have black or color bars recorded on them. (Remember that the real-time recording of black will give you the continuous control track needed for insert editing.) To minimize tracking problems, many editors like to lay the control track with the VTR that is actually used as a record VTR during the editing process.

- In a tape-based system, set up both source and record VTRs. The record VTR must be in the assemble or insert mode. Calibrate the audio levels of the source and record VTRs (see section 10.2).
- When finished editing, rewind the edit master tape and play it without interruption. You may discover some discrepancies between the video and audio tracks or problems with continuity that you did not notice when you worked edit by edit. Nonlinear editing lets you rearrange the video and audio data files to smooth the transitions relatively easily. Audio sweetening is a little more cumbersome. Complex audio sweetening requires that you strip the audio track off the videotape for the necessary manipulation and then dub the audio track back onto the videotape again. Frame-accurate synchronization of video and audio requires SMPTE time code for both video and audio tracks.
- When working with a disk-based system, allow plenty of time for transferring the source tapes to the hard disk of the editing system. Back up the stored material, even if it is time-consuming. Backing up video and audio files is much less time-consuming than having to recapture all the source material.
- Put the various tapes of a specific scene into one file (also called a *bin*) and those of the next scene in another. This storage method will make it easier for you to visualize where things are and to call up the various shots.

MAIN POINTS

- There are two basic editing modes, off-line and on-line. Off-line in linear editing means to use lower-quality equipment for the rough cut; in nonlinear editing it means to capture the selected shots in low-resolution. It can be used by both systems to produce an edit decision list (EDL). On-line means for both systems to prepare the final edit master tape.
- Linear systems are all tape-based and do not allow random access of information. Nonlinear systems are all disk-based and allow random access.

- Linear editing is performed with single-source, expanded single-source, and multiple-source systems. Single-source systems have a source (or play) VTR and a record (or edit) VTR, which are normally governed by an edit controller. Expanded single-source systems may contain an audio mixer, a switcher, and a C.G. (character generator). Multiple-source systems have two or more source VTRs and permit a great variety of transitions.
- The control track, or pulse-count, linear editing system uses pulses of the control track for locating specific edit-in and -out points, automatic prerolling of the source and record VTRs, previewing and executing the edit at a specific point on the edit master tape, and reviewing the edit. The control track system does not supply a specific frame address, however, and is not frame-accurate.
- Time code editing uses a specific code that gives each frame a unique address. It fulfills the same functions as the control track system but is frame-accurate. The most popular time code is the SMPTE/EBU time code.
- In assemble editing all video, audio, control, and address tracks on the edit master tape are erased to make room for the shot to be copied over from the source tape (containing its own video, audio, and control track information for the record VTR). The record VTR will regenerate the control tracks of the copied shots and try to form a continuous control track. If the newly assembled control track is not perfectly aligned, the edits will cause brief video breakups—or sync rolls—at the edit points.
- In insert editing the entire control track is prerecorded continuously on the edit master tape before any editing takes place. It prevents breakups at the edit points and allows separate video and audio editing.
- In AB rolling two VTRs (A-roll and B-roll) feed their material simultaneously into two separate video inputs of the switcher. The editing is done by switching between the A-roll and the B-roll tapes.
- In AB-roll editing the switcher is replaced by the edit controller, which helps select the various shots from the source A VTR and the source B VTR.
- Nonlinear editing (NLE) requires capturing all analog and digital source tapes on the hard disk or optical disc storage systems. Digital source tapes must still be transferred to the hard disk of the editing system. Most storage systems use some kind of compression to store a maximum amount of video and audio data.
- The re-editing phase consists of the shooting phase, the review phase, and the preparation phase.
- The editing procedures include shot selection, shot sequencing, audio sweetening, and creation of the final edit master tape.

13.2

Making Editing Decisions

Good editors must be able to tell a story efficiently while maximizing viewer interest. This requires that they operate an editing system, visualize a smooth shot sequence while looking at a number of single shots, and select the appropriate transitions for such a sequence. Good editors can also detect continuity problems, such as the talent holding the coffee cup in his left hand in the medium shot and in his right hand in the following close-up. Once you have mastered the editing system you are using, you will realize that the real art of editing is in storytelling and applying aesthetic sequencing principles. This section demonstrates some of the major ones.³

EDITING FUNCTIONS

Combine, shorten, correct, and build

BASIC TRANSITION DEVICES

The cut, the dissolve, the wipe, and the fade

MAJOR EDITING PRINCIPLES

Continuity editing (subject identification, the mental map, vectors, movement, color, and sound), complexity editing, context, and ethics

EDITING FUNCTIONS

Editing is done for different reasons. Sometimes you need to arrange shots so that they tell a story. Other times you may have to eliminate extraneous material to make a story fit a given time slot, or you may want to cut out the shot where the talent stumbled over a word or substitute a close-up for an uninteresting medium shot. These different reasons are all examples of the four basic editing functions: (1) combine, (2) shorten, (3) correct, and (4) build.

COMBINE

The simplest editing is combining program portions by hooking the various video-recorded pieces together in the proper sequence. The more care that was taken during the production, the less work you have to do in postproduction. For example, most soap operas are shot in long, complete scenes or in even longer sequences with a multicamera studio setup; the sequences are then combined in postproduction. Or, you may select various shots taken at a friend's wedding and simply combine them in the order in which they occurred.

SHORTEN

Many editing assignments involve cutting the available material to make the final videotape fit a given time slot or to eliminate extraneous material. As an ENG editor, you will find that you often have to tell a complete story in an unreasonably short amount of time and that you have to pare down the available material to its bare minimum. For example, the producer may give you only twenty seconds to tell the story of a downtown fire, although the ENG team had proudly returned with twenty minutes of exciting footage.

Paradoxically, when editing ENG footage, you will discover that although you have an abundance of similar material, you may lack certain shots to tell the story coherently. For example, when screening the fire footage you may find that there are many beautiful shots of flames shooting out of windows and of firefighters on ladders, pouring water into the building, but no pictures of the wall collapsing, which injured a firefighter.

CORRECT

Much editing time is spent on correcting mistakes, either by eliminating unacceptable portions of a scene or by replacing them with better ones. This type of editing can be simple—merely cutting out the part during which the talent coughed and replacing it with a retake. But it can also be challenging, especially if the retake does not match

For a more detailed treatment of aesthetic principles, see Herbert Zettl, Sight Sound Motion, 4th ed. (Belmont, Calif.: Thomson Wadsworth, 2005).

the rest of the recording. You may find, for example, that some of the corrected scenes differ noticeably from the others in color temperature, sound quality, or field of view (shot too close or too loose in relation to the rest of the footage). In such cases the relatively simple editing job becomes a formidable postproduction challenge and, in some cases, a nightmare. Although most nonlinear editing software makes remarkably powerful color correction features available, applying them is often a tedious and highly time-consuming affair. This is one of the reasons why you should pay particular attention to color matching during production.

BUILD

The most difficult, but also the most satisfying, editing assignments are when you can build a show from a great many takes. Postproduction is no longer ancillary to production but constitutes the major production phase. For example, when you use a single camcorder during a filmstyle field production, you need to select the best shots and put them in the proper sequence in postproduction editing. Film-style refers to a motion picture technique whereby you repeat a brief scene several times and shoot it from a variety of angles and fields of view, irrespective of the scripted event sequence. But when editing these shots, you cannot simply select some and combine them in the sequence in which they were taken; rather, you have to go back to the script and rearrange the shots to fit the story line. The story is literally built shot-by-shot. ZVL12 EDITING→ Functions→ select | combine | condense | correct | try it

BASIC TRANSITION DEVICES

Whenever you put two shots together, you need a *transition*—a device that implies that the two shots are related. There are four basic transition devices: (1) the cut, (2) the dissolve, (3) the wipe, and (4) the fade. In addition, there are countless special effects available that can serve as transitions. Examples are flips, page turns, or fly effects (see chapter 14). Although they all have the same basic purpose—to provide an acceptable link between shots—they differ in function, that is, how we are to perceive the transition in a shot sequence.

CUT

The *cut* is an instantaneous change from one image (shot) to another. It is the most common and least obtrusive transition device, assuming that the preceding and following shots show some continuity. The cut itself is not visible; all

you see are the preceding and following shots. It resembles most closely the changing field of the human eye. Try to look from one object to another located some distance away. Notice that you do not look at things in between, as you would in a camera pan, but that your eyes jump ahead to the second position, as in a cut.

The cut, like all other transition devices, is basically used for the clarification and intensification of an event. *Clarification* means that you show the viewer the event as clearly as possible. For example, in an interview show the guest holds up the book she has written. To help the viewer identify the book, you cut to a close-up of it.

Intensification means that you sharpen the impact of the screen event. In an extreme long shot, for example, a football tackle might look quite tame; when seen as a tight close-up, however, the action reveals its brute force. By cutting to the close-up, the action has been intensified.

DISSOLVE

The *dissolve*, or *lap dissolve*, is a gradual transition from shot to shot, the two images temporarily overlapping. Whereas the cut itself cannot be seen on-screen, the dissolve is a clearly visible transition. Dissolves are often used to provide a smooth bridge for action or to indicate the passage of time. Depending on the overall rhythm of an event, you can use slow or fast dissolves. A very fast one functions almost like a cut and is therefore called a *soft cut*. For an interesting and smooth transition from a wide shot of a dancer to a close-up, for instance, simply dissolve from one camera to the other. When you hold the dissolve in the middle, you will create a *superimposition*, or *super*. A slow-dissolve will indicate a relatively long passage of time; a fast dissolve, a short one.

Because dissolves are so readily available in NLE software, you may be tempted to use them more often than necessary or even desirable. A dissolve will inevitably slow down the transition and, with it, the scene. If dissolves are overused, the presentation will lack precision and accent and will bore the viewer.

WIPE

There is a great variety of *wipes* available, the simplest of which is when the base picture is replaced by another one that moves conspicuously from one screen edge to the other. Other wipe effects look as though the top picture is peeled off a stack of others, or a diamond expanding from the center of the top picture gradually shows the one underneath. The wipe is such an unabashed transition device that it is normally classified as a special effect.

The wipe tells the viewers that they are definitely going to see something else, or it injects some interest or fun into the shot sequence. Wipes and other such effects are especially magnified on the large 16×9 HDTV screen. Like with any other special effect, you should use discretion; overused or inappropriate wipes easily upstage the shots they are connecting. (The various wipes and special-effects transitions are discussed in chapter 14.)

FADE

In a *fade* the picture either goes gradually to black (*fade-out*) or appears gradually on the screen from black (*fade-in*). You use the fade to signal a definite beginning (fade-in) or end (fade-out) of a scene. Like the curtain in a theater, it defines the beginning or the end of a portion of a screen event.

As such, the fade is technically not a true transition. Some directors and editors use the term *cross-fade* for a quick fade to black followed immediately by a fade-in to the next image. Here the fade acts as a transition device, decisively separating the preceding and following images from each other. The cross-fade is also called a *dip to black*.

You are certainly familiar with the unfortunate tendency to cut directly from one commercial to the other without connecting them with some transition device that would tell us where one commercial ends and the other begins. Such juxtapositions can easily lead to embarrassing meanings, similar to a montage effect in film, where two adjoining images are intended to create special meanings.

A brief dip to black could reduce, or even eliminate, this potentially funny or inappropriate montage effect.

That said, do not go to black too often—the program continuity will be interrupted too many times by fades that all suggest final endings. The other extreme is the nevergo-to-black craze: some directors do not dare go to black for fear of giving the viewer a chance to switch to another channel. If a constant dribble of program material is the only way to hold a viewer's attention, however, the program content, rather than the presentation techniques, should be examined. ZVL13 SWITCHING→ Transitions→ fade | try it

MAJOR EDITING PRINCIPLES

To give your editing direction and make your sequencing choices less arbitrary, you need to know the purpose of the show and the specific context of the event you are to re-create through editing. For example, the event context for the five out-of-order shots (clips) in figure 13.20 is a young woman getting into her car to drive home after work. **SEE 13.20** Take a close look at these five frames, representing the beginnings of brief shots recorded on the source tape. How would you arrange them so that they cut together well while effectively telling the story?

Without peeking ahead, renumber the shots in the order you would sequence them to tell the story of the woman getting into the car and driving off. Now look at the three edited versions. **SEE 13.21-13.23** Identify the one you think is the best combination of shots.

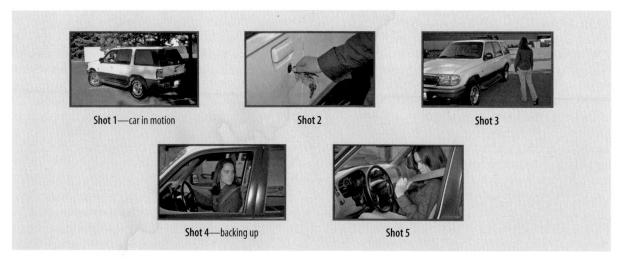

13.20 SOURCE TAPE SHOT SEQUENCE

The event context for these shots is a woman getting into a car to drive home after work. This sequence is as it appears on the source tape.

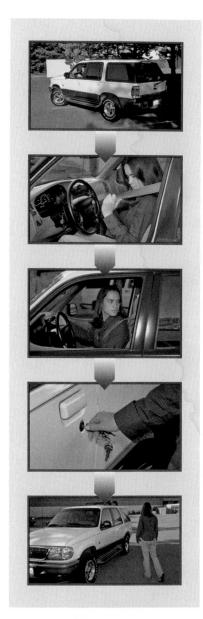

13.21 EDITING SEQUENCE 1 Evaluate this sequence to determine whether the shots are ordered to provide event continuity.

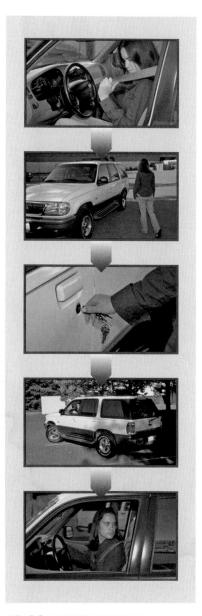

13.22 EDITING SEQUENCE 2 Evaluate this sequence to determine whether the shots are ordered to provide event continuity.

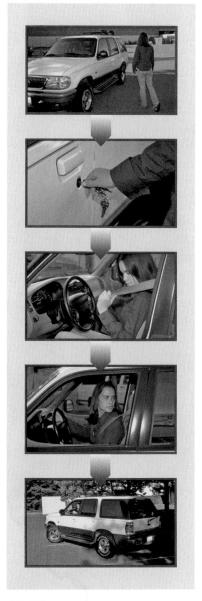

13.23 EDITING SEQUENCE 3 Evaluate this sequence to determine whether the shots are ordered to provide event continuity.

If you selected sequence 3, you made the right choice. Here's why: Obviously, the driver needs to walk to the car (shot 3) and unlock the door (shot 2) before fastening the seat belt (shot 5). The next action is to back the car out (shot 4). Finally, we see the car driving off (shot 1).

Nonlinear editing is not unlike the preceding exercise: to supply structure to a number of shots, initially represented as individual stills, which you then run as clips. You probably noticed that this is the exact opposite of linear editing, where you start out with running sequences and then freeze particular frames that mark the edit points.

This shot selection was based primarily on story continuity. Equally important aspects of editing concern complexity editing and preserving context. You should realize that all editing principles—including aesthetic ones—are conventions and not absolutes. They work well under most circumstances and are a basic part of the visual literacy of most television viewers and production personnel. Depending on the event context and the communication aim, some of the "do's" of editing may easily become the "don'ts" and vice versa.

CONTINUITY EDITING

Continuity editing refers to the achievement of story continuity despite the fact that great chunks of the story are

actually missing, and to assemble the shots in such a way that viewers are largely unaware of the edits. Specifically, you need to observe these aesthetic factors: (1) subject identification, (2) the mental map, (3) vectors, (4) movement, (5) color, and (6) sound.

Subject identification The viewer should be able to recognize a subject or an object from one shot to the next. Therefore, avoid editing between shots of extreme changes in distance. **SEE 13.24** If you cannot maintain visual continuity for identification, bridge the gap by telling the viewer that the shot is, indeed, the same person or thing. **ZVL14** EDITING→ Continuity→ subject ID

Despite what was just noted, trying to edit together shots that are too similar can lead to even worse trouble—the *jump cut*. This occurs when you edit shots that are identical in subject yet slightly different in screen location; the subject seems to jerk from one screen location to another as if pushed by an unseen force. **SEE 13.25** To avoid a jump cut, try to find a succeeding shot that shows the object from a different angle or field of view, or insert a cutaway shot. **SEE 13.26**

Mental map Because television has a relatively small screen, we normally see little of a total scene in the on-

13.24 EXTREME CHANGES IN DISTANCE

When you cut from an extreme long shot to a tight close-up, viewers may not recognize exactly whose close-up it is.

13.25 JUMP CUT

If the size, screen position, or shooting angle of an object is only slightly different in two succeeding shots, the object seems to jump within the screen.

13.26 CUTAWAYYou can avoid a jump cut by changing image size and/or angle of view or by separating the two shots with a cutaway, as shown here.

screen space. Rather, the many close-ups suggest, or should suggest, that the event continues in the off-screen space. What you show in the on-screen space defines the off-screen space as well. For example, if you show person A looking screen-right in a close-up, obviously talking to an off-screen person (B), the viewer would expect person B to look screen-left on a subsequent close-up. **SEE 13.27 AND 13.28** What you have done—quite unconsciously—is help the

viewer construct a *mental map* that puts people and things in a logical place regardless of whether they are in on- or off-screen space. Once the map is in place, the viewer expects the subsequent screen positions to adhere to it.

The mental map is so strong that if the subsequent shot showed person B also looking screen-right, the viewer would think that both persons A and B are talking to a third party.

13.27 MENTAL MAP SHOT 1Here person A's screen-right gaze (his index vector) suggests that person B must be located in the off-screen space to the right.

13.28 MENTAL MAP SHOT 2 When we now see person B in a close-up looking screen-left, we assume person A to be in the left off-screen space.

13.29 MAINTAINING SCREEN POSITIONS IN REVERSE-ANGLE SHOOTING

In this over-the-shoulder reverse-angle shot sequence, the interviewer and the interviewee maintain their basic screen positions.

To help you facilitate and maintain the viewer's mental map, you need to know something more about vectors.

Vectors Continuity editing is little more than using graphic, index, and motion vectors in the source material to establish or maintain the viewer's mental map. If you were to apply the vectors to the example of on-screen person A talking to off-screen person B, the screen-right index vector of A needs to be edited to the screen-left index vector of B. Although the index vectors of the two persons are converging in off-screen space, they indicate that A and B are talking with each other rather than away from each other.

Maintaining screen positions is especially important in over-the-shoulder shots. If, for example, you show a reporter interviewing somebody in an over-the-shoulder two-shot, the viewer's mental map expects the two people to remain in their relative screen positions and not switch places during a reverse-angle shot. **SEE 13.29**

One important aid in maintaining the viewer's mental map and keeping the subjects in the expected screen space in reverse-angle shooting is the vector line. The *vector line* (also called the *line*, the *line of conversation and action*, or the *hundredeighty*) is an extension of converging index vectors or of a motion vector in the direction of object travel. **SEE 13.30**

When doing reverse-angle switching from camera 1 to camera 2, you need to position the cameras on the same side of the vector line. **SEE 13.31** Crossing the line with one of the two cameras will switch the subjects' screen positions and make them appear to be playing musical chairs, thus upsetting the mental map. **SEE 13.32**

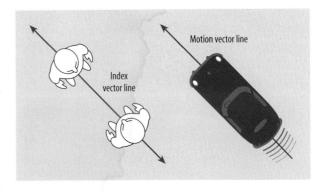

13.30 VECTOR LINE

The vector line is formed by extending converging index vectors or a motion vector.

Crossing the motion vector line with cameras (placing cameras on opposite sides of a moving object) will reverse the direction of object motion every time you cut. You will also see the opposite camera in the background. **SEE 13.33** To continue a screen-left or screen-right object motion, you must keep both cameras on the same side of the vector line. **ZVL15** EDITING→ Continuity→ mental map | try it

Movement When editing, or cutting an action with a switcher, try to continue the action as much as possible from shot to shot. The following discussion covers some of the major points to keep in mind.

To preserve motion continuity, cut *during* the motion of the subject, not before or after it. For example, if you have a close-up of a man preparing to rise from a chair, cut to a wider shot just after he has started to rise but before

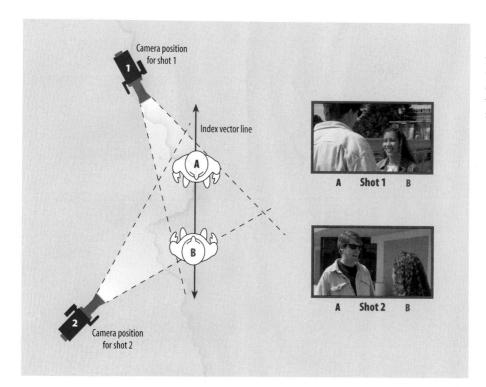

13.31 VECTOR LINE AND PROPER CAMERA POSITIONS

To maintain the screen positions of persons A and B in over-the-shoulder shooting, the cameras must be on the same side of the vector line.

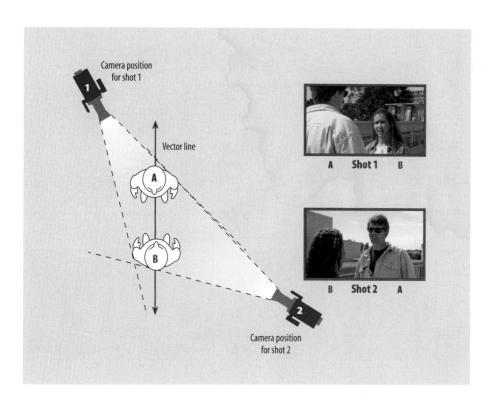

13.32 CROSSING THE VECTOR LINE

When one of the cameras crosses the vector line, persons A and B will switch positions every time you cut between the two cameras.

13.33 CROSSING THE MOTION VECTOR LINE

When crossing the motion vector line with cameras, the object motion will be reversed in each shot.

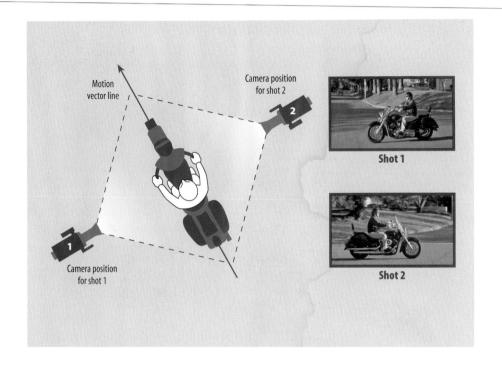

he finishes the movement. Or, if you have the choice, you can let him almost finish the action on the close-up (even if he goes out of the frame temporarily) before cutting to the wider shot. But do not wait until he has finished getting up before going to the wider shot. **ZVL16** EDITING > Continuity > cutting on motion

If one shot contains a moving object, do not follow it with a shot that shows the object stationary. Similarly, if you follow a moving object in one shot with a camera pan, do not cut to a stationary camera in the next shot. Equally jarring would be a cut from a stationary object to a moving one. You need to have the subject or camera move in both the preceding and the subsequent shots.

When working with footage in which the action has been shot from both sides of the motion vector line (resulting in a reversal of screen directions), you must separate the two shots with a cutaway or a head-on shot so that the reversed screen direction can be perceived as continuing. **SEE 13.34**

Color One of the most serious continuity problems occurs when colors in the same scene don't match. For example, if the script for an EFP calls for an exterior MS (medium shot) of a white building followed by an MS of somebody walking to the front of the same building, it should not suddenly turn blue. As obvious as such a discrepancy may be, color continuity is not always easy

13.34 CUTAWAY

If you want to suggest continuing motion of two shots that show the objects converging, you need to insert a cutaway that has a neutral screen direction.

to maintain, even if you are careful to white-balance the cameras for each new location and lighting situation. What can throw you off are lighting changes you may not notice in the fervor of production. For example, the temporary blocking of the sun by some clouds can drastically influence the color temperature, as can the highly polished red paint of a car reflecting onto the white shirt of a person standing next to it.

The more attention you pay to white-balancing the camera to the prevailing color temperature of the lighting, the easier it is to maintain color continuity in postproduction. As mentioned before, any type of color correction in postproduction is difficult and time-consuming.

Sound When editing dialogue or commentary, take extra care to preserve the general rhythm of the speech. The pauses between shots of a continuing conversation should be neither much shorter nor much longer than the ones in the unedited version. In an interview the cut (edit or switcher-activated) usually occurs at the end of a question or an answer. Reaction shots, however, are often smoother when they occur during, rather than at the end of, phrases or sentences. But note that action is generally a stronger motivation for a cut than dialogue. If somebody moves during the conversation, you must cut on the move, even if the other person is still in the middle of a statement.

ZVL17 EDITING→ Continuity→ sound

As discussed in chapter 10, ambient (background) sounds are very important in maintaining editing continuity. If the background noise acts as environmental sounds, which give clues to where the event takes place, you need to maintain these sounds throughout the scene, even if it was built from shots actually taken from different angles and at different times. You may have to supply this continuity by mixing in additional sounds in the postproduction sweetening sessions.

When editing video to music, try to cut with the beat. Cuts determine the beat of the visual sequence and keep the action rhythmically tight, much as the bars measure divisions in music. If the general rhythm of the music is

casual or flowing, dissolves are usually more appropriate than hard cuts. But do not be a slave to this convention. Cutting "around the beat" (slightly earlier or later than the beat) on occasion can make the cutting rhythm less mechanical and intensify the scene.

COMPLEXITY EDITING

Complexity editing is a deliberate break with editing conventions to increase the complexity and intensity of a scene. Your selection and sequencing of shots is guided no longer by the need to maintain visual and aural continuity but by ways of getting and keeping the viewers' attention and increasing their emotional involvement. Complexity editing does not mean that you should flaunt the rules of continuity editing but rather that you may deliberately break some of them to intensify your communication intent.

Many commercials use complexity editing to make us sit up and take notice. Even the jump cut has gained prominence as an aesthetic intensifier. You have undoubtedly seen the erratic editing that makes a person jump from one screen location to the next, even when he is only talking about the virtues of a credit card. Much of music television (MTV) editing is based on the complexity principle. Although hardly necessary, the jarring discontinuity of shots further intensifies the high energy of the music.

Complexity editing is also an effective intensification device in television plays. For example, to capture the extreme confusion of a person driven to the point of a breakdown, you may want to cross the vector line with the cameras to show the person in a quick series of flip-flop shots. **SEE 13.35**

CONTEXT

In all types of editing, but especially when editing news stories and documentaries, you must preserve the true context in which the main event took place. Assume that the news footage of a speech by a local political candidate contains a funny close-up of an audience member sound asleep. But when you screen the rest of the footage, you discover that all the other audience members were

13.35 COMPLEXITY EDITING

Here the shooting from both sides of the vector line creates a disturbing flip-flop, intensifying the subject's confusion.

not only wide awake but quite stimulated by the candidate's remarks. Are you going to use the close-up? Of course not. The person asleep was in no way representative of the overall context in which the event—the speech—took place.

You must be especially careful when using stock shots in editing. A *stock shot* depicts a common occurrence—clouds, beach scenes, snow falling, traffic, crowds—that can be applied in a variety of contexts because its qualities are typical. Some television stations either subscribe to a stock-shot library or maintain their own collections.

Here are two examples of using stock shots in editing: When editing the speech by the political candidate, you find that you need a cutaway to maintain continuity during a change in screen direction. You have a stock shot of a news photographer. Can you use it? Yes, because a news photographer certainly fits into the actual event context. But should you use a stock shot of the audience happily clapping after the candidate reads the grim statistics of Labor Day traffic accidents, just to preserve visual continuity? Definitely not. The smiling faces of the audience are certainly out of place in this context.

ETHICS

Because as editor you have even more power than the cameraperson over what and what not to show and to construct different meanings of the basic event footage, this section ends with a brief discussion of *ethics*, or principles of right conduct.

The willful distortion of an event through editing is not a case of poor aesthetic judgment but a question of ethics. The most important principle for the editor, as for all production people working with the presentation of nonfictional events (news and documentaries rather than drama), is to remain as true to the actual event as possible. For example, if you were to add applause simply because your favorite political candidate said something you happen to support, although in reality there was dead silence, you would definitely be acting unethically. It would be

equally wrong to edit out all the statements that go against your convictions and leave only the ones with which you agree. If someone presents pro and con arguments, be sure to present the most representative of each. Do not edit out all of one side or the other to meet the prescribed length of the segment.

Be especially careful when juxtaposing two shots that may generate by implication a third idea not contained in either of the two shots. To follow a politician's plea for increased armaments with the explosion of an atomic bomb may unfairly imply that this politician favors nuclear war. These types of montage shots are as powerful as they are dangerous. Montage effects between video and audio information are especially effective; they may be more subtle than the video-only montages but are no less potent. For example, adding the penetrating and aggravating sounds of police sirens to the footage of "for sale" signs of several houses in a wealthy neighborhood would probably suggest that the neighborhood is changing for the worse. The implied message is to not buy any houses in this "crimeridden" neighborhood.

Do not stage events just to get exciting footage. For example, if a police officer has made a successful rescue and all you got was the rescued person on a stretcher, do not ask the officer to return to the scene of the accident to simulate the daring feat. Although reenactments of this sort have become routine for some ENG teams, stay away from them. There is enough drama in all events if you look closely enough and take effective pictures. You do not have to stage anything.

Finally, you are ultimately responsible to the viewers for your choices as an editor. Do not violate the trust they put in you. As you can see, there is a fine line between intensifying an event through careful editing practices and distorting an event through careless or unethical ones. The only safeguard the viewers have against irresponsible persuasion and manipulation is your responsibility as a professional communicator and your basic respect for your audience.

MAIN POINTS

- The four basic editing functions are: (1) to combine—to hook various videotaped pieces together pretty much in the sequence in which they were videotaped; (2) to shorten—to make the program fit a given time slot and to eliminate extraneous material; (3) to correct—to cut out bad portions of a scene and replace them with good ones; and (4) to build—to select and sequence shots that will advance a specific story.
- There are four basic transition devices: (1) the cut—an instantaneous change from one shot to another; (2) the dissolve—a temporary overlapping of two shots; (3) the wipe—having one image gradually replace another in various ways; and (4) the fade—having the picture gradually appear from black or go to black.
- There is a great variety of special effects that also can be used for transitions.
- The three major editing principles are continuity, complexity, and maintaining context.
- Continuity editing means to establish continuity in subject identification, subject placement, movement, color, and sound. It should facilitate the viewer's mental map of where things are or should be or where they should move.
- Graphic, index, and motion vectors are pictorial forces that play an important part in establishing and maintaining continuity from shot to shot.
- Complexity editing is a deliberate break with editing conventions to increase the complexity and intensity of a scene.
- In editing nonfiction, ethics becomes the overriding editing principle.

ZETTL'S VIDEOLAR

For your reference, or to track your work, each Video-Lab program cue in this chapter is listed here with its corresponding page number.

ZVL1 EDITING→ Editing introduction 284

ZVL2 EDITING→ Linear editing→ system 290

ZVL3 EDITING→ Postproduction guidelines→ tape basics 292

EDITING→ Postproduction guidelines→ time code 293

ZVL5 EDITING→ Nonlinear editing→ system 298

ZVL6 EDITING→ Production guidelines→ pickup 300

EDITING→ Production guidelines→ cutaways 300

7471-8 EDITING→ Postproduction guidelines→ VTR log

ZVL9 EDITING→ Continuity→ vectors 303

ZVL10 EDITING -> Continuity -> quiz 304

ZVL11 EDITING→ Linear editing→ paper edit 304

ZVL12 EDITING→ Functions→ select | combine | condense | correct | try it

ZVL13 SWITCHING→ Transitions→ fade | try it 310

ZVL14 EDITING→ Continuity→ subject ID 312

ZVL15 EDITING→ Continuity→ mental map | try it 314

ZVL16 EDITING→ Continuity→ cutting on motion 316

ZVL17 EDITING→ Continuity→ sound

317

14

Visual Effects

Even news presentations are so loaded with video special effects that they often rival, if not surpass, the latest video games. Titles dance across the screen, change color, and zoom in and out. News anchors, field reporters, and guests are squeezed into side-by-side boxes when talking to one another. The brief stories that introduce the latest troubles in this world often end in a freeze-frame and then peel off the screen and tumble out of sight to make room for the next batch of maladies.

The screen is often loaded with simultaneous information. While the anchor's comments about a tragic traffic accident are accompanied by graphic video footage, the stock market quotes crawl across the bottom of the screen, and the side panel reveals the latest sports scores and weather. Throughout it all, the station or network logo is solidly embedded in a corner.

Such electronic wizardry is so readily available that it may tempt you to substitute effect for content. Do not fall into the trap of camouflaging insignificant content or poorly shot or edited pictures with electronic effects. As dazzling as the effects may be, they cannot replace the basic message. When used judiciously, however, many effects can enhance production considerably and give the message added impact.

Whenever you intend to use a visual effect, ask yourself: *Is it really necessary? Does it help clarify and intensify my message? Is it appropriate?* For example, a freeze-frame showing the new tennis champion lifting her trophy in triumph is a perfectly appropriate closing shot; to apply the same technique to a victim of a terrorist bombing is not. If you can answer yes to these three basic questions, leave the effect in. If you answer no or even maybe to any of them, leave it out.

In section 14.1, Electronic Effects and How to Use Them, we examine standard electronic effects and digital video effects; section 14.2, Nonelectronic Effects and How to Use Them, looks at some of the more practical optical and mechanical effects.

KEY TERMS

- chroma keying Effect that uses color (usually blue or green) for the backdrop, which is replaced by the background image during a key.
- **computer-manipulated DVE** Digital video effects created by a computer using an existing image (camera-generated video sequence, video frame, photo, or painting) and enhancing or changing it in some way.
- **defocus** Simple yet highly effective optical effect wherein the camera operator zooms in, racks out of focus, and, on cue, back into focus again. Used as a transitional device or to indicate strong psychological disturbances or physiological imbalance.
- **diffusion filter** Filter that attaches to the front of the lens; gives a scene a soft, slightly out-of-focus look.
- **digital video effects (DVE)** Visual effects generated by a computer or digital effects equipment in the switcher.
- **gobo** In television, a scenic foreground piece through which the camera can shoot, thus integrating the decorative foreground with the background action. In film a gobo is an opaque shield used for partially blocking a light, or the metal cutout that projects a pattern on a flat surface.

- **key** An electronic effect. *Keying* means cutting with an electronic signal one image (usually lettering) into a different background image.
- **matte key** Keyed (electronically cut in) title whose letters are filled with shades of gray or a specific color.
- special-effects generator (SEG) An image generator built into the switcher that produces special-effects wipe patterns and key effects.
- **star filter** Filter that attaches to the front of the lens; changes prominent light sources into starlike light beams.
- **super** Short for *superimposition*. A double exposure of two images, with the top one letting the bottom one show through.
- wipe Transition in which a second image, framed in some geometric shape, gradually replaces all or part of the first image.

14.1

Electronic Effects and How to Use Them

A judicious use of visual effects presupposes that you know which effects are available. Some effects can be readily created during a production, such as title keys and various wipes; others need to be built with digital equipment in the pre- or postproduction phase. This section discusses the two major types of visual effects.

STANDARD ANALOG VIDEO EFFECTS

Superimposition, key, chroma key, and wipe

DIGITAL VIDEO EFFECTS

Computer-manipulated effects; manipulation of image size, shape, light, and color; manipulation of motion; and manipulation of multi-images.

STANDARD ANALOG VIDEO EFFECTS

The *special-effects generator* (*SEG*) is built into all production switchers. It can produce a dazzling variety of special effects reliably and with ease. Many electronic effects have become so commonplace in television production that they have lost their specialty status and are simply considered part of the standard visual arsenal. These include (1) the superimposition, (2) the key, (3) the chroma key, and (4) the wipe. You can accomplish all of these effects with the standard analog switcher and its built-in SEG.

SUPERIMPOSITION

A superimposition, or super for short, is a form of double exposure. The picture from one video source is electronically superimposed over the picture from another. As explained in chapter 11, the super is easily achieved by activating both mix buses with the fader bar (see figure 11.9b). A distinct characteristic of a super is that you can see through the superimposed image to the one that lies beneath it. You can then vary the strength of either picture (signal) by moving the fader bar toward one mix bus or the other.

In case you cannot key a title over a background image, you can still use a super for the title effect. When "supering" titles, one camera is focused on the super card, which has white letters on a black background. The background picture can be supplied by either another camera (focused on a live event, such as a long shot of a sports stadium) or any other video source. Because the black card does not reflect any light, or only an insignificant amount, it will remain invisible during the mixing of the two video sources.

More often supers are used for creating the effects of inner events—thoughts, dreams, or processes of imagination. The traditional (albeit overused) super of a dream sequence shows a close-up of a sleeping person, with images superimposed over his or her face. Sometimes supers are used to make an event more complex. For example, you may want to super a close-up of a dancer over a long shot of the same dancer. If the effect is done properly, we are given new insight into the dance. You are no longer photographing a dance but helping create it. **ZVL1** SWITCH-ING→ Transitions→ mix/dissolve

KEY

Keying means using an electronic signal to cut out portions of a television picture and fill them in with various colors or portions of another image. The basic purpose of a key is to add titles to a background picture or to cut another picture (the image of a weathercaster) into the background picture (the satellite weather map). The lettering for the title is generally supplied by a C.G. (character generator) (see chapter 15). You can also use a title card for keying titles. The card looks exactly like the super card (white letters on a black background), but in a key the letters are electronically cut into the base picture and then filled with a white or color signal. SEE 14.1 ZVL2 >SWITCHING→ Effects→ keys

You may be somewhat bewildered hearing about keys, mattes, and matte keys—all seemingly referring to the same thing. It really doesn't matter what term you use, so long

as you are consistent and all members of the production team know what you mean. There are basically three types of keys: (1) the internal key, (2) the external key, and (3) the matte key. Because chroma keying works on a different principle, we discuss it separately later in this section.

Internal key The *internal key* uses two signals—one supplies the background picture, and the other supplies the outline for "cutting" (the letters). The signal that is doing the cutting is also used to fill the holes (in the form of the letters). **SEE 14.2**

To achieve a clean key, in which the letters are cut into the base picture without any tearing or breakup, you may have to first adjust the key-level (or clip) control and the gain control (see chapter 11). On our Grass Valley 100 switcher, the gain control is right above the clip control in the key control section (see figure 11.4). The clip control, or clipper, adjusts the optimal luminance (brightness) level for the key signal, and the gain control adjusts the signal strength. Both have an optimal setting for a clean, tear-free key. You can preset the key effect and then watch the preview monitor to check that the key shows up and whether the letters are tearing or otherwise displaying fuzzy edges. Simply turn the clipper knob until the letters appear sharp. If this maneuver does not fix the problem, adjust the gain control. On many switchers with downstream keyers, you can push down the key-level control to display the total key effect on the preview monitor.

You can, of course, also key shapes of objects into the base picture so long as they have enough contrast relative to the base picture that their edges do not tear.

External key The *external key* uses three signals: the background signal, the hole-cutting signal, and a third signal, often called the foreground signal, which is filling the hole. This third video source can be colors from the C.G., a VTR (videotape recorder), or even a second camera (assuming the background video is also supplied by a camera). For example, if you want to key the charactergenerated letter *L* over a dancer, and you want to fill the *L* with burlap to give it some texture, you could have a second camera focus on a piece of burlap and then combine the effect through external keying so that the letter appears as though it were cut out of burlap. **SEE 14.3** You could also fill the letter, or any other base picture cutout, with an animated scene.

Matte key If the cutout portions of the title are filled with various grays or colors generated by the switcher

14.1 KEY

When keying a title over a base picture, the key signal cuts a hole into the base picture in the shape of the letters supplied by the C.G.

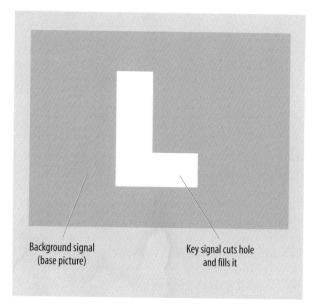

14.2 INTERNAL KEY

In an internal key, the signal that is doing the cutting is also used to fill in the hole.

or embellished with contours or shadows, it is a *matte key*. **SEE 14.4** You can select any of the popular matte key modes: the edge mode, the drop-shadow mode, or the outline mode.

In the *edge mode*, each letter has a thin, black outline around it. **SEE 14.5** In the *drop-shadow mode*, the letters have a black shadow contour that makes them appear

14.3 EXTERNAL KEY

In this example the letter *L* is supplied by the C.G. and keyed into the camera 1 video (base picture of the dancer). Camera 2 is focused on the burlap and supplies the external signal that fills the cutout letters.

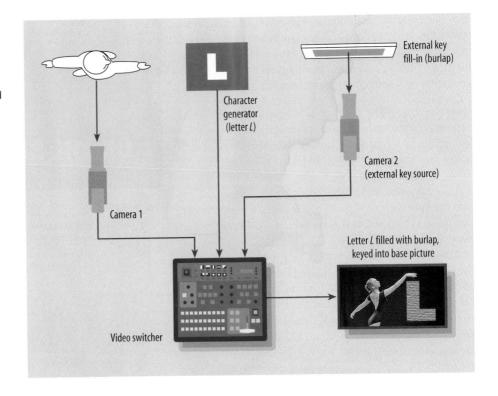

three dimensional. **SEE 14.6** In the *outline mode*, the letters themselves appear in outline form, with the base picture filling the inside. **SEE 14.7**

Most switchers allow you to choose the key mode that will make the titles look attractive or prevent them from getting lost in a busy background. Some keys are semitransparent and let the background show through, similar to a super. This effect is a favorite technique for displaying statistics while still letting you see the full-screen background action.

CHROMA KEY

Chroma keying is a special effect that uses a specific color (chroma), usually blue or green, as the backdrop for the person or object that is to appear in front of the background scene. During the key the blue or green backdrop will be replaced by the background video source without affecting the foreground object. A typical example is the weathercaster standing in front of a weather map or a satellite picture. During the chroma key, the computergenerated weather map or satellite image replaces all blue or green areas—but not the weathercaster. The key effect makes the weathercaster appear to be standing in front of the weather map or satellite image. **SEE 14.8**

Because the chroma key responds to the *hue* of the backdrop rather than to the *brightness* (luminance) contrast as in a regular key, be sure that the chroma-key area is painted uniformly (even blue or green with a fairly high saturation throughout the area) and especially evenly lighted. Uneven background lighting will prevent a full replacement of the blue or green backdrop by the background video or cause the foreground image to tear.

If the on-camera talent wears something similar to the backdrop color, such as a blue sweater, while standing in front of the blue chroma-key area, the blue of the sweater will also be replaced by the background image during the key. Unless you want to shock your audience with a special effect in which part of the weathercaster disappears, don't let him or her wear anything blue in front of the blue chroma-key set. If the talent likes to wear blue, use green as the backdrop color.

Even blue eyes can present a problem during close-ups in chroma keying, although, fortunately, most blue eyes reflect or contain enough other colors and are not saturated enough to keep them from becoming transparent. If the weathercaster stands too close to the chroma-key area, the reflections of the blue background on part of his or her clothing or hair may cause the key to tear. Such

14.4 MATTE KEY

In a matte key, the cutout letter is filled with shades of gray or with a color supplied by the switcher or C.G.

14.5 MATTE KEY IN EDGE MODE

The edge mode matte key puts a black border around the letter to make it more readable than with the normal key.

14.6 MATTE KEY IN DROP-SHADOW MODE

The drop-shadow matte key adds a prominent attached shadow to the letter as though a three-dimensional letter were illuminated by a strong spotlight.

14.7 MATTE KEY IN OUTLINE MODE

The outline matte key makes the letter appear in outline form. It shows only the contour of the letter.

14.8 CHROMA KEY EFFECT: WEATHERCAST

A In this chroma key, the weathercaster stands in front of a blue backdrop.

B During the key the blue backdrop is replaced by this computer-enhanced satellite photo.

C The weathercaster seems to be standing in front of the satellite photo.

problems may also occur especially if the lighting on the weathercaster has extremely fast falloff. The deep shadows, which are apt to be seen as blue by the camera, may cause the image to tear during the key.

Recall that you can counteract this nuisance to some extent by using light-yellow or amber gels on the *back lights* (not background lights) because the yellow or amber back light neutralizes the blue shadows, thus eliminating the tearing. When using green as the chroma-key color, you need to use a light (desaturated) magenta (bluish red) gel to counteract the green reflections.

Studio use of chroma key Despite the availability of highly sophisticated *digital video effects* (*DVE*), the chromakey process is used extensively in various studio production situations. The previous discussion focuses on some of the most popular uses of chroma-key effects in weathercasts, but there are other situations in which chroma keying is equally applicable and effective. Recall the lighting situation discussed briefly in chapter 8: the CEO wanted to give her speech sitting behind her desk, which was in front of a large picture window. Because she is proud of the spectacu-

lar view, she wanted the camera to capture her against the window. If the suggested lighting solutions do not remedy the lighting problems (silhouette effect, high color temperature), you can transport her office into the studio for a chroma-key effect. Set up a similar desk and chair in the studio in front of a blue chroma-key backdrop. Then have a camera focus on a photograph of the spectacular view. Use this camera to supply the background image during the key. Because the studio gives you such good lighting control, you can make the chroma key look almost more realistic than if you were in her actual office. **SEE 14.9**

You can also use chroma keying to create a variety of scenic backgrounds or environments. Assume, for example, that you would like to show a tourist shooting some footage of a museum. The museum background is accessed from an ESS "slide" (electronic still store frame). Camera 1 focuses on the tourist with his camcorder, standing in front of an evenly lighted, well-saturated blue backdrop. Through chroma keying, all the blue areas will be replaced by the background image as provided by the ESS system, and the tourist will appear to be standing in front of the museum. SEE 14.10 ZVL3 SWITCHING→ Effects→ special effects

14.9 CHROMA-KEY EFFECT: WINDOW A In this chroma key, a suitable background view is selected from the ESS (electronic still store) system.

B A studio camera focuses on the office set in front of a green chromakey backdrop.

C Through chroma keying there seems to be a picture window behind the CEO sitting at her desk.

14.10 CHROMA-KEY EFFECT: SIMULATED LOCATION

A The source for the background image is a video frame of the museum exterior from the ESS system.

B The studio camera focuses on the actor playing a tourist in front of a blue chroma-key backdrop.

C All blue areas are replaced by the background image; the tourist appears to be in front of the museum.

Ultimatte The *Ultimatte* is a specific type of blue-screen (chroma) keying. This system produces a crisp and highly stable key that is hard to distinguish from an actual foreground/background scene. It allows you to mix fore-ground and background cameras so precisely so that the lighting and movement of foreground are transferred to the background. For example, if the figure were to move in front of the blue screen during the key, the shadow would also become part of the background and move across the background scene. Some complex multicamera productions, such as soap operas, use Ultimatte to key in ceilings of the realistic sets of living rooms or hallways.

Auto key tracking If you use live action in front of a blue backdrop to key it into a small, three-dimensional set model, such as the interior of an airliner or a spaceship, you need to synchronize the movements of the foreground camera (looking at the live action) and the background camera (looking at the model). This synchronization is necessary to make the shift of perspective of the foreground camera coincide with that of the background camera. For example, if you zoom in on the people in the foreground, the background scene needs to change in size also. Ambitious film and HDTV (high-definition television) productions still rely on such *auto key tracking* effects, although sophisticated computer software can accomplish such perspective synchronization in postproduction quite readily.

EFP chroma key Chroma keying is also useful during electronic field productions and big remotes, especially if the talent is not able to stand directly in front of the desired background scene, such as a stadium or government building. When using a chroma-key effect during a sports remote, for example, the talent may even be in

the studio, with the remote feed (long shot of the football stadium) serving as the chroma-key background.

If you do the chroma keying on location, with the talent standing outdoors, watch out for reflections from the sky. With blue as the chroma-key color, the blue reflections from the sky may fool the chroma keyer and let the background image shine through, or at least cause the edges of the foreground figure to break up. To avoid such problems, switch to green for the chroma-key color and put the talent in front of a green cloth backdrop. \blacktriangleleft

WIPE

In a *wipe* a second image in some geometric shape gradually replaces parts or all of the first (on-air) image. Although, technically, the second picture gradually overlaps the first in some geometric fashion, perceptually it looks as though the second image wipes the first image off the screen.

The two simplest wipes are the vertical and the horizontal. A *vertical wipe* gives the same effect as pulling down a window shade over the screen. Just as the window shade wipes out the picture you see through the window, the image from one camera is gradually replaced by a second image that seems to push the first image upward or downward off-screen. **SEE 14.11** The *horizontal wipe* works in the same way except that the base picture is replaced by the second image from the side. **SEE 14.12** The line that separates the two images is called the *wipe border*. **ZVL4** SWITCHING Transitions wipe | try it

Soft wipe In a *soft wipe*, the wipe border is purposely obscured or eliminated to have the two images blend into each other. You can adjust the softness of the border through a rotary control on the switcher (see figure 11.4).

14.11 VERTICAL WIPE

In a vertical wipe, one picture is gradually replaced by another from the bottom up or from the top down.

14.12 HORIZONTAL WIPE

In a horizontal wipe, one picture is gradually replaced by another from the side.

14.13 SOFT WIPE

In a soft wipe, the demarcation line between the two images—the wipe border—is softened so that the images blend together.

14.14 DIAMOND WIPE

In a diamond wipe, the second video source is gradually revealed in an expanding diamond-shaped cutout.

The soft wipe looks almost like a single shot consisting of two separate images. **SEE 14.13**

Wipe patterns The more complicated wipes can take on geometric shapes. In a *diamond wipe*, one picture starts in the middle of the other picture and wipes it off the screen outwardly in the shape of a diamond. **SEE 14.14** In a *corner wipe*, the second image starts from a screen corner and wipes the base picture off the screen diagonally. *Box wipes* and *circle wipes* are also frequently used: instead of the diamond, the geometric shape is a rectangle or a circle.

You can select the appropriate wipe configuration by pressing the corresponding button in the wipe selectors section of the switcher (see figure 11.4) or by calling up a preprogrammed wipe from the switcher's memory. **SEE 14.15** As pointed out in chapter 11, the speed of the wipe is determined by how fast you move the fader bar or by dialing in a certain *auto transition* rate.

Wipe positions and directions If you activate wipes with the special-effects fader bar, you can stop the wipe anyplace along its travel, depending on how far you move the fader bar. If the switcher has a directional mode switch for wipes, check that it is set properly. In the normal mode,

the vertical wipe moves from top to bottom. In the reversal mode, the wipe moves from bottom to top. Similarly, you can reverse the wipe and have it move from screen-right to screen-left or vice versa. The wipe can also be made to reverse itself in flip-flop fashion every time you move the fader bar.

If you use a box wipe or a circle wipe, you usually have some latitude in changing its shape. For example, you can make an ellipse out of a circle or a rectangle out of a square. With the joystick you can position the wipe pattern (such as a circle wipe) anywhere on-screen (see figure 11.11).

Split screen If you stop a vertical, horizontal, or diagonal wipe before its completion, you get a split-screen effect, or, simply, a *split screen*. Each portion shows a different picture. To set up for an effective split screen with a horizontal wipe, you must have one camera's image (designated for the left half of the split screen) in the left side of the viewfinder and the other camera's image in the right side (for the right half of the split screen). During the wipe the left- and right-screen areas block out each other's unwanted picture portions. **SEE 14.16** It goes without saying that you need to preview such effects before putting them on the air.

14.15 WIPE PATTERNS

The various wipe configurations are normally marked on the buttons in the wipe selectors section of the switcher.

14.16 SPLIT SCREEN

A In this horizontal split-screen effect, camera 1 frames in the left side of the viewfinder the image designated to become the left half of the split screen.

B Camera 2 places its image in the right side of the viewfinder.

C In the completed split-screen wipe, the two images appear in the designated sides of the frame.

Spotlight effect The spotlight effect looks like a softedged circle wipe except that it lets the base picture show through (similar to a super). You can use this effect to draw attention to a specific portion of the screen as though you were shining a spotlight on it. SEE 14.17

DIGITAL VIDEO EFFECTS

As you know, digital video effects (DVE) are much richer and more flexible than their analog counterparts. The computer has an astonishing capacity to manipulate video images and, more important, create new ones. Once a video image is in digital form, you can change its shape and color pretty much at will and add new ones from your digital repertoire. If you need new images, there is an abundance of software programs to create landscapes, sets, cartoon figures, and even realistic-looking people from scratch.

Although many digitally generated video effects are done in postproduction, you will have access to many DVE before and during production. Various weather maps, complex transitions between stories, or animated titles are often done in preproduction and then simply called up by the

14.17 SPOTLIGHT EFFECT

The spotlight effect looks like a soft-edged circle wipe with the base picture showing through.

TD (technical director) when needed. Many less complex DVE are routinely used during a live production, such as placing the anchorperson and guests in side-by-side boxes on-screen or displaying multiple boxes that show different views of a playback of an especially intriguing moment in sports. All nonlinear editing (NLE) systems offer an array of effects for making transitions and combining or altering video images. As you undoubtedly know, effects software can turn your desktop computer into a powerful NLE and DVE machine.

COMPUTER-MANIPULATED EFFECTS

Computer-manipulated DVE take an existing image (camera-generated video sequence, video frame, photo, or painting) and enhance or change it in some way. Although the actual process of digitally manipulating images is quite complicated, the principle is relatively simple. As an example, let's manipulate the color, shape, and size of a video frame showing a close-up of a face. In digitizing the videotape frame, you translate the continuous change of color, brightness, and shapes (analog) of the face into a great number of discrete dots—pixels—each having several assigned values (binary numbers) for such attributes as hue, brightness, saturation, and position. This process is not unlike translating a photo into a tile mosaic.

Let's assume that you want to manipulate a mosaic of your friend that was copied from a photo. You can readily change the color as well as the shape of the face. To make the brown eyes blue, you simply replace some of the brown tiles with blue ones. If you want to make the nose red, you can add some red tiles to the nose. You can also change the shape of the nose. Take some tiles out to make the nose smaller or thinner, or add some to make it bigger. You can also use smaller or larger tiles to decrease or increase the size of the whole head. When using DVE rather than mosaic tiles, such changes are done with incredible speed and accuracy. The computer stores all such effects, so you can retrieve them in an instant.

Fast access to an effect or an effects sequence is especially important when complex effects follow one another in rapid succession during a production, such as a weather or sports report. During the production even the best TD with the most elaborate special-effects switcher could not create in real time all the effects normally contained in *bumpers* (the very brief yet visually complex program material dividing show segments or separating a show from a commercial). This is why complex effects are usually rendered in preproduction and then called up by the TD in production.

When interfacing digital with standard (analog) effects (such as keys and wipes), you can greatly increase the visual effects palette. To make sense out of the potential of DVE, we divide them into three areas: (1) manipulation of image size, shape, light, and color; (2) manipulation of motion; and (3) creation and manipulation of multi-images.

IMAGE SIZE, SHAPE, LIGHT, AND COLOR

A great variety of effects is available for manipulating the size, shape, light, and color of an image. Some of the more prominent are: (1) shrinking and expanding, (2) stretching, (3) positioning and point of view, (4) perspective, (5) mosaic, and (6) posterization and solarization. Many of these DVE change a realistic picture into a basically graphical image.

Shrinking and expanding Shrinking refers to decreasing a picture's size while keeping the entire picture and its aspect ratio (width to height) intact. Unlike cropping, where you actually remove some of the picture information, you simply render the whole picture smaller. DVE allow you to shrink the entire picture from its original full-screen size to a mere point on the screen (zero-size). Or you can do the reverse, starting with a zero-size image and expanding it to full frame or even larger so that you see only a close-up detail of the expanded image. Because the visual effect is similar to a zoom-out (shrinking) or a zoom-in (expansion), this effect is also called a *squeeze-zoom*. **SEE 14.18**

Stretching With DVE you can stretch an image horizontally or vertically. Again, the stretching is not done by cropping the picture to fit a new frame but by distorting the total image so that its borders attain a new aspect ratio. **SEE 14.19**

Positioning and point of view The shrunk (squeeze-zoomed) image can be positioned anywhere in the frame. For example, you can freeze the first frame of a news videotape, shrink the image through a squeeze-zoom in, and position it in a box over the newscaster's shoulder. You can then roll the VTR, letting the story come alive while simultaneously expanding it (squeeze-zoom out) to a full-screen image. **SEE 14.20**

Perspective You can distort an image in such a way that it looks as though it is floating in the three-dimensional video space. When combined with motion, such a 3-D video space is greatly intensified. **SEE 14.21**

14.18 SHRINKING

Through shrinking, also called a squeeze-zoom, you can reduce the total full-frame image to a smaller frame that contains the same picture information.

14.19 STRETCHING

With DVE you can change the aspect ratio of an image so that it appears vertically stretched.

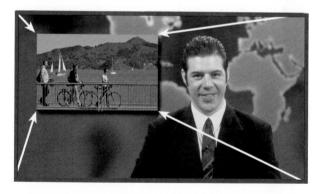

14.20 POSITIONING OF SQUEEZE-ZOOMED IMAGE

In this case a frame from a news clip was shrunk (squeeze-zoomed in) and then placed over the newscaster's shoulder.

14.21 PERSPECTIVE

Through DVE you can distort an image so that it seems to float in the three-dimensional screen space.

Mosaic In the *mosaic* effect, the video image (static or in motion) is distilled into many discrete, equal-sized squares of limited brightness and color (see figure 3.6). The resulting screen image looks like an actual tile mosaic. Such an image appears to contain greatly enlarged pixels.

SEE 14.22 This technique is sometimes used to obscure parts of the body or a guest's identity. The mosaiclike distortion shows the person's face but renders the features unrecognizable.

Posterization and solarization In *posterization* the brightness values (luminance) and the shades of the individual colors are collapsed so that the image is reduced to a few single colors and brightness steps. For example, the colors on a face show up as though they were painted by number with only a few paints. This image looks like a poster, hence the name of the effect. **SEE 14.23**

Solarization combines a positive and a negative image of the subject. Some solarization effects result in a complete

14.22 MOSAIC EFFECT

Here the image is changed into equalsized squares resembling mosaic tiles. In the electronic mosaic, as in a traditional tile mosaic, you can change the size of the tiles.

14.23 POSTERIZATION

In posterization the brightness values are severely reduced. The picture takes on a high-contrast look.

14.24 SOLARIZATION

Solarization is a special effect that is produced by a partial polarity reversal of an image. In a color image, the reversal results in a combination of complementary hues.

polarity reversal, in which the black areas turn white and the white areas turn black. In color the polarity reversal produces complementary colors (yellow and blue, red and green). When combined such effects often look like highly overexposed images. **SEE 14.24**

MOTION

There are so many possibilities for making various effects move that a sensible and common terminology has not yet been developed. Don't be surprised to hear the director in the control room or the editor in the editing room using the sound language of cartoons—"squeeze," "bounce," or "fly"—when calling for certain motion effects. Some terms have been coined by DVE manufacturers, others by imaginative production personnel. Let's look at a few of the more popular effects: (1) slide and peel effects, (2) snapshots, (3) rotation and bounce effects, (4) fly effect, and (5) cube spin.

Slide and peel effects The *slide effect* is the opposite of a horizontal wipe. Instead of having the second picture (B) take over the territory of the first picture (A), in a slide the first picture (A) simply slides to one side, revealing the second picture (B) underneath. **SEE 14.25** The slide effect can also work vertically or diagonally.

A variation of the slide effect is the *peel effect*, wherein image A curls up as though it were peeled off a pad of paper images, revealing image B underneath. **SEE 14.26**

Snapshots The *snapshot effect* consists of multiple freeze-frames that update individually at various rates. What you see on-screen is a kind of ripple effect from image to image. Each frame area can be filled with a separate picture, to build sequentially a multiscreen effect. **SEE 14.27**

Rotation and bounce effects With the *rotation effect*, you can spin any image on all three axes, individually or simultaneously: the x-axis, representing width; the y-axis,

14.25 SLIDE EFFECT

In a slide effect, video A seems to slide off to one side or corner, revealing video B underneath.

14.26 PEEL EFFECT

In a peel effect, video A seems to curl and peel off a stack of pictures, revealing video B underneath.

14.27 SNAPSHOT EFFECT

In a snapshot effect, the individual screen divisions show successively updated freeze-frames.

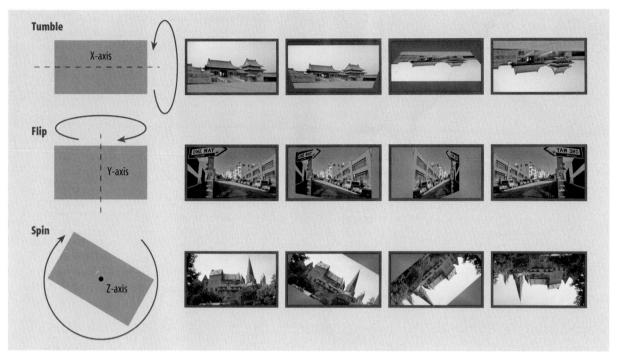

14.28 ROTATION EFFECT

In a rotation effect, the image can be revolved around the x-axis (tumble), the y-axis (flip), and the z-axis (spin).

14.29 BOUNCE EFFECT In a bounce effect, the image seems

In a bounce effect, the image seems to bounce from screen edge to screen edge.

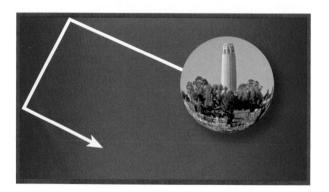

representing height; and the z-axis, representing depth. Although rotation terminology varies, normally a "tumble" refers to an x-axis rotation, a "flip" to a y-axis rotation, and a "spin" to a z-axis rotation. **SEE 14.28**

In a *bounce effect*, the shrunk video A image is deflected from screen edge to screen edge against the video B background. The video A "bouncing ball" can change shape or flip while moving. **SEE 14.29**

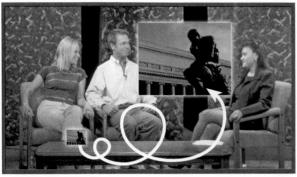

Fly effect In the *fly effect*, a video B insert expands from zero-size and flies to another screen position against the video A background. During the fly video B can rotate, tumble, flip, spin—or whatever tickles your fancy. **SEE 14.30**

Cube spin The rotation can also be applied to three-dimensional effects. The well-known *cube spin* shows a rotating cube, with each of the three visible sides displaying a different static or moving image. **SEE 14.31**

MULTI-IMAGES

The *multi-image effects* include the various possibilities of dividing the screen into sections or of having a specific image update itself. The former we call secondary frame effects, the latter, echo effects.

14.31 CUBE SPIN

In a cube spin, a rotating cube displays a different static or moving image on each of the three visible sides.

Secondary frame The *secondary frame effect* shows several images, each clearly contained within its own frame. A common use of such an effect is to show host and guest simultaneously in separate frames, talking to each other from different locations. To emphasize that they are speaking to each other, although both are actually looking into the camera (at the viewer), the frames are sometimes tilted toward each other through a digital perspective change. **SEE 14.32** You can split the screen into four or more areas, each with four or more people or events displayed.

Echo The *echo effect* is created when a static object is mirrored, similar to seeing yourself many times in opposing barbershop mirrors, or a moving object that leaves a continuous trail of previous positions. **SEE 14.33 AND 14.34** You can also make each successive echo image smaller or

14.32 SECONDARY FRAME EFFECT

The trapezoidal distortion of the frames makes us perceive two people talking to each other rather than to the viewer.

14.33 ECHO EFFECT: STATIC OBJECT

In this echo effect, a static image is repeated many times and the copies are placed in close proximity to one another.

larger so that together they seem to recede to or advance from the vanishing point (where the image seems to disappear at the horizon).

MAIN POINTS

- The two types of electronic visual effects are standard electronic (analog) effects and digital video effects (DVE).
- The four standard electronic effects are the superimposition, key, chroma key, and wipe.
- A superimposition, or super, is a form of double exposure.
 The picture from one camera is electronically superimposed over the picture from another, making the supered image seem transparent.
- Keying means electronically cutting out portions of a television picture and filling them in with a color or a third image. The main purpose of a key is to add titles or objects to a base (background) picture. There are three basic types of keys: internal key, external key, and matte key.

14.34 ECHO EFFECT: MOTION

In this echo effect, the moving dancer trails her previous movements.

- A matte key effect fills the base picture cutouts with various grays or colors generated by the switcher. The standard matte key modes are edge, drop shadow, and outline.
- Chroma keying uses a blue or green backdrop, which, during the key, is replaced by the background image. The foreground image appears to be in front of the keyed background image.
- In a wipe a portion of or a complete television picture is gradually replaced by another. The geometrically shaped wipe configurations can be selected via buttons on the switcher or by calling up a preprogrammed effect from the switcher's memory.
- DVE can be interfaced with standard (analog) effects.
- Some DVE are the result of computer manipulations of camera-generated video. A computer-manipulated effect is often created in real time during the production.
- The more common DVE used in production are prerecorded manipulations of image size, shape, light, and color (shrinking and expanding, stretching, positioning and point of view, perspective, mosaic, and posterization and solarization); motion (slide and peel effects, snapshots, and rotation, bounce, fly, and cube-spin effects); and multiimages (secondary frame and echo effects).

14.2

Nonelectronic Effects and How to Use Them

Will you now need expensive, high-end switchers and computers with unique software programs to create the dazzling digital video effects discussed in section 14.1? Not at all. You will be surprised to find that even a moderate desktop system can create many knock-their-socks-off effects. And you can save a great deal of time and effort by staying with some of the tried-and-true optical and mechanical effects perfected in filmmaking and during the predigital stages of television production.

Optical effects include the use of scenic devices placed in front of the camera or attachments to the lens that manipulate the image. The illusion of snow, rain, or smoke can often be produced more readily by mechanical rather than by digital means. Before using such effects, however, ask whether they are really necessary. If the answer is yes, try them out before the production to ensure that they are reliable. There are two other factors to consider before setting up optical or mechanical effects.

The first is the relative mobility of television equipment. Rather than bringing a cumbersome fog machine into the studio to simulate fog, simply take the camera outside on a foggy day or use a lens filter that simulates fog. When using I-F (internal focus) lenses on ENG/EFP cameras, you can attach any type of filter to the front of the lens and keep it from rotating even when you focus.

The second factor is the enormous communicative power of television audio. In many instances you can

curtail or eliminate a variety of video effects by combining good sound effects with a simple video presentation. The sound of pouring rain, for example, combined with a close-up of a dripping-wet actor may well preclude the use of a rain machine. On television, reaction is often more telling than action. For example, to suggest a car crash, you can simply show a close-up of a shocked onlooker combined with the familiar crashing sounds, making the scene certainly more economical and safer than having stunt drivers wreck new cars.

This section takes a brief look at some of the optical and mechanical effects that are still in use because they have proven to be effective, reliable, and easy to do.

OPTICAL EFFECTS

Television gobos, reflections, star filter, diffusion filters, and defocus

▶ MECHANICAL EFFECTS

Rain, snow, fog, wind, smoke, fire, and lightning

OPTICAL EFFECTS

There are five major optical effects: (1) television gobos, (2) reflections, (3) star filter, (4) diffusion filters, and (5) defocus.

TELEVISION GOBOS

In television and film production, the term gobo enjoys great popularity. Unfortunately, this popularity extends to the number of definitions. In film production gobo is often used to mean flag, which, as you recall, refers to a small solid or semitransparent shield used to block the light from hitting certain areas. In lighting terminology it can stand for cucoloris or cookie, the small metal cutout that is inserted into an ellipsoidal spotlight to produce shadow patterns. In video production a gobo is a cutout or an object that acts as an actual foreground frame for background action. Traditional gobos consist of such foreground pieces as picture frames, prison bars, or oversized keyholes. For example, you may want to introduce a fashion model by looking at her first through a picture frame, then dollying in to a closer shot while losing the picture frame. A simple cardboard cutout can simulate the popular keyhole gobo. The camera can dolly in to it and then look through it to observe the goings on in the magic toy kingdom. A few simple bars attached to mic stands will lock the prisoner firmly in his cell. SEE 14.35

The advantage of using a gobo instead of an electronic key is that you can dolly in to the gobo, or arc past it, to gradually reveal the total background event. To create a

14.35 TELEVISION GOBO This television gobo places the actor behind bars.

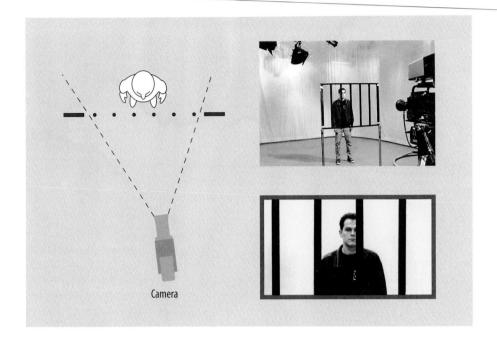

similar effect through DVE would require complicated pre- or postproduction work.

REFLECTIONS

You can achieve startling effects by reflecting a scene off mirrors, silver polyester sheets, or water. You are no doubt familiar with the well-known (and well-worn) over-the-shoulder shot of a person looking into a mirror and then seeing someone approaching from behind. (Be careful that this "someone" isn't the camera!)

Bouncing some lights off a mirror mosaic can produce interesting effects, and shooting into it will make the reflected scene look startlingly cubist. To make such a mirror mosaic, glue several large pieces of a broken mirror onto plywood or Masonite. If you are superstitious, see if your software contains such an effect before breaking a mirror.

Sheets of highly reflecting polyester, such as silver Mylar, serve as a flexible mirror. For example, you can have dancers move in front of suspended panels (such as 10-by-4-foot Mylar sheets) and then point the camera at the reflections. By allowing the Mylar sheets to move (by the air movement from the studio air-conditioning system or a slow-moving fan), you will create a great variety of random effects.

You can achieve a similar effect by pointing the camera at a tub filled with water and then causing the water to ripple. For good reflections the inside of the tub should be

painted black. If you need more control over the reflections, of course, you need to use DVE.

Whenever you want to achieve good reflections, the light must be on the event that is to be reflected and not on the reflector itself. For example, if somebody looks too dark when seen in a mirror or water tub shot, put more light on the person, not on the mirror or water.

STAR FILTER

One of the most common filter effects is created with the *star filter*, a lens attachment that changes high-intensity light sources or reflections into four or six starlike beams. This effect is often used to intensify the street lamps on a rainy night, the beams of car headlights, or the colored lights illuminating a singer or musical group. The studio lights as caught by the wide-angle camera, and even the glitter on the performer's clothes as seen by the close-up camera, are all transformed into prominent starlike rays on the television screen. You can also use a star filter to heighten the emotional impact of a candlelight procession, a church service, or an establishing shot of a night scene. **SEE 14.36**

DIFFUSION FILTERS

Diffusion filters give an entire scene a soft, slightly outof-focus look. Some diffusion filters soften only the edges of a picture and leave the center clear and sharp. Others soften the whole scene. You can use diffusion filters to em-

14.36 STAR FILTER EFFECT
The star filter changes bright light sources into starlike light beams.

phasize the gentle or romantic nature of a scene or even to soften a performer's face. **SEE 14.37** Paradoxically, HDTV has rekindled the use of diffusion filters. In the quest for making electronic cinema look like film, DPs (directors of photography) have been trying out a variety of diffusion filters to soften the harsh, superdefinition of HDTV.

Try experimenting with various filter media that you can stretch over the lens, such as plastic wrap, gauze, or nylon stockings. You may find that software filters look much more artificial than your stocking-over-the-lens method.

A *fog filter*, a specific type of diffusion filter, creates the illusion of fog. If you don't have such a filter, you can achieve a similar effect by very lightly greasing the edges of a piece of glass with a thin layer of petroleum jelly and taping it over the lens. If you grease only the edges, leaving a clear area in the middle, you get a softening of the edges, with the center remaining in sharp focus. *Do not grease the lens directly!* The grease, or its subsequent removal, could permanently damage an expensive zoom lens. Whatever

filter device you use, keep it away from the lens glass—even a small scratch will put a lens out of service.

DEFOCUS

The *defocus* effect is one of the simplest yet most highly effective optical effects. The camera operator simply zooms in, racks out of focus, and, on cue, back into focus again. This effect is used as a transitional device or to indicate strong psychological disturbances or physiological imbalance. A popular rack focus application is to start out of focus on a series of lights, such as burning candles or reflecting water drops, and then rack into focus to reveal the actual light source in the scene.

For a transition you could rack out of focus on a closeup of a young girl seated at a table, change actors quickly, and then rack back into focus on an old woman sitting in the same chair. Because complete defocusing conceals the image almost as completely as going to black, it is possible to change the field of view or the objects in front of the camera while on the air.

MECHANICAL EFFECTS

Mechanical effects are needed mostly in the presentation of television plays. Although small commercial stations may have little opportunity to do drama, colleges and universities are more frequently involved in the production of plays. You may also find that nonbroadcast television productions call for such effects. For example, the studio production of a scene on traffic safety may call for rain, and one on fire safety may call for smoke.

Although the techniques for producing common mechanical effects are not universally agreed upon, such effects offer an excellent opportunity for experimentation.

14.37 DIFFUSION EFFECT A The original close-up without filtration.

B The image takes on a dreamlike quality when shot with a diffusion filter.

Before you engage in applying any mechanical effect, ask yourself three questions: *Is the effect doable? Is it reliable? Is it safe?* If your answer to all three is yes, go ahead. If one of them is a no, resort to your DVD software.

Remember that many effects are best achieved by shooting under the desired conditions. For example, to videotape somebody waiting at a bus stop in the rain, take the camcorder to a bus stop on a rainy day. As mentioned, you can also suggest many situations by showing an effect only partially while relying on the audio track to supply the rest of the information. Also, through chroma keying you can use many effects from a prerecorded source, such as a still photo, a videotape, or the ESS system.

That said, some special effects are relatively easy to achieve mechanically, especially if the effect itself remains peripheral and authenticity is not a primary concern. Keep in mind that effects need not look realistic to the people in the studio; all that counts is how they appear to the television viewer.

RAIN

Soak the actors' clothes with water and superimpose the rain from a videotape recording. If you want to show rain through a window, mist the windowpane with a spray bottle, back the window with a chroma-key drop, and chroma-key rain into the window area. Avoid water in the studio—even a small amount can be hazardous to performers and equipment. The best option is to simply wait for a rainy day and shoot outside.

SNOW

Spray commercial snow from aerosol cans on a piece of glass in front of the lens or sprinkle plastic snow from above. Cover the actors with plastic snow. As with rain, take your scene outside when it is snowing.

FOG

The widely used method of putting dry ice into hot water unfortunately works only in silent scenes because the bubbling noise it makes may be so loud that it drowns out the dialogue. Dry-ice fog is also heavier than air and tends to settle just above the studio floor. If you must shoot fog indoors, rent a fog machine. If the fog does not have to move, simply use a fog filter on the lens.

WIND

Use large electric fans to simulate wind. The problem, of course, is the noise. You can either drown out the fan noise with recorded wind noise during the videotaping or replace

14.38 FIRE EFFECT

To project flickering onto a set, move a batten with silk or nylon strips stapled to it in front of an ellipsoidal or PAR spot.

the noise with the desired sounds in postproduction. To minimize the fan noise, try to "blimp" the fans as much as possible by shielding them with sound-absorbing material. Have the performers wear lavalieres for voice pickup or use shotgun mics that are close to the performers but turned away from the fans. If you simulate the wind effect caused by riding in a convertible, note that the occupants' hair often flies toward the front, against the direction of travel, and not toward the back of the car, opposite the direction of travel.

SMOKE

Do not make smoke by pouring mineral oil on a hotplate; although effective visually, this type of smoke smells bad and irritates the eyes and throats of crew and talent. And if the oil gets too hot, it may catch fire. Commercial smoke machines produce less-irritating smoke, but they tend to leave an oily film on performers, lenses, equipment, and the studio floor. It may be easiest and least expensive to simply super a stock shot of smoke over a scene.

FIRE

Never use fire inside the studio. The risk is simply too great for the effect. Use sound effects of burning, and have flickering light effects in the background. For the fire reflections, staple large strips of silk or nylon cloth or aluminum foil on a small batten and project the shadows onto the set with an ellipsoidal spot. **SEE 14.38** You can also reflect a strong spotlight off of aluminum foil or a silver Mylar

sheet. By moving the sheet, the light reflections on the actors and the set suggest the flickering of fire. You can also try to super a videotape of flames over the scene.

When using a barbecue grill outdoors, carefully ignite rags soaked in kerosene and shoot the scene through the flames. Again, be extremely careful with even small fires. Always have a fire extinguisher at the ready and be sure that the fire is completely out before leaving the scene.

LIGHTNING

Place two large photo flash units about ten feet apart. Trigger them one right after the other. Lightning should always come from behind the set or scene. Don't forget the audio effect of thunder. Obviously, the quicker the thunder succeeds the light flash, the closer we perceive the thunderstorm to be.

You may be tempted to imitate the spectacular explosions you see in so many movies (usually to make up for story deficiencies). Don't even think of it. Even demolition experts, the production crew, and especially the stunt people are apprehensive on "pyro-days," production times when pyrotechnic devices are used. As with fire, stay away from explosive devices, even if you have "experts" guaranteeing that nothing bad will happen. You can *suggest* explosions: Take a close-up of a frightened face and slowly solarize it to the sounds of various explosions. Your next shot can show dust settling over the scene of destruction. A bag of flour dumped into the scene from a ladder will do the trick.

MAIN POINTS

- Optical effects include television gobos, reflections, star filters, diffusion filters, and defocus.
- A television gobo is a cutout or three-dimensional object through which the camera looks at the scene.
- Mirrors can be used for unusual camera angles and cubist effects. Water is also effective for reflections.
- Star filters turn light sources into four- or six-point starlike rays. Diffusion filters soften all or part of the camera picture and can simulate fog. Defocus effects are used as transitions and for suggesting an actor's subjective experience.
- Mechanical effects include rain, snow, fog, wind, smoke, fire, and lightning. Avoid water—and at all costs, fire—inside the studio. Never set off a detonating device; simply suggest explosions through appropriate light and sound effects.

ZETTL'S VIDEOLAR

For your reference, or to track your work, each *Video-Lab* program cue in this chapter is listed here with its corresponding page number.

ZVL1 SWITCHING→ Transitions→ mix/dissolve 322

ZVL2 SWITCHING→ Effects→ keys 322

ZVL3 SWITCHING→ Effects→ special effects 326

ZVL4 SWITCHING→ Transitions→ wipe | try it 327

15

Design

Although you are probably very conscious of design and style when buying clothes or an automobile, you may be unaware of specific design elements when watching an opening show title or the living room set of a daytime drama. You may be dazzled by an animated title that does everything but pop out of the screen, but you're probably not motivated to analyze its aesthetic qualities. And you probably perceive the living room in the daytime drama as exactly that—a living room—not carefully placed scenery and properties. We all know, of course, that all such design elements are meticulously planned.

In fact, design, or the lack of it, permeates everything a television production company shows on the air and off. It sets the style of the video presentation, if not of the production company as a whole. Design includes not only the colors and the letters of a show title and the look of a studio set but also the production company's stationery, office furniture, hallway artwork, and logo. The CNN logo, for example, suggests up-to-date, no-nonsense news. **SEE 15.1**

But a handsome logo does not automatically carry its design qualities over to the programming or the on-air graphics or scenery. It is important to develop a design consciousness for everything you do; a well-executed logo is merely the symbol for such awareness, not its sole cause.

Section 15.1, Designing and Using Television Graphics, stresses the major design considerations of television graphics. Section 15.2, Scenery and Props, looks at major aspects of television scenery and properties.

KEY TERMS

- **aliasing** The steplike appearance of a computer-generated diagonal or curved line. Also called *jaggies* or *stairsteps*.
- **aspect ratio** The width-to-height proportions of the standard television screen and therefore of all analog television pictures: 4 units wide by 3 units high. For DTV and HDTV, the aspect ratio is 16 × 9.
- **character generator (C.G.)** A dedicated computer system that electronically produces a series of letters, numbers, and simple graphic images for video display. Any desktop computer can become a C.G. with the appropriate software.
- color compatibility Color signals that can be perceived as black-and-white pictures on monochrome television sets. Generally used to mean that the color scheme has enough brightness contrast for monochrome reproduction with a good grayscale contrast.
- essential area The section of the television picture, centered within the scanning area, that is seen by the home viewer, regardless of masking or slight misalignment of the receiver. Also called safe title area or safe area.
- **flat** A piece of standing scenery used as a background or to simulate the walls of a room.

- **floor plan** A diagram of scenery and properties drawn on a grid pattern. Can also refer to *floor plan pattern*.
- **floor plan pattern** A plan of the studio floor, showing the walls, the main doors, the location of the control room, and the lighting grid or batten.
- **graphics generator** Dedicated computer or software that allows a designer to draw, color, animate, store, and retrieve images electronically. Any desktop computer with a high-capacity RAM and hard drive can become a graphics generator with the use of 2-D and 3-D software.
- grayscale A scale indicating intermediate steps from TV white to TV black. Usually measured with a nine- or seven-step scale.
- **props** Short for *properties*. Furniture and other objects used for set decoration and by actors or performers.
- **scanning area** Picture area that is scanned by the camera pickup device; in general, the picture area usually seen in the camera viewfinder and the preview monitor.

15.1

Designing and Using Television Graphics

When watching television you may be more captivated by the opening titles than the show that follows. Even when the program consists of a no-nonsense interview or a simple product demonstration, we seem obliged to have the title burst onto the scene, make its dancing letters change shape and color at least once, and have at least three different backgrounds moving slowly underneath it. Such titles are usually supported by high-energy sound effects.

You may wonder whether we spend an inordinate amount of time and effort on the graphics compared with the program itself. Even if we don't, computer-generated video graphics have become a major factor in television production. Because creating such titles requires highly specialized computer skills, rather than competence in television production, we limit our discussion to the following:

SPECIFICATIONS OF TELEVISION GRAPHICS

Aspect ratio, scanning and essential areas, out-of-aspect-ratio graphics, matching STV and HDTV aspect ratios, information density and readability, color, style, and synthetic images

SPECIFICATIONS OF TELEVISION GRAPHICS

When comparing a television screen with a movie screen, you will see two obvious differences: the standard television (STV) screen is much smaller and much narrower than the movie screen. These two factors have a profound influence on the design specifications of television graphics. Even a large-screen television set is considerably smaller than the average-sized motion picture screen. The relatively

small size of the STV screen limits the amount of writing you can display and demands fonts (lettering) that can be clearly seen. The limited screen width in relation to its height means that the titles do not have as much room to play across the screen and therefore must be kept closer to the center. Other design requirements of television graphics are common to all graphic design and deal more with readability, style, and color.

This section takes a closer look at the following design requirements and specifications: (1) aspect ratio, (2) scanning and essential areas, (3) out-of-aspect-ratio graphics, (4) matching STV and HDTV aspect ratios, (5) information density and readability, (6) color, (7) style, and (8) synthetic images.

ASPECT RATIO

As discussed in chapter 2, *aspect ratio* is the relationship between screen width and screen height—the shape of the television frame. The frame and the size of the screen ultimately determine how much information you can place into the screen and where to position it for maximum impact. Because the aspect ratios of standard and high-definition television are different, we discuss them separately whenever necessary.

STV aspect ratio The aspect ratio of the traditional television screen is 4×3 ; that is, the ratio of picture width to picture height is 1.33:1. You may want to remember the aspect ratio as being 4 units wide by 3 units high, regardless of whether the units are inches or feet. Anything that appears on-screen must obviously fit within this aspect ratio. **SEE 15.2**

HDTV aspect ratio The aspect ratio of the high-definition television screen is 16×9 , which can also be expressed as 1.78:1. Compared with standard television, the HDTV screen is horizontally stretched, resembling more the motion picture aspect ratio. **SEE 15.3**

All graphical information must be contained within these aspect ratios. Recall from chapter 14 that you can change the aspect ratio of pictures within the television screen through various digital video effects (DVE), but you can't change the dimensions of the screen itself. You can divide the screen into secondary screens of various aspect ratios, and you can block off areas of the screen and thus simulate different aspect ratios, but you are nevertheless confined to the set aspect ratio of the television screen.¹

See Herbert Zettl, Sight Sound Motion, 4th ed. (Belmont, Calif.: Thomson Wadsworth, 2005), pp. 186–95.

15.2 STV ASPECT RATIO

The STV (standard television) aspect ratio is 4 units wide by 3 units high.

15.3 HDTV ASPECT RATIO

The HDTV (high-definition television) aspect ratio is 16 units wide by 9 units high. Compared with STV, it is horizontally stretched.

SCANNING AND ESSENTIAL AREAS

Unlike the painter or still photographer, who has full control over how much of the picture shows within the frame, we cannot be so sure about how much of the video pictures videotaped or broadcast are actually seen on the home screen. There is an inevitable picture loss every time you make another videotape dub and, especially, during transmission. Also, not all television receivers are as carefully adjusted as the preview monitors in a control room or editing room. Even if you gave the proper headroom when framing a close-up shot in a studio interview, your shots may have lost most or all the headroom by the time they reach the home receiver. The same is true for titles

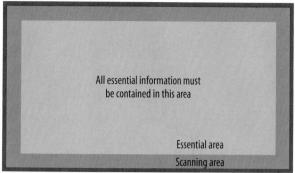

15.4 SCANNING AND ESSENTIAL AREAS

The scanning area is what the camera viewfinder and the preview monitor show. The essential, or safe title, area is what appears on the home television screen.

that are framed too close to the screen edge. Because the edge information is often lost, you may end up with incomplete titles or the first and last digits missing from a telephone number.

How can you ensure that the information you send is actually seen on the home screen? Is there a standard that will more or less guarantee that all essential picture information, such as a title or telephone number, will appear in its entirety? The answer is a qualified yes. Although not mathematically precise, there are guidelines to help you keep picture information from getting lost during dubbing or transmission. Basically, these guidelines tell you to keep vital information away from the screen edges. Just how far away you should be from the edge when framing a shot is prescribed by the scanning and essential areas.

The *scanning area* includes the picture you see in the camera viewfinder and on preview monitors in the control room. It is the area actually scanned by the camera pickup device (the CCDs). The *essential area*, also called *safe title area* or, simply, *safe area*, is centered within the scanning area. It is the portion seen by the home viewer, regardless of the masking of the set, transmission loss, or slight misadjustment of the receiver. **SEE 15.4**

Obviously, information such as titles and telephone numbers should be contained within the essential area. But just how large is the essential area? It is usually smaller than you think—about 70 percent of the total area. Many *character generators* (*C.G.s*) automatically keep a title within the essential area. The better studio cameras have a device that electronically generates a frame within the viewfinder, outlining the safe area.

If your C.G. does not have such a built-in safety net, you need to create your own. Most word-processing or

We now return to our regular programming.

Ne now return to ou egular programming

15.5 TITLE BEYOND ESSENTIAL AREA

A On the preview monitor, you can still see the complete title, although it comes close to the edges. **B** When viewed on the home receiver, the information that lies outside the essential area is lost.

drawing programs let you create a rectangle and then reduce it by a specific percentage. You could, for example, draw a rectangle that is close to your computer screen borders, then reduce this 100 percent area to a 70 percent one. These new borders would then outline the essential area for you. You could use the same method for creating the essential area for a 16×9 format.²

After some practice you will be able to compensate in the camera framing for the picture loss or place a title within the essential area without having to juggle percentages. The surest way to test a title is to project it on the preview monitor. If the letters come close to the edges of the preview monitor, the title extends beyond the essential area and will certainly be cut off when seen by the home viewer. **SEE 15.5**

OUT-OF-ASPECT-RATIO GRAPHICS

You will inevitably run into situations in which the pictures to be shown do not fit the requirements of the television aspect ratio and essential area. Most often you encounter this problem when someone brings in an out-of-aspectratio chart or poster to pitch an upcoming event during a promotional interview or to illustrate a point in a sales meeting. More often than not, you must cover such meetings live-on-tape without much chance for postproduction. Many oversized graphics are vertical and do not adhere to the 4×3 , much less the 16×9 , aspect ratio. The problem with an out-of-aspect-ratio graphic is that, when shown in its entirety, the information on the graphic becomes so small that it is no longer readable. **SEE 15.6** By moving the

tl
2. The Adobe Photoshop software, for example, lets you type in the

aspect ratio and the desired area percentage.

camera close enough that the graphic fits the aspect ratio of the television screen, you inevitably cut out important information. **SEE 15.7**

If the lettering and other visual information are simple and bold enough, you can mount the entire out-of-aspectratio chart on a larger card that is in aspect ratio. You simply pull back with the camera and frame up on the large card, keeping the out-of-aspect-ratio information as screen-center as possible. On a vertically oriented graphic without lettering, you could possibly tilt up and reveal the information bit by bit. If done smoothly, this gradual revelation adds drama. With lettering, however, such a tilt does not add drama but simply makes the graphic more difficult to read.

You encounter the same framing difficulty when trying to cover writing on a blackboard or whiteboard for the standard 4×3 aspect ratio. If you zoom out all the way to show the entire whiteboard, the text is difficult to read. If you zoom in to a close-up, you can see only part of the writing. **SEE 15.8** The correct way of presenting whiteboard information is to divide the whiteboard into 4×3 or 16×9 aspect ratio fields and contain the writing within each of these fields. The camera can then get a close-up of the entire sentence. Even when working in the HDTV aspect ratio, you should write the information in blocks rather than across the width of the whiteboard. **SEE 15.9**

MATCHING STV AND HDTV ASPECT RATIOS

You may wonder why digital television did not maintain the traditional 4×3 aspect ratio, much as computer screens did. The main reason for the horizontally stretched 16×9 ratio is that it readily accommodates the wide-screen movie

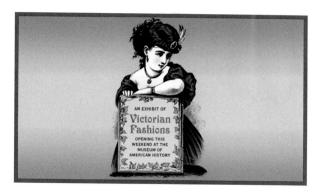

15.6 OUT-OF-ASPECT-RATIO GRAPHIC

When trying to frame this out-of-aspect-ratio graphic in its entirety, most of the information becomes difficult to read if not totally illegible.

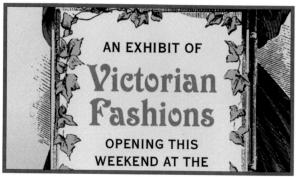

15.7 INFORMATION LOSS IN CLOSE-UP

When you try to get a closer shot, all information outside the aspect ratio is lost.

15.8 ASPECT RATIO PROBLEM

Normal writing on a whiteboard can present a typical aspect ratio problem. The camera cannot show a close-up of a message that spans the full width of the whiteboard.

15.9 PROPER USE OF ASPECT RATIO

If the whiteboard is divided into proper aspect ratio fields, the camera can see the entire message even in a close-up.

15.10 FULL-FRAME MOVIES ON STV Making the entire frame of a wide-screen movie fit into the 4×3 aspect ratio of STV results in empty (black) screen space on the top and the bottom of the screen. The resulting horizontal aspect ratio is called letterbox.

15.11 STV PICTURE ON HDTV SCREEN When showing a standard 4×3 television picture on the 16×9 screen, there are empty dead zones, or side bars, on both sides of the screen. This is called the pillarbox aspect ratio.

format. When showing a wide-screen movie on a traditional television, either both sides of the frame are crudely amputated or the images are displayed in the "letterbox" that shows the movie in its full width but necessitates the black stripes at the top and the bottom of the screen. **SEE 15.10** Sometimes, the 16×9 frame is digitally squeezed into the 4×3 frame, making everything look taller and skinnier than in the original shot. To avoid such picture distortions, some films are subjected to the *pan-and-scan* process whereby the more important portions of the wide-screen frame are selected to fit the 4×3 frame. But this process is quite costly and does not maintain the integrity of the original shot compositions.

When shown on the 16×9 HDTV screen, movies suffer only slight picture loss, but we are now faced with the problem of showing the standard 4×3 television programs. We can either stretch or enlarge the STV image so that it fills the full width of the HDTV screen. When we stretch the STV image to fill the width of the wide screen, everything looks fat, including the people. When enlarging the STV image so that it fills the 16×9 screen, objects and people undoubtedly lose some of their headroom—and sometimes even their heads and feet! You can also place the full 4×3 frame in the center of the 16×9 screen, leaving black stripes, called *dead zones* or *side bars*. This is sometimes called *pillarboxing*. **SEE 15.11**

Interestingly enough, some programs make a virtue out of this unavoidable handicap. You may have seen MTV presentations or commercials that are letterboxed, with black borders at the top and the bottom of the screen. This is to imply that they were originally shot for

wide-screen movie presentation rather than television distribution, which supposedly lends more prestige to the program. Many producers are quite pleased to have this additional screen space. They consider the side bars anything but "dead" space and fill it with additional program information and advertisements. The side bars are also a timesaver—often the previous show's credits are shown on a side bar while the new program segment is already under way. We as viewers seem to accept quite readily the stretching or fattening effect of digital manipulation.

INFORMATION DENSITY AND READABILITY

Taking a cue from overcrowded Web pages, there is a tendency to load the screen with a great amount of information. And in our quest to squeeze as much information as possible on the relatively small television screen, the print used for on-the-air copy gets smaller and smaller.

Information density There is some justification for crowding the screen if the data simultaneously displayed are related and add relevant information. For example, if in a home-shopping show you show a close-up of an item and simultaneously display the retail price, the sale price, and the telephone number to call, you are providing the viewer with a valuable service. On the other hand, if you show a newscaster reading the news in one corner of the screen, display the weather report in another, run stock market numbers and sports scores across the top and the bottom, and show station logos and ads all at the same

15.12 SCREEN CLUTTER

This screen has so much unrelated information that it is difficult to make sense of it amid the visual clutter.

15.13 PROPER STRUCTURE OF MULTIPLE SCREEN ELEMENTS

The arrangement of these multiple screens and information areas makes it relatively easy to seek out the desired information.

time, you run the risk of information overload in addition to excessive screen clutter. **SEE 15.12**

If the elements are properly arranged according to the principles of composition, however, such additional information can add significantly to the basic communication. When these mini-screens are thoughtfully arranged within the basic television frame, we are less likely to be overwhelmed and can pick and choose among the information presented. **SEE 15.13**

Readability In television graphics *readability* means that you should be able to read the words that appear onscreen. As obvious as this statement is, it seems to have eluded many a graphic artist. Sometimes titles explode onto and disappear from the screen so quickly that only video game champs and people with superior perceptive abilities can actually see and make sense out of them; or the letters

are so small and detailed that you can't read them without a magnifying glass.

Such readability problems occur regularly when motion picture credits are shown on a traditional 4×3 screen. First, as already pointed out, the titles generally extend beyond the essential area, so you can see only parts of them. Second, the credit lines are so small that they are usually impossible to read on the low-resolution STV screen. Third, the letters themselves are not bold enough to show up well on television, especially if the background is busy. These problems are greatly minimized on a 16×9 HDTV screen; but in consideration of the many viewers watching standard television, you need to aim for a high degree of readability. What, then, makes for optimal readability? Here are some recommendations:

- Keep all written information within the essential area.
- Choose fonts (letters of a particular size and style) that have a bold, clean contour. The limited resolution of the television image does not reproduce thin-lined fonts, whose fine strokes and serifs are susceptible to breakup when keyed. Sometimes even bold, sans serif fonts can get lost in the background and need to be reinforced with a drop shadow or color outline.
- Limit the amount of information. The less information that appears on-screen, the easier it is to comprehend. Some television experts suggest a maximum of seven lines per title. It is more sensible to prepare a series of titles on several C.G. "pages," each displaying a small amount of text, than a single page with an overabundance of information.
- Format all lettering into blocks for easily perceivable graphical units. **SEE 15.14** This block layout is often used in well-designed Web pages. If the titles are scattered, they look unbalanced and are hard to read. **SEE 15.15** Scattered information is a typical characteristic of a poorly designed Web page.
- Do not key lettering into too busy a background. If you must add lettering over a busy background—such as scores and names of players over the live picture of a football stadium—select a simple, bold font. **SEE 15.16**

The same principles apply when you animate a title using special effects. In fact, if the title twists and tumbles around the screen, the letters must be even more legible than if they were used for a static, straightforward title.

Bear in mind that whenever you use printed material as on-air graphics, including reproductions of famous paintings, professional photographs, illustrated books,

15.14 BLOCK ORGANIZATION OF TITLES

When titles are arranged in blocks, related information is graphically organized for easy perception.

15.15 SCATTERED TITLES

When titles are scattered, the information is difficult to read.

and similar matter, you must obtain copyright clearance. If you have subscribed to a computer image service, your copyright limits depend on the amount of user fees you pay.

COLOR

Because color is an important design element, you need to know something about its attributes and components. Most important, you must familiarize yourself with the aesthetics of color—that is, how various colors go together and how the television system reacts to them.

Color attributes As explained in chapter 3, color is determined by three factors, called *attributes*: hue, saturation, and brightness. *Hue* refers to the color itself—that is, whether it is blue, green, red, or yellow. *Saturation* (sometimes called *chroma*) indicates the color strength—a strong or pale red, a washed-out or rich green. *Brightness*,

15.16 BOLD LETTERS OVER A BUSY BACKGROUND

This title reads well despite the busy background. The letters are bold and differ sufficiently in brightness from the background.

or *luminance*, indicates how light or dark a color appears. Most high-end digital editing equipment and graphics programs list these attributes as important factors for color manipulation.

Grayscale The relative brightness of a color is usually measured by how much light it reflects. The television system is not capable of reproducing pure white (100 percent reflectance) or pure black (0 percent reflectance); at best it can reproduce an off-white (about 70 percent reflectance for monochrome television and only about 60 percent for color) and an off-black (about 3 percent reflectance). We call these brightness extremes *TV white* and *TV black*. If you divide the brightness range between TV white and TV black into distinct steps, you have the television *grayscale*.

The most common number of brightness steps between TV white and TV black on a grayscale is nine,

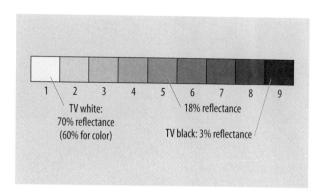

15.17 NINE-STEP GRAYSCALE

The nine-step grayscale shows nine different grays, ranging from TV white on the left to TV black on the right.

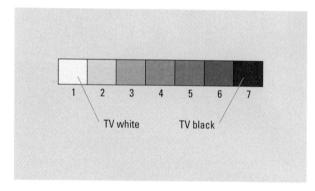

15.18 SEVEN-STEP GRAYSCALE

Most STV sets reproduce seven distinct grays, from TV white to TV black.

although you will find that by the time the signal arrives at your home receiver, you can be lucky to measure seven steps. **SEE 15.17** A grayscale of seven steps is therefore more realistic for monochrome television. **SEE 15.18** The new HDTV systems, however, not only produce superior resolution (picture sharpness) but also extend the grayscale. Such an extended grayscale is necessary for achieving the "film look" of HDTV. Like film, HDTV can display many more subtle steps of gray between TV white and TV black. Note that the middle value of the grayscale is not 30 percent but 18 percent. This means that you need considerably more light to get from the very bright step 3 to an even brighter step 2 than when moving from the darker 8 to the slightly lighter 7.

Compatible color Technically, *color compatibility* means that the graphic is equally readable on a black-

and-white television set as on a color one. In production it simply means that a color picture shows up well and with enough brightness contrast on a black-and-white television set. For titles there should be a healthy brightness contrast. When you use exclusively high-energy colors for a title, such as red lettering on a green or blue background, the difference in hue is so obvious that you might be tempted to neglect the grayscale difference. As different as they seem on a color monitor, if they have the same brightness they are unreadable on a monochrome monitor (see figure 3.28).

Even if the colors you use are not intended for reproduction on a black-and-white television set, good brightness contrast is also important for a color rendition. It aids the picture's resolution and three-dimensionality and helps separate the various colors (see figure 3.29). With a little experience you will find that just by squinting your eyes while looking at the set, you can determine fairly well whether two colors have enough brightness contrast to ensure compatibility.

Aesthetics of color The recognition and the application of color harmony cannot be explained in a short paragraph; they require experience, practice, sensitivity, and taste. Rather than try to dictate which colors go with what other colors, you can more easily divide the colors into "high-energy" and "low-energy" and then match their energies.

The high-energy colors include bright, highly saturated hues, such as rich reds, yellows, and blues. The low-energy group contains more-subtle hues with a low degree of saturation, such as pastel colors. Normally, you should keep the colors of the background low-energy and the foreground high-energy. In a set (as in your home), the background (walls) is usually less colorful than the set pieces and dressings, such as rugs, sofas, pictures, and pillows. **SEE 15.19 AND 15.20** Titles work on the same principle: you will find that an easily readable title has high-energy lettering on a low-energy background.

Of course, the colors must also be appropriate for the event. For example, if the titles are intended to announce a high-energy show, such as a vivacious dance number, high-energy colors for both the title and the background are fitting. If, however, you use the same high-energy colors to introduce a discussion on the latest budget deficit, the choice is inappropriate, even if the title has good readability.

Independent of aesthetics, only top-of-the-line television cameras can handle highly saturated reds. Unless there is an abundance of baselight, the video camera "sees red"

15.19 HIGH-ENERGY COLORS

The energy of a color is determined mainly by its saturation. High-energy colors are highly saturated hues, usually at the red and yellow end of the spectrum. They are especially effective when set against a low-energy background.

15.20 LOW-ENERGY COLORS

Low-energy colors are desaturated hues. Most pastel colors are low-energy.

when looking at red-at best, distorting the red color or, in some cases, making red areas in the shot vibrate (excessive video noise) or bleed into adjacent areas. This color bleeding is not unlike the bleeding of one sound track into another. When working with prosumer and lesser-quality cameras, suggest that the talent not wear highly saturated red clothing and that scene designers not paint large areas with saturated reds. This problem becomes especially noticeable in EFP, where you generally work in less-thanoptimal lighting conditions.

STYLE

Style, like language, is animate and nonstatic. It changes according to the specific aesthetic demands of a given location and time. To ignore it means to communicate less effectively. You learn style not from a book but primarily through being sensitive to your environment—by experiencing life with open eyes and ears and, especially, an open heart. The way you dress now compared with the way you dressed ten years ago is an example of a change in style. Some people not only sense the prevailing style but also manage to enhance it with a personal, distinctive flair.

Sometimes it is the development of television equipment that influences presentation styles more than personal creativity or social need. As emphasized in chapter 14, DVE equipment contributed not only to a new graphical awareness but also to an abuse of style. Often animated titles are generated not to reflect the prevailing aesthetic taste or to signal the nature of the upcoming show but simply because it is fun to see letters dance on-screen. Although flashy graphics in news may be tolerated because they express and intensify the urgency of the message, they are inappropriate for shows that explore a natural disaster or plays that delve into an intense relationship between two people.

You may have noticed that contemporary television graphics are imitating the colors and layout of computer Web pages. Some television graphics even parrot the shortcomings of the computer image, such as the aliasing ("jaggies") of diagonals or curves in lines and letters, differently colored horizontal strips that contain lettering and small product icons, or the scattering of tiny secondary windows on the main television screen (see figure 15.12). One of the reasons for such emulation is to be hip and on the cutting edge. More often than not, however, such screen clutter reflects more the bad taste of the graphic designer than a new trend.

Regardless of whether you are a trendsetter, you should try to match the style of the artwork with that of the show.

15.21 ANIMATED 3-D RENDERING

High-powered digital software can generate and animate realistic-looking three-dimensional objects.

But do not go overboard and identify your guest from China with Chinese lettering or your news story about the devastating flood with titles that bob across the screen. Do not abandon good taste for effect. In a successful design, all images and objects interrelate and harmonize with one another—from the largest, such as the background scenery, to the smallest, such as the fruit bowl on the table. Good design displays a continuity and coherence of style.

SYNTHETIC IMAGES

Synthetic images refer to pictures that are created entirely with the computer. Most desktop imaging software offers thousands of different hues, thin and thick lines, shapes, and various brush strokes and textures for creating electronic art. A television weathercast is a good example of the many capabilities of a large-scale graphics generator. The basic territorial map, temperature zones, high- and low-pressure zones, symbols for sunshine and forms of precipitation, lettering, moving clouds, and various temperature numbers—all are generated by the digital graphics generator.

Depending on storage capacity and software sophistication, you can create and store complex graphical sequences, such as animated three-dimensional titles that unfold within another animated 3-D environment, or multilayered mattes that twist within a 3-D video space.³ **SEE 15.21–15.23**

Some computer programs, based on complex mathematical formulas, allow you to paint irregular shapes, called *fractals*, which are used to create realistic and fantasy landscapes and countless abstract patterns. **SEE 15.24**

15.22 GENERATED GRAPHICS

Software specifically for graphics generators can create a variety of three-dimensional titles or moving images.

15.23 DIGITAL RENDERING: THE VATICAN

This animated fly-by sequence shows the Piazza San Pietro in Vatican City from various points of view.

^{3.} Zettl's VideoLab 3.0 has a great number of 2-D and 3-D animated renderings, which you can control interactively.

15.24 FRACTAL LANDSCAPE

Most painting software allows you to "paint" irregular images using mathematical formulas.

MAIN POINTS

- Design is an overall concept that includes such elements as the fonts for titles, the station logo, the look of the news set, and even the office furniture.
- The major purposes of television graphics are to give you specific information, to tell you something about the nature of the event, and to grab your attention.
- The standard television (STV) aspect ratio is 4 × 3, which means that the screen is 4 units wide by 3 units high. Wide-screen high-definition television (HDTV) has a wider aspect ratio of 16 × 9. The aspect ratios are also expressed as 1.33:1 for STV and 1.78:1 for HDTV. The horizontally

- stretched HDTV screen format accommodates wide-screen movies.
- The scanning area is what the camera viewfinder and the preview monitor show. The essential, or safe title, area is the portion seen by the viewer, regardless of transmission loss or slight misadjustment of the receiver.
- Out-of-aspect-ratio graphics need special consideration to make them fit the STV or HDTV television screen.
- ◆ To show the full width of movies or HDTV on the 3 × 4 STV screen, letterboxing (leaving black stripes on the top and the bottom of the frame) is necessary. When STV programs are shown on wide-screen HDTV, black stripes, called dead zones or side bars, are used on both sides of the screen, a process called pillarboxing.
- To avoid information overload when showing unrelated information simultaneously on a single screen, arrange the elements in easy-to-read mini-screens or text blocks.
- Good readability results when the written information is within the essential area, the letters are relatively large and have a clean contour, the background is not too busy, and there is good color and brightness contrast between the lettering and the background.
- Color compatibility means that the color image translates into distinct brightness values (grayscale steps) when seen on a monochrome receiver. Most television systems reproduce at best nine separate brightness steps. These steps, ranging from TV white (1) to TV black (9), make up the television grayscale.
- Synthetic images are generated entirely by computer graphics. They can be still or animated.

15.2

Scenery and Props

Although you may never be called upon to design or build scenery, you will likely set up scenery in the studio or fix up an interior at a remote location. Setting up even a small interview set requires that you know what the various pieces of scenery are called and how to read a floor plan. Your ability to see an existing on-location interior as a "set" will not only speed up camera placement and lighting but also help you determine if it needs redecorating for maximally effective camera shots. Knowing how to manage studio space through scenery and properties will also help you structure screen space in general.

▶ TELEVISION SCENERY

Standard set units, hanging units, platforms and wagons, and set pieces

PROPERTIES AND SET DRESSINGS

Stage props, set dressings, hand properties, and the prop list

► ELEMENTS OF SCENE DESIGN

The floor plan, set backgrounds and platforms, and studio floor treatments

TELEVISION SCENERY

Because the television camera looks at a set both at close range and at a distance, scenery must be detailed enough to appear realistic yet plain enough to prevent cluttered pictures. Regardless of whether it's a simple interview set or a realistic living room, a set should allow for optimal camera angles and movement, microphone placement and occasionally boom movement, appropriate lighting, and maximum action by performers. Fulfilling these requirements are four types of scenery: (1) standard set units, (2) hanging units, (3) platforms and wagons, and (4) set pieces.

STANDARD SET UNITS

Standard set units consist of softwall and hardwall *flats* and a variety of set modules. Both are used to simulate interior or exterior walls. Although television stations and nonbroadcast production houses use hardwall scenery almost exclusively, softwall scenery is more practical for high-school and college television operations.

Softwall flats The flats for standard *softwall* set units are constructed of a lightweight wood frame covered with muslin or canvas. They have a uniform height but various widths. The height is usually 10 feet (about 3 meters) or 8 feet (about 2½ meters) for small sets or studios with low ceilings. Width ranges from 1 to 5 feet (30 centimeters to 1½ meters). When two or three flats are hinged together, they are called *twofolds* (also called a *book*) or *threefolds*. Flats are supported by *jacks*, wood braces that are hinged or clamped to the flats and weighted down by sandbags or metal weights. **SEE 15.25**

Softwall scenery has numerous advantages: it is relatively inexpensive to construct and can usually be done in the scene shops of theater departments; it lends itself to a great variety of set backgrounds; it is easy to move and store; it is easy to set up, brace, and strike; and it is relatively easy to maintain and repair. The problems with softwall scenery are that it is difficult to hang pictures on the flats, and they often shake when someone closes a door or a window on the set or when something brushes against them.

Hardwall flats Hardwall flats are much sturdier than softwall flats and are preferred for more-ambitious television productions. Hardwall scenery does have a few drawbacks: hardwall units do not always conform to the standard set dimensions of softwall scenery, and the flats are heavy and difficult to store. (In the interest of your—and the flats'—well-being, do not try to move hardwall scenery by yourself.) Hardwall flats also reflect sound more readily than do softwall flats, which can easily interfere with good audio pickup. For example, if a set design requires that two hardwall flats stand opposite and in close proximity to each other, the talent operating in this

15.25 SOFTWALL FLATS

Softwall flats consist of a wood frame covered with muslin or canvas.

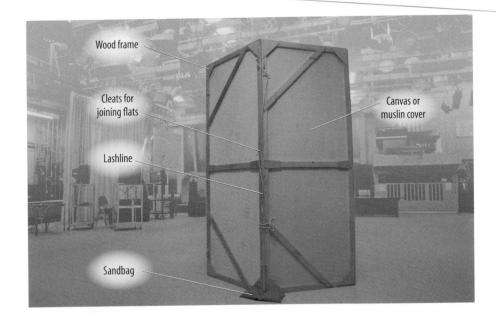

15.26 HARDWALL SET

This set was constructed with hardwall flats for a specific television drama. Note the specific set props that give the set its character.

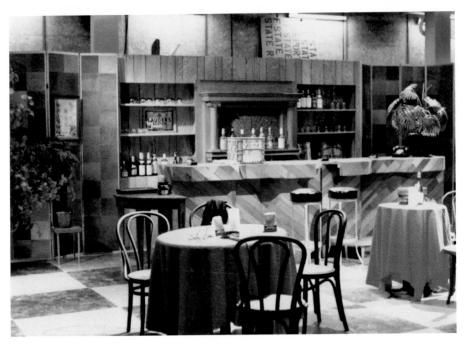

space will most likely sound as though they were speaking inside a barrel.

Most hardwall scenery is built for specific shows—such as newscasts, interview areas, and soap operas—and remains set up for the length of the series. Carefully constructed hardwall scenery is a must for HDTV or any other form of digital television that has a higher picture resolution than STV. **SEE 15.26**

Set modules For small television stations or educational institutions, where you do not have the luxury of building new sets for every show, you may consider versatile set modules that can be used in a variety of configurations. A *set module* is a series of flats and three-dimensional set pieces whose dimensions match, whether they are used vertically (right side up), horizontally (on their sides), or in various combinations.

15.27 MUSLIN CYCLORAMAThe muslin cyc runs on overhead tracks and normally covers three sides of the studio.

For example, you might use a modular hardwall set piece as a flat in one production and as a platform in the next. Or you can dismantle a modular desk and use the boxes (representing the drawers) and the top as display units. A wide variety of set modules is commercially available.

HANGING UNITS

Whereas flats stand on the studio floor, *hanging units* are supported from overhead tracks, the lighting grid, or lighting battens. They include (1) the cyclorama, (2) drops, and (3) drapes and curtains.

Cyclorama The most versatile hanging background is a *cyclorama*, or *cyc*, a continuous piece of muslin or canvas stretched along two, three, and sometimes even all four studio walls. **SEE 15.27** Some cycs have on a second track a curtain of loosely woven material, called a *scrim*, hanging in front of them to break the light before it hits the cyc, producing a soft, uniform background. A fairly light color (light gray or beige) is more advantageous than a dark cyc. You can always make a light cyc dark by keeping the light off it, and you can colorize it easily using floodlights (scoops or softlights) with color gels attached. A dark cyc will let you do neither. Some studios have hardwall cycs, which are not actually hanging units but are built solidly against the studio wall. **SEE 15.28**

Most studios use a *ground row* to blend the bottom edge of the muslin cyc into the studio floor. **SEE 15.29**

15.28 HARDWALL CYC

The hardwall cyc is made of hardwall material and is permanently installed on one or two sides of the studio.

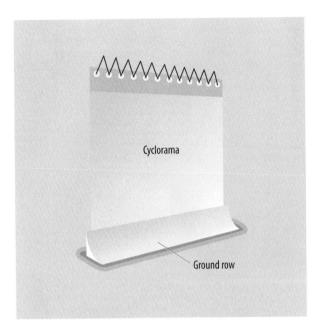

15.29 GROUND ROW

The ground row runs along the bottom of the cyc to make it blend into the studio floor.

Drop A *drop* is a wide roll of canvas with a background scene painted on it. It commonly serves stylized settings where the viewer is aware that the action occurs in an artificial setting. Some drops consist of large photomurals (which are commercially available) for more-realistic background effects.

A *chroma-key drop* is a wide roll of chroma-key blue or green cloth that can be pulled down and even stretched over part of the studio floor for chroma keying.

You can make a simple and inexpensive drop by suspending a roll of seamless paper (9 feet wide by 36 feet long), which comes in a variety of colors. Seamless paper hung from a row of flats provides a continuous cyclike background. Simply roll it sideways and staple the top edge to the flats. You can paint it for a more detailed background or use it for a *cookie* projection. **SEE 15.30**

Drapes and curtains Stay away from overly detailed patterns or fine stripes when choosing drapes. Unless you shoot with HDTV cameras, fine patterns tend to look smudgy, and contrasting stripes often cause *moiré* interference. Drapes are usually stapled to 1×3 battens and hung from the tops of the flats. Most curtains should be translucent enough to let the back light come through without revealing scenic pieces that may be in back of the set.

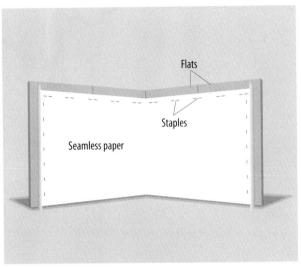

15.30 SEAMLESS PAPER DROP

A simple yet effective backdrop can be constructed by hanging a roll of seamless paper from a row of flats.

PLATFORMS AND WAGONS

The various types of platforms are elevation devices. Typical platforms are 6 or 12 inches (roughly 15 or 30 centimeters) high and can be stacked. Sometimes the whole platform is called a riser, although technically a *riser* is only the elevation part of the platform without its (often removable) top. If you use a platform for interviews, for example, you may want to cover it with carpeting. This cover not only will look good on camera but will also absorb the hollow sounds of people moving on the platform. You can further dampen this sound by filling the platform interior with foam rubber.

Some of the 6-inch platforms have four casters so that they can be moved around. Such platforms are called wagons. You can mount a portion of a set, or even a whole set, on a series of wagons and, if the doors are big enough, move these sections with relative ease in and out of the studio. Once in place, wagons should be secured with wood wedges and/or sandbags so they do not move unexpectedly. **SEE 15.31**

Larger risers and hardwall scenery are often supported by a slotted-steel frame, which works like a big erector set. You can cut the various slotted-steel pieces to any length and bolt them together in any configuration. Slotted steel has several advantages: it is durable and relatively lightweight, and it allows easy dismantling of scenic pieces—an important consideration when storage space is at a premium.

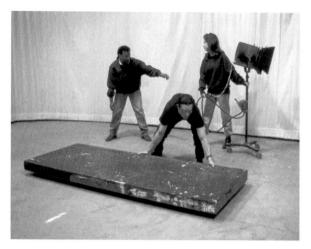

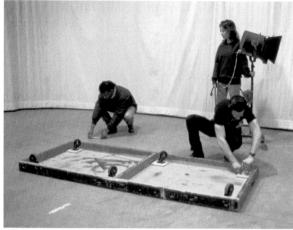

15.31 PLATFORMS AND WAGONS
Platforms are usually 6 or 12 inches high. When equipped with sturdy casters, they are called wagons.

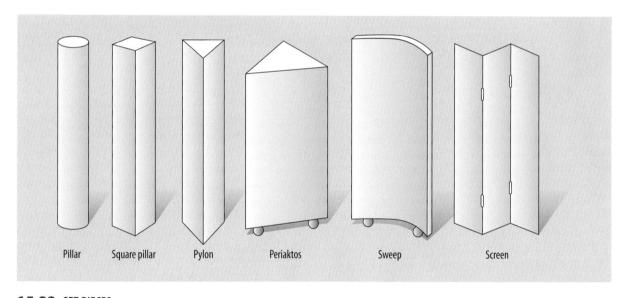

15.32 SET PIECES

Set pieces are freestanding scenic elements that roll on casters for quick and easy repositioning.

SET PIECES

Set pieces are important scenic elements. They consist of freestanding three-dimensional objects, such as pillars, *pylons* (which look like thin, three-sided pillars), *sweeps* (curved pieces of scenery), folding screens, steps, and *periaktoi*, plural for *periaktos*—a three-sided standing unit that looks like a large pylon. Most periaktoi move and swivel on casters and are painted differently on each side to allow for quick scene changes. For example, if one side is painted a warm yellow and the other a chroma-key blue,

you can change the neutral yellow background to any scene by swiveling the periaktos to the chroma blue side while chroma-keying a specific background scene. **SEE 15.32**

There are numerous advantages to using set pieces: you can move them easily, they are self-supporting, and they quickly and easily establish three-dimensional space. Although set pieces are freestanding and self-supporting (which are, after all, their major advantages), always check whether they need additional bracing. At a minimum they must be able to withstand bumps by people or cameras.

As a general rule, it is always better to overbrace than to underbrace a set. As in all other aspects of television production, do not forsake safety for convenience or speed.

PROPERTIES AND SET DRESSINGS

After having struggled with softwall and hardwall scenery, you will find that it is really the properties and the set dressings that give the environment a specific look and style. Much like decorating your room, it is primarily the furniture and what you hang on the walls that distinguish a particular environment, rather than the walls themselves. Because good television has more close-ups than medium and long shots, the three types of *props*—stage props, set dressings, and hand props—must be realistic enough to withstand the close scrutiny of the camera.

STAGE PROPS

Stage props include common furniture and items constructed for a specific purpose, such as news desks, panel tables, and a variety of chairs. You should also have enough furniture to create settings for a modern living room, a study, an office, a comfortable interview area, and perhaps some type of outdoor area with a patio table and chairs. For an interview set, relatively simple chairs are more useful than large, upholstered ones. You don't want the chairs to take on more prominence than the people sitting in them. Try to get chairs and couches that are not too low, so that sitting and rising gracefully is not problematic, especially for tall people.

The problem with stage props is finding adequate storage space for them. Store the heavier items on the floor and the smaller props on shelves. Always use a prop cart to transport heavy items—it will save your back and the stage props.

SET DRESSINGS

Set dressings are a major factor in determining the style and the character of a set. Although the flats may remain the same from one show to another, the dressings help give each set individual character. They include such items as draperies, pictures, lamps and chandeliers, fireplaces, flowerpots, plants, candleholders, and sculptures. Secondhand stores provide an unlimited source for these things. In an emergency you can always raid your own office or living quarters.

HAND PROPERTIES

Hand properties consist of all items that are actually handled by the performer during a show. They include dishes,

silverware, telephones, radios, and desktop computers. In television the hand props must be realistic: use only real objects. A papier-mâché chalice may look regal and impressive on stage, but on the television screen it looks dishonest if not ridiculous. Television is very dependent on human action. Think of hand props as extensions of gestures. If you want the actions to be sincere and genuine, the extension of them must be real as well. If an actor is supposed to carry a heavy suitcase, make sure the suitcase is actually heavy. Pretending that it is heavy does not go over well on television.

If you must use food, check carefully that it is fresh and that the dishes and silverware are meticulously clean. Liquor is generally replaced by water (for clear spirits), tea (for whiskey), or fruit juice (for red wine). With all due respect for realism, such substitutions are perfectly appropriate.

As obvious as it sounds, see to it that hand props actually work and that they are on the set for the performers to use. A missing prop or a bottle that doesn't open at the right time may cause costly production delays.

PROP LIST

In small routine productions, the floor manager or a member of the floor crew normally takes care of the props. More-elaborate productions, however, have a person assigned exclusively to the handling of props—the *property manager*. To procure the various props and ensure that they are available at the camera rehearsal and taping sessions, you need to prepare a *prop list*. Some prop people divide the list into stage props, set dressings, and hand props, although in most cases the various types of props are combined on a single list. **SEE 15.33** Always double-check that all the props mentioned in the script appear on the prop list and that they are actually available for camera rehearsal and taping sessions.

If you need to strike the set and set it up again for subsequent taping sessions, mark all the props and take several digital photos of the set before putting the props away. This way you will have an instant record of what props were used and where they are in the set. A missing prop, or one that is placed in a different location for the next taping session can create a serious continuity problem for the editor.

Most production studios have a collection of standard props—vases, plants, tablecloths, tables, chairs, couches, and so forth. Unless you do productions that need props on a regular basis, such as a comedy series or daytime drama, you can borrow most set and hand props when needed. It is usually easier to find an office that can be stripped of

five outside bushes 6' blue sofa two rubber plants set of eight family photos potted palm sunflower painting transparent curtains Picasso print low 8' cabinet magazines square end table newspaper small chest of drawers books two bookcases stereo chair (with armrests) tea set blue wing chair lamp for end table coffee table Indian sculpture round end table louvered screen

15.33 PROPLIST

This prop list contains all set props, set dressings, and hand properties shown in the set in figure 15.35.

its furniture for the production day than to buy and store various office sets. If you do an especially ambitious production, such as a period play, you can always call on the theater arts department of a local college or high school or rent the props from a commercial company.

ELEMENTS OF SCENE DESIGN

Before you design a set, you must know what the show is all about. Talk to the director about his or her concept for the show, even if it is a simple interview. You arrive at a set design by defining the necessary spatial environment for optimal communication rather than by copying what you see on the air. For example, you may feel that the best way to inform viewers is not by having an authoritative newscaster read stories from a pulpitlike contraption but by moving the cameras into the newsroom itself and out into the street where events are happening. If the show is intended to be shot with a single camera for heavy post-production editing, it may be easier to take the camera to the street corner rather than to re-create the street corner in the studio.

But even if the show is slated for the studio, you can often streamline the set design by taking some time to discover just what the show is all about. Try to visualize the entire show in screen images and work from there. For example, even if the interview guest is a famous defense

lawyer, you don't automatically have to set up a typical lawyer's office complete with antique desk, leather chairs, and law books in the background. Ask about the nature of the interview and its intended communication objective. Your design depends on the answers you get, such as: "The basic idea is to probe the conscience and the feelings of the defense lawyer rather than hear about future defense strategies. The viewer should see intimate close-ups of the guest during most of the interview." Does this interview require an elaborate lawyer's set? Not at all. Considering the shooting style that includes a majority of tight close-ups, two comfortable chairs in front of a simple background will do just fine.

When the show is sketched out on a fairly detailed *storyboard*, your set deign is frequently predetermined. Nevertheless, speak to the producer and director if you think you have a much better idea.

Let's now move to the major elements of scene design: (1) the floor plan, (2) set backgrounds and platforms, and (3) studio floor treatments.

FLOOR PLAN

A set design is drawn on the *floor plan pattern*, which is literally a plan of the studio floor. It shows the floor area, the main studio doors, the location of the control room, and the studio walls. The lighting grid or batten locations are normally drawn on the floor area to give a specific orientation pattern according to which the sets can be placed. In effect, the grid resembles the orientation squares of a city map. **SEE 15.34** The completed *floor plan* should convey enough information that the floor manager and crew can put up the set and dress it, even in the absence of the director or set designer. You may find that both the floor plan pattern and the finished floor plan that shows the scenic design are called "floor plan."

The scale of the floor plan pattern varies, but it is normally ¼ inch = 1 foot. All scenery and set properties are then drawn on the floor plan pattern in the proper position relative to the studio walls and the lighting grid. For simple setups you may not need to draw the flats and the set properties to scale; you can approximate their size and placement relative to the grid. **SEE 15.35**

More-elaborate sets, however, require a floor plan that, like a blueprint for a house, is drawn precisely to scale. Even if you don't have to draw a floor plan to scale, you are greatly aided if you use templates that have cutouts of standard furniture. They normally come in a scale of ¼ inch = 1 foot and are readily available in college bookstores or art-supply stores. Most art directors use computer software to make floor plans and set designs.

15.34 FLOOR PLAN PATTERN

The floor plan pattern shows the dimensions of the studio floor, which is further defined by the lighting grid or similar pattern. The set is drawn on this basic studio grid.

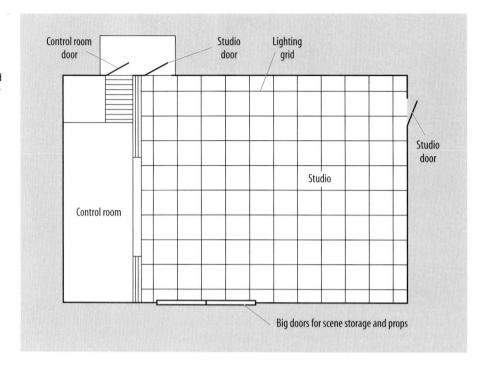

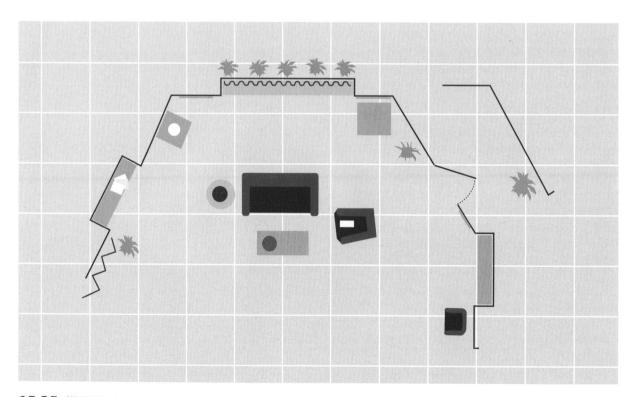

15.35 SIMPLE FLOOR PLAN

This floor plan shows all the necessary scenery, set props, and dressings as well as the more prominent hand props. It is usually not drawn precisely to scale.

Floor plan functions The floor plan is an important tool for all production and engineering personnel. The director uses it to visualize the show and to block the major actions of performers, cameras, and microphone booms. It is essential to the floor crew, who must set up the scenery and place the major properties. The LD (lighting director) needs it for designing the general light plot. The audio technician can become familiar with specific microphone placement and possible audio problems.

Although you may not intend to become a set designer, you should nevertheless know how to draw a basic floor plan and translate it into an actual set, into movement of performers and cameras, and, finally, into television images.

Set positioning Whenever possible, try to locate the set where the lights are. Position it so that the back lights, key lights, and fill lights hang in approximately the right positions. Sometimes an inexperienced designer will place a set in a studio corner, where most of the lighting instruments have to be rehung for proper illumination, whereas in another part of the studio the same set could have been lighted with the instruments already in place. If you use the floor plan as the basis for the light plot, simply add a transparent overlay and sketch in the major light sources.

As you can see once again, you cannot afford to specialize in a single aspect of television production. Everything interrelates, and the more you know about the various production techniques and functions, the better your coordination of those elements will be.

When drawing a floor plan, watch for the following potential problem areas.

Many times a carelessly drawn floor plan will indicate scenery backing, such as the walls of a living room, not wide enough to provide adequate cover for the furniture or other items placed in front of it. The usual problem is that the furniture and other set pieces are drawn much too small relative to the background flats. For example, on an out-of-scale floor plan a single threefold (covering about 10 feet of width) might show adequate cover for an entire set of living room furniture, when it actually is barely wide enough to back a single couch in the actual set. The furniture always seems to take up more room in reality than on the floor plan. One way to avoid such design mistakes is to draw the in-scale furniture on the floor plan first, then add the flats for the backing. You will find that the computer helps greatly with such design tasks. Basic interior-decorating software programs show the most common pieces of furniture to scale and let you move them around on-screen until they are in the right place on your floor plan.

- During the setup you may notice that the available studio floor space is always less than the floor plan indicates. Limit the set design to the actual space available.
- Always place active furniture (used by the performers) at least 6 feet (roughly 2 meters) from the set wall so that the back lights can be directed at the performance areas at not too steep an angle. Also, the director can use the space between wall and furniture for camera placement and talent movement.

SET BACKGROUNDS AND PLATFORMS

The background of a set helps unify a sequence of shots and places the action in a single continuous environment. It can also provide visual variety behind relatively static foreground action. Most platforms are used to keep the camera at eye level with the seated talent.

Backgrounds You can achieve scenic continuity by painting the background a uniform, usually low-energy color or by decorating it so that viewers can easily relate one portion of the set to another. Because in television we see mostly environmental detail, you must give viewers clues so they can apply closure to the shot details and form a mental map of the continuous environment (see chapter 13). A uniform background color or design, or properties that point to a single environment such as the typical furnishings of a kitchen—all help viewers relate the various shots to a specific location.

Although set continuity is an important element in scene design, a plain background is not the most interesting scenic background. You need to "dress" the set by hanging artwork, posters, or other objects on the wall to break it up into smaller yet related areas. When you dress a plain background with pictures or other objects, place them so that they are in camera range. For example, if you hang a picture between two interview chairs, it will show only in the straight-on two-shot but not in the individual closeups. If you want more background texture in the close-up shots, position pictures so that they are seen by the cameras during cross-shooting. **SEE 15.36**

Platforms Because camera operators like to adjust their cameras to the most comfortable working height, which is not necessarily the most effective aesthetic point of view, performers seated in normal chairs on the studio floor are positioned lower than the average camera working height, so the camera looks down on them. This point of view carries subtle psychological implications of inferiority and also creates an unpleasant composition. For events where performers are seated most of the time, place the chairs

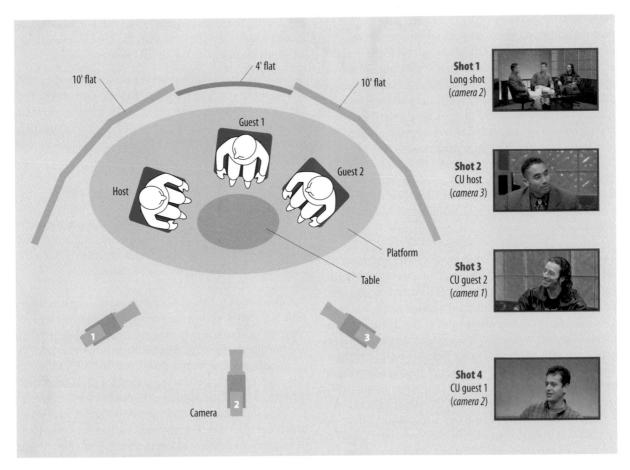

15.36 BACKGROUND DRESSING

The establishing (long) shot of this interview set shows that the background flats provide some visual texture and interest for the host (camera-left) and guest 2 (far right), but not for guest 1 in the middle. The subsequent close-ups confirm this design problem.

on a platform (anywhere from 6 to 12 inches high). The camera can then remain at a comfortable operating height, shooting the scene at eye level. **SEE 15.37**

STUDIO FLOOR TREATMENTS

A common source of headaches for the scene designer is the studio floor. Although seen only occasionally in long shots, an untreated studio floor looks unattractive, as though the scene were played in a warehouse or garage. Two primary considerations in dressing the studio floor are that the treatment not interfere with camera and boom travel and that it be easily removable once the show is over. The most popular floor treatments include (1) rugs and mats, (2) rubber tiles, (3) glue-on strips, and (4) paint; there is also the option of (5) virtual floors.

Rugs and mats Although rugs are an excellent and realistic floor treatment, they often get in the way of cameras and booms. Tape the edges of a rug in place to prevent it from bunching up under the dolly wheels or pedestal skirt when the camera travels over it. The same goes for grass mats: secure them with tape so that they do not slip on the smooth studio floor. The rug is usually the first property placed so that other scenery and props can be put on it as necessary.

Rubber tiles Flexible rubber tiles make excellent floor patterns for offices, dance sets, large rooms, or hallways. They are available in contrasting, low-energy colors (normally off-white and off-black) and are easy to install. Simply lay the tiles (each is 3 square feet, or roughly 1 square

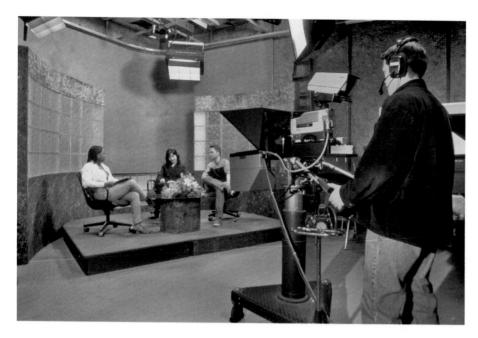

15.37 PLATFORM COMPENSATING FOR CAMERA HEIGHT

To avoid having the camera look down at people who are seated, chairs should be placed on a platform so that the camera can shoot from eye level.

meter) on the studio floor in the desired pattern, and the natural adhesion keeps them in place. Just for good measure, tape the outer edges to the studio floor so that camera travel does not move them. Because footprints tend to show, clean the tiles with soapy water before the camera rehearsal and the final taping.

Glue-on strips Another excellent floor treatment is glue-on strips, which come in different patterns and have a removable backing like shelf paper. You can adhere them side by side on the studio floor and remove them just as easily. Cameras and booms have no travel restrictions. These glue-on patterns are quite expensive, however, and are used only for elaborate productions.

Paint Some set designers prefer to treat the studio floor with water-soluble paint. Most paints that persist through rehearsals and videotaping, however, are hard to remove and usually leave some residue on the studio floor. Check with the studio supervisor before you start wielding a paintbrush.

Virtual floors Sometimes complex floor patterns are computer-generated and digitally inserted in the scene. As you can imagine, such procedures need skilled postproduction people and are so time-consuming that they are of little use in routine productions.

MAIN POINTS

- Television scenery encompasses the three-dimensional aspects of design.
- There are four types of scenery: standard set units, that is, hardwall and softwall flats and set modules; hanging units, such as cycs, drops, and curtains; platforms and wagons; and set pieces, such as pillars, screens, and periaktoi.
- The three basic types of properties are stage props, such as furniture, news desks, and chairs; set dressings, such as pictures, draperies, and lamps; and hand props—items such as dishes, telephones, and computers that are actually handled by the talent.
- When a set must be struck and set up again for a subsequent taping session, take digital photos of all set details to ensure consistency of the setup.
- ◆ A floor plan is drawn on a floor plan pattern and shows the exact location of the scenery and the set properties relative to the lighting grid. The floor plan is essential for the director to prepare the preliminary blocking of talent, cameras, and microphone booms; for the floor crew to set up the scenery and place the major set properties; and for the lighting director to design the basic light plot.
- Studio floors can be covered with rubber tiles, glue-on patterns, or paint without interfering with camera movement. Rugs are useful only if cameras do not have to move on and off of them while on the air. Virtual floors that can be digitally inserted in the scene require skilled and timeconsuming postproduction.

16

Production People

Television production is teamwork—you've heard this many times. But why does it take a whole team when you can do a reasonably good job with your camcorder all by yourself? Wouldn't total control of the production process and no one interfering with your creativity be better? Aren't the other team members more of a liability than an asset? As you probably suspected, the answer to the last two questions is a simple no.

In professional television production, you must rely on a great number of people, each of whom performs a highly specific function. For example, you may be all by yourself when chasing a news story with an ENG camcorder, but when you bring the videotape back to the station, it is the rest of the news department that gets your story on the air. Someone decides just where in the newscast your story should be placed; others edit your videotape, write a sensible news story from your cursory notes, put it on the videotape recorder or video server for playback at a specific time, and ensure that the final video and audio signals reach the transmitter. A multicamera EFP or studio production obviously requires more than one person to get the project done.

Section 16.1, What Production People Do, will help you recognize the various team members involved in television production and precisely what it is that they do. This section also discusses the specific on-camera techniques of television performers and actors. It also explains the major floor manager's cues. Section 16.2, How to Do Makeup and What to Wear, briefly describes the makeup performers and actors use and what type of clothing looks good on-camera.

KEY TERMS

- **above-the-line personnel** A budgetary division referring to nontechnical personnel.
- **actor** A person (male or female) who appears on-camera in dramatic roles. Actors always portray someone else.
- **below-the-line personnel** A budgetary division referring to technical personnel.
- **blocking** Carefully worked-out movement and actions by the talent and for all mobile television equipment.
- **cue card** A large, hand-lettered card that contains copy, usually held next to the camera lens by floor personnel.
- **foundation** A makeup base over which further makeup such as rouge and eye shadow is applied.
- **makeup** Cosmetics used to enhance, correct, or change appearance.
- **news production personnel** People assigned exclusively to the production of news, documentaries, and special events.

- **nontechnical production personnel** People concerned primarily with nontechnical production matters that lead from the basic idea to the final screen image. Also called *above-the-line personnel*.
- pancake A makeup base, or foundation makeup, usually watersoluble and applied with a small sponge.
- **pan stick** A foundation makeup with a grease base. Used to cover a beard shadow or prominent skin blemish.
- **performer** A person who appears on-camera in nondramatic shows. Performers play themselves and do not assume someone else's character.
- talent Collective name for all performers and actors who appear regularly on television.
- **technical production personnel** People who operate the production equipment. Also called *below-the-line personnel*.
- **teleprompter** A prompting device that projects the moving (usually computer-generated) copy over the lens so that the talent can read it without losing eye contact with the viewer. Also called *auto cue*.

16.1

What Production People Do

Even the most sophisticated television production equipment and computer interfaces will not replace *you* in the television system. You and those working with you still reign supreme in the production process. The equipment cannot make ethical and aesthetic judgments for you; it cannot tell you exactly which part of the event to select and how to present it for optimal communication. You make such decisions within the context of the general communication intent and through interaction with other members of the production team—the people in front of the camera (talent) and those behind it (production staff, technical crews, engineers, and other station personnel). You may soon discover that the major task of television production is working not so much with equipment as with people.

NONTECHNICAL PRODUCTION PERSONNEL

Those concerned primarily with the production, from idea to final screen image

► TECHNICAL PERSONNEL AND CREW

Those concerned with the operation of the production equipment

▶ NEWS PRODUCTION PERSONNEL

Those concerned specifically with the production of news and special events

TELEVISION TALENT

Television performers and actors

▶ PERFORMANCE TECHNIQUES

Camera, audio, timing, postproduction continuity, the floor manager's cues, and prompting devices

ACTING TECHNIQUES

Audience, blocking, memorizing lines, timing, postproduction, and the director/actor relationship

AUDITIONS

Preparation, appearance, and creativity

NONTECHNICAL PRODUCTION PERSONNEL

The nontechnical production personnel are generally involved in translating a script or an event into effective television images. **SEE 16.1** They are also called above-the-line personnel because they fall under a different budget category from the technical crew, who are called below-the-line personnel. The nontechnical production people normally include the executive producer, the producer, the director, and the art director and assistants, as well as the writers and the talent.

As with all such classifications, the above- and belowthe-line division is anything but absolute or even uniform. For example, in some productions the *PA* (*production assistant*) or the *floor manager* are classified in the belowthe-line category; in others they belong among the abovethe-line personnel. **SEE 16.2**

Although the DP (director of photography) is technically a below-the-line production person, the position is frequently regarded and budgeted as an above-the-line item. The term, borrowed from film production, has found its way into television production. In standard theatrical film production, the DP is mainly responsible for lighting and the proper exposure of the film rather than for running the camera. In smaller film productions and EFP, however, the DP actually operates the camera as well as does the lighting. So when you hear an independent television producer/director looking for a reliable and creative DP, he or she is primarily referring to an experienced EFP camera operator. What you need to realize and remember is that all members of the production team are equally important, regardless of whether they are classified as above-the-line or below-the-line, or whether they sit in the director's chair or help carry some lights to a field location.

ZVL1 PROCESS→ People→ nontechnical

16.1 NONTECHNICAL PRODUCTION PERSONNEL

PERSONNEL NONTECHNICAL PR	FUNCTION RODUCTION PERSONNEL
NONTECHNICAL FI	ODDCITON FERSONNEL
Executive producer	In charge of one or several large productions or program series. Manages budget and coordinates with client station management, advertising agencies, financial supporters, and talent and writers' agents.
Producer	In charge of an individual production. Is responsible for all personnel working on the production and for coor dinating technical and nontechnical production elements. Often serves as writer and occasionally as director
Associate producer (AP)	Assists producer in all production matters. Often does the actual coordinating jobs, such as telephoning talent and confirming schedules.
Line producer	Supervises daily production activities on the set.
Field producer	Assists producer by taking charge of remote operations (away from the studio). At small stations may be part of producer's responsibilities.
Production manager	Schedules equipment and personnel for all studio and field productions.
Production assistant (PA)	Assists producer and director during actual production. During rehearsal takes notes of producer's and/or director's suggestions for show improvement.
Director	In charge of directing talent and technical operations. Is ultimately responsible for transforming a script into effective video and audio messages. At small stations may often be the producer as well.
Associate director (AD)	Assists director during the actual production. In studio productions does timing for director. In complicated productions helps "ready" various operations (such as presetting specific camera shots or calling for a VTR to start). Also called <i>assistant director</i> .
Talent	Refers to all performers and actors who regularly appear on television.
Actor	Someone who portrays someone else on-camera.
Performer	Someone who appears on-camera in nondramatic activities. Performers portray themselves.
Announcer	Reads narration but does not appear on-camera. If on-camera, the announcer moves up into the talent category.
Floor manager	In charge of all activities on the studio floor. Coordinates talent, relays director's cues to talent, and supervises floor personnel. Except for large operations, responsible for setting up scenery and dressing the set. Also called <i>floor director</i> or <i>stage manager</i> .
Floor persons	Set up and dress sets. Operate cue cards or other prompting devices, easel cards, and on-camera graphics. Sometimes help set up and work portable field lighting instruments or microphone booms. Assist camera operators in moving camera dollies and pulling camera cables. At small stations also act as wardrobe and makeup people. Also called <i>grips, stagehands</i> , or <i>utilities personnel</i> .

16.1 NONTECHNICAL PRODUCTION PERSONNEL (continued)

PERSONNEL	FUNCTION		
ADDITIONAL P	RODUCTION PERSONNEL		
In small operations these	e production people are not always part of the permanent staff, or their functions are fulfilled by other personnel.		
Writer	At smaller stations or in corporate television, the scripts are often written by the director or producer. Usually hired on a freelance basis.		
Art director	In charge of creative design aspects of show (set design, location, and/or graphics).		
Graphic artist	Prepares computer graphics, titles, charts, and electronic backgrounds.		
Makeup artist	Does the makeup for all talent. Usually hired on a freelance basis.		
Costume designer	Designs and sometimes even constructs various costumes for dramas, dance numbers, and children's shows. Usually hired on a freelance basis.		
Wardrobe person	Handles all wardrobe matters during production.		
Property manager	Maintains and manages use of various set and hand properties. Found in large operations only. Otherwise, props are managed by the floor manager.		
Sound designer	Constructs the complete sound track (dialogue and sound effects) in postproduction. Usually hired on a freelance basis for large productions.		

TECHNICAL PERSONNEL AND CREW

The technical production personnel consist of people who are primarily concerned with operating equipment. They are usually part of the crew. The technical personnel include camera operators, audio and lighting people, videotape operators, video editors, and C.G. operators. The term technical does not refer to electronic expertise but rather to operating the equipment with skill and confidence. The true engineers, who understand electronics and know where to look when something goes wrong with a piece of equipment, usually do not operate equipment; rather, they ensure that the whole system operates smoothly, supervise its installation, and maintain it. You may find that in larger professional operations, however, the technical production people are still called engineers, mainly to satisfy the traditional job classification established by the labor unions. SEE 16.3 ZVL2 PROCESS→ People→ technical

Keep in mind that many of the functions of technical and nontechnical production people overlap and even change, depending on the size, location, and relative complexity of the production. For example, you may initially have acted as a producer when setting up the videotaping of the semiannual address of a corporation president; then, on the day of the production, you may find yourself busy with such technical production matters as lighting and running the camera. In larger productions, such as soap operas, your job responsibility is much more limited. When acting as a producer, you have nothing to do with lighting or camera operation. And, when working the camera, you may have to wait patiently for the lighting crew to finish, even if the production is behind schedule and you have nothing else to do at the time.

NEWS PRODUCTION PERSONNEL

Almost all television broadcast stations produce at least one daily newscast; in fact, the newscasts are often the major production activity at these stations. Because news departments must be able to respond quickly to a variety

16.2 ABOVE-THE-LINE AND BELOW-THE-LINE PERSONNEL

The division between above-the-line and below-the-line personnel is not always clear-cut. Generally, above-the-line personnel include the nontechnical personnel, and below-the-line personnel include the technical (production crew and engineering) personnel.

Executive producer	Production manager	Sound designer
Producer	Director	■ Talent
Associate producer (AP)	Associate director (AD)	■ Writer
Production assistant (PA)	Art director	
BELOW-THE-LINE		
Studio supervisor	■ Floor persons	■ Videotape editor
Technical director (TD)	■ Video operator (VO)	■ Makeup artist
Camera operators	Audio technician	Wardrobe people
Lighting director (LD)	C.G. operator	Scenery and property personn

of production tasks, such as covering a downtown fire or a protest at city hall, there is generally little time to prepare for such events. News departments therefore have their own *news production personnel*. These people are dedicated exclusively to the production of news, documentaries, and special events and perform highly specific functions. **SEE 16.4**

Of course, as in any other organization, television and corporate video involve many more people than what you see listed in the figures in this section, such as clerical personnel and the people who answer phones, schedule various events, sell commercial time, negotiate contracts, actually build and paint the sets, and clean the building. Because these support personnel operate outside the basic production system, their functions aren't discussed here.

TELEVISION TALENT

When you look at the people appearing regularly on television and talking to you—telling you what to buy, what is

happening around the world, or what the weather is going to be like—you may feel that the job is not too difficult and that you could easily do it yourself. After all, most of them are simply reading copy that appears on a *teleprompter*. But when you actually stand in front of the camera, you quickly learn that the job is not as easy as it looks. Appearing relaxed on-camera, and pretending that the camera lens or the teleprompter is a real person to whom you are talking, takes hard work and a good amount of talent and skill. This is why we call all people appearing regularly on television *talent*. Although television talent may have varied communication objectives—some seek to entertain, educate, or inform; others seek to persuade, convince, or sell—all strive to communicate with the television audience as effectively as possible.

You can divide television talent into two categories: performers and actors. The difference between them is fairly clear-cut. Television *performers* are engaged basically in nondramatic activities: they play themselves and do not assume roles of other characters; they sell their

16.3 TECHNICAL PERSONNEL AND CREW

engineer-in-charge

FUNCTION ENGINEERING STAFF These people are actual engineers who are responsible for the purchase, installation, proper functioning, and maintenance of all technical equipment. Chief engineer In charge of all technical personnel, budgets, and equipment. Designs system, including transmission facilities, and oversees installations and day-to-day operations.

Assistant chief engineer

Assists chief engineer in all technical matters and operations. Also called *engineering supervisor*.

Studio or remote

Oversees all technical operations. Usually called *EIC*.

Maintenance engineer Maintains all technical equipment and troubleshoots during productions.

NONENGINEERING TECHNICAL PERSONNEL

Although skilled in technical aspects, the following technical personnel do not have to be engineers but usually consist of technically trained production people.

Technical director (TD)	Does the switching and usually acts as technical crew chief.

Camera operators Operate the cameras; often do the lighting for simple shows. When working primarily in field

productions (ENG/EFP), they are sometimes called videographers or shooters.

Director of photography (DP) In film productions, in charge of lighting. In EFP, operates EFP camera.

Lighting director (LD) In charge of lighting; normally found mostly in large productions.

Video operator (VO) Adjusts camera controls for optimal camera pictures (shading). Sometimes takes on additional

technical duties, especially during field productions and remotes. Also called shader.

Audio technician In charge of all audio operations. Works audio console during the show.

Also called audio engineer.

Videotape operator Runs the videotape machine and/or disk-based recording devices.

Character generator Types and/or recalls from the computer the names and other graphic material to be

(C.G.) operator integrated with the video image.

Videotape editor Operates postproduction editing equipment. Often makes or assists in creative

editing decisions.

Digital graphic artistRenders digital graphics for on-air use. Can be nontechnical personnel.

16.4 NEWS PRODUCTION PERSONNEL

PERSONNEL	FUNCTION
News director	In charge of all news operations. Bears ultimate responsibility for all newscasts.
Producer	Directly responsible for the selection and placement of the stories in a newscast so that they form a unified, balanced whole.
Assignment editor	Assigns reporters and videographers to specific events to be covered.
Reporter	Gathers the stories. Often reports on- camera from the field.
Videographer	Camcorder operator. In the absence of a reporter, decides on what part of the event to cover. Also called <i>news</i> photographer or shooter.
Writer	Writes on-the-air copy for the anchors. The copy is based on the reporter's notes and the available videotape.
Videotape editor	Edits videotape according to reporter's notes, writer's script, or producer's instructions.
Anchor	Principal presenter of newscast, normally from a studio set.
Weathercaster	On-camera talent, reporting the weather.
Traffic reporter	On-camera talent, reporting local traffic conditions.
Sportscaster	On-camera talent, giving sports news and commentary.

own personalities to the audience. Television *actors*, on the other hand, always portray someone else: they project a character's personality rather than their own, even if the character is modeled after their own experience. Their stories are always fictional.

Although there are distinct differences between television performers and television actors, the groups do share several functions. All talent communicate with the viewers through the television camera and must keep in mind the

nuances of audio, movement, and timing. And all talent interact with other television personnel—the producer, the director, the floor manager, the camera operator, and the audio technician.

PERFORMANCE TECHNIQUES

The television performer speaks directly to the camera, plays host to various guests, or communicates with other performers or the studio audience; he or she is also fully aware of the presence of the television audience at home. This latter audience, however, is not the large, anonymous, and heterogeneous television audience that modern sociologists study. For the television performer, the audience is an individual or a small, intimate group who has gathered in front of a television set.

If you are a performer, try imagining your audience as a family of three, seated in their favorite room, about 10 feet away from you. With this picture in mind, you have no reason to scream at the "millions of viewers out there in videoland"; a more successful approach is to talk quietly and intimately to the family who were kind enough to let you into their home.

When you assume the role of a television performer, the camera becomes your audience. You must adapt your performance techniques to its characteristics and to other production aspects such as audio and timing. In this section we discuss (1) the performer and the camera, (2) the performer and audio, (3) the performer and timing, (4) the performer and postproduction, (5) the floor manager's cues, and (6) prompting devices.

PERFORMER AND CAMERA

The camera is not simply an inanimate piece of machinery; it sees everything you do or don't do. It sees how you look, move, sit, and stand—in short, how you behave in a variety of situations. At times it looks at you much more closely and with greater scrutiny than a polite person would ever dare to do. It reveals the nervous twitch of your mouth when you are ill at ease and the expression of mild panic when you have forgotten a name. The camera does not look away when you scratch your nose or ear. It faithfully reflects your behavior in all pleasant and unpleasant details. As a television performer, you must carefully control your actions without letting the audience know that you are conscious of doing so.

Camera lens Because the camera represents your audience, you must look directly into the lens (or the prompting

device in front of it) whenever you intend to establish eye contact with the viewer. As a matter of fact, you should try to look *through* the lens, rather than at it, and keep eye contact much more than you would with an actual person. If you merely look at the lens instead of looking through it, or if you pretend that the camera operator is your audience and therefore glance away from the lens ever so slightly, you break the continuity and intensity of the communication between you and the viewer; you break, however temporarily, television's magic.

Camera switching If two or more cameras are used, you must know which one is on the air so that you can remain in direct contact with the audience. When the director switches cameras, you must follow the floor manager's cue (or the change of *tally lights*) quickly but smoothly. Do not jerk your head from one camera to the other. If you suddenly discover that you have been talking to the wrong one, look down as if to collect your thoughts and then casually look up and glance into the "hot" camera. Continue talking in that direction until you are again cued to the other camera. This method works especially well if you work from notes or a script, as in a newscast or an interview. You can always pretend to be looking at your notes when, in reality, you are changing your view from the wrong camera to the right one.

If the director has one camera on you in a *medium shot* (MS) and the other camera in a *close-up* (CU) of the object you are demonstrating, such as the guest's book during an interview, it is best to keep looking at the medium-shot camera during the whole demonstration, even when the director switches to the close-up camera. You will not be caught looking the wrong way because only the medium-shot camera is focused on you. **SEE 16.5** You will also find that it is easier to read the copy off a single teleprompter, rather than switch from one to another in midsentence.

Close-up techniques The tighter the shot, the harder it is for the camera to follow movement. If a camera is on a close-up, you must restrict your motions severely and move with great care. During a song, for example, the director may want to shoot very closely to intensify an especially emotional passage. Try to stand as still as possible; do not wiggle your head. The close-up itself is intensification enough. All you have to do is sing well.

When demonstrating small objects on a close-up, hold them steady. If they are arranged on a table, do *not* pick them up. You can either point to them or tilt them a little to give the camera a better view. There is nothing more frustrating to the camera operator and the director

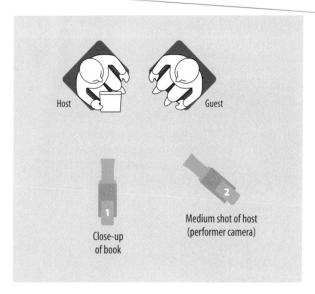

16.5 PERFORMER CAMERA

When one camera (camera 1) is on a close-up of the product (the book), and the other (camera 2) is on a medium shot of the host, the host should continue looking into camera 2 during the close-up.

than a performer who snatches the product off the table just when the camera has a good close-up of it. A quick look at the studio monitor usually tells you how to hold the object for maximum visibility on-screen. If two cameras are used, "cheat" (orient) the object somewhat toward the close-up camera, but do not turn it so much that it looks unnaturally distorted on the medium-shot camera.

Warning cues In most nondramatic shows—lectures, demonstrations, interviews, and the like-there is generally not enough time to work out a detailed blocking scheme. The director usually just walks the performers through some of the most important crossovers from one performance area to the other and through a few major actions, such as complicated demonstrations. During the on-the-air performance, you as a performer must therefore give the director and the studio crew visual and audible warnings of your unrehearsed actions. Before you stand up, for instance, first shift your weight and position your arms and legs; this signals the camera operator as well as the microphone boom operator to prepare for your move. If you pop up unexpectedly, the camera may stay in one position, focusing on the middle part of your body, which won't make for the most interesting shot to say the least.

If you intend to move from one set area to another, you may use audio cues. For instance, you can warn the

production crew by saying: "Let's go over to the children and ask them..." or "If you will follow me over to the lab area, you can see..." Such cues sound natural to the viewer, who is generally unaware of the fast reactions these seemingly innocuous remarks actually trigger. You must be specific when you cue unrehearsed visual material. For example, you can alert the director to the upcoming visuals by saying: "The first picture shows..." This cueing device should not be used too often, however. If you can alert the director more subtly yet equally directly, do so.

Do not try to convey the obvious. The director, not the talent, runs the show. Don't tell the director to bring the cameras a little closer to get a better view of a small object, especially if the director has already obtained a good close-up through a zoom-in. Also, avoid walking toward the camera to demonstrate an object. You may walk so close to the camera that it has to tilt up into the lights to keep your face in the shot or so close that the zoom lens can no longer focus. The zoom lens allows the camera to get to you much faster than you can get to the camera.

PERFORMER AND AUDIO

As a television performer, besides looking natural and relaxed, you must speak clearly and effectively; it rarely comes naturally. Don't be misled into believing that a resonant voice and affected pronunciation are the two prime requisites for a good announcer or other performer. On the contrary: first, you need to have something important to say; second, you need to say it with conviction and sincerity; third, you must speak clearly so that everyone can understand you. Thorough training in television announcing is an important prerequisite for any performer. Most novices speak much too fast, as though they wanted to get through the on-camera torture as quickly as possible. Don't speed up when you come to the end of a sentence or paragraph. Take a deep breath and *slow down*. You will be amazed how much more relaxed you will be.

Microphone technique The following summarizes the main points about handling microphones and assisting the audio technician. (See chapter 9 for an in-depth discussion of the basic microphone techniques.)

Most often you will work with a *lavaliere* microphone. Once it is properly fastened, you do not have to worry about it, especially if you are relatively stationary during the performance. If you have to move from one set area to another on-camera, watch that the mic cord does not get tangled up with the set or props. Gently pull the cable behind you to keep the tension off the mic itself. A wireless

lavaliere will enable you to move within the performance area without having to worry about a cable.

- When using a hand mic, check that you have enough cable for your planned actions. Speak *across* it, not into it. If you are interviewing someone in noisy surroundings, such as a downtown street, hold the microphone close to your mouth when you are talking, then point it toward the person as he or she responds to your questions.
- When working with a boom mic (including a hand-held shotgun or one that is mounted on a fishpole), be aware of the boom movements without letting the audience know. Give the boom operator enough warning so that he or she can anticipate your movements. Move slowly so that the boom can follow. In particular, do not make fast turns because they involve a great amount of boom movement. If you have to turn fast, try not to speak until the boom has been repositioned.
- Do not move a desk mic once it has been placed by the audio technician. Even if the microphone is pointing away from you toward another performer, it was probably done purposely to achieve better audio balance.

In all cases, treat microphones gently. Mics are not intended to be hand props, to be tossed about or twirled by their cords like a lasso, even if you see such misuse occasionally in an especially energetic rock performance.

Audio level A good audio technician will ask you for an *audio level* before you go on the air. Many performers have the bad habit of rapidly counting to ten or mumbling and speaking softly while the level is being taken, then, when they go on the air, blasting their opening remarks. If a level is taken, speak as loudly as you will in your opening remarks and as long as required for the audio technician to adjust the volume to an optimal level.

Opening cue At the beginning of a show, all microphones are dead until the director gives the cue for audio. You must therefore wait until you receive the opening cue from the floor manager or through the *I.F.B.* (*interruptible foldback*, or *feedback*) system. If you speak beforehand, you will not be heard. Do not take your opening cue from the red tally lights on the cameras unless you are so instructed. When waiting for the opening cue, look into the camera that is coming up on you and not at the floor manager.

PERFORMER AND TIMING

Live and live-on-tape television operate on split-second timing. Although it is ultimately the director's responsibility to get the show on and off the air on time, you as the performer have a great deal to do with successful timing.

Aside from careful pacing throughout the show, you must learn how much program material you can cover after you have received a 3-minute, a 2-minute, a 1-minute, a 30-second, and a 15-second cue. You must, for example, still look comfortable and relaxed although you may have to cram a lot of program material into the last minute while at the same time listen to the director's or producer's I.F.B. On the other hand, you must be prepared to fill an extra thirty seconds without appearing to grasp for words and things to do. This presence of mind, of course, is achieved through practical experience and cannot be learned solely from a textbook.

PERFORMER AND POSTPRODUCTION

When you work on a brief commercial or announcement that presents a continuous event but that is shot film-style over a period of several days or even weeks for postproduction, you must look the same in all the videotaping sessions. Obviously, you must wear the same clothes. You must also wear the same jewelry, scarf, and tie from one taping session to the next. You cannot have your coat buttoned one time and unbuttoned the next. Makeup and hairstyle too must be identical for all sessions. Have digital photos taken of yourself from the front, sides, and back immediately after the first taping session for an easy and readily available reference.

Most important, you must maintain the same level of energy throughout the taping sessions. For example, you cannot end one session full of energy and then be very low-key the next day when the videotaping resumes, especially when the edited version does not suggest any passage of time between takes. On repeat takes, try to maintain identical energy levels.

FLOOR MANAGER'S CUES

Unless you are connected with the producer and the director via I.F.B., it is the floor manager who provides the link between the director and you, the performer. The floor manager can tell you whether your delivery is too slow or too fast, how much time you have left, and whether you are speaking loudly enough or holding an object correctly for a close-up shot.

Although various stations and production houses use slightly different cueing signals and procedures, they normally consist of time cues, directional cues, and audio cues. If you are working with an unfamiliar production crew, ask the floor manager to review the cues before you go on the air. **SEE 16.6**

React to each cue immediately, even if you think it is not appropriate at that particular time. The director would not give the cue if it were not necessary. A truly professional performer is not one who never needs cues but rather one who can react to all signals quickly and smoothly.

Do not look nervously for the floor manager if you think you should have received a cue; he or she will find you and draw your attention to the signal. When you receive a cue, do not acknowledge it in any way; the floor manager will know whether you noticed it.

You will find that receiving and reacting to I.F.B. information during a performance is no easy task. We all know how difficult it can be to continue a telephone conversation when someone close by is trying to tell us what else to communicate to the other party. But when reporting news in the studio or in the field, such simultaneous communication is common. You must learn to listen carefully to the I.F.B. instructions of the director or producer without letting the audience know that you are listening to someone else while talking to them. Do not interrupt your communication with the audience when getting I.F.B. instructions, even if the transmission is less than perfect. If during a live remote you can't understand what is being said on the I.F.B. channel, however, you may have to stop your narration to tell the audience that you are getting some important information from your director. Listen carefully to the I.F.B. instructions, then go on with what you were saying. Try not to adjust your earpiece while on the air. If at all possible, wait until the camera cuts away from you to do an adjustment.

PROMPTING DEVICES

Prompting devices have become an essential production tool, especially for news or speeches. The audience has come to expect the newscaster to talk directly to them rather than read the news from a script, although we all know that the newscaster cannot possibly remember the entire news copy. We expect speakers to deliver copious and complicated information without having to think about what to say next. Prompting devices are also helpful to performers who fear they may suddenly forget their lines or who have no time to memorize a script.

Prompting devices must be totally reliable, and the performer must be able to read the copy without appearing to lose eye contact with the viewer. Two devices have proved especially successful: cue cards and the teleprompter.

16.6 FLOOR MANAGER'S CUES

The floor manager uses a set of standard hand signals to relay the director's commands to the on-the-air talent.

CUE	SIGNAL	MEANING	SIGNAL DESCRIPTION
TIME CU	ES		
Standby		Show about to start.	Extends hand above head.
Cue		Show goes on the air.	Points to performer or live camera.
On time		Go ahead as planned (on the nose).	Touches nose with forefinger.
Speed up		Accelerate what you are doing. You are going too slowly.	Rotates hand clockwise with extended forefinger. Urgency of speed-up is indicated by fast or slow rotation.
Stretch		Slow down. Too much time left. Fill until emergency is over.	Stretches imaginary rubber band between hands.

16.6 FLOOR MANAGER'S CUES (continued)

CUE	SIGNAL	MEANING	SIGNAL DESCRIPTION
TIME CUES			
Wind up		Finish up what you are doing. Come to an end.	Similar motion to speed-up, but usually with arm extended above head. Sometimes expressed with raised fist, good-bye wave, or hands rolling over each other as if wrapping a package.
Cut		Stop speech or action immediately.	Pulls index finger in knifelike motion across throat.
5 (4, 3, 2, 1) minute(s)		5 (4, 3, 2, 1) minute(s) left until end of show.	Holds up five (four, three, two, one) finger(s) or small card with number on it.
Half minute		30 seconds left in show.	Forms a cross with two index fingers or arms. Or holds card with number.
15 seconds		15 seconds left in show.	Shows fist (which can also mean wind up). Or holds card with number.
Roll VTR (and countdown) 2, 1, take VTR		VTR is rolling. Tape is coming up.	Holds extended left hand in front of face, moves right hand in cranking motion. Extends two, one finger(s); clenches fist or gives cut signal.

16.6 FLOOR MANAGER'S CUES (continued)

CUE	SIGNAL	MEANING	SIGNAL DESCRIPTION
DIRECTI	ONAL CUES		
Closer		Performer must come closer or bring object closer to camera.	Moves both hands toward self, palms in.
Back		Performer must step back or move object away from camera.	Uses both hands in pushing motion, palms out.
Walk		Performer must move to next performance area.	Makes a walking motion with index and middle fingers in direction of movement.
Stop		Stop right here. Do not move any more.	Extends both hands in front of body, palms out.
OK		Very well done. Stay right there. Do what you are doing.	Forms an $\mathcal O$ with thumb and forefinger, other fingers extended, motioning toward talent.

16.6 FLOOR MANAGER'S CUES (continued)

CUE	SIGNAL	MEANING	SIGNAL DESCRIPTION
AUDIO CUI	F S		
Speak up		Performer is talking too softly for present conditions.	Cups both hands behind ears or moves hand upward, palm up.
Tone down		Performer is too loud or too enthusiastic for the occasion.	Moves both hands toward studio floor, palms down, or puts extended forefinger over mouth in <i>shhh</i> -like motion.
Closer to mic		Performer is too far away from mic for good audio pickup.	Moves hand toward face.
Keep talking		Keep on talking until further cues.	Extends thumb and forefinger horizontally, moving them like a bird's beak.

Cue cards Used for relatively short pieces of copy, there are many types of *cue cards*, and the choice depends largely on what the performer is used to and what he or she prefers. Usually, they are fairly large posterboards on which the copy is hand-lettered with a felt-tipped marker. The size of the cards and the lettering depends on how well the performer can see and how far away the camera is. Even the handling of cue cards is easier said than done. A good floor person holds the cards as close to the lens as

possible, the hands do not cover any of the copy, and he or she follows the performer's lines so that the changes from one card to the next are smooth. **SEE 16.7**

As a performer you must learn to read by peripheral vision so that you will not lose eye contact with the lens. Get together with the floor person handling the cards to double-check their correct order. If the floor person forgets to change the card at the appropriate moment, snap your fingers to attract his or her attention; in an emergency you

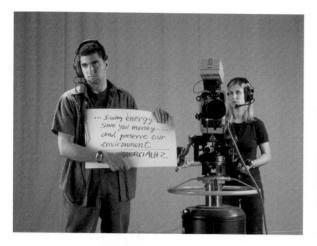

16.7 HANDLING CUE CARDS

A This is the wrong way to hold a cue card: the card is too far away from the lens, and the hands cover part of the copy. The floor person cannot see the copy and does not know when to change the card.

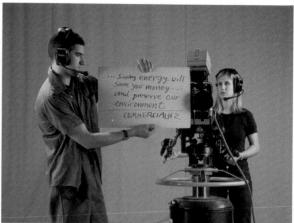

B This is the correct way to hold a cue card: the floor person does not cover the copy, holds the card close to the lens, and reads along with the talent.

may have to ad-lib until the system is functioning again. You should study the topic long before the show begins, enabling you to ad-lib sensibly at least for a short time. If your performance is shot for postproduction, ask the director to stop the tape so that the cards can be put in the correct order.

Studio teleprompter The most effective prompting device is the *teleprompter*, or *auto cue*, which uses a small monitor or flat-panel video display upon which the copy scrolls. The monitor screen is then reflected onto a glass angled over the camera lens. You can read the copy, which now appears in front of the lens but which remains invisible to the camera. This way you do not have to glance to the side but can maintain eye contact with the viewer at all times. **SEE 16.8**

Most often the copy is typed into a computer that acts as a combination word processor and character generator. It can produce the text in several font sizes and *scroll* (often referred to as *crawl*) the copy up and down the screen at various speeds. The copy is then sent to the teleprompter monitor mounted on the camera. All cameras used in the production display the same copy.

In newscasts the anchorperson should have the text as it appears on the teleprompter also printed out as *hard copy*. This script serves as backup in case the prompting device fails. Such copy also gives the anchor a reason to glance down to indicate a story transition, to change

Glass plate reflecting image from monitor

Flat panel or monitor displaying copy

Copy as it appears to talent

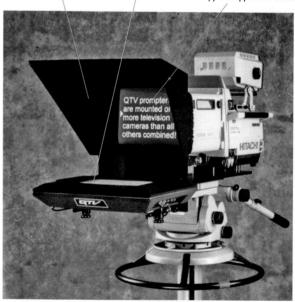

16.8 TELEPROMPTER DISPLAY OF COPY

The monitor or flat-panel display reflects the copy onto a glass plate directly over the lens. The lettering remains invisible to the camera, but the talent can read the copy while keeping eye contact with the audience.

382 Chapter 16 PRODUCTION PEOPLE

16.9 FIELD PROMPTER

A lightweight prompter with a flat-panel video display can be mounted on any type of field camera. Like a studio prompter, it projects the text directly over the lens.

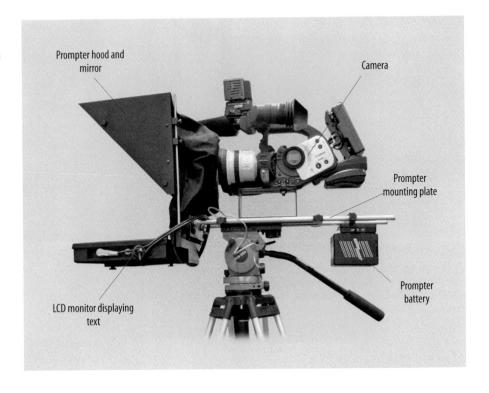

cameras, or to see during a commercial break what is coming up next.

When using a teleprompter, the distance between you and the camera is no longer arbitrary. The camera must be close enough for you to read the copy without squinting but not so close that the home viewer can see your eyes moving back and forth. If the minimum camera distance is too far to see the teleprompter copy comfortably, have the font size made bigger.

Field prompter Have you ever wondered how some correspondents can stand on a busy city street and report a well-written story without ever stumbling or searching for words? Although some certainly have that skill, others use some kind of prompting device. If the copy is brief, handheld cue cards or even some notes will do. Longer copy calls for a *field prompter*.

There are several models of field prompters, including a miniature version of the studio teleprompter. The flat-panel video displays are so lightweight that they can be attached to a tripod. Most high-end field prompters can be hooked up to a laptop computer with prompting software. **SEE 16.9** You can adjust the size of the font and scroll the copy at various speeds. Low-end prompters use a paper roll mounted immediately below or to one side of

the lens. A small electric motor rolls the hand-lettered copy from the bottom to the top. In more-elaborate models, the copy is back-lighted and projected onto a piece of clear plastic mounted in front of the lens, similar to a studio teleprompter.

Similar units can be used independent of the camera and held by a floor person or mounted on a tripod directly above or below the camera lens. Regardless of the quality of the teleprompter, you should always be familiar enough with the subject matter to be able to talk about it intelligently if the prompting device fails.

ACTING TECHNIQUES

In contrast to the television performer, the television actor assumes someone else's character and personality. (In this discussion the term *actor* refers to both male and female talent.) To become a good television actor, you obviously must first master the art of acting, a subject beyond the scope of this chapter. This discussion focuses on how to adapt your acting to the peculiarities of the television medium. Many excellent actors consider television the most difficult medium in which to work. They must function effectively within an environment crowded with confusing and impersonal technical gear, and they often get less

attention from the director than do the camera operator and the sound technician.

AUDIENCE

The biggest difference between stage acting and screen acting is that you are not playing for a stationary live audience but for a constantly moving camera that never blinks or offers feedback on your performance. Worse, your performance is chopped up into short takes that rarely, if ever, allow you to work up to a memorable performance pitch. Each of the little performance segments must be on the mark. In most takes the camera moves around you, looking at you at close range and from a distance as well as from above and below. It may look at your eyes, your feet, your hands, your back-whatever the director selects for the audience to see. And at all times you must look completely convincing and natural; the character you are portraying must appear on-screen as a believable human being. Keep in mind that you are playing to a virtual audience that is almost always standing right next to you, looking at you from very close up and from all angles. You need not (and should not) project your motions and emotions as you would when acting on-stage. The television camera does the projecting—the communicating—for you. Be aware of the camera or cameras, but don't ever acknowledge their presence.

Internalization of your role, as opposed to externalization, is a key factor in your performance. You must attempt to become as much as possible the person you are portraying, rather than act out the character. Because of the close scrutiny of the camera and the intimacy of the close-up, your reactions become as important as your actions. You can often communicate feelings more readily by reacting to a situation than by contributing to it through action.

BLOCKING

You must be meticulous in following rehearsed *block-ing*—where you should move and what you should do in relation to the set, the other actors, and the television equipment. Sometimes inches are significant, especially if the show is shot primarily in close-ups. Precise television lighting and the limited microphone radius when booms are used also force you to adhere strictly to the established blocking.

Once the show is on the air, you have an obligation to follow the rehearsed action. This is not the time to innovate just because you have a sudden inspiration. If the director has not been warned of your change, the new blocking will always be worse than the previously rehearsed one. The

camera has a limited field of view; if you want to be seen, you must stay within it.

Some directors have the floor manager mark the exact spots for you to stand or the paths of movement. This is called *spiking* your position. Look for these tape or chalk marks and follow them without being too obvious. If such spike marks are not used, establish a *blocking map* by remembering where you stand for specific shots in relation to the set and the props. For example, for your scene with the office manager you stand to the left of the file cabinet; for the scene in the doctor's office, you walk counterclockwise around the desk and stop at the camera-right corner of the desk.

In over-the-shoulder and cross-shots, you need to see the camera lens if you are to be seen by the camera. If you cannot see the lens, the camera cannot see you. Even the lighting instruments can help you with blocking. For example, to be sure you're in the light when coming through a door, move forward until you feel the warmth of the lights on your forehead.

Sometimes the director will position you in a way that seems entirely wrong to you, especially in relation to the other actors. Don't try to correct this on your own by arbitrarily moving away from the designated spot. A certain camera angle and zoom-lens position may very well warrant unusual blocking to achieve a certain effect. Do not second-guess the director.

When you are handling props, the camera is often on a close-up. This means that you must remember all the rehearsed actions and execute them in exactly the same way and with the same speed as they were initially rehearsed. Don't appear nervous when using props (unless the director calls for it), but handle them routinely as extensions of your gestures. The way you handle props, such as taking off your glasses, cleaning them, and putting them on again, can often sharpen your character.

MEMORIZING LINES

As a television actor, you must be able to learn your lines quickly and accurately. If, as is the case in soap operas, you have only one evening to learn a great amount of lines for the next day, you must indeed be a quick study. You cannot ad-lib during such performances simply because you have played the role for so long. Most of your lines are important not only from a dramatic point of view but also because they serve as video and audio cues for the whole production team. Your last line of a speech is often a trigger for several key actions in the control room: to switch to another camera, to roll a videotape insert, or to call up a special effect.

For a single-camera EFP or film-style studio production, each shot is set up and recorded separately. Such a production approach often gives you a chance to read over your lines for each take. Although this approach may make it easier to remember lines, it is harder to maintain continuity of action and emotion. Good television actors do not rely on prompting devices; after all, you should live, not read, your role. Nevertheless, many good actors like to have all their lines backed up by cue cards, just in case. Most of the time, they never look at them. But even if the cue cards function only as a safety net, their contribution to a good performance more than justifies their use.

TIMING

Like the television performer, as an actor you must have an acute sense of timing. Timing matters for pacing your performance, for building to a climax, for delivering a punch line, and for staying within a tightly prescribed clock time. Even if a play is videotaped scene-by-scene, you still need to observe carefully the stipulated running times for each take. You may have to stretch a scene without making it appear to drag, or you may need to gain ten seconds by speeding up a scene without destroying its solemn character. You must be flexible without stepping out of character.

Always respond immediately to the floor manager's cues. Do not stop in the middle of a scene simply because you disagree with a specific cue; you're not privy to all the goings-on in the control room. Play the scene to the end and then speak up. Minor timing errors can often be corrected in postproduction.

ACTOR AND POSTPRODUCTION

As you know, most television plays are videotaped piecemeal, which means that you are not able to perform a play from beginning to end as in a theater production. You cannot be upbeat during the first part of the videotaping and then, a week later when the scene is continued, project a low-energy mood. Often scenes are shot out of sequence for production efficiency and, ultimately, to save money, so it is not possible to have a continuous and logical development of emotions, as is the case in a continuous live or live-on-tape pickup. Scenes are inevitably repeated to make them better or to achieve various fields of view and camera angles. This means that, as an actor, you cannot

psych yourself up for a single show-stopping performance. Rather, you need to maintain your energy and motivation for each take. Television unfailingly detects subtle nuances and levels of energy and the accompanying acting continuity—or lack thereof.

One of the most important qualities to watch for when continuing a scene that was started some days before is the *tempo* of your performance. If you moved slowly in the first part of the scene, do not race through the second part unless the director wants such a change. It usually helps to watch a videotape of your previous performance so that you can continue the scene with the same energy level and tempo.

DIRECTOR/ACTOR RELATIONSHIP

As a television actor, you cannot afford to be temperamental; too many people have to be coordinated by the director. Although you as an actor are an extremely significant element in the production, other production people are too—the camera operators, the TD, the audio technician, and the LD, to name but a few.

Even if you have no intention of becoming a television actor, you should make an effort to learn as much about acting as possible. An able actor is generally an effective television performer; a television director with training in acting is generally better equipped to deal with talent than one who has no knowledge of the art.

AUDITIONS

All auditions are equally important, whether you are trying out for a one-line off-camera utterance or a principal role in a dramatic series. Whenever you audition give your best. You can prepare yourself even if you don't know beforehand what you will be reading. Wear something appropriate that looks good on-camera and be properly groomed. Keep your energy up even if you have to wait half a day before you are called to deliver your line.

When you get the script beforehand, study it carefully. For example, if you are doing a commercial for a soft drink, become as familiar as possible with the product, the company that makes it, and the advertising agency producing the commercial. Knowing about the product gives you a certain confidence that inevitably shows up in your deliv-

ery. Listen carefully to the instructions given to you before and during the audition. Remember that television is an intimate medium.

When instructed to demonstrate a product, practice before you are on-camera to make sure you know how, for example, to open the easy-to-open package. Ask the floor crew to help you prepare a product for easy handling. Also find out how close the majority of shots will be so that you can keep your actions within camera range.

As an actor be sure to understand thoroughly the character you are to portray. If the script does not tell you much about the character, ask the director or producer to explain how he or she perceives it. You should be able to sense the specifics of the character even when given only minimal cues. Decide on a behavior pattern and follow it, even if your interpretation may be somewhat off base. If the director's perceptions run counter to your interpretation, do not argue. Most important, do not ask the casting director to provide you with the "proper motivation" as you may have learned in acting school. At this point it is assumed that you can analyze the script and motivate yourself for the reading. Realize that you are auditioned primarily on how well and how quickly you perceive the script's image of the character and how close you can come to it in speech and sometimes also in actions.

Be creative without overdoing it. When auditions were held for the male lead in a television play about a lonely woman and a rather crude and unscrupulous man who wanted to take advantage of her, one of the actors added a little of his own interpretation of the character that eventually got him the part. While reading an intimate scene in which he was supposed to persuade the leading lady to make love to him, he manicured his fingernails with slightly rusty fingernail clippers. In fact, this aggravating fingernail clipping was later written into the scene.

Finally, when auditioning—as when participating in athletics or any competitive activity—be aware, but not afraid, of the competition. Innate acting talent is not always the deciding factor in casting a part. Sometimes the director may have a particular image in mind of the physical appearance and the behavior of the actor—heavy and awkward, light and agile, or lean and muscular—that overrides acting skill. Sometimes a well-known actor who can guarantee a large audience may win out. As an actor you need to be prepared to take it repeatedly on the chin.

MAIN POINTS

- Nontechnical production personnel are concerned primarily with the nontechnical production elements, such as scriptwriting and directing. They are normally classified as above-the-line personnel.
- Technical production personnel are primarily concerned with the operation and the maintenance of the equipment.
 They are normally among the below-the-line personnel.
- News production personnel are assigned exclusively to the production of news, documentaries, and special events.
- Regardless of the specific job functions of the technical and nontechnical personnel, they all have to interact as a team.
- Television talent refers to all persons who perform regularly in front of the camera. They are classified into two large groups: performers and actors.
- Television performers are basically engaged in nondramatic shows, such as newscasts, interviews, and game shows. They portray themselves. Television actors portray someone else.
- The television performer must adapt his or her techniques to the characteristics of the camera and the other production elements, including audio, timing, postproduction, the floor manager's cues, and prompting devices.
- Because the camera lens represents the audience, performers must look through the lens to establish and maintain eye contact with the viewer. If cameras are switched, performers must transfer their gaze to the hot camera smoothly and naturally.
- Timing is an important performance requirement. A good performer must respond quickly yet smoothly to the floor manager's time, directional, and audio cues.
- Prompting devices have become essential in television production. The two most frequently used devices are cue cards and the teleprompter.
- Television acting requires that the actor overcome the lack of an actual audience and internalize the role, restrict gestures and movements because of close-ups, follow exactly the rehearsed blocking, memorize lines quickly, have a good sense of timing, maintain continuity in physical appearance and energy level over a series of takes, and keep a positive attitude despite occasional neglect by the director.
- Performers and actors should prepare as much as possible for auditions, dress properly for the occasion (role), and sharpen the character through some prop or mannerism.

16.2

How to Do Makeup and What to Wear

When you hear of *makeup*, you may think of movies in which actors are transformed into monsters or odd-looking aliens or of how to fake a variety of wounds. You may even argue that the way performers or actors look is less important than the substance of what they say or do. But most television makeup is done not so much to transform appearance as to make someone look as good as possible on-camera. The same goes for clothing. Unless you act in a period play, most actors wear clothes that fit the role, and performers choose clothes that make them look attractive on-camera.

The aim of section 16.2 is to help you choose makeup, clothing, or costumes that not only fit but also add to the overall production values and communication intent.

■ MAKEUP

Materials, application, and technical requirements

CLOTHING AND COSTUMING

Line, texture and detail, and color

MAKEUP

All *makeup* is used for three basic reasons: (1) to enhance appearance, (2) to correct appearance, and (3) to change appearance.

Standard over-the-counter makeup is used daily by many women to accentuate and improve their features.

Minor skin blemishes are covered up, and the eyes and lips are emphasized. Makeup can also be used to correct closely or widely spaced eyes, sagging flesh under the chin, a short or long nose, a slightly too prominent forehead, and many similar minor "flaws." If a person is to portray a specific character in a play, a complete change of appearance may be necessary. Dramatic changes of age, ethnicity, and character can be accomplished through creative makeup techniques. Make-up artists working for crime show series have a field day. Their grisly renderings of all sorts of bodily harm are often so realistic that they border on the repulsive; but they are, nevertheless, testimony to the high artistic skills of the makeup artists.

The various purposes for applying cosmetics require different techniques, of course. Enhancing someone's appearance calls for the least complicated procedure; correcting someone's appearance is slightly more complicated; and changing an actor's appearance may require involved and complex makeup techniques. Making a young actor look eighty years old is best left to the professional makeup artist. You need not learn all about corrective and character makeup methods, but you should have some idea of the basic materials, techniques, and technical requirements of television makeup.

MATERIALS

A great variety of excellent television makeup material is available. Most makeup artists in the theater arts department of a college or university have up-to-date product lists. In fact, most large drugstores can supply you with the basic materials for enhancing a performer's appearance. Women performers are generally experienced in cosmetic materials and techniques; men may, at least initially, need some advice.

The most basic makeup item is a *foundation* that covers minor blemishes and cuts down light reflections on oily skin. Water-based cake makeup foundations, generally referred to as *pancake*, are preferred over the more cumbersome grease-based foundations, called *pan stick*. The Krylon AquaColor Base or Maybelline EverFresh pancake series is probably all you need for most makeup jobs. The colors range from a warm, light ivory to dark shades for dark-skinned performers.

Women can use their own lipsticks, so long as the reds do not contain too much blue. For dark-skinned talent, a warm red, such as coral, is often more effective than a darker red that contains a great amount of blue. Other materials, such as eyebrow pencil, mascara, and eye shadow, are generally part of every woman performer's makeup kit.

Materials such as hairpieces or even latex masks are part of the professional makeup artist's inventory. They are of little use in most nondramatic productions.

APPLICATION

It is not always easy to persuade nonprofessional performers, especially men, to put on necessary makeup. You may do well to look at the guests on-camera before deciding whether they need any. If they do, you must be tactful in suggesting its application. Try to appeal not to the performer's vanity but to his or her desire to contribute to a good performance. Explain the necessity for makeup in technical terms, such as color and light balance.

All makeup rooms have large mirrors so that talent can watch the entire makeup procedure. Adequate, even illumination is critical. The color temperature of the light in which the makeup is applied must match, or at least closely approximate, that of the production illumination. Most makeup rooms have two illumination systems that can be switched from the indoor (3,200K) standard to the outdoor (5,600K) standard.

When makeup is applied in the studio, have a small mirror on hand. Most women performers are glad to apply the more complicated makeup themselves—lipstick and mascara, for instance. In fact, most professional television talent prefer to apply their makeup themselves; they usually know what kind they need for a specific television show.

When using a water-based pancake makeup, apply it evenly with a wet sponge over the face and adjacent exposed skin areas. Get the base right up into the hairline, and have a towel ready to wipe off the excess. If close-ups of hands are shown, apply pancake base to them and the arms. This is especially important for performers who demonstrate small objects on-camera. If an uneven suntan is exposed (especially when women performers wear backless dresses or different kinds of bathing suits), all bare skin areas must be covered with base makeup. Bald men need a generous amount of pancake foundation to tone down inevitable light reflections and to cover up perspiration.

Be careful not to give male performers a baby-face complexion through too much makeup. It is sometimes desirable to have a little beard area show. Frequently, a slight covering up of the beard with a pan stick is all that is needed. If additional foundation is necessary, a panstick around the beard area should be applied first and then set with powder. A very light application of a yellow or orange greasepaint satisfactorily counteracts the blue of a heavy five-o'clock shadow. There are professional beard covers available.

Because your face is the most expressive communication agent, try to keep your hair out of your face as much as possible.

TECHNICAL REQUIREMENTS

Like so many other production elements, makeup must yield to the demands of the television camera. These limitations include color distortion, color balance, and close-ups.

Color distortion As mentioned, skin tones are the only real color references the viewer has for color adjustment on a home receiver. Their accurate rendering is therefore of the utmost importance. Because cool colors (hues with a blue tint) have a tendency to overemphasize bluishness, especially in high-color-temperature lighting, warm colors (warm reds, oranges, browns, and tans) are preferred for television makeup. They usually provide more sparkle, especially when used on a dark-skinned face.

The color of the foundation makeup should match the natural skin tones as closely as possible, regardless of whether the face is naturally light or naturally dark. Again, to avoid bluish shadows, warm rather than cool foundation colors are preferred. Be careful, however, that light-colored skin does not turn pink. As much as you should guard against too much blue in a dark face, you must watch for too much pink in a light face.

The skin reflectance of a dark face can produce unflattering highlights. These should be toned down by a proper pancake foundation or a translucent powder. Otherwise the video operator will have to compensate for the highlights through shading, making the dark picture areas unnaturally dense.

Color balance Generally, the art director, scene designer, makeup artist, and costume designer coordinate all the colors in production meetings. In nonbroadcast productions, where freelance people are usually hired for scene design and makeup, such coordination is not always easy. In any case try to communicate the various color requirements to all these people as best you can. Some attention beforehand to the coordination of the colors used in the scenery, costumes, and makeup certainly facilitates the production process.

Sometimes the surrounding colors reflect on the performer's clothing or face, which the camera shows as noticeable color distortions. One way of avoiding such reflections is to have the talent step far enough away from the reflecting surfaces. When such a move is not possible,

apply an adequate amount of pancake makeup and additional powder to the discolored skin areas. The viewer will tolerate to some extent the color distortion on clothing but not on skin areas.

Close-ups Television makeup must be smooth and subtle enough that the talent's face looks natural even in an extreme close-up. The skin should have a normal sheen, neither too oily (high reflectance) nor too dull (low reflectance but no brilliance—the skin looks lifeless). The subtlety of television makeup goes directly against theater makeup techniques, in which features and colors are greatly exaggerated for the benefit of the spectators in the back rows. Good television makeup remains largely invisible, so a close-up of a person's face under actual production lighting conditions is the best criterion for judging the necessity for and quality of makeup. If the performer or actor looks good on-camera without makeup, none is needed. If the performer needs makeup and the close-up of his or her finished face looks normal, the makeup is acceptable. If it shows, the makeup must be toned down.

All makeup must be applied under the lighting conditions in which the production is taped. This is because each lighting setup has its own color temperature. Reddish light (low color temperature) may require cooler, more bluish makeup than would higher-color-temperature lighting. In higher-color-temperature lighting (more bluish light), you need to use warmer (more reddish) makeup. (For a review of color temperature, see chapter 7.) ZVL3 LIGHTS Color temperature > light sources

CLOTHING AND COSTUMING

In small-station operations and most nonbroadcast productions, you are mainly concerned with clothing the performer rather than costuming the actor. The performer's clothes should be attractive and stylish but not too conspicuous or showy. Television viewers expect a performer to be well dressed but not overdressed. After all, he or she is a guest in the viewer's home, not a nightclub performer.

CLOTHING

The type of clothing you wear as a performer depends largely on your personal taste. It also depends on the type of program or the occasion and the particular setting. Obviously, you dress differently when reporting live in the field during a snow storm than when taking part in a panel discussion on the homeless in your city. Whatever the occasion, some types of clothing look better on television than others. Because the camera may look at you both from a

distance and at close range, the lines, texture, and details are as important as the overall color scheme.

Line Television has a tendency to add a few extra pounds to the performer, even if they are not digitally stretched to make a 3×4 picture fit the 16×9 screen. Clothing cut to a slim silhouette helps combat this problem. Slim dresses and closely tailored suits look more attractive than do heavy, horizontally striped fabrics and baggy styles. The overall silhouette of the clothing should look pleasing from a variety of angles and should appear slim-fitting yet comfortable.

Texture and detail Whereas line is especially important in long shots, the texture and the detail of clothing become important at close range. Textured material often looks better than plain, but avoid patterns that have too much contrast or are too busy. Closely spaced geometric patterns such as herringbone weaves and checks cause a moiré effect, which looks like superimposed vibrating rainbow colors (see figure 3.20). Stripes may extend beyond the garment and bleed through surrounding sets and objects. Extremely fine detail in a pattern will either look too busy or appear smudgy. Note that most high-quality studio monitors have moiré-suppression circuits built-in, but most home receivers do not. You may not always be aware of the moiré problem a herringbone jacket or checked tie may cause when watching yourself in the mirror. If you suspect possible moiré problems, view the talent's attire on a television set that does not contain such preventive circuits.

Make your clothing more interesting on-camera not by choosing a detailed cloth texture, but by adding decorative accessories, such as scarves and jewelry. Although jewelry style depends, of course, on the performer's taste, in general he or she should limit it to one or two distinctive pieces. The sparkle of rhinestones can become an exciting visual accent when dressing for a special occasion, such as the televised fund-raising dinner or a concert by the community symphony, but they are obviously out of place when interviewing a crime victim.

Color The most important consideration for choosing colors is that they harmonize with the set. If the set is lemon yellow, do not wear a lemon yellow dress. As mentioned before, avoid saturated red, unless you are working with highend studio cameras. If you are taking part in blue chroma keying (such as in weathercasting), avoid wearing blue unless you want to become transparent during the chroma key. Even a blue scarf or tie may give you trouble.

You can wear black or a very dark color, or white or a very light color, so long as the material is not glossy and highly reflective. But avoid wearing a combination of the two. If the set is very dark, avoid a starched white shirt. If the set colors are extremely light, do not wear black. As desirable as a dramatic color contrast is, extreme brightness variations cause difficulties for even the best cameras. Stark white, glossy clothes can turn exposed skin areas dark on the television screen or distort the more subtle colors, especially when the cameras are on automatic iris. Darkskinned performers should avoid highly reflecting white or light-yellow clothes. If you wear a dark suit, reduce the brightness contrast by wearing a pastel shirt. Light blue, pink, light green, tan, or gray—all show up well on television. As always, when in doubt as to how well a certain color combination photographs, preview it on-camera on the set and under the actual lighting conditions.

If two prospective weathercasters—a man and a woman—were now to ask you for advice on what to wear, what would you tell them?

Both should wear something comfortable that does not look wide or baggy. Because of chroma keying, avoid wearing anything blue (or green, if the chroma-key backdrop is green). If possible, tell them the color of the set background so they can avoid wearing the same hue. The woman might wear a slim suit or dress of plain, simple colors. Avoid black-and-white combinations, such as a black jacket over a highly reflecting white blouse. She should avoid highly contrasting narrow stripes or checks and wear as little jewelry as possible, unless she wants to appear flashy. The man might wear a slim suit or slacks and a plain coat, with a plain tie or one with a bold but subtle pattern. He should avoid wearing a white shirt under a black or dark blue suit, as well as clothes or accessories with checkered or herringbone patterns.

COSTUMING

For most normal productions in nonbroadcast, or non-network, operations, you do not need costumes. If you do a play or a commercial that involves costumed actors, you can always rent the necessary articles from a costume company or borrow them from the theater arts department of a local high school or college. Theater arts departments usually have a well-stocked costume room from which you can draw most standard uniforms and period costumes. If you use stock costumes on television, they must look convincing even in a tight close-up. The general construction and, especially, the detail of theater accessories are often too coarse for the television camera.

The color and pattern restrictions for clothing also apply for costumes. The total color design—the overall balance of colors among scenery, costumes, and makeup—is important in some television plays, particularly in musicals and variety shows, where long shots often reveal the total scene, including actors, dancers, scenery, and props. As pointed out before, rather than try to balance all the hues, it is easier to balance the colors by their relative aesthetic energy. You can accomplish this balance by keeping the set relatively low-energy (colors with low saturation) and the set accessories and costumes high-energy (high-saturation colors).

MAIN POINTS

- Makeup and clothing are important aspects of the talent's preparation for on-camera work.
- Makeup is used for three basic reasons: to enhance, to correct, and to change appearance.
- Warm colors generally look better than cool colors because the camera tends to emphasize the bluishness of cool colors; but avoid wearing red.
- Makeup must be smooth and subtle to appear natural in the actual production lighting and on extreme close-ups. The most basic makeup item is a foundation that covers minor blemishes. Water-based pancake foundations, which come in a variety of skin tones, are generally used for television makeup.
- The techniques of television makeup do not differ drastically from applying ordinary makeup, especially if the purpose is to enhance or correct appearance.
- These factors are important when choosing clothing: line, whereby a slim cut is preferred; texture and detail, which must not make the clothing appear too busy; and color, which should harmonize yet contrast with the dominant color of the set. Tightly striped or checkered patterns and herringbone weaves, as well as highly saturated reds and a combination of black-and-white fabrics, should be avoided.

ZETTL'S VIDEOLAB

For your reference, or to track your work, each *Video-Lab* program cue in this chapter is listed here with its corresponding page number.

ZVL1 PROCESS→ People→ nontechnical 368

ZVL2 PROCESS→ People→ technical 370

ZVL3 LIGHTS→ Color temperature→ light sources

388

17

Producing

As a producer you have to wear many hats, sometimes all at once. You may have to act as a psychologist and a businessperson to persuade management to buy your idea, argue as a technical expert for a certain piece of equipment, or search as a sociologist to identify the needs and the desires of a particular social group. After some sweeping creative excursions, you may have to become pedantic and double- and triple-check details, such as whether there is enough coffee for the guests who appear on your show.

Section 17.1, What Producing Is All About, examines the techniques involved in the various stages of producing a television show. Section 17.2, Dealing With Schedules, Legal Matters, and Ratings, looks at some production activities that lie outside the area of production techniques but are nevertheless important tasks for a producer.

KEY TERMS

- **demographics** Audience research factors concerned with such data as age, gender, marital status, and income.
- **effect-to-cause model** Moving from idea to desired effect on the viewer, then backing up to the specific medium requirements to produce such an effect.
- **facilities request** A list that contains all technical facilities needed for a specific production.
- **medium requirements** All content elements, production elements, and people needed to generate the defined process message.
- **process message** The message actually received by the viewer in the process of watching a television program.
- **production schedule** The calendar that shows the preproduction, production, and postproduction dates and who is doing what, when, and where.
- program proposal Written document that outlines the process message and the major aspects of a television presentation.

- **psychographics** Audience research factors concerned with such data as consumer buying habits, values, and lifestyles.
- rating Percentage of television households tuned to a specific station in relation to the total number of television households.
- share Percentage of television households tuned to a specific station in relation to all households using television (HUT); that is, all households with their sets turned on.
- **target audience** The audience selected or desired to receive a specific message.
- time line A breakdown of time blocks for various activities on the actual production day, such as crew call, setup, and camera rehearsal.
- treatment Brief narrative description of a television program.

17.1

What Producing Is All About

Producing means seeing to it that a worthwhile idea gets to be a worthwhile television presentation. As a producer you are in charge of this idea-to-presentation process and for completing the various tasks on time and within budget. You are responsible for the concept, financing, hiring, and overall coordination of production activities—not an easy job by any means!

Although each production has its own creative and organizational requirements, there are nevertheless techniques, or at least approaches, that you can apply to television production in general. These methods can help guide you from the early stages of generating ideas to final postproduction activities.

Section 17.1 walks you through these major production steps.

- PREPRODUCTION PLANNING: FROM IDEA TO SCRIPT Program ideas, production models, program proposal, budget, and script
- PREPRODUCTION PLANNING: COORDINATION People, facilities request, schedules, permits and clearances, and publicity and promotion
- LINE PRODUCER: HOST AND WATCHDOG

 Playing host, watching the production flow, and evaluating the production

POSTPRODUCTION ACTIVITIES

Postproduction editing, evaluation and feedback, and recordkeeping

PREPRODUCTION PLANNING: FROM IDEA TO SCRIPT

As a *producer* you are primarily concerned with preproduction planning and coordination. It is up to you to take care of all the production details necessary to move with precision and efficiency from the initial idea to the actual production activities.

Most producers complain about the lack of time and money available for their productions. Although you could always use more time and a bigger budget, you must learn to deliver high-quality television programming even within such restrictions. Once you have acquired a certain production routine, you will find that more time and money do not necessarily make for a better show, especially if the initial idea is weak. To help you become maximally efficient and effective in your preproduction activities, we focus here on (1) program ideas, (2) production models, (3) the program proposal, (4) the budget, and (5) the script.

GENERATING PROGRAM IDEAS

Everything you see and hear on television started with an idea. As simple as this may sound, developing good and especially workable show ideas on a regular basis is not easy. As a television producer, you cannot wait for the occasional divine inspiration but must generate worthwhile ideas on demand.

Generating ideas Despite the volumes of studies written on the creative process, exactly how ideas are generated remains a mystery. Sometimes you will find that you have one great idea after another; at other times you cannot think of anything exciting, regardless of how hard you try. You can break through this idea drought by engaging several people to do *brainstorming*: Have everybody sit around in a circle and put a small audiotape recorder in the middle. Start the brainstorming session with something as neutral and wide open as, for example: "Knock, knock!" The next person in line will probably say: "Who's there?" and you're on your way. Do not criticize anything anyone says, even if it seems totally unrelated to the previous comments. The aim of brainstorming is to break through the conceptual blocks, and not yield to or reinforce them.

When you have finished the brainstorming session, you can play back the comments and pick some that seem

17.1 PARTIAL CLUSTER

Clustering is a form of written brainstorming. You start with a central idea and branch out to whatever associations come to mind.

relevant to the task at hand. You may find that the so-called off-the-wall comments can trigger workable ideas more readily than the ones that seemed more appropriate. For example, a brainstorming session for a new cell phone model may produce the following string of comments: "any time," "friend in your handbag," "prison," "cloister," "ice hockey," "fist fight," and so forth. Although prison and cloister may conjure up usable images that show people using cell phones in their cells, we are probably inclined to dismiss ice hockey as an apparently disinterested joker's comment. A later review, however, may well trigger a shift from the idea of using the tiny phones in cells to an ice-hockey game. During a power play, the star center races toward the empty goal, ready to put the puck into the net, but then he stops, pulls out his cell phone, and says, "Hello?" You can take it from there. Whatever the outcome, we have, to use the lingo of the production world, a new angle.

A more structured way of generating ideas is called *clustering*, a kind of brainstorming whereby you write down your ideas rather than say them aloud. To begin you write a single keyword, such as *cell phone*, and circle it. You then spin off idea clusters that somehow relate to the initial keyword. **SEE 17.1**

As you can see, clustering is a more organized means of brainstorming, but it is also more restrictive. But because clustering shows patterns better than brainstorming does, it serves well as a structuring technique. Although clustering is usually done by individuals, you can easily have a group of people engage in clustering and then collect the results for closer scrutiny.

Organizing ideas Once you have decided on the general program idea and the angle-the general context or focus of the show—you can ask other production people to help with fleshing out the details. Assume for a moment that the general idea is to do a program series on fine arts in the public schools with the angle of "Are the arts necessary to a well-rounded education?" In the organizing stage, you may have one person make a list of possible celebrity guests who advocate arts-based education and can talk about the advantages that it gives students in other areas of life. Another colleague could list the financial ramifications of including the arts and could weigh the costs against the benefits. A third person could research the available artsbased programs available to kids through nonprofits and community groups. Someone else could contact young actors and musicians to participate in the program and discuss how the arts enrich their lives and help them do better in school.

There is no single or correct formula for organizing ideas and translating them into an effective television program. Because production involves a great number of diverse yet connected pursuits, you learn its function most profitably by considering it a web of interlinking activities. In the production process, as in any other, various elements and tasks interact with one another to achieve the desired product—a program that affects the viewer in a certain way. The process helps you determine which people you require, what they should do, and what equipment is necessary to produce a specific program.

ZVL1 PROCESS→ Ideas

USING PRODUCTION MODELS

Production models describe the flow of activities necessary to move from the idea to the televised message. They help you organize the production process and facilitate your coordination efforts. The effect-to-cause model, for example, streamlines preproduction and makes your production activities more efficient and goal-directed.

Effect-to-cause model As do most other production models, the *effect-to-cause model* starts with a basic idea; but instead of moving from the basic idea directly to the

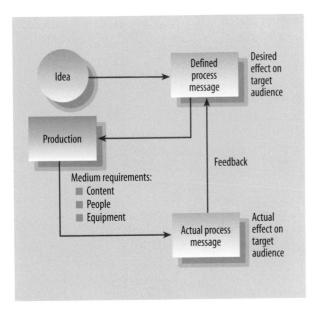

17.2 EFFECT-TO-CAUSE PRODUCTION MODEL

The effect-to-cause production model jumps from the initial idea directly to the desired effect—the process message. Then it backs up to the medium requirements that suggest the production elements and processes necessary to produce the defined process message.

production process, it jumps to the desired communication effect on the target audience. Because this communication effect is generated by the process of the viewer's watching and listening to television messages, we call this effect the *process message*. After all, it is the desired communication effect—the *defined process message*—that should drive the production process, rather than the initial idea. This means that as a producer you should know exactly what you want to achieve—what you want the target audience to learn, do, and feel—before deciding on the specific *medium requirements* that would lead to such an effect. The more the *actual process message* (viewer effect) matches the defined one, the more successful the communication. **SEE 17.2**

The advantage of this model is that the precise definition of the process message will help content and production people work as a team and will facilitate selecting the necessary production personnel and equipment. By first carefully defining the desired effect on the audience, you can then decide quite easily on the specific people you need to do the job (content expert, writer, director, and crew), on where to do the production most effectively (studio or field), and on the necessary equipment (studio or field cameras, types of mics, and so forth).

Let's apply the model to the interview with the famous defense lawyer mentioned in chapter 15 and see how it can influence the entire production process.

When approaching the production in the usual way—moving directly from the basic idea to the production process—you would probably think of getting an interviewer who is very skilled in law, perhaps even an ex-lawyer who has become a television personality. Then you would probably talk to the art director to design an appropriate environment for the interview—a well-to-do lawyer's office with an elegant desk, leather chairs, and lots of law books in the background. You would then have to arrange for the taping date, studio time, transportation for the guest, talent fees, and many more such details. You would also need to get together with the host (the exlawyer) to agree on a few questions: "What were your most famous cases?" "How many did you win?" "Have you ever refused important cases?" and so forth.

When using the effect-to-cause model, on the other hand, you would come up with several process messages. Here are two of the more obvious ones:

Process message 1: The viewer should gain insight into some of the major defense strategies used by the guest.

In this case the questions would revolve around some of the lawyer's former cases and the reasons for their success or failure. Would you need an interviewer who understands the law? Yes. The interviewer could interpret the legal language for the audience or immediately challenge the lawyer's ethics within the framework of the law. The elaborate studio set resembling the lawyer's office would also be appropriate. You may even consider conducting this interview on location in the lawyer's actual office.

Process message 2: The viewer should gain deeper insight into the conscience and feelings of the lawyer when handling an especially difficult case, as well as how he deals with personal ethics when applying specific defense strategies.

Do you now need a host who is a legal expert? Not at all. In fact, a psychologist would probably be better suited to conduct this interview. You would probably want to use close-ups of the guest throughout most of the show. You may even stay on a close-up of the guest when the host asks questions. Reaction shots (the guest listening to questions) are often more telling than action shots (the guest answering). Does this interview require an elaborate set? No. Because the interview deals primarily with the lawyer as a person rather than the person as a lawyer, you can

conduct it in any environment. Two comfortable chairs on an interview set are all you would need.

There has been a great reluctance in television production to show "talking heads"—people talking on close-ups without any supporting visual material. Do not blindly adopt this prejudice. So long as the heads talk well, there is no need for additional visual material. ZVL2 PROCESS >> Effect-to-cause >> basic idea | desired effect | cause

WRITING THE PROGRAM PROPOSAL

Once you have a clear idea of the process message and how you want to communicate it, you are ready to write the program proposal. Don't take this proposal lightly—it is a key factor in getting your program on the air as opposed to simply ending up in a "good idea" file on your hard drive.

A *program proposal* is a written document that stipulates what you intend to do. It briefly explains the process message and the major aspects of the presentation. Although there is no standard format for a program or series proposal, it should at a minimum include the following information:

- Program or series title
- Objective (process message)
- Target audience
- Show format
- Show treatment (usually includes the angle)
- Production method
- Tentative budget

If you propose a series, attach a sample script for one of the shows and a list of the titles of the other shows in the series.

Program title Keep the title short but memorable. Perhaps it is the lack of screen space that forces television producers to work with shorter titles than do filmmakers. Instead of naming your show *The Trials and Tribulations of a University Student*, simply say *Student Pressures*.

Process message or program objective This is a brief explanation of what the production is to accomplish. You can revise the process message so that it is less formal. For example, rather than say, "The process message is to have high-school students exposed to at least five major consequences of running a stop sign," you may write that

the program's objective is "to warn teenage drivers not to run stop signs."

Target audience The *target audience* is whom you would primarily like to have watch the show—the elderly, preschoolers, teenagers, homemakers, or people interested in traveling. A properly formulated process message will give a big clue as to the target audience. Even when you want to reach as large an audience as possible and the audience is not defined, be specific in describing the potential audience. Instead of simply saying "general audience" for a proposed comedy series, describe the primary target audience as "the eighteen-to-thirty generation" or the "over-sixty crowd in need of a good laugh."

Once you are in the actual preproduction stage, you can define the target audience further in terms of *demographics*—such as gender, ethnicity, education, income level, household size, religious preference, or geographical location (urban or rural)—as well as of *psychographics*, such as consumer buying habits, values, and lifestyles. Advertisers and other video communicators make extensive use of such demographic and psychographic descriptors, but you needn't be that specific in your initial program proposal.

Show format Do you propose a single show, a new series, or part of an existing series? How long is the intended show? An example would be a two-part one-hour program dealing with the various uses of helicopters around the world. This information is vital for planning a budget or, for a station or network, to see whether it fits into the program schedule.

Show treatment A brief narrative description of the program is called a *treatment*. Some of the more elaborate treatments have storyboardlike illustrations. The treatment should not only say what the proposed show is all about but also explain its angle. It should also reflect in its writing the style of the show. The style of a treatment for an instructional series on computer-generated graphics, for example, should differ considerably from that of a situation comedy. Do not include specific production information such as types of lighting or camera angles; save this information for the script. Keep the treatment brief and concise. It should simply give a busy executive some idea of what you intend to do. **SEE 17.3 ZVL3 PROCESS→ Proposals→ treatment**

Production method A well-stated process message will indicate where the production should take place and how

TREATMENT FOR THE FOURTH PROGRAM OF THE SIGHT SOUND MOTION INSTRUCTIONAL VIDEO SERIES

The fourth program of the instructional video series $\frac{\text{Sight Sound Motion}}{\text{condense}}$ is intended to explain the advantages of z-axis blocking (toward and away from the camera) over x-axis blocking (along the width of the screen).

We open with dancers moving into view from close to the camera, unfurling a yellow nylon ribbon away from the camera along the z-axis. More dancers join in and dance toward and away from the camera, always close to the z-axis ribbon. A second camera, positioned perpendicular to the first, sees the dance progressing sideways, with the dancers moving in and out of the frame along the x-axis. An off-camera narrator explains the differences between z-axis and x-axis blocking over especially telling freeze-frames. We unfreeze the action, with the narrator pointing out how z-axis blocking fits the small STV screen better than x-axis blocking. The same scene is then played for the 16 x 9 HDTV format. The advantage of the extended x-axis is then explained.

We switch to a brief dramatic scene in which two people are first blocked along the x-axis and then along the z-axis. Again the narrator explains the advantages of z-axis blocking for the 4 x 3 STV screen. The same scene is reblocked for the extended x-axis of the HDTV screen. These explanations are followed by a selection of brief scenes from up-to-date television shows that exhibit especially prominent z-axis and x-axis blocking.

We end the program by having the dancers move into view again, rolling up the yellow z-axis ribbon toward the camera.

17.3 TREATMENT

The treatment tells the reader in narrative form what a program is all about.

you can do it most efficiently. Should you do a multiple- or single-camera studio production or a single-camera EFP? Is the show more effectively shot live-on-tape in larger segments with three or four cameras in iso positions, or shot single-camera film-style for postproduction? What additional materials (costumes, props, and scenery) do you need? What performers or actors?

ZVL4 PROCESS→ Methods→ location | studio | single-camera | multi-camera

Tentative budget Before preparing the tentative budget, you must have up-to-date figures for all production services, rental costs, and wages in your area. Independent production and postproduction houses periodically issue rate cards that list costs for services and the rental of major production items. Stay away from high-end services unless quality becomes your major concern.

PREPARING A BUDGET

When working for a client, you need to prepare a budget for all preproduction, production, and postproduction costs, regardless of whether the cost is, at least partially, absorbed by the salaries of regularly employed personnel or the normal operating budget. You need to figure the costs not only for obvious items—script, talent, production personnel, studio and equipment rental, and postproduction editing—but also for items that may not be so apparent, such as videotape, certain props, food, lodging, entertainment, transportation of talent and production personnel, parking, insurance, and clearances or user fees for location shooting.

When producing a show for a local station or a small independent company, the basic personnel and equipment costs are usually included in the overall production budget. In such cases you need only list additional costs, such as overtime, expendable supplies, and script and talent fees, which, by the way, can be unexpectedly high.

There are many ways to present a budget, such as by separating preproduction (for example, script, travel to locations and meetings, location scouting, and storyboard), production (talent, production personnel, and equipment or studio rental), and postproduction (editing and sound design), or by dividing it into above-the-line and belowthe-line expenses.

Above-the-line budgets include expenses for above-theline personnel, such as writers, directors, art directors, and talent, usually called "creative personnel." This does not imply that other production personnel, such as camera operators or editors, are not creative; it simply refers to those who are more concerned with the conceptualization of ideas and production processes rather than the operation of equipment that will transform the ideas into a show. *Below-the-line budgets* include the expenses for below-the-line personnel, such as the production crew, as well as equipment and studio space.

Dividing a budget into preproduction, production, and postproduction categories will give you a more workable breakdown of expenditures than the above- and below-the-line division, especially when you have to bid on a specific production job. Because most production companies show their overall charges in this tripart division, the client can more easily compare your charges against those of the other bidders.

When you first present your proposal, the client may be interested not so much in how you broke down the expenses but more in the bottom-line figure. It is therefore critical that you think of all the probable expenses, regardless of whether they occur in preproduction, production, or postproduction. In this undertaking the computer can be of great assistance. Software programs can help you detail the various production costs and can recalculate them effortlessly if you need to cut expenses or if the production requirements change.

An example of a detailed *tripart budget* of an independent production company is shown in the accompanying figure. It is structured according to preproduction, production, and postproduction costs. **SEE 17.4**

Obviously, even as an independent producer you may not have to prepare such a detailed budget for all of your productions. Some simple productions may require only that you fill out the summary of costs. You can always adapt the budget shown in figure 17.4 to suit your specific production needs.

Whenever you prepare a budget, be realistic. Do not underestimate costs just to win the bid—you would probably regret it. It is psychologically, as well as financially, easier to agree to a budget cut than to ask for more money later on. On the other hand, do not inflate the budget to ensure enough to get by, even after severe cuts. Be realistic about the expenses, but do not forget to add at least a 15 to 20 percent contingency. In general, a show always takes a little longer and costs more than anticipated. **ZVL5** PROCESS Proposals budget | try it

Presenting the proposal Now you are ready to present your proposal. As an independent producer, you must prepare a proposal that satisfies the client. If you are

PRODUCTION BUDGET

CLIENT: PROJECT TITLE: DATE OF THIS BUDGET: SPECIFICATIONS:			
$\ensuremath{NOTE}\xspace$. This estimate is subject to the producer's review of the final shooting script.			
SUMMARY OF COSTS	ESTIMATE	ACTUA	
PREPRODUCTION			
Personnel			
Equipment and facilities			
Script			
PRODUCTION			
Personnel			
Equipment and facilities			
Talent			
Art (set and graphics) Makeup			
Music			
Miscellaneous (transportation, fees)			
POSTPRODUCTION			
Personnel			
Facilities			
Tape stock			
INSURANCE and MISCELLANEOUS			
CONTINGENCY (20%)			
TAX			
CRAND TOTAL			
GRAND TOTAL			

17.4 BUDGET CATEGORIES

These detailed budget categories are structured according to preproduction, production, and postproduction costs.

BUDGET DETAIL	ESTIMATE	ACTUAL
PREPRODUCTION		
Personnel		
Writer (script)		
Director (day)		
Art director (day)		
PA (day)		
SUBTOTAL		
PRODUCTIO N		
Personne1		
Director		
Associate director		
PA		
Floor (unit) manager		
Camera (DP)		
Sound		
Lighting		
VTR		
C.G.		
Grips (assistants)		
Technical supervisor		
Prompter Makeup and wardrobe		
Talent		
Equipment and facilities		
Studio/location		
Camera		
Sound		
Lighting		
Sets		
C.G./graphics		-
VTR		
Prompting	-	
Remote van		
Intercom		
Transportation, meals, and housing		
Copyrights		
SUBTOTAL		

17.4 BUDGET CATEGORIES (continued)

POSTPRODUCTION	N ESTIMATE ACTUAL
Personnel Director Editor Sound editor	
Facilities Dubbing Window dubs Off-line linear Off-line nonlinear On-line linear On-line nonlinear DVE Audio sweetening ADR/Foley	
Tape stock SUBTOTAL	
M I S C E L L A N E O U S Insurance Public transportation Parking Shipping/courier Wrap expenses Security Catering SUBTOTAL	
GRAND TOTAL	

17.4 BUDGET CATEGORIES (continued)

working in a station, you give your proposal to the executive producer or directly to the program manager. For program proposals that concern educational or public service issues, you should contact the public service director of the station. Documentaries are usually the purview of the news department. If you deal with a network, you need to go through an agent. When approaching a station, you may have more chance of success if you already have a sponsor to back your project.

See to it that your proposal is free of spelling errors and presented attractively and professionally.

WRITING THE SCRIPT

Unless you write the script yourself, you'll need to hire a writer. The writer will translate the process message into a television presentation—at least on paper. It is then up to the director to translate the script into the actual video and audio images that make up the television show.

It is important that the writer understand the program objective and, especially, the defined process message. If a writer disagrees with the process message and does not develop a better one, find another writer. Agree on a fee in advance—some writers charge enough to swallow up your whole budget. Once the writer understands your objectives, you must indicate the script format you need. (See chapter 18 for examples of script formats.)

One of the greatest challenges for a writer is to write good dialogue. Dialogue should sound natural, but it must be a cut above what you would hear if you were to record a real conversation in a living room, restaurant, supermarket, or school board meeting. When reading dialogue try to "hear" people—not just what they say but how they say it. Good dialogue should make you envious that you didn't speak that eloquently when you were in a similar situation. 1

ZVL6 PROCESS > Ideas > scripts

PREPRODUCTION PLANNING: COORDINATION

Before you begin coordinating the various production elements—assembling a production team, procuring studios, or deciding on location sites and equipment—ask yourself once again whether the planned production is possible within the given time and budget and, if so, whether the

method (medium translation of defined process message) is indeed the most efficient.

For example, if you are doing a documentary on the conditions of the various residence hotels in your city, it is certainly easier and more cost-effective to go there and videotape an actual hotel room than to re-create one in the studio. On the other hand, if you are doing a magazinestyle show on the history of your high school, you could stage the major part of the production in the studio and shoot only a minimum portion on location. For a drama a specific scene might be shot more advantageously in a friend's kitchen than in a complicated studio kitchen setup. Keep in mind that the studio affords optimal control but that EFP offers a limitless variety of scenery and locations at little additional cost. Bear in mind, however, that most field productions lack the production control you enjoy in the studio, and they require extensive use of postproduction time and facilities.

Once you've made a firm decision about the most effective production approach, you have to deliver what you promised to do in the proposal. You begin this coordination phase by (1) establishing clear communication channels among all the people involved in the production; you can then proceed with coordinating the other major production elements: (2) the facilities request, (3) schedules, (4) permits and clearances, and (5) publicity and promotion. Realize that it is not your occasional flashes of inspiration that make you a good producer but your meticulous attention to detail.

PEOPLE

Whom to involve in the post-script planning stages depends, again, on your basic objective, the process message, and whether you are an independent producer who has to hire additional above-the-line and below-the-line personnel or whether you are working for a station or large production company that has most essential creative and crew people already on its payroll and available at all times.

As producer you are the chief coordinator among the various production people. You must be able to contact every single team member quickly and reliably. Your most important job, therefore, is to establish a database with such essential information as names, positions, home addresses, business addresses, e-mail addresses, and various phone, beeper, and fax numbers. **SEE 17.5**

Don't forget to let everyone know how *you* can be contacted, as well. Don't rely on secondhand information. Your communication is not complete until you hear back

See Robert L. Hilliard, Writing for Television, Radio, and New Media, 8th ed. (Belmont, Calif.: Wadsworth, 2004). Also see Herbert Zettl, Sight, Sound, Motion, 4th ed. (Belmont, Calif.: Thomson Wadsworth, 2005), pp. 334–36.

Production Perso Sight Sound Moti Program 4					
Name E-mail	Position	Home address Work address	Home phone Work phone	Home fax Work fax	Cell phone Pager
Herbert Zettl hzettl@best.com	Producer	873 Carmenita, Forest Knolls SFSU, 1600 Holloway, SF	(415) 555-3874 (415) 555-8837	(415) 555-8743 (415) 555-1199	(415) 555-1141
Gary Palmatier bigcheese@ideas-		5343 Sunnybrook, Windsor 5256 Aero #3, Santa Rosa	(707) 555-4242 (707) 555-8743	(707) 555-2341 (707) 764-7777	(707) 555-9873
Robaire Ream robaire@mac.com	AD	783 Ginny, Healdsburg Lightsaber, 44 Tesconi, Novato	(707) 555-8372 (415) 555-8000	(415) 555-8080	(800) 555-8888
Sherry Holstead 723643.3722@comp		88 Seacrest, Marin SH Assoc, 505 Main, Sausalito	(415) 555-9211 (415) 555-0932	(415) 555-9873 (415) 555-8383	(415) 555-0033
Renee Wong rn_wong2@earthli	TD nk.com	9992 Treeview, San Rafael P.O. Box 3764, San Rafael	(415) 555-9374 (800) 555-7834	(415) 555-8273 (800) 555-8734	(415) 555-3498 (415) 555-8988
Steve Storc hamlet23@aol.com	Talent	253 Robertson, Canoga Park Le Dome, 32 Sunset, LA	(212)		(213) 555-7832 8734

17.5 DATABASE: PRODUCTION PERSONNEL

To be able to quickly contact each production team member, the producer needs reliable contact information.

from the party you were trying to contact. A good producer triple-checks everything.

FACILITIES REQUEST

The *facilities request* lists all pieces of production equipment and often all properties and costumes needed for a production. The person responsible for filling out such a request varies. In small-station operations or independent production companies, it is often the producer or director; in larger operations it is the production manager.

The facilities request usually contains information concerning date and time of rehearsal, taping sessions, and on-the-air transmission; title of production; names of producer and director (and sometimes talent); and all technical elements, such as cameras, microphones, lights, sets, graphics, costumes, makeup, VTRs, postproduction facilities, and other specific production needs. It also lists the studio and control room needed. If you do EFP, you need to add the desired mode of transportation for

yourself and the crew and the exact on-site location. If the production involves an overnight stay, communicate the name and the location of the accommodations, including the customary detail, such as phone numbers, when and where to assemble the next morning, and so forth.

The facilities request, like the script, is an essential communication device. Be as accurate as possible when preparing it. Late changes will only invite costly errors. If you have a fairly accurate floor plan and light plot, attach them to the facilities request. Such attachments will give the crew a fairly good idea of what production problems they may have to face.

Facilities requests are usually distributed as "soft copy" via the internal computer system as well as hard copy. **SEE 17.6** The advantage of using a computer network is that you can make changes easily without having to recall, correct, and reissue the printed copies.

Regardless of which type of production you do, always try to get by with as little equipment as possible. The

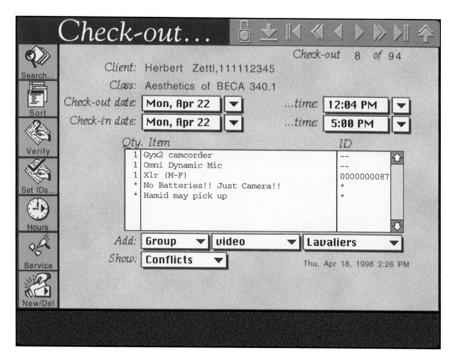

17.6 COMPUTER-BASED FACILITIES REQUEST

This computer-based facilities request lists all equipment needed for a specific production. Usually, the equipment permanently installed in a studio does not have to be listed again, but it must be scheduled.

more you use, the more people you need to operate it and the more that can go wrong. Do not use equipment just because it is available. Review your original process message and verify that the chosen equipment is indeed the most efficient and that the necessary equipment is actually available and within the scope of the budget. Consult your technical staff, which may include your favorite DP or TD, on specific use of equipment and other production tasks. Their expertise extends way beyond the use of television equipment, and they are usually quite willing to help solve especially difficult production problems.

SCHEDULES

The *production schedule* should tell everybody involved in the production who is doing what, when, and where over the course of the production. Create a realistic schedule and stick to it. Assigning too little time will result not in a higher level of activity but usually in a higher level of anxiety and frustration. It is almost always counterproductive. On the other hand, allowing too much time for a production ac-

tivity will not necessarily improve the production. Besides being costly, wasting time can make people apathetic and, surprisingly enough, fail to meet deadlines.

One of your most important responsibilities as producer is to check constantly on the progress of each activity and see where everybody stands relative to the stipulated deadlines. If you don't care whether deadlines are met, you might as well do away with them. If schedules aren't met, find out why. Again, do not rely on secondhand information. Call the people who are behind schedule and find out what the problem is. It is your job to help solve these problems and get everybody back on track, or to change the schedule if necessary. (See figure 17.7 for an actual shooting schedule.) Always inform *all* the production people of *all* the changes you make—even if they seem rather insignificant at the time.

PERMITS AND CLEARANCES

Most productions involve people and facilities that ordinarily have no connection with your station or production company. These production elements need extra attention. Get the necessary permits for your crew to gain admission to a meeting or sporting event, as well as a parking permit close to the event. You may also need a permit from city hall (the mayor's media coordinator and the police department) or a specific insurance policy to shoot downtown. Do not ignore such requirements! "Better safe than sorry" applies to all field productions—not just to actual production activities but also to protecting yourself from legal action if a production assistant stumbles over a cable or if a bystander slips on a banana peel while watching your taping. (Copyright and union clearances are discussed in section 17.2.)

PUBLICITY AND PROMOTION

The best show is worthless if no one knows about it. Meet with the publicity and promotions departments (usually combined in one office or even a single person) during preproduction and inform them about the upcoming production. Even if the target audience is highly specific, you still must aim to reach as many viewers as possible. The job of the publicity people is to narrow the gap between the potential and the actual audience.

LINE PRODUCER: HOST AND WATCHDOG

If you have done your job right, you can now let the director and, if you have one, the line producer, take over. The *line producer* is usually on the set for each production of a program series and deals with day-to-day production details. If you are also acting as line producer once you have done all the preproduction, you are still responsible for the actual production and should therefore stay involved until it has been completed. Most often your immediate duties as a line producer are to take care of the guests and to act as a second pair of eyes for the director.

PLAYING HOST

If you've booked guests, you need to get them into the studio. How do they get to the studio and back to their hotel? Be sure to have someone (preferably you) greet them when they arrive. There is nothing more embarrassing than having guests wandering through the station, trying to find you or the studio. Have a reception room (an actual or makeshift green room) ready with coffee and tea,

enabling guests to relax as much as possible before going into the studio.

WATCHING THE PRODUCTION FLOW

Although you should stay out of the director's way as much as possible, you should still keep an eye on the general production flow. Even if you did not draw up the *time line*—the time blocks for the various production activities—yourself, you are responsible for seeing that people stick to it. (We discuss the importance of the time line in section 17.2.) Sometimes a director gets hung up on a minor detail and does retake after retake only to find that there is practically no time left to tape the rest of the program. In this case you should remind the director to move on and to stay on schedule.

If you notice that the lighting or audio people are taking an inordinate amount of setup time, you may talk to the TD or the AD about it. When the director needs additional equipment or props to improve on a scene, you can approve the extra expense on the spot and call the appropriate people to get the requested items.

EVALUATING THE PRODUCTION

One of the most important functions of the producer during the production is to look over the director's shoulder at the various takes. It is not unusual for a director to get so involved in coordinating all the production details that he or she loses track of the overall look and flow of a scene. As a good producer, you can watch the scene from a different perspective—more as a critical viewer than as a member of the production team. This is not unlike watching a chess game and seeing all the mistakes and missed possibilities of the other players.

If you have suggestions concerning the show, take notes or dictate your comments to the production assistant during the rehearsal and then convey them to the director (and the talent and crew if necessary) at various rehearsal or short taping breaks, called *notes*, during which production problems are discussed and fixed. Unless you see a big mistake that obviously escaped the director's attention or if something totally unexpected happens that needs your immediate attention, do not interfere during the actual performance. Keep in mind that although you as the producer coordinated all production elements up to this moment, the director is now in charge of translating your idea into the finished product—the television program.

POSTPRODUCTION ACTIVITIES

If your production was done live or live-on-tape, you are just about done. You still need to write thank-you notes to the people who have made special contributions to the program and complete all required reports (such as music clearances and talent releases), unless the director takes care of such matters. More often, however, you now need to begin coordinating the postproduction activities, among them: (1) postproduction editing, (2) evaluation and feedback, and (3) recordkeeping.

POSTPRODUCTION EDITING

Your activities in the postproduction phase may involve a simple check that the people and the facilities for the off-line and on-line editing are still available and that postproduction progresses according to schedule. In case of emergency, be prepared to reschedule the whole postproduction process. Some producers feel that they need to closely supervise all the video-editing and audio-sweetening activities, whereas others leave such responsibilities to the director. Nevertheless, you should always be available in case the editor or director wants your advice about a particularly sensitive editing decision.

EVALUATION AND FEEDBACK

If the production is for a corporation or other nonbroadcast organization, arrange a viewing date for the client. In fact, you should always show the client the completed off-line version of the production before doing any final on-line editing. If you have taken the effect-to-cause approach, the client would have been continuously involved in the production and most changes would have been made by now. Don't show a half-finished editing version that, for example, lacks the background music. Most clients are not sufficiently sophisticated in production to be able to mentally fill in the missing parts. Your off-line editing should be as complete as possible. Still, the showing of the finished on-line version is not the time to discover major production mistakes. Regardless of what you show, keep an open mind during the "screening" of your off-line production and listen carefully to the client's recommendations for changes. Do not haggle with the client about your production decisions. Have the director explain why a scene was shot in a certain way or why some of the original script had to be changed.

If the show solicits viewer feedback ("Please call the 800-number or visit our Web site"), see to it that the feed-

back facilities are in place. Viewers can get very annoyed if they find that their well-intentioned efforts to communicate with the station are ignored. Have competent and friendly phone operators standing by to take the viewers' calls and be sure the Web site is functioning. If you solicit written feedback ("Please drop us a postcard, or fax or e-mail your comments"), assign someone to handle and respond quickly to the correspondence. Keep a record of all unsolicited calls (positive and negative) and file all written communication (letters, postcards, faxes, and e-mail).

Finally, sit back and objectively view the finished production. Does it, at least in your judgment, meet the objectives of the defined process message? Determining the real impact—the actual process message—of the program is difficult. Nevertheless, try to gather as much feedback as possible (from reviewers and colleagues as well as viewers) to determine how close the defined process message came to the actual one. The closer the match, the more successful the production. **ZVLT** PROCESS > Effect-to-cause > actual effect

RECORDKEEPING

Each time you finish a production, file a cassette copy or DVD for archival purposes. The news department uses such archives as a "morgue"—a resource about people and places that might become newsworthy again. Such a copy will also protect you from unreasonable claims by an irate client.

Besides the videotape copy of your on-line production, put together a file that contains the pertinent preproduction, production, and postproduction records. At a minimum such a file should contain: the final program proposal, the budget, the time line (including rehearsals, crew calls, and so forth), facilities requests, the list of production personnel, the list of talent, talent contracts and releases, various permits, and the shooting script. File and cross-reference it with the videotape copy or DVD so that you have access to both when needed.

As you remember from the beginning of this chapter, producing means managing ideas and coordinating people, equipment, activities, and details. Again, triple-check everything. Don't leave anything to chance. Finally, never breach the prevailing ethical standards of society and the trust the audience has—and inevitably must—put in you. Whatever you do, use as your guideline a basic respect and compassion for your audience and the people who appear in your show.

MAIN POINTS

- Producing means seeing to it that a worthwhile idea becomes a worthwhile television show. The producer manages a great number of people and coordinates an even greater number of activities and production details.
- ◆ The effect-to-cause model starts with the basic idea, then defines the desired audience effect—the process message. The definition will determine the medium requirements: content elements, production elements, and people. The closer the actual process message (actual effect) matches the defined one, the more successful the communication.
- The program proposal normally contains the following minimum information: program or series title, objective, target audience, show treatment, production method, and tentative budget.
- The tripart budget is generally divided into preproduction, production, and postproduction costs. It must include all

- major and minor expenses, unless they are absorbed by the overall operating budget.
- The script is the most important preproduction element.
 It determines the entire production process.
- Preproduction coordination involves selecting and contacting the production people, deciding on facilities and production locations, scheduling all production activities, and taking care of permits, clearances, publicity, and promotion.
- During the production the producer acts as host, watches the production flow, and oversees the general quality of the show.
- Postproduction activities include scheduling postproduction facilities and people, supervising the editing, a final evaluation of the program, handling solicited and unsolicited feedback, and recordkeeping.

17.2

Dealing with Schedules, Legal Matters, and Ratings

As a producer you need such specific production skills as designing an efficient time line and quickly accessing accurate information. Although you may have the services of a legal department, you will inevitably have to deal with broadcast guilds and unions as well as copyrights and other legal matters. Finally, you must be conversant in the rudiments of ratings.

► TIME LINE

The daily time line, event sequencing, and the production schedule

► INFORMATION RESOURCES

Local resources, computer databases, and basic reference books and directories

UNIONS AND LEGAL MATTERS

Nontechnical and technical unions, copyrights and clearances, and other legal considerations

AUDIENCE AND RATINGS

Target audience, and ratings and share

TIME LINE

The daily *time line* is normally worked out by the director, the line producer, and/or the production or unit manager. This person is in charge of the day's production—from loading the EFP vehicles or unlocking the studio doors

to putting back the equipment and filing the crew's lunch receipts. In smaller operations, however, the producer functions not only as the preproduction organizer but also as the production manager of the various activities during the production day. In this case you need to know how to design a maximally efficient time line, which will save not only time and money but also—and especially—energy. Even if you are not directly responsible for the day-to-day time line, you should keep an eye on it and see that it is maximally efficient.

The efficiency of the production schedule depends to a large extent on proper *event sequencing*. For example, do not order a complicated opening title sequence from the art department if the writer is still struggling with the script. Nor should you argue with the director over the lighting requirements or number of cameras before you have visited the remote location or seen a floor plan.

In EFP especially, the event sequence should be determined by production requirements (location, weather, sets, and the like) and not necessarily by the scripted sequence. See which events can be scheduled together, such as the opening or closing of a show, or other widely spread scenes that nevertheless play in the same location. Although moving from set to set in a studio production as scripted may not cause too many logistical problems, unnecessarily changing locations in the field does.

Establish a tentative schedule of events and try to fit them into the production schedule. Such an event schedule will show you not only how a single production day should progress but also the flow of an entire production series. For example, you may find that with only a few changes of set properties you can use a single set for the whole series, or that you can shoot several sequences at the same location although the various shows may ultimately be shown in a different sequence. **SEE 17.7**

INFORMATION RESOURCES

As a producer you must be a researcher as well as somewhat of a scrounger. On occasion you may have only a half hour to get accurate information, for example, about a former mayor who is celebrating her ninetieth birthday. Or you may have to procure a skeleton for your medical show, a model of a communications satellite for your documentary on telecommunications, or an eighteenth-century wedding dress for your history series.

Fortunately, the vast resources on the Internet put the world's information at your fingertips. And if you know the site address, it is practically instantaneous. You may

Show/Scene Subject	Date/Time	Location	Facilities	Talent/Personnel
energy conservation scenes 1 & 2 openings & closings	Aug. 8 11:30- 4:30	solar heating plant	normal EFP as per fax of 7/2	Janet & Bill EFP crew as schedul DIRECTOR: John H.
energy \$ 2, 3, 4 sections on solar panel demonstrations	Aug. 10 8:30- 2:30	solar heating plant	normal EFP as per fax of 7/2	Janet & Bill EFP crew as schedul DIRECTOR: John H.
energy \$ 5, 6 installation of solar heating panels	Aug. 11 8:30- 4:30	Terra Linda Housing Project	normal EFP as per fax of 7/2	No TalenT (v.o. in pos EFP crew as schedul DIRECTOR: John H.

17.7 EVENT SEQUENCING

Event sequencing results in a production schedule that shows all scenes shot in a specific location.

find, however, that the sheer volume of online information makes it difficult to find a specific item quickly. It may sometimes be faster and more convenient to use readily available printed sources or to call the local library. For example, a call to the local hospital or high-school science department may procure the skeleton more quickly than initiating a Web search. You could ask the community college science department or perhaps even the local cable company for the satellite model, and contact the historical society or the college theater arts department for the wedding dress.

Besides Internet sources, the following are some additional references and services you should have on hand.

- Telephone directories. There is a great deal of information in a telephone book. Get the directories of your city and the outlying areas. Also try to get the telephone directories of the larger institutions with which you have frequent contact, such as city hall, the police and fire departments, other city or county agencies, major federal offices, city and county school offices, newspapers and radio stations, colleges and universities, and museums. On the Internet you can obtain in seconds the telephone number of practically any phone user in the world.
- Airline schedules. Even if you have easy online access to airline schedules, keep up-to-date directories of the major

airlines. Have a reliable contact person at the local airport and at an established travel agency.

- Transportation and delivery. Have the numbers of one or two taxi companies as well as bus and train schedules. Keep in mind that taxis can transport things (such as the skeleton for your medical program) as well as people. Establish contact with at least two reliable inter- and intracity delivery services.
- Reference books and CD-ROMs. Your own reference library should have an up-to-date dictionary; a set of Who's Who in America and the regional volumes; a recent international biographical dictionary; an up-to-date encyclopedia that presents subjects clearly and concisely (you may find the simple yet concise World Book encyclopedia more helpful than the detailed Encyclopaedia Britannica); and a comprehensive, up-to-date atlas. Most current reference books are also available on CD-ROM. Also have on hand the phone number of the reference desk at the local library. An efficient reference librarian can, and is usually happy to, dig up all sorts of information with amazing speed. They can also do quick Internet research in libraries worldwide.

If you work for a cable company or television station, collect some basic references. Besides professional journals and yearbooks, put some of the latest editions of broadcast

textbooks on your shelf. These volumes will give you quick and accurate information about a variety of issues.

Other resources. The local chamber of commerce usually maintains a list of community organizations and businesses. A list of the major foundations and their criteria for grants may also come in handy. If you are doing a series on a specific subject, such as medical practices, energy conservation, or housing developments, you will have to get some major reference works in that area.

UNIONS AND LEGAL MATTERS

Most directors, writers, and talent belong to a guild or union, as do almost all below-the-line personnel. As a producer you must be alert to the various union regulations in your production area. Most unions stipulate not only salaries and minimum fees but also specific working conditions, such as overtime, turnaround time (stipulated hours of rest between workdays), rest periods, who can legally run a studio camera and who cannot, and so forth. If you use nonunion personnel in a union station, or if you plan to air a show that has been prepared outside the station with nonunion talent, check with the respective unions for proper clearance.

UNIONS

There are two basic types of unions: those for nontechnical personnel and those for technical personnel. Nontechnical unions are mainly those for performers, writers, and directors. **SEE 17.8** Technical unions include all television technicians, engineers, and occasionally a variety of production personnel, such as microphone boom operators, ENG/EFP camera operators, and floor personnel. **SEE 17.9**

Be especially careful about asking studio guests to do anything other than answer questions during an interview. If they give a short demonstration of their talents, they may be classified as performers and automatically become subject to AFTRA fees (see figure 17.8). Likewise, do not request the floor crew to do anything that is not directly connected with their regular line of duty, or they too may collect talent fees. Camera operators usually have a contract clause that ensures them a substantial penalty sum if they are willfully shown by another camera on the television screen. Acting students who appear in television plays produced at a high school or college may become subject to AFTRA fees if the play is shown on the air by a broadcast station, unless you clear their on-the-air appearance with the station and/or the local AFTRA office.

17.8 NONTECHNICAL UNIONS

AFTRA	American Federation of Television and Radio Artists. This is the major union for television talent. Directors sometimes belong to AFTRA, especially when they double as announcers and on-the-air talent. AFTRA prescribes basic minimum fees, called scale, which differ from area to area. Most well-known talent (such as prominent actors and local news anchors) are paid well above scale.
DGA	Directors Guild of America. A union for television and motion picture directors and associate directors. Floor managers and production assistants of large stations and networks sometimes belong to "the Guild."
WGA	Writers Guild of America. A union for writers of television and film scripts.
SAG	Screen Actors Guild. Important organization, especially when film is involved in television production. Also includes some actors for videotaped commercials and larger video productions.
SEG	Screen Extras Guild. A union for extras participating in major film or video productions.
AFM	American Federation of Musicians of the United States and Canada. Important only if live orchestras are used in the production.

COPYRIGHTS AND CLEARANCES

If you use copyrighted material on your show, you must procure proper clearances. Usually, the year of the copyright and the name of the copyright holder are printed right after the © copyright symbol. Some photographs, reproductions of famous paintings, and prints are often copyrighted as are, of course, books, periodicals, short stories, plays, and music recordings. Shows or music that you may record off the air or download from the Internet as well as many CD-ROMs and DVDs are also subject to copyright laws. When you as an artist are trying to protect your rights, you may find that the copyrights are rather vague; but when you as a producer use copyrighted material, you usually run into stringent laws and regulations. When in doubt, check with an attorney about copyright clauses and public domain before using other people's material in your production.

17.9 TECHNICAL UNIONS

IBEW International Brotherhood of Electrical Workers. This union includes studio, master control, and maintenance engineers and technicians. It may also include ENG/EFP camera operators and floor personnel.

NABET
National Association of Broadcast Employees and
Technicians. This engineering union may also include floor
personnel and nonengineering production people (such as
boom operators and dolly operators).

IATSE International Alliance of Theatrical Stage Employees,
Moving Picture Technicians, Artists and Allied Crafts of the
United States, Its Territories and Canada. This union includes
primarily stage hands, grips (lighting technicians), and stage
carpenters. Floor managers and even film camera and lighting
personnel can also belong.

OTHER LEGAL CONSIDERATIONS

Check with legal counsel about up-to-date rulings on *libel* (written and broadcast defamation), *slander* (lesser oral defamation), *plagiarism* (passing off as one's own the ideas or writings of another), the right to privacy (not the same in all states), obscenity laws, and similar matters. In the absence of legal counsel, the news departments of major broadcast stations or university broadcast departments generally have up-to-date legal information available.

AUDIENCE AND RATINGS

As a producer in a television station, you will probably hear more than you care to about the various aspects of specific television audiences and ratings. Ratings are especially important for commercial stations because the cost for commercial time sold by the station is determined primarily by the estimated size of the target audience. Even when working in corporate television, you will find that audience "ratings" are used to gauge the relative success of a program.

TARGET AUDIENCE

Broadcast audiences, like those for all mass media, are usually classified by demographic and psychographic characteristics. The standard *demographic descriptors* include gender, age, marital status, education, ethnicity, and income or economic status. The *psychographic descriptors*

pertain to the general lifestyle, such as consumer buying habits and even personality and persuasiveness variables. When you fill out the registration card that comes with a new electronic product, you are actually supplying highly valuable psychographic information.

Despite sophisticated techniques of classifying audience members and determining their lifestyles and potential acceptance of a specific program or series, some producers simply use a neighbor as a model and gear their communication to that particular person and his or her habits. Don't be surprised if an executive producer turns down your brilliant program proposal with a comment such as, "I don't think my neighbor Cathy would like it." For many entertainment programs, such a subjective approach to prejudging the worth of a program might be acceptable. If you are asked to do a goal-directed program such as driver education or a commercial on the importance of water conservation, however, you need to identify and analyze the target audience more specifically. The more you know about the target audience, the more precise your defined process message and, ultimately, the more effective that message will be.

RATINGS AND SHARE

An audience *rating* is the percentage representing an estimate of television households with their sets tuned to a station in a given population (total number of television households). You get this percentage by dividing the projected number of households tuned to your station by the total number of television households:

For example, if 75 households of your rating sample of 500 households are tuned to your show, your show will have a rating of 15 (the decimal point is dropped when the rating figure is given):

$$\frac{75}{500} = 0.15 = 15 \text{ rating points}$$

A *share* is the percentage of television households tuned to your station in relation to all households using television (HUT). The *HUT* figure represents the total pie—or 100 percent. Here is how a share is figured:

For example, if only 200 of the sample households have their sets actually in use (HUT = 200 = 100 percent),

the 75 households tuned into your program constitute a share of 38:

$$\frac{75}{200} = 0.375 = share of 38$$

Various rating services, such as A. C. Nielsen, carefully select representative audience samples and query these samples through diaries, telephone calls, and meters attached to their television sets.

The problem with the rating figures is not so much the potential for error in projecting the sample to a larger population but rather that the figures do not indicate whether the household whose set is turned on has any people watching or, if so, how many. The figures also do not indicate the impact of a program on the viewers (the actual process message). Consequently, you will find that your show is often judged not by the significance of your message, the impact it has on the audience, or how close the actual effect of the process message came to the defined effect, but simply by the rating and share figures. As frustrating as the rating system in broadcast television is, you must realize that you are working with a mass medium that by definition bases its existence on large audiences.

MAIN POINTS

- Careful event sequencing greatly facilitates production scheduling and activities. This approach is especially helpful for a production series.
- A producer needs quick and ready access to a great variety
 of resources and information. The Internet is an almost
 instantaneous and total information resource. Telephone
 directories, airline and other transportation schedules, and
 basic reference books and CD-ROMs are also important
 resources.
- Most nontechnical and technical production personnel belong to guilds or unions, such as the Directors Guild of America (DGA) or the National Association of Broadcast Employees and Technicians (NABET).
- The usual copyright laws apply when copyrighted material (such as video and audio material, printed information, and CD-ROMs) is used in a television production.
- An audience rating is the percentage of television households with their sets tuned to a station in a given sample population owning TV sets. A share is the percentage of households tuned to a specific station in relation to all other households using television (HUT).

ZETTL'S VIDEOLAB

For your reference, or to track your work, each *Video-Lab* program cue in this chapter is listed here with its corresponding page number.

ZVL1 PROCESS → Ideas 39

ZVL2 PROCESS→ Effect-to-cause→ basic idea | desired effect | cause 395

ZVL3 PROCESS→ Proposals→ treatment **395**

PROCESS→ Methods→ location | studio | single-camera | multi-camera 397

ZVL5 PROCESS→ Proposals→ budget | try it 397

ZVL6 PROCESS→ Ideas→ scripts **401**

ZVL7 PROCESS→ Effect-to-cause→ actual effect 405

18

The Director in Preproduction

As a *director* you tell talent and the entire production team what to do before, during, and after the actual production. But before you can tell *them* what to do, you obviously need a clear idea of what *you* need to do: think about what the program should look like and how to get from the idea to the television image.

More specifically, as a director you must be able to translate an idea, a script, or an actual event (such as an interview, a parade, or a tennis match) into effective television pictures and sound. You translate the defined process message (the expected outcome of the program) into the various medium requirements and then combine them through the production process into a specific television program. You must decide on the people (talent and crew) and the technical production elements (cameras, mics, sets, lighting, and so forth) that will produce the intended effect—the process message—and coordinate all these elements with maximum efficiency and effectiveness. And you must do so with style.

Section 18.1, How a Director Prepares, looks at the director's roles and specific preproduction activities. Section 18.2, Moving from Script to Screen, offers some guidelines on image visualization and sequencing and how to analyze a script. The director's activities in the production and postproduction phases are the focus of chapter 19.

KEY TERMS

- **fact sheet** Lists the items to be shown on-camera and their main features. May contain suggestions of what to say about the product. Also called *rundown sheet*.
- **fully scripted format** A complete script that contains all dialogue or narration and major visualization cues.
- **locking-in** An especially vivid mental image—visual or aural—during script analysis that determines the subsequent visualizations and sequencing.
- **script** Written document that tells what the program is about, who says what, what is supposed to happen, and what and how the audience should see and hear the event.
- semiscripted format Partial script that indicates major video cues in the left (video) column and partial dialogue and major audio cues in the right (audio) column. Used to describe a show for which the dialogue is indicated but not completely written out.

- **sequencing** The control and structuring of a shot series during editing.
- **show format** Lists the show segments in order of appearance. Used in routine shows, such as daily game or interview shows.
- **storyboard** A series of sketches of the key visualization points of an event, with the corresponding audio information.
- visualization Mentally converting a scene into a number of key television images, not necessarily in sequence. The mental image of a shot.

18.1

How a Director Prepares

As a television director, you are expected to be an artist who can translate ideas into effective pictures and sounds, a psychologist who can encourage people to give their best, a technical adviser who can solve problems the crew would rather give up on, and a coordinator and stickler for detail who leaves nothing unchecked. Not an easy job by any means! Although some directors think that their profession requires a divine gift, most good directors acquired and honed their skills through painstaking study and practice.

▶ THE DIRECTOR'S ROLES

Artist, psychologist, technical adviser, and coordinator

PREPRODUCTION ACTIVITIES

Process message, production method, production team and communication, scheduling, script formats, script marking, floor plan and location sketch, and facilities request

SUPPORT STAFF

Floor manager, associate (or assistant) director, and production assistant

THE DIRECTOR'S ROLES

The various roles you must assume as a director are not as clear-cut as you will see them described in this section. They frequently overlap, and you may have to switch from one to another several times just in the first five minutes of rehearsal. Even when pressed for time and pressured by people with a variety of problems, always pay full attention to the task at hand before moving on to the next one.

DIRECTOR AS ARTIST

In the role of an artist, a director is expected to produce pictures and sound that not only convey the intended message clearly and effectively but which do so with flair. You need to know how to look at an event or a script, quickly recognize its essential quality, and select and order those elements that help interpret it for a specific audience. Flair and style enter when you do all these things with a personal touch—when, for example, you shoot a certain scene very tightly to heighten its energy or when you select unusual background music that helps convey a specific mood. But unlike the painter, who can wait for inspiration and can retouch the painting over and over until it is finally right, the television director is expected to be creative by a specific clock time and to make the right decisions the first time around.

DIRECTOR AS PSYCHOLOGIST

Because you must deal with a variety of people who approach television production from different perspectives, you need to also assume the role of psychologist. For example, in a single production you may have to communicate with a producer who worries about the budget, technicians who are primarily concerned with the technical quality of pictures and sound, temperamental talent, a designer who has strong ideas about the set, and the mother of a child actor, who thinks your close-ups of her daughter are not tight enough.

Not only must you get everyone to perform at a consistently high level, you also have to get them to work as a team. Although there is no formula for directing a team of such diverse individuals, the following are some basic guidelines that will help you exercise the necessary leadership.

Be well prepared and know what you want to accomplish. You cannot possibly get people to work for a common goal if you do not know what it is.

- Most the specific functions of each team member. Explain to all the individuals what you want them to do before holding them accountable for their work.
- Be precise about what you want the talent to do. Do not be vague with your instructions or intimidated by a celebrity. The more professional the talent, the more readily they will follow your direction.
- Project a secure attitude. Be firm but not harsh when giving instructions. Listen to recommendations from other production staff but do not yield your decision making to them.
- Do not ridicule someone for making a mistake. Point out the problems and suggest solutions. Keep the overall goal in mind.
- Treat the talent and all members of the production team with respect and compassion.

DIRECTOR AS TECHNICAL ADVISER

Although you do not have to be an expert in operating the technical equipment, as a director you should still be able to give the crew helpful instructions on how to use it to achieve your communication goal. In the role of technical adviser, you are acting much like a conductor of a symphony orchestra. The conductor may not be able to play all the instruments in the orchestra, but he or she certainly knows the sounds the various instruments can generate and how they ought to be played to produce good music. The preceding chapters were designed to give you a satisfactory background in technical production.

DIRECTOR AS COORDINATOR

In addition to your artistic, psychological, and technical skills, you must be able to coordinate a great many production details and processes. The role of coordinator goes beyond directing in the traditional sense, which generally means blocking the talent and helping them give peak performances. Especially when directing nondramatic shows, you must expend most of your effort on cueing members of the production team (both technical and nontechnical) to initiate certain video and audio functions, such as getting appropriate camera shots, rolling VTRs, riding audio levels, switching among cameras and special effects, retrieving electronically generated graphics, and switching to remote feeds. You still need to pay attention to the talent, who sometimes (and rightly so) feel that they play second fiddle

to the television machine. You also need to coordinate productions within a rigid time frame in which every second has a hefty price tag attached. Such coordinating requires practice, and you should not expect to be a competent director immediately after reading this chapter.

PREPRODUCTION ACTIVITIES

As with producing, the more effort you expend on preproduction planning, the easier, more efficient, and especially more reliable your directing will be in the actual production phase. Specifically, you need to focus on the following major preproduction points and activities: (1) process message, (2) production method, (3) production team and communication, (4) scheduling, (5) script formats, (6) script marking, (7) floor plan and location sketch, and (8) facilities request.

PROCESS MESSAGE

Before you do anything, revisit the *process message*—the purpose of the show and its intended effect on a specific audience (see chapter 17). If you are not quite sure what the show is to accomplish, check with the producer. Only then can you make all other personnel understand what the show is about and the expected outcome of the production. An early agreement between producer and director about specific communication goals and production type and scope can prevent many frustrating arguments and costly mistakes. Keep the producer apprised of your plans, even if you have been given responsibility for all creative decisions. Keep a record of telephone calls, save your e-mail, and follow up on major verbal decisions with memoranda.

PRODUCTION METHOD

If you thoroughly understand the process message, the most appropriate production method becomes clear—that is, whether the show is best done in the studio or in the field, live or on videotape, single-camera or multicamera, and in sequential or nonsequential event order. If, for example, the process message is to help the viewer participate in the excitement of watching a Thanksgiving Day parade, you need to do a live, multicamera remote in the field. A traffic safety segment on observing stop signs may require a single-camera approach and plenty of postproduction time. To help the audience gain a deeper insight into the thinking and the work habits of a famous painter, you might observe the painter in her studio over

several days with a small, single camcorder and then edit the videotaped material in postproduction. If the viewer is to share the excitement of the participants in a new game show and is encouraged to call in while the game is in progress, the show must obviously be a live, multicamera studio production.

PRODUCTION TEAM AND COMMUNICATION

The producer is generally responsible for identifying and organizing the nontechnical and technical production teams. If you are a staff director in a station or large production company, the production teams are assigned to you according to scheduling convenience rather than the individual skills of the team members. If, however, you can select your team, you obviously pick those people who can do the best job for the specific production at hand. Note that one floor manager may be excellent in the studio but not in the field, or that a superb ENG/EFP camera operator may perform quite poorly when asked to handle a heavier studio camera. Check with the producer on all your decisions and get his or her approval for your choices. Don't leave anything to chance and don't assume that someone else will take care of a production detail. The producer should be in constant contact with you during the entire preproduction phase. If you think the producer should have contacted you, don't just sit back and complain—pick up the phone and call him or her.

Once you know your team, establish procedures to facilitate your supervision of the preproduction activities. For example, have the art director call or e-mail you when the tentative floor plan is ready; request that the talent notify you when they receive the script. Brief production meetings promote efficient communication among key team members, assuming you have invited them and they are all in attendance.

When working with freelancers, you need to know how to reach them and they need to know how best to contact you. Give all team members a printout of your production personnel database (see figure 17.5) and keep all contact information close at hand. It is often quicker to locate a telephone number in a regular card file than to fire up a computer. ZVL2 PROCESS→ People→ nontechnical

SCHEDULING

Prepare a detailed schedule for preproduction activities that is based on the producer's production schedule. This will help you keep track of who is supposed to do what, and when an assignment should be done. Using scheduling software can make it relatively easy to cross-check the activities of the various team members.

ZVL3 PROCESS→
Phases→ preproduction | production

SCRIPT FORMATS

Your most important preproduction element is the script. A good *script* tells you what the program is about, who is in it, what each person says, what is supposed to happen, and how the audience should see and hear the event. It also gives you specific clues as to the necessary preproduction, production, and postproduction activities. Even if you are not a writer, you need to be thoroughly familiar with the various script formats: (1) the fully scripted format, or complete script; (2) the semiscripted format, or partial script; (3) the show format; and (4) the fact, or rundown, sheet.

Fully scripted format—**the complete script** The *fully scripted format* is a complete script that includes every word that is to be spoken during a show as well as basic audio and video instructions. Dramatic shows, comedy skits, soap operas, news shows, and most major commercials use the fully scripted format. **SEE 18.1**

There are advantages and disadvantages to directing a fully scripted show. You have the advantage of visualizing the individual shots and sequencing them before going into rehearsal. You also have definite cue lines and instructions for what shots the cameras are to get. But these cue lines are also a potential liability. If the actor or performer forgets the exact text and begins to ad-lib, your shooting procedure may be seriously affected. As you will see when directing a multicamera show, the last few words of an actor's speech may trigger a number of technical operations; and if these important words aren't uttered, you must *stop down* (interrupt the videotaping) and retake the scene. Also, a fully scripted show has little flexibility in adjusting its overall running time.

Newscasts are always fully scripted. **SEE 18.2** They include every word the news anchors speak and instructions for what visuals or events the director must call up at a particular time. As a director you have little room for creativity; you follow the script and call up the various video and audio segments in the right order at the right time. As you recall, the computer connected to the robotic camera pedestals, mounting heads, and zoom lenses selects and executes camera shots. The computer program

SCENE 6

A FEW DAYS LATER. INTERIOR. CITY HOSPITAL EMERGENCY WAITING ROOM. LATE EVENING.

YOLANDA is anxiously PACING back and forth in the hospital hallway in front of the emergency room. She has come straight from her job to the hospital. We see the typical hospital traffic in an emergency room. A DOCTOR (friend of CHUCK'S) PUSHES CARRIE in a wheelchair down the hall toward YOLANDA.

CARRIE

(in wheelchair, but rather cheerful)

Hi, Mom!

YOLANDA

(anxious and worried)

Carrie-are you all right? What happened?

CARRIE

I'm OK. I just slipped.

DOCTOR (simultaneously)

She has a sprained right wrist. Nothing serious . . .

CARRIE

Why is everybody making such a big deal out of it?

YOLANDA

(cutting into both CARRIE'S and DOCTOR'S lines)

Does it hurt? Did you break your arm?

18.1 DRAMA SCRIPT

The fully scripted format, or complete script, contains every word of the dialogue and descriptions of primary character action. It gives minimal visualization and sequencing instructions.

Noon News 04/15 Hunter's Point Package Studio: KRISTI ((Kristi)) A LANDLORD IN HUNTER'S POINT IS UNDER FIRE FOR DANGEROUS LIVING CONDITIONS IN HIS BUILDINGS. RESIDENTS COMPLAIN OF RASHES . . . HEADACHES AND NOSEBLEEDS. MARTY GONZALES ASKED SEVERAL TENANTS WHO SAY THAT ALL OF THIS IS DUE TO TOXIC MOLD ((In-cue: "There is no official confirmation Package 1 that these buildings are infested with toxic Video and Audio mold, but it sure looks like it . . .)) Server 03 0:42 **PACKAGE** File 023 ((Out-cue: ". . . I wish somebody would do something about it.")) Studio: KRISTI ((Kristi)) THE LANDLORD DENIES THESE CHARGES AND SAYS IT MUST BE THE FOGGY WEATHER. WE'LL TALK TO THE LANDLORD AND HEALTH OFFICIALS RIGHT AFTER THESE MESSAGES. Server 03 File 112 **BUMPER** COMMERCIAL (California Cheese) File 005 COMMERCIAL (Winston Enterprises) File 007

18.2 NEWS SCRIPT

The news script contains every word spoken by the anchorperson (Kristi), except for the occasional chitchat, and instructions for all major video sources used. A "package" is a previously shot and edited story that contains an on-location reporter and the people interviewed.

could just as easily take over the news directing—or rather coordinating—function by following and executing the various cues of a fully scripted news routine. Indeed, there are highly effective computerized news systems in which the director does not direct from a control room but merely calls up a complex computer display and manipulates the various video and audio segments via the keyboard and the mouse. But the computer cannot react creatively when a script must be changed because of a breaking story or when something goes wrong, such as the prompting system's breaking down or the anchor's forgetting an important cue line.

Documentaries or documentary-type shows are often fully scripted. Because a documentary is intended to record an event rather than reconstruct one, scripts are frequently written *after* the field production. Documentary scripts therefore guide the postproduction phase rather than the actual production. The script will then indicate which video or sound bites to use, or it will dictate the voice-over segments by the off-camera narrator. The major video and action cues are usually listed in the video column, and all spoken words and sound effects are listed in the audio column. **SEE 18.3** Writing a detailed script before gathering the source tapes makes no sense. Instead of documenting an event, you would merely be looking for one or creating one that fits your prejudices. **ZVL4** PROCESS Ideas Scripts

Semiscripted format—the partial script The semiscripted format indicates only a partial dialogue. In general the opening and closing remarks are fully scripted, but the bulk of what people say is only alluded to, such as: "Dr. Hyde talks about new educational ideas. Dr. Seel replies." This kind of script is almost always used for interviews, product demonstrations, educational program series, variety shows, and other program types that feature a great amount of ad-lib commentary or discussion.

In a semiscripted format, it is important to indicate specific cue lines that tell the director when to roll a videotape, key a C.G. title, or break the cameras to another set area. **SEE 18.4**

Show format The *show format* lists only the order of particular show segments, such as "interview from Washington," "commercial 2," or "book review." It also lists the major set areas in which the action takes place, or other points of origination, as well as major clock and running times for the segments. A show format is frequently used in studio productions that have established performance routines, such as a daily morning show, a panel show, or a quiz show. **SEE 18.5**

Fact, or rundown, sheet A *fact sheet*, or *rundown sheet*, lists the items that are to be shown on-camera and indicates roughly what should be said. **SEE 18.6** No specific video or audio instructions are given. The fact sheet is usually supplied by a manufacturer or an advertiser who wants a particular performer to ad-lib about a particular item.

If the demonstration of the item is somewhat complicated, the director may rewrite the fact sheet and indicate key camera shots to help coordinate the talent's and the director's actions. Unless the demonstration is extremely simple, such as holding up a book by a famous novelist, directing solely from a fact sheet is not recommended. Ad-libbing by both director and talent rarely works out satisfactorily, even if the videotaping is intended for post-production editing.

There is software that will help you format a script or change quickly and effortlessly from one format to another. Some of the more sophisticated programs can also reformat a script that was originally created by a standard word-processing program.

SCRIPT MARKING

Proper marking of a script will aid you greatly in multicamera directing from the control room or on location. In control room directing, you need to coordinate many people and machines within a continuous time frame. The marked script becomes a road map that guides you through the intricacies of a production. Although there is no single correct way of marking a script, certain conventions and standards have been developed. Obviously, a fully scripted show requires more and more-precise cueing than does an interview that is directed from a show format. Live or live-on-tape productions directed from the control room in a continuous time frame need more-elaborate script markings than do scripts used in discontinuous studio or field productions, where you stop and reset between takes or small series of takes. But even in discontinuous singlecamera productions, a well-marked script will help you remember various camera and talent positions and make your directing more exacting.

Script marking for instantaneous editing (switch-

ing) Whatever script marking you may choose or develop, it must be clear, readable, and, above all, consistent. Once you arrive at a working system, stick with it. As in musical notation, where you can perceive whole passages without reading each individual note, the script-marking system permits you to interpret and react to the written cues without having to consciously read each one. The following three figures provide examples of various kinds

VALLEY PAINTERS Air date: 7/15 4:00 P.M.

VIDEO

AUDIO

VTR montage

AUDIO-IN:

SOT 00:25

"WHEN YOU DRIVE THROUGH THIS VALLEY
JUST NORTH OF SAN FRANCISCO . . ."
OUT: ". . . GROUP FIVE—A REMARKABLE
UNION OF FIVE WORLD-RENOWNED ARTISTS."

Julia in

JULIA:

Woodacre studio

The founding members of Group $5\ldots$ a painter, a singer, a potter, a documentary video maker, and a poet \ldots all celebrated artists, did not really know each other \ldots and certainly not that they

all lived in the San Geronimo Valley.

VTR 02 (Valley shots) 00:15 VO Julia They moved there to get away from city life . . . to trade the city's nervousness for the calm of rolling hills, ancient oaks, and redwoods. An artists' guild was farthest from their minds . . .

CU Talia Aiona in her studio SOT 02:31 IN: "No, no! No obligation to agents,
galleries, groups . . . anybody . . ."

OUT: . . . "until I met Phil in the Forest Knolls Post Office . . . sort of 'painter meets Mr. Video.'"

Julia in

JULIA:

Woodacre studio

The Mr. Video was Phil Arnone, an award-winning video artist who sees the world with a child's

curiosity and intensity.

VTR 03 (Footage from Arnone's "city lines") VO Julia 00:08 His world consists not of spectacular vistas but, much like Talia's paintings, of high-energy,

close-up details.

VTR 04 Arnone in editing room SOT 03:26

IN: "Yes, I am a child when it comes to looking at things, at events happening around me . . ." OUT: ... "Talia and I are definitely soul brother

and sister."

18.3 FULLY SCRIPTED DOCUMENTARY

In this script the video information and the audio information are in two columns. The video is usually page-left, and the audio is page-right.

VIDFO AUDIO KATY: CU of Katy But the debate about forest fires is still going on. If we let the fire burn itself out, we lose valuable timber and kill countless animals, not to speak of the danger to property and the people who live there. Where do you stand, Dr. Hough? DR. HOUGH: Cut to CU of (SAYS THAT THIS IS QUITE TRUE BUT THAT Dr. Hough THE ANIMALS USUALLY GET OUT UNHARMED AND THAT THE BURNED UNDERBRUSH STIMULATES NEW GROWTH.) KATY: Cut to Couldn't this be done through controlled two-shot burning? DR. HOUGH: (SAYS YES BUT THAT IT WOULD COST TOO MUCH AND THAT THERE WOULD STILL BE FOREST FIRES TO CONTEND WITH.)

18.4 SEMISCRIPTED FORMAT, OR PARTIAL SCRIPT

This script shows the video information in the left (video) column but only partial dialogue in the right (audio) column. The host's questions are usually fully scripted, but the answers are only briefly described.

of script marking. **SEE 18.7–18.9** Take a look at the markings in figure 18.7 and compare them with those in figures 18.8 and 18.9. Which script seems cleaner and more readable to you?

The script in figure 18.7 shows information that is more confusing than helpful. By the time you've read all the cue instructions, you will certainly have missed part or all of the action and perhaps even half of the talent's lines. You do not have to mark all stand-by cues or any other obvious cues that are already implied. For example, "ready" cues are always given before a cue, so they need not be part of your script markings.

In contrast, the markings in figures 18.8 and 18.9 are clean and simple. They are kept to a minimum, and there

is little writing. You are able to grasp all the cues quickly without actually reading each word. As you can see, the cues in figure 18.8 provide the same information as those in figure 18.7, but they allow you to keep track of the narration, look ahead at upcoming cues, and especially watch the action on the preview monitors. Let us now highlight some of qualities of a well-marked script from a director's point of view (refer to figure 18.8).

- All action cues are placed *before* the desired action.
- If the shots or camera actions are clearly described in the video column (page-left), or the audio cues in the audio column (page-right), simply underline or circle the printed instructions. This keeps the script clean and uncluttered.

PEOPLE, PLACES, POLITICS SHOW FORMAT (Script attached)

VTR DATE: 2/3

FACILITIES REQUEST: BECA 415

AIR DATE: 2/17

RUNNING TIME: 25:30

DIRECTOR: Whitney

HOST: Kipper

OPEN

VIDEO

AUDIO

STANDARD OPENING/VTR SOT

EFFECTS #117

ANNOUNCER: The Television Center of

the Broadcast and Electronic Communication

Arts Department, San Francisco State

University, presents "People, Places, Politics"

--a new perspective on global events.

KEY C.G. TOPIC TITLE Today's topic is:

VTR #:

PSAs 1 & 2

OPENING STUDIO SHOT PHIL INTRODUCES GUESTS

KEY C.G.

NAMES OF GUESTS

CUS OF GUESTS GUESTS DISCUSS TOPICS

CU OF Phil

CLOSES SHOW

PSAs 3 & 4

CLOSE

KEY C.G. ADDRESS

ANNOUNCER: To obtain a copy of today's

program, write to "People, Places, Politics," BECA Dept., San Francisco State University,

San Francisco, CA 94132 E-mail: BECA@sfsu.edu

KEY C.G. NEXT WEEK

Tune in next week when we present:

"Television and Democracy."

THEME MUSIC UP AND OUT

18.5 SHOW FORMAT

The show format contains only essential video information in the left (video) column and the standard opening and closing announcements in the right (audio) column.

How a Director Prepares

VIDEO PRO CD-ROM COMMERCIAL

SHOW:

DATE:

PROPS:

Desktop computer running Zettl's VideoLab 3.0. Triple-I Web page. Video Pro poster and multimedia awards in background. Video Pro package with disc as hand props.

- 1. New multimedia product by Image, Imagination, Incorporated.
- 2. Sensational success. Best Triple-I product yet.
- Based on ZVL 2.1, which won several awards for excellence, including the prestigious Invision Gold Medal.
- 4. Designed for the production novice and the video professional.
- Truly interactive. Provides you with a video studio in your home. Easy to use.
- You can proceed at your own speed and test your progress after each exercise.
- 7. Will operate on Windows or Macintosh platform.
- Special introductory offer. Expires Oct. 20. Hurry. Available
 in all major software stores. For more information or the
 dealer nearest you, visit Triple-I's Web page at
 http://www.iii.tv.

18.6 FACT, OR RUNDOWN, SHEET

The fact sheet, or rundown sheet, lists the major points of the product to be demonstrated. No specific video or audio information is given. The talent ad-libs the demonstration, and the director follows the talent's action with the camera.

But if the printed instructions are hard to read, do not hesitate to repeat them with your own symbols.

- If the script does not indicate a particular transition from one video source to another, it is always a cut. A large handwritten 2 next to a cue line means that the upcoming transition is a cut to camera 2. It also implies a "ready 2" before the "take 2" call.
- If the show requires rehearsals, do preliminary script marking in pencil so you can make quick changes without creating a messy or illegible script. Once you are ready for

the dress rehearsal, however, you should have marked the script in bold letters. Have the AD (assistant, or associate, director) and the floor manager copy your markings on their own scripts.

- Mark the cameras by circled numbers all in one row. This allows you to see quickly which camera needs to be readied for the next shot.
- In addition to the camera marking, number each shot in consecutive order, starting with 1, regardless of the camera you use for the shot. **SEE 18.10** These numbers will

Ready on effects
Take effects
Ready to wipe to VIR
Roll VTR and
Take VIR4
Track up on VTR4

VIDEO

AUDIO

Effects

Wipe to: VTR (SOT) (showing a series of paintings from realism to expressionism) AUDIO IN-CUE: "ALL THE PAINTINGS WERE DONE BY ONE ARTIST . . . PICASSO"

PICASSU"

OUT-CUE: ". . . PHENOMENAL CREATIVE FORCE"

MS Barbara by the easel

But even Picasso must have had some bad days and painted some bad pictures. Cue Barbara and Take a look. The woman's hands are obviously not right. Did Picasso

obviously not right. Did Picasso deliberately distort the hands to make

CU of painting

Key effects

Ready camera 3 on the easel-closeup Look at the outline. He obviously struggled. The line is unsure, and Take camera 3

he painted this section over at least three times. Because the rest of the painting is so realistically done, the distorted hands seem out of place. This is quite different from his later period, when he distorted images to

intensify the event.

Insert time IN-CUE: "DISTORTION MEANS POWER.
THIS COULD HAVE BEEN PICASSO'S
FORMULA . . . "

4:27 mir OUT-CUE: ". . . EXPRESSIVE POWER THROUGH DISTORTION IN HIS LATER PAINTINGS."

CU Barbara

But the formula "distortion means power" does not always apply. Here again it seems to weaken the event. Take a look at . . . Ready to foll VTR4 Segment 2

Roll UTR 4 and take UTR 4

Ready camera 2 Cue Barbara and take camera 2

18.7 BAD SCRIPT MARKING

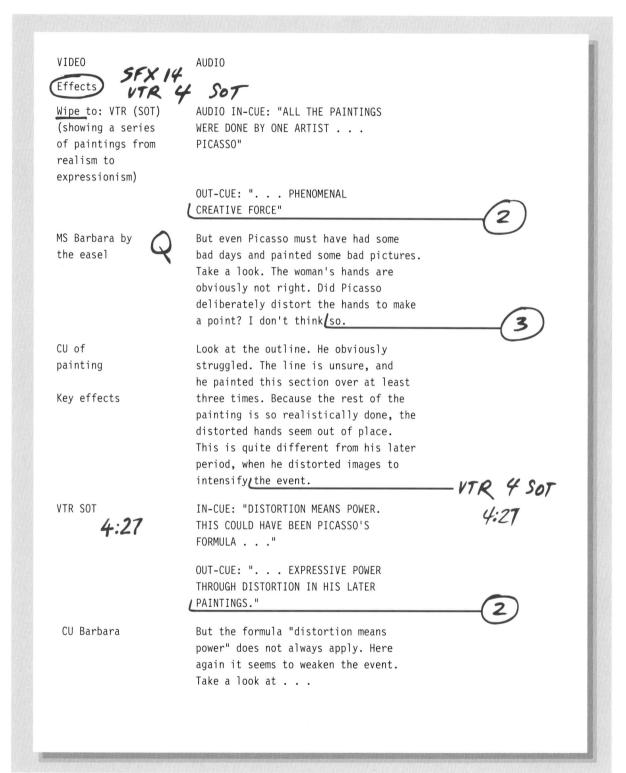

18.8 GOOD SCRIPT MARKING

This script is clearly marked and can be easily read by the director.

SCENE 6 A FEW DAYS LATER. INTERIOR. CITY HOSPITAL EMERGENCY WAITING ROOM. LATE EVENING. YOLANDA is anxiously PACING back and forth in the hospital hallway in front of the emergency room. She has come straight from her job to the hospital. We see the typical hospital traffic in an emergency room. A DOCTOR (friend of CHUCK'S) PUSHES CARRIE in a wheelchair down the hall toward YOLANDA.	2 V3 89 2 Q yol Q Doc+ Cerrice
CARRIE (in wheelchair, but rather cheerful) Hi, Mom! YOLANDA	90 () CU YOI
(anxious and worried) Carrie—are you all right? What (happened? CARRIE	91 2-5 Doct Carrie
I'm OK. I just slipped. DOCTOR (simultaneously) She has a sprained right wrist. Nothing (serious CARRIE Why is everybody making such a big deal out (of it?	93 (1) CU
YOLANDA (cutting into both CARRIE'S and DOCTOR'S lines) Does it hurt? Did you break your (arm?	94 (2) 0/5 Yol

18.9 DRAMA SCRIPT MARKING

This multicamera dramatic script marking shows the cameras used, the shot number, the type of shot, and the major actions. Note the blocking sketch at the beginning of this scene.

	mera 2
Shot	Hospital scene 6
89	MS Yolanda Eollow
91	2-Shot Carrie & Doctor
94	CU Carrie

18.10 SHOT SHEET

Each camera has its own shot sheet, indicating the location of the scene, the shot number, the type of shot, and the subject or person(s) to be in it.

not only help you ready the various shots for each camera but also make it easy to delete a shot during rehearsal. All you need to do is say, "delete shot 89," and camera 2 will skip the shot that shows Yolanda pacing back and forth (see figure 18.9).

- You may want to devise a symbol that signifies action, such as someone coming through the door, walking over to the map, sitting down, or getting up. In figure 18.9 this cue is a handwritten arrow ().
- If there are several moves by the talent, draw little maps of these moves (see figure 18.9). Such blocking sketches are usually more helpful to recall talent moves, camera positions, and traffic than are storyboard sketches of shot compositions.

Script marking for postproduction editing The marking of the script for discontinuous takes consists of a careful breakdown and indication of the various scenes, their locations (restaurant, front entrance), and principal

visualizations (camera point of view, field of view). You then number the scenes in the proposed production sequence, ending up with a list of scenes that refers to the original script by page number. Here is an example:

LOCATION	SCENE	SCRIPT PAGES	
Restaurant	2	28–32	
	3	37–49	
Restaurant	6	61–72	
entrance	14	102-110	

In the script itself, you are free to use whatever markings you prefer. When videotaping discontinuous takes for postproduction, you obviously have more time to consult the script than during a live or live-on-tape multicamera production. For discontinuous taping it may help to mark the talent movements on the script as well as draw next to the dialogue small storyboard sketches that show unusual shot framings. Such sketches assist in recalling what you had in mind when preparing the script. Many film directors storyboard every shot of the entire movie before ever shooting a single frame of film. Once again, a variety of software packages will assist you in producing storyboards. Some of these programs contain standard shots of streets, interiors, and so forth in which you can paste the characters and then move them around until they are in the desired positions.

FLOOR PLAN AND LOCATION SKETCH

Unless you direct a routine studio production that occurs on the same set, such as a news, interview, or game show, you need a floor plan for preproduction. As explained in chapter 15, the *floor plan* shows the location of the scenery and the set properties relative to a grid pattern and the available action areas. Like the script, the floor plan helps you visualize various shots and translate them into major camera positions and camera traffic patterns. It also influences, and sometimes dictates, how you block the talent.

With some practice you can do almost all the talent blocking and camera positioning simply by looking at the floor plan. You will also be able to spot potential blocking, lighting, audio, and camera problems. For example, if "active" furniture (that which is used by talent) is too close to the scenery, you will have problems with back lighting. Or if there is a rug on the floor, a camera may not be able to dolly all the way into the set. (Interpreting a floor plan to visualize shots and spot potential problems is discussed in section 18.2.)

When the production takes place in the field, you need an accurate location sketch, which represents a

"field floor plan" showing the major elements of the production environment. For example, if the single-camera production takes place inside a painter's studio, you need to know the location of the door, tables, easels, cabinets, and, especially, the windows. **SEE 18.11** If the event happens outdoors, the location sketch should show the street, major buildings, driveways, and so forth (see figure 18.19). Even if a field production happens in an actual field, make a sketch so that the crew knows which field it is and how best to get there. \blacktriangleleft

FACILITIES REQUEST

The *facilities request* is usually not prepared by the director but by some other member of the production team (producer, AD, or technical director). If someone else originates the facilities request, you need to examine it carefully to see that the equipment requested is sufficient and appropriate for the planned production. For example, a single boundary microphone or three table mics may give you a much better audio pickup during a six-person panel discussion than would six lavalieres. Or you may prefer two indepen-

18.11 LOCATION SKETCH: ARTIST'S STUDIO

This location sketch of an artist's studio shows the major dimensions, doors, windows, and furnishings.

dent camcorders for your EFP pickup rather than a remote truck. List all special requests as well, such as a working television receiver in the living room set or working phones for actors who are talking to each other in a multicamera scene. Check beforehand that the requested equipment will actually be available at the scheduled time.

Generally, the more time and effort you devote to preproduction, the less time and effort you will have to spend during the production. Production efficiency does not mean to hurry through a production regardless of quality; it means extensive preproduction.

SUPPORT STAFF

Your immediate support staff consists of the floor manager, the PA (production assistant), and, in larger operations, the AD.

FLOOR MANAGER

The *floor manager* is also called the floor director, stage manager, or unit manager, even though the unit manager functions more like a production manager or line producer who takes care of the daily production and budgetary details. As a floor manager, your primary functions are to coordinate all activities on the "floor" (studio or on-location site) and relay the cues from the director to the talent.

Before the production, as the floor manager you need to oversee and help the floor crew set up scenery, place set and hand props, dress the set, and put up displays. During rehearsals and the production, you must coordinate the floor crew and the talent and relay the director's talent cues. After the production you are responsible for striking the set and the props or restoring the remote production site to its original condition.

The following are some points to keep in mind when managing the floor.

- Unless you are doing a routine show that is produced on a "permanent" set (one that is not struck after each show), you need to obtain a detailed floor plan and prop list. Check with the art director and the director about any specific features or changes. Get a marked script from the director so that you can anticipate talent and camera traffic. Have the director look at the set before fine-tuning the lighting. Once the lighting is complete, even minor set changes can require major lighting adjustments. When the set is put up and dressed, take a digital photo of it. Such a record is much more readily accessible than a videotape.
- You are responsible for having all hand props on the set and in operating condition. For example, if the show involves a studio demonstration of a new laptop computer,

run the specific series of computer programs a few times to see how it works. Hard-to-open jars or bottles are a constant challenge to the performer. Twist the lid of a jar slightly or loosen the bottle cap so that the talent can remove it without struggling. This small courtesy can prevent many retakes and frayed nerves and is usually a quick way of establishing trust between you and the talent.

- Check that the teleprompter works and that the correct copy is displayed.
- If you use an on-camera slate in the field, have it ready and filled out with the essential information. Have several pens available as well as a rag to erase the writing.
- For complex productions study the marked script before the rehearsal and add your own cues, such as talent entrances and exits and prop, costume, or set changes. In case of doubt, ask the director for clarification.
- Introduce yourself to the talent and the guests and have a designated place for them to sit while waiting in the studio. Because most production people are quite busy (including the director and the producer), you are the one who must establish and maintain a rapport with the talent and the guests throughout the production. Verify that they have signed the proper release forms and other necessary papers. Ask them periodically whether they would like some water or coffee, whether they are comfortable, and whether you can be of assistance. When working with outside talent, review your major cues with them (see chapter 19). When using a teleprompter, ask the performers whether the font size is big enough and whether its distance from the camera is tolerable.
- During the rehearsal of a fully scripted show, follow the script as much as possible and anticipate the director's cues. If hand props are used, return them to their original positions after each take. Keep notes on especially difficult camera travels or talent actions. If the production is shot in segments for postproduction editing, pay particular attention to continuity of the talent's appearance, positions, and major moves.
- Always carry a pen or pencil, a broad marking pen, a roll of masking and gaffer's tape, and a piece of chalk (for taping down props and equipment and for *spiking*—marking—talent and camera positions). Also have a large pad ready so you can write out messages for the talent in case the I.F.B. system breaks down or is not used.
- During rehearsal deliver all cues as though you were on the air, even if the director stands right next to you. You do not always have to remain next to the camera when cueing. As much as possible, position yourself so that you can see

the talent's eyes. This is one of the reasons why you should not be tied to a studio camera's intercom outlet.

- During the show do not cue on your own, even if you think the director has missed a cue. Rather, ask the director on the intercom whether you should give the cue as marked and rehearsed. If there are interruptions in the videotaping because some technical problems are being discussed in the control room, inform the talent about what is going on. Tell the performers that they did a good job but that the director has to work out some technical details. During extended problem-solving interruptions, invite the talent to get out from under the lights and relax in the small studio area you have set up for them—but don't let them wander off.
- After the show thank the talent or guests and show them out of the studio. You then need to supervise the strike of the set in the studio or of the items set up on location. Be careful not to drag scenery or prop carts across cables that might still be on the studio floor. Locate objects that were brought in by a guest, such as a precious statue, a book, or the latest desktop computer, and see to it that they are returned. If you shot indoors on location, put things back as you found them. A small location sketch or photo will be of great help when trying to return things to the way they were. When shooting on location, remember that you are a guest operating in someone else's space.

ASSOCIATE, OR ASSISTANT, DIRECTOR

As an associate, or assistant, director (AD), you mainly assist the director in the production phase—the rehearsals and the on-the-air performance or taping sessions. In complex studio shows, a director may have you give all standby cues (for example: "Ready to cue Mary, ready 2 CU of John") and preset the cameras by telling the camera operators on the intercom the upcoming shots or camera moves. This frees up the director somewhat to concentrate more on the preview monitors or the talent's performance. Once preset by you, the director then initiates the action by the various action cues: "Ready 2, take 2," or, in fast dialogue, simply by snapping fingers.

In elaborate field productions, you may have to direct the *run-throughs* (rehearsals) for each take, which enables the director to stand back and observe the action on the field (line) monitor.

As an AD you are also responsible for the timing of the show segments and the overall show during rehearsals as well as during the actual production. Even in studio productions, be prepared to take over and direct the show or portions of it during rehearsal. This gives the director a chance to see how the shots look and, especially, how the segment or show flows.

PRODUCTION ASSISTANT

As a production assistant (PA), you must be prepared to do a variety of jobs—from duplicating and distributing the script, looking for a specific prop, and welcoming the talent, to calling a cab, getting coffee, and taking notes for the producer and the director (unless the AD is taking notes). Usually, note taking is the PA's most important assignment. You simply follow the producer and/or director with a pad and pen and record everything they mumble to themselves or tell you to write down. During the "notes" breaks, you simply read back your notes item by item. When in the field, you may also have to keep a field log of all the production takes, which helps the postproduction editor locate shots on the source tapes. ZVL5 EDITING→ Production guidelines→ field log

MAIN POINTS

- A television director must be an artist who can translate a script or an event into effective television pictures and sound, a psychologist who can work with people of different temperaments and skills, a technical adviser who knows the potentials and the limitations of the equipment, and a coordinator who can initiate and keep track of myriad production processes.
- A clear understanding of the process message (desired effect) will help the director decide on the most appropriate type of production (single-camera or multicamera, studio or field, live or live-on-tape, or continuous or discontinuous takes for postproduction).
- There needs to be effective and frequent communication among the director, the talent, and all the members of the production team.
- The detailed schedule for preproduction activities should be realistic and fit into the overall production schedule of the station or production company.
- The various script formats are the fully scripted format, or complete script; the semiscripted format, or partial script; the show format; and the fact sheet or rundown sheet.
- Precise and easy-to-read script markings help the director and other key production personnel anticipate and execute a great variety of cues.
- The floor plan or location sketch enables the director to plan major camera and talent positions and traffic.
- The facilities request is an essential communications device for procuring the necessary equipment and properties.
- The director's immediate support staff are the floor manager, the AD (associate, or assistant, director), and the PA (production assistant).

18.2

Moving from Script to Screen

Now that you know the basics of directing, including script formats and how to mark them, you need to learn how to translate the words of the script into effective pictures and sound. This translation process is called visualization—seeing the script in pictures and hearing the accompanying sounds. Yes, visualization refers not only to the mental imaging of pictures but also of sound. There is no sure-fire formula for this translation process; it requires a certain amount of imagination and artistic sensitivity and lots of practice. The best way to practice is to carefully observe the events around you—how people behave in a classroom or a restaurant or on a bus or an airplane—and mentally note what makes one event so different from the others. When you read a description of some happening in a newspaper, magazine, or novel, try to visualize it as screen images and sound.

This section will help you with these visualization processes—the translation of the various script formats into picture and sound images and sequences.

VISUALIZATION AND SEQUENCING

Formulating the process message, medium requirements, and interpreting the floor plan and the location sketch

SCRIPT ANALYSIS

Locking-in point and translation, and the storyboard

VISUALIZATION AND SEQUENCING

Directing starts with the visualization of the key images. Because we see only what the camera sees, you need to carry the initial visualization further and translate it into such directing details as where people and things should be placed relative to the camera and where the camera should be positioned relative to the event (people and things). You must then consider the *sequencing* of the portions of this visualized event through postproduction editing or switching. Concurrently, you must *hear* the individual shots and the sequence. In television, "hearing" a particular picture or picture sequence can be as important as seeing it in your mind.

As mentioned, a carefully defined process message facilitates the visualization process and, especially, makes it more precise. After deciding on what the target audience is to see, hear, feel, or do, you can follow the effect-to-cause model and determine just how the key shots should look and how to accomplish them.

Here is an example: You are to direct three segments of a program series on teenage driving safety. The first assignment is an interview, consisting of a female interviewer who regularly hosts the weekly half-hour community service show, a male police officer who heads the municipal traffic safety program, and a female student representative of the local high school. The second assignment is an interview with a male high-school student who has been confined to a wheelchair since a serious car accident. The third is a demonstration of some potential dangers of running a stop sign.

The scripts available to you at this point are very sketchy and more resemble brief rundown sheets than partial script formats. **SEE 18.12–18.14**

Because the producer has an unusually tight deadline for the completion of the series, she asks that you get started with the preproduction planning despite the lack of more-detailed scripts. She can give you only a rough idea of what each show is supposed to accomplish: Segment 1 should inform the target audience (high-school and college students) of the ongoing efforts by the police department to cooperate with schools to teach traffic safety to young drivers; segment 2 should shock the viewers into an awareness of the consequences of careless driving; and segment 3 should make the audience aware of the potential dangers of running a stop sign.

Let's apply the effect-to-cause model and see how these scripts can be translated into video programs. ZVL6 PROCESS→ Effect-to-cause→ basic idea | desired effect | cause

TRAFFIC SAFETY SERIES

Program No: 2 Interview (Length: 26:30)

VTR Date: Saturday, March 16, 4:00-5:00 P.M. STUDIO 2

Air Date: Tuesday, March 19

Host:

Yvette Sharp

Guests:

Lt. John Hewitt, traffic safety program,

City Police Department

Rebecca Child, senior and student representative,

Central High School

Video

STANDARD OPENING

CU of Hostess

CU of host

faces camera 2-shot of guests INTRODUCES SHOW
INTRODUCES GUESTS

FIRST QUESTION

INTERVIEW: Lieutenant John Hewitt is the officer in charge of the traffic safety program. Is a twenty-year veteran of the City Police Department. Has been in traffic safety for the past eight years.

NOTE: HE WILL REFER TO A TEN-POINT PROGRAM (DISPLAY VIA C.G.).

Rebecca Child is the student representative of Central High. She is an A student, on the debate team, and on the championship volleyball team. She is very much in favor of an effective traffic safety program but believes that the city police are especially tough on high-school students and are out to get them.

STANDARD CLOSE

CU of host CLOSING REMARKS
LS of host and guests THEME
CG credits

18.12 TRAFFIC SAFETY STUDIO INTERVIEW

This script for a studio interview on traffic safety is written in the semiscripted format. Note that this script gives some information on the guests appearing on the show.

TRAFFIC SAFETY SERIES

Program No: 5 Location Interview (Length: 26:30) EFP Date: Friday, March 29, 9:00 A.M.—all day

Postproduction to be scheduled Air Date: Tuesday, April 9

Interviewer: Yvette Sharp
Interviewee: Jack Armstrong

Address:

49 Baranca Road, South City

Tel.: 990 555-9990

OPENING AND CLOSING ARE TO BE DONE ON LOCATION

Jack is a high-school senior. He has been confined to a wheelchair since he was hit by a car running a stop sign. The other driver was from his high school. Jack was an outstanding tennis player and is proud of the several trophies he won in regional tournaments. He is a good student and coping very well. He is eager to participate in the traffic safety program.

NOTE: EMPHASIS SHOULD BE ON JACK, GET GOOD CUS.

18.13 TRAFFIC SAFETY FIELD INTERVIEW

This location interview is written in the semiscripted format and gives information about the guest to be interviewed.

TRAFFIC SAFETY SERIES

Program No: 6 Running Stop Signs (Length: 26:30) EFP Date: Sunday, April 7, 7:00 A.M.—all day VTR Date: Tuesday, April 9, 4:00 P.M.—4:30 P.M.

Postproduction to be scheduled Air Date: Saturday, April 16

EFP Location:

Intersection of West Spring Street and

Taraval Court

Contact:

Lt. John Hewitt, traffic safety program,

City Police Department Tel.: 990 555-8888

OPENING AND CLOSING (YVETTE) ARE TO BE DONE ON LOCATION

EFP: Program should show car running a stop sign at intersection and the consequences: almost hitting a pedestrian, jogger, bicycler; running into another car, etc. Detailed script will follow.

STUDIO: Lt. Hewitt will briefly demonstrate some typical accidents, using toy cars on a magnetic board.

NOTE: LT. HEWITT WILL PROVIDE ALL VEHICLES AND DRIVERS AS WELL AS TALENT. HE WILL TAKE CARE OF ALL TRAFFIC CONTROL, VEHICLE PARKING, AND COMMUNICATIONS. CONFIRM EFP APRIL 5.

ALTERNATE POLICE CONTACT: Sgt. Fenton McKenna (same telephone)

FORMULATING THE PROCESS MESSAGE

Despite the sketchy scripts and process messages, many images have probably entered your head already: the police officer in his blue uniform sitting next to the high-school student; a young man straining to move his wheelchair up a ramp to his front door; a car almost hit in an intersection by another car running a stop sign. Before going any further, however, you may want to define more precise process messages.

Process message 1: The interview with the traffic safety officer and the student representative should demonstrate to high-school and college students a ten-point traffic safety program to help teenagers become more-responsible drivers. It should also demonstrate how police and students could cooperate in this effort.

Process message 2: The interview with the student in the wheelchair should make viewers (of the desired target audience) gain a deeper insight into his feelings and attitudes since his accident and empathize with him.

Process message 3: The program should show viewers at least four different accidents caused by running a stop sign and demonstrate how to avoid them.

A careful reading of these process messages should make your visualization a little more precise. For example, just how do you see the three people (host, officer, and student representative) interacting in the interview? What shots and shot sequences do you feel would best communicate the interview to the audience? Do you visualize a different approach to the interview with the student in the wheelchair? The demonstration of running a stop sign probably triggers some stereotypical Hollywood video and audio images, such as glass shattering, tires squealing, and cars spinning and crashing into each other.

MEDIUM REQUIREMENTS

Without trying to be too specific, you can now proceed from some general visualizations to the medium requirements: certain key visualizations and sequencing, production method (multicamera studio show or singlecamera EFP), necessary equipment, and specific production procedures.

Here is how you might arrive at specific medium requirements for each segment (process message).

Segment 1 The interview is strictly informational. What the people say is more important than getting to know them. The student may not always agree with the officer's views, so the two may not only answer the interviewer but also talk to each other.

18.15 TRAFFIC SAFETY INTERVIEW: ROUGH SKETCH

This rough sketch for a studio interview set shows the approximate locations of the chairs and the cameras.

The sequencing will probably show the three people in three-shots (host and two guests), two-shots (host and guest, two guests talking), and individual close-ups. These shots can best be accomplished by having the guests sit together across from the interviewer. **SEE 18.15** According to the sketchy script, the officer's ten-point program on traffic safety and other items should be shown on-screen as C.G. graphics, unless he brings an easel card.

The show is obviously best done live-on-tape in the studio. There you can put the guests in a neutral environment, have good control over the lighting and the audio, switch among multiple cameras, and use the C.G.

Now you can become more specific about the medium requirements: set, cameras, microphones, lighting, and additional equipment. Because the participants do not move around, the host and the guests can wear lavaliere mics for the audio pickup. The lighting should be normal, that is, fairly high-key, slow-falloff lighting so the viewer can see everyone well. There is no need for dramatic shadows. Perhaps you can persuade the police officer to take off his cap to avoid annoying shadows on his face. How about cameras? Three or two? Even a lively exchange of ideas between the officer and the student will not require terribly fast cutting. Assuming that the host and the guests sit across from one another, you really need only two cameras (see figure 18.15).

Camera 2 can get the opening and closing shots but is otherwise assigned to the host. Camera 1 can get two-shots and CUs of the guests, as well as over-the-shoulder (of the host) three-shots. In addition to the normal control room and studio facilities, you will need to request a VTR and tape (don't forget to request the appropriate tape), the C.G.,

and a limited amount of postproduction time, in case you need to stop down for some reason during the interview. Unless you have teleprompters to show the ten-point traffic program (displayed by the C.G.), you need a line monitor that all talent can see.

Segment 2 In contrast to segment 1, the segment 2 interview is much more private. Its primary purpose is not to communicate specific information but to have an emotional impact on the audience. The communication is intimate and personal; viewers should strongly empathize with the young man in the wheelchair. These aspects of the process message suggest quite readily that we visit him in his own environment—his home—and that, except for the opening shots, we should see him primarily in close-ups and extreme close-ups rather than in less intense medium and long shots. Again, you will inevitably visualize certain key shots that you have called up from your personal visual reservoir. Your task now is to interpret those images and all other aspects of the process message into a specific production approach and medium requirements.

Considering the major aspects of the process message (revealing the student's feelings and thoughts and having the audience develop empathy with him), the general production type and the specific medium requirements become fairly apparent. It is best done single-camera style in the student's home. First, the single camera and the associated equipment (lights and mics) cause a minimum intrusion into the environment. Second, the interview itself can be unhurried and stretch over a considerable period of time. Third, the interview does not have to be continuous; it can slow down, be briefly interrupted, or be stopped and then picked up at any time. The production can be out of sequence. You may want to start with videotaping the actual interview and then tape the opening shots of the student moving up the ramp in his wheelchair and the reaction shots of the interviewer. If the student happens to refer to his athletic trophies, you can videotape them (and other significant items in the house) after the interview and then assemble all the segments in postproduction editing.

Here are some of the specific (and modest) medium requirements: camcorder, videotapes, batteries, tripod, playback monitor, two lavaliere mics, portable lighting kit, shotgun mic, small audio mixer, miscellaneous production items (extension cords, portable slate, and so forth), and good postproduction facilities. Compared with segment 1, this production needs considerably more editing time. To facilitate your visualization and sequencing, try to visit the student in his home prior to the videotaping. Meeting the student and getting to know him in his home will

give you a sense of the atmosphere, enable you to plan the shots more specifically, and more accurately determine the medium requirements.

Segment 3 This production is by far the most demanding of you as a director. It requires the coordination of different people, locations, and actions. Start with some key visualizations. Running a stop sign is obviously best shown by having a car actually do it. To demonstrate the consequences of such an offense, you may need to show the car going through the stop sign, barely missing a pedestrian or bicyclist who happens to be in the intersection, or even crashing into another car.

Now is the time to contact the producer again and ask her some important questions: Who will provide the vehicles for this demonstration? Who drives them? What about insurance? You may not need Hollywood stunt drivers for these demonstrations, but in no way should you have students perform these feats. Perhaps the police can assist you and the producer by furnishing both cars and experienced drivers. Who will be the harassed bicyclist and the pedestrian? Is there adequate insurance for all actors and extras involved? Will the police close portions of the street and the intersection for the shoot? For how long?

If the segment involves choreographing actual stunts, you would need a fire engine and ambulance standing by, just in case the stunt does not go exactly as planned. You had better abandon the project at this point and ask the producer to pass it on to a more experienced director, or to redesign this segment.

You could, however, suggest simulating these close-call actions through extensive video and audio postproduction. Assuming that the producer likes your alternate approach and that the police department will furnish cars, drivers, extras, and all necessary traffic control during the shoot, how would you carry out this directing assignment?

The key word in the process message is *demonstrate*. You need to show what is happening rather than merely talk about it. The demonstration obviously takes you on location—an actual street corner. The officer's later use of toy cars and a magnetic board to demonstrate a typical intersection accident and how to avoid it can best be done in the studio and integrated into the show in postproduction editing (see figure 18.14).

Considering the complexity of the action and the limited production time available (the intersection can be blocked for only brief periods), you should use several camcorders that cover the action simultaneously from different angles and fields of view. You can then have the camcorders synchronize the start of the time codes

(remember the flash-frame?) to expedite the extensive (AB-roll) postproduction editing. You can do the studio portion live-on-tape with a simple two-camera setup (one for a cover shot and the other for close-ups).

To ensure maximum safety of all concerned, first shoot those scenes that involve the car running the stop sign, then move to the scenes of the frightened pedestrian jumping back onto the curb and the bicyclist trying to get out of the way (of the imagined oncoming car). To simulate the sight and the sound of crashing into another car, simply show the pedestrian's frightened face; then, later, go to a junkyard for a shot of a badly damaged car. By editing the two shots together and adding familiar crashing sounds, you can simulate the impact convincingly without endangering anyone or wrecking any cars. You might think of using a subjective camera that shows going through the intersection from the driver's point of view. 1 The camera operator can simply sit in the backseat and have the camera look past the driver through the windshield. For additional subjective camera shots, mount the camcorder on the hood of the car with a beanbag (see chapter 5).

A fast zoom-in on the car while it is moving toward the camera will definitely lead to an intensification of the shot and an exciting sequence when intercut with progressively closer shots of the pedestrian's frightened face. Be sure to get enough cutaways so that you can maintain the continuity of motion vectors during editing.

Whatever key visualizations and sequencing you choose, they will probably require the same basic field equipment: two or three camcorders, mounting equipment (beanbags, clothesline, tape, camera braces), a battery-powered monitor for replay, two or three shotgun mics and fishpoles, an audio mixer, two or three reflectors (for CUs of talent), and other standard production items such as a slate, videotapes, headsets for the audio operator, and walkie-talkies for the field intercom.

The major part of this production will be the off- and on-line editing, as the simulation of near misses requires extensive video and audio postproduction. The audio portion is therefore especially important because sounds intensify scenes and help elicit mental images of unseen action. Such standard sound effects as squealing tires, crash sounds, and a police siren will intensify the scene and make the simulated crash believable. You may also want to include voice-over narration by the series host.

Don't forget to copy and carefully log the field footage. If you have a nonlinear system, capture the takes, put them

in the right *bins* (files), window-dub the field tapes down to VHS, and start with the paper-and-pencil editing.

INTERPRETING THE FLOOR PLAN AND THE LOCATION SKETCH

Let's go back to the first segment—the studio interview with the police officer and the high-school representative—and assume that the novice art director took your rough sketch of the interview setup (figure 18.15) and worked up the floor plan and the prop list as shown in the next figure. **SEE 18.16** What do you think of the floor plan? Would you give your go-ahead to have the scenery set up accordingly?

Take another look at the floor plan and try to visualize some of the key shots, such as opening and closing three-shots, two-shots of the guests talking to the host and to each other, and individual CUs of the three people. Visualize the foreground as well as the background because the camera sees both. There are some definite camera problems with this floor plan.

Given the way the chairs are placed, an opening three-shot would be difficult to achieve. If camera 2 shoots from straight on, the chairs are probably too far apart. At best the host and the guests would seem glued to the screen edges, placing undue emphasis on the painting in the middle. Also, you would probably overshoot the set on both ends. The guests would certainly block each other in this shot.

18.16 INTERVIEW SET: FLOOR PLAN AND PROP LIST

This floor plan and prop list, based on the rough sketch of an interview set, reveal serious production problems.

See Herbert Zettl, Sight Sound Motion, 4th ed. (Belmont, Calif.: Thomson Wadsworth, 2005), pp. 210–13.

18.17 INTERVIEW SET: CAMERA POSITIONS

The camera positions reveal some of the production problems caused by this setup.

- If you shoot from the extreme left (camera 1) to get an over-the-shoulder shot from the host to the guests, you will overshoot the set. On a close-up you would run the risk of the rubber plant's seeming to grow out of the guest's head. **SEE 18.17**
- If you cross-shoot with camera 2, you will again overshoot the set, and the second rubber plant would most likely appear to grow out of the host's head (see figure 18.17).
- If you pulled the cameras more toward the center to avoid overshooting, you would get nothing but profiles.

Aside from problems with camera shots, there are additional production problems:

- White hardwall panels hardly create the most interesting background. The surface is too plain, and its color is too bright for the foreground scene, rendering skin tones unusually dark. Because the host is an African American woman, the contrast problem with the white background is even more extreme—and you cannot correct the problem by putting more light on her.
- See how close the chairs are to the background flats? Any key light and fill light will inevitably strike the back-

ground too, adding to the silhouette effect. The back lights would also function as front (key) lights, causing fast falloff (dense attached shadows) toward the camera side. If you were now to lighten up the shadows on the faces with additional fill light coming from the front of the set (roughly from camera 2's position), it would inevitably hit the white flats, aggravating the silhouette effect.

- The acoustics may also prove to be less than desirable because the microphones are very close to the sound-reflecting hardwall flats.
- The prop list signals yet more problems. The large upholstered chairs are definitely not appropriate for an interview. They look too pompous and would practically engulf their occupants.
- Because most of the setup requires cross-shooting from extreme angles, the painting is useless. If you want to break up the plain background with a picture, hang it so that it serves as a background in most of the shots. If you happen to know something about art history, you may suspect that the tight, contrasting patterns of Brigit Riley's paintings would probably cause a moiré effect.
- Finally, with the chairs directly on the studio floor, either the cameras would have to look down on the performers, or the camera operators would have to pedestal all the way down and stoop for the entire interview.

As you can see, even this simple floor plan and prop list reveal important clues to a variety of production problems. You should now talk to the novice art director, point out the potential problems, and suggest some ways the floor plan could be revised. **SEE 18.18** Here are some possibilities:

- Enlarge the background so that it provides cover even for extreme cross-shooting angles. Use flats of a different color and texture (such as a medium-dark wood panel pattern). Perhaps break up the background with a window flat or a few narrow flats to give it a more three-dimensional feel.
- Place pictures or bookcases where they will be seen in the most frequent camera shots. Do not let a corner of a picture appear to grow out of the talent's head.
- Use simple chairs that are comfortable yet will not swallow the occupants; put the chairs on a riser and position them at least 6 feet from the background (which will improve back lighting).
- Turn the chairs outward somewhat (swivel them to face the center camera position) so that the cameras will not have to cross-shoot from such extreme angles.

Get rid of the rubber plants on the set. Although they look great to the naked eye, they become compositional hazards on-camera.

This is much better, but there is no time for resting on your laurels. The AD has just come back from a location survey for the segment on running the stop sign and shows you her location sketch. **SEE 18.19** She feels that there may be several potential production problems. Look at the sketch and see if you agree with her.

Yes, there certainly are a few serious problems that beg for immediate attention.

- The intersection is obviously downtown. You can therefore expect a great deal of traffic to pass through, and the police would not close this intersection for anything but a real accident.
- Even if the intersection were not in the middle of downtown, the proximity of the bank and the supermarket would make closing the intersection, even for a little while, unfeasible.
- A schoolyard is very noisy during recess. Unless you do not mind the laughing and yelling of children during the production, every school recess means a forced recess for the production crew.

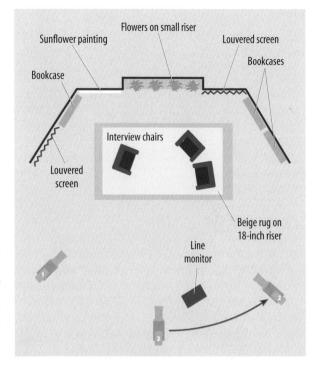

18.18 INTERVIEW SET: REVISED

The revised floor plan for the interview provides for adequate background cover and interesting shots.

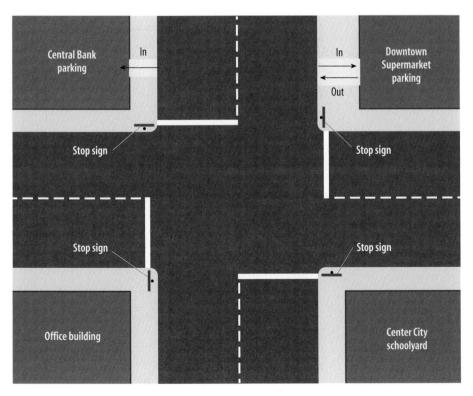

18.19 LOCATION SKETCH FOR STOP SIGN SEGMENT

This location sketch points to several major problems that make the field production unfeasible.

The four-way stop signs make the intersection less hazardous, even if someone runs one of them. The demonstration is much more effective if one of the streets has through traffic.

The solution to these problems is relatively simple: have the producer contact the police department and find a two-way-stop intersection in a quiet neighborhood that has very little traffic. There should be sufficient alternate routes so that a temporary closure of the intersection will not cause traffic delays or prevent neighbors from getting to and from their homes.

SCRIPT ANALYSIS

Explaining all the intricacies of analyzing and interpreting nondramatic and dramatic scripts is far beyond the scope of this book. The importance of translating a process message into medium requirements has already been noted. Translating a script into various directing requirements calls for a similar procedure. The following list offers some basic guidelines on reading a script as a director.

LOCKING-IN POINT AND TRANSLATION

Locking-in means that you conjure up a vivid visual or aural image while reading the script. This locking-in may well occur at the very opening scene, at the closing scene, or at any particularly striking scene in between. Do not try to force this locking-in process. It may well occur as an audio rather than a video image. If the script is good, the locking-in is almost inevitable. Nevertheless, there are a few steps that will expedite the process.

- Read the script carefully—don't just glance at it. The video and audio information provide an overview of the show and how complex the production will be. Try to isolate the basic idea behind the show. Better yet, try to formulate an appropriate process message, if it isn't already stated in the original proposal.
- Try to lock-in on a key shot, a key action, or some key technical maneuver. For example, you may lock-in on the part of the running-a-stop-sign script where a pedestrian has to jump back on the curb because of the oncoming car.
- You can now begin to translate the images into concrete production requirements, such as camera positions, specific lighting and audio setups, videotape recording, and postproduction activities.

Analyzing a dramatic script is, of course, quite a bit more complicated than translating the video and audio instructions of a nondramatic script into the director's production requirements. A good dramatic script operates on many conscious and unconscious levels, all of which need to be interpreted and made explicit. Above all, you should be able to define the theme of the play (the basic idea—what the story is all about), the plot (how the story moves forward and develops), the characters (how one person differs from the others and how each reacts to the situation at hand), and the environment (where the action takes place). In general, television drama emphasizes theme and character rather than plot, and inner, rather than outer, environment. Isolate all points of conflict.

After the locking-in, further analysis depends greatly on what production method you choose: whether you shoot the play in sequence with multiple cameras and a switcher or with a single camera in discontinuous, out-of-sequence takes.

STORYBOARD

Once you have successfully locked-in and begun to visualize the various takes and scenes, you may want to make rough sketches of or otherwise record these visualizations so you won't forget them. A sequence of visualized shots is called a *storyboard*; it contains key visualization points and audio information. **SEE 18.20**

A storyboard is usually drawn on preprinted storyboard paper, which has areas that represent the television screen. Another area, usually below the screens, is dedicated to audio and other information. A storyboard can also be drawn on plain paper or created by computer. Storyboard software programs offer a great many stock images (houses, streets, highways, cars, living rooms, and offices, for example) into which you can place figures and move them into various positions in the storyboard frame. **SEE 18.21**

Most commercials are carefully storyboarded shot-byshot before they ever go into production. Storyboards help people who make decisions about the commercial see the individual shots and imagine them in sequence.

Storyboards are also used for other types of single-camera productions that contain a great number of especially complicated discontinuous shots or shot sequences. A good storyboard offers immediate clues to certain production requirements, such as general location, camera position, approximate focal length of the lens, method of audio pickup, cutaways, amount and type of postproduction, talent actions, set design, and hand props.

THE RETURN OF AGENT 12 Page 132 DETONATION FILMS Shot: 327 Shot: 328 Shot: 329 DRAMATIC DOWNSHOT ON AGENT 12 CU – Agent 12 FAST CU - JETPACK rises As the thruster IGNITES! As he ROCKETS into the air, the ground dropping away AGENT 12 below as he streaks UP and PAST CAM, trailing flame. Jetpack! Maximum burn! Audio: ROAR of jets. Audio: ROAR of jets, pitch drops in Doppler effect. Shot: 330 Shot: 331 Shot: 332 ON DR. VENGEANCE TRACKING LS - Agent 12 continues ascent. Reacting to what he's seeing on screen. SCOTT about to speak up . . . This shot appears on screen in following shot. He can't believe it. DR. VENGEANCE Awww, MAN! Who gave him a jetpack? Shot: 333 Shot: 334 Shot: 335 ANGLE ON THE ROOF - Showing TIGER and GAMEBOY MLS TIGHTEN and CANT to CU Dr. Vengeance shouts into radio handset. sprinting for the howitzer controls. The massive ... but thinks better of it. cannons overshadow the entire roof. Audio: KLAXON horn sounds. DR. VENGEANCE DR. VENGEANCE (CONT RADIO) Tiger! Gameboy! Scramble! Ready the roof guns!

18.20 HAND-DRAWN STORYBOARD

The hand-drawn storyboard shows the major visualization points and sometimes lists the key audio sections or the shot sequence.

Careful Roadways PSA

VO: The amazing function between the eyes and brain is called the "sense of vision."

VO: The human vision system processes information faster than a Cray supercomputer.

VO: The human eye outperforms our best video.

VO: Human vision updates images, including the details of motion and color, on a time scale so rapid

VO: That a "break in the action" is almost never perceived.

VO: The Cray supercomputer can process more than a hundred million arithmetic operations per second.

18.21 COMPUTER-GENERATED STORYBOARD

The computer-generated storyboard uses 3-D graphics that can be used to create a variety of exterior and interior environments in which images of people can be placed and moved about.

MAIN POINTS

- For the director preproduction starts with visualizing the key images, which means interpreting the individual shots as television video and audio images. These visualized images must then be perceived in a certain order, a process called sequencing.
- A properly stated process message will yield important clues to visualization and sequencing and, consequently, to the production method and medium requirements.
- Visualizing and sequencing give the director a sense of camera and talent positions and traffic.
- A careful study of the floor plan or location sketch and the prop list helps in planning equipment and talent traffic and reveals potential production problems.
- Script analysis should lead to a locking-in point—an especially vivid visual or audio image—that determines the subsequent visualizations and sequencing.
- The storyboard shows key visualization points of an event with accompanying audio information as well as the proper sequencing of the shots.

ZETTL'S VIDEOLAB

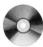

For your reference, or to track your work, each *Video-Lab* program cue in this chapter is listed here with its corresponding page number.

ZVL1 PROCESS → Process introduction 412

ZVL2 PROCESS→ People→ nontechnical 416

PROCESS→ Phases→ preproduction | production 416

ZVL4 PROCESS → Ideas → scripts 419

ZVL5 EDITING→ Production guidelines→ field log 430

PROCESS→ Effect-to-cause→ basic idea | desired effect | cause 431

19

The Director in Production and Postproduction

Now that you have prepared yourself so well in preproduction, it's time to step into the television control room, or go on location, and direct. In fact, all the meticulous preparation means little if you cannot direct or coordinate the various elements during the production phase. Section 19.1, Multicamera Control Room Directing, gives an overview of what is required of you when directing various multicamera studio and remote productions. In section 19.2, Single-camera Directing, Postproduction, and Timing, you will learn about so-called film-style directing and general postproduction duties.

KEY TERMS

- camera rehearsal Full rehearsal with cameras and other pieces of production equipment. Often identical to the dress rehearsal.
- **clock time** The time the clock shows. Specifically, the time at which a program starts and ends. Also called *schedule time*.
- dress rehearsal Full rehearsal with all equipment operating and with talent in full dress. The dress rehearsal is often videotaped. Often called *camera rehearsal* except that the camera rehearsal does not require full dress for talent.
- **dry run** Rehearsal without equipment, during which the basic actions of the talent are worked out. Also called *blocking* rehearsal.
- **film-style shooting** Directing method for single-camera production wherein you move from an establishing long shot to medium shots, then to close-ups of the same action. Also used to mean single-camera production.
- intercom Short for intercommunication system. Used by all production and technical personnel. The most widely used system has telephone headsets to facilitate voice communication on several wired or wireless channels. Includes other systems, such as I.F.B. and cell phones.

- **multicamera directing** Simultaneous coordination of two or more cameras for instantaneous editing (switching). Also called *control room directing*.
- single-camera directing Directing a single camera (usually a camcorder) in the studio or field for takes that are separately recorded for postproduction. Also called film-style directing.
- subjective time The duration we feel.
- time line A breakdown of time blocks for various activities on the actual production day, such as crew call, setup, and camera rehearsal.
- walk-through Orientation session with the production crew (technical walk-through) and the talent (talent walk-through) wherein the director walks through the set and explains the key actions.

19.1

Multicamera Control Room Directing

As in preproduction, your role in both the production and the postproduction phases is marked by meticulous planning, coordination, and team building. Like so many other production activities, directing has its own language. Your first task in becoming a director is, of course, to learn to speak this lingo with clarity and confidence. Only then can you fulfill your difficult task as master juggler of schedules, equipment, people, and artistic vision. Section 19.1 takes you through the major steps of multicamera, or control room, directing.

▶ THE DIRECTOR'S TERMINOLOGY

Terms and cues for visualization, sequencing, special effects, audio, VTR, and the floor manager

MULTICAMERA DIRECTING PROCEDURES

Directing from the control room, and intercom systems

DIRECTING REHEARSALS

Script reading; dry run, or blocking rehearsal; walk-through; camera and dress rehearsals; walk-through/camera rehearsal combination; and preparing a time line

▶ DIRECTING THE SHOW

Standby procedures and on-the-air procedures

THE DIRECTOR'S TERMINOLOGY

As does any other human activity in which many people work together at a common task, television directing demands a precise and specific language. This jargon, which must be understood by all members of the team, is generally called the *director's language* or, more specifically, the *director's terminology*. It is essential for efficient, error-free communication among the director and the other members of the production team.

By the time you learn television directing, you will probably have mastered most production jargon in general and perhaps even the greater part of the director's specific lingo. Like any language the director's terminology is subject to habit and change. Although the basic vocabulary is fairly standard, you will hear some variations among directors. And as new technology develops, the director's language changes accordingly.

The terminology listed here reflects primarily multicamera directing from the studio or remote truck control room—the type of directing that requires the most precise terminology. A single inaccurate call can cause a number of serious mistakes. You can also use most of these terms in single-camera directing, regardless of whether the production happens in the studio or in the field.

Whatever terminology you use, it must be consistently precise and clear and it must be understood by everyone on the production team; there is little time during a show to explain. The shorter and less ambiguous the signals, the better the communication. The following tables list the director's terminology for visualization, sequencing, special effects, audio, VTR, and cues to the floor manager.

MULTICAMERA DIRECTING PROCEDURES

When *multicamera directing*, you direct and coordinate various production elements simultaneously from a television control room in the studio or the remote truck (see chapter 20). You generally try to create as finished a product as possible, which may or may not need some postproduction editing. When doing a live telecast, you have no chance to fix anything in postproduction; your directing is the final cut. Multicamera directing involves the coordination of many technical operations as well as the actions of the talent. You will find that, at first, managing the complex machinery—cameras, audio, graphics, videotape, remote feeds, and the clock—provides the greatest challenge. But once you have mastered the machines to some extent, the

most difficult job will be dealing with people—those in front of the camera (talent) as well as those behind it (production people).

ZVL1 PROCESS→ Methods→ multi-camera

DIRECTING FROM THE CONTROL ROOM

In multicamera directing you need to be concerned with not only the visualization of each shot but also the immediate sequencing of the various shots. It includes the directing of live shows, live-on-tape productions, and longer show segments that are later assembled but not otherwise altered in relatively simple postproduction. Multicamera directing always involves the use of a control room, regardless of whether it is attached to the studio, inside a remote truck, or temporarily assembled in the field. Because the control room is designed specifically for multicamera production

and for the smooth coordination of all other video, audio, and recording facilities and people, multicamera directing is often called *control room directing*.

Because the camera rehearsals and the directing activities happen in the relative isolation of the control room, your lifeline is a reliable and flawlessly working intercommunication system that connects you with the rest of the control room personnel, the studio crew, and, if necessary, the talent.

CONTROL ROOM INTERCOM SYSTEMS

The control room *intercom* systems provide immediate voice communication among all production and technical personnel. The most common systems are the P.L., the I.F.B., and the S.A. systems.

19.1 DIRECTOR'S VISUALIZATION CUES

The visualization cues are directions for the camera to achieve optimal shots. Some of these visualizations can be achieved in postproduction (such as an electronic zoom through digital magnification), but they are much more easily done with proper camera handling.

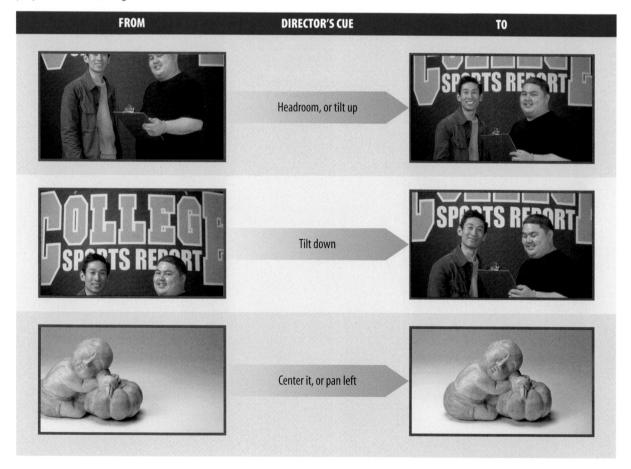

19.1 DIRECTOR'S VISUALIZATION CUES (continued)

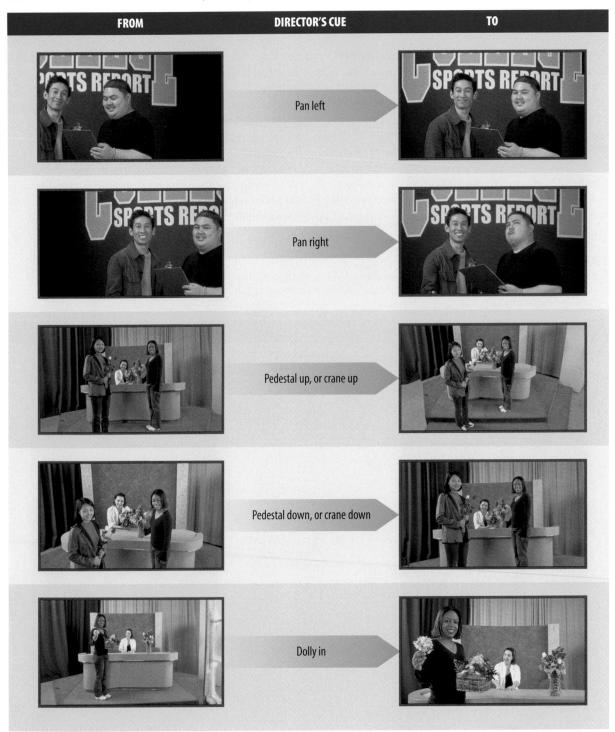

19.1 DIRECTOR'S VISUALIZATION CUES (continued)

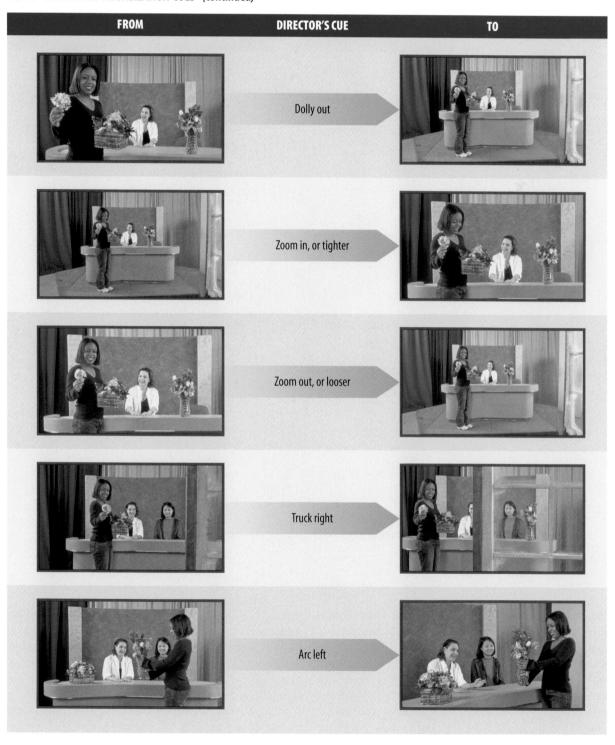

19.2 DIRECTOR'S SEQUENCING CUES

The sequencing cues help get from one shot to the next. They include the major transitions.

CTION	DIRECTOR'S CUE
ut from camera 1 to camera 2.	Ready two — take two.
issolve from camera 3 to camera 1.	Ready one for dissolve — dissolve.
lorizontal wipe from camera 1 o camera 3.	Ready three for horizontal wipe [over 1] — wipe. or:
	Ready effects number <i>x</i> [the number being specified by the switcher program] — effects.
ade in camera 1 from black.	Ready fade in one — fade in one.
	Ready up on one — up on one.
ade out camera 2 to black.	Ready black — go to black.
short fade to black between ameras 1 and 2.	Ready cross-fade to two — cross-fade.
Cut between camera 1 and VTR 2 assuming that VTR 2 is already rolling and "locked" or in a "parked" position).	Ready VTR two [assuming the videotape is coming from VTR 2] — take VTR two. [Sometimes you simply call the VTR number as it appears on the switcher. If, for example, the VTR is labeled 6, you say: Ready six — take six.]
Cut between VTR and C.G.	Ready C.G. — take C.G. or: Ready effects on C.G. — take effects.
Cut between C.G. titles.	Ready change page — change page.

The P.L. intercom Most small stations and independent production studios use the telephone intercommunication, or *P.L.* (*private line* or *phone line*), *system*. All production and technical personnel who need to be in voice contact with one another wear standard telephone headsets with an earphone and a small microphone for talkback. Every production studio has three or more intercom outlets for plugging in the headsets for the floor manager, the floor crew, and the microphone boom operator. In addition, each camera has two intercom outlets: one for the camera operator and the other for a member of the floor crew. It is

best, however, to have the floor crew connect their headsets to the wall outlets rather than the extra camera outlet. A tie to the camera not only limits their operation radius but also interferes with the camera's flexibility. There is always the danger of the floor manager's yanking the camera while trying to catch the talent's attention.

Larger studios employ a wireless intercom system for the floor personnel. These systems furnish a regular talkback headset for the floor manager but sometimes only an earplug and a small pocket receiver for the rest of the crew.

19.3 DIRECTOR'S SPECIAL-EFFECTS CUES

Special-effects cues are not always uniform, and, depending on the complexity of the effect, directors may invent their own verbal "shorthand." Whatever cues are used, they need to be standardized among the production team.

	DIRECTOR'S CUE
o super camera 1 over 2.	Ready super one over two — super.
o return to camera 2.	Ready to lose super— lose super. or:
	Ready to take out one — take out one.
o go to camera 1 from the super.	Ready to go through to one—through to one.
o key the C.G. over the base picture on camera 1.	Ready key C.G. [over 1] — key.
o key the studio card title on camera 1 over the base picture on camera 2.	Ready key one over two — key.
o fill the keyed-out title from the studio card on camera 1 with a yellow hue over the base picture on camera 2.	Ready matte key one, yellow, over two — matte key.
o have the title from the C.G. appear in drop-	Ready C.G. drop shadow over one — key C.G.
hadow outline over the base picture on camera 1.	[Sometimes the director may use the name of the C.G. manufacturer,
	such as Chyron. Thus, you would say:
	Ready Chyron over one — key Chyron. Because the C.G. information is almost always keyed, the "key" is
	usually omitted in the ready cue.] or:
	Ready effects, drop shadow — take effects.
	[Some directors simply call for an "insert," which refers to the downstream
	keyer. Usually the lettering mode [drop shadow or outline] is already
	programmed into the C.G. So you just say:
	Ready insert seven — take insert.]
o have a wipe pattern appear over a picture,	Ready circle wipe two over one — wipe.
uch as a scene on camera 2, and replace a scene	[Any other wipe is called for in the same way except that the specific
on camera 1 through a circle wipe.	wipe pattern is substituted for "circle wipe." If you need a soft wipe, simply call for "Ready soft wipe" instead of "Ready wipe."]
o have an insert (video B) grow in size	Ready squeeze out — squeeze.
n a zoomlike motion, replacing the base	or:
icture (video A).	Ready effect sixteen — squeeze out.
o achieve the reverse squeeze video B getting smaller).	Ready squeeze in — squeeze.
o achieve a great many transitions through wipes.	Ready wipe effect twenty-one — wipe.

19.4 DIRECTOR'S AUDIO CUES

Audio cues involve cues for microphones, starting and stopping various audio sources, such as CD players, and integrating or mixing these sources.

ACTION	DIRECTOR'S CUE
To activate a microphone in the studio.	Ready to cue talent. [Or something more specific, like Mary — cue her. The audio engineer will automatically open her mic.] or:
	Ready to cue Mary — open mic, cue her.
To start music.	Ready music — music.
To bring the music under for an announcer.	Ready to fade music under — music under, cue announcer.
To take the music out.	Ready music out — music out.
	Fade music out.
To close the microphone in the studio (announcer's mic) and switch over to the sound on videotape.	Ready SOT [sound on tape] — close mic, track up. or:
	Ready SOT — SOT.
To roll audio recording.	Ready audiotape — roll audiotape . [Do not just say, "Roll tape," because the TD may start the VTR.] or:
	Ready Zip x — play.
To fade one sound source under and out while simultaneously fading another in (similar to a dissolve).	Ready cross-fade from [source] to [other source] — cross-fade.
To go from one sound source to another without interruption (usually two pieces of music).	Ready segue from [source] to [other source] — segue.
To increase program speaker volume for the director.	Monitor up, please.
To play a sound effect from a CD.	Ready CD cut x — play.
	Ready sound effect x — play.
To put slate information on videotape (either open floor manager's mic or talkback patched to VTR).	Ready to read slate — read slate.

19.5 DIRECTOR'S VTR CUES

The VTR cues are used to start and stop the videotape recorder, to slate a video recording, and to switch to the VTR output.

ACTION	DIRECTOR'S CUE
To start videotape for recording a program.	Ready to roll VTR one — roll VTR one. [Now you have to wait for the "in-record" or "speed" confirmation from the VTR operator.]
To "slate" the program after the VTR is in the record mode. The slate is on camera 2 or on the C.G.; the opening scene is on camera 1. (We are assuming that the color bars and the reference level audio tone are already on the tape.)	Ready two [or C.G.], ready to read slate—take two [or C.G.], read slate.
To put the opening 10-second beeper on	Ready black, ready beeper — black, beeper.
the audio track and fade in on camera 1.	Ten — nine — eight — seven — six — five —
(Do not forget to start your stopwatch	four — three — two — cue Mary — up on one.
as soon as camera 1 fades in.)	[Start your stopwatch.]
To stop the videotape on a freeze-frame.	Ready freeze — freeze.
To roll the videotape out of a freeze-frame.	Ready to roll VTR three — roll VTR three.
To roll the videotape for a slow-motion effect.	Ready VTR four slo-mo — roll VTR four.
	or:
	Ready VTR four slo-mo — slo-mo four.
To roll a VTR as a program insert while	Ready to roll VTR three, SOT—roll VTR three.
you are on camera 2; sound is on tape.	Two — one, take VTR three, SOT.
Assuming a 2-second roll.	If you do not use a countdown because of instant start, simply say:
	Ready VTR three, roll and take VTR three.
	[Start your stopwatch for timing the VTR insert.]
To return from VTR to camera and Mary	Ten seconds to one, five seconds to one.
on camera 1. (Stop your watch and	Ready one, ready cue Mary — cue Mary, take one.
reset it for the next insert.)	

Some shows require a simultaneous feed of program sound and control room signals to other production personnel, such as the microphone boom operator or studio musicians (usually the band or orchestra leader), who have to coordinate their actions with both the program sound and the director's cues. In such cases you can use a double headset wherein one of the earphones carries the intercom signals and the other carries the program sound.

Sometimes when you work in noisy surroundings or near a high-volume sound source, such as a rock band, you may need a double-muff headset, which filters out the high-volume sounds at least to some degree. The mic in such headsets does not transmit the ambient sound and is activated only when you speak into it.

In most television operations, production and technical crews use the same intercom channel, which means that everyone can be heard by everyone else. Most of these systems also have provisions for separating the lines for different functions. For example, while the technical director (TD) confers with the video operator on one channel, the

19.6 DIRECTOR'S CUES TO THE FLOOR MANAGER

The directional cues are always given from the camera's point of view, not the talent's. "Left" means camera-left; "right" means camera-right.

director may, at the same time, give instructions to the floor crew. Larger studios and remote trucks provide a dozen or more separate intercom channels.

The I.F.B. system You use an *I.F.B.* (*interruptible foldback* or *interruptible feedback*) *system* in shows with highly flexible formats or when program changes are likely to occur while on the air. The I.F.B. system connects the control room (director and producer) directly with the performers, bypassing the floor manager. The performer wears a small earpiece that carries the total program sound (including his or her own voice) unless the director, the producer, or any other member of the control room team connected with the system interrupts the program sound with specific instructions.

For example, an on-camera field reporter in Washington who is describing the arrival of foreign dignitaries can hear herself until the director cuts in and says, "Throw it back to New York"—that is, for the talent to tell the viewers that the program is returning to the origination center in New York. But while the director is giving these instructions, the viewer still hears the field reporter's continuous description of the event. Relaying such messages through an off-camera floor manager would be much too slow and inaccurate in as tight a show as a newscast or a live telecast of a special event. The producer uses I.F.B. to supply the host with follow-up questions while interviewing a guest.

Needless to say, such a system works only with a highly experienced announcer and producer or director. There are countless occasions when the interruptible foldback system unfortunately acts as a performer interrupt device because the inexperienced performer cannot maintain effective commentary while listening simultaneously to the producer's instructions.

The S.A. system The S.A. (studio address) system is used by the control room personnel, primarily the director, to give instructions to people in the studio not connected by the P.L. system. Also called studio talkback, the S.A. system uses a speaker similar to a public address system, helping communicate directly with everyone in the studio. For example, you may use it to give some general instructions to everybody, especially at the beginning of a rehearsal, or to inform talent and production personnel of a temporary delay. Also, if most personnel happen to be off the P.L. headsets, as is frequently the case during a short break, you can use the talkback system to call them back to work.

Considering the importance of the intercom system, you should include it in routine facilities checks. If you dis-

cover faulty headsets or an imperfect intercom line, report it to the maintenance crew and have it fixed right away. A faulty intercom can be more detrimental to a multicamera production than a defective camera.

DIRECTING REHEARSALS

Unless you are doing a live remote pickup of a special event, you need to rehearse as much as possible. Rehearsals not only give you and the rest of the production team practice in what to do during the taping session but they also readily reveal any major and minor flaws or omissions in your preproduction preparation.

Ideally, you should be able to rehearse everything that goes on videotape or on the air. Unfortunately, in practice this is hardly the case. Because the amount of scheduled rehearsal time always seems insufficient, the prerehearsal preparations (discussed in chapter 18) become extremely important. To make optimal use of the available time during scheduled rehearsals, you might try the following methods: (1) script reading, (2) dry run, or blocking rehearsal, (3) walk-through, (4) camera and dress rehearsals, and (5) walk-through/camera rehearsal combination. Note, however, that you rarely go through all of these steps. Many nondramatic shows are rehearsed simply by walking the talent through certain actions, such as moving to a display table and holding items properly for close-ups, or walking to the performance area to greet the guest. Routine shows, such as daily news shows with interviews by the same talent, are not rehearsed at all.

SCRIPT READING

Under ideal conditions every major production should begin with a script-reading session. Even for a relatively simple show, you should meet at least once with the talent, the producer, the PA (production assistant), and the key production personnel—AD (assistant director), TD, and floor manager—to discuss and read the script. Bring the floor plan along; it will help everyone visualize just where the action takes place and point out some potential production problems. In this session, which normally doubles as a production meeting, you should address these points:

- Explain the process message, including the purpose of the show and its intended audience.
- Outline the major actions of the performers, the number and the use of hand props, and the major crossovers (walking from one performance area to another while on-camera).

 Discuss the performer's relationship to the guests, if any. In an interview, for example, discuss with the host the key questions and what he or she should know about the guest. Normally, such talent preparation is done by the producer.

Chapter 19

The script-reading sessions are, of course, particularly important if you are rehearsing TV specials or a television drama. You will find that the time you invest in thorough script interpretation is regained during subsequent rehearsals.

In the script-reading sessions for onetime plays, you should discuss the process message objective, the structure of the play (theme, plot, and environment), and the substance of each character. An extremely detailed analysis of the characters is probably the most important aspect of the dramatic script-reading session. The actor who really understands his or her character, role, and relationship to the event has mastered the principal part of his or her performance. After this analysis the actors tend to block themselves (under your careful guidance, of course) and move and "act" naturally. You no longer need to explain the motivation for each move. More than any other, the television actor must understand a character so well that he or she is no longer acting out, but rather is living, the role. The internalization of the character, which can be quite readily achieved through extensive script-reading sessions, will almost always enhance the actor's television performance.

When you direct a daily daytime serial or a weekly situation comedy with an ensemble cast, such intense and repeated character explorations are obviously superfluous. By the second or third episode, the actors will have a firm grip on their roles and how to relate to the other members of the cast.

DRY RUN, OR BLOCKING REHEARSAL

In the dry run, also called blocking rehearsal, the basic actions of the talent are worked out. By that time you must have a very good idea of where the cameras should be in relation to the set and where the actors should be in relation to the cameras and to one another.

The dry run presupposes a detailed floor plan and thorough preparation by the director. It also presupposes that the actors have pretty much internalized their characters and roles. Tell them where the action should take place (the approximate location in the imagined set area-the actual set is rarely available at this point) and let them block as naturally as possible. Watch their actions as screen images, not from the point of view (POV) of a live audience. Adjust their blocking and your imagined camera positions so that you are reasonably assured that you will achieve the visualized screen image in the actual camera rehearsal. Do not fuss about specially framed shots at this time; you can always make such adjustments during the camera rehearsal. Be ready to give precise directions to the actor who is asking what to do next. Rather than always knowing what to do without the director's help, a good actor asks what to do and then does it convincingly and with precision.

Generally, try to observe the following in a dry run:

- Hold the dry run in the studio or a rehearsal hall. In an emergency any room will do. Use tables, chairs, and chalk marks on the floor for sets and furniture.
- Work out the blocking problems. Use a director's viewfinder or a small consumer camcorder, bearing in mind that a studio camera is not as flexible; you cannot tilt a studio camera sideways or lower it close to the floor for a from-below-eye-level shot. Have the PA take notes of the major blocking maneuvers. Allow time later for reading back these notes so you can correct the blocking.
- Try to block according to the actors' most natural movements, but keep in mind the camera and microphone positions and moves. Some directors walk right to the spot where the active camera will be and watch the proceedings from the camera's POV. If you block nondramatic action, observe first what the performers would do without the presence of a camera. As much as possible, try to place the cameras to suit the action rather than the other way around.
- If it will help, call out all major cues, such as "cue Lisa," "ready two, take two," and so forth.
- Run through the scenes in the order in which they are to be taped. If you do the show live or live-on-tape, try to go through the whole script at least once. If you cannot rehearse the whole script, pick the most complicated parts for rehearsal. In a nondramatic show, rehearse the opening as much as time allows. Inexperienced talent often stumble over the opening lines, with the show going downhill from there.
- Time each segment and the overall show. Allow time for long camera movements, music bridges, announcer's intro and closing, opening and closing credits, and so forth.
- Reconfirm the times and/or dates for the upcoming rehearsals.

WALK-THROUGH

The *walk-through* is an orientation session that helps the production crew and talent understand the necessary medium and performance requirements quickly and easily. You can have both a technical walk-through and a talent walk-through. When pressed for time, or when doing a smaller production, combine the two.

The walk-throughs as well as the camera rehearsals occur shortly before the actual on-the-air performance or taping session. Walk-throughs are especially important when you are shooting on location. The talent will get a feel for the new environment, and the crew will discover possible obstacles to camera and microphone moves. This is especially important when camera and fishpole operators have to walk backward during a scene.

Technical walk-through Once the set is in place, gather the production crew—AD, floor manager, floor personnel, TD, LD (lighting director), camera operators, audio engineer, and boom or fishpole operator—for the *technical walk-through*. Explain the process message objective and your basic concept of the show. Then walk them through the set and explain these key factors: basic blocking and actions of talent, camera locations and traffic, specific shots and framings, mic locations and moves, basic cueing, scene and prop changes, if any, and major lighting effects.

The technical walk-through is especially important for EFP and big remotes, where the crew in the performance area must often work during the setup under the guidance of the floor manager rather than the director, who is isolated in the remote truck (see chapter 20). Have the AD or PA take notes of all your major decisions; then have the notes read back and discussed so that the technical crew can take care of the various problems.

Talent walk-through While the production people go about their tasks, take the performers on a *talent walk-through*—a short excursion through the set or location; explain once again their major actions, positions, and crossovers. Tell them where the cameras will be in relation to their actions and whether they are to address the camera directly. Here are some of the more important aspects of the talent walk-through:

- Point out to each performer his or her major positions and walks. If the performer is to look directly into the camera, indicate which camera it is and/or where it will be positioned.
- Explain briefly where and how they should work with specific props. For example, tell the actor that the coffeepot

will be here and how he should walk with the coffee cup to the couch—in front of the table, not behind it. Explain your blocking to the talent from the POV of the camera. Urge the performer not to pick up the display objects but to leave them on the table so that the camera can get a good close-up. Have the performer go through part of the demonstration, and watch this simulation from the camera's POV. Watch that the performer does not block important close-ups.

- Have all the talent go through their opening lines, then have them skip to the individual cue lines (often at the end of their dialogue). If the script calls for ad-lib commentary, ask the talent to ad-lib so that everyone will get an idea of what it sounds like.
- Allow enough time for makeup and dressing before the camera rehearsal. During the talent walk-through, try to stay out of the crew's way as much as possible. Again, have the AD or PA take notes. Finish the walk-through early enough so that everyone can take a break before the camera rehearsal.

CAMERA AND DRESS REHEARSALS

The following discussion of camera rehearsals is primarily for studio productions and big multicamera remotes that are directed from a control room. (Camera rehearsals for EFPs are discussed in section 19.2.)

Essentially, the camera rehearsal is a full rehearsal that includes all cameras and other production equipment. In minor productions the camera rehearsal and final dress rehearsal, or dress, are almost always the same, the only difference being that the talent is already properly dressed and made-up for the final taping. Frequently, the camera rehearsal time is cut short by technical problems, such as lighting or mic adjustments. Do not get nervous when you see most of the technical crew working frantically on the intercom system or audio console five minutes before airtime. Be patient and try to stay calm. Realize that you are working with a highly skilled group who know just as well as you do how much depends on a successful performance. Like all other systems, the television system sometimes breaks down. Be ready to suggest alternatives should the problem prevail.

The two basic methods of conducting a camera rehearsal for a live or live-on-tape production are the stop-start method and the uninterrupted run-through. A *stop-start rehearsal* is usually conducted from the control room, but it can also be done, at least partially, from the studio floor. An *uninterrupted run-through rehearsal* is always conducted from the control room.

With the stop-start method, the camera rehearsal is interrupted when you encounter a problem so that you can discuss it with the crew or talent; then you resume at a logical spot in the script, hoping that the problem is not repeated. It is a thorough albeit time-consuming method. But even the uninterrupted run-through rarely remains uninterrupted. Nevertheless, you should call for a *cut* (stop all action) only when a grave mistake has been made—one that cannot be corrected later. All minor mistakes and fumbles are corrected after the run-through. Dictate notes of all minor problems to the PA or AD and have them read back at scheduled rehearsal breaks (called *notes*); provide enough time for following up on the items listed (*reset*).

Because many studio shows are videotaped in segments, an uninterrupted run-through will be interrupted anyway at each scene or segment as marked in the script. If you plan to do the entire show live, or to videotape the show in one uninterrupted take, go through as long a segment as possible in the uninterrupted run-through. A long stretch without any interruptions not only gives you an overview of the general development and build of the show, but also helps the performers or actors enormously in their pacing. The uninterrupted run-through is one of your few opportunities to get a feel for the overall rhythm of the show.

In larger productions camera rehearsals and the dress rehearsal are conducted separately. Whereas in camera rehearsals the actors are not yet dressed and you may stop occasionally to correct some blocking or technical problem, dress rehearsals are normally done in full costume and are run straight through. You stop only when major production problems arise. Many times, as in the videotaping of a situation comedy before a live audience, the video recording of the dress rehearsal is combined with that of the "on-the-air" performance to make the final edit master tape that is then broadcast.

WALK-THROUGH/CAMERA REHEARSAL COMBINATION

As necessary as the preceding rehearsal procedures seem, they are rarely possible in smaller operations. First, most directing chores in nonbroadcast or nonnetwork productions are of a nondramatic nature, demanding less rehearsal effort than dramatic shows. Second, because of time and space limitations, you are lucky to get rehearsal time equal to or slightly more than the running time of the entire show. Forty-five or even thirty minutes of rehearsal time for a half-hour show is not uncommon. In some cases you have to jump from a cursory script reading to a camera rehearsal immediately preceding the on-the-air perfor-

mance or taping. In these situations you have to resort to a walk-through/camera rehearsal combination.

Because you cannot rehearse the entire show, you simply rehearse as well as possible the most important parts. Usually, these are the transitions rather than the parts between them. *Always direct this rehearsal from the studio floor.* If you try to conduct it from the control room, you will waste valuable time explaining shots and blocking over the intercom system.

Here are some of the major points for conducting a walk-through/camera rehearsal combination:

- Get all production people into their respective positions—all camera operators at their cameras (with the cameras uncapped and ready to go); the fishpole mic ready to follow the sound source; the floor manager ready for cueing; and the TD, the audio console operator, and, if appropriate, the LD ready for action in the control room.
- Have the TD feed the studio monitor with a tripart or quad split, with each of the three or four mini-screens showing a respective camera feed. This split-screen display will serve as your preview monitors. Have a simple stand mic set up in the studio for you to relay your directing calls from the studio floor to the control room. If you cannot do such a split-screen display for your studio monitor, have the TD execute all of your switching calls and feed the line-out pictures to the studio monitor. This way everybody can see the shots and the sequence you selected.
- Walk the talent through all the major parts of the show. Rehearse only the critical transitions, crossovers, and specific shots. Watch the action on the studio monitor.
- Give all cues for music, sound effects, lighting, videotape rolls, slating procedures, and so forth to the TD via the open studio mic, but do not have them executed (except for the music, which can be easily reset).
- Even if you are on the floor yourself, have the floor manager cue the talent and mark the crucial spots on the studio floor with chalk or masking tape.

If everything goes fairly well, you are ready to go to the control room. Do not allow yourself or the crew to get hung up on some insignificant detail. Always view the problems in the context of the overall show and the time available. For example, do not fret over a picture that seems to hang slightly high on the set wall while neglecting to rehearse the most important crossovers with the talent.

From the control room, contact the cameras by number and verify that the operators can communicate with you. Then briefly rehearse once more from the control room the most important parts of the show—the opening, closing, major talent actions, and camera movements.

Try to rehearse by yourself the opening and closing of a show prior to camera rehearsal. Sit in a quiet corner with the script and, using a stopwatch (for practice), start calling out the opening shots: "Roll VTR. Ready slate—take slate. Ready black, ready beeper. Black, beeper. Ready to cue Lynne. Ready to fade up on two. Cue Lynne, up on two," and so on. By the time you enter the control room, you will practically have memorized the opening and closing of the show and will be able to pay full attention to the control room monitors and the audio.

Once you are in the control room, the only way you can see the floor action is via the preview monitors. You should therefore develop a mental map of the major talent and camera movements and of where the cameras are in relation to the primary performance areas. To help you construct and maintain this mental map, always try to position the cameras counterclockwise, with camera 1 on the left and the last camera on the far right.

As pressed for time as you may be, try to remain cool and courteous to everyone. Also, this is not the time to make drastic changes; there will always be other ways in which the show might be directed and even improved, but the camera rehearsal is not the time to try them out. Reserve sudden creative inspirations for your next show. Stick as closely as possible to the *time line*. Do not rehearse right up to videotaping or airtime. Give the talent and crew a brief break before the actual taping. Don't just tell them "Take five" (take a five-minute break); tell them the exact time to be back in the studio.

PREPARING A TIME LINE

As with every other aspect of television production, moving a show from the rehearsal phase to the on-the-air performance is governed by strict time limits. In larger operations the *time line* is worked out by the production manager. In smaller production companies, the director or the producer will establish the time line for a specific production day.

Time line: interview The following example shows a time line for a half-hour interview (actual length: 23 minutes), featuring two folk singers who have gained world fame because of their socially conscious songs. The singers, who accompany themselves on acoustic guitars, are scheduled to give a concert the following day on the university commons. Their contract does not allow the presence of television cameras during the actual concert, but they, their manager, and AFTRA (the talent union)

agreed that the singers could come to the studio for a brief interview and to play a few short selections. The process message is relatively simple: *To give viewers an opportunity to meet the two singers, learn more about them as artists and concerned human beings, and watch them perform.* To save money and time, the show is scheduled for live-on-tape production. This means that the director will direct the show as though it were going on the air live, or at least with as few *stop-downs* (interruptions whereby the videotape is stopped) as possible.

TIME LINE: INTERVIEW

11:00 a.m.	Crew call
11:10-11:30 a.m.	Tech meeting
11:30 a.m1:00 p.m.	Setup and lighting
1:00-1:30 p.m.	Lunch
1:30–1:45 p.m.	Production meeting: host and singers
1:45–2:30 p.m.	Run-through and camera rehearsal
2:30-2:40 p.m.	Notes and reset
2:40-2:45 p.m.	Break
2:45-3:30 p.m.	Tape
3:30-3:45 p.m.	Spill
3:45–4:00 p.m.	Strike

As you can see from this time line, a production day is divided into blocks of time during which certain activities take place.

11:00 a.m. Crew call This is the time the crew must arrive at the studio.

11:10–11:30 a.m. **Tech meeting** You start the day with a technical meeting during which you discuss with the crew the process message and the major technical requirements. One of these requirements is the audio setup because the singers are obviously interested in good sound. Although the eventual telecast of this interview is monophonic, the videotaping should nevertheless be done in stereo. You should also explain what camera shots you want. The sincerity of the artists and their guitar-playing skills are best conveyed by CUs and ECUs, and you may want to shift the attention from one singer to the other through a rack focus effect. The audio technician may want to discuss the specific mic setup with you, such as stand mics for the performance and wireless lavalieres for the singers' crossover. The TD (acting as studio crew chief) may ask about the desired lighting and confirm the use of two additional digital VTRs. These VTRs can produce digital mini-cassettes for the guests simultaneously with the master recording. You or the producer can then hand the guests the tapes right after the show as a small thank-you gesture. You will find that discussing such details in advance will shorten the setup time considerably.

11:30 a.m.—1:00 p.m. Setup and lighting This should be sufficient time to set up the standard interview set and light the interview and performance areas. Although as director you are not immediately involved in this production phase, you might want to keep an eye on the setup so that you can make minor changes before the lighting is done. For example, the two stools for the singers may be placed too far apart and too close to the cyc, or you may want the audio technician to use smaller and lighter mic stands so that you can get better shots of the singers.

1:00–1:30 p.m. Lunch Tell everyone to be back by 1:30 sharp—not 1:32 or 1:35—which means that everyone has to be able to leave the studio at exactly 1:00, even if there are still some technical details left undone. Minor technical problems can be solved during the production meeting with the host and the singers.

1:30–1:45 p.m. Production meeting: host and singers When the singers and their manager arrive at this meeting, they have already been introduced to the host by the producer. In this meeting confirm their musical selections and the running time for each. Discuss the opening, the closing, and the crossover to the performance area. For example, you might explain that you will stop down briefly before their first number but not when they return to the interview set. Ask them about the transitions between songs. Will they address the camera or simply segue from one song to the next? Tell them some of your visualization ideas, such as shooting very tightly during especially intense moments in their songs and for intricate guitar sections.

1:45–2:30 p.m. Run-through and camera rehearsal Although the setup is relatively simple and there will be little camera movement during the songs, you need to rehearse the crossovers from the interview set to the performance area and back. You may also want to rehearse some of the unusually tight shots or the rack focus shots from one singer to the other. Then go through the opening and the closing with all facilities (theme music, credits, and name keys). Dictate to the PA any production problems you may discover during this rehearsal for the notes segment. Do not get upset when the audio technician repositions mics during the camera rehearsal; after all, good audio is important in this production. You may be done before 2:30 p.m.

2:30–2:40 p.m. Notes and reset You now gather the key production people—producer, AD, TD, audio technician, LD, floor manager, and host—to discuss any production problems that may have surfaced during the rehearsal. Ask the PA to read the notes in the order written down. Direct the production team to take care of the various problems. At the same time, the rest of the crew should get the cameras into the opening positions, reset the pages of the character generator, load the DAT and VTRs with tape (the record VTR as well as the two additional VTRs for the singers' mini-cassette copies), and make minor lighting adjustments.

2:40–2:45 p.m. **Break** This short break will give everyone a chance to get ready for the taping.

2:45–3:30 p.m. Tape You should be in the control room and roll the tape at exactly 2:45 p.m.—not 2:50 or 3:00. If all goes well, the half-hour show should be *in the can*, or finished, by 3:30, including the stop-down time for the first crossover.

3:30–3:45 p.m. Spill This is a grace period because we all know that television is a complex, temperamental machine that involves many people. For example, you may have to redo the opening or the closing because the C.G. did not deliver the correct page for the opening credits or because the host gave the wrong time for the upcoming concert.

3:45–4:00 p.m. Strike During the *strike* time, you can thank the singers and their manager, the host, and the crew. Arrange for a playback in case they want to see and especially listen to the videotape recording right away. Play back the audio track through the best system you have. All the while keep at least one eye on the strike, but do not interfere with it. Trust the floor manager and the crew to take down the set and clean the studio for the next production in the remaining fifteen minutes.

One of the most important aspects of a time line is sticking to the time allotted for each segment. You must learn to get things done within the scheduled time block and, more important, to jump to the next activity at the precise time shown on the schedule, regardless of whether you have finished your previous chores. Do not use up the time of a scheduled segment with the preceding activity. A good director terminates an especially difficult blocking rehearsal at midpoint to meet the scheduled notes and reset period. Inexperienced directors often spend a great amount of time on the first part of the show or on a relatively minor detail, then go on the air without having rehearsed the

rest of the show. The time line is designed to prevent such misuse of valuable production time.

Time line: soap opera Here is an example of a time line for a more complicated one-hour soap opera. Assume that the setup and the lighting were accomplished the night before (from 3 to 6 a.m.) and that many set changes will happen after 6 p.m.

PRODUCTION SCHEDULE: SOAP OPERA

6:00-8:00 a.m.	Dry run—rehearsal hall
7:30 a.m.	Crew call
8:00-8:30 a.m.	Tech meeting
8:30-11:00 a.m.	Camera blocking
11:00-11:30 a.m.	Notes and reset
11:30 a.m12:30 p.m.	Lunch
12:30-2:30 p.m.	Dress rehearsal
2:30-3:00 p.m.	Notes and reset
3:00-5:30 p.m.	Tape
5:30-6:00 p.m.	Spill

As you can see, this time line leaves no time for you to think about what to do next. You need to be thoroughly prepared to coordinate the equipment, technical people, and talent within the tightly prescribed time frame. There is no time allotted for striking the set because the set stays up for the next day's production.

DIRECTING THE SHOW

Directing the on-the-air performance or the final taping session is, of course, the most important part of your job as a director. After all, the viewers do not sit in on the rehearsals—all they see and hear is what you finally put on the air. This section gives some pointers about standby procedures and on-the-air directing. Again, we assume that you are doing a live or live-on-tape multicamera show or at least the videotape recording of fairly long, uninterrupted show segments that require a minimum of postproduction editing. You will notice that you can transfer multicamera directing skills much more readily to single-camera direction than the other way around.

STANDBY PROCEDURES

Here are some of the most important standby procedures to observe immediately preceding an on-the-air telecast.

Call on the intercom every member of the production team who needs to react to your cues—TD, camera

operators, mic operator, floor manager and other floor personnel, videotape operator, LD or lighting technician, audio technician, and C.G. operator. Ask them if they are ready.

- Check with the floor manager to make sure that everyone is in the studio and ready for action. Tell the floor manager who gets the opening cue and which camera will be on first. From this point on, the floor manager is an essential link between you and the studio.
- Announce the time remaining until the telecast or taping. If you are directing a videotaped show or show segments, have the TD, C.G. operator, and audio engineer ready for the opening slate identification. You can save time by having the AD or TD direct the recording of the videotape leader (bars and tone) before airtime. Check that the slate shows the correct information. Verify the spelling of names that you will use as key inserts.
- Again, alert everyone to the first cues.
- Check that the videotape operator is ready to roll the tape, and check with the camera operators and audio engineer about their opening actions.
- Ready the opening C.G. titles and music and have the floor manager get the talent into position.

ON-THE-AIR PROCEDURES

Assuming you direct a live-on-tape show, such as the interview with the singers just described, you must first go through the usual videotape rolling procedures (see figure 19.5).

Directing from the control room Once the videotape is properly rolling and slated, you can begin the actual recording. You are now on the air. Imagine the following opening sequence:

Ready to come up on three [CU of Lynne, the interview host]. Ready to cue Lynne. Open mic, cue Lynne, up on [or "fade in"] three [Lynne addresses camera 3 with opening sentence]. Ready C.G. opening titles—take C.G. Cue announcer. Change page. Change page. Ready three [which is still on Lynne]. Cue Lynne—take three [introduces guests]. One, two-shot of singers. Two, cover [wide shot of all three]. Ready one—take one. Ready two, open mics [guest mics in the interview set]—take two. Ready three—take three [Lynne is asking her first question]. One, on Ron [CU of one of the singers]. Ready one—take one. Two, on Marissa [the other singer]. Ready two—take two.

By now you are well into the show. Listen carefully to what is being said so that you can anticipate the proper shots. Have the floor manager stand by to give Lynne time cues to the crossover. When you stop down for the crossover, wait until the singers leave the frame before stopping down. This way you can logically cut from a CU of Lynne introducing the singers to an establishing shot of the performance area. After the singers have returned to the interview set, watch the time carefully and give closing time cues to Lynne. After the one-minute cue, you must prepare for the closing. Are the closing credits ready? Again, watch the time.

Thirty seconds. Wind her up. Wind her up [or "give her a wrap-up"]. Fifteen [seconds]. C.G. closing credits. Two, zoom in on Ron's guitar. Ready two, ready C.G. Cut Lynne. Take two. Cut mics. Cue announcer. Two, hold it. Roll credits. Ready to key C.G. [over camera 2], key C.G. Lose key. Ready black—fade to black. Hold. Stop VTR. OK, all clear. Good job, everyone.

Unfortunately, not every show goes this smoothly. You can contribute to a smooth performance, however, by paying attention to the following on-the-air directing procedures.

- Give all signals clearly and precisely. Be relaxed but alert. If you are too relaxed, everyone will become somewhat lethargic, thinking that you don't really take the show too seriously.
- Cue talent *before* you come up on him or her with the camera. By the time he or she speaks, the TD will have faded in the picture.
- Indicate talent by name. Do not tell the floor manager to cue just "him" or "her," especially if the talent consists of several "hims" or "hers" anticipating a cue sooner or later.
- Do not give a ready cue too far in advance or the TD or camera operator may have forgotten it by the time your take cue finally arrives. Repeating the same ready cue may trigger a take by the TD.
- Do not pause between the take and the number of the camera. Do not say, "Take [pause] two." Some TDs may punch up the camera before you say the number.
- Meep in mind the number of the camera already on the air, and do not call for a take or dissolve to that camera. Watch the preview monitors as much as possible. Do not bury your head in your script or fact sheet.

- Do not ready one camera and then call for a take to another. In other words, do not say, "Ready one—take two." If you change your mind, nullify the ready cue—"No" or "Change that"—then give another.
- Talk to the cameras by number, not by the name of the operator. What if both operators were named Pat?
- Call the camera first before you give instructions. For example: "One, stay on the guitar. Two, give me a close-up of Ron. Three, CU of Marissa. One, zoom in on the guitar."
- After you have put one camera on the air, immediately tell the other camera what to do next. Do not wait until the last second; for example, say, "Take two. One, stay on this medium shot. Three, tight on Ron's guitar." If you reposition a camera, give the operator time to recalibrate the zoom lens; otherwise, the camera will not stay in focus during subsequent zooms.
- If you make a mistake, correct it as well as you can and go on with the show. Do not meditate on how you could have avoided it while neglecting the rest of the show. Pay full attention to what is going on. If recording live-on-tape, stop the tape only when absolutely necessary: too many false starts can sap the energy out of even the most seasoned performers and crew.
- Spot-check the videotape after each take to make sure that the take is actually on tape and technically acceptable. Check the audio. Then go on to the next one. It is always easier to repeat a take one right after the other than to go back at the end of a strenuous taping session and try to recapture the mood and the energy level of the original take.
- If you use the stop-start method in a single-camera production where you tape one shot at a time, you should play back each take at least partially before going on to the next one. This will confirm that the take is actually recorded. Pick up the next segment at a logical place before your stop-down of the present one.
- If there is a technical problem that you must solve from the control room, tell the floor manager about it on the intercom or use the S.A. system to inform the whole studio about the slight delay. The talent then know that there is a technical delay and that it was not caused by them. The people on the floor can use this time to relax, however busy it may be for you in the control room.

- During the show speak only when necessary. If you talk too much, people will stop listening and may miss important instructions. Worse, the crew will follow your example and start chatting on the intercom.
- Prepare for the closing cues. Give the necessary time cues to the floor manager slightly ahead of the actual time to compensate for the delay between your cue and the talents' reception of it.
- When you have the line in black (your final fade to black), call for a VTR stop and give the all-clear signal. Thank the crew and the talent for their efforts. If something went wrong, do not storm into the studio to complain. Take a few minutes to catch your breath, then talk calmly to the people responsible for the problem. Be constructive in your criticism and help them avoid the mistake in the future. Just telling them that they made a mistake helps little at this point.

Directing from the floor Assuming that you have a competent associate director, you can also direct some fully-scripted scenes of sitcoms or soaps from the floor, very much like doing a walk-through/camera rehearsal. In this setup each of the three or four cameras feeds, in iso-camera fashion, its own VTR; the cameras also feed the switcher and the line-out VTR. You can then have the AD

conduct the instantaneous editing and call for the various takes according to your marked script. Or you yourself can quietly call for the takes via headset, assuming that you are not overheard by the mic that picks up the actors' lines. In either case you end up with a director's cut through instantaneous editing and three or four source tapes for subsequent postproduction editing (producer's or client's cut).

MAIN POINTS

- The two principal methods of television directing are multicamera and single-camera.
- Both directing methods use a precise terminology that facilitates talent and crew activities.
- Multicamera directing involves the simultaneous use of two or more cameras and instantaneous editing with a switcher. It is done from the control room.
- The various rehearsals include script reading; dry run, or blocking rehearsal; walk-through; camera and dress rehearsals; and walk-through/camera rehearsal combination.
- Directing from the control room requires adhering to a precise time line for the rehearsals and the on-theair performance as well as following clear standby and on-the-air procedures.

19.2

Single-camera Directing, Postproduction, and Timing

In *single-camera directing* you are concerned primarily with directing various takes for later assembly in postproduction. The big difference between directing multicamera and single-camera productions is that multicamera productions are continuous and single-camera productions are discontinuous. *Continuous* in this context means that you do not stop after each shot but rather sequence a series of shots through instantaneous editing (switching) with a minimum of interruption or none at all. In single-camera studio productions, the videotaping is *discontinuous*: you no longer intend to record on tape a finished product that needs little or no postproduction for broadcast but rather to produce effective source tapes that can be shaped into a continuous program through extensive postproduction.

SINGLE-CAMERA DIRECTING PROCEDURES

Visualization, script breakdown, rehearsals, and videotaping

POSTPRODUCTION ACTIVITIES

Protection copies, VTR log, and sequencing

► CONTROLLING CLOCK TIME

Schedule time and running time, clock back-timing and fronttiming, and converting frames into clock time

CONTROLLING SUBJECTIVE TIME

Pace and rhythm

SINGLE-CAMERA DIRECTING PROCEDURES

This section focuses on the following major aspects of single-camera studio directing: (1) visualization (2) script breakdown, (3) rehearsals, and (4) videotaping. ZVL2 PROCESS→ Methods→ single-camera

VISUALIZATION

Even if you are videotaping a production discontinuously—shot-by-shot—your basic visualization is not much different from what it would be when continuous-shooting with multiple cameras and instantaneous editing. As described in chapter 18, the first reading of a script may conjure up some locking-in points—key visualizations that set the style for the entire production. This process is intuitive and depends a great deal on your own perception of the environment and the situation. It also depends on how you perceive the people in a documentary or the development of characters in a scripted drama. The script may guide you toward mental pictures of individual shots but should not dictate your visualization. The locking-in point happens more or less intuitively. It is triggered by a visual or aural description that resonates somehow with your own experience.

Once you have established locking-in points that determine your general shooting style, you must go back to the script and break it down for discontinuous videotaping. Now the order in which you videotape the shots is no longer guided by the script context, the narrative, or even aesthetic continuity but strictly by convenience and efficiency. For example, you may want to videotape all the scenes in the hospital corridor, then the waiting-room scenes, then all the operating-room scenes, then all the scenes in the patient's room, and so forth, irrespective of when they actually occur in the story.

To give you an idea of how script preparation for multicamera shooting differs from the single-camera approach, take another look at figure 18.9, showing the director's markings of a brief multicamera drama script. How would you break down the very same script segment for a single-camera shoot? Write down a series of shots that show Yolanda meeting Carrie in the hospital hallway, then compare it with the breakdown in figure 19.7. **SEE 19.7**

SCRIPT BREAKDOWN

As you can see, the breakdown is more detailed and not necessarily in the order of the action. Note that this script breakdown is just one of many possibilities.

RECEPTION ROOM AND HALLWAY

- 1. Yolanda in the reception room
- 2. Hallway: Yolanda pacing up and down the hallway in the vicinity of the emergency room
- 3. Hallway: Typical hospital traffic--nurses, a gurney, a wheelchair, visitors with flowers, a doctor and a nurse, a physical therapist protecting a person on crutches
- 4. Hallway: Doctor pushes Carrie in wheelchair
- 5. POV Carrie: Yolanda
- 6. CU Yolanda
- 7. POV Yolanda: Doctor and Carrie

YOLANDA RUSHING TOWARD DOCTOR AND CARRIE

- 1. Hallway: Yolanda rushes toward Doctor and Carrie
- 2. Reverse-angle shot (POV Carrie): Yolanda
- 3. Same shots with gurney traffic interfering with Yolanda's approach (Steadicam)

CARRIE AND YOLANDA

- 1. CU Carrie: "Hi, Mom!"
- 2. CU Yolanda: "Carrie--are you all right? What happened?"
- 3. CU swish pan from Carrie to Yolanda: "Carrie--are you all right? What happened?"
- 4. CUs and ECUs of Carrie
- 5. CUs and ECUs of Yolanda
- 6. CUs and ECUs of doctor

19.7 SINGLE-CAMERA SCRIPT BREAKDOWN

Videotape takes are grouped for convenience and efficiency, not for narrative order.

If more convenient, you could have taped the third scene (Carrie and Yolanda) before the scene of Yolanda rushing up to the doctor and Carrie. Shooting a scene in such bits and pieces requires that the actors repeat their lines and actions several times identically; you must watch carefully that the individual shots will eventually cut together into a seamless scene. This means that you must also connect the various visualization points so that the scene and the sequences have both narrative (story) and continuity of aesthetic energy.

Continuity Continuity means that all the shots in a sequence connect seamlessly so that they are no longer recognized by the audience as individual shots but as a single scene. As explained in chapter 18, a detailed storyboard will aid you greatly in seeing individual shots as a sequence. Even if you don't have the time or the resources to design storyboards for each sequence, you must try to visualize how well the shots cut together and watch for continuity errors during the videotaping. If, for example, Yolanda kisses her daughter on the left cheek in the medium shot, do not let her switch to the right cheek during the close-ups of the same scene. Such gross continuity mistakes usually mean reshooting or dropping the scene. You could use DVE (digital video effects) equipment to flop the shot in postproduction, but then you flop everything else too, including the background. Such "fixing-it-in-post" techniques are time-consuming and should not be used as a safety net for careless directing.

Close-ups and cutaways Whatever breakdown you have, be sure to get some CUs and ECUs of all the people in the scene for intensification and possible cutaways. How you start and finish a specific take can make the postproduction editor's job a delight or a nightmare. As a director you are responsible for providing the editor with shots that can eventually be assembled into a continuous and sensible sequence.

Film-style shooting Your attention to continuity is especially important when you shoot "film-style." In the classic sense of *film-style shooting*, you move from an establishing long shot to medium shots and then to close-ups of the same action. Or, if more convenient, you can videotape some of the close-ups first and then do all the long shots. As in filmmaking you may find yourself repeating an action several times to get various fields of view (long shots, medium shots, and close-ups) or angles to correct block-

ing or performance problems. Pay close attention to every detail so that the action is indeed identical when repeated. The AD and your informed and alert crewmembers will often help you avoid costly continuity mistakes: the camera operator might catch the kiss problem, for example, or may point out that the talent has her coat buttoned for this shot but wore it unbuttoned in the previous shots. In film and elaborate video productions, a designated continuity person watches out for such mistakes.

REHEARSALS

In single-camera directing, you rehearse each take immediately before videotaping it. Walk the talent and the camera and microphone operators through each take, explaining what they should and should not do. Have the single camera connected to a monitor so that you can watch the action on-screen and, if necessary, make necessary corrections before the videotaping. If you shoot simultaneously with two ENG/EFP cameras, feed their video into two preview monitors. You can set up small, battery-powered monitors on a simple card table and relay your directions to the camera operators via a P.L. system.

VIDEOTAPING

Slate each take. When in the field, use a simple handheld slate. If you're in a hurry, you can audio-slate the takes (have the floor manager read the next take number and title into the hot mic). Have the VTR operator or the PA keep an accurate field log. Always watch for continuity mistakes, but be careful not to wear out talent and crew with too many retakes; there is a point where retakes become counterproductive because of talent and crew fatigue. Finally, have the VTR operator or the PA label all videotapes and boxes and verify that the labels correspond with the field log.

Once again, follow your time line. As with taping multicamera shows, there is a tendency to do needless retakes simply because you have the better part of the day ahead of you—but then you suddenly find yourself running out of time and are forced to speed through the remaining takes.

POSTPRODUCTION ACTIVITIES

Your postproduction activities as director depend on how complex the postproduction editing promises to be. If extensive postproduction is required, you are generally still responsible for the major editing and sound-mixing decisions—but leave the editing tasks to the video editor. Once you have communicated the process message, a good editor needs only minimal supervision (or, as editors like to call it, "interference") by the director. Nevertheless, it is a good idea to work with the editor until the completion of postproduction. If you have a specific sequence in mind, share it with the editor but then leave it up to him or her to find the most effective shots.

Protection copies Before the actual editing begins, make *protection copies* of all source tapes. You can do this while the tapes are being window-dubbed for off-line editing (keying the time code over the pictures of the off-line dub—see chapter 13). If you use a nonlinear editing system, you can capture all videotape footage from a single VTR, then create a VTR log and various files for the footage. When creating such files, name them logically so that you can easily locate them again. Before engaging in the actual editing, back up all video and audio files on an external hard drive or disc.

VTR log The videotape editor or the AD must now go through all the tapes and log each one on the VTR log. Some editors like to have all takes—good or bad—logged, because occasionally the "bad" takes turn out to be more usable than the "good" ones. Tell the person who is doing the logging to include the various vectors in the vector column (see chapter 13). Finally, all spoken words must be transcribed.

Sequencing There is actually little difference from a directing point of view whether you tell the TD to "take two" or tell the editor to edit this shot to that one. In any case, try to work with—not against—the editor. An experienced editor can help you greatly in the sequencing process, but do not hesitate to assert yourself if you feel strongly about a certain editing decision. Even a seasoned editor might balk at your request for a high-energy inductive shot that shows an event as a series of CUs and ECUs. In this case it might help to do either a paper-and-pencil edit or an actual digital off-line rough-cut and hand it over to the editor (see chapter 13). Your major concern when editing is no longer the visualization but the sequencing of the various shots. In the postproduction process, you will quickly understand the value of your cutaway shots and be thankful for your awareness of continuity during the videotaping.

You should also keep an eye—or, rather, an ear—on the audio *sweetening*, especially with extensive audio

postproduction. When the editing phase is finished, check the entire off-line edit for serious technical and aesthetic discrepancies. When everything looks right, you can have an edit master tape produced on-line.

CONTROLLING CLOCK TIME

In commercial television, time is indeed money: each second of broadcast time has a monetary value. Salespeople sell time to their clients as though it were a tangible commodity. One second of airtime may cost much more than another, depending on the potential audience an event may command. *Clock time*, also known as *schedule time*, is defined as the time at which a program starts and ends. Because television operations are scheduled second-by-second, clock time is a critical element in television production.

SCHEDULE TIME AND RUNNING TIME

When videotaping a show, you don't have to worry about its *schedule time*—the start time of the program when it's aired. But you are responsible for the accurate *running time*—the length of a program or program segment—so that it can fit the prescribed time slot in the day's programming. When directing a live show such as a newscast, you use the control room clock for meeting the schedule times (the switch to network news) and the stopwatch for measuring the running times of the program inserts (the individual videotaped stories).

CLOCK BACK-TIMING AND FRONT-TIMING

Although the master control computer calculates almost all the start and end times of programs and program inserts, and a variety of pocket calculators help you add and subtract clock times, you should nevertheless know how to do time calculations even in the absence of electronic devices. For example, a performer may request at the last minute specific time cues, which you then have to figure by hand.

Back-timing One of the most common time controls involves cues to the talent so that he or she can end the program as indicated by the schedule time. In a 30-minute program, the talent normally expects a 5-minute cue and subsequent cues with 3 minutes, 2 minutes, 1 minute, 30 seconds, and 15 seconds remaining in the show. To figure out such time cues quickly, you simply back-time from the scheduled end time or the start time of the new program

segment (which is the same thing). For example, if the log shows that your live *What's Your Opinion?* show is followed by a Salvation Army *public service announcement (PSA)* at 4:29:30, at what clock times do you give the talent the standard time cues, assuming that the standard videotaped close takes 30 seconds?

You should start with the end time of the panel discussion, which is 4:29:00, and subtract the various time segments. (You do not back-time from the end of the program at 4:29:30 because the standard videotaped close will take up 30 seconds.) When, for example, should the moderator get her 3-minute cue or the 15-second wind-up cue?

Let's proceed with back-timing this particular program:

4:24:00	5 minutes to VTR Ba	ck-time to here
4:26:00	3 minutes	↑
4:27:00	2 minutes	
4:28:00	1 minute	
4:28:30	30 seconds	
4:28:45	15 seconds	
4:29:00	Cut moderator for VTR close	Start here
4:29:30	PSA (Salvation Army)	

When subtracting time, you may find it convenient to take a minute from the minute column and convert it into seconds, especially if you have to subtract a large number of seconds from a small number. Similarly, you can take an hour from the hour column and convert it into minutes.

5:15:22	5:14:82
-14:27	-14:27
	5:00:55
or:	
5:02:43	4:62:43
-55:30	- 55:30
	4:07:13

Front-timing To keep a show—such as a live newscast with many recorded inserts—on time, you need to know more than the start and end times of the program and the running times of the various inserts. You also need to know when (using clock time) the inserts are to be run; otherwise you cannot figure whether you are ahead or behind with the total show.

To figure out the additional clock times for each break or insert, simply add the running times to the initial clock time as shown on the log or the show format. As with backtiming, you need to convert the seconds and the minutes on a scale of 60 rather than 100. Compute the seconds,

minutes, and hours individually, then convert the minutes and seconds to the 60 scale.

CONVERTING FRAMES INTO CLOCK TIME

Because in the NTSC system we figure that 30 frames make up 1 second, the frames roll over after 29, with the thirtieth frame starting the new second. But seconds and minutes roll over after 59. You must therefore convert frames into seconds, or seconds into frames, when front- or back-timing time code numbers. Again, you need to compute the frames, seconds, minutes, and hours individually, then convert the frames on the 30 scale and the seconds and the minutes on the 60 scale.

For example:

$$\begin{array}{c} 00:01:58:29 \\ +\ 00:00:03:17 \\ \hline 00:01:61:46 \longrightarrow 00:01:62:16 \longrightarrow 00:02:02:16 \end{array}$$

Note that you simply added the frames, then subtracted 30 for the additional second.

Fortunately, the time code will do this for you automatically. There are also computer programs and handheld calculators available that take care of the rollovers of clock time as well as frame time.

CONTROLLING SUBJECTIVE TIME

The control of *subjective time*—the duration you feel—is much more subtle and difficult than the control of objective time. Even the most sophisticated computer cannot tell you whether a newscaster races through her copy too fast or whether a dramatic scene is paced too slowly and drags for the viewer. In determining subjective time, you must rely on your own judgment and sensitivity to the relation of one movement or rhythm to another. Although two persons move with the same speed, one may seem to move much more slowly than the other. What makes the movements of the one person appear faster or slower?¹

Watch how rush-hour traffic reflects nervous energy and impatience while actually the vehicles move more slowly than when traveling on an open freeway. Good comedians and musicians are said to have "a good sense

See the discussion of subjective time in Herbert Zettl, Sight Sound Motion, 4th ed. (Belmont, Calif.: Thomson Wadsworth, 2005), pp. 226–28.

of timing," which means that they have excellent control of subjective time—the pace and the rhythm of the performance the audience perceives.

There are many terms to express the relative duration of subjective time. You hear of *speed*, *tempo*, *pace*, *hurrying*, *dragging*, and other similar expressions. To simplify the subjective-time control, you may want to use only two basic concepts: pace and rhythm. The *pace* of a show or show segment is how fast or slow it feels. *Rhythm* supplies the beat.

There are many ways to increase or decrease the pace of a scene, a segment, or an overall show. One is to speed up the *action* or the delivery of the dialogue, very much like picking up the tempo of a musical number. Another is to increase the *intensity*—the relative excitement—of a scene. Usually, this is done by introducing or sharpening some conflict, such as raising the voices of people arguing, having one car briefly lose control while being pursued by another, or shooting the scene in tighter close-ups. A third possibility is to increase the *density* of the event by having more things happen within a specific block of running time. If you want to slow down a scene, you do just the opposite.

Whatever you change, you must always perceive the pace in relation to the other parts of the show and to the show as a whole. Fast, after all, is fast only if we can relate the movement to something slower. Finally, as you may have guessed, a precise process message should suggest the overall pace and rhythm of a show.

- such production factors as location or getting various points of view or close-ups of the same action.
- When shooting film-style, the action is always repeated for various points of view, fields of view, and camera angles.
- Each take is normally rehearsed immediately before its videotaping.
- When videotaping always slate each take with a field slate or verbally, label all videotapes, and stick to the time line.
- Always make protection copies of the source tapes or the imported video and audio files before beginning the postproduction editing.
- Log all takes—good and bad—on the VTR log and note the various vectors.
- As a director, guide, but do not interfere with, the postproduction editing and audio sweetening.
- The two important clock times are schedule time (start and end of a program) and running time (program length).
- Back-timing means figuring specific clock times (usually for cues) by subtracting running time from the schedule time at which the program ends. Front-timing means starting at the clock time that marks the beginning of a program and then adding specific running times.
- When converting frames into clock time, you must have the frames roll over to the next second after 29, but seconds and minutes after 59.
- Subjective time refers to the time duration we feel. It includes the concepts of pace and rhythm. Pace is how slow or fast a scene feels; rhythm supplies the beat.

MAIN POINTS

- Single-camera production starts, as does multicamera production, with the visualization of key shots.
- The script breakdown in single-camera production is guided more by production convenience and efficiency than by visualization and sequencing. The production sequence is dictated not by the event sequence but by

ZETTL'S VIDEOLAB

For your reference, or to track your work, each *Video-Lab* program cue in this chapter is listed here with its corresponding page number.

ZVL1 PROCESS→ Methods→ multi-camera 447

PROCESS → Methods → single-camera 464

20

Field Production and Big Remotes

When you see one of those big television trailer rigs pull up and production crews start unloading cameras, microwave and satellite uplink dishes, miles of cable, and other pieces of television equipment, you know that a big remote is in the offing. Why undergo such an effort when you could simply grab a few small camcorders to shoot the same field event? This chapter provides some answers.

Section 20.1, ENG, EFP, and Big Remotes, takes a closer look at each of these three field production methods. Section 20.2, Covering Major Events, offers further information about standard television setups of sports remotes and other field events; how to interpret location sketches; major field communication systems; signal transport; and cable distribution.

KE-Y TERMS

- big remote A production outside the studio to televise live and/or record live-on-tape a large scheduled event that has not been staged specifically for television. Examples include sporting events, parades, political gatherings, and studio shows that are taken on the road. Also called, simply, remote.
- **broadband** A high-bandwidth standard for sending information (voice, data, video, and audio) simultaneously over fiber-optic cables.
- direct broadcast satellite (DBS) Satellite with a relatively highpowered transponder (transmitter/receiver) that broadcasts from the satellite to small, individual downlink dishes; operates on the Ku-band.
- **downlink** The antenna (dish) and equipment that receive the signals coming from a satellite.
- **field production** All productions that happen outside the studio; generally refers to electronic field production (EFP).
- **instant replay** Repeating for the viewer, by playing back videotape or disk-stored video, a key play or an important event immediately after its live occurrence.
- **isolated (iso) camera** Feeds into the switcher and into its own separate video recorder.
- **Ku-band** A high-frequency band used by certain satellites for signal transport and distribution. The Ku-band signals can be influenced by heavy rain or snow.

- **location sketch** A rough map of the locale of a remote telecast. For an indoor remote, the sketch shows the room dimensions and the furniture and window locations. For an outdoor remote, the sketch indicates the location of buildings, the remote truck, power sources, and the sun during the time of the telecast.
- **microwave relay** A transmission method from the remote location to the station and/or transmitter involving the use of several microwave units.
- mini-link Several microwave setups that are linked together to transport the video and audio signals past obstacles to their destination (usually the television station and/or transmitter).
- **remote survey** A preproduction investigation of the location premises and event circumstances. Also called *site survey*.
- **remote truck** The vehicle that carries the program control, the audio control, the video-recording and instant-replay control, the technical control, and the transmission equipment.
- uplink Earth station transmitter used to send video and audio signals to a satellite.
- **uplink truck** A small truck that sends video and audio signals to a satellite.

20.1

ENG, EFP, and Big Remotes

When a television production happens outside the studio, we call it a *field production*. We normally distinguish among *electronic news gathering (ENG)* that covers daily news events, *electronic field production (EFP)* that deals with smaller scheduled events, and *big remotes* that are done for major events, such as sports, parades, and political conventions.

There are advantages to taking a production out of the studio and into the field:

- You can place or observe an event in its real setting or select a specific setting for a fictional event.
- You have an unlimited number and a variety of highly realistic settings to choose from.
- You can use available light and background sounds so long as they accomplish your technical and aesthetic production requirements.
- You can save on production people and equipment because many EFP productions require less equipment and crew than similar studio productions (unless you do a complex EFP or a big remote).
- You avoid considerable rental costs for studio use and, if you work for a station, studio scheduling problems.

There are disadvantages as well:

- You do not have the production control the studio affords. Good lighting is often difficult to achieve in the field, both in indoor and outdoor locations, as is high-quality audio.
- On outdoor shoots the weather always presents a hazard. For example, rain or snow can cause serious delays simply because it is too wet or too cold to shoot outside. A few clouds may give you considerable continuity problems when the preceding takes showed clear skies.
- You are always location dependent, which means that some locations require the close cooperation of nonproduction people. For example, if you shoot on a busy downtown street, you will need the help of the police to control traffic and onlookers.
- When shooting on city, county, or federal property, you may need a permit from these agencies plus additional insurance stipulated by them.
- Field productions also normally require crew travel and lodging as well as equipment transportation.

As a television professional, you need to cope with these disadvantages. After all, you can't squeeze a football field into a studio. With ENG and relatively simple EFP, the production efficiency of shooting in the field usually outweighs the lack of production control. Although ENG and EFP have been discussed throughout this book, the focus here is on their specific field production requirements.

ELECTRONIC NEWS GATHERING

ENG production features

▶ ELECTRONIC FIELD PRODUCTION

EFP preproduction; production with equipment check, setup, rehearsals, videotaping, and strike/equipment check; and postproduction

BIG REMOTES

Preproduction remote survey, and production procedures by director, floor manager, and talent

ELECTRONIC NEWS GATHERING

Electronic news gathering is the most flexible remote operation. As pointed out in previous chapters, one person with a camcorder can handle a complete ENG assignment. Even if the signal must be relayed back to the station or transmitter, ENG requires only a fraction of the

equipment and the people of a big remote. Sometimes the *shooter*, or *videographer* (news camera operator), will also take care of the signal feed from the news vehicle to the station.

ENG PRODUCTION FEATURES

The major production features of ENG are the readiness with which you can respond to an event, the mobility possible in the coverage of an event, and the flexibility of ENG equipment and people. Because ENG equipment is compact and self-contained, you can get to an event and videotape or broadcast it faster than with any other type of television equipment. An important operational difference between ENG and EFP or big remotes is that ENG requires no preproduction. ENG systems are specifically designed for immediate response to a breaking story. In ENG you exercise no control over the event but merely observe it with your camcorder and microphone as best you can.

Even when working under extreme conditions and time restrictions, experienced shooters can quickly analyze an event, pick the most important parts of it, and videotape pictures that edit together well. For important events the ENG team normally consists of two people—the videographer and the field reporter. Many ENG stories are covered by a single shooter and narrated later by an anchor during the newscast. ENG equipment can go wherever you go. It can operate in a car, an elevator, a helicopter, or a small kitchen. Your shoulder often substitutes for a heavy tripod.

With ENG equipment you can either videotape an event or transmit it live. Note that "videotaping" includes other camcorder recording methods, such as the video and audio capture on hard drives, optical discs, or flash memory devices (flash drives). The transmission equipment has become so compact and flexible that a single camera operator can accomplish even a live transmission. Most ENG vehicles (usually vans) are equipped with a microwave transmitter, which, when extended, can establish a transmission link from the remote location to the station. **SEE 20.1** When doing a live transmission, you connect the camera cable to the microwave transmitter. You can also use such a microwave link to quickly transmit to the station the uncut videotape directly from the camcorder video recorder or the recorder in the ENG van.

SATELLITE UPLINK

If you cannot establish a signal connection between your ENG location and the station, you need to request a *satellite uplink van*. This van looks like a small remote truck and contains computer-assisted uplink equipment and, when

20.1 ENG VAN

This regular-sized van houses the extendible microwave transmission device and a variety of intercommunications equipment.

used for news, one or two VTRs as well as cuts-only editing equipment. The VTRs can record the camera output and play back a rough-cut or even unedited news videotapes for immediate uplinking. **SEE 20.2**

Newspeople prefer uplinking "hot" video recordings (videotaped or disk-captured moments before the transmission) to live transmission because it permits repeated transmission in case the satellite feed is temporarily interrupted or lost altogether. To further safeguard against signal loss, two VTRs or disk recorders are sometimes used for the recording and playback of the same news story. If something goes wrong with one machine, you can quickly switch over to the next for the same material.

20.2 SATELLITE UPLINK VAN

The satellite news vehicle is a portable earth station. It sends television signals to the Ku-band satellites.

Such uplinks are pressed into service whenever big and especially newsworthy events are scheduled, such as a presidential election, a summit meeting of heads of state, a high-profile criminal trial, or the world soccer finals. But the uplink truck is also used locally for the distribution of news stories, national and international teleconferencing, or whenever a signal cannot be sent readily by microwave or cable.

ELECTRONIC FIELD PRODUCTION

As you already know, EFP uses both ENG and studio techniques. From ENG it borrows its mobility and flexibility; from the studio it borrows its production care and quality control. The following discussion of some fundamental steps of preproduction, production, and postproduction in the field assumes that you are still functioning as the director. This way you have to deal with production detail that is important for each member of the EFP team, regardless of the specific jobs assigned.

PREPRODUCTION

Compared with ENG, in which you simply respond to a situation, EFP requires careful planning. Recall that the first step in any preproduction activity is to translate the process message into the most effective and efficient production method—whether to shoot it indoors or outdoors, single- or multicamera, in the normal sequence of events or shot-by-shot. The second step is to translate the chosen production method into specific medium requirements—equipment and people. Assuming that you have practiced this translation of process message into production requirements (see chapter 17), we jump to the actual preproduction activities: (1) location survey, (2) initial production meeting, and (3) field production time line.

Location survey To get to know the environment in which the production will take place, make an accurate *location sketch*—a map of the locale of a remote telecast. For an indoor remote, the sketch shows the room dimensions and the furniture and window locations. For an outdoor remote, it indicates the location of buildings, the EFP vehicle, power sources, and the sun during the time of the telecast.

To refresh your memory, take another look at the location sketch of the artist's studio in figure 18.11. This sketch gives important information about lighting and audio requirements, camera positions, and shooting sequences. Although technical preparations may not be your immediate concern, check on the availability of power (wall outlets), the acoustics (small room, reflective walls, and traffic noise from nearby freeway), and potential lighting problems (large windows). (Location surveys are discussed further in the context of big remotes later in this chapter).

Ask the producer whether he or she has secured accommodations, shooting permits, parking, and food for talent and crew. If the production is literally in a field, are the most basic conveniences available?

Initial production meeting The initial production meeting involves all key personnel, including the PA (production assistant), the floor manager, and the crew chief or camera operator. For more-complex field productions that involve several indoor locations, you may want to include the LD (lighting director). At a minimum you should meet with the PA (who may double as the audio/VTR operator) and the camera operator. Explain the process message and what you hope to accomplish. Distribute the location sketch and discuss the major production steps.

It is critical that everyone knows the exact location of the production and how to get there. Can everyone fit into the EFP van? Who is riding with whom? Who needs to come first to the station for equipment check-out, and who will go directly to the location? Who will drive the van? Hand out the time line and ask the PA to distribute it (via fax and/or e-mail) to all other crewmembers who may not be at the meeting. As you can see, transportation

to and from the location is an essential scheduling issue. If the field production is outdoors, what do you do in case of rain or snow? Always have an alternate time line ready.

Field production time line A shooting schedule for a fairly elaborate field production may look like this:

TIME LINE: FIELD PRODUCTION

7:30–8:15 a.m.	Equipment check-out
8:15 a.m.	Departure
9:15 a.m.	Estimated arrival time
9:30–10:00 a.m.	Production meeting with talent and crew
10:00-11:00 a.m.	Technical setup
11:00-11:30 a.m.	Lunch
11:30 a.m12:00 p.m.	Technical and talent walk-through
12:00-12:20 p.m.	Notes and reset
12:20-12:30 p.m.	Break
12:30-1:00 p.m.	Segment 1 tape
1:00-1:15 p.m.	Notes and reset for segment 2
1:15–1:45 p.m.	Segment 2 tape
1:45–1:55 p.m.	Break
1:55-2:10 p.m.	Notes and reset for segment 3
2:10-2:40 p.m.	Segment 3 tape
2:40-3:00 p.m.	Spill
3:00-3:30 p.m.	Strike
3:30 p.m.	Departure
4:30 p.m.	Estimated arrival time at station
4:30-4:45 p.m.	Equipment check-in

PRODUCTION: EQUIPMENT CHECK

Again, apprise the crew of the schedule and the aim of the production. Go over the time line and the rundown sheet of the major locations and taping sessions. Be extra careful when loading the equipment. Unlike studio productions, where all the equipment is close at hand, in field productions you need to bring everything to the location. Even if you have done the same EFP a dozen times, always use an equipment checklist. A wrong cable or adapter can cause undue delays or even the cancellation of the entire production.

Before loading equipment onto a vehicle, check each item to see that it works properly. At a minimum do a test recording of picture and sound before leaving for the location shoot.

Equipment checklist The following equipment checklist is intended as a general guide and may not include all the items you need to take along. Depending on the relative

complexity of the EFP, you may need considerably less or more than the items listed.

- Cameras. Field camera or camcorders? Have they been checked out? Do you have the appropriate lenses and lens attachments (usually filters), if any? What camera mounts do you need: tripods, tripod dollies, portable pedestals, clamps, Steadicam mount, high hats, beanbags, or portable jib arms? Do you have enough batteries? Are they fully charged? Do they fit the specific camcorders you use in the EFP?
- Video recorders and recording media. If you use field cameras instead of camcorders, you need to take one or more VTRs or disk recorders. Do you have the proper videocassettes for the VTRs? Take plenty of cassettes along. Check that the actual tape length matches the label on the box. When you think you have enough tape, add two more cassettes for good measure. Do the cables fit the jacks on the recorder and the ENG/EFP camera?
- Monitor, RCU, and scopes. You need a monitor for playback or checking the camera's shots. If the monitor is battery-powered, do you have enough batteries? If you do a multicamera EFP with a switcher, each camera input needs a separate preview monitor. If you have a narrator describing the action, you need a separate monitor for him or her. In critical (film-style) field productions for which you use a single high-quality camera, you need additional equipment: an RCU (remote control unit) and test equipment to enable you to adjust the camera for optimal performance; a waveform monitor (oscilloscope) to help you adjust the brightness (keeping the white and black levels within tolerable limits); and a vector scope (color control) to help adjust the camera so that it produces true colors.
- Audio. If you have not checked out the acoustics of the location, take several types of mics. Check your wireless lavalieres. Do you have enough batteries for the wireless mic transmitters? Do the portable mics fit the channel frequency of the receiver? All remote mics, including the lavalieres, should have windscreens. Shotgun mics need additional wind jammers. Choose the most appropriate mounting equipment, such as clamps, stands, and fishpoles. Do you need a small field mixer? Does it work properly? If you use a separate audio recorder, check it out before taking it on location. Do you have enough videocassettes for the whole production? Don't forget headsets for the fishpole operator and the audio-recording technician.
- Power supply. Do you have the right batteries for the monitors, camcorders or field cameras, and audio

equipment? Are they fully charged? If using AC, do you have the right AC/DC adapters? Do you have enough AC extension cords to reach the AC outlet? Unless battery-driven, you also need AC power and extension cords for the monitors. Take a few power strips along, but be careful not to overload the circuits.

- Cables and connectors. Do you have enough camera cables, especially if there is a long run between the camera and the RCU? Are there enough coax and AC cables for monitor feeds? Always take a sufficient amount of mic cables along, even if you plan to use wireless mics. The mic cables may save a whole production day if the wireless system breaks down or is unusable on location. Do you have the right connectors for the mic cables and jacks (usually XLR connectors, but sometimes RCA phono)? Bring some adapters for video and audio cables (BNC to RCA phono and XLR to RCA phono and vice versa). Although you should avoid adapters as much as possible (they are always a potential trouble spot), bring some along that fit the cables and a variety of input jacks, just to be safe.
- Lighting. You can light most interiors with portable lighting instruments. Bring several lighting kits. Check that the kits actually contain the normal complements of lights, stands, and accessories. Do the lights work? Always pack a few spare lamps. Do the lamps actually fit the lighting instruments used? Do they burn with the desired color temperature (3,200K or 5,600K)? Do you have enough reflectors (white foam core), umbrella reflectors, diffusion material (scrims and screens), and color gels for regulating color temperature? The color gels most often needed are the amber or light-orange ones for lowering the color temperature and the light-blue ones for raising it.

If there are windows to contend with, you may need large sheets of neutral density (ND) filters (that cut down the light without changing the color temperature) or amber color media to cover the windows and thus lower the color temperature. Just to be safe, take some muslin along to block unwanted light that may enter through an off-camera window, and a black cloth to cut down unwanted reflections.

Other important items to take along are: a light meter, light stands and clamps, sandbags to secure the portable light stands, some pieces of 1×3 lumber to construct a light bridge for back lights, a roll of aluminum foil for heat shields, extra barn doors, flags, and a dozen or so wood clothespins to attach scrims or color gels to barn doors.

Intercom. If the single-camera EFP is taking place in a confined area, you don't need elaborate intercom systems;

you can call your shots right from the production area. But if the event covers a large outdoor area, you need a small power megaphone and walkie-talkies and cellular phones to communicate with the widely dispersed crew and the station, if necessary. If you use the multicamera and switcher system for a live or live-on-tape pickup, such as for the high-school state championship basketball game, you need headsets and intercom (often regular audio) cables.

Miscellaneous. There are a few more items that are often needed for a field production: extra scripts and time lines; field log sheets; slate and dry-erase markers; regular rain umbrellas and "raincoats" (plastic covers) for cameras; star filters and fog filters, if any; white cards for white-balancing; a teleprompter, if applicable; blank cue cards or large newsprint pad and marker; an easel; and several rolls of gaffer's tape and masking tape. You also need white chalk, more sandbags, wood clothespins, rope, makeup kit and bottled water, towels, flashlights, and a first-aid kit.

PRODUCTION: SETUP

Once everyone knows what is supposed to happen, the setup will be relatively smooth and free of confusion. Although as director you may not be responsible for the technical setup, you should watch carefully that the equipment is put in the right places.

For example, when shooting indoors, will the lights be out of camera range? Are they far enough away from combustible material (especially curtains) and properly insulated (with aluminum foil, for example)? Are the back lights high enough so that they will be out of the shot? Is there a window in the background that might cause lighting problems? (The window in the artist's studio in figure 18.11 would certainly present a problem if you had to shoot the large sculpture.) Does the room look too cluttered? Too clean? Are there any particular audio problems you can foresee? If the talent wears a wired lavaliere mic, does the mic cord restrict talent mobility? If you use a shotgun mic, can the fishpole operator get close enough to the talent and, especially, move with the talent without stumbling over furniture? Are pictures hung where the camera can see them? Look behind the talent to see whether the background will cause any problems (such as lamps or plants seeming to extend from the talent's head).

When outdoors check for obvious obstacles that may be in the way of the camera, fishpole operators, and talent. Look past the shooting location to see whether the background fits the scene. Are there bushes, trees, or telephone poles that may, again, appear to extend from the talent's head? Large billboards are a constant background

hazard. What are the potential audio hazards? Although the country road may be quiet now, will there be traffic at certain times? Are there any factory whistles that may go off in the middle of your scene?

PRODUCTION: REHEARSALS

Most often your rehearsals are limited to a quick walkthrough. But you may need more rehearsals if the EFP requires the interaction of more than one or two persons.

Walk-through Before you start with the actual rehearsal and taping, you should have a brief walk-through first with the crew and then with the talent to explain the major production points, such as camera positions, specific shots, and principal actions. In relatively simple productions, you can combine the technical and talent walk-throughs. The more thorough you are in explaining the action during the walk-throughs, the more efficient the actual videotaping will be. Have the PA follow you and write down all major and minor production problems that need to be solved.

Always follow the walk-through with the notes session, then have the crew take care of the remaining problems. Don't forget to give the talent and crew a short break before starting with the rehearsal and taping sessions.

Rehearsal As pointed out earlier, single-camera field directing has its own rehearsal technique. Basically, you rehearse each take immediately before videotaping it. You walk the talent and the camera and fishpole operators through the take, explaining what they should and should not do. Videotape some of the critical scenes and watch and listen to the playback. You may want to change the mic or the mic position for a better, less noisy pickup.

PRODUCTION: VIDEOTAPING

Just before the actual taping, ask the *director of photography* (*DP*) and/or the camera operator whether the camera is properly white-balanced for the scene location. Sometimes clouds or fog move in between the rehearsal and the taping, changing the color temperature of the light. Slate all takes and have the PA or the VTR operator record them on the field log.

Watch the background action as well as the main foreground action. For example, curious onlookers may suddenly appear out of nowhere and get in your shot, or the talent may stop her action exactly in line with a distant fountain that then appears to spring out of her head. Listen carefully to the various foreground and background sounds during the take. Do not interrupt the taping because there was a faint airplane noise. Most likely, such noise will get

buried by the main dialogue or the additional sounds added in postproduction (such as music). But the noise of a nearby helicopter that interrupts a Civil War scene definitely calls for a retake.

At the end of each take, have the talent stand quietly and let the camera record a few seconds of additional material. This cushion will be of great help to the editor in postproduction. Videotape some usable cutaways and record location sounds and room ambience for each location. The recorded "silence" will help bridge possible audio drops at edit points in postproduction.

When you feel that you have a series of good takes, play them back on the field monitor to see whether they are indeed acceptable for postproduction. If you detect gross problems, you can still do some retakes before moving on to the next scene or location.

PRODUCTION: STRIKE AND EQUIPMENT CHECK

Have the location reset (furniture, curtains, and the like) the way you found it and the place cleaned before you leave. Pick up all scripts, shot sheets, and log sheets. Do not leave pieces of gaffer's tape stuck on floors, doors, or walls, and take away your trash. When loading the EFP vehicle, the floor manager, crew chief, or PA should run down the equipment checklist to see that everything is back in the vehicle before leaving or changing locations. Check that the source tapes are all properly labeled and—most important—loaded onto the vehicle. Some directors insist on carrying the source tapes personally.

POSTPRODUCTION

EFP postproduction activities are, for all practical purposes, identical to those of single-camera studio productions: making protection copies and window dubs, logging all takes on the source tapes, capturing the various takes on the hard drive of your editing computer, doing a rough-cut, and finally doing an on-line edit that is transferred to the edit master tape.

BIG REMOTES

A big remote, or simply remote, is done to televise live or to record live-on-tape large, scheduled events that have not been staged specifically for television, such as sporting events, parades, or political gatherings. All big remotes use high-quality field cameras (studio cameras with high zoom ratio lenses) in key positions, a number of ENG/EFP cameras, and an extensive audio setup. The cameras and the various audio elements are coordinated

20.3 REMOTE TRUCK

The remote truck is a complete control center on wheels. It contains program, audio, video, and technical control centers as well as C.G. and recording facilities.

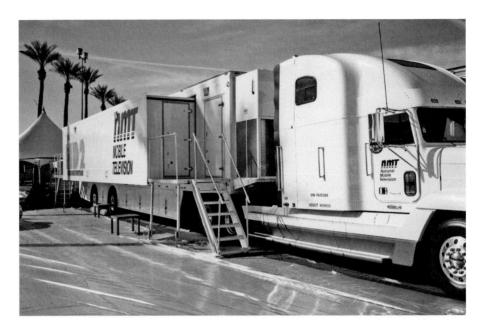

from a mobile control center—the *remote truck*. Remote trucks are usually powered by a portable generator, with a second one standing by in case the first one fails. If there is enough power available at the remote site, the truck is connected to the available power, with a single generator serving as backup.

The remote truck represents a compact studio control room and equipment room. It contains the following control centers:

- Program control center, also called production, with preview and line monitors, a switcher with special effects, a character generator, and various intercom systems (P.L., P.A., and elaborate I.F.B. systems)
- Audio control center with a fairly large audio console, ATRs and DATs, other digital recording media, monitor speakers, and intercom systems
- Video-recording center with several high-quality VTRs and/or digital recording devices that can handle regular recordings, do instant replays, and play in slow-motion and freeze-frame modes
- Technical center with CCUs (camera control units), line monitors, patchboards, a generator, and signal transmission equipment SEE 20.3 AND 20.4

In very big remotes, one or more additional trailers may be used for supplemental production and control equipment. Because the telecast happens away from the studio, some production procedures are quite different from those for studio productions. We therefore examine the following production aspects: (1) preproduction—the remote survey, and (2) production—equipment setup and operation, as well as floor manager and talent procedures.

PREPRODUCTION: THE REMOTE SURVEY

Like any other scheduled production, a big remote requires thorough preparation—only more so. One problem with preparing for big remotes is that the event you cover is normally a onetime happening that you cannot rehearse. It would be ridiculous to ask two national hockey teams to repeat the whole game for you, or to ask political leaders to restate their lively debate verbatim just so you can have your rehearsal. A remote of an award ceremony, however, allows some limited rehearsals; you can rehearse with stand-ins filling in for the master of ceremonies and the possible winners. Still, you have no control over the event itself but must follow it as best you can. Your production preparations must take these, and several other such considerations, into account. Yet another problem is that you can truck only the control room and the technical facilities to the site—not the studio itself. Cameras, microphones, and often lighting need to be brought to the remote location and made operational.

One of the key preparations is the remote survey. Many of the survey items for big remotes are equally applicable for various electronic field productions, such as a

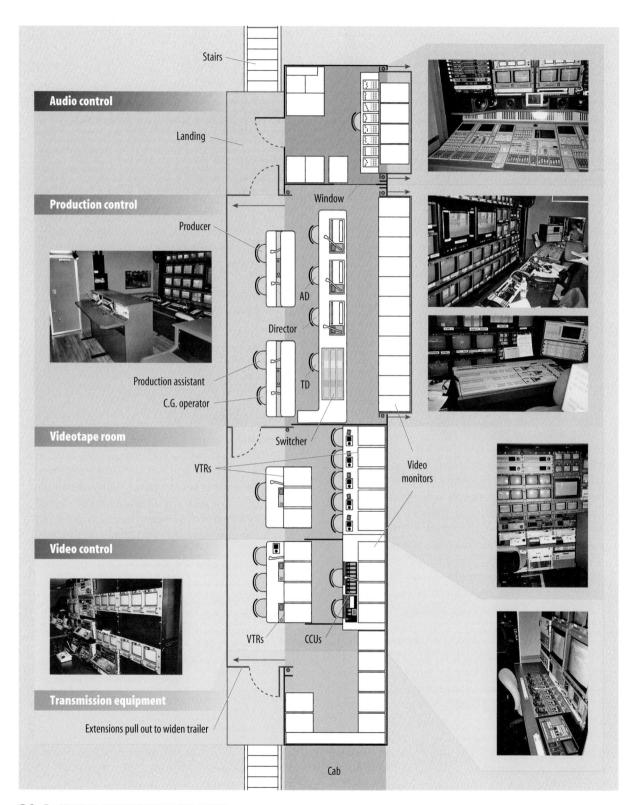

20.4 CONTROL CENTERS IN REMOTE TRUCK

The remote truck carries the program control, the audio control, the video-recording and instant-replay center, the technical center, and the transmission equipment.

visit to a car manufacturing plant or an MTV segment. As the name implies, a *remote survey*, or *site survey*, is a preproduction investigation of the location premises and the event circumstances. It should provide you with answers to some key questions about the nature of the event and the technical facilities necessary to televise it.

Contact person Your first concern is to talk to someone who knows about the event. This person, called the *contact* person, or simply contact, may be the public relations officer of an institution or someone in a supervisory capacity. Call the contact to find out what he or she knows about the event and whether he or she can refer you to others who might answer your questions. In any case, get the contact's full name and position, business and e-mail addresses, and business, home, fax, cell, and pager numbers. Then make an appointment for the actual remote survey. Ideally, the time of day of the survey should be the same as that of the scheduled remote telecast because the location of the sun is extremely important for outdoor remotes as well as for indoor remotes where windows will be in the shots. Arrange to have the contact person with you during the production. Establish an alternate contact and copy him or her on information you send to the primary contact. Sometimes the contact person comes down with a cold on your production day.

Survey party The survey itself is concerned with production and technical considerations. The remote survey party therefore includes people from production and engineering. The minimum party usually consists of the producer, the director, and the technical director (TD) or technical supervisor of the remote. Additional production and technical supervisory personnel, such as the production manager and the chief engineer, may join the survey party, especially if the remote covers an important event and includes such elements as complex microwave or satellite links.

In general, the production requirements are first determined, then the technical people try to make the planned production procedures technically possible. Depending on the complexity of the telecast, extensive compromises must often be made by production people as well as by technical personnel.

As director you can make such compromises only if you know what the particular technical setup and pickup problems are and what changes in procedures will help overcome them. You should therefore familiarize yourself with the production as well as the engineering requirements of television remotes. Although many production

and technical survey questions overlap, for better clarification we consider them separately here.

Production survey The following table lists the key questions you should ask during the *production survey*. **SEE 20.5** A good location sketch can help you prepare for the production and anticipate major problems (see figures 20.14 through 20.17).

Technical survey The *technical survey* shown here lists only those items that directly influence the production procedures and, ultimately, your portion of the remote survey. **SEE 20.6** Technical points that have already been mentioned in the production survey, such as cameras and microphones, are not listed again.

PRODUCTION: EQUIPMENT SETUP AND OPERATION

There is no clear-cut formula for setting up equipment for a remote telecast. As with a studio production, the number of cameras, the type and the number of microphones, the lighting, and so forth depend entirely on the event or, more precisely, on the process message as defined in the preproduction meetings. Employing a great number of cameras, microphones, and other types of technical equipment does not necessarily guarantee a better telecast than when using less equipment. In fact, one or two camcorders are often more flexible and effective than a cumbersome remote truck with the fanciest video, audio, recording, and switching gear. For such standard big-remote operations as the live coverage of major sporting events, however, the remote truck provides essential equipment and production control.

Once set up, many of the production routines of big remotes do not differ significantly from studio productions. There are nevertheless some procedures in big-remote operations, such as instant replays, that you will not find in normal studio productions. For the following discussion, let's assume that you are functioning first as a director of a big remote, then as a floor manager, and finally as talent.

Directing the setup Because the actual on-the-air telecast of big remotes is usually live, the directing procedures bear little resemblance to the other field production methods; they more closely resemble live or live-on-tape studio productions.

As soon as the remote truck is in position, conduct a thorough technical walk-through. Tell the technical staff where you want the stationary cameras located and what

20.5 REMOTE SURVEY: PRODUCTION

These are the key questions you should ask during the production survey.

SURVEY ITEM	KEY QUESTIONS
Contact	Who are your principal and alternate contacts? Title; business and e-mail addresses; business, home, and cell phone numbers; and fax and pager numbers.
Place	Where is the exact location of the telecast? Street address, telephone number.
Time	When is the remote telecast? Date, time. What is the arrival time of the truck? Who is meeting you at the site for positioning the truck?
Nature of event	What is the exact nature of the event? Where does the action take place? What type of action do you expect? The contact person should be able to supply the necessary information.
Cameras (stationary)	How many cameras do you need? Use as few as possible. Where do you need the cameras? Do not place cameras on opposite sides of the action. In general, the closer together they are, the easier and less confusing the cutting will be. Shoot with the sun, not against it. Try to keep it behind or to the side of the cameras for the entire telecast. The press boxes of larger stadiums are generally located on the shadow side.
	If possible, survey the remote location during the exact time of the scheduled telecast. If it is not a sunny day, determine the position of the sun as closely as possible.
	Are there any large objects blocking the camera view, such as trees, telephone poles, or billboards? Will you have the same field of view during the actual telecast? A stadium crowd, for instance, may block the camera's field of view, although the view is unobstructed during the survey.
	Can you avoid large billboards in the background of shots, especially if the advertising competes with your sponsor's product?
	Do you need camera platforms? Where? How high? Can the platforms be erected at a particular point? Can you use the remote truck as a platform? If competing stations are also covering the event, have you obtained exclusive rights for your camera positions? Where do you want iso cameras positioned?
Cameras (mobile)	Do you need to move certain cameras? What kind of floor is there? Can the camera be moved on a field dolly, or do you need remote dollies (usually with large, inflatable rubber tires)? Will the dolly with the camera fit through narrow hallways and doors? Can you use ENG/EFP cameras instead of large studio/field cameras? What is their action radius? Can you connect them to a remote truck by cable (less chance of signal interference or signal loss), or do you have to send the signal back to the remote truck via microwave?
ighting	Do you need additional lighting? Where and what kind? Can the instruments be hung conveniently, or do you need light stands? Do you need to make arrangements for back lights? Will the lights be high enough so that they are out of camera range? Do you have to shoot against windows? If so, can they be covered or filtered to block out undesirable daylight? Can you use reflectors?

20.5 REMOTE SURVEY: PRODUCTION (continued)

SURVEY ITEM	KEY QUESTIONS
Audio	What type of audio pickup do you need? Where do you need to place the mics? What is the exact action radius so far as audio is concerned? How long must the mic cables be? Which are stationary mics and which are handled by the talent? Do you need long-distance mics, such as shotgun or parabolic mics? Do you need wireless mics? Can their signals reach the wireless receivers?
	Do you need such audio arrangements as audio foldback or a speaker system that carries the program audio to the location? Can you tie into the "house" public address system? Do you need long-distance mics for sound pickups over a long range?
Intercommunications	What type of intercom system do you need? Do you have to string intercom lines? How many I.F.B. channels and/or stations do you need and where do they go? Is there a need for a P.A. talkback system? Are there enough telephone lines available?
Miscellaneous production items	If a C.G. is unavailable, easels are needed for title cards. Do you need a clock? Where? Do you need line monitors, especially for the announcer? How many? Where should they be located? Will the announcer need a preview monitor to follow iso playbacks? Do you have a camera slate in case the C.G. cannot be used?
Permits and clearances	Have you (or the producer, if you do not act as producer-director) secured clearances for the telecast from police and fire departments? Do you have written clearances from the originators of the event? Do you have parking permits for the remote truck and other production vehicles?
	Do you have passes and parking for all technical and production personnel, especially when the event requires entrance fees or has some kind of admission restrictions?
Other production aids	Does everyone have a rundown sheet of the approximate order of events? These sheets are essential for the director, floor manager, and announcer and are extremely helpful to the camera operators, audio engineer, and additional floor personnel. Does the director have a spotter who can identify the major action and the people involved? In sports remotes, spotters are essential.

field of view you require (how close or wide a shot you need to get with each camera). Get the cameras as close to the action as possible to avoid overly narrow-angle zoom lens positions. Apprise the crew of the approximate moves and ranges of mobile cameras and what audio needs you have. Unless in a booth, specify where the announcers are going to be so that the monitors, mics, and intercom can be properly routed.

While the technical crew is setting up, hold a production meeting with the contact person, the producer, the AD (assistant director), the floor manager, the PA, the talent, and, if not directly involved in the setup, the TD or

technical supervisor. Have the contact describe the anticipated event. Explain how you intend to cover it. Although it is the producer's job to alert the talent to the prominent features of the event, such as a prize-winning float in the parade, be prepared to take over in case the producer is sidetracked by some other problem. Delegate the setup supervision to the AD, floor manager, and TD. Do not try to do everything yourself.

Pay attention to all communication systems, especially the intercom. During the telecast you will have no chance to run in and out of the remote truck to the actual site; all your instructions will come via voice communication

20.6 REMOTE SURVEY: TECHNICAL

The technical survey lists only those items that directly influence the production procedures.

SURVEY ITEM	KEY QUESTIONS
Power	Assuming you do not work from a battery pack or your own generator, is enough electricity available on-site? Where? You will need at least 200 amps for the average remote operation, depending on the equipment used. Does the contact person have access to the power outlets? If not, who does? Make sure the contact is available during the remote setup and the actual production. Do you need extensions for the power cables? If you use a generator, do you have a second one for backup?
Location of remote truck and equipment	Where should the remote truck be located? Its proximity to the available power is critical if you do not have a power generator. Are you then close enough to the event location? Keep in mind that there is a maximum length for camera cables beyond which you will experience video loss. Watch for possible sources of video and audio signal interference, such as nearby X-ray machines, radar, or any other high-frequency electronic equipment.
	Does the remote truck block normal traffic? Does it interfere with the event itself? Reserve parking for the truck. Have you asked the police for assistance? Do you need RCUs for portable cameras?
Recording devices	If the program is recorded, do you have the necessary VTRs in the truck? Do you need additional VTRs or digital hard drives for instant replays? If you have to feed the audio and video signals back to the station separately, are the necessary phone lines cleared for the audio feed? Do you have enough tape to cover the full event? Have you made provisions for switching reels without losing part of the event? Are the iso cameras properly patched into the switcher and into separate recording devices?
Signal transmission	If the event is fed back to the station for videotape recording or directly to the transmitter for live broadcasting, do you have a good microwave or satellite uplink location? Do you need microwave mini-links? Double-check on the requirements for feeding the satellite uplink.
Cable routing	How many camera cables do you need? Where do they have to go? How many audio cables do you need? Where do they have to go? How many intercom lines do you need? Where do they have to go? How many AC (power) lines do you need? Where do they go? Route the cables in the shortest possible distance from remote truck to pickup point, but do not block heavily traveled hallways, doors, walkways, and so on. Do the cables have to cover a great span? If so, string a rope and tie the cable to it to relieve the tension.
ighting	Are there enough AC outlets for all lighting instruments? Are the outlets fused for the lamps? Do not overload ordinary household circuits (usually 15 amps). Do you have enough extension cords and power strips (or simple multiple wall plugs) to accommodate all lighting instruments and the power supply for monitors and electric clocks?
Communication systems	What are the specific communication requirements? P.L.s? I.F.B. channels? Telephone lines? Cell phones? P.A. systems? Long-range walkie-talkies? Two-way radios?

from the truck. Discuss the coverage of the event in detail with the floor manager, who holds one of the most critical production positions during a remote.

- Usually, you as director have no control over the event itself; you merely try to observe it as faithfully as possible. Once again, check with the contact person and the announcer on the accuracy of the rundown sheet and the specific information concerning the event. Ask the talent to double-check on the pronunciation of the names of major participants.
- Walk through the site again and visualize the event from the cameras' perspectives. Are they in the optimal shooting positions? Are they all on one side of the principal vector line so that you will not reverse the action on-screen when cutting from one to another? If shooting outdoors, will any of the cameras be blinded by the sun? Will the sun be directly behind the cameras (which, in effect, will wash out the viewfinder images)? Experienced camera operators will use an umbrella or flags attached to the camera to prevent the sun from washing out their viewfinders.
- Keep in mind that you are a guest while covering a remote event. Unless television is an integral part of the event, such as in most sports, try to work as quickly and as unobtrusively as possible. Do not make a big spectacle of your production. Realize that you are basically intruding on an event and that the people involved are usually under some stress.

Directing the on-the-air telecast Once you are on the air, try to keep on top of the event as well as possible. If you have a good spotter (the contact person and/or the AD), you will be able to anticipate certain happenings and be ready for them with the cameras. Here are some general points to remember:

- Speak loudly and clearly. Usually, the site is noisy and the camera operators and the floor crew may not hear you very well. Put your headset mic close to your mouth. Yell if you have to, but do not get frantic. Tell the crewmembers to switch off their headset talkbacks to prevent the ambient sound from entering the intercom system.
- Listen to the floor manager and the camera operators. They may help spot event details and report them to you as they occur.
- Watch the monitors carefully. Often the off-air cameras will get especially interesting shots, but do not be tempted by cute yet meaningless or even event-distorting shots. If, for example, the great majority of an audience listens attentively to the orchestra, do not single out the

one person who is conducting in the back row, as colorful a shot as this may be.

- Listen to the audio. A good announcer will give you clues as to the development of the event and sometimes direct your attention to a significant event detail.
- If things go wrong, keep calm. For example, if a spectator blocks the key camera or if the camera operator swish-pans to another scene because he thinks his camera is off the air, don't scream at the camera operator that he is still "hot" or at the floor manager to "get this jerk out of the way." Simply cut to another camera.
- Exercise propriety and good taste in what you show the audience. Avoid capitalizing on accidents (especially during sporting events) or situations that are potentially embarrassing to the person on-camera, even if such situations might appear hilarious to you and the crew at the moment.

Instant replay In an *instant replay*, a key play or event segment is repeated for the viewer. Instant-replay operations usually use *iso cameras* (which feed into the switcher and have their own separate video recorders) and recording devices (VTRs, hard disks, or read/write optical discs) that have unusually fast search-and-retrieval speeds. Some large sports remotes employ a second, separate switcher that is dedicated exclusively to inserting instant replays. In very big remotes, the instant-replay and special-effects operations (including the C.G.) are handled in a separate trailer.

During the replay DVE (digital video effects) are often used to explain a particular play. The screen may be divided into several squeezed boxes or corner wipes, each displaying a different aspect of the play; or it may function as an electronic blackboard that shows simple line drawings over the freeze-frame of an instant replay, very much like the sketches on a traditional blackboard. Game and player statistics are displayed using the C.G. Some of the information is preprogrammed and stored on the computer disk, but up-to-date statistics are continuously entered by a C.G. operator. The whole instant-replay and C.G. operation is usually guided by the producer or the AD. The director is generally much too occupied with the real-time coverage to worry about the various replays and special effects.

When watching an instant replay of a key action, you may notice that the replay either duplicates exactly the sequence you have just seen or, more frequently, shows the action from a slightly different perspective. In the first case, the picture sequence of the regular game coverage—that is, the line output—has been recorded and played back; in the second case, it is the pickup of an iso camera that

has been recorded and played back. In sports the principal function of the iso cameras is to follow key plays or players for instant replay. Iso cameras are also used in a variety of remote productions, such as an orchestra performance with a multicamera setup. In this case you may have an iso camera on the conductor at all times, which provides a convenient cutaway in postproduction.

When a remote production is done for postproduction rather than live, all cameras may be used in iso positions, with each camera's output recorded by a separate VTR or digital recording device. The output of all iso cameras is then used as source material for extensive postproduction editing.

Director's postshow activities The remote is not finished until all the equipment is struck and the site is restored to its original condition. As a director of big remotes, you should pay particular attention to the following postshow procedures.

- If something went wrong, do not storm out of the remote truck, accusing everyone, except yourself, of making mistakes. Cool off first.
- Thank the crew and the talent for their efforts. Nobody ever wants a remote to look bad. Thank especially the contact person and others responsible for making the event and the remote telecast possible. Leave as good an impression of you and your team as possible with the persons responsible. Remember that when you are on remote location, you are representing your company and, in a way, the whole of "the media."
- Thank the police for their cooperation in reserving parking spaces for the remote vehicles, controlling the spectators, and so forth. Remember that you will need them again for your next remote telecast.
- See to it that the floor manager returns all the production equipment to the station.

PRODUCTION: FLOOR MANAGER AND TALENT PROCEDURES

As the floor manager, you play a key role in big remotes. The "floor" activities you have to manage have increased considerably in size and complexity.

Floor manager's procedures As a floor manager (also called stage manager or unit manager on big remotes), you have, next to the director and the TD, the major responsibility for the success of the remote telecast. Because you are close to the scene, you often have a better overview of the event than does the director, who is isolated in the

remote truck. The following points will help you make the big-remote production a successful one.

- Familiarize yourself with the event ahead of time. Find out where it is taking place, how it will develop, and where the cameras and the microphones are positioned relative to the remote truck. Make a sketch of the major event developments and the equipment setup (see section 20.2).
- Triple-check all intercom systems. Find out whether you can hear the instructions from the remote truck and if you can be heard there. Check that the intercom is working properly for the other floor personnel. Check all wireless headsets, I.F.B. channels, walkie-talkies, and any other field communication devices.
- Be aware of the traffic in the production area. Try to keep onlookers away from the equipment and the action areas. Be polite but firm. Work around the crews from other stations. Be especially aware of reporters from other media. It would not be the first time that a news photographer snapping pictures just happens to stand right in front of your key camera. Appeal to the photographer's sense of responsibility: say that you too have a job to do in trying to inform the public.
- If the telecast is to be videotaped, have the slate ready, unless the C.G. is used for slating.
- Check that all cables are properly secured to minimize potential hazards to the people in the production area. If not done by the technical crew, tape cables to the floor or sidewalk and put a mat over the cables at major pedestrian traffic areas.
- Introduce yourself to the police officers assigned to the remote and fill them in on the major event details. Introduce them to the talent. The police are generally more cooperative and helpful when they get to meet on-the-air personalities and feel that they are part of the remote operation.
- Help the camera operators with spotting key event details. Discuss with the cable pullers (floor personnel) the action radius of the portable cameras.
- Relay all director's cues immediately and precisely. Position yourself so that the talent sees the cues without having to look for you. (Most of the time, announcers are hooked up to the I.F.B. via small earphones, so the director can cue them directly without the floor manager as an intermediary.)
- Have several 3×5 cards handy so you can write cues and pass them to the talent, just in case you lose the I.F.B. channel.

- When talent is temporarily off the air, keep them informed about what is going on. Help keep their appearance intact for the next on-the-air performance and offer encouragement and positive suggestions.
- After the telecast pick up all the production equipment for which you are directly responsible—easels, platforms, sandbags, slates, and headsets. Double-check whether you have forgotten anything before you leave the remote site. Make use of the director's or TD's equipment checklist.

Talent procedures The general talent procedures (as discussed in chapter 16) also apply to remote operations, but there are some points that are especially pertinent for you as talent.

- Familiarize yourself thoroughly with the event and your specific assignment. Know the process message and do your part to effect it. Review the event with the producer, the director, and the contact person.
- Test your microphone and your intercommunication system. If you work with an I.F.B. system, check it out with the director or TD.
- Werify that your monitor is working. Ask the floor manager to have the TD punch up the line-out picture as soon as the cameras are uncapped. Ask for at least color bars to be put on-line.
- If you have the help of a contact person or a spotter, discuss again the major aspects of the event and the communication system between the two of you once you're on the air. For example, how is the spotter going to tell you what is going on while the microphone is hot?
- Werify the key participants and the pronunciation of their names. Little is more embarrassing for all involved than when names of locally well-known people are mispronounced by the television commentators.
- When you're on the air, tell the audience what they cannot see for themselves. Do not report the obvious. For example, if you see the celebrity stepping out of the airplane and shaking hands with the people on the tarmac, do not say, "The celebrity is shaking hands with some people"; tell who is shaking hands with whom. If a football player lies on the field and cannot get up, do not tell the audience that the player apparently got hurt—they can see that for themselves; tell them who the player is and what might have caused the injury. Also, follow up this announcement periodically with more-detailed information on the injury and how the player is doing.

- Do not get so involved in the event that you lose your objectivity. On the other hand, do not remain so detached that you appear to have no feelings whatsoever.
- If you make a mistake in identifying someone or something, admit it and correct it as soon as possible.
- Do not identify event details solely by color, as colors are often distorted on home receivers. For instance, refer to the runner not only as the one in the red trunks but also as the one on the left side of the screen.
- As much as possible, let the event itself do the talking. Keep quiet during extremely tense moments. For example, do not talk during the incredibly tense pause between the starter's "Get set" command and the firing of the starter's pistol in the 100-meter track finals.¹
- For a more detailed description of announcing a remote, see Stuart W. Hyde, *Television and Radio Announcing*, 10th ed. (Boston: Houghton Mifflin, 2004).

MAIN POINTS

- The three types of remotes are ENG (electronic news gathering), EFP (electronic field production), and big remotes.
- ENG is the most flexible remote operation. It offers speed in responding to an event, maximum mobility while on location, and flexibility in transmitting the event live or in recording it with camcorders for immediate transmission by the station or for postproduction editing.
- Unlike ENG, which has little or no preparation time for covering a breaking story, EFP must be carefully planned. In this respect it is similar to big remotes. EFP is normally done with an event that can be interrupted and restaged for repeated videotaping. It is most often done with a single camera or sometimes with iso cameras that shoot an event simultaneously.
- A big remote televises live, or records live-on-tape, a large scheduled event that has not been staged specifically for television, such as a sporting event, parade, political gathering, or congressional hearing.
- All big remotes use high-quality cameras in key positions and ENG/EFP cameras for more-mobile coverage. Big remotes usually require extensive audio setups.
- Big remotes are coordinated from the remote truck, which contains a program control center, an audio control center, a video-recording center, and a technical center with CCUs and transmission equipment.
- Big remotes require extensive production and technical surveys as part of the preproduction activities.
- In sports remotes instant replay is one of the more complicated production procedures. It is normally handled by an instant-replay producer or an AD.

20.2

Covering Major Events

As you know by now, EFP and especially big remotes require meticulous preproduction work and planning. Such careful preparation is particularly important for onetime happenings, such as sporting events. No two remotes are exactly the same, and there are always unique circumstances that require adjustments and compromises. This section includes some typical setups for sports remotes, how to read location sketches, and some examples of typical indoor and outdoor remote setups.

SPORTS REMOTES

Pickup requirements for baseball, football, soccer, basketball, tennis, boxing or wrestling, and swimming

LOCATION SKETCH AND REMOTE SETUPS

Reading location sketches, indoor remotes, and outdoor remotes

COMMUNICATION SYSTEMS

ENG, EFP, and big-remote communication systems

SIGNAL TRANSPORT

Microwave transmission; communication satellites frequencies, uplinks, and downlinks; and cable distribution

SPORTS REMOTES

Many big remotes are devoted to the coverage of sporting events. The number of cameras used and their functions depend almost entirely on who is doing the remote. Networks use a great amount of equipment and personnel for the average sports remote. For especially important games, such as the Super Bowl or World Cup soccer, a crew of a hundred or so people set up and operate twenty or more cameras, countless mics, monitors, and intercom and signal-distribution systems. There are several large trailers that house the control room and the production equipment. For the coverage of a local high-school game, however, you must get by with far less equipment. You may have only two cameras and three mics to do the pickup. Local stations or smaller production companies usually supply only the key production and technical personnel (producer, director, AD, PA, floor manager, TD, engineering supervisor, and audio technician) and hire a remote service that includes a remote truck, all equipment, and extra technical personnel.

The following figures illustrate the minimum video and audio pickup requirements for baseball, football, soccer, basketball, tennis, boxing or wrestling, and swimming. **SEE 20.7-20.13** Sometimes small ENG/EFP cameras are used in place of the larger high-quality studio/field cameras or are added to the minimal setups described here.²

LOCATION SKETCH AND REMOTE SETUPS

To simplify preproduction you as the director, or your AD, should prepare a location sketch. Like the studio floor plan, the location sketch shows the principal features of the environment in which the event takes place (stadium and playing field, street and major buildings, or hallways and rooms). This location sketch will help you decide on the placement of cameras and microphones, it will help the TD decide on the location of the remote truck and the cable runs, and, if indoors, it will help the LD determine the type and the placement of lighting instruments.

READING LOCATION SKETCHES

As you recall from section 20.1, the location sketch for indoor events should indicate the general dimensions of the room or hallway; the location of windows, doors, and furniture; and the principal action (where people are seated or where they will be walking). It helps if the sketch also contains such details as power outlets; actual width of especially narrow hallways, doors, and stairs; direction the doors open; and prominent thresholds, rugs, and other items that may present problems for the movement of cameras mounted on tripod dollies.

^{2.} For more-elaborate miking of various sporting events, see Stanley R. Alten, *Audio in Media*, 7th ed. (Belmont, Calif.: Thomson Wadsworth, 2005), pp. 263–78.

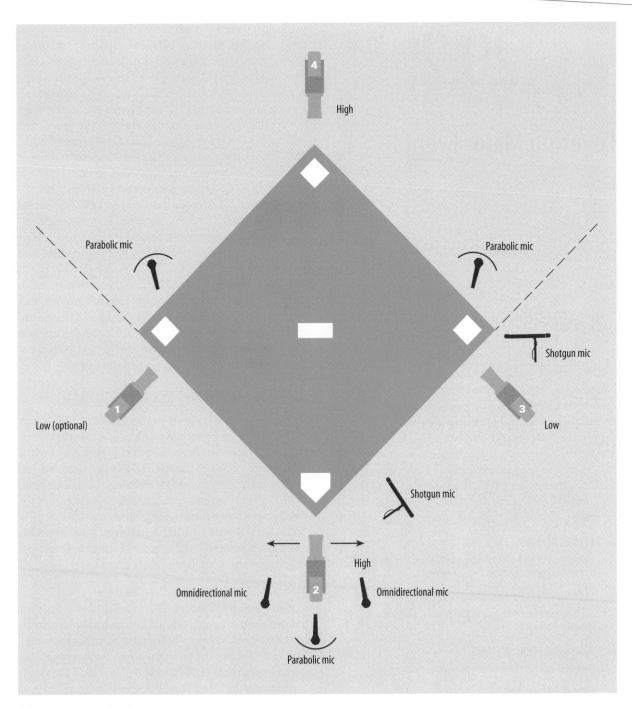

20.7 BASEBALL SETUP

Number of cameras: 3 or 4

- C1: Near third base; low, optional
- C2: Behind home plate; high
- C3: Near first base; low; watch for action reversal when intercutting with C1
- C4: opposite C2 in center field; high; watch for action reversal

Number of mics: 6 or 7

- 2 omnidirectional mics high in stands for audience
- 2 shotgun mics or a parabolic (mobile) mic behind home plate for game sounds
- 2 or 3 parabolic mics for field and audience sounds

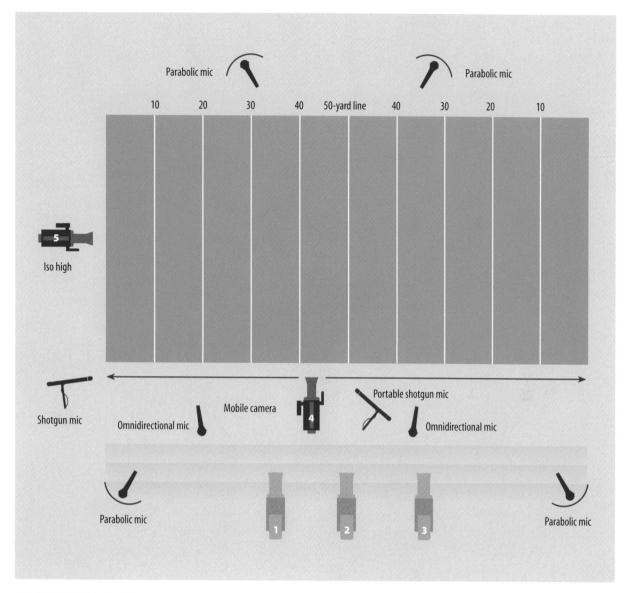

20.8 FOOTBALL SETUP

Number of cameras: 4 or 5

C1, C2, C3: High in the stands, near the 35-, 50-, and 35-yard lines (press box, shadow side)

C4: Portable or on dolly in field

C5: Optional iso camera behind goal (portable ENG/EFP or big camera)

- 2 omnidirectional mics in stands for audience
- 2 shotgun or parabolic mics on field
- 2 parabolic reflector mics in stands and 2 on opposite side of field

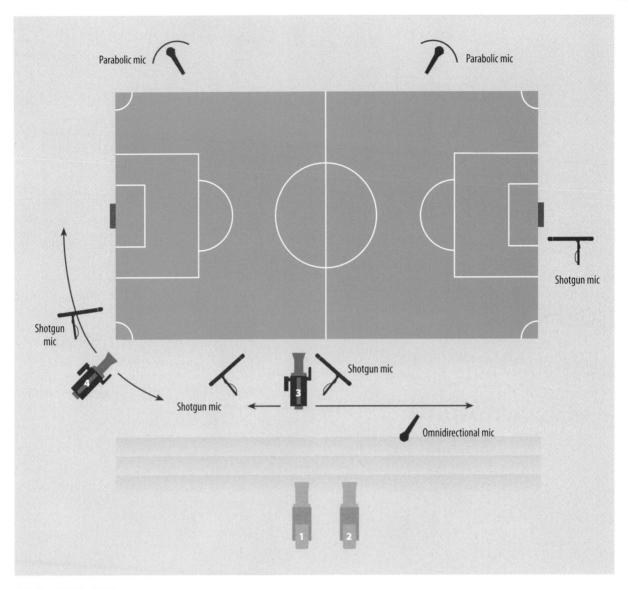

20.9 SOCCER SETUP

Number of cameras: 3 or 4

- C1: Left of centerline (high)
- C2: Right of centerline (high)
- C3: Mobile on field
- C4: Optional, left corner; may be used as iso camera and mobile camera on field

All four cameras are on shadow side of field.

- 1 omnidirectional mic in stands for audience
- 4 shotgun mics on field
- 2 parabolic mics on opposite side of field

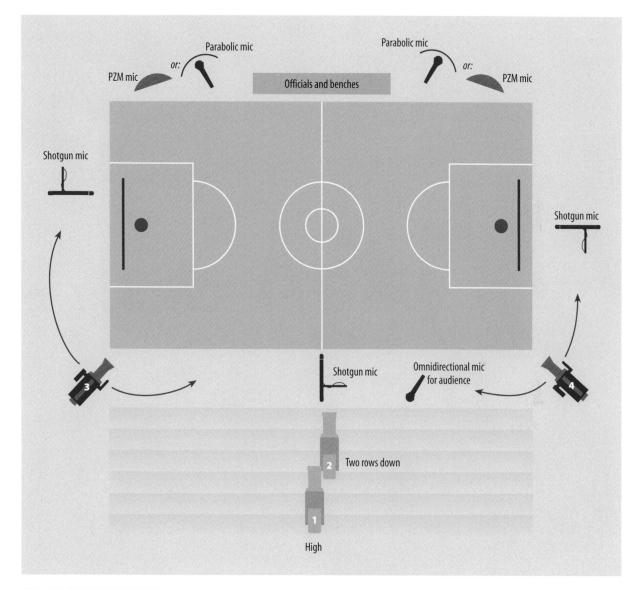

20.10 BASKETBALL SETUP

Number of cameras: 4

- C1: High in stands, left of centerline—follows game
- C2: Lower (2 rows down) in stands, right of centerline (fairly close to C1)—gets close-ups
- C3: In left corner (mobile)
- C4: In right corner (mobile)

- 1 omnidirectional mic in stands for audience
- 2 PZM or parabolic mics in stands for audience
- 2 shotgun mics behind each basket for game sounds
- 1 shotgun mic at center court

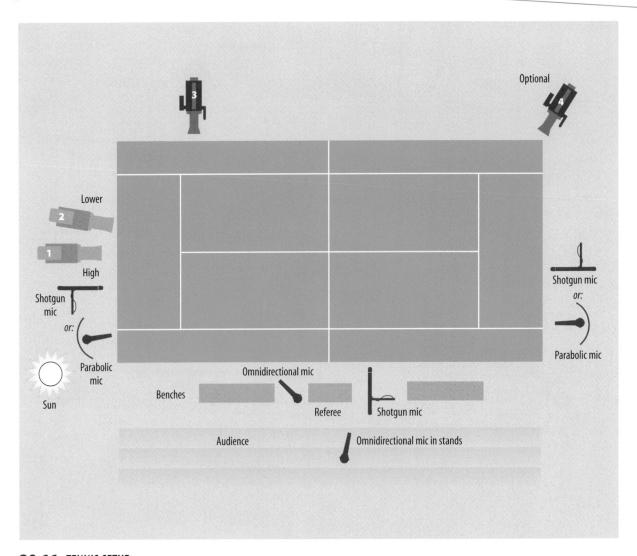

20.11 TENNIS SETUP

Number of cameras: 3 or 4

- C1: At end of court, high enough so that it can cover total court, shooting with the sun
- C2: Next to C1, but lower
- C3: At side of court, opposite officials or where players rest between sets (mobile); also shoots CUs of players
- C4: If four cameras are used, C3 shoots CUs of left player, C4 of right player

- 1 omnidirectional mic in stands for audience
- 1 omnidirectional mic for referee's calls
- 3 shotgun mics at center court and on each end of court for game sounds, or 2 parabolic mics on each end of court and 1 shotgun mic at center court

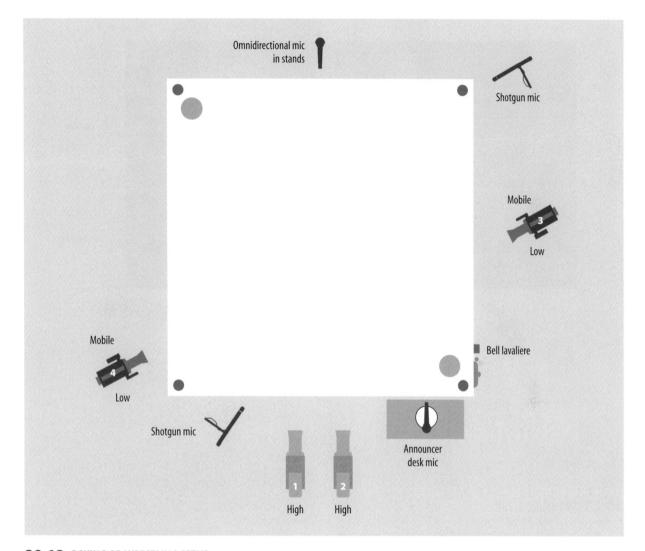

20.12 BOXING OR WRESTLING SETUP

Number of cameras: 3 or 4

- C1: High enough to overlook the entire ring
- C2: About 10' feet to the side of C1; high, slightly above ropes; used for replays
- C3: ENG/EFP mobile camera carried on floor, looking through the ropes
- C4: ENG/EFP mobile camera carried on floor, looking through the ropes

All mobile cameras have their own camera shotgun mics.

- 1 omnidirectional mic for audience
- 2 shotgun mics for boxing sounds and referee
- 1 lavaliere for bell
- 1 desk mic for announcer

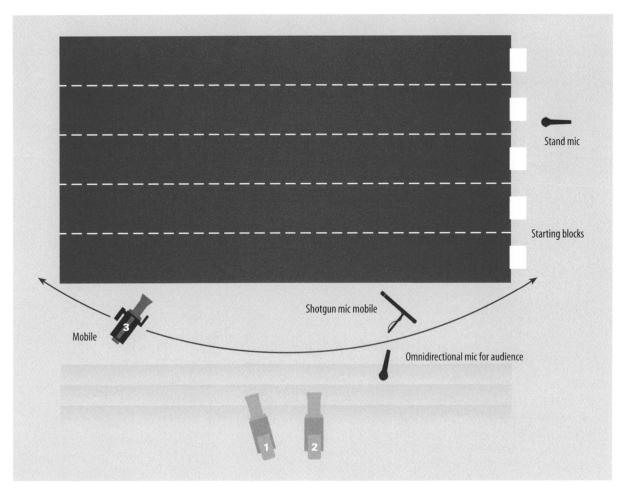

20.13 SWIMMING SETUP

Number of cameras: 2 or 3

C1: High in stands, about at center of pool—follows swimmer

C2: Next to C1—gets close-ups

C3: Optional ENG/EFP mobile camera on side and ends of pool

Number of mics: 3

- 1 omnidirectional mic in stands for audience
- 1 shotgun mic at pool level for swimmers
- 1 omnidirectional mic on stand

The sketch of an outdoor remote should indicate the locations of buildings, the remote truck, the major power source (if any), steps, steep inclines, fences, and the sun travel during the time of the remote.

Before continuing, try to read the following indoor location sketch (figure 20.14) and the outdoor location sketch (figure 20.15); list as many production requirements as you can determine from the sketches, then pencil in the type and the placement of cameras and microphones. Compare your lists and equipment placement with figures 20.16 and 20.17 and the following production requirements sections.

Public hearing The occasion is a newsworthy public hearing at city hall. **SEE 20.14** Assuming that you are the director of the remote, what can you tell from this sketch? How much preparation can you do? What key questions does the sketch generate? Limiting the questions to the setup within this hearing room, what are the camera, lighting, audio, and intercom requirements?

Parade The outdoor remote is intended for a Sunday afternoon live multicamera telecast. The estimated time of the telecast is from 3:30 to 5:30 p.m. The location sketch in figure 20.15 shows the action area as well as the major

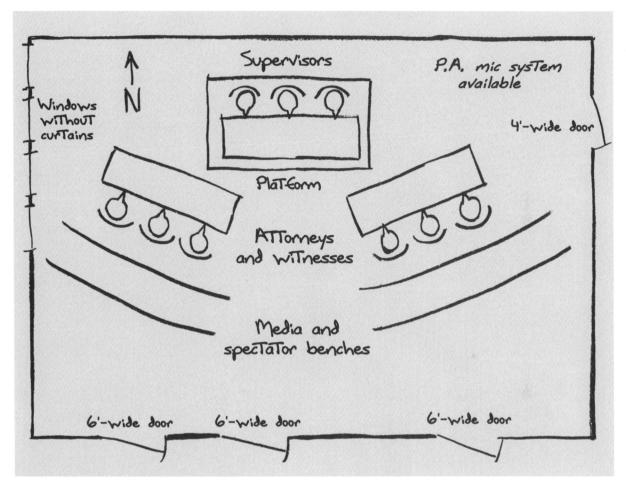

20.14 LOCATION SKETCH OF CITY HALL HEARING ROOM

facilities. What setup and production clues can you devise from this location sketch? **SEE 20.15**

Now compare your list and sketch for the city hall hearing room with the setup shown in the next figure. **SEE 20.16**

PRODUCTION REQUIREMENTS FOR PUBLIC HEARING (INDOOR REMOTE)

- Cameras. This setup requires two ENG/EFP cameras on tripod dollies connected by cable to the remote truck. C1 will cover the supervisors; C2 will cover the attorneys, witnesses, and spectators.
- Lighting. The hearing is scheduled for 3 p.m. The large window presents a definite lighting problem. There are two
- solutions: (1) cover it with drapes and add floodlights or (2) have camera 2 truck closer to the supervisor's table and try to avoid shooting the window when covering the attorneys on the window-side table. Now the window can act as a large key light. In this case all additional floodlighting must have blue gels to raise the color temperature to the outdoor (5,600K) norm. If the room is high enough, place some back lights. Are there enough AC outlets for the lights? Are they on different circuits? There may be some access problems if the mic and lighting cables are strung across the doorways.
- Audio. Because the hearing room is already equipped with a P.A. system, tie into the existing mics. If the system is not operational, desk mics are the most logical solution.

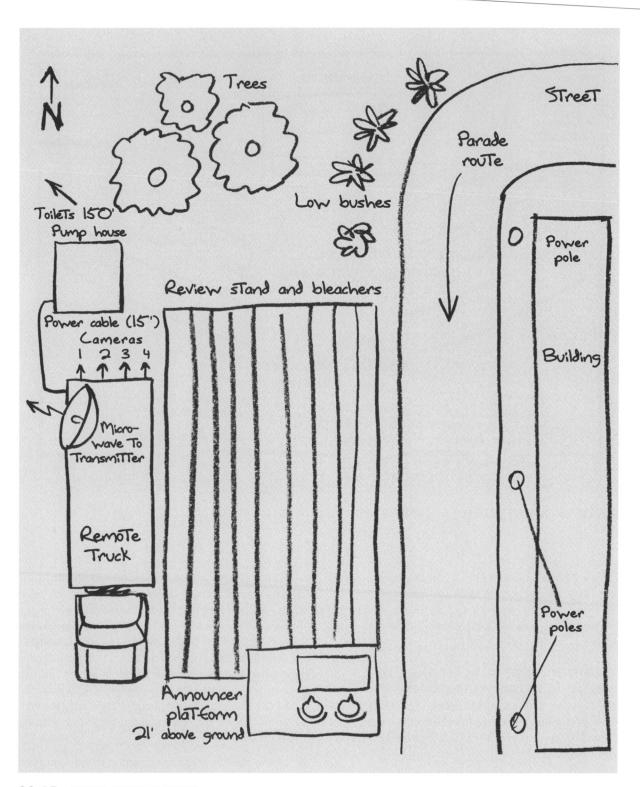

20.15 LOCATION SKETCH OF PARADE

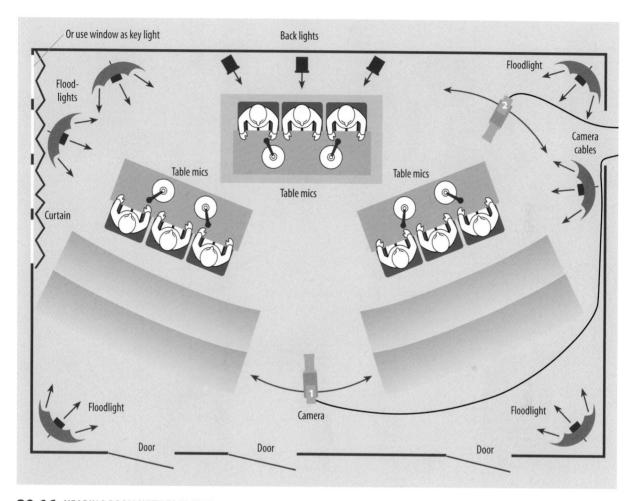

20.16 HEARING ROOM WITH FACILITIES

One additional mic should be placed on each of the three tables (supervisor and two witness tables) just in case the existing audio system stops working.

- Intercommunications. Because there is little or no cueing involved (usually for the start and the end of the taping only), the floor manager can plug the headsets into one of the cameras. If ENG/EFP cameras are used, separate intercom cables may have to be strung for the floor manager and each camera operator.
- Other considerations. Camera cables can be routed through the side door. If the room has a hardwood floor, the cameras could dolly into various positions for optimal shots. Because there is much traffic in the room, all cables must be taped to the floor and covered by rubber mats. Camera 1 will be in heavy traffic because of the public access doors.

Now compare your list and sketch for the parade with the setup shown in the next figure. **SEE 20.17**

PRODUCTION REQUIREMENTS FOR PARADE (OUTDOOR REMOTE)

- Location of remote truck. The truck is in a good location. It's fairly close to a power source (pump house) and the camera positions, minimizing cable runs.
- Cameras. You'll need a minimum of four cameras: C1 and C2 (studio/field cameras) on top of the bleachers, and C3 and C4 (ENG/EFP) on the street. C2 can also cover talent. C4 could also be mounted on a field jib at street level.
- Lighting. Because the videotaping is scheduled for 3:30 to 5:30 p.m., there is sufficient light throughout the telecast. The sun is mostly in back of the cameras throughout the

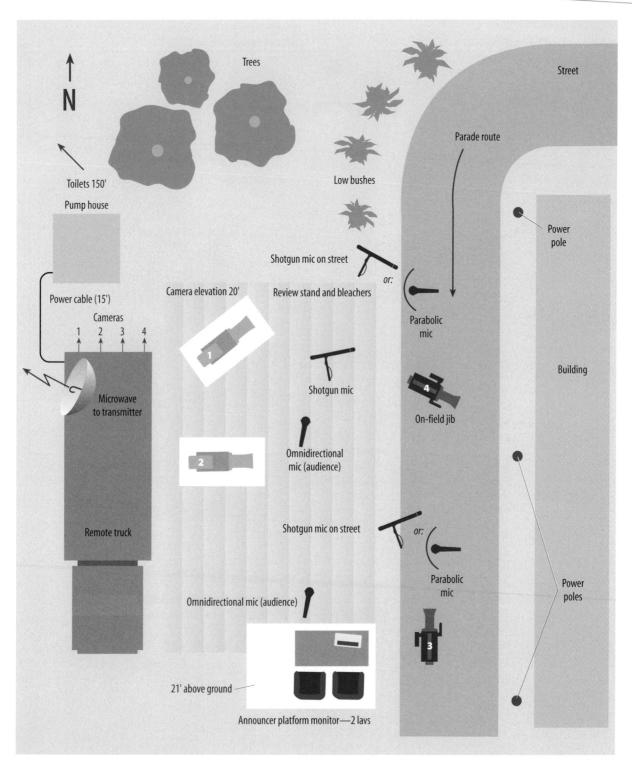

20.17 LOCATION SETUP FOR PARADE

telecast, so you may need a device to prevent the sun from washing out the viewfinders of cameras 1 and 2.

- Audio. There are three types of audio pickup: (1) the voice pickup of the two announcers, (2) the bands in the parade, and (3) the sounds of the spectators. Use lavaliere mics with windscreens or desk mics for the talent. Use two shotgun or parabolic mics (one high in the stands, the other just above ground level) for the bands. Use one omnidirectional mic near the announcer platform for the crowd noise. All mics need windscreens, and the shotgun mics need wind jammers.
- Intercommunications. The camera operators are connected to the normal P.L. lines of the camera cables. You'll need a separate intercom line for the floor manager's head-set. Use I.F.B. for the talent. At least two telephone lines for intercommunication come from the truck: a direct line to the station and the transmitter and another line for general voice communication.
- Signal transmission. You'll use a direct microwave link to the transmission tower (and from there to the station). Audio is sent via telephone lines (independent of microwave). This separation ensures audio continuity if the microwave link fails.
- Other considerations. Cameras 1 and 2 need a field lens to catch close-ups of the action around the bend (40×). Can camera 2 be pedestaled high enough so that it will not be blocked by people standing up in the bleachers? You'll need a large monitor for the talent and a second monitor for backup. Shade the monitors from the sun. Route the cables underneath the platform to reduce the potential tripping hazard. The ENG/EFP cameras (3 and 4) need cable pullers in addition to the camera operators. Toilet facilities are fairly close to the pump house. Raincoats and umbrellas may be needed for crew, talent, and cameras just in case the weather report predicting a beautiful day is wrong.

COMMUNICATION SYSTEMS

Well-functioning communication systems are especially important for production people in the field, regardless of whether the "field" is the street corner across from the station or one in London. These systems must be highly reliable and must enable the people at home base to talk with the field personnel, and the field personnel to talk with one another. When doing ENG you must be able to receive messages from the news room as well as the police and fire departments. As a producer or director, you need to reach the talent directly with specific information, even while the talent is on the air.

We have come to expect the relatively flawless transporting of television pictures and sound, regardless of whether they originate from the mayor's downtown office or the orbiting space station. Although communication systems and signal distribution are the province of the technical crew, you should still be familiar with them so that you will know what is available to you. This section provides a brief overview of ENG, EFP, and big-remote communication systems.

ENG COMMUNICATION SYSTEMS

Electronic news gathering has such a high degree of readiness not only because of the mobile and self-contained camera/recorder/audio unit but also because of elaborate communication devices. Most ENG vehicles are equipped with cell phones, scanners that continuously monitor the frequencies used by police and fire departments, a paging system, and two-way radios. Scanners lock in on a certain frequency as soon as they detect a signal and let you hear the conversation on that frequency.

These communication systems also make it possible for your station's news room to contact you while you are on the road and give you a chance to respond immediately to police and fire calls. Sometimes news departments use codes to communicate with their "cruising" field reporters to prevent the competition from getting wind of a breaking story.

EFP COMMUNICATION SYSTEMS

A single-camera EFP needs the least sophisticated communication system. Because the director is in direct contact with the crew and the talent at the shoot location, no intercom system is needed. Generally, widely dispersed crewmembers keep in touch with one another via walkietalkies or cell phones. As pointed out earlier, a small power megaphone might save your voice when giving directions collectively to talent and crew.

The EFP van is normally equipped with phone jacks for regular phone connections, but cell phones will usually suffice. If the EFP uses multiple cameras that are coordinated from a central location, a headset intercom system must be set up for the communication among director, TD, and crew. When doing a live telecast from the field, an I.F.B. system is added.

BIG-REMOTE COMMUNICATION SYSTEMS

Big remotes need communication systems between the remote truck (or any other remote control room) and the production people and crew, between the truck and the station, and between the truck and the talent. The truck and the production crew communicate through a regular

P.L. (private line or phone line) system, which uses the P.L. channels in the camera cable, separately wired P.L. lines, or wireless P.L.s. During a complicated setup in which the crew is widely scattered (such as when covering a downhill ski race), walkie-talkies are also used. If necessary, the P.L. communication can be carried by telephone lines from truck to station.

The I.F.B. (interruptible foldback or feedback) system is one of the most important lines of communication between the producer or director and the talent during a big remote. If several reporters or commentators are involved in the same event, you can switch among several I.F.B. channels so that, if necessary, you can address the field reporters and commentators individually. If needed, your I.F.B. instructions to the talent can be transmitted via satellite over great distances. Realize, however, that there is inevitably a slight delay before the talent receives your instructions. In sports remotes, the talent occasionally wear headsets through which they receive instructions from the truck.

The remote truck is, of course, equipped with several wired telephone lines, two-way radios, cell phones, paging systems, and walkie-talkies.

SIGNAL TRANSPORT

Signal transport refers to the systems available to you when transmitting the video and audio signals from their origin (microphone and camera) to the recording device or transmitter, and from the point of origin to various reception points. Signal transport includes (1) microwave transmission, (2) communication satellites, and (3) cable systems.

MICROWAVE TRANSMISSION

If you need to maintain optimal camera mobility during a live pickup, such as when shooting interviews from a convention floor, you cannot use a camera cable but must send the signal back to the remote truck via microwave.

From camera to remote truck There are small, portable, battery-powered transmitters that can be mounted on the camera. If the distance from camera to receiving station is not too great, you can use this system to relay the camera video and audio signals to the remote truck without too much difficulty. To minimize interference by other stations covering the same event, you can transmit on several frequencies, a practice called *frequency agility*.

If you need a more powerful microwave transmitter, you can mount the small dish on a tripod and place it close

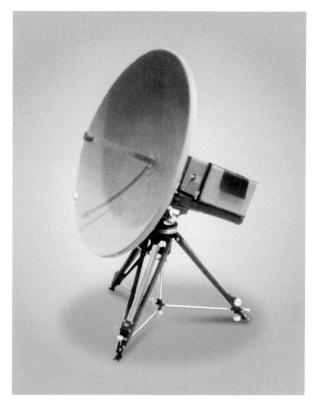

20.18 TRIPOD-MOUNTED MICROWAVE TRANSMITTER This small tripod-mounted microwave transmitter can relay camera signals over a considerable distance.

to the camera action radius. That way you can work at a considerable distance from the remote truck while using only a relatively short cable run from camera to microwave transmitter. This type of link is especially useful if a cable run would create potential hazards, such as when strung from a building across high-tension wires or across busy streets. **SEE 20.18**

The main problem with camera-to-truck microwave links is interference, especially if several television crews are covering the same event. Even if you use a system with relatively great frequency agility, your competition may be similarly agile and overpower you with a stronger signal.

From remote van to station or transmitter The longer, and usually much more complex, signal link is from the remote van to the television station. (Although sometimes the signal is sent directly to the transmitter, we will call the end point of this last link before the actual broadcast the "station.") You can send the signals from the

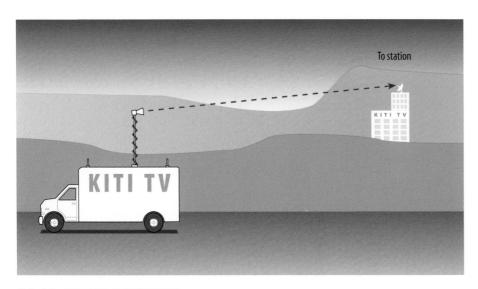

20.19 DIRECT MICROWAVE LINK

You can transmit the signal via microwave from the remote van back to the station only if there is a clear, unobstructed line of sight.

remote van directly to the station only if you have a clear, unobstructed line of sight. **SEE 20.19**

Because the microwave signal travels in a straight line, tall buildings, bridges, or mountains that are in the line of sight between the remote van and the station may block the signal transmission. In such cases several microwave links, called *mini-links*, have to be established to carry the signal around these obstacles. **SEE 20.20**

In metropolitan areas the various television stations have permanent *microwave relays* installed in strategic locations so that remote vans can send their signals back from practically any point in their coverage area. If these permanent installations do not suffice, helicopters are used as microwave relay stations. Permanent microwave relays are also used for transmitting the video of permanently installed cameras that monitor the weather and/or traffic.

COMMUNICATION SATELLITES: FREQUENCIES, UPLINKS, AND DOWNLINKS

The communication satellites used for broadcast are positioned in a geosynchronous orbit 22,300 miles above the earth. In this orbit the satellite moves synchronously with the earth, thereby remaining in the same position relative to it.

Satellite frequencies Communication satellites operate on two frequency bands—the lower-frequency *C-band*

and the higher-frequency *Ku-band* ("kay-you-band"). Some satellites have transponders for C-band as well as Kuband transmission and can convert internally from one to the other. A *direct broadcast satellite* (*DBS*) has a relatively high-powered transponder (transmitter/receiver) that broadcasts from the satellite to small individual downlink dishes (which you can buy in larger electronic stores and install yourself). A DBS operates on the Ku-band.

The C-band is a highly reliable system that is relatively immune to weather interference. Because the C-band works with microwave frequencies, it may interfere with ground-based microwave transmission. To avoid such interference, the C-band operates with relatively low power; because of the low power, the ground stations need large dishes, which range anywhere from 15 to 30 feet. Such large dishes are obviously not suitable for mobile uplink trucks. To use the C-band, the television signals must be transported to and from permanent ground stations.

The C-band requires careful scheduling. It is usually crowded with regular transmissions, such as daily network or cable programming. The other problem is that even if some C-band transponders (in the satellite) are available, the uplinks and the downlinks may be busy with signal transmission, so you cannot access the transponders.

The *Ku-band*, on the other hand, operates with more power and smaller dishes (3 feet or less) that can be mounted and readily operated on mobile trucks or on

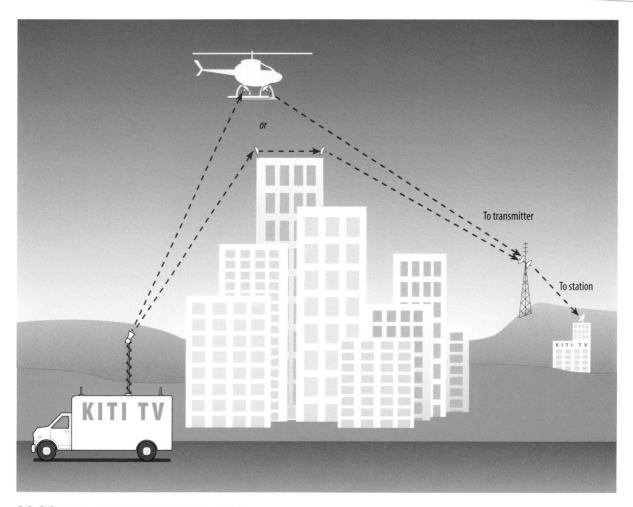

20.20 MINI-LINK FROM REMOTE VAN TO STATION

If there is no clear line of sight between the remote location and the station, the microwave signal must be transported via transmission mini-links.

your rooftop. The Ku-band is also less crowded than the C-band and allows immediate, virtually unscheduled access to various uplinks. One of the major problems with the Ku-band is that it is susceptible to weather; rain and snow can seriously interfere with transmission.

Uplinks and downlinks Television signals are sent to a satellite through an *uplink* (earth station transmitter), received, amplified by the satellite, and beamed back at a different frequency (actually rebroadcast) by the satellite's own transmitter to one or several receiving earth stations, called *downlinks*. The receiver-transmitter unit in the satellite is called a *transponder*, a combination of *transmitter*

and *responder* (receiver). Many satellites used for international television transmission have built-in translators that automatically convert one electronic signal standard, such as the NTSC system, into another, such as the European PAL system.

Because the satellite transmission covers a large area, simple receiving stations (downlinks) can be set up in many widely dispersed parts of the world. **SEE 20.21** In fact, these strategically placed satellites can spread their *footprint* (coverage area) over the whole earth.

Specialized vans can provide mobile uplinks for the transport of television signals. These *uplink trucks* operate on the very same principle as a microwave van except that

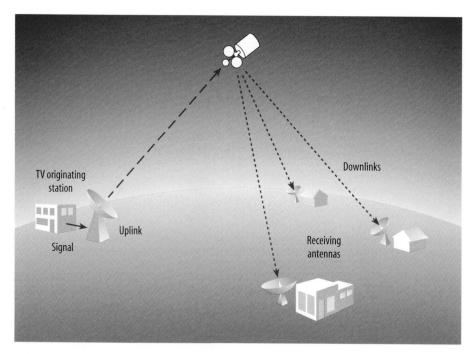

20.21 SATELLITE UPLINK AND DOWNLINKS

The uplink sends television signals to the satellite. The downlinks receive television signals from the satellite.

they send the television signals to a satellite rather than to a receiving microwave dish. As noted in section 20.1, satellite uplink vans usually contain additional equipment, such as several video recorders and editing equipment.

CABLE DISTRIBUTION

As you know, television audio and video signals are also distributed via coax (coaxial) or fiber-optic cable. The *coax cable* transports the video and audio information on an electromagnetic carrier wave at a relatively low radio frequency.

A *fiber-optic cable* consists of a great number of fiber-optic strands, each of which is thinner than a human hair and capable of carrying a great amount of information. When using fiber-optic cables for signal transport, the electronic (video and audio) signals are encoded at the point of origin into bursts of light, which are decoded into electrical signals at the destination. When you bundle many of these strands together into a fiber-optic cable of only half the thickness of a normal coax cable, you have

a transmission device with an ultimately higher transmission capacity. Fiber-optic cables are normally used for *broadband* transmission, which provides a high-bandwidth conduit for the simultaneous transport of all sorts of data, voice, and video signals. Besides their obvious advantages of light weight and high information capacity, fiber-optic cables are relatively immune to moisture and electrical interference and can transport the signal over several miles without reamplification.

Both types of cable are used extensively for the transport of television signals to television stations and remotes. They are also used as a nonbroadcast home-delivery system of television signals by cable and telephone companies. The typical signal transport and distribution system by cable companies consists of a *head end* (origination point) that receives the signal from satellites or television transmitters. From there the signals are amplified and distributed along a *trunk line* to many feeder lines. The *feeder lines* bring the signals to various locations, such as city streets or blocks. Finally, *drop lines* bring the signals into individual homes. **SEE 20.22**

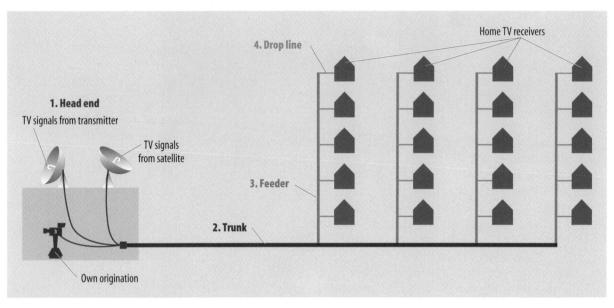

20.22 CABLE TELEVISION SYSTEM

The cable distribution system consists of: (1) the head end, where the signals are collected or originated; (2) the trunk, through which the signals are sent to the feeders; (3) the feeders, which bring the signals to various localities (city streets and blocks); and (4) the drop lines, which connect the feeders to individual homes.

MAIN POINTS

- Many big remotes are devoted to the coverage of sporting events. Networks typically use a great amount of equipment and personnel for sports remotes, but good coverage is also possible with less equipment.
- There are standard setups for most sporting events, which can be augmented with more cameras and audio equipment.
- Location sketches are a valuable preproduction aid for big remotes. For an indoor remote, they may show the general dimensions of a room or hallway; the locations of windows, doors, and furniture; and the principal action areas. Outdoor location sketches may show buildings, remote truck location, power source, steep inclines or steps, the path of the sun, and the location and/or direction of the main event.
- A good location sketch can aid the director and the technical supervisor in deciding on major camera locations, focal lengths of zoom lenses, lighting and audio setups, and intercommunication systems.

- Remote operations depend heavily on reliable intercommunication systems, including the P.L. system, walkie-talkies, pagers, cell phones, and multichannel I.F.B. systems. The I.F.B. information can be transmitted via telephone lines and/or satellite to widely scattered talent in remote locations.
- Remote signals are usually transported via microwave, satellite, or cable.
- ◆ Communication satellites used for broadcast operate in the lower-frequency C-band and the higher-frequency Ku-band.

ETTL'S VIDEOLAR

For your reference, or to track your work, the VideoLab program cue in this chapter is listed here with its corresponding page number.

ZVL1 PROCESS→ Methods→ location | studio

474

Epilogue

You are now in command of one of the most powerful means of communication and persuasion. Use it wisely and responsibly. Treat your audience with respect and compassion. Whatever role you play in the production process—pulling cables or directing a network show—you influence many people. Because they cannot communicate back to you very readily, they must—and do—trust your professional skills and judgment. Do not betray that trust.

Glossary

- **480p** The lowest-resolution scanning system of DTV (digital television). The *p* stands for *progressive*, which means that each complete television frame consists of 480 visible, or active, lines that are scanned one after the other (out of 525 total scanning lines). It is sometimes considered the low end of HDTV.
- **720p** A progressive scanning system of HDTV (high-definition television). Each frame consists of 720 visible, or active, lines (out of 750 total scanning lines).
- **1080i** An interlaced scanning system of HDTV (high-definition television). The *i* stands for *interlaced*, which means that a complete frame is formed from two interlaced scanning fields. Each field consists of 539.5 visible, or active, lines (out of 1,125 total scanning lines). As with the traditional NTSC analog television system, the 1080i system produces 60 fields or 30 complete frames per second.
- **above-the-line personnel** A budgetary division referring to nontechnical personnel. *See* **nontechnical production personnel**.
- above-the-line A budgetary division including expenses for nontechnical personnel, such as producers, directors, and talent.
- AB-roll editing Creating an edit master tape from two source VTRs, one containing the A-roll, the other the B-roll. The editing is initiated by the edit controller rather than through switching.
- **AB rolling** The simultaneous and synchronized feed from two source VTRs (one supplying the A-roll, the other the B-roll) to the switcher for instantaneous editing as though they were live sources.
- **AC** Stands for *alternating current*. Electric energy as supplied by normal wall outlets.
- **actor** A person (male or female) who appears on-camera in dramatic roles. Actors always portray someone else.

- **AD** Stands for *associate* or *assistant director*. Assists the director in all production phases.
- **additive primary colors** Red, green, and blue. Ordinary white light (sunlight) can be separated into the three primary light colors. When these three colored lights are combined in various proportions, all other colors can be reproduced. The process is called *additive color mixing*.
- **address code** An electronic signal that marks each frame with a specific address. *See* **SMPTE/EBU time code**.
- ad-lib Speech or action that has not been scripted or specially rehearsed.

ADR See automatic dialogue replacement

advanced television See digital television (DTV)

AFTRA Stands for *American Federation of Television and Radio Artists.* A broadcasting talent union.

AGC See automatic gain control

- **aliasing** The steplike appearance of a computer-generated diagonal or curved line. Also called *jaggies* or *stairsteps*.
- ambience Background sounds.
- analog A signal that fluctuates exactly like the original stimulus.
- analog recording systems Record the continually fluctuating video and audio signals generated by the video and/or audio source.
- **aperture** Iris opening of a lens, usually measured in *f*-stops.
- arc To move the camera in a slightly curved dolly or truck.
- **architecture** Refers to the electronic logic design of a switcher.
- **aspect ratio** The width-to-height proportions of the standard television screen and therefore of all analog television pictures: 4 units wide by 3 units high. For DTV and HDTV, the aspect ratio is 16×9 .

assemble editing Adding shots in linear editing on videotape in consecutive order without first recording a control track on the edit master tape.

ATR See audiotape recorder

- ATV Stands for advanced television. See digital television (DTV).
- audio The sound portion of television and its production. Technically, the electronic reproduction of audible sound.
- **audio control booth** Houses the audio, or mixing, console; analog and digital playback machines; a patchbay; computer(s); speakers; intercom systems; a clock; and a line monitor.
- **audio-follow-video** A switcher that automatically changes the accompanying audio along with the video source.

audio monitor See program speaker

- **audio postproduction room** For postproduction activities such as sweetening; composing music tracks; adding music, sound effects, or laugh tracks; and assembling music bridges and announcements.
- audiotape recorder (ATR) A reel-to-reel audiotape recorder.
- **audio track** The area of the videotape used for recording the sound information.

auto cue See teleprompter

- **auto-focus** Automated feature whereby the camera focuses on what it senses to be your target object.
- auto-iris Automatic control of the lens diaphragm.
- **automatic dialogue replacement (ADR)** The synchronization of speech with the lip movements of the speaker in postproduction. Not really automatic.
- **automatic gain control (AGC)** Regulates the volume of the audio or video level automatically, without using manual controls.
- **auto transition** An electronic device that functions like a fader bar.
- **background light** Illumination of the set, set pieces, and backdrops. Also called *set light*.
- **back light** Illumination from behind the subject and opposite the camera.
- **back-timing** The process of figuring additional clock times by subtracting running times from the schedule time at which the program ends.

- **balance** (1) Audio: a proper mixing of various sounds. (2) Video: relative structural stability of picture elements (objects or events). Balance refers to the interrelationship between stability and tension in a picture and can therefore be stable (little pictorial tension), neutral (some tension), or unstable (high pictorial tension).
- **balanced mic or line** Professional audio wiring with three connectors or wires: two that carry substantially the same audio signal out of phase and one that is a ground shield. Relatively immune to hum and other electronic interference.
- **barn doors** Metal flaps mounted in front of a lighting instrument that control the spread of the light beam.

base See baselight

baselight Even, nondirectional (diffused) light necessary for the camera to operate optimally. Normal baselight levels are 150 to 200 foot-candles (1,500 to 2,000 lux) at *f*/8 to *f*/16. Also called *base*.

baselight level See operating light level

- **batten** A horizontal metal pipe that supports lighting instruments in a studio.
- **beam splitter** Compact internal optical system of prisms and filters within a television camera that separates white light into the three primary colors: red, green, and blue (RGB). Also called *prism block*.
- **beeper** A series of audio beeps (normally eight), exactly 1 second apart, at the beginning of each take for videotape cueing.
- **below-the-line** A budgetary division referring to equipment and technical services of a particular show and the cost of the below-the-line technical personnel.
- **below-the-line personnel** A budgetary division referring to technical personnel. *See* **technical production personnel**.

big boom See perambulator boom

- **big remote** A production outside the studio to televise live and/or record live-on-tape a large scheduled event that has not been staged specifically for television. Examples include sporting events, parades, political gatherings, and studio shows that are taken on the road. Also called, simply, *remote*.
- **binary** A number system with the base of 2.
- **binary digit (bit)** The smallest amount of information a computer can hold and process. A charge is either present, represented by a *1*, or absent, represented by a *0*. One

bit can describe two levels, such as on/off or black/white. Two bits can describe four levels (2² bits); three bits, eight levels (2³ bits); four bits, sixteen (2⁴ bits), and so on. A group of eight bits (2⁸) is called a *byte*. See also **byte**.

bit See binary digit

- **black** Darkest part of the grayscale, with a reflectance of approximately 3 percent; called *TV black*. "To black" means to fade the television picture to black.
- **blocking** Carefully worked-out movement and actions by the talent and for all mobile television equipment.

blocking rehearsal See dry run

- **BNC** Standard coaxial cable connector for professional video equipment.
- **book** Two flats hinged together. Also called *twofold*.
- **boom** (1) *Audio*: microphone support. (2) *Video*: part of a camera crane. (3) To move the camera via the boom of the camera crane; also called *crane*.
- **border** Electronically generated edge that separates letters or picture areas from the background.
- **boundary microphone** Microphone mounted or put on a reflecting surface to build up a pressure zone in which all the sound waves reach the microphone at the same time. Ideal for group discussions and audience reaction. Also called *pressure zone microphone* (*PZM*).
- **brightness** The color attribute that determines how dark or light a color appears on the monochrome television screen or how much light the color reflects. Also called *lightness* and *luminance*.
- **broad** A floodlight with a broadside, panlike reflector.
- **broadband** A high-bandwidth standard for sending information (voice, data, video, and audio) simultaneously over fiber-optic cables.

bump-down See dub-down

bump-up See dub-up

- burn-in A permanent trace of an image in a video display.
- **bus** (1) A row of buttons on the switcher. (2) A common central circuit that receives electrical signals from several sources and that feeds them to a common or several separate destinations.
- **bust shot** Framing of a person from the upper torso to the top of the head.
- **byte** Eight bits. Can define 256 discrete levels (2⁸ bits), such as shades of gray between black and white. *See also* **binary digit** (**bit**).

- **cable television** (1) Distribution device for broadcast signals via coaxial or fiber-optic cable. (2) Production facility for programs distributed via cable.
- **calibrate** (1) *Audio*: to make all VU meters (usually of the audio console and the record VTR) respond in the same way to a specific audio signal. (2) *Video*: to preset a zoom lens to remain in focus throughout the zoom.
- **camcorder** A portable camera with the videotape recorder or some other recording device attached or built into it to form a single unit.
- **cameo lighting** Foreground figures are lighted with highly directional light, with the background remaining dark.
- **camera** The general name for the *camera head*, which consists of the lens (or lenses), the main camera with the imaging device and the internal optical system, electronic accessories, and the viewfinder.
- **camera chain** The television camera (head) and associated electronic equipment, including the camera control unit, sync generator, and power supply.
- **camera control unit (CCU)** Equipment, separate from the camera head, that contains various video controls, including color fidelity, color balance, contrast, and brightness. The CCU enables the video operator to adjust the camera picture during a show.
- camera head The actual television camera, which is at the head of a chain of essential electronic accessories. It comprises the imaging device, lens, and viewfinder. In ENG/EFP cameras, the camera head contains all the elements of the camera chain.
- **camera-left and camera-right** Directions given from the camera's point of view; opposite of "stage-left" and "stage-right," which are directions given from the actor's point of view (facing the audience or camera).
- camera light Small spotlight mounted on the front of the camera, used as an additional fill light. (Frequently confused with tally light.) Also called *eye light* or *inky-dinky*.

camera pickup device See chip

- **camera rehearsal** Full rehearsal with cameras and other pieces of production equipment. Often identical to the dress rehearsal.
- **cam head** A camera mounting head for heavy cameras that permits extremely smooth tilts and pans.
- **cant** Tilting the shoulder-mounted or handheld camera sideways.

- **canting effect** Visual effect in which the scene is put on a slight tilt, causing a slanted horizon line.
- (1) Lens cap: a rubber or metal cap placed in front of the lens to protect it from light, dust, or physical damage.(2) Electronic device that eliminates the picture from the camera pickup device.

capacitor microphone See condenser microphone

- **capture** Transferring video and audio information to a computer hard drive for nonlinear editing.
- **cardioid** Heart-shaped pickup pattern of a unidirectional microphone.
- **cassette** A video- or audiotape recording or playback device that uses tape cassettes. A cassette is a plastic case containing two reels—a supply reel and a takeup reel.
- **C-band** A frequency band for certain satellites. It is relatively immune to weather interference. *See also* **Ku-band**.
- **CCD** Stands for *charge-coupled device*. See **chip**.
- **C-clamp** A metal clamp with which lighting instruments are attached to the lighting battens.

C channel See chrominance channel

- CCU See camera control unit
- CD See compact disc

C.G. See character generator

- character generator (C.G.) A dedicated computer system that electronically produces a series of letters, numbers, and simple graphic images for video display. Any desktop computer can become a C.G. with the appropriate software.
- **charge-coupled device (CCD)** The imaging element in a television camera. *See* **chip**.
- **cheat** To angle the performer or object toward a particular camera; not directly noticeable to the audience.
- **chip** A common name for the camera's imaging device. Technically, it is known as the *charge-coupled device* (*CCD*). The chip consists of a great number of imaging sensing elements, called *pixels*, that translate the optical (light) image into an electronic video signal. Also called *camera pickup device*.
- **chroma-key drop** A well-saturated blue or green canvas backdrop that can be pulled down from the lighting grid to the studio floor as a background for chroma keying.
- **chroma keying** Effect that uses color (usually blue or green) for the backdrop, which is replaced by the background image during a key.

- **chrominance channel** Consists of the three color (chroma) signals in a video system. The chrominance channel is responsible for each of the basic color signals: red, green, and blue (RGB). Also called *C channel*.
- clip (1) To compress the white and/or black picture information or prevent the video signal from interfering with the sync signals. (2) A short series of video frames (shots) as captured on the hard drive and identified by a file name or number.

clip control See key-level control

clip light Small internal reflector spotlight that is clipped to pieces of scenery or furniture with a gator clip. Also called *PAR (parabolic aluminized reflector) lamp*.

clipper See key-level control

- **clock time** The time the clock shows. Specifically, the time at which a program starts and ends. Also called *schedule time*.
- **close-up (CU)** Object or any part of it seen at close range and framed tightly. The close-up can be extreme (extreme or big close-up—*ECU*) or rather loose (medium close-up—*MCU*).
- **closure** Short for *psychological closure*. Mentally filling in spaces of an incomplete picture. *See also* **mental map**.
- **coding** To change the quantized values into a binary code, represented by 0's and 1's, and the specific grouping of the coded bits. Also called *encoding*.
- **color bars** A color standard used by the television industry for the alignment of cameras and videotape recordings. Color bars can be generated by most professional portable cameras.
- **color compatibility** Color signals that can be perceived as black-and-white pictures on monochrome television sets. Generally used to mean that the color scheme has enough brightness contrast for monochrome reproduction with a good grayscale contrast.
- **colorizing** The creation of color patterns or color areas through a computer.

color media See gel

- **color temperature** The standard by which we measure the relative reddishness or bluishness of white light. It is measured on the Kelvin (K) scale. The standard color temperature for indoor light is 3,200K, for outdoor light, 5,600K. Technically, the numbers express Kelvin degrees.
- comet-tailing Occurs when the camera pickup device is unable to process bright lights in a very dark scene or

- extremely bright highlights that are reflected off polished surfaces. The effect looks like red or blue flames trailing the bright object when the object or camera moves.
- **compact disc (CD)** A small, shiny disc that contains information (usually sound signals) in digital form. A CD player reads the encoded digital information using a laser beam.
- **complexity editing** The juxtaposition of shots that primarily, though not exclusively, helps intensify the screen event. Editing conventions as advocated in continuity editing are often purposely violated.
- **component system** A process in which the luminance (Y, or black-and-white) signals and color (C) signals, or all three color signals (RGB), are kept separate throughout the recording and storage process. Comprises the Y/C component, Y/color difference component, and RGB component systems.
- **composite system** A process in which the luminance (Y, or black-and-white) signal and the chrominance (C, or red, green, and blue) signal as well as sync information are encoded into a single video signal and transported via a single wire. Also called *NTSC signal*.
- **compression** (1) *Electronics*: reducing the amount of data to be stored or transmitted by using coding schemes that pack all original data into less space (*lossless* compression) or by throwing away some of the least important data (*lossy* compression). (2) *Video*: the crowding effect achieved by a narrow-angle (telephoto) lens wherein object proportions and relative distances seem shallower.
- **computer-generated DVE** Digital video effects created entirely by computer hardware and software.
- **computer-manipulated DVE** Digital video effects created by a computer using an existing image (camera-generated video sequence, video frame, photo, or painting) and enhancing or changing it in some way.
- **condenser microphone** A microphone whose diaphragm consists of a condenser plate that vibrates with the sound pressure against another fixed condenser plate, called the *backplate*. Also called *electret* or *capacitor microphone*.
- **contact** A person, usually a public relations officer, who knows about an event and can assist the production team during a remote telecast.
- **continuity editing** The preservation of visual continuity from shot to shot.
- **continuous-action lighting** Overlapping triangle lighting for all major performance areas. Also called *zone lighting*.

- contrast ratio The difference between the brightest and the darkest portions in the picture (often measured by reflected light in foot-candles). The contrast ratio for most cameras is normally 40:1 to 50:1, which means that the brightest spot in the picture should not be more than forty or fifty times brighter than the darkest portion without causing loss of detail in the dark or light areas. High-end digital cameras can exceed this ratio.
- **control room** A room adjacent to the studio in which the director, the technical director, the audio engineer, and sometimes the lighting director perform their various production functions.

control room directing See multicamera directing

- **control track** The area of the videotape used for recording the synchronization information (sync pulse). Provides reference for the running speed of the VTR, for the placing and reading of the video tracks, and for counting the number of frames.
- **control track system** An editing system that counts the control track pulses and translates this count into elapsed time and frame numbers. It is not frame-accurate. Also called *pulse-count system*.
- **convertible camera** An ENG/EFP camera adapted for studio use. Equipped with a large viewfinder and controlled by the CCU.
- cookie A popularization of the original term cucoloris or cucaloris. Any pattern cut out of thin metal that, when placed inside or in front of an ellipsoidal spotlight (pattern projector), produces a shadow pattern. Also called gobo.
- **counterweight battens** Steel pipes that support lighting instruments and corresponding power outlets that can be raised and lowered to a specific height by a counterweight or motorized system.
- **CPU** Stands for *central processing unit*. Processes information in a computer according to the instructions it receives from the software.
- **crab** Sideways motion of the camera crane dolly base.
- **crane** (1) Motion picture camera support that resembles an actual crane in both appearance and operation. The crane can lift the camera from close to the studio floor to more than 10 feet above it. (2) To move the boom of the camera crane up or down. Also called *boom*.
- **crawl** The horizontal movement of electronically generated copy (the vertical movement is called a *roll*). Can also refer to the program that activates such a movement.

- cross-fade (1) Audio: transition method whereby the preceding sound is faded out and the following sound is faded in simultaneously; the sounds overlap temporarily. (2) Video: transition method whereby the preceding picture is faded to black and the following picture is faded in from black.
- **cross-keying** The crossing of key lights for two people facing each other.
- **cross-shot (X/S)** Similar to the over-the-shoulder shot except that the camera-near person is completely out of the shot.

CU See close-up

cucoloris See cookie

- **cue** (1) Signal for various production activities. (2) To select a certain spot in the videotape or film.
- **cue card** A large, hand-lettered card that contains copy, usually held next to the camera lens by floor personnel.

cue-send See foldback

- **cue track** The area of the videotape used for such information as in-house identification or SMPTE address code. Can also be used for an additional audio track.
- **cut** (1) The instantaneous change from one shot (image) to another. (2) Director's signal to interrupt action.
- **cutaway** A shot of an object or event that is peripherally connected with the overall event and that is often neutral as to its screen direction (such as a straight-on shot). Used to intercut between shots to facilitate continuity.

cuts-only editing system See single-source editing system

cyc See cyclorama

cyc light See strip light

cyclorama A U-shaped continuous piece of canvas for backing of scenery and action. Also called *cyc*.

DAT See digital audiotape

DBS See direct broadcast satellite

DC Stands for direct current.

- **DCT** Stands for *discrete cosine transform*. A complex method of dividing a digital image into 8 × 8 pixel blocks and translating the pixel positions into frequencies. The redundant frequencies are eliminated. Most compression techniques are based on DCT.
- **decoding** The reconstruction of a video or audio signal from a digital code.

- **definition** How sharp an image appears. In television, the number and size of pixels that make up the screen image. *See also* **resolution**.
- **defocus** Simple yet highly effective optical effect wherein the camera operator zooms in, racks out of focus, and, on cue, back into focus again. Used as a transitional device or to indicate strong psychological disturbances or physiological imbalance.
- **delegation controls** Controls on the switcher that assign specific functions to a bus.
- **demographics** Audience research factors concerned with such data as age, gender, marital status, and income.
- **depth of field** The area in which all objects, located at different distances from the camera, appear in focus. Depth of field depends on the focal length of the lens, its *f*-stop, and the distance between the object and the camera.
- **depth staging** Arrangement of objects on the television screen so that foreground, middleground, and background are each clearly defined.
- **diaphragm** (1) *Audio*: the vibrating element inside a microphone that moves with the air pressure from the sound. (2) *Video: See* **iris**.
- **dichroic filter** A mirrorlike color filter that singles out from the white light the red light (red dichroic filter) and the blue light (blue dichroic filter), with the green light left over. Also called *dichroic mirror*.

dichroic mirror See dichroic filter

- **diffused light** Light that illuminates a relatively large area with an indistinct light beam. Diffused light, created by floodlights, produces soft shadows.
- **diffusion filter** Filter that attaches to the front of the lens; gives a scene a soft, slightly out-of-focus look.
- **digital** Usually means the binary system—the representation of data in the form of binary digits (on/off pulses).
- **digital audiotape (DAT)** The sound signals are encoded on audiotape in digital form. Includes digital recorders as well as digital recording processes.
- digital cart system A digital audio system that uses built-in hard drives, removable high-capacity disks, or read/write optical discs to store and access almost instantaneously a great amount of audio information. It is normally used for the playback of brief announcements and music bridges.

digital lens See digital zoom lens

- digital recording systems Sample the analog video and audio signals and convert them into discrete on/off pulses. These digits are recorded as 0's and 1's.
- digital still store system See electronic still store (ESS) system
- **digital television (DTV)** Digital television systems that generally have a higher image resolution than STV (standard television). Also called *advanced television* (*ATV*).
- digital versatile disc (DVD) The standard DVD is a read-only, high-capacity (4.7 gigabytes or more) storage device of digital audio and video information. Also called *digital videodisc*.
- digital videodisc See digital versatile disc (DVD)
- **digital video effects (DVE)** Visual effects generated by computer or digital effects equipment in the switcher.
- **digital zooming** Simulated zoom by cropping the center portion of an image and electronically enlarging the cropped portion. Digital zooms lose picture resolution.
- digital zoom lens A lens that can be programmed through a small built-in computer to repeat zoom positions and their corresponding focus settings.
- **digitize** To convert analog signals into digital (binary) form or to transfer information in a digital code.
- **dimmer** A device that controls the intensity of light by throttling the electric current flowing to the lamp.
- direct broadcast satellite (DBS) Satellite with a relatively high-powered transponder (transmitter/receiver) that broadcasts from the satellite to small, individual downlink dishes; operates on the Ku-band.

direct bus See program bus

direct input See direct insertion

- **direct insertion** Recording technique wherein the sound signals of electric instruments are fed directly to the mixing console without the use of speaker and microphone. Also called *direct input*.
- **directional light** Light that illuminates a relatively small area with a distinct light beam. Directional light, produced by spotlights, creates harsh, clearly defined shadows.
- director of photography (DP) In major motion picture production, the DP is responsible for the lighting (similar to the LD in television). In smaller motion picture productions and in EFP, the DP will operate the camera. In television, it refers to the camera operator, or shooter.
- **disc** An optical computer storage device that uses a laser beam for the read/write function.

- **disk** A computer storage device that can store data on concentric tracks. There are removable medium-capacity floppy disks, and large-capacity hard disks normally built into the hard drive.
- **disk-based video recorder** All digital video recorders that record or store information on a hard disk or read/write optical disc. All disk-based systems are nonlinear.
- **dissolve** The gradual replacement of one image by another through a temporary double exposure. Also called *lap dissolve*.
- distortion Unnatural alteration or deterioration of sound.
- **diversity reception** Setup for a single wireless microphone wherein more than one receiving station is established, so one can take over when the signal from the other gets weak.
- **dolly** (1) Camera support that enables the camera to move in all horizontal directions. (2) To move the camera toward (dolly in) or away from (dolly out or back) the object.
- **double headset** A telephone headset (earphones) that carries program sound in one earphone and the P.L. information in the other. Also called *split intercom*.
- **downlink** The antenna (dish) and equipment that receive the signals coming from a satellite.
- **downloading** The transfer of files that are sent in data packets. Because these packets are often transferred out of order, the file cannot be seen or heard until the downloading process is complete. *See also* **streaming**.
- **downstream keyer (DSK)** A control that allows a title to be keyed (cut in) over the picture (line-out signal) as it leaves the switcher.

DP See director of photography

- **drag** Degree of friction needed in the camera mounting head to allow smooth panning and tilting.
- **dress** (1) What people wear on-camera. (2) Decorating a set with set properties. (3) Dress rehearsal.
- dress rehearsal Full rehearsal with all equipment operating and with talent in full dress. The dress rehearsal is often videotaped. Often called *camera rehearsal* except that the camera rehearsal does not require full dress for talent.
- **drop** Large, painted piece of canvas used for scenery backing.
- **drop frame** A video recording mode in which single frames are periodically overlooked (dropped) by the SMPTE time code to make it match the actual elapsed clock time.

- **drop lines** Section of cable television distribution system that connects individual homes.
- **dropout** Loss of part of the video signal, which shows up on-screen as white or colored glitches. Caused by uneven videotape iron-oxide coating (bad tape quality or overuse) or dirt.
- **dry run** Rehearsal without equipment, during which the basic actions of the talent are worked out. Also called *blocking rehearsal*.

DSK See downstream keyer

DTV See digital television

- **dual-redundancy** The use of two identical microphones for the pickup of a sound source, whereby only one of them is turned on at any given time. A safety device that permits switching over to the second microphone in case the active one becomes defective.
- dub The duplication of an electronic recording. Dubs can be made from tape to tape, or from record or disc to tape and vice versa. The dub is always one generation away from the recording used for dubbing. In analog systems each dub shows increased deterioration. Digital dubbing produces copies almost identical in quality to the original.
- **dub-down** Dubbing (copying) picture and sound information from a higher-quality VTR format to a lower-quality one. Also called *bump-down*.
- **dub-up** Dubbing (copying) picture and sound information from a lower-quality videotape format to a higher-quality one. Also called *bump-up*.
- **DVCAM** Digital videotape recording system developed by Sony.
- **DVCPRO** Digital videotape recording system developed by Panasonic.

DVD See digital versatile disc

DVE See digital video effects

- **dynamic microphone** A microphone whose sound pickup device consists of a diaphragm that is attached to a movable coil. As the diaphragm vibrates with the air pressure from the sound, the coil moves within a magnetic field, generating an electric current. Also called *moving-coil microphone*.
- **echo** A sound that is reflected from a single surface and perceived as consecutive, rapidly fading, and repetitious. *See also* **reverberation**.

echo effect Visual effect wherein the same video image is repeated as though it were placed between two opposite mirrors. Also used to describe an effect in which a moving object trails its previous frames.

ECU See extreme close-up

- **edit controller** Machine that assists in various editing functions, such as marking edit-in and edit-out points, rolling source and record VTRs, and activating effects equipment. Often a desktop computer with specialized software. Also called *editing control unit*.
- **edit decision list (EDL)** Consists of edit-in and edit-out points, expressed in time code numbers, and the nature of transitions between shots.
- **editing** The selection and assembly of shots in a logical sequence.

editing control unit See edit controller

edit master tape The videotape on which the selected portions of the source tapes are edited. Used with the record VTR.

edit VTR See record VTR

EDL See edit decision list

- **effects buses** Program and preview buses on the switcher, assigned to perform effects transitions.
- **effect-to-cause model** Moving from idea to desired effect on the viewer, then backing up to the specific medium requirements to produce such an effect.

EFP See electronic field production

electret microphone See condenser microphone

- **electron gun** Produces the electron (scanning) beam in a television receiver.
- electronic cinema A high-definition television camera that has a frame rate of 24 frames per second, which is identical to the frame rate of a film camera. Most electronic cinema cameras use high-quality, state-of-the-art lenses and high-definition viewfinders.
- **electronic field production (EFP)** Television production outside the studio that is normally shot for postproduction (not live). Usually called *field production*.
- electronic still store (ESS) system An electronic device that can grab a single frame from any video source and store it in digital form. It can retrieve the frame randomly in a fraction of a second.
- **ellipsoidal spotlight** Spotlight producing a very defined beam, which can be shaped further by metal shutters.

ELS See extreme long shot

electronic news gathering (ENG) The use of portable camcorders or cameras with separate portable VTRs, lights, and sound equipment for the production of daily news stories. ENG is usually not planned in advance and is often transmitted live or immediately after post-production.

encoding See coding

ENG See electronic news gathering

ENG/EFP cameras and camcorders High-quality portable field production cameras. When the camera is docked with a VTR or other recording device, or has the recording device built into it, it is called a *camcorder*.

environment General ambience of a setting.

equalization Controlling the quality of sound by emphasizing certain frequencies while de-emphasizing others.

essential area The section of the television picture, centered within the scanning area, that is seen by the home viewer, regardless of masking or slight misalignment of the receiver. Also called *safe title area* or *safe area*.

ESS system See electronic still store (ESS) system

establishing shot See extreme long shot (ELS) and long shot (LS)

expanded system A television system consisting of equipment and procedures that allows for selection, control, recording, playback, and transmission of television pictures and sound.

extender See range extender

external key The cutout portion of the base picture is filled by the signal from an external source, such as a second camera

extreme close-up (ECU) Shows the object with very tight framing.

extreme long shot (ELS) Shows the object from a great distance. Also called *establishing shot*.

eye light See camera light

facilities request A list that contains all technical facilities needed for a specific production.

fact sheet Lists the items to be shown on-camera and their main features. May contain suggestions of what to say about the product. Also called *rundown sheet*.

fade The gradual appearance of a picture from black (*fade-in*) or its disappearance to black (*fade-out*).

- **fader** A sound-volume control that works by means of a button sliding horizontally along a specific scale. Identical in function to a pot. Also called *slide fader*.
- **fader bar** A lever on the switcher that activates preset transitions, such as dissolves, fades, and wipes, at different speeds. It is also used to create superimpositions.
- falloff (1) The speed with which light intensity decays. The speed (degree) with which a light picture portion turns into shadow area. Fast falloff means that the light areas turn abruptly into shadow areas and there is a great brightness difference between light and shadow areas. Slow falloff indicates a very gradual change from light to dark and a minimal brightness difference between light and shadow areas.
- **fast lens** A lens that permits a relatively great amount of light to pass through at its maximum aperture (relatively low *f*-stop number at its lowest setting). Can be used in low-light conditions.

fc See foot-candle

feed Signal transmission from one program source to another, such as a network feed or a remote feed.

feedback (1) *Audio:* piercing squeal from the loudspeaker, caused by the accidental reentry of the loudspeaker sound into the microphone and subsequent overamplification of sound. (2) *Communications:* reaction of the receiver of a communication back to the communication source. (3) *Video:* wild streaks and flashes on the monitor screen caused by reentry of a video signal into the switcher and subsequent overamplification.

feeder lines Section of cable television distribution system that brings the signal to various parts of a city.

fiber-optic cable Thin, transparent fibers of glass or plastic used to transfer light from one point to another. When used in broadcast signal transmission, the electrical video and audio signals use optical frequencies (light) as the carrier wave to be modulated.

field (1) A location away from the studio. (2) One-half of a complete scanning cycle, with two fields necessary for one television picture frame. There are 60 fields, or 30 frames, per second in standard NTSC television.

field log A record of each take during the videotaping. *See also* **VTR log**.

field of view The portion of a scene visible through a particular lens; its vista. Expressed in symbols, such as *CU* for close-up.

- **field production** All productions that happen outside the studio; generally refers to electronic field production (EFP).
- **figure/ground** (1) *Audio:* emphasizing the most important sound source over the general background sounds. (2) *Video:* objects seen in front of a background; the ground is perceived to be more stable than the figure.
- fill light Additional light on the opposite side of the camera from the key light to illuminate shadow areas and thereby reduce falloff. Usually done with floodlights.

film-style directing See single-camera directing

- **film-style shooting** Directing method for single-camera production wherein you move from an establishing long shot to medium shots, then to close-ups of the same action. Also used to mean single-camera production.
- **fishpole** A suspension device for a microphone; the mic is attached to a pole and held over the scene for brief periods.
- **fixed-focal-length lens** A lens whose focal length cannot be changed (contrary to a zoom lens that has a variable focal length). Also called *prime lens*.
- **flag** A thin, rectangular sheet of metal, plastic, or cloth used to block light from falling on specific areas. Also called *gobo*.

flare See halo

flash drive See flash memory device

flash memory card See flash memory device

flash memory device A small read/write portable storage device that can download, store, and upload very fast (in a flash) a fairly large amount (1 gigabyte or more) of digital information. Also called *flash drive*, *stick flash*, *flash stick*, or *flash memory card*.

flash stick See flash memory device

- **flat** (1) *Lighting*: even illumination with minimal shadows (slow falloff). (2) *Scenery*: a piece of standing scenery used as a background or to simulate the walls of a room.
- **flat response** Measure of a microphone's ability to hear equally well over its entire frequency range. Is also used as a measure for devices that record and play back a specific frequency range.
- **flicker** A periodic change in brightness; when pixels of one frame begin to fade, they are activated again by the next frame scan.
- **floodlight** Lighting instrument that produces diffused light with a relatively undefined beam edge.

- **floor plan** A diagram of scenery and properties drawn on a grid pattern. *See also* **floor plan pattern**.
- **floor plan pattern** A plan of the studio floor, showing the walls, the main doors, the location of the control room, and the lighting grid or batten. *See also* **floor plan**.
- **floor stand** Heavy stand mounted on a three-caster dolly, designed specifically to support a variety of lighting instruments. An extension pipe lets you adjust the vertical position of the lighting instrument to a certain degree.
- **fluid head** Most popular mounting head for lightweight ENG/EFP cameras. Balance is provided by springs. Because its moving parts operate in a heavy fluid, it allows very smooth pans and tilts.
- **fluorescent** Lamps that generate light by activating a gasfilled tube to give off ultraviolet radiation, which lights up the phosphorous coating inside the tubes.
- focal length The distance from the optical center of the lens to the front surface of the camera's imaging device at which the image appears in focus with the lens set at infinity. Focal lengths are measured in millimeters or inches. Short-focal-length lenses have a wide angle of view (wide vista); long-focal-length (telephoto) lenses have a narrow angle of view (close-up). In a variable-focal-length (zoom) lens, the focal length can be changed continuously from wide-angle (zoomed out) to narrowangle (zoomed in) and vice versa. A fixed-focal-length (or prime) lens has a single designated focal length.
- **focus** A picture is in focus when it appears sharp and clear on-screen (technically, the point where the light rays refracted by the lens converge).
- **focus control unit** Control that activates the focus mechanism in a zoom lens.
- **foldback** The return of the total or partial audio mix to the talent through headsets or I.F.B. channels. Also called *cue-send*.
- **Foley stage** A variety of equipment set up in a recording studio to produce common sound effects, such as footsteps, doors opening and closing, and glass breaking.
- **follow focus** Maintaining the focus of the lens in a shallow depth of field so that the image of an object is continuously kept sharp and clear even when the camera or object moves.
- **follow spot** Powerful special-effects spotlight used primarily to simulate theater stage effects. It generally follows action, such as dancers, ice skaters, or single performers moving in front of a stage curtain.

- foot-candle (fc) The American unit of measurement of illumination, or the amount of light that falls on an object. One foot-candle is the amount of light from a single candle that falls on a 1-square-foot area located 1 foot away from the light source. See also lux.
- **format** Type of television script indicating the major programming steps; generally contains a fully scripted show opening and closing.
- **foundation** A makeup base over which further makeup such as rouge and eye shadow is applied.
- fps Stands for frames per second. See frame rate.
- **fractal** Computer program based on complex mathematical formulas that is used to create realistic and fantasy landscapes and a great variety of abstract patterns.
- frame (1) The smallest picture unit in film, a single picture.
 (2) A complete scan of all picture lines by the electron beam. See interlaced scanning and progressive scanning.
- **frame rate** The number of complete video frames the video system is producing each second. Also expressed as *fps*. The NTSC standard of traditional American television is 30 fps. The 480p and 720p scanning systems normally have a frame rate of 60 fps. Some HD electronic cinema cameras have a frame rate of 24 fps and/or variable frame rates. The standard 1080i HDTV system has a frame rate of 30 fps.
- framestore synchronizer Image stabilization and synchronization system that stores and reads out one complete video frame. Used to synchronize signals from a variety of video sources that are not genlocked.
- **frame timing** The front- or back-timing of time code numbers, which include hours, minutes, seconds, and frames. Frames roll over to the next second after twenty-nine, but seconds and minutes after fifty-nine.
- **freeze-frame** Continuous replaying of a single frame, which is perceived as a still shot.
- frequency Cycles per second, measured in hertz (Hz).
- **frequency response** Measure of the range of frequencies a microphone can hear and reproduce.
- **Fresnel spotlight** One of the most common spotlights, named after the inventor of its lens. Its lens has steplike concentric rings.
- **friction head** Camera mounting head that counterbalances the camera weight by a strong spring. Good only for relatively light cameras.

- **front-timing** The process of figuring out clock times by adding given running times to the clock time at which the program starts.
- f-stop The calibration on the lens indicating the aperture, or iris opening (and therefore the amount of light transmitted through the lens). The larger the f-stop number, the smaller the aperture; the smaller the f-stop number, the larger the aperture.

full shot See long shot

- **fully scripted format** A complete script that contains all dialogue or narration and major visualization cues.
- **gain** (1) *Audio:* level of amplification for audio signals. "Riding gain" means keeping the sound volume at a proper level. (2) *Video:* electronic amplification of the video signal, boosting primarily picture brightness.
- **gel** Generic term for color filters put in front of spotlights or floodlights to give the light beam a specific hue. *Gel* comes from *gelatin*, the filter material used before the invention of more-durable plastics. Also called *color media*.
- **generating element** The primary part of a microphone. It converts sound waves into electric energy.
- generation The number of dubs away from the original recording. A first-generation dub is struck directly from the source tape. A second-generation tape is a dub of the first-generation dub (two steps away from the original tape), and so forth. In analog recordings, the greater the number of nondigital generations, the greater the quality loss. Digital recordings remain virtually the same through many generations.
- **genlock** (1) Locking the synchronization generators from two different origination sources, such as remote and studio. Allows switching from source to source without picture rolling. (2) Locking the house sync with the sync signal from another source (such as a videotape).
- **gigabyte** 1,073,741,824 bytes (230 bytes); usually figured as roughly 1 billion bytes.
- **giraffe boom** A medium-sized microphone boom that can be operated by one person. Also called *tripod boom*.
- **gobo** In television, a scenic foreground piece through which the camera can shoot, thus integrating the decorative foreground with the background action. In film a gobo is an opaque shield used for partially blocking a light, or the metal cutout that projects a pattern on a flat surface. *See also* **cookie** and **flag**.
- **graphics generator** Dedicated computer or software that allows a designer to draw, color, animate, store, and retrieve images electronically. Any desktop computer with a

high-capacity RAM and hard drive can become a graphics generator with the use of 2-D and 3-D software.

graphic vector See vector

- **grayscale** A scale indicating intermediate steps from TV white to TV black. Usually measured with a nine- or seven-step scale.
- halo Dark or colored flare around a very bright light source or a highly reflecting object. Also called *flare*.
- **hand props** Objects, called *properties*, that are handled by the performer.
- hard copy A computer printout of text or graphics. In computer editing, the hard copy prints out the EDL. (Soft-copy information appears only on the computer screen.)
- hard drive A high-capacity computer storage disk. Floppy disks have a lower storage capacity. Often called *hard disk*.

HDV See high-definition video

HDTV See high-definition television

- head assembly (1) Audio: small electromagnets that erase the signal from the tape (erase head), put the signals on the tape (record head), and read (induce) them off the tape (playback head). (2) Video: small electromagnets that put electrical signals on the videotape or read (induce) the signals off the tape. Video heads, as well as the tape, are in motion.
- **head end** Section of cable television distribution system where signals are collected or originated.
- **headroom** The space left between the top of the head and the upper screen edge.
- headset microphone Small but good-quality omni- or unidirectional mic attached to padded earphones; similar to a telephone headset but with a higher-quality mic.
- **helical scan** The diagonally slanted path of the video signal when recorded on the videotape. Also called *helical VTR* or *slant-track*.

helical VTR See helical scan

- HID light Stands for halide iodide discharge. Uses a highintensity lamp that produces light by passing electricity through a specific type of gas. Has its ballast attached to the lamp. Similar to the HMI light. See metal halide discharge.
- **high-definition television (HDTV)** Has at least twice the picture detail of standard (NTSC) television. The 720p uses 720 visible, or active, lines that are normally scanned

- progressively each 1/60 second. The 1080i standard uses 60 fields per second, each field consisting of 539.5 visible, or active, lines. A complete frame consists of two interlaced scanning fields of 539.5 visible lines. The *refresh rate* (complete scanning cycle) for HDTV systems can vary.
- **high-definition television (HDTV) camera** Video camera that delivers pictures of superior resolution, color fidelity, and light-and-dark contrast; uses high-quality CCDs and zoom lens.
- high-definition video (HDV) A recording system that produces images of the same resolution as HDTV (720p and 1080i) with equipment that is similar to standard digital video camcorders. The video signals are much more compressed than those of HDTV, however, which results in lower overall video quality.
- **high hat** Cylindrical camera mount that can be bolted to a dolly or scenery to permit panning and tilting the camera without a tripod or pedestal.
- **high-key** Light background and ample light on the scene. Has nothing to do with the vertical positioning of the key light.
- high-Z High impedance. See also impedance.
- **HMI light** Stands for *hydragyrum medium arc-length iodide*. Uses a high-intensity lamp that produces light by passing electricity through a specific type of gas. Needs a separate ballast. Similar to the HID light. *See* **metal halide discharge**.
- **horizontal blanking** The temporary starvation of the electron beam when it returns to write another scanning line.
- **hot** (1) A current- or signal-carrying wire. (2) A piece of equipment that is turned on, such as a hot camera or a hot microphone.
- hot spot Undesirable concentration of light in one spot.
- **house number** The in-house system of identification for each piece of recorded program material. Called the *house number* because the code numbers differ from station to station (house to house).
- **hue** One of the three basic color attributes; hue is the color itself—red, green, yellow, and so on.

hundredeighty See vector line

- **HUT** Stands for *households using television*. Used in calculating share, the HUT figure represents 100 percent of all households using television. *See also* **share**.
- Hz Hertz, which measures cycles per second.

- IATSE Stands for International Alliance of Theatrical Stage Employees, Moving Picture Technicians, Artists and Allied Crafts of the United States, Its Territories and Canada. Trade union.
- **IBEW** Stands for *International Brotherhood of Electrical Workers*. Trade union for studio and master control engineers; may include floor personnel.

$\textbf{I.F.B.} \ \textit{See} \ \textbf{interruptible} \ \textbf{foldback} \ \textbf{or} \ \textbf{interruptible} \ \textbf{feedback}$

I-F lens See internal focus (I-F) lens

- **impedance** Type of resistance to the signal flow. Important especially in matching high- or low-impedance microphones with high- or low-impedance recorders.
- **impedance transformer** Device allowing a high-impedance mic to feed a low-impedance recorder or vice versa.
- **incandescent** The light produced by the hot tungsten filament of ordinary glass-globe or quartz-iodine light bulbs (in contrast to fluorescent light).
- incident light Light that strikes the object directly from its source. An incident-light reading is the measure of light in foot-candles (or lux) from the object to the light source. The light meter is pointed directly into the light source or toward the camera.

index vector See vector

inky-dinky See camera light

inner focus lens See internal focus (I-F) lens

- **input overload distortion** Distortion caused by a microphone when subjected to an exceptionally high-volume sound. Condenser microphones are especially prone to input overload distortion.
- **insert editing** Requires the prior laying of a control track on the edit master tape. The shots are edited in sequence or inserted into an already existing recording. Necessary mode for editing audio and video tracks separately.
- **instant replay** Repeating for the viewer, by playing back videotape or disk-stored video, a key play or an important event immediately after its live occurrence.

instantaneous editing See switching

- **intercom** Short for *intercommunication system*. Used by all production and technical personnel. The most widely used system has telephone headsets to facilitate voice communication on several wired or wireless channels. Includes other systems, such as I.F.B. and cell phones.
- **interframe compression** A compression technique that borrows recurring pixels from previous frames, thus reducing the number of pixels.

- interlaced scanning In this system the beam skips every other line during its first scan, reading only the odd-numbered lines. After the beam has scanned half of the last odd-numbered line, it jumps back to the top of the screen and finishes the unscanned half of the top line and continues to scan all the even-numbered lines. Each such even- or odd-numbered scan produces a *field*. Two fields produce a complete *frame*. Standard NTSC television operates with 60 fields per second, which translates into 30 frames per second.
- internal focus (I-F) lens A mechanism of an ENG/EFP lens that allows focusing without having the front part of the lens barrel extend and turn.
- **internal key** The cutout portion of the base picture is filled with the signal that is doing the cutting.
- interruptible foldback or interruptible feedback (I.F.B.)

 Communication system that allows communication with the talent while on the air. A small earpiece worn by on-the-air talent carries program sound or instructions from the producer or director.
- **in-the-can** A term borrowed from film, which referred to when the finished film was literally in the can. It now refers to a finished television recording; the show is preserved and can be broadcast at any time.
- **intraframe compression** A compression method that looks for and eliminates redundant pixels in each frame.
- **inverse square law** The intensity of light falls off as $1/d^2$ from the source, where d is distance from the source. It means that light intensity decreases as distance from the source increases. Valid only for light sources that radiate light isotropically (uniformly in all directions) but not for light whose beam is partially collimated (focused), such as from a Fresnel or an ellipsoidal spot.
- **ips** Stands for *inches per second*. An indication of tape speed.
- **iris** Adjustable lens-opening that controls the amount of light passing through the lens. Also called *diaphragm* or *lens diaphragm*.
- **isolated (iso) camera** Feeds into the switcher and into its own separate video recorder.
- **jack** (1) A socket or phone-plug receptacle. (2) A brace for scenery.
- **jib arm** Similar to a camera crane. Permits the jib arm operator to raise, lower, and tongue (move sideways) the jib arm while titling and panning the camera.
- **jogging** Frame-by-frame advancement of videotape with a VTR. *See also* **stop-motion**.

- **JPEG** A video compression method mostly for still pictures, developed by the Joint Photographic Experts Group.
- **jump cut** (1) Cutting between shots that are identical in subject yet slightly different in screen location. The subject seems to jump from one screen location to another for no apparent reason. (2) Any abrupt transition between shots that violates the established continuity.
- **Kelvin (K)** Refers to the Kelvin temperature scale. In lighting it is the specific measure of color temperature—the relative reddishness or bluishness of white light. The higher the K number, the more bluish the white light. The lower the K number, the more reddish the white light.
- **key** An electronic effect. *Keying* means cutting with an electronic signal one image (usually lettering) into a different background image.
- **key bus** A row of buttons on the switcher, used to select the video source to be inserted into a background image.
- **key-level control** Switcher control that adjusts the key signal so that the title to be keyed appears sharp and clear. Also called *clip control* or *clipper*.
- key light Principal source of illumination.
- **kicker light** Usually directional light that is positioned low and from the side and the back of the subject.
- **kilobyte** 1,024 bytes (210 bytes); usually figured as roughly 1,000 bytes.
- kilowatt (kW) 1,000 watts.
- **knee shot** Framing of a person from approximately the knees up.
- **Ku-band** A high-frequency band used by certain satellites for signal transport and distribution. The Ku-band signals can be influenced by heavy rain or snow. *See also* **C-band**.
- kW See kilowatt
- **lag** Smear that follows a moving object or motion of the camera across a stationary object under low light levels.
- lap dissolve See dissolve
- **lavaliere microphone** A small microphone that can be clipped onto clothing.
- **layering** Combining two or more key effects for a more complex effect.
- **LD** Stands for *lighting director*.
- **leader numbers** Numerals used for the accurate cueing of the videotape and film during playback. The numbers

- from 10 to 3 flash at 1-second intervals and are sometimes synchronized with short audio beeps.
- **leadroom** The space left in front of a person or an object moving toward the edge of the screen. *See also* **noseroom**.
- **lens** Optical lens, essential for projecting an optical (light) image of a scene onto the film or the front surface of the camera pickup device. Lenses come in various fixed focal lengths or in a variable focal length (zoom lenses) and with various maximum apertures (iris openings).

lens diaphragm See iris

- **lens prism** A prism that, when attached to the camera lens, produces special effects, such as the tilting of the horizon line or the creation of multiple images.
- **level** (1) *Audio*: sound volume. (2) *Video*: signal strength (amplitude).
- libel Written or televised defamation.
- **lighting** The manipulation of light and shadows: to provide the camera with adequate illumination for technically acceptable pictures; to tell us what the objects on-screen actually look like; and to establish the general mood of the event.
- **lighting triangle** The triangular arrangement of key, back, and fill lights. Also called *triangle lighting*. See **photographic lighting principle**.
- **light level** Light intensity measured in lux or foot-candles. *See also* **foot-candle** (**fc**) and **lux**.

lightness See brightness

- **light plot** A plan, similar to a floor plan, that shows the type, size (wattage), and location of the lighting instruments relative to the scene to be illuminated and the general direction of the beams.
- light ratio The relative intensities of key, back, and fill. A 1:1 ratio between key and back lights means that both light sources burn with equal intensities. A 1:½ ratio between key and fill lights means that the fill light burns with half the intensity of the key light. Because light ratios depend on many production variables, they cannot be fixed. A key:back:fill ratio of 1:1:½ is often used for normal triangle lighting.
- limbo Any set area that has a plain, light background.

line See vector line

linear editing Analog or digital editing that uses tape-based systems. Selection of shots is nonrandom.

line monitor The monitor that shows only the line-out pictures that go on the air or on videotape. Also called *master monitor* or *program monitor*.

line of conversation and action See vector line

line-out The line that carries the final video or audio output for broadcast.

line producer Supervises daily production activities on the set.

lip-sync Synchronization of sound and lip movement.

live-on-tape The uninterrupted videotape recording of a live show for later unedited playback.

location sketch A rough map of the locale of a remote telecast. For an indoor remote, the sketch shows the room dimensions and the furniture and window locations. For an outdoor remote, the sketch indicates the location of buildings, the remote truck, power sources, and the sun during the time of the telecast.

location survey Written assessment, usually in the form of a checklist, of the production requirements for a remote.

locking-in An especially vivid mental image—visual or aural—during script analysis that determines the subsequent visualizations and sequencing.

lockup time The time required by a videotape recorder for the picture and sound to stabilize once the tape has been started.

log The major operational document: a second-by-second list of every program aired on a particular day. It carries such information as program source or origin, scheduled program time, program duration, video and audio information, code identification (house number, for example), program title, program type, and additional pertinent information.

long-focal-length lens See narrow-angle lens

long shot (LS) Object seen from far away or framed loosely. Also called *establishing shot* or *full shot*.

lossless compression Rearranging but not eliminating pixels during storage and transport. *See also* **compression**.

lossy compression Throwing away redundant pixels during compression. Most compression methods are of the lossy kind. *See also* **compression**.

low-angle dolly Dolly used with high hat to make a camera mount for particularly low shots.

low-key Dark background and illumination of selected areas. Has nothing to do with the vertical positioning of the key light.

low-Z Low impedance. See also impedance.

LS See long shot

lumen The light intensity power of one candle (light source radiating isotropically, i.e., in all directions).

luminaire Technical term for lighting instrument.

luminance The measured brightness (black-and-white) information of a video signal (reproduces the grayscale). Also called *Y signal*.

luminance channel A separate channel within color cameras that deals with brightness variations and allows them to produce a signal receivable on a black-and-white television. The luminance signal is usually electronically derived from the chrominance signals. Also called *Y channel*.

luminant Lamp that produces the light; the light source.

lux European standard unit for measuring light intensity: 1 lux is the amount of 1 lumen (one candlepower of light) that falls on a surface of 1 square meter located 1 meter away from the light source; 10.75 lux = 1 fc; usually roughly translated as 10 lux = 1 fc. *See also* **footcandle** (fc).

macro position A lens setting that allows it to be focused at very close distances from an object. Used for close-ups of small objects.

makeup Cosmetics used to enhance, correct, or change appearance.

master control Nerve center for all telecasts. Controls the program input, storage, and retrieval for on-the-air telecasts. Also oversees technical quality of all program material.

master monitor See line monitor

matte key Keyed (electronically cut in) title whose letters are filled with shades of gray or a specific color.

MCU Medium close-up.

MD See mini disc

M/E bus Short for *mix/effects bus*. A row of buttons on the switcher that can serve a mix or an effects function.

medium requirements All content elements, production elements, and people needed to generate the defined process message.

medium shot (MS) Object seen from a medium distance. Covers any framing between a long shot and a close-up. Also called *waist shot*.

- **megabyte** 1,048,576 bytes (220 bytes); usually figured roughly as 1 million bytes.
- **megapixel** A CCD or digital image containing about 1 million pixels. The higher the number of pixels, the higher the picture resolution. Generally used to indicate the relative quality of digital still cameras.
- **mental map** Tells viewer where things are or are supposed to be in on- and off-screen space. *See also* **closure**.
- metal halide discharge Produces light by passing electricity through a specific type of gas. Needs a ballast to start the light and keep it burning evenly. Includes HID and HMI lights.

mic See microphone

- **microphone** A small, portable assembly for the pickup and conversion of sound into electric energy. Also called *mic*.
- **microwave relay** A transmission method from the remote location to the station and/or transmitter involving the use of several microwave units.

MIDI See musical instrument digital interface

- mini-cassette A small $(2\frac{1}{2} \times 1\frac{1}{8} \text{ inch or } 65 \times 47 \text{mm}) \frac{1}{4}$ -inch tape cassette used in digital consumer or prosumer cameras. It allows one hour of recording with standard recording speed.
- mini disc (MD) Optical 2½-inch-wide disc that can store one hour of CD-quality audio.
- mini-link Several microwave setups that are linked together to transport the video and audio signals past obstacles to their destination (usually the television station and/or transmitter).
- **minimum object distance (MOD)** How close the camera can get to an object and still focus on it.
- **mix bus** (1) *Audio:* a mixing channel for audio signals. The mix bus combines sounds from several sources to produce a mixed sound signal. (2) *Video:* rows of buttons on the switcher that permit the mixing of video sources, as in a dissolve or a super.
- **mixdown** Final combination of sound tracks on a single or stereo track of an audio- or videotape.

mix/effects bus See M/E bus

mixing (1) *Audio:* combining two or more sounds in specific proportions (volume variations) as determined by the event (show) context. (2) *Video:* creating a dissolve or superimposition via the switcher.

- mix-minus Type of multiple audio feed missing the part that is being recorded, such as an orchestra feed with the solo instrument being recorded. Also refers to program sound feed without the portion supplied by the source that is receiving the feed.
- mm Millimeter, one-thousandth of a meter: 25.4mm = 1 inch.

MOD See minimum object distance

- **moiré effect** Color vibrations that occur when narrow, contrasting stripes of a design interfere with the scanning lines of the television system.
- monitor (1) Audio: speaker that carries the program sound independent of the line-out. (2) Video: high-quality television set used in the television studio and control rooms. Cannot receive broadcast signals.
- **monochrome** One color. In television it refers to a camera or monitor that reads only various degrees of brightness and produces a black-and-white picture.
- **monopod** A single pole onto which you can mount a camera.
- **montage** The juxtaposition of two or more, often seemingly unrelated, shots to generate a third overall idea, which may not be contained in any one.
- **mosaic** Computer-generated visual effect that looks as though the image is composed of mosaic tiles.

motion vector See vector

moving-coil microphone See dynamic microphone

- MP3 A widely used compression system for digital audio. Most Internet-distributed audio is compressed in the MP3 format.
- **MPEG** A compression technique for moving pictures, developed by the Moving Picture Experts Group.
- MPEG-2 The compression standard for motion video.
- MPEG-4 The compression standard for Internet streaming.

MS See medium shot

- **multicamera directing** Simultaneous coordination of two or more cameras for instantaneous editing (switching). Also called *control room directing*.
- **multiple-microphone interference** The canceling out of certain sound frequencies when two identical microphones close together are used to record the same sound source on the same tape.

- **multiplexing** A method of transmitting video and audio signals on the same carrier wave simultaneously or sequentially in time.
- multiple-source editing system Editing system having two or more source VTRs.
- musical instrument digital interface (MIDI) A standardized protocol that allows the connection and interaction of various digital audio equipment and computers.
- NAB Stands for National Association of Broadcasters.
- **NABET** Stands for *National Association of Broadcast Employees* and *Technicians*. Trade union for studio and master control engineers; may include floor personnel.
- **narrow-angle lens** Gives a close-up view of an event relatively far away from the camera. Also called *long-focal-length* or *telephoto lens*.

ND filter See neutral density filter

- **neutral density (ND) filter** Filter that reduces the incoming light without distorting the color of the scene.
- **news production personnel** People assigned exclusively to the production of news, documentaries, and special events.
- noise (1) Audio: unwanted sounds that interfere with the intentional sounds, or unwanted hisses or hums inevitably generated by the electronics of the audio equipment. (2) Video: electronic interference that shows up as "snow."

NLE See nonlinear editing

- **non-drop frame mode** A video-recording mode in which the slight discrepancy between actual frame count and elapsed clock time is ignored by the SMPTE time code.
- **nonlinear editing (NLE)** Allows instant random access to shots and sequences and easy rearrangement. The video and audio information is stored in digital form on computer hard disks or read/write optical discs. Uses disk-based computer systems.
- **nontechnical production personnel** People concerned primarily with nontechnical production matters that lead from the basic idea to the final screen image. Also called *above-the-line personnel*.
- **normal lens** A lens or zoom lens position with a focal length that approximates the spatial relationships of normal vision.
- **noseroom** The space left in front of a person looking or pointing toward the edge of the screen. *See also* leadroom.

NTSC Stands for *National Television System Committee*. Normally designates the composite television signal, consisting of the combined chroma information (red, green, and blue signals) and the luminance information (black-and-white signal). *See* composite system.

NTSC signal See composite system

- **off-line editing** In linear editing it produces an edit decision list or a videotape not intended for broadcast. In nonlinear editing the selected shots are captured in low resolution to save computer storage space.
- **omnidirectional** Pickup pattern in which the microphone can pick up sounds equally well from all directions.
- **on-line editing** In linear editing it produces the final high-quality edit master tape for broadcast or program duplication. In nonlinear editing it requires recapturing the selected shots at a higher resolution.
- **operating light level** Amount of light needed by the camera to produce a video signal. Most color cameras need from 100 to 250 foot-candles of illumination for optimal performance at a particular *f*-stop, such as *f*/8. Also called *baselight level*.
- **optical disc** A digital storage device whose information is recorded and read by laser beam.

O/S See over-the-shoulder shot

oscilloscope See waveform monitor

- **over-the-shoulder shot (O/S)** Camera looks over a person's shoulder (shoulder and back of head included in shot) at another person.
- PA Stands for production assistant.
- **P.A.** Stands for *public address*. Loudspeaker system. Also called *studio talkback* or *S.A.* (*studio address*) *system*.
- **pace** Perceived duration of the show or show segment. Part of subjective time.
- pan To turn the camera horizontally.
- **pancake** A makeup base, or foundation makeup, usually water-soluble and applied with a small sponge.
- pan stick A foundation makeup with a grease base. Used to cover a beard shadow or prominent skin blemish.
- **pantograph** Expandable hanging device for lighting instruments
- **paper-and-pencil editing** The process of examining window-dubbed, low-quality (VHS) source tapes and creating a preliminary edit decision list by writing down edit-in and edit-out numbers for each selected shot. Also called *paper editing*.

PAR (parabolic aluminized reflector) lamp See clip light

parabolic reflector microphone A parabolic small dish whose focal center contains a microphone. Used for pickup of faraway sounds.

patchbay See patchboard

- **patchboard** A device that connects various inputs with specific outputs. Also called *patchbay*.
- **pattern projector** An ellipsoidal spotlight with a cookie (cucoloris) insert, which projects the cookie's pattern as a cast shadow.
- **peak program meter (PPM)** Meter in audio console that measures loudness. Especially sensitive to volume peaks, it indicates overmodulation.
- pedestal (1) Heavy camera dolly that permits raising and lowering the camera while on the air. (2) To move the camera up and down via a studio pedestal. (3) The black level of a television picture; can be adjusted against a standard on the waveform monitor.
- **perambulator boom** Mount for a studio microphone. An extension device, or boom, is mounted on a dolly, called a *perambulator*, that permits rapid and quiet relocation anywhere in the studio. Also called *big boom*.
- **performer** A person who appears on-camera in nondramatic shows. Performers play themselves and do not assume someone else's character.
- **periaktos** A triangular piece of scenery that can be turned on a swivel base.
- **phantom power** The power for preamplification in a condenser microphone, supplied by the audio console rather than a battery.
- phone plug A ¼-inch plug most commonly used at both ends of audio patch cords. These plugs are also used to route sound signals over relatively short distances from various musical instruments, such as electric guitars or keyboards.
- photographic lighting principle The triangular arrangement of key, back, and fill lights, with the back light opposite the camera and directly behind the object, and the key and fill lights on opposite sides of the camera and to the front and the side of the object. Also called *triangle lighting*.
- **pickup** (1) Sound reception by a microphone. (2) Reshooting parts of a scene for postproduction editing.
- **pickup pattern** The territory around the microphone within which the microphone can "hear equally well," that is, has optimal sound pickup.

picture element See pixel

- **pipe grid** Heavy steel pipes mounted above the studio floor to support lighting instruments.
- **pixel** Short for *pic*ture *ele*ment. (1) A single imaging element (like the single dot in a newspaper picture) that can be identified by a computer. The more pixels per picture area, the higher the picture quality. (2) The light-sensitive elements on a CCD that contain a charge.
- **P.L.** Stands for *private line* or *phone line*. Major intercommunication system in television production.

play VTR See source VTR

- **plot** How a story develops from one event to the next.
- **point of view (POV)** As seen from a specific character's perspective. Gives the director a clue to camera position.
- **polar pattern** The two-dimensional representation of a microphone pickup pattern.
- **polarity reversal** The reversal of the grayscale; the white areas in the picture become black, and the black areas become white. Color polarity reversal in colors results in the complementary color.
- **pop filter** A bulblike attachment (either permanent or detachable) on the front of a microphone, which filters out sudden air blasts, such as plosive consonants (*p*, *t*, and *k*) delivered directly into the mic.
- **ports** (1) Slots in the microphone that help achieve a specific pickup pattern and frequency response. (2) Jacks on the computer for plugging in peripheral hardware.
- **posterization** Visual effect that reduces the various brightness values to only a few (usually three or four) and gives the image a flat, posterlike look.
- **postproduction** Any production activity that occurs after the production. Usually refers to either videotape editing or audio sweetening (postscoring and mixing sound for later addition to the picture portion).
- **postproduction editing** The assembly of recorded material after the actual production.
- pot Short for potentiometer. A sound-volume control.

POV See point of view

PPM See peak program meter

- **preamp** Short for *preamplifier*. Strengthens weak electrical signals produced by a microphone or camera pickup device before they can be further processed (manipulated) and amplified to normal signal strength.
- preproduction Preparation of all production details.

preroll To start a videotape and let it roll for a few seconds before it is put in the playback or record mode so that the electronic system has time to stabilize.

preset/background See preview/preset bus

preset board A program device into which several lighting setups (scenes) can be stored and later retrieved.

preset monitor (PST) Allows previewing of a shot or an effect before it is switched on the air. Its feed can be activated by the *TAKE* button. Similar to preview monitor.

pressure zone microphone (PZM) See boundary microphone

preview/preset bus Rows of buttons on the switcher used to select the upcoming video (preset function) and route it to the preview monitor (preview function) independent of the line-out video. Also called preset/background.

preview (P/V) monitor (1) Any monitor that shows a video source, except for the line (master) and off-the-air monitors. (2) A color monitor that shows the director the picture to be used for the next shot.

prime lens See fixed-focal-length lens

prism block See beam splitter

process message The message actually received by the viewer in the process of watching a television program.

producer Creator and organizer of television shows.

production personnel (nontechnical) See nontechnical production personnel

production personnel (technical) See technical production personnel

production schedule The calendar that shows the preproduction, production, and postproduction dates and who is doing what, when, and where.

production switcher Switcher located in the studio control room or remote truck, designed for instantaneous editing.

program (1) A specific television show. (2) A sequence of instructions, encoded in a specific computer language, to perform predetermined tasks.

program/background See program bus

program bus The bus on a switcher whose inputs are directly switched to the line-out. Allows cuts-only switching. Also called *direct bus* or *program/background*.

program length See running time

program monitor See line monitor

program proposal Written document that outlines the process message and the major aspects of a television presentation.

program speaker A loudspeaker in the control room that carries the program sound. Its volume can be controlled without affecting the actual line-out program feed. Also called *audio monitor*.

progressive scanning In this system the electron beam starts with line 1, then scans line 2, then line 3, and so forth, until all lines are scanned, at which point the beam jumps back to its starting position to repeat the scan of all lines.

props Short for *properties*. Furniture and other objects used for set decoration and by actors or performers.

PSA Public service announcement.

PST See preset monitor

psychographics Audience research factors concerned with such data as consumer buying habits, values, and lifestyles.

psychological closure See closure

pulse-count system See control track system

P/V See preview monitor

pylon Triangular set piece, similar to a pillar.

PZM Stands for *pressure zone microphone*. See **boundary microphone**.

quad-split Switcher mechanism that makes it possible to divide the screen into four variable-sized quadrants and fill each one with a different image.

quantization See quantizing

quantizing A step in the digitization of an analog signal. It changes the sampling points into discrete values. Also called *quantization*.

quartz A high-intensity incandescent light whose lamp consists of a quartz or silica housing (instead of the customary glass) that contains halogen gas and a tungsten filament. Produces a very bright light of stable color temperature (3,200K). Also called *TH* (tungsten-halogen). See also tungsten-halogen (TH).

quick-release plate Mounting plate used to attach camcorders and ENG/EFP cameras to the fluid head.

rack focus To change focus from one object or person closer to the camera to one farther away or vice versa.

radio frequency (RF) Broadcast frequency divided into various channels. In an RF distribution, the video and audio signals are superimposed on the radio frequency carrier wave. Usually called *RF*.

radio mic See wireless microphone

- **range extender** An optical attachment to the zoom lens that extends its focal length. Also called *extender*.
- rating Percentage of television households tuned to a specific station in relation to the total number of television households. See also share
- **RCA phono** Video and audio connectors for consumer equipment.

RCU See remote control unit

- rear projection (R.P.) Translucent screen onto which images are projected from the rear and photographed from the front.
- **record VTR** The videotape recorder that edits the program segments as supplied by the source VTR(s) into the final edit master tape. Also called *edit VTR*.
- **reel-to-reel** A tape recorder that transports the tape past the heads from one reel (the supply reel) to the other reel (the takeup reel).
- **reference black** The darkest element in a set, used as a reference for the black level (beam) adjustment of the camera picture.
- **reference white** The brightest element in a set, used as a reference for the white level (beam) adjustment of the camera picture.
- **reflected light** Light that is bounced off the illuminated object. A reflected-light reading is done with a light meter held close to the illuminated object.
- **refresh rate** The number of complete digital scanning cycles per second. *See* **frame**.

remote See big remote

- **remote control unit (RCU)** (1) The CCU control separate from the CCU itself. (2) A small, portable CCU that is taken into the field with the EFP camera. *See also* **camera control unit (CCU)**.
- **remote survey** A preproduction investigation of the location premises and event circumstances. Also called *site survey*.
- **remote truck** The vehicle that carries the program control, the audio control, the video-recording and instant-replay control, the technical control, and the transmission equipment.

- **resolution** The measurement of picture detail. Resolution is influenced by the imaging device, the lens, and the television set that shows the camera picture. Often used synonymously with *definition*.
- **reverberation** Reflections of a sound from multiple surfaces after the sound source has ceased vibrating. Generally used to liven sounds recorded in an acoustically "dead" studio. *See also* **echo**.

RF See radio frequency

RF mic See wireless microphone

- **RGB** Red, green, and blue—the basic colors of television.
- **RGB component system** Analog video-recording system wherein the red, green, and blue signals are kept separate throughout the entire recording and storage process and are transported via three separate wires.
- **ribbon microphone** A microphone whose sound pickup device consists of a ribbon that vibrates with the sound pressures within a magnetic field. Also called *velocity mic*.
- **riser** (1) Small platform. (2) The vertical frame that supports the horizontal top of the platform.

robotic See robotic pedestal

- **robotic pedestal** Motor-driven studio pedestal and mounting head. It is guided by a computerized system that can store and execute a great number of camera moves. Also called *robotic*.
- **roll** (1) Graphics (usually credit copy) that move slowly up the screen; *see also* **crawl**. (2) Command to start the videotape recorder.
- **rough-cut** The first tentative arrangement of shots and shot sequences in the approximate order and length. Done in off-line editing.

R.P. See rear projection

rundown sheet See fact sheet

- **running time** The duration of a program or program segment. Also called *program length*.
- **runout signal** The recording of a few seconds of black at the end of each videotape recording to keep the screen in black for the video changeover or editing.

run-through Rehearsal.

5.A. Stands for studio address. Loudspeaker system. See studio talkback.

safe area See essential area

safe title area See essential area

526

- **sampling** The process of reading (selecting and recording) from an analog electronic signal a great many equally spaced, tiny portions (values) for conversion into a digital code.
- **saturation** The color attribute that describes a color's richness or strength.
- **scale** Basic minimum fees for television talent as prescribed by the talent union.
- **scanning** The movement of the electron beam from left to right and from top to bottom on the television screen.
- **scanning area** Picture area that is scanned by the camera pickup device; in general, the picture area usually seen in the camera viewfinder and the preview monitor.
- **scene** Event details that form an organic unit, usually in a single place and time. A series of organically related shots that depict these event details.
- **scenery** Background flats and other pieces (windows, doors, pillars) that simulate a specific environment.

schedule time See clock time

- **scoop** A scooplike television floodlight.
- scrim (1) Lighting: a spun-glass material that is put in front of a lighting instrument as an additional light diffuser or intensity reducer. (2) Scenery: loosely woven curtain hanging in front of a cyclorama to diffuse light, producing a soft, uniform background.
- script Written document that tells what the program is about, who says what, what is supposed to happen, and what and how the audience should see and hear the event.
- script marking A director's written symbols on a script to indicate major cues.
- search (1) In editing, the variable speed control that forwards or reverses the videotape to the right address (shot). During the search the image remains visible on-screen.(2) The systematic examination of information in a computer database.
- **secondary frame effect** Visual effect in which the screen shows several images, each of which is clearly contained in its own frame.
- **SEG** (1) Stands for *Screen Extras Guild.* Trade union. (2) *See* **special-effects generator**.
- **selective focus** Emphasizing an object in a shallow depth of field through focus while keeping its foreground and/or background out of focus.
- **semiscripted format** Partial script that indicates major video cues in the left (video) column and partial dialogue and

- major audio cues in the right (audio) column. Used to describe a show for which the dialogue is indicated but not completely written out.
- **sequencing** The control and structuring of a shot series during editing.
- **servo stabilizer** Mechanism in certain camera mounts that absorbs wobbles and jitters.
- servo zoom control Zoom control that activates motordriven mechanisms.
- **set** Arrangement of scenery and properties to indicate the locale and/or mood of a show.

set light See background light

set module Series of flats and three-dimensional set pieces whose dimensions match, whether they are used vertically, horizontally, or in various combinations.

shader See video operator (VO)

- shading Adjusting picture contrast to the optimal contrast range; controlling the color and the white and black levels.
- **share** Percentage of television households tuned to a specific station in relation to all households using television (HUT); that is, all households with their sets turned on. *See also* **rating.**
- **shooter** An ENG/EFP camera operator. Sometimes called *DP* (*director of photography*) in EFP.
- **shot box** Box containing various controls for presetting zoom speed and field of view; usually mounted on the camera panning handle.

shot list See shot sheet

- **shot sheet** A list of every shot a particular camera has to get. It is attached to the camera to help the camera operator remember the shot sequence. Also called *shot list*.
- **shotgun microphone** A highly directional microphone for picking up sounds from a relatively great distance.
- show format Lists the show segments in order of appearance. Used in routine shows, such as daily game or interview shows.
- **shrinking** The reduction of the total frame to a smaller frame that contains the same picture content.
- **shuttle** Fast-forward and fast-rewind movement of videotape to locate a particular address (shot) on the tape.
- side light Usually directional light coming from the side of an object. Acts as additional fill light or a second key light and provides contour.

- **signal processing** The various electronic adjustments or corrections of the video signal to ensure a stable and/ or color-enhanced picture. Usually done with digital equipment.
- **signal-to-noise (S/N) ratio** The relation of the strength of the desired signal to the accompanying electronic interference (the noise). A high S/N ratio is desirable (strong video or audio signal relative to weak noise).
- **silhouette lighting** Unlighted objects or people in front of a brightly illuminated background.
- **single-camera directing** Directing a single camera (usually a camcorder) in the studio or field for takes that are separately recorded for postproduction. Also called *film-style directing*.
- **single-source editing system** Basic editing system that has only one source VTR. Also called *cuts-only editing system*.

site survey See remote survey

slander Oral defamation.

slant-track See helical scan

slate (1) Visual and/or verbal identification of each videotaped segment. (2) A small blackboard or whiteboard upon which essential production information is written. It is recorded at the beginning of each take.

slide fader See fader

- sliding rod Small steel pipe that supports a lighting instrument and can be moved into various vertical positions. It is attached to the lighting batten by a modified C-clamp.
- **slow lens** A lens that permits a relatively small amount of light to pass through at its maximum aperture (relatively high *f*-stop number at its lowest setting). Can be used only in well-lighted areas.
- **slow motion** A scene in which the objects appear to be moving more slowly than normal. In film, slow motion is achieved through high-speed photography and normal playback. In television, slow motion is achieved by slowing down the playback speed of the tape, which results in multiple scanning of each television frame.
- **SMPTE/EBU time code** Electronic signal recorded on the cue or address track of a videotape or a track of a multitrack audiotape to give each frame a specific address. The time code reader translates this signal into a specific number (hour, minutes, seconds, and frames) for each frame.

S/N See signal-to-noise ratio

- **snow** Electronic picture interference; looks like snow on the television screen.
- **softlight** Television floodlight that produces extremely diffused light.
- **soft wipe** Transition in which the demarcation line between two images is softened so the images blend into each other.
- **solarization** A special effect produced by a partial polarity reversal of an image. In a monochrome image, thin black lines are sometimes formed where the positive and negative image areas meet. In a color image, the reversal results in a combination of complementary hues.
- **SOT** Stands for *sound on tape*. The videotape is played back with pictures and sound.
- **sound bite** Brief portion of someone's on-camera statement.
- **sound perspective** Distant sound must go with a long shot, close sound with a close-up.
- **source tape** The videotape with the original footage.
- **source VTR** The videotape recorder that supplies the program segments to be assembled by the record VTR. Also called *play VTR*.
- special-effects controls Buttons on a switcher that regulate special effects. They include buttons for specific wipe patterns, the joystick positioner, DVE, color, and chromakey controls.
- **special-effects generator (SEG)** An image generator built into the switcher that produces special-effects wipe patterns and key effects.
- **spiking** To mark on the studio floor with chalk or gaffer's tape critical positions of talent, cameras, or scenery.

split intercom See double headset

- **split screen** Multi-image effect caused by stopping a directional wipe before its completion, each screen portion therefore showing a different image within its own frame.
- **spotlight** A lighting instrument that produces directional, relatively undiffused light with a relatively well-defined beam edge.
- **spotlight effect** Visual effect that looks like a super of a clearly defined circle of light over a base picture. Used to draw attention to a specific picture area.
- spreader A triangular base mount that provides stability and locks the tripod tips in place to prevent the legs from spreading.

- **squeeze-zoom** The continuous expansion or shrinking of a screen image without cropping it.
- **stand-by** (1) A warning cue for any kind of action in television production. (2) A button on a videotape recorder that activates the rotation of the video heads or head drum independent of the actual tape motion. In the *stand-by* position, the video heads can come up to speed before the videotape is started.
- **star filter** Filter that attaches to the front of the lens; changes prominent light sources into starlike light beams.
- **Steadicam** Camera mount whose built-in springs hold the camera steady while the operator moves.

stick flash See flash memory device

- stock shot An image of a common occurrence—clouds, storm, traffic, crowds—that can be repeated in a variety of contexts because its qualities are typical. There are stock-shot libraries from which any number of such shots can be obtained.
- **stop-motion** A slow-motion effect in which one frame jumps to the next, showing the object in a different position. *See also* **jogging**.
- **storyboard** A series of sketches of the key visualization points of an event, with the corresponding audio information.
- **streaming** A way of delivering and receiving digital audio and/or video as a continuous data flow that can be listened to or watched while the delivery is in progress. *See also* **downloading**.
- **strike** To remove certain objects; to break down scenery and remove equipment from the studio floor after the show.
- **striped filter** Extremely narrow, vertical stripes of red, green, and blue filters attached to the front surface of the single pickup device (single chip). They divide the incoming white light into the three light primaries without the aid of a beam splitter. More-efficient filters use a mosaic-like pattern instead of stripes to generate the light primaries.
- **strip light** Several self-contained lamps arranged in a strip; used mostly for illumination of the cyclorama or chromakey area. Also called *cyc light*.
- **studio camera** High-quality camera and zoom lens that cannot be maneuvered properly without the aid of a pedestal or some other camera mount.
- **studio monitor** A video monitor located in the studio, which carries assigned video sources, usually the video of the line-out.

- **studio talkback** A public address loudspeaker system from the control room to the studio. Also called *S.A.* (*studio address*) or *P.A.* (*public address*) *system*.
- subjective time The duration we feel.
- subtractive primary colors Magenta (bluish red), cyan (greenish blue), and yellow. When mixed these colors act as filters, subtracting certain colors. When all three are mixed, they filter out one another and produce black.
- **super** Short for *superimposition*. A double exposure of two images, with the top one letting the bottom one show through.
- **supply reel** Reel that holds film or tape, which it feeds to the takeup reel.
- **surround sound** Sound that produces a soundfield in front of, to the sides of, and behind the listener by positioning loudspeakers either to the front and rear or to the front, sides, and rear of the listener.

S-video See Y/C component system

- **sweep** (1) Electronic scanning. (2) Curved piece of scenery, similar to a large pillar cut in half.
- **sweep reversal** Electronic scanning reversal; results in a mirror image (horizontal sweep reversal) or in an upsidedown image (vertical sweep reversal).
- **sweetening** Variety of quality adjustments of recorded sound in postproduction.
- **switcher** (1) Technical crew member doing the video switching (usually the technical director). (2) A panel with rows of buttons that allows the selection and assembly of various video sources through a variety of transition devices, and the creation of electronic special effects.
- **switching** A change from one video source to another during a show or show segment with the aid of a switcher. Also called *instantaneous editing*.
- **sync generator** Part of the camera chain; produces electronic synchronization signal.
- **sync pulses** Electronic pulses that synchronize the scanning in the various video origination sources (studio cameras and/or remote cameras) and various recording, processing, and reproduction sources (videotape, monitors, and television receivers). *See also* **control track**.
- sync roll Vertical rolling of a picture caused by switching among video sources whose scanning is out of step. Also noticeable on a bad edit in which the control tracks of the edited shots do not match.

- **system** The interrelationship of various elements and processes whereby the proper functioning of each element is dependent on all others.
- **system microphone** Microphone consisting of a base upon which several heads can be attached that change its sound pickup characteristic.
- **systems design** A plan that shows the interrelation of two or more systems. In television production it shows the interrelation of all major production elements as well as the flow (direction) of the production processes.
- take (1) Signal for a cut from one video source to another.
 (2) Any one of similar repeated shots taken during video-taping and filming. Sometimes take is used synonymously with shot. A good take is the successful completion of a shot, a show segment, or the videotaping of the whole show. A bad take is an unsuccessful recording, requiring another take.
- **take button** Same as *auto transition*. A button on the switcher that activates automatically a specific transition.
- **takeup reel** Reel that receives (takes up) film or tape from the supply reel. Must be the same size as the supply reel to maintain proper tension.
- **talent** Collective name for all performers and actors who appear regularly on television.
- **tally light** Red light on the camera and/or inside the view-finder, indicating when the camera is on the air.
- **tape-based video recorder** All video recorders (analog and digital) that record or store information on videotape. All tape-based systems are linear.

tape cassette See cassette

- **tapeless system** Refers to the recording, storage, and playback of audio and video information via computer storage devices rather than videotape.
- **target audience** The audience selected or desired to receive a specific message.

TBC See time base corrector

TD Stands for technical director.

technical production personnel People who operate the production equipment. Also called *below-the-line personnel*.

telephoto lens See narrow-angle lens

teleprompter A prompting device that projects the moving (usually computer-generated) copy over the lens so that the talent can read it without losing eye contact with the viewer. Also called *auto cue*.

- **television system** Equipment and people who operate the equipment for the production of specific programs. The basic television system consists of a television camera and a microphone that convert pictures and sound into electrical signals, and a television set and a loudspeaker that convert the signals back into pictures and sound.
- **test tone** A tone generated by the audio console to indicate a 0 VU volume level. The 0 VU test tone is recorded with the color bars to give a standard for the recording level.
- **theme** (1) What the story is all about; its essential idea. (2) The opening and closing music in a show.

TH (tungsten-halogen) lamp See quartz

threefold Three flats hinged together.

three-shot Framing of three people.

tilt To point the camera up or down.

- **time base corrector (TBC)** Electronic accessory to a video recorder that helps make playbacks or transfers electronically stable.
- time code Gives each television frame a specific address (number that shows hours, minutes, seconds, and frames of elapsed tape). It is frame-accurate. *See also* SMPTE/EBU time code.
- **time compressor** Instrument that allows a recorded videotape to be replayed faster or more slowly without altering the original audio pitch.
- **time cues** Cues to the talent about the time remaining in the show.
- time line (1) *Production:* a breakdown of time blocks for various activities on the actual production day, such as crew call, setup, and camera rehearsal. (2) *Nonlinear editing:* shows all video and audio tracks of a sequence and the clips they contain. Each track has individual controls for displaying and manipulating the clips.
- **tongue** To move the boom or jib arm with the camera from left to right or right to left.
- track Another name for truck (lateral camera movement).
- **tracking** (1) An electronic adjustment of the video heads so that in the playback phase they match the recording phase of the tape. It prevents picture breakup and misalignment, especially in tapes that have been recorded on a machine other than the one used for playback. (2) Another name for *truck* (lateral camera movement).
- transponder A satellite's own receiver and transmitter.
- **treatment** Brief narrative description of a television program.

triangle lighting See photographic lighting principle

- **triaxial cable** Thin camera cable in which one central wire is surrounded by two concentric shields.
- trim (1) Audio: to adjust the signal strength of mic or line inputs. (2) Video: to lengthen or shorten a shot by a few frames during editing; also to shorten a videotaped story.
- **tripod** A three-legged camera mount. Can be connected to a dolly for easy maneuverability.

tripod boom See giraffe boom

- **truck** To move the camera laterally by means of a mobile camera mount. Also called *track*.
- **trunk** Central cable in a distribution device. Section of cable television distribution system through which signals are sent and to which the feeders are connected.
- **tungsten-halogen (TH)** The kind of lamp filament used in quartz lights. The tungsten is the filament itself; the halogen is a gaslike substance surrounding the filament enclosed in a quartz housing. *See also* **quartz**.
- twofold Two flats hinged together. Also called book.
- two-shot Framing of two people.
- unbalanced mic or line Nonprofessional microphones that have as output two wires: one that carries the audio signal and the other acting as ground. Susceptible to hum and electronic interference.
- unidirectional Pickup pattern in which the microphone can pick up sounds better from the front than from the sides or back.
- **uplink** Earth station transmitter used to send video and audio signals to a satellite.
- uplink truck A small truck that sends video and audio signals to a satellite.

variable-focal-length lens See zoom lens

- vector Refers to a force with a direction. Graphic vectors suggest a direction through lines or a series of objects that form a line. Index vectors point unquestionably in a specific direction, such as an arrow. Motion vectors are created by an object or a screen image in motion.
- **vector line** A dominant direction established by two people facing each other or through a prominent movement in a specific direction. Also called the *line*, the *line of conversation and action*, or the *hundredeighty*.
- vector scope A test instrument for adjusting color in television cameras.

velocity mic See ribbon microphone

- **vertical blanking** The return of the electron beam to the top of the screen after each cycle of the basic scanning process.
- **vertical key light position** The relative distance of the key light from the studio floor, specifically with respect to whether it is above or below the eye level of the performer. Not to be confused with *high* and *low-key lighting*, which refer to the relative brightness and contrast of the overall scene.
- VHS Stands for *video home system*. A consumer-oriented ½-inch VTR system. Used extensively in all phases of television production for previewing and off-line editing.
- video (1) Picture portion of a television program.(2) Nonbroadcast production activities.
- videocassette A plastic container in which a videotape moves from a supply reel to a takeup reel, recording and playing back program segments through a videotape recorder.
- **video leader** Visual material and a control tone recorded ahead of the program material. Serves as a technical guide for playback.
- video operator (VO) In charge of initial camera setup (white-balancing the camera and keeping the brightness contrast within tolerable limits) and for picture control during the production. Also called *shader*.
- video recorder (VR) Can be a videotape recorder or a digital disk-based recording device.
- **videotape recorder (VTR)** Electronic recording device that records video and audio signals on videotape for later playback or postproduction editing.
- videotape tracks Most videotape systems have a video track, two or more audio tracks, a control track, and sometimes a separate time code track.
- **video track** The area of the videotape used for recording the picture information.
- viewfinder Generally means electronic viewfinder (in contrast to the optical viewfinder in a film or still camera); a small television set that displays the picture as generated by the camera.
- **visualization** Mentally converting a scene into a number of key television images, not necessarily in sequence. The mental image of a shot.

VO See video operator

volume The relative intensity of the sound; its relative loudness.

volume unit (VU) meter Measures volume units, the relative loudness of amplified sound.

VR See video recorder

VTR See videotape recorder

VTR log A list of all takes on the source videotapes compiled during the screening (logging) of the source material. It lists all takes—both good (acceptable) and no good (unacceptable)—in consecutive order by time code address. Often done with computerized logging programs. A vector column facilitates shot selection. See also field log.

VU meter See volume unit meter

W Watt.

wagon A platform with casters, which can be moved about the studio.

waist shot See medium shot

- walk-through Orientation session with the production crew (technical walkthrough) and the talent (talent walkthrough) wherein the director walks through the set and explains the key actions.
- **waveform monitor** Electronic measuring device showing a graph of an electrical signal on a small CRT (cathode-ray tube) screen. Also called *oscilloscope*.
- wedge mount Wedge-shaped plate attached to the bottom of a studio camera; used to attach the heavier cameras to the cam head.
- white balance The adjustments of the color circuits in the camera to produce a white color in lighting of various color temperatures (relative reddishness or bluishness of white light).
- wide-angle lens A short-focal-length lens that provides a broad vista of a scene.
- **window dub** A "bumped-down" copy of all source tapes that has the time code keyed over each frame.
- windscreen Material (usually foam rubber) that covers the microphone head or the entire microphone to reduce wind noise.
- **wipe** Transition in which a second image, framed in some geometric shape, gradually replaces all or part of the first image.

- wireless microphone A system that transmits audio signals over the air rather than through microphone cables. The mic is attached to a small transmitter, and the signals are received by a small receiver connected to the audio console or recording device. Also called *RF* (radio frequency) mic or radio mic.
- workprint (1) A dub of the original videotape recording for viewing or off-line editing. (2) In film a dub of the original footage for doing a rough-cut.
- **wow** Sound distortions caused by a slow start or variations in speed of an audiotape.
- **XLR connector** Three-wire audio connector used for all balanced audio cables.

X/S See cross-shot

Y channel See luminance channel

- Y/C component system Analog video-recording system wherein the luminance (Y) and chrominance (C) signals are kept separate during signal encoding and transport but are combined and occupy the same track when actually laid down on videotape. The Y/C component signal is transported via two wires. Also called *S-video*.
- Y/color difference component system Video-recording system in which three signals—the luminance (Y) signal, the red signal minus its luminance (R–Y) signal, and the blue signal minus its luminance (B–Y)—are kept separate throughout the recording and storage process.

Y signal See luminance

z-axis Line representing an extension of the lens from the camera to the horizon—the depth dimension.

zone lighting See continuous-action lighting

- **zoom** To change the lens gradually to a narrow-angle position (zoom-in) or to a wide-angle position (zoom-out) while the camera remains stationary.
- **zoom lens** A variable-focal-length lens. It can gradually change from a wide shot to a close-up and vice versa in one continuous move.
- **zoom range** The degree to which the focal length can be changed from a wide shot to a close-up during a zoom. The zoom range is often stated as a ratio; a 20:1 zoom ratio means that the zoom lens can increase its shortest focal length twenty times.

Selected Reading

- Alten, Stanley R. *Audio in Media*, 7th ed. Belmont, Calif.: Thomson Wadsworth, 2005. [Audio]
- Alton, John. *Painting with Light*. Berkeley: University of California Press, 1995. [Classic on photographic lighting]
- Barr, Tony. *Acting for the Camera*, rev. ed. New York: Harper Collins, 1997. [Talent, directing]
- Begleiter, Marcie. *From Word to Image*. Studio City, Calif.: Michael Wiese Productions, 2001. [Visualizing and storyboarding shots]
- Burrows, Thomas D., Lynne S. Gross, James Foust, and Donald N. Wood. *Video Production: Disciplines and Techniques*, 8th ed. Boston: McGraw-Hill, 2001. [Production techniques, general]
- Button, Bryce. *Nonlinear Editing*. Lawrence, Kan.: CMP Books, 2002. [Emphasis on editing aesthetics; includes CD-ROM]
- Compesi, Ronald J. *Video Field Production and Editing*, 6th ed. Boston: Allyn and Bacon, 2003. [ENG/EFP, editing]
- Donald, Ralph, and Thomas Spann. *Fundamentals of Television Production*. Ames, Iowa: Iowa State University Press, 2000. [General television production techniques]
- Gross, Lynne S., and Larry W. Ward. *Digital Moviemaking*. Belmont, Calif.: Thomson Wadsworth, 2004. [EFP, editing]
- Hausman, Carl, Lewis B. O'Donnell, and Philip Benoit. *Announcing: Broadcast Communicating Today*, 5th ed. Belmont, Calif.: Thomson Wadsworth, 2004. [Radio and television announcing]
- Hickman, Harold R. *Television Directing*. New York: McGraw-Hill, 1991. [Still one of the better books on multicamera directing]
- Hyde, Stuart W. *Idea to Script: Storytelling for Today's Media*. Boston: Allyn and Bacon, 2003. [Writing as a consequence of psychological needs and desires]
- ——. *Television and Radio Announcing*, 10th ed. Boston: Houghton Mifflin, 2004. [Talent, announcing]

- Katz, Steven D. *Film Directing Shot by Shot*. Studio City, Calif.: Michael Wiese Productions, 1991. [Single-camera directing]
- Lowell, Ross. *Matters of Light and Depth.* Philadelphia: Broad Street Books, 1992. [All you need to know about lighting]
- Luther, Arch, and Andrew Inglis. *Video Engineering*, 3rd ed. New York: McGraw-Hill, 1999. [Technical information on analog and digital video]
- Millerson, Gerald. *The Technique of Television Production*, 13th ed. Boston: Focal Press, 1999. [Production techniques, general]
- ——. Lighting for Television and Film, 3rd ed. Boston: Focal Press, 1999. [Lighting]
- Musburger, Robert. *Single Camera Video Production*, 3rd ed. Boston: Focal Press, 2002. [Single-camera production techniques]
- Olson, Robert. *Art Direction for Film and Video*, 2nd ed. Boston: Focal Press, 1999. [Scene design]
- Overbeck, Wayne G. *Major Principles of Media Law*. Belmont, Calif.: Wadsworth, 2005. [Media law]
- Pogue, David. *iMovie4 and iDVD: The Missing Manual*. Sebastopol, Calif.: Pogue Press/ O'Reilly, 2004. [Specific guide to Apple iMovie and iDVD but valid for all nonlinear editing]
- Rabiger, Michael. *Directing: Film Techniques and Aesthetics*, 3rd ed. Boston: Focal Press, 2003. [Directing]
- Simon, Mark. *Storyboards: Motion in Art*, 2nd ed. Boston: Focal Press, 2000. [Visualizing, drawing storyboards]
- Thompson, Roy. Grammar of the Edit. Boston: Focal Press, 1993. [Basic editing principles]
- Weise, Marcus, and Diana Waynand. *How Video Works*. Boston: Focal Press, 2004. [Explanation of how analog and digital video signals are recorded and manipulated]
- Weston, Judith. *Directing Actors*. Studio City, Calif.: Michael Wiese Productions, 1996. [Film and video acting and directing]
- The Film Director's Intuition: Script Analysis and Rehearsal Techniques. Studio City, Calif.: Michael Wiese Productions, 2003. [How to get from script to screen creatively and effectively]
- Zettl, Herbert. *Video Basics 4*. Belmont, Calif.: Thomson Wadsworth, 2004. [Production techniques, general]
- ——. Zettl's Video Lab 3.0. Belmont, Calif.: Thomson Wadsworth, 2004. Interactive multimedia DVD-ROM (Macintosh and Windows platforms). [Major video production techniques: camera, lights, audio, switching, editing, and process]

Index

480i system, 47

480p system, 38, 39, 47

Artists), 409 postproduction, 12, 234, 720p system, 38-39, 47, 66 Art director, 368, 370, 371 235-239 AGC (automatic gain control), 720p/30 system, 50 Artifacts, 33, 50, 56, 152 sweetening, 234, 305, 307 111, 233 1080i system, 39, 47, 50 Aspect ratios, 34-35 synchronizing, 238 Air-conditioning, in studio, 19 transcribing, 236 and framing shots, 116-119 AKG D112 microphone, 213 for HDTV, 34-35, 82, volume control, 221, 231 AB-roll editing, 291, 295, 297 Aliasing, 352 123-124, 344-345, 346-348 See also Sound AB rolling, 295-297 Ambience, 240 matching STV and HDTV, Audio connectors, 60 Above-the-line 346-348 Ambient sounds, 111, 208, Audio console, 12, 220-224 budget, 397 out-of-aspect-ratio graphics, 215-216, 239, 240, 301, 317 computer-assisted, 223-224 personnel, 368, 371 346-347 American Federation of in-line, 223 and screen motion, 123-124 Acoustic guitar, microphone Musicians of the United input, 220-221 for STV, 34-35, 344-345, setups for, 214, 215 States and Canada (AFM), mix, 12, 221 346-348 409 Acoustics, in studios, 19 module, 220-221 switching between, 51, 63-64 American Federation of monitor and cue, 223 Acting, techniques, 382-384 traditional, 34-35, 123-124 Television and Radio Artists output, 222-223 Action radius, 196 Assemble editing, 294–295 (AFTRA), 409 phantom power, 223 Active lines, on TV screen, 36 Assignment editor, 373 quality control, 221-222 Ampere, 186 Actors, 369, 373 volume control, 221 Assistant chief engineer, 372 Analog, versus digital, 28, 30-35 and audience, 383 Audio control booth, 22, 229-230 cameras, 46-47 Associate or assistant director and auditions, 384-385 (AD), 20, 369, 371, 430 Audio controls, 5, 268 Analog audio editing, 235-236 and blocking, 383 Associate producer (AP), 369, 371 Audio cues, director's, 380, 452 Analog audio synchronizer, 238 and director, 383, 384 ATR (audiotape recorder), 223 Audio dub control (VTR), 268 and memorizing lines, Analog editing system, 26 Attenuator, 221 383-384 Audio engineer, 22 Analog recording systems, and postproduction, 384 225-227, 262 Audience Audio-follow-video switchers, 258 and props, 383 actor and, 383 Analog signal, 30, 31, 46 Audio level control, 62, 111 and rehearsals, 456 feedback, 405 Audio mixer, 5, 11, 233, 290 Analog switcher, 258 and timing, 384 ratings and, 410-411 Audio monitor, 5, 62 Analog video effects, 322-329 share, 410-411 AD (associate director), 20, 369, Audio patchboard, 22 Analog video track, 266-267 target, 395, 410 Audio pool, 206 Analog videotape recording, 262, Audio, 10-12 Adapters, 107, 186 269-270 Audio postproduction room, 237 balance, 201 Additive color mixing, 64-65, 154 and digitization, 30-32 calibration, 230-231 Audio-recording systems, 225 Address code, 281 Anchor, news, 373 compression, 12 Audio signal, 4 ADR (automatic dialogue recorrecting problems with, 236 Animation of titles, 349 Audio slate, 227, 281 placement), 238-239, 294 editing, 235-236 Announcer, 369 Audio system, 5 Aesthetic compression, and and environment, 239, 301 Anti-aliasing, 30 calibration of, 230-231 narrow-angle lens, 85-86 interference, 203 AP (associate producer), 369, 371 Audio technician, 371, 372 level, 375 AFM (American Federation of Audio tracks, 267 Musicians of the United Aperture, lens, 75, 78 mixing, 290 States and Canada), 409 depth of field and, 78 performer and, 375 Audiocassette recorder, 226-227

Apple iPod, 229

Arc camera movement, 82, 96-97

pickup and microphones,

191-192, 211-213

AFTRA (American Federation

of Television and Radio

Audiotape recorder (ATR), 223 Audio/video synchronizing, 238, 272, 294, 307 Auditions, 384-385 Auto cue, 381 Auto-focus, 48, 74, 80-81, 111 Auto-iris, 48, 76, 77, 179 Auto key tracking, 327 Auto transition device, 250, 328 Automatic dialogue replacement (ADR), 238-239, 294 Automatic gain control (AGC), 111, 233 Automatic moisture shutdown, VTR, 269 B-roll, 291 Back light, 145, 161, 162, 163, 167, 174, 326 window as, 180-182 Back-timing, 467-468 Background bus, 246 Background color, 253 Background dressing, 363-364 Background light, 161, 163-164, Backing up recordings, 307 Backplate, microphone, 209 Balanced microphone or line, 210-214 Ballast, for HMI lamp, 153 Bandwidth, 36 Barn door, 132, 136, 144-145, 162, 164, 172, 176 attaching color gels to, 154 attaching scrim to, 138-139 Bars and tone, 279 Baseball remote setup, 488 Baselight level, 55, 130, 150, 152 - 153Basic television system, 4, 5 Basketball remote setup, 491 Battens, counterweight, 176 Batteries for camcorders, 59-60, 106, 107, 112 for cameras, 50-60 for lighting, 186 Beam, light, 146-147 Beam splitter, RGB, 42-44, 74 Beanbag mount, 98, 99 Below-the-line budget, 397

personnel, 368, 371, 409

Bending the needle, 222 Betacam cameras, (Sony), 13, 14, 46 Betacam SP recording system, 262, 269-270 Betacam SX recording system, 271, 272 Beverdynamic M58 microphone, Beyerdynamic M160 microphone, 212, 214, 215 Beyerdynamic M500 microphone, 212, 215 Big boom, 200-201 Big remotes, 7, 85, 477-486 and chroma keying, 327 communication systems for, 499-500 equipment setup and operation, 480-485 postshow activities, 485 preproduction, 478-480 production, 480-486 sporting events, 85, 487-495 technical walk-through for, 457 truck for, 478-479 Bin, 307, 437 Binary code, 28, 33 Binary digit, 28-30 Bit, 28-30 Black, fade to, 251, 252 Black level, 173 Blacking, 278 Blackout, 147 Blanking, horizontal and vertical, 36 Blocking, 167, 374, 383, 456 Blocking map, 383 Blocking rehearsal, 456 BNC connector, 60 Book (twofold), 355 Boom microphones, 170, 172, 194, 197-201, 240 how to use, 201, 375 Boom movement, 96-97 Boom shadow, controlling, 172 Bounce effect, 333-334 Boundary microphone, 203-204, 206, 207 Box wipe, 328 Boxing remote setup, 493

Brainstorming, 392-393

263, 350

Brightness, color, 64, 65, 66, 253,

Broad, 132, 161, 167 Broadband transmission, 33, 503 Budget, production, 397-401 above- and below-the-line, 397 tentative, 397 tripart, 397-400 Bump down, bump up, 293, 301 Bumpers, 330 Buses, switcher, 244-248 background, 246 direct, 244 effects, 246 key, 246, 247 mix, 221, 245 mix/effects (M/E), 246-248 preset, 245, 249 preview, 245-246 preview/preset, 246, 247 program, 244-245, 246, 247, 249 Bust shot, 115–116 C-band frequency, 501 C channel, 65 C-clamp, 142, 176 C signal, 45, 66 Cable distribution, 503-504 Cable guards for dolly, 92, 93, 113 Cable puller, 111 Cable television system, 504 Cables, 58, 60, 107, 113, 476 camera, 46, 57-58, 60 coax, 503 extension cords, 186 fiber-optic, 58, 503 microphone, 210, 214 multicore, 58 taping, 204 triaxial (triax), 58 Calibration of audio system, 230-231 of zoom lens, 75, 111, 112, 113, 230 Cam head, 95 Camcorder, 4, 48-50, 274 audio systems on, 50 and auto-iris, 48, 76, 77 batteries, 106 camera mounts for, 98-99 consumer, 42, 48-50, 52, 70, 71, 72, 76, 79, 81, 94 ENG/EFP, 8-9, 48, 76, 102 focus control on, 80 HDV, 50 holding, 108 and high-capacity hard drive, 14 and interpolation, 71

lenses for, 8, 48, 50 operating techniques for, 90, 108-111 panning, 109 and prism block, 42, 44 professional, 49-50 prosumer, 50, 52, 59, 72, 79, 102, 274 and sound recording, 11 as studio camera, 48, 49 tapeless, 48 tripod for, 9 and viewfinder, 108 and white-balancing, 52 working the, 106-112 zoom range on, 70, 72 Cameo lighting, 169-170 Camera, 8-9. See also Lens; Television camera batteries, 50-60 cables, 46, 57-58, 60 care of, 106-107 positions, and vector line, 315-316 robotic, 9, 22 subjective, 437 Camera/bars selection switch, 62 Camera chain, 45-46 Camera control unit (CCU), 4, 5, 6, 23, 45-46, 49, 55, 76, 112 Camera head, 45 Camera lights, 139-140 Camera mounting equipment, 8, 9,90-102 beanbag, 98, 99 cam heads, 94-95 camera mounting heads, 94-95 fluid heads, 94 handheld camera, 90, 108-110 high hat, 98, 99 jibs, 100, 101 leveling ball and bowl, 92, 94 monopod, 90-91 portable pedestal, 94 quick-release plate, 95 rail system, 102 robotic pedestals, 100-102 shoulder-mounted camera, 90, 110 Steadicam, 98-99 studio crane, 100, 101 studio pedestal, 8, 92-94, 113 tripod, 91-92 wedge mount, 95 Camera movements, 95-96 Camera operator, 371, 372 Camera rehearsal, 456-458, 460 Camera switching, 374

Clipper, 252, 323

Camera-to-object distance, depth Clipping, 173 Color bars, 279, 295 Continuity of field and, 78 color, 316-317 Clock, 21-22 Color gels (media), 153-154, 170, Canting effect, 96-97 editing for, 312-317 181, 326 Clock time and mental map, 312-313 Capacitor microphone, 209 controlling, 467-468 Color television, image formamovement, 314-316 tion for, 28 Capture, 279, 298-299 converting frames into, 468 and script breakdown, 466 Communication satellites, Cardioid microphone, 191, 206, Close-up (CU) shot, 123 sound, 240, 317 501-503 211-213 and aspect ratio, 35, 118 visual, 240 Communication systems, field, and cutaways, 466 Cart system, digital, 228 Continuous-action lighting, 499-500 and depth of field, 78 Cassette, analog and DAT, 227 166-167 extreme, 113 Compact disc (CD), 12, 14, 223, Cathode ray tube (CRT), 38 229, 274 Contrast, 57, 65-66, 185 framing, 115-116, 117-118 CCD (charge-coupled device), 7, lighting for, 180-182 Contrast ratio, 57, 151, 169, Compact disc-read-only memory 42-43, 48, 50, 53, 55, 56, 57, 172-173 makeup and, 388 (CD-ROM), 14 63-64, 72 performer and, 374 measuring, 173 Compact disc-read/write CCD process, 63-64 and sound, 239 (CD-RW), 14 Control room. See Studio control CCU (camera control unit), 4, 5, and wide-angle lens, 92 room Complexity editing, 317 6, 23, 45-46, 49, 55, 76, 112 and zoom lens, 73-74 Control room directing, 419 Component switcher, 258 CD (compact disc), 14, 223, 229, Closure, 120-123 Control tone, 230 Component video-recording Clothing Control track, 267, 278 system, 264 CD-ROM (compact disc-readfor auditions, 384 Component video signal, 66 Control track editing, 291-293 only memory), 14 and chroma keying, 324, 388 CD-RW (compact disc-read/ Composite switcher, 256-258 Control track pulse, 291 and color, 173 write), 14 Composite video-recording Control track system, 291 and lavaliere mics, 195 C.G. operator, 371, 372 system, 263 performers', 388-389 Cookie projection, 130, 163, Composite video signal, 66 Character-generated slate, 280 337, 358 Clustering, for generating ideas, Compression, aesthetic, and Character generator (C.G.), 4, 393 Copyright clearance, 409 narrow-angle lens, 85–86 16-17, 22, 244, 280, 290, CMOS chip, 50, 63 Corner wipe, 328 322, 345 Compression, audio, 12 CNN logo, 342-343 Costume designer, 370 Character generator (C.G.) Compression of digital data, 34, Costumes, 389 Coax cable, 503 operator, 371, 372 265-266 Coding, in digitization, 30–32 Counterweight battens, 141 Charge-coupled device (CCD), 7, interframe and intraframe, 42-43, 48, 50, 53, 55, 56, 57, Collimated light, 152 265-266, 299 Counterweight rail, 141-142 63-64, 72 JPEG and MPEG-2 standards Color Crab steering position, 93, 96 for, 265-266, 273, 275, 299 Chief engineer, 372 additive mixing of, 64-65, 154 Crane movement, 96-97 lossless and lossy, 34, 265-266, Chinese lantern, 137-138 aesthetics of, 351-352 Crawl, 381 attributes of, 64, 350 Chip (charge-coupled device), 7, Crew, 370 and nonlinear editing, 299 background, 253 42-43, 63 Computer, as editing system, 290 Crew call, 459 bleeding, 352 Chroma-key backdrop, 358 Cross-fade, 310 brightness, 64, 65, 66, 253, Computer-assisted Chroma keying, 133, 170-171, 263, 350 audio console, 223-224 Cross-keying, 167, 181 324-327 clothing and, 388-389 edit controller, 287, 290 and big remotes, 327 Cross-shot (X/S), 115-116, 383 compatibility, 351 facilities request, 402-403 and set pieces, 359 CRT (cathode ray tube), 38 continuity editing and, logging, 304, 305, 306 and talent clothing, 324, 388 Cube spin effect, 335 316-317 patching, 148, 225 Chrominance, 45, 63, 64, 65 distortion, 168, 169 Cucoloris, 130, 337 scheduling, 416 and analog composite system, high- and low-energy, 351-352 storyboards, 440, 442 Cue cards, 380-381, 384 263 hue, 64, 253, 350 Computer disks, for audio and Y/C component system, Cues image formation for, 28, 30 recording, 14 264 audio, 380, 452 luminance, 45, 63, 64, 65, 253, Computer-manipulated DVE, directional, 379 Chrominance channel, 65 263, 350 330-336 director's, 446-454 Circle wipe, 328 makeup and, 387-388 Condenser microphones, 195, floor manager's, 376-380 Circuits, determining requiremixing, 64-65 209, 223 sequencing, 450 ments, 186 and RGB, 28, 30 Connectors, 58, 60, 107, 476 special-effects, 451 saturation, 64, 253, 350, Clarification, through cut, 309 audio, 60 time, 377-378 351-352 Clip, 299, 304 visualization, 447-449 video, 60 television graphics and, Clip control, 252, 323 VTR, 453 350-352 Contact person, on remotes, Clip light, 136 480, 485 Cue-send, 215 temperature, 132, 158-160

and white balancing, 51-52

Context, editing for, 317-318

Curtains, scenery, 358

Cut or take, 244, 248-249, 309 Diffusing spotlights, 138–139 Digital video effects (DVE), 33, Disk-based video recorder, 263, jump cut, 312, 317 258, 298, 326, 329-336 287, 307 Diffusion filter, 139, 184, 338-339 soft cut, 309 computer-manipulated, Dissolves, 245, 246, 249-251, 309 Diffusion tent, 10, 137, 139, 140 330-336 Cut (stop action), 458 Distortion, distance Diffusion umbrella, 139 Digital videotape recorders, 267, Cutaway shots, 300-301, narrow-angle lens and, 85 Digital audio console, 224 270-273 312-313, 316, 466 normal lens and, 84 Digital audio workstation Digital videotape recording, 262 Cuts-only editing system, 288, 290 wide-angle lens and, 82-83 (DAW), 237-238 Digital zooming, 70-71, 80 Cyc light, 132-133, 163 Diversity reception, 202 Digital audiotape recorder Digitization process, 30-32 Cyclorama (cyc), 130, 132, Documentaries (DAT), 12, 227-228 357-358 Dimmer, 147-148 lighting for, 9 Digital Betacam SX, 14, 272 scripts for, 419, 420 and color temperature, 148 Digital camcorder, 26, 48, 50-51, computer-assisted, 147 Dolby surround sound, 241 DAT (digital audiotape recorder), 56, 275, 278, 299 12, 227-228 Dimmer control board, 20 Dolly, 82, 83, 86, 92, 113 Digital cart system, 228 Data transfer, 274-275 Dip to black, 310 Dolly in, out, 96-97 Digital computer disk, 12 Database Direct box, 210 Double-muff headset, 453 Digital editing systems, 26 for news files, 26 Direct broadcast satellite (DBS), Downlinks, satellite, 502-503 Digital graphic artist, 372 of production personnel, 501 Downloading files, 33 401-402, 416 Digital recording systems, 262 Direct bus, 244 Downstream keyer (DSK), DAW (digital audio workstation), Digital rendering, 353 Direct input, 215 252-253, 323 237-238 Digital-S videotape recorder Direct insertion, 215 DP (director of photography), dB (decibels), 55 system, 14 368, 372, 477 Directing DBS (direct broadcast satellite), Digital signal, versus analog, 28, big remotes, 480-484 Dramas 501 30 - 31microphones for, 194 from control room, 461-463 Dead zones, 348 Digital storage devices, 274, 275 script for, 416, 417 from the floor, 463 Decibels, 55 Digital subscriber line (DSL), 33 multicamera, 446-455 script marking for, 426 Decoding compressed data, 34 Digital switcher, 256, 258 on-the-air telecast, 484 Drapes, scenery, 358 Defocus effect, 339 rehearsals, 430, 455-461 Digital tape recording system Dress rehearsals, 457-458 show, 461-463 (DTRS), 227 Delegation controls, 246, Dressing rooms, 25 single-camera, 464-466 247-248 Digital television (DTV), 26-38 Drop frame mode, 294 Demographics, audience, 395, 410 Directional controls for light, 480i system, 47 Drop lines, 503 144-149 480p system, 38, 39, 47 Density of an event, 469 Drop-shadow mode, 323-325 720p system, 38-39, 47, 66 Directional cues, 379 Depth of field, 55, 76-78, 123 Drops, 358 720p/30 system, 50 Directional light, 9, 158 and camera-to-object distance, Dry run rehearsal, 456 1080i system, 39, 47, 50 78 Directional microphone, 196 and aspect ratio, 34-35 DSK (downstream keyer), and focal length, 77-78 Director, 20, 368, 369, 371 benefits of, 32-35 252-253, 323 great, 77 and audio mixing, 232 and color, 28, 30 narrow-angle lens and, 86-87 DSL (digital subscriber line), 33 and controlling time, 467-469 compared with analog, 28, normal lens and, 84-85 DTRS (digital tape recording cues to floor manager, 454 30-35 shallow, 77 system), 227 cues to production team, compression of signal, 34 wide-angle lens and, 84 446-453 DTV. See Digital television and computers, 33, 34 Design and editing, 467 Dual-redundancy microphone image creation in, 28 of scenery and props, 355-365 and intercom system, 19, system, 195, 204 and process of digitization, of television graphics, 344-354 483-484 30 - 32Dub down, 293 Desk microphone, 203-205, and performers, 375, 383 quality of, 32-33 Dubbing 211-213 postproduction activities of, resolution, by format, 38-39 audio, 12 466-467 how to use, 204-205, 232, 375 and signal transport, 33-34 of dialogue, 238-239 preproduction activities of, DGA (Directors Guild of and special effects, 33 and DTV, 33 413-442 America), 409 systems for, 37-38 and quality loss, 345 relationship with actors, 384 Dialogue Digital versatile disc (DVD), 14, sounds, 12 roles of, 114, 414-415 automatic replacement of, window, 301-302 223, 229, 274 support staff for, 429-430 238-239 for archiving, 276 DV VTR system, 271-272 terminology, 446-450 writing, 401 Digital versatile disc-read-only timing devices for, 21-22 DVCAM (Sony), 13, 14, 48, 267, Diamond wipe, 328 memory (DVD-ROM), 14 271, 272 Director of photography (DP), Diaphragm, microphone, 209 Digital versatile disc-read/write 368, 372, 477 DVCPRO (Panasonic), 13, 14, 48, Dichroic filter, 183 (DVD-RW), 14 66, 267, 271, 272 Directors Guild of America Diffused light, 9, 10, 158, 161, 170 Digital video (DV) system, 49 (DGA), 409 DVD. See Digital versatile disc

shot sequencing, 300, 305,

310-312

Fast lens, 76

fc (foot-candle), 55, 150

servo zoom control for, 79

shoulder-mounted, 110

DVD-ROM (digital versatile discsingle-source system, 288–290 audio production for, shutter speed on, 62 read-only memory), 14 232-234, 239 sound, 216, 235-236 sound and audio controls, 62 cameras for, 46, 48, 49 split, 295 DVD-RW (digital versatile standby switch for, 62 communication systems for, disc-read/write), 14 transition devices for, 309-310 Steadicam mount for, 98-99 transitions, adding, 305 in studio configurations, DVE. See Digital video effects and cutaways, 301 with switcher, 242-258 48-49 Dynamic microphones, 195-196, time code, 293-294 editing, 301, 304, 308 viewfinder for, 60-62 equipment checklist, 277-278 video to audio, 236 VTR controls, 62 fieldpacks for, 274 VTR switch on, 62 Editing control unit, 15 Earphones, 198 white balance in, 61, 62, 110 lighting for, 9, 133-140 EDL. See Edit decision list EBU (European Broadcasting microphones for, 194, 195, working the, 106-112 Effect-to-cause model, 393-395, Union), 293 196, 197, 201, 202, 205, zoom lens on, 70-72, 78, 84, 215-216 86, 111 Echo effect, 335-336 Effects buses, 246 prompter for, 382 Engineering staff, 370, 371, 372 Edge mode, 323-325 sound recording in, 11, 239 EFP. See Electronic field Environment, sound recordings Edit controller, 15, 235, 288-289, van for, 473 production and, 239, 301 290, 292, 293 Electronic shutter, 56 Egg crate, 132 Equalization, 222 Edit decision list (EDL), 15, Electronic still store (ESS) sys-Electret condenser microphone, 286-287, 297, 298, Equipment checklists, 277-278, 209 tems, 246, 274, 287, 326 304-305, 299 475-476 Electric power, calculating Electro-Voice 635N/D microcomputer-generated, 299, 304, Erase head, 226 phone, 211 305, 306 requirements for, 186 ESS (electronic still store) paper-and-pencil, 304-305 Electron beam, 28 Electro-Voice RE50 microphone, systems, 246, 274, 287 Edit master tape, 235, 278, 288, Electron gun, 28 Essential area, 112, 345-346 295, 306 Ellipsoidal spotlight, 129-130 Electronic cinema, 66 Ethics, editing and, 318 Edit points, 288 Encoder, 66 Electronic field production European Broadcasting Union Edit VTR, 288 (EFP), 7-12, 474-477 Encoding, in digitization, 30-32 (EBU), 293 Editing, 304-307 audio production for, End-of-tape warning, 61 Event sequencing, 407, 408 232-234, 475 AB-roll, 295, 297 Energy, visual, 240 Executive producer, 368, 369, 371 camcorders for, 7, 8-9 AB rolling, 295-297 Energy, wasting, 176 Expanded production systems, cameras for, 7, 46, 48, 49 assemble, 294-295 ENG. See Electronic news 4-7 chroma keying for, 327 audio, 235-236 gathering communication systems for, Expanding images, 330 complexity, 317 476, 499 ENG/EFP cameras and camcordand context, 317-318 Explosion effects, 341 and depth of field, 85 ers, 7, 46, 48, 49 continuity, 312-317 External key, 323-324 audio level control, 62 editing, 477 control track, 291-293 External sync, 46 equipment checklist, 277-278, batteries for, 59-60, 106, 107, and director, 467 Extreme close-up (ECU) shot, 475-476, 477 112 ethics and, 318 113, 115-116, 117-118 and event sequencing, 407, 408 cable for, 60 functions, 308-309 lighting for, 9-10, 133-140, camera/bars selection switch, and aspect ratio, 35, 118 insert, 235, 295, 307 178-186 Extreme long shot (ELS), instantaneous, 12, 242-258 location sketch for, 427-429 camera mounts for, 98-99 115-116 laptop, 288-289 location survey for, 184-185, connectors for, 60 Eye shadows, controlling, 171–172 linear, 15, 279, 284, 286–287, fieldpacks for, 274 288-297 microphones for, 194-195, filter wheel for, 60, 62 multiple-source systems for, Facilities request, 402-403, 201, 202, 215-216 fluid heads for, 94 290-291 428-429 mixing for, 233-234 focus control on, 80 to music, 317 Fact sheet, 419, 423 postproduction, 477 gain control, 61, 62 nonlinear, 15-16, 263, power supply for, 475-476 intercom system for, 59 Fade-out, fade-in, 310 273, 279, 284, 287-288, preproduction for, 474-475 jacks on, 62 297-304, 312 Fader, 221 prompter for, 382 off-line and on-line, 286-287 lenses for, 8, 60, 337 master, 252 rehearsals, 477 paper-and-pencil, 467 operating techniques for, Fader bar, 245, 246, 250, 251, 252, and safety, 178 109-111 portable editor, 288-289 special effects, 328 setup, 476-477 operational controls for, 59-62 postproduction, 14-16, 154, Fades, 245, 251, 310 sound recording in, 11, 475 276, 284-318, 405, 427 playback on, 61 Falloff, 130, 145, 158, 161, 162, strike, 477 pre-editing, 291, 300-304 pneumatic pedestals for, 93-94 technical walk-throughs for, 457 principle, 287-288 power supply for, 59-60 fast, 162, 167-168 time line for, 475 power switch for, 62 pulse-count, 291-293 slow, 179 videotaping, 477 shot selection, 304 range extender for, 72

Electronic news gathering (ENG),

7-12, 472-474

Flip-flop switching, 249

Follow spot, 130

Federal Communications Floodlights, 10, 130-133 Fonts, choosing, 349 Graphic artist, 370, 372 Commission (FCC), 23 broad, 132 Football remote setup, 489 Graphic generators, 4, 17 Chinese lantern, 137-138 Feed, 23 Foot-candle (fc), 55, 150 Graphic vector, 303 and color temperature, 183 Feeder lines, 503 Footprint, 502 Graphics. See Television graphics cyc light, 132-133 Fiber-optic cable, 58, 503 Foundation makeup, 386-387 Graphics generator, 353 for flat lighting, 165-166 Grass Valley 100 switcher, 247, fluorescent, 132, 138 480i system, 47 and image scanning, 28, 29 248, 252, 323 incandescent, 131 480p system, 38, 39, 47 depth of, 55, 76-78 as key light, 130 Grayscale, 64, 350-351 Fractal images, 353-354 Field lens, 70-72 LED light, 138 Grips, 369 Frame, 28, 29, 292-293 portable, 136-138 Field lighting, 133-140, 178-186 Ground row, 357-358 converting into clock time, scoop, 131 Field log, 281, 282 294, 468 softlight, 131, 137-138 Field of view Frame rate, 28, 36-38, 50, 55, 66, Hand microphones, 195-197, strip light, 132-133 250, 273, 292, 294 framing shots and, 115-116 211-213 V-light, 136-137 and narrow-angle lens, 85 how to use, 196-197, 375 Framestore synchronizer, 269 Floor manager or floor director, and normal lens, 84 Hand properties, 24, 360, 429 Framing shots, 115-124 175, 368, 369, 371, 429-430 and wide-angle lens, 82 and aspect ratio, 116-119 actor and, 384 Handheld camcorder operating Field producer, 369 close-up, 117-118 techniques, 90 big remotes and, 485-486 and closure, 120-123 Field production, 4, 472-504 cues, 376-380 Handheld shotgun mic, 198, 375 creating depth, 123 kit for, 107-108 cues from director to, 74, 454 Hanging microphones, 206-207 and field of view, 115-116 lighting instruments for, and talent, 384, 429, 430 Hanging units, for scenery, 133-140 and headroom, 118-119 Floor persons, 369, 371 357-358 horizontal view, 116-117 Field prompter, 382 Floor plan, 175, 361-363 Hard copy, 381 and leadroom, 119-120 Field zoom lens, 70, 72 interpreting, 437-440 Hard disk VTR systems, 273-274 and motion, 123-124 Fieldpacks, 274 Floor plan pattern, 361–362 and noseroom, 119-120 Hard drives, 14, 48, 228-229, 273-274 Figure/ground principle, 162, 239 Floor stand, 142-144 and screen size, 115 portable, 274 vertical view, 116-117 File management, 298 Floor treatments, on sets, 364-365 Hardwall cyc, 357 Frequency agility, 500 Fill light, 161, 162, 163, 174 Hardwall flats, 355-356 Fluid head, 94 Frequency response, 209, 210 Film-style shooting, 66, 309, 466 Fluorescent floodlight bank, 132, HDTV. See High-definition Fresnel spotlight, 128-130, 139, Filter wheel, 58, 60, 62 165-166, 167 television 140, 162, 165 Filters portable, 138 small portable, 133-134 HDV. See High-definition video audio, 193, 222 Fluorescent tubes, 153 Front-timing, 468 Head assembly color, in camera, 42-44, 60 ATR, 226 Fluorescent lighting, shooting Frosted gel, 138-139 dichroic, 183 with, 9 DAT, 227 diffusion, 338-339 f-stop, 45, 55, 75–76, 152–153 VTR, 266 Fly effect, 335 fog, 339 and depth of field, 78 Head end, cable system, 503 gels as, 153-154 Focal length of lens, 73-74, 77-78 Fully scripted documentary, 420 mosaic, 43-44 Headroom, 118-119 Focus, 74-75, 82-87 Fully scripted format (complete neutral density, 58, 76, 153, Headset microphone, 201, 450, auto, 48, 111 script), 416-419 179, 181, 476 and defocus, 339 Furniture on set, 162 pop, 192, 195 double-muff, 453 follow, 111 star, 338-339 and HDTV, 33, 58, 81, 111, Helical scan, 266 Gain, 55-56 striped, 43-44 113, 339 Hertz (Hz), 210 riding the, 193 internal, 337 Fire effect, 340-341 Hi8 camcorder (Sony), 46 Gain control, 61, 62, 221, 222, 323 rack, 86, 339 FireWire (Apple) cables, 51, 58, Hi8 videotape recording system, automatic, 111 selective, 86 60, 229, 255, 272, 274, 275 Gels, color, 153-154, 181 Focus assist, 113 Fishpole boom, 172, 198-199, 375 Hidden microphone, 207 and chroma keying, 170, 326 Focus control, 78, 80-81 Flag, 130, 145, 337 High-contrast lighting, 167-169 frosted, 138-139 Focus ring, 74, 80, 110, 111 Flash memory device (flash High-definition television mixing, 154 drive), 228, 274 Fog effect, 339, 340 for white balancing, 160 (HDTV), 33 Flat lighting, 131, 165-166 Foil reflector, 146 and aspect ratio, 34-35, Generation, videotape, 262 344-345, 346-348 Flat-panel displays, 38 Foldback, 215, 232 Genlock, 46, 269 cameras for, 47-48, 50, 66 Flat response, 210 Foley stage, 238-239 Giraffe microphone boom, and flat-panel displays, 38 Flats, 24, 162, 355-357 Follow focus, 111 199-200 focusing, 33, 58, 81, 111, 113,

Gobo, 130, 145, 337-338

339

High-definition television Ikegami Editcam, 274 wireless, 19, 450 JVC recording systems, 273 (HDTV) (continued) i-link (Sony) cable, 51, 272, 275 Interference, microphone, 203, framing shots for, 116-117, 118 204, 206 Illogical closure, 122-123 Kelvin degrees (K), 51, 159 and gravscale, 351 Interframe compression, Illumination. See Lighting Key bus, 246, 247 receivers for, 38 265-266, 299 Image blur, 56 Key-level control, 252, 323 recording system, 271, 273 Interlaced scanning, 28-29, 36, 37 and resolution, 38-39, 50, Image creation, 28 Key light, 130, 161-162, 163, 167 Internal focus (I-F) lens, 80, 337 52-55 eye shadows and, 171-172 Image enhancers, 55 and sound, 222, 240-241 Internal key, 323 window as, 180-182 Image format, of lens, 72 and surround sound, 222-223, Internal reflector spotlight, 136 Key-to-back-light ratio, 174 Image manipulation, 330-336 236, 241 International Alliance Key-to-fill-light ratio, 174 Image stabilization device, 72, 86 High-definition video (HDV) of Theatrical Stage Keyboard, 238 Imaging device, on TV camera, 8, camcorders, 50 Employees, Moving Picture Keying, 16, 252-253, 322-327 recording system, 271, 42, 43-45, 56 Technicians, Artists and and auto key tracking, 327 272-273 Allied Crafts of the United Impedance, in microphones, 210 chroma, 133, 170-171, States, Its Territories and High-energy colors, 351-352 Impedance transformer, 210 324-327, 359 Canada (IATSE), 410 High hat mount, 98, 99 In the can, 460 and external key, 323-324 International Brotherhood of High-key scene, lighting for, Incandescent floodlight, 131 and internal key, 323 Electrical Workers (IBEW), 164, 174 and matte key, 323-324, 325 Incandescent lamp, 153, 183 410 High-Z microphone, 210 titles, 322 Interpolation, 71 Incident light, 150-151, 176 and Ultimatte, 327 HMI lamp, 134, 153, 176 Interruptible foldback (I.F.B.) Index vector, 119-120, 303 Kicker light, 161, 165 HMI light, 134-135 intercom system, 21, 201, Indoor light, shooting in, 375, 376, 455, 500 Knee shot, 115-116 Horizontal blanking, 36 180 - 183Interview set Ku-band frequency, 501-502 Horizontal detail (lines of resolu-Indoor remotes, production for, camera positions for, 437-439 tion), 54-55 kW (kilowatt), 129 495-497 floor plan and prop list for, Horizontal retrace, 36 Information density, in graphics, 437-439 348-349 Horizontal wipe, 327 Lag, image, 153 lighting for, 175 In-line consoles, 223 Hot-patching, 176 Lamp-reflector unit, 129 mics for, 194 Input modules, audio, 220-221 Hot spot, 135, 170 Lamps Interviewing children, 197 preserving, 176 Input overload distortion, 209 House number, 24 Intraframe compression, 265, 299 types of, 153 House sync, 46, 269 Input/output (I/O) modules, 223 Inverse square law, 151-152 Lap dissolve, 309 Insert editing, 235, 295, 306 Households using television iPod (Apple), 229 Laptop editing system, 288-289 (HUT), 410-411 Instant replays, 276, 484-485 Iris, lens, 45, 75, 76 Large-area lighting, 167, 168 Hue, 64, 253, 350 Instantaneous editing, 12, auto, 48, 76, 179 242-258 Large-capacity hard disks, Hundredeighty, 314 remote control of, 76 273-274 script marking for, 419, HUT (households using televi-ISDN (integrated services digital 423-427 Lavaliere microphones, 193-195, sion), 410-411 network), 33 Integrated services digital net-202, 209, 213 Hydragyrum medium arc-length Isolated (iso) camera, 59, disadvantages of, 194, 240 work (ISDN), 33 iodide, 153 484-485 hanging, 206 Intensification, through cut, 309 Hypercardioid microphone, 192, Isotropic radiation, 151 hidden, 207 Intensity controls for lighting, 208, 211-213 performer and, 375 146-149 **Jacks** productions used in, 194 Interactive digital television, 33 IATSE (International Alliance wireless, 194, 195, 207 camera, 62 Intercom system, 19, 21, 59 of Theatrical Stage patch panel, 148, 224 Layering special effects, 248 fn, Employees, Moving Picture and big remotes, 476, 478, 482, RF, 269 251 Technicians, Artists and 484, 485, 486, 499 VTR, 269 LCD (liquid crystal display), 38 Allied Crafts of the United in the control room, 430, 447, XLR, 60 States, Its Territories and LD (lighting director), 22, 130, 450, 453, 455, 461, 462, 463 Jacks for set support, 355 Canada), 410 175, 363, 371, 372 for EFP, 476 Jaggies, 352 IBEW (International Brotherinterruptible foldback or Leader numbers, 280 hood of Electrical feedback (I.F.B.), 21, 455 Jib arm, 100, 101 Leadroom, 119-120 Workers), 410 for multicamera productions, Jitter, avoiding, 268-269, 288 LED light, 138 59 IEEE 1394, 272, 275 Joint Photographic Experts LED VU meter, 223 private line/phone line (P.L.), I-F (internal focus) lens, 80, 337 Group (JPEG), 34 19, 22, 450, 453, 455 LEDs (light-emitting diodes), 222 I.F.B. (interruptible foldback or JPEG compression, 34, 265 studio address (S.A.), 455 Legal considerations, for producfeedback), 21, 201, 375, studio talkback, 21 Jump cut, 312, 317 tion, 409, 410 376, 455, 500

Lens, 8, 42, 48, 70–87. See also	and depth of field, 78	outdoor, 179–180	Line monitor, 4, 5, 6, 21, 201, 245
f-stop; Zoom lens	diffused, 9, 10, 158, 161, 170	ratios, 174	Line of conversation and action,
and aesthetic compression,	directional, 9, 158	silhouette, 133, 164, 170	314
85–86	fill, 161, 162, 163, 167, 174	studio, 9–10, 128–133, 158–177	Line-out, 4, 5, 6, 13, 222
and aperture, 75, 78	fluorescent, 9	techniques, 10	Line-out tie-in, 216
auto-focus, 48, 74, 80, 111	incident, 150–151	triangle, 162–163, 165–166,	- 0.0000000 (00000 0000 0000 × 0000000
auto-iris, 48, 76–77, 111, 140,	indoor, 180–183	180–183	Line producer, 369, 404
179, 180	intensity, 146–149, 150–152,	trimming, 142	Linear editing, 15, 279, 284,
calibrating, 75 camcorder, 8, 48, 50	174–175	with windows, 180–182	286–287, 288–297
and camera-to-object distance,	key, 161–162, 163, 167,	Lighting control, 22–23	assemble editing, 294–295
78	171–172, 181–182	Lighting control equipment,	audio, 235
and depth of field, 76–78	kicker, 161	22-23, 140-149	control track and time code
diaphragm, 75	low, 72	Lighting director (LD), 22, 130,	editing, 291–294 expanded single-source
ENG/EFP, 8, 60, 337	operating levels, 55, 152	175, 363, 371, 372	system, 289–290
fast, 76	outdoor, 134, 179–180	Lighting instruments, 10,	insert, 278, 295–296, 301, 307
field, 70–72	reflected, 151, 172, 173	126–154. See also Lamps	multiple-source systems,
focal length of, 73–74	sensitivity of camera, 55, 146	camera light, 139–140	290–291
focus control in, 74–75	set, 161, 163–164 side, 161	clip light, 136	off- and on-line, 286–287
format, 72	window as, 180–182	and color temperature, 132,	single-source system, 288–289
<i>f</i> -stop, 45, 55, 75–76, 152–153		182–183	split, 295
HDTV, 50	Light-emitting diodes (LEDs),	control equipment for,	Linear video recording, 263
interchangeable, 60	222	140–149	
internal focus (I-F), 80, 337	Light level, operating, 55	diffusion tent, 10, 137, 139	Lip sync, 294
iris, 75–76, 77	Light meter, 173	dimmer control board, 20	Liquid crystal display (LCD),
macro position of, 74	Light plot, 175-176	directional controls for,	38, 61
and minimum object distance	Light stand, portable, 144	144–146	Live mixing, 231–232
(MOD), 73–74	Lighting, 9–10, 158–186. See also	field, 133–140	Location sketches, 427-429
narrow-angle, 85-87	Lighting instruments	floodlights, 10, 130–133,	for big remotes and sports
normal, 84–85	baselight, 55, 130, 150, 152–153	136–138, 183	remotes, 487–495
operational controls for, 78-81	below eye level, 165	fluorescent banks, 132, 165–166, 167, 182–183	for electronic field production,
optical characteristics of,	bouncing, 138	Fresnel spotlight, 128–129,	474
72–78	cameo, 169–170	133–134, 161, 165	interpreting, 437–440
performer and, 373-374	camera lights, 139–140	handheld, 139	for parade, 496
presetting, 75	chroma-key, 133, 170–171	HMI light, 134-135, 176, 182	Location survey, 184-185, 474
prime, 82	and color distortion, 168, 169	incandescent lamps, 153, 183	Locking-in point, 440, 464
quality of, 53	and color temperature, 132,	intensity controls for, 146-149	Lockup time, 281
range extender for, 72, 76	158–160	internal reflector spot, 136	Log, 21, 24
slow, 76	continuous-action, 166-167	lamp types for, 153	computerized, 299, 304, 305,
speed, 76	and contrast, 172-174	lighting kits, 136, 140	306
studio, 70–72	and controlling shadows,	mounting devices for, 140-144	field, 281, 282
wide-angle, 82–84	171–172	portable, 9, 10, 133-140	program, 24
zoom, 8, 48, 60, 70–72, 75, 84,	cross-keying, 167	positions of, 185	VTR, 287, 302–304, 467
106, 111, 112, 113	dimmer, 147–148	power for, 185–186	Logos, 342-343
zoom range, 70–72, 74, 79, 80, 112	ENG/EFP, 9–10, 133–140,	and safety, 176	Long-distance microphone, 208
	178–186, 476	soft box, 10	
Lens extenders, 59	falloff, 130, 145, 158, 161, 162,	softlights, 131–132, 137–138,	Long shot (LS)
Lens flare, 145	167–168, 179	161, 165–166	and depth of field, 78, 115–116
Letterbox format, 348	field, 133–140, 178–186	spotlights, 10, 128–130,	and sound, 239 wide-angle, 83
Leveling ball and bowl, 92, 94	flat, 131, 165–166 high-contrast, 167–169	133–136, 138–139 studio, 10, 128–133	
Libel, 410	high-key, 164, 174	umbrellas, light-reflecting,	Lossless and lossy compression,
Light	indoor, 180–183	182–183	34, 265–266, 299
available, 9, 178–185	intensity, 146–149, 150–152	V-light, 136–137, 182	Loudspeaker, 4
back, 161, 162, 163, 167, 174	kicker, 165	Lighting kit, 136, 140	Low-energy colors, 351–352
background, 161, 163–164	large areas, 167, 168, 182–183	0 0	Lowel-Light Manufacturing, 136
balancing intensity of,	low-key, 163, 174	Lighting patchboard, 20, 148–149	Low-impedance microphones,
174–175	minimum, 55	Lighting pole, 129	210
baselight, 55, 130, 150, 152–153	for moonlight illusion, 165, 174	Lightness, of color, 64	Low-key scene, lighting for, 163,
beam, 146–147	multiple-triangle, 166	Lightning effect, 341	174
contrast, 57, 65-66, 185	at night, 184	Line input, audio, 220	Low-Z microphone, 210
	- 0		1

Mosaic effect, 332

Lumen, 151-152 Luminaire, 128 Luminance, 45, 63, 64, 65, 253, 263, 350 and composite system, 263 and Y/C component system, and Y/color difference component system, 264 Luminance channel, 65-66 Luminant, 153 Lux, 55, 150 Macintosh platform, 34, 256, 298 Macro position of lens, 74 Maintenance engineer, 371, 372 Makeup, 386-388 Makeup and dressing rooms, 25, 387 Makeup artist, 370, 371 Manual zoom control, 79-80 Master control, 23-24 Master control switcher, 256, 257 Master control switching area, 23 Master fader, 252 Matte box, 66 Matte key, 323-325 MBps (megabytes per second), 60 MD (mini disc), 228 MDM (modular digital multitrack) recorders, 227

M/E (mix/effects) bus, 246-248 Mechanical video effect, 339-341 Medium requirements, 394, 435-437 Medium shot (MS) and field of view, 115-116 and performer, 374 Megahertz (MHz), 30 Memorizing lines, 383-384 Memory sticks and cards, 14 Mental map, 312-314

Menu camera viewfinder, 48, 58, 60, 61,62 of editing files, 299 portable mixer, 233 postproduction switchers, 255 professional CD and DVD players, 229 Metal halide lamp. See HMI lamp Microphones, 4, 5, 11, 192–216

and balanced output, 210-214

big boom, 200-201

boom, 170, 172, 194, 197-201, 240, 375 boundary, 203-204, 206, 207, 215 brands of, 211-213 capacitor, 209 cardioid, 191, 206 checking, 107 condenser, 195, 209, 223 desk, 203-205, 211-213, 232, 375 directional, 196 dual-redundancy, 195 dynamic, 195-196, 209 electret condenser, 209 electronic characteristics of, 190-193 fishpole, 172, 198-199, 375 and flat response, 210 frequency response of, 210 generating element of, 190 giraffe boom, 199-200 hand, 195-197, 211-213, 375 handheld, 195-197 handheld shotgun, 198, 375 hanging, 206-207 headset, 201 hidden, 207 hypercardioid, 192, 208 and impedance, 210 and interference, 204 lavaliere, 193-195, 202, 206, 207, 209, 213, 240, 375 long-distance, 208 mobile, 193-203 moving-coil, 209 for music, 194, 195, 202, 205, 210, 214-215, 216 omnidirectional, 191, 196, 201, 203, 208 operational characteristics of, 193-208 for outdoor use, 195, 196, 198-199 parabolic reflector, 208 perambulator boom, 200-201 pickup patterns of, 191-192, 211-213 and polar pattern, 191 pop filter for, 192, 195 ports, 198 pressure zone, 203-204, 215 radio frequency (RF), 202 ribbon, 191, 195-196, 209 shotgun, 197-199, 208, 209, 211 sound-generating elements of, 209-210 and sound quality, 210 stand, 205-206, 211-213 stationary, 193, 203-208 supercardioid, 192

system, 193 techniques for using, 375 tripod boom, 199-200 ultracardioid, 192 unbalanced, 210 unidirectional, 191, 196, 201, 203 velocity, 209 and wind jammer, 193 and windsock, 192 and windscreen, 192-193, 195 wireless, 194, 195, 202-203 Mic-level input, 220 Microwave relays, 501 Microwave transmission, 473, 500-501 MIDI (musical instrument digital interface), 237 Mini-cassettes, 262, 273 Mini disc (MD), 228 Mini-links, microwave, 501, 502 Mini plug, 60, 210, 214 Minimum illumination, 55 Minimum object distance (MOD), 73-74 Mix bus, 221, 245 Mixdown, 236 Mix/effects (M/E) bus, 246-248 Mixer audio, 5, 11 portable, 233 Mixing audio, 11, 12, 221, 233-234 live, 231-232 postproduction, 234, 236 Mix-minus feed, 232 MOD (minimum object distance), 73-74 Modular digital multitrack (MDM) recorders, 227 Moiré effect, 56-57, 358, 388 Moisture shutdown, automatic, 269 Monitors audio console, 220 control room, 21 line, 4, 5, 6, 21, 201, 245 preview (P/V), 4, 5, 6, 21, 245 studio, 19-20, 21, 176-177 video, 21 waveform, 45, 57, 475 Monochrome viewfinders, 9, 58

Morgue, news, 405

Mosaic filter, 43-44 314-316 140-144 453, 455 ence, 204 290-291 Music editing, 317 filter Negative closure, 112-123 Neumann KMR 81i microphone, Neutral density (ND) filter, 58, 76, 153, 179, 181, 476 News director, 373 Monopod, 90-91 Moonlight, lighting effect, 165, News production personnel,

Motion-JPEG, 34 Motion vector, 120, 303 Motion vector line, crossing, Mounting equipment, lighting, Moving-coil microphones, 209 Moving Picture Experts Group (MPEG), 34, 265 MP3 audio format, 228 MPEG (Moving Picture Experts Group), 34, 265 MPEG compression formats, 34 MPEG-2, 265, 266, 273, 299 MPEG-4, 275 Multicamera directing, 446, 450, Multicore cable, 58 Multifunction switchers, 246-248 Multi-image effects, 335 Multiple-microphone interfer-Multiple-source editing system, Multiple-triangle lighting, 166 microphones for, 194, 195, 202, 205, 210, 214-215, 216 Musical instrument digital interface (MIDI), 237 NABET (National Association of Broadcast Employees and Technicians), 410 Narrow-angle lens, 85-87 National Association of Broadcast Employees and Technicians (NABET), 410 National Television System Committee (NTSC), 28, 36, 47, 53, 66, 72, 263 ND. See Neutral density (ND)

370-371, 373

News script, 416, 418, 419

remote control, 102

lighting, 20, 148-149

News set in newsroom, 18-19 Optical discs, 14, 48, 274 Patching, 148, 176, 224 Pillarboxing, 348 computer-assisted, 148, 225 Newscast Optical filters, 61 Pillars, 359 hot-, 176 mixing for, 232 Optical video effects, 337-339 Pipe grid, 141 script for, 416, 418, 419 Pattern projector, 129-130 Optical zooming, 70-71 PixBox portable switching Nielsen rating service, 411 Pattern selector, 252 system, 254, 255 Oscilloscope, 45, 475 Nightshot mode, 55 Pause control, VTR, 268 Pixelized images, 44-45 Out-of-aspect-ratio graphics, NLE. See Nonlinear editing 346-347 PC platform. See Windows Pixels, 28, 34, 38, 44-45, 53-55, platform Noise 63-64, 330 Outdoor light, shooting and, artifacts, 33, 55, 152 PDP (plasma display panel), 38 and zooming, 71 179-180 signal-to-noise ratio, 56 HMI light for, 134 Peak program meter (PPM), 222 P.L. (private line) intercom video, 56 in overcast daylight, 180 system, 19, 22, 450, 453, Pedestal, studio, 8, 9, 47, 92-94 455, 500 Non-drop frame mode, 294 robotic, 100-102 Outdoor remotes, production for, 497-499 Plagiarism, 410 Nonlinear editing (NLE), 15-16, Pedestal up, down, 92, 96-97, 113 263, 273, 279, 284, 287-288, Outdoors, microphones for, 195, Plasma display panel (PDP), 38 Peel effect, 333 297-304 196, 198-199 Plate mount, 95 Perambulator boom, 200-201 audio, 235-236 Outline mode, 324-325 Platforms, scenery, 358-359, and capture, 279, 298-299 Performance techniques, 373-382 Output controls, audio, 222-223 363-365 and compression, 299 Performers, 369, 371, 373-376 Overexposing, 57 and shot sequencing, 312 Play VTR, 288 audio and, 375 and storage, 299 Over-the-shoulder shot (O/S), camera and, 373-375 Playback, 61 and visual effects, 330 115-116, 124, 314, 383 and close-ups, 374 Playback head, 226 and clothing, 173, 195, 324, 376 Nonlinear video recording, Polar pickup patterns, 191 15-16, 263floor manager's cues and, 376 PA (production assistant), 368, Polarity reversal, 333 postproduction and, 376 Nontechnical production 369, 371, 430 Pop filter for microphone, 192, prompting devices and, 371, personnel, 368-370 P.A. (public address system), 21 unions for, 409 376, 380-382 Pace, 469 and switching cameras, 374 Portable equipment Normal lens, 84-85 Packets, data, 33 timing and, 375-376 camera pedestal, 94 Normaled connections, 224 and warning cues, 374-375 DAT recorder, 227 Pads, 300 Noseroom, 119-120 editor, 288-289 Periaktos, 359 PAL composite system, 263 Notes, 460 floodlights, 136-138 Permits and clearances, 403-404 Pan-and-scan process, 348 producer, 404, 458 hard drives, 274 Personnel. See Production Pan-and-tilt heads, 92, 94-95 production assistant, 430, 458 lighting instruments, 9, 10, personnel Pan left, pan right, 94, 95, 97, 133-140 NTSC (National Television Perspective 108-109 mixer, 233 System Committee), 28, 36, distorting, as special effect, 47, 53, 66, 72, 263 reflector, 146 Pan stick makeup, 386, 387 330-331 spotlights, 133-136, 138-139 NTSC composite system, 28, 53, Panasonic AG-MX70 switcher, and narrow-angle lens, 85 265, 270 switching system, 254, 255 sound, 194, 239-240 NTSC signal, 36, 66, 256, 263 Ports, microphone, 198 Panasonic DVCPRO system, 13, and wide-angle lens, 82, 83 14, 48, 273 Positive closure, 121 Phantom power, 191, 223 Pancake makeup, 386, 387 Obscenity laws, 410 Postdubbing of dialogue, Phone plug, 60, 210, 214 238-239 OCP (operation control panel), 45 Panning, of sound, 240 Photographic lighting principle, Posterization, 332 Pantograph, 142, 143 Off-line editing, 286-287 162-163 Postproduction, 405 Omnidirectional microphone, Paper-and-pencil edit, 467 Photography, defined, 8 actor and, 384 191, 196, 201, 203, 208, Paper-and-pencil EDL, 304-305 Piano, microphone setups for, audio, 12, 234, 235-239 211-213 214-215 PAR lamp, 136 director and, 466-467 On-line editing, 286-287 Pickup device, on TV camera, 42 Parabolic reflector microphone, editing, 14-16, 154, 276, On-the-air procedures, 461–463 Pickup patterns, microphone, 284-318, 405 Open-face spotlight, 135-136 191-192, 211-213 Parades, production require-EFP, 477 cardioid, 191, 206, 211-213 Open-reel audio recorder, ments for, 494-499 evaluation and feedback, 405 225-226 hypercardioid, 192, 208, Patch cords, 224 mixing, 234, 236 211-213 Opening cue, 375 performer and, 376 Patchbay, 22, 148-149, 224-225, omnidirectional, 191, 196, recordkeeping, 405 Operating light level, 55 230, 237 201, 203, 208, 211-213 room, audio, 237 wired, 224-225 Operation control panel (OCP), polar, 191 switchers, 255-256 Patchboard, 22, 148-149 supercardioid, 192, 211-213 Postshow activities, 485 Operator control panel for audio, 22 unidirectional, 191, 201, 203,

211-213

Pot (potentiometer), 221

Power supply calculating electric power requirements, 186 camera, 46 for ENG/EFP cameras, 59-60 for lighting, 185-186 for remote truck (generator), 478, 483 for studio cameras, 57 Power switch, 62 PPM (peak program meter), 222 Pre-editing, 291, 300-304 preparation phase, 301-304 review phase, 301 shooting phase, 300-301 Preparation phase of pre-editing, 301-304 Preproduction, 277-279, 392-404, 413-442 big remote and, 478-480 coordination, 401-404 edit preparation, 278-279 EFP and, 474–475 equipment checklist for, 277 generating program ideas, 392-393 planning, 392-404, 414-440, 478-480 scheduling during, 277, 416 Preread function, editing, 290 Preroll, 288 Presence, sound, 192, 239 Preset bus, 245, 249 Preset/background, 246 Presetting zoom lens, 75, 111, 112, 113 Pressure zone microphone (PZM), 203-204, 215 Preview bus, 245-246 Preview/preset bus, 246-247 Preview (P/V) monitor, 4, 5, 6, 21, 245 Prism block, 42, 74 Private line (P.L.) intercom system, 19, 22, 450, 453, 455, 500 Process message, 394, 395, 431 director and, 415 formulating, 435 Producer, 368, 369, 370, 371, 373, 390-411 and evaluating production, 404 information resources for, 407-409 line, 369, 404 and postproduction, 405 and preproduction planning, 392-404

and scheduling, 407-408 Production, 13, 279-282, 392-411 big remote and, 480-486 budget, 397-401 checkpoints for, 280-281 EFP, 475-477 ENG, 473 evaluating, 404, 405 facilities, 402-403 field, 7-12, 474-477 method, 395-397, 415-416 models, 393-397 on-air procedures for, 461-463 permits and clearances, 403-404 recordkeeping during, 281 schedule, 403, 407-409 standby procedures for, 461 systems for, 4-7 Production assistant (PA), 368, 369, 371, 430 Production manager, 369, 371 Production meeting, 460, 474-475 Production models, 393-395 Production personnel, 8, 368-389, 401-402 above-the-line, 368, 371 below-the-line, 368, 371 communicating with, 416 database of, 401-402, 416 news, 370-371, 373 nontechnical, 368-370 support staff, 429-430 talent, 371-373 technical, 370 and unions, 409 Production survey, for remotes, 480, 481-482 Production switchers, 12-13, 254-255 Production system, basic and expanded, 4-7 Professional Sound PSC MilliMic microphone, 213 Program/background, 244 Program bus, 244-245, 246, 247, Program control, 21-22 Program duplication and distribution, 276 Program feeds, 23 Program input, 23 Program log, 24, 256 Program monitor, 6, 21

Program objective, 395

Program proposal, 395-401 presenting, 397-401 Program speakers, 20 Program storage and retrieval, 23 - 24Program title, 395 Programming, 13 Progressive scanning systems, 36 - 37Promotion, production process and, 404 Prompting devices, 376–382 Prop list, 360-361, 437 Properties (props), 24, 360-361 actor and, 383 Property manager, 360, 370, 371 Prosumer camcorder, 50, 52, 59, 72, 79, 102, 274 Protection copies of source tapes, 467 PSA (public service announcement), 23, 468 Psychographics, audience, 395, Psychological closure, 120-123 Public address system (P.A.), 21 Public hearings, production requirements for, 494-497 Public service announcement (PSA), 23, 468 Publicity, production process and, 404 Pulse-count editing, 291-293 Pulse-count system, 291 Pylon, 359 PZM (pressure zone microphone), 203-204, 215 Quality control, audio, 221-222 Quantizing, 30, 32 Quartz lamp, 153, 176, 182 Quick-release plate, 95 Rack focus, 86, 112, 113, 339 Radio frequency (RF) microphone, 202

Rain effect, 340

Range extender, 72, 76

Ratings, audience, 410-411

RCA phono plug, 60, 210, 214, RCU (remote control unit), 45, 50, 475 R-DAT recorders, 227 Readability, television graphics and, 349-350 Read/write optical discs, 274 Real time, 295 Record head, 226 Record inhibitor, 278 Record protection, 278 Record VTR, 15, 288 Recordkeeping, postproduction, Record/playback heads, 266 Redundancy, spatial and temporal, 265 Reel numbers, 302 Reel-to-reel audiotape recorder, Reference black and white, 173 Reference frame, 266 Reflected light, 151, 172, 173 Reflection effects, 338 Reflectors, 145-146 shooting in outdoor light and, 179 - 180shooting in indoor light and, 181 Refresh rate, 36, 37 Rehearsals blocking, 456 camera, 456-458, 460 directing, 430, 455–461 dress, 457-458 dry run, 456 for EFP, 477 script reading, 455-456 for single camera, 466 stop-start, 457-458 walk-through, 457 Remote control unit (RCU), 45, 50, 475 Remote engineer in charge, 372 Remote setups for big remotes, 7, 480–485 for sporting events, 487-494 Radio frequency (RF) output, Remote survey, 478-480, 481-483 VTR, 269 Remote truck, 478-479 Rail system for camera and microwave transmission, mounting, 102 500

Remote van, and microwave

Reporter, 373

transmission, 473, 500-501

351-352

Scanning area, 345-346

Reset, 458, 460 Scanning lines, 53-55 Sensitivity, camera specification, 55 Resolution Scanning systems, 36-38 DTV, 38-39, 50 Sequencing, of shots, 300, 305, interlaced, 28-29, 36, 37 HDTV, 52-55 progressive, 36-37 310-312, 431-434, 467 Retrace, horizontal and Scene design, 361-365 Sequencing cues, director's, 450 vertical, 36 Servo focus, 80 Scene numbers, 302 Reverb controls, 222 Servo zoom control, 79 Scenery, 24-25, 355-360 Reverse-angle shot, 314 Schedule time, 467 Review phase, pre-editing, 301 backgrounds, 363-364 Schedules, production, 403, designing, 361-365 RF jacks, 269 407-409 dressings, 24, 360 RF microphone, 202 and clock time, 467-468 floor plans for, 361-363 and director, 416 RF output, VR, 269 flooring on, 364-365 and subjective time, 468-469 RGB component system, 264, 267 furniture, 162, 360, 363 and time line, 404 RGB system, 28, 30 for interview, 175, 437-439 Scoop floodlight, 131, 161, 167 and beam splitter, 42-44 platforms, 358-359, 363-365 Screen Actors Guild (SAG), 409 and color mixing, 64-65 positioning, 363 Screen-center mark, 112 component system, 264, 267 properties, 24, 360-361 and white balancing, 51-52 Screen clutter, 349 strike, 206, 360, 460, 477 Ribbon microphone, 191, studio, 24-25 Screen Extras Guild (SEG), 409 195-196, 209 Set designer, 175 Screen size, and framing, 115 Riding in the red, 222 Scrim, 130, 138-139, 357 Set light, 161, 163-164 Riding the gain, 193, 222, 231 Script reading, rehearsals and, Set modules, 356-357 Risers, 358 455-456 Set pieces, 359-360 Robotic camera mounts, 100-102 Scripts Set units, 355 Robotic cameras, 9, 22, 80 analysis of, 440-442 Setup breakdown for single-camera, Robotic pedestal, 100-102 big-remote production, 464-466 Rock groups, microphones for, 480-484 documentary, 419, 420 215, 216 EFP production, 476-477 drama, 416, 417, 440 Room tone, 216, 301 720p scanning system, 37-38, formats, 416-419 47,66 Rotation effect, 333-334 marking, 419-427, 429 720p/30 system, 50 Rough-cut, 305 news, 416, 418, 419 Shader, 45, 173 Routing switchers, 256 partial, 419, 421 semiscripted, 419, 421, 432, Shading, 57 Rundown sheet, 419, 423 Smear, 56 433, 434 Shadows, controlling, 171-172, Running time, 467 software for formatting, 419 Run-out signal, 281 visualization and sequencing Share, audience, 410-411 Run-throughs, 430, 460 of, 431-434, 464 Shock mount, 198 writing, 401 Shooter, 473 Scroll, 381 S.A. (studio address) intercom Shooting phase of production, system, 455 Scrub through, 305 108-111 Safe title area, 58, 345 Search control, VTR, 268 after, 111-112 Safety Secondary frame effect, 335 before, 107-108 EFP shooting and, 178, 186 SEG (Screen Extras Guild), 409 pre-editing, 300-301 and studio lights, 176 SEG (special-effects generator), Shot list, 299 SAG (Screen Actors Guild), 409 251, 322 Shot sequence, 300, 305, 310-312 Sampler sound device, 238 Selective focus, 86 Shot sheet, 112, 113, 114, 423, 427 Sampling, 30, 31, 265, 272 Semiscripted format (partial Shotgun microphones, 197-199, Satellite script), 419, 421, 432, 433, 208, 209 downlink, 502-503 fishpole for, 198-199 frequencies, 501-502 Sennheiser MKE 102 microhow to use, 198 uplink, 473-474, 502-503 phone, 213 Shots. See specific type uplink van, 474-475 Sennheiser MKH 60 microphone, Shoulder-mounted camera, 90 Saturation, color, 64, 253, 350, 211

Sennheiser MKH 70 microphone,

211

Show format, 395, 419, 422

Show treatment, 395, 396

Shrinking images, 330-331 Shure SM57 microphone, 212 Shure SM58 microphone, 212, 215 Shure SM81 microphone, 212, 215 Shutter speed, 56 control, 62 Shuttle control, VTR, 268 Side bars, 348 Side light, 161, 164-165 Signal-to-noise (S/N) ratio, 56 Signal processing, 55 Signal transport, 33-34, 500-504 Silhouette lighting, 133, 164, 170 Singers, audio and mic setups for, 195-196, 202, 205, 210, 214-215, 232 Single-camera directing, 464-466 Single-source system, editing, 288-290 Site survey, 480 Skin tones, and color temperature, 159, 386-387 Slander, 410 Slant-track VTR systems, 266 Slate, 280, 281, 301 audio, 227, 281 Slide effect, 333 Slide faders, 222 Sliding rod, 142-143 Slow falloff, 161, 162, 179 Slow lens, 76 Smoke effect, 340 SMPTE (Society of Motion Picture and Television Engineers), 293 SMPTE time code, 238, 267, 299, 307 SMPTE/EBU time code, 293 Snapshot effect, 333 Snow (video artifacts), 56 Snow effect, 340 SNV (satellite news vehicle), 474 Soccer remote setup, 490 Society of Motion Picture and Television Engineers (SMPTE), 293 Soft box, 10, 137, 139, 140 Soft cut, 309 Soft wipe, 327-328 Softlight, 131-132, 161, 165-166

portable, 137-138

Subjective time, controlling,

Softwall flats, 355-356 Solarization, 332–333 Sony Betacam cameras, 13, 14, 46 Sony DVCAM system, 13, 14, 48 Sony ECM 55 microphone, 213 Sony ECM 77 microphone, 213 Sony ECM 672 microphone, 211 SOT (sound on tape), 232 Sound. See also Microphones aesthetics, 239-240 ambient, 111, 208, 215-216, 239, 240, 301, 317 continuity, 240, 317 and digital recording, 33 dubbed, 12 editing, 235-236, 302-303 energy, 190, 208, 209, 240 and environment, 239, 301 and figure/ground principle, 239 overmodulated, 231 perspective, 194, 239-240 pickup, 190-216 prerecorded, 12 presence, 192, 239 quality, controlling, 236-237 separating sounds, 233 stereo, 240 surround, 222-223, 236, 241 visual representation of, 236 Sound bite, 235, 304 Sound control equipment, 11-12, 220-234 audio console, 12, 220-224 audio control booth, 22, 229-230 audio mixer, 5, 11, 233, 290 ENG/EFP, 12, 232-234 patchbay, 22, 148-149, 224-225, 230, 237 recording and playback devices, 12, 225-229 studio, 12, 229-232 Sound designer, 370, 371 Sound effects, 238-239 Sound-generating elements of microphone, 209 Sound on tape (SOT), 232 Sound pickup. See Microphones Sound volume controls, 62 Source tape, 288, 310 protection copies of, 467 Source VTR, 15, 288 Spatial redundancy, 265 Speakers, in studio control room, 20, 21

Special effects, 13, 16-17, 33. See also Keying; Visual effects chroma-key, 170-171, 324-327 controls for, 251-253 layering, 248 fn, 251 wipes as, 309-310 Special-effects cues, director's, 451 Special-effects generator (SEG), 251, 322 Spiking actor's position, 383, 429 Spill, 460 Spilling over, 222 Split edit, 295 Split screen, 13, 328-329 Sports remotes, 85, 487-495 Sportscaster, 373 Spotlight effect, 329 Spotlights, 10, 128-130 clip light, 136 diffusing portable, 138-139 ellipsoidal, 129-130 external reflector, 135 follow, 130 Fresnel, 128-130, 133-134, 139, 140, 161, 162, 165 HMI light, 134-135 internal reflector, 136 open-face, 135-136 portable, 133-136 Spreader, tripod, 91-92 Stabilizer, image, 72, 86 Stage manager, 369, 485 Stage props, 360 Stagehands, 369 Stand microphone, 205-206, 211-213 Standard television (STV), aspect ratio for, 34-35, 344-345, 346-348 Standby mode, 268 Standby procedures, 461 Standby switch, 62 Star filter effect, 338-339 Station breaks, 23 Stationary robotic camera mount, 102 Steadicam mount, 98-99 Stereo sound, 240-241 Stock shot, 318 Stop down, 416 Stop-start rehearsal, 457-458 Stopwatch, 22

Storage systems, 23-24, 274, 275, 299. See also Videorecording systems Storyboards, 304, 361, 440-442 Streaming, 33 Streaming video, 275 Stretching images, 330-331 Striking the set, 206, 360, 460, 477 Strip light, 132-133 Striped filter, 43-44 Studio. See Television studio Studio address (S.A.) intercom system, 455 Studio camera, 8, 47-48 care of, 112, 114 checking the, 112-113 ENG/EFP camcorder as, 48, 49 intercom system on, 59 lens on, 70-72 operational items and controls for, 57-59 remote iris control on, 76 and servo zoom control, 79 tally light on, 59 and telephoto lens, 86 viewfinder on, 58-59 working the, 112-114 See also Lens; Zoom lens Studio control room, 20-23 audio control, 22, 220-225 directing from, 461-463 intercom system in, 21, 455 lighting control, 22 monitors, 21 program control, 21-22 switching in, 22 video control, 23 Studio crane, 100, 101 Studio engineer in charge, 372 Studio flooring, 364-365 Studio lighting instruments, 10, 128-133 Studio monitor, 19-20, 21, 176-177 Studio pedestal, 8, 9, 47, 92-94 Studio set, 24-25 Studio supervisor, 371 Studio talkback, 21, 455 Studio teleprompter, 381-382 Studio zoom lens, 70 STV (standard television), aspect ratio for, 34-35, 344-345, 346-348 Style, television graphics and, 352-353 Subjective camera, 437

468-469 Subtractive color mixing, 64-65, 154 Sunlight, shooting in, 179-180 Supercardioid pickup pattern, 192, 211-213 Superimposition (super), 245, 246, 251, 309 Supply reel, 226 Surround sound, 222-223, 236, 241 S-VHS videotape recorder, 13, 14, 46, 264, 269, 270, 271 record protection on, 278 S-video system, 262, 264 connector for, 60 iack for, 269 Sweeps, 359 Sweet spot, 240 Sweetening, audio, 234, 240, 307, 467 Swimming remote setup, 494 Switchers, 4, 5, 6, 12-13, 22, 290 analog, 258 architecture, 248 audio-follow-video, 258 buses, 244-248 component, 258 composite, 256-258 delegation controls, 246, 247-248 digital, 256, 258 functions of, 254-256 interface, 257 key-level control, 252, 323 layout of, 244-248 manual, 24 master control, 256, 257 multifunction, 246-248 operation of, 248-253 postproduction, 255-256 production, 12-13, 254-255 routing, 256 software, 255-256 Switching, 12-13, 22, 242-258, 284 flip-flop, 249 script marking for, 419, 423-427 Sync generator, 45, 46 Sync pulse, 46, 267, 278, 291 Sync roll, 295 Sync track, 267 Synchronizer, audio/video, 238, 294, 307 Synthetic images, 353-354

System, 4 System microphone, 193 Take numbers, 302 Takeup reel, 226 Taking a level, 231 Talent, 368, 369, 371-373. See also Actors; Performers and auditions, 384-385 and big remotes, 486 and clothing color, 173, 388-389 and floor manager, 429, 430 and makeup, 386-388 and performance techniques, 373-382 and prompting devices, 376-382 walk-through, 457 Talking heads, 395 Tally light, 48, 59, 113, 374 Tape numbers, 302 Tape-based digital recording systems, 227-228, 263. 273-275. See also Linear editing Tape-based video recorders, 266-273 Tapeless recording systems, 14, 23, 228-229 Target audience, 395 TD (technical director), 20, 112, 254, 371, 372 Tech meeting, 459 Technical director (TD), 20, 112, 254, 371, 372 Technical personnel and crew, 370-372 unions for, 410 Technical survey, for remotes, 480, 483 Technical walk-through rehearsals, 57 Telephoto lens, 85-87 Teleprompter, 371 field, 184, 382 studio, 112, 381-382 Telescope hanger, 142-143 Telescoping pedestal column, 93 Television camera, 8-9, 42-66 analog versus digital, 46-47 beam splitter on, 42-43, 44 and camera lights, 139-140 consumer, 8 and control unit (CCU), 4, 5, 6, 23, 45-46, 49, 55, 76, 112

electronic cinema, 66 electronic shutter on, 56 ENG/EFP, 48 filter, for color, 42-44 and focus-assist feature, 81 functions of, 42-43 and gain control, 55-56 HDV, 50 HDTV, 47-48, 66 imaging device on, 8, 42, 43-45 isolated (iso), 59, 484-485 lens for, 8, 42, 48, 50, 69-87 mounting equipment for, 8, 9, 87-102 movements, 95-96 parts of, 42, 43 and performers, 373-375 pickup device on, 42 robotic, 9, 22, 80 studio, 8, 47-48 types of, 46-50 and video signal, 42-45 viewfinder, 9, 42, 48, 58-59 wedge mount for, 95 See also Camera mounting equipment; ENG/EFP cameras and camcorders Television gobos, 130, 145, 337-338 Television graphics, 344-354 and aspect ratio, 344-347 and color, 350-352 generated, 353-354 information density in, 348-350 out-of-aspect-ratio, 346-347 readability of, 349-350 scanning and essential areas, 345-346 style of, 352-353 synthetic, 353-354 Television receiver, 4-5, 13, 37, 38, 66, 117, 269, 345, 429 Television studio, 4-7, 18-20 acoustic treatment in, 19 air-conditioning in, 19 audio equipment in, 220-232 ceiling height of, 18 doors in, 19 floor for, 18 intercom system in, 19 lighting in, 9-10, 128-133, 158-177 makeup and dressing rooms in, 25 program speakers in, 20 scenery and properties in, 24-25 size of, 18

studio monitors in, 19-20 support areas, 24-25 wall outlets in, 20 Television system, 4 Temporal redundancy, 265 1080i system, 38, 47, 50 Tennis remote setup, 492 Test tone, 279 Three-dimensional effects, 330, 353 Threefold, 355 Three-shot, 115-116 Thunder box, 241 Tilt up, down, 96-97 Time base corrector (TBC), 269 Time code, 281, 291, 292, 293, 302 and window dub, 301-302 Time code editing, 293-294 Time code generator, 293 Time code recording, 227, 293 Time cues, 377-378 Time line, 404, 407, 460-461, 466 EFP, 475 preparing, 459-461 Timing, performer and, 375-376, Title key, 16 Title. See also Character generator (C.G.) animated, 349 and aspect ratio, 346 and busy background, 349-350 block layout for, 349-350 and color, 351 and downstream keyer, 252 fonts for, 349 keys, 246 and readability, 349-350 and safe title area, 58, 345 superimposing, 322 Tongue left, right, 96-97 Track left, right, 96-97 Tracking control, VTR, 268-269 Traffic reporter, 373 Transcribing audio track, 236 Transducing light into electricity, 55 sound into electricity, 190 Transition devices, 305, 309-310 Transmitter, 5, 6, 473, 500-501 Transponder, 502 Treatment, 395, 396

Triangle lighting, 162-163, 165–166, 180–183 Triaxial (triax) cable, 58 Tricycle steering position, 93 Trim control, audio, 221 Trim the lights, 142 Tripart budget, 397-400 Tripod, 9, 91-92, 93 Tripod boom, 199-200 Tripod dolly, 92 Truck left, right, 82, 86, 96-97 Trunk line, 503 TV black, TV white, 350-351 Twofolds, 355 Two-shot, 115-116, 124 Ultimatte, 327 Ultracardioid microphone, 192 Umbrella reflector, 183 Unbalanced microphone or line, 210 Unidirectional microphone, 191, 201, 203, 211–213 Uninterrupted run-through rehearsal, 457-458 Unions, 409, 410 Unit manager, 485 Uplink trucks, 502-503 Uplinks, satellite, 473-474, 502-503 Utilities personnel, 369

Variable-focal-length lens, 73 VCR (videocassette recorder), 13 Vector scope, 45 Vectors, 303, 314-316 crossing vector line, 314-316 graphic, 303 index, 119-120, 303 motion, 120, 303, 314-316 Velocity microphone, 209 Vertical blanking, 36 Vertical detail (lines of resolution), 53-55 Vertical retrace, 36 Vertical wipe, 327 VHS cassette, record protection on, 278 VHS videotape recorder, 13, 14, 262, 269, 270 Video/audio synchronizing, 238, 272, 294, 307

Video connector, 60

Video control, 23 Video effects analog, 322-329 digital, 33, 258, 298, 326, 329-336 Video leader, 279-280 Video monitors, 21 Video noise, 56 Video operator (VO), 5, 51, 57, 76, 112, 173, 177, 279, 371, 372 Video production switcher. See Switcher Video recording archiving, 276 duplication and distribution, 276 and time delay, 276 Video-recording systems, 261-282 analog, 262 composite and component, 263-264 and compression, 265 digital, 262 disk-based, 263, 287, 307 flash memory, 274 hard disk, 273-274 linear, 263 nonlinear, 264 read/write optical, 274 and sampling, 265 tape-based, 266-273 tapeless, 14, 23, 273-275 Y/C component, 264 Video servers, 273 Video signal, 4 Videocassette recorder (VCR), 13 Videographer, 373, 473 Videotape editor, 371, 372, 373 Videotape operator, 45, 371, 372 Videotape recorder (VTR), 4, 13-14, 223, 266-267 analog, 262, 266-267, 269-270 checking, 107 controls, 267-269 cues, 453 digital, 262, 267, 270-273 formats, 13-14 and framestore synchronizer, 269 jacks for, 269 log, 287, 302-304, 467 and moisture shutdown, 269 preread function of, 290 source, 15, 288 and time base corrector, 269 Videotape recording, 266-267

checkpoints for, 280-281 Videotape tracks, 266 Videotaping EFP, 477 Viewfinder, 9, 42, 48, 58-59, 60-62, 66 on camcorder, 108 indicators, 61 on studio camera, 113 Visible lines, on TV screens, 36 Visual continuity, 240 Visual effects, 16-17, 251-253, 322-341 analog, 322-329 bounce, 333-334 chroma keying, 324-327 computer-manipulated, 330 cube spin, 335 defocus, 339 diffusion filter, 338-339 digital, 33, 258, 298, 326, 329-336 distorted perspective, 330-331 echo, 335-336 fire, 340-341 fly, 335 fog, 339, 340 and fractals, 353-354 gobos, television, 130, 145, 337-338 keying, 322-327 lightning, 341 mechanical, 339-341 mosaic, 16, 332 multi-image, 335-336 nonelectronic, 337-341 optical, 337-339 peel, 333 perspective, 330–331 positioning images, 330-331 posterization, 332 rain, 340 reflections, 338 rotation, 333-334 secondary frame, 335 shrinking and expanding, 330-331 slide, 333 smoke, 340 snapshot, 333 snow, 340 solarization, 332-333 split screen, 13, 328–329 spotlight, 329 star filter, 338-339 stretching, 330-331 superimposition, 322 synthetic, 353-354 wind, 340 wipes, 246, 309-310, 327-329

Visualization cues, director's, 446-449 Visualization of script, 431–434, 464 V-light, 136-137, 182 VO (video operator), 5, 51, 57, 76, 112, 173, 177, 279, 371, 372 Voice coil, 209 Volts, 186 Volume control, 221, 231 Volume unit (VU) meter, 222 VTR. See Videotape recorder VTR controls, 62 VTR cues, director's, 453 VTR log, 287, 302-304, 467 VTR operator, 280-281 VTR switch, 62 VU (volume unit) meter, 222 Wagons, 358-359 Walkie-talkies, 59 Walk-through rehearsals, 457, 458-459, 477 Wall outlets, in television studio, 20 Wardrobe person, 370, 371 Watts, 186 Waveform monitor, 45, 57, 475 Weathercaster, 373 Weathercasting and chroma-key effect, 170-171, 324-325 clothing for, 324, 389 maps for, 17, 353 special effects for, 353 Wedge mount, 95 WGA (Writers Guild of America), 409 White-balance indicator, 62 White-balancing the camera, 45, 51-52, 138 and color temperature, 159, 183, 317 White level, 173 Wide-angle lens, 82-84 Wind effect, 340 Wind jammer, 193, 215 Window dub, 301-302, 304 Windows platform, 34, 256, 298 Windscreen, 192-193, 195, 208, 215 Windsock, 192-193 Wipe controls, 252 Wipe mode, 252

Wipe patterns, 252, 328-329 Wipes, 246, 309-310, 327-329 horizontal, 327 positions and directions, 328 soft, 327-328 split screen, 13, 328-329 vertical, 327 Wired patchbay, 224-225 Wireless microphone, 194, 195, 202-203 how to use, 203 Wire-mesh screen, 147 Workprints, 293 Wrestling remote setup, 493 Writer, 368, 370, 371, 373, 401 Writers Guild of America (WGA), 409 XLR connector, 60, 210, 214 X/S (cross-shot), 115-116, 383 Y channel, 65-66

Y channel, 65–66 Y signal, 45, 65–66 Y/C component system, 258, 264, 265, 267, 270 Y/color difference component system, 264, 265, 267, 269, 272

Z-axis, 123 Zebra pattern, 61 Zeppelin, 192 Zip disks, 228, 274, 278 Zoom control, 78-80 Zoom lens, 8, 48, 60, 70-72, 106 calibrating, 75, 111, 112, 113 checking the, 112 field, 70 focal length of, 73-74, 77-78 focusing, 74 and graphics, 84 and lens format, 72 maximum positions of, 70-71 and minimum object distance (MOD), 73-74 presetting, 75, 111, 112 range of, 70-72 range extender for, 72 stabilizers for, 72 studio, 70-72 types of, 70-72 Zoom range, 70-72 Zooming, 70-72, 84, 96-97 on camcorder, 50, 108

digital versus optical, 70-72, 80